THE ARCHITECTURAL DRAWINGS OF
ANTONIO DA SANGALLO THE YOUNGER
AND HIS CIRCLE

THE ARCHITECTURAL DRAWINGS OF ANTONIO DA SANGALLO THE YOUNGER AND HIS CIRCLE

VOLUME I

Fortifications, Machines, and Festival Architecture

General Editor CHRISTOPH L. FROMMEL
Editor NICHOLAS ADAMS

Coordination by Christoph Jobst

THE ARCHITECTURAL HISTORY FOUNDATION
New York, New York

The MIT Press Cambridge, Massachusetts, and London, England

Library of Congress Cataloging-in-Publication Data

The Architectural drawings of antonio da Sangallo
the Younger and his circle/general editor, Christoph
L. Frommel; editor, Nicholas Adams
p. cm.
Includes bibliographical references and index.
Contents: v. 1. Fortifications, machines, and festival
architecture.
ISBN 0-262-06155-4
1. Sangallo, Antonio da, 1484–1546—Catalogs.
2. Architectural drawing—16th century—Italy—
Catalogs. I. Frommel, Christoph Luitpold. II. Adams,
Nicholas.
NA2707.S26A4 1993
720'.22'22—dc20
93-25102

Christoph L. Frommel is co-director of the
Bibliotheca Hertziana in Rome. Nicholas Adams is
professor of architectural history at Vassar College,
Poughkeepsie, New York.
Designed and typeset by Bessas & Ackerman.

This volume was conceived in close collaboration
with the Bibliotheca Hertziana (Max Planck
Institute) whose facilities and staff helped to make it
possible.

The preparation of the volumes that constitute this
work was made possible by the National
Endowment for the Humanities, an independent
federal agency, which provided a Challenge Grant
and an Access grant.

The Challenge Grant was matched by Skidmore,
Owings & Merrill, the J. M. Kaplan Fund, the
Graham Foundation for Advanced Studies in Fine
Arts, the Samuel H. Kress Foundation, Mrs. Barnett
Newman, and the Lauder Foundation.

Entries by Nicholas Adams, Enzo Bentivoglio,
Fabiano Fagliari Zeni Buchicchio, Marcello Fagiolo,
Francesco Paolo Fiore, Hildegard Giess, Pier Nicola
Pagliara, Simon Pepper, Gustina Scaglia, Gian Luca
Veronese. With contributions by Ian Campbell,
Maria Losito, and Gabriele Morolli. Coordination
provided by Christoph Jobst (1984–88). Translations
by Renate Franciscono and Jean Molli.

Contents

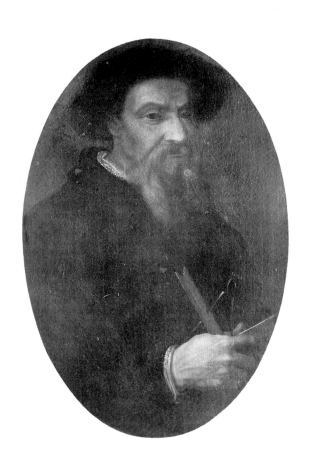

Acknowledgments

The idea of a corpus of the architectural drawings of Antonio da Sangallo and his circle was born during a series of discussions in 1983 with the Architectural History Foundation. It has been a project long on my mind. Since my student years I have worked with the architectural drawings of the Renaissance, especially those of Antonio da Sangallo the Younger, and it became overwhelmingly clear to me that the lack of or inadequate publication of most of these drawings presented a significant impediment. Every study of an important building in central Italy from the period after 1500 necessitated the review of sometimes thousands of drawings—often a pleasurable but always a time-consuming task. Luckily most of them can be studied in the Gabinetto dei Disegni of the Uffizi under unusually agreeable conditions. Yet their arrangement, attribution, and dating often no longer accord with contemporary research.

This untapped resource is a boon to scholarship and presents a very special kind of challenge. For the drawings left by Antonio the Younger and his long-time partner Peruzzi were the first to survive in their entirety. This was possible only because architectural drawings began to take on a hitherto unrecognized importance in the course of the fifteenth century. Because Antonio worked for many years in close collaboration first with Bramante, then with Raphael, his early drawings are the most important supplement to the few surviving drawings of these two masters. Briefly put, not only are Antonio's drawings the earliest to afford a comprehensive insight into architectural creation, they also reflect one of the most important epochs of architectural history and mark the beginning of a new style of architectural drawing. Many of the methods and ways of representing architecture still valid today were developed at that time.

Coping with such a project was beyond the capacity of a single individual. Thanks to the help of the Architectural History Foundation, it was possible to assemble a team of proven authorities, who parceled out the drawings of Antonio and his workshop among themselves on the basis of their typology, topography, and chronology. Many questions could only be answered in common, especially because a single drawing often includes a variety of different objects. Despite the generosity of the publisher, the wealth of material demanded extreme restriction in our commentaries, and we are therefore aware that our results often remain fragmentary and in need of improvement.

Inevitably, an undertaking of this sort must bow to the exigencies of time, economy, and organization: The assembling of a corpus of more than a thousand drawings with contributions from almost two dozen collaborators writing in three languages requires enormous patience. Initial plans were to publish the entire corpus in numerical order following the Uffizi system. The advantages this would have offered (ease of use, single point reference) were offset, in the end, by the impossibility of bringing the scholars' work on distinct topics to completion at the same time. Cross-references between topics were also difficult to balance. In the end we have organized the material into subjects, following the work of the scholars themselves. The corpus will be a multi volume publication. A series of indices and appendices will allow further cross-subject searches within each volume.

Antonio da Sangallo the Younger's universal abilities, which embraced not only many types of architecture but also the construction of machines and war engines, archaeology, stage design, mathematics, and astronomy, can in this way be appreciated more clearly. Within each volume we have maintained numerical sequence. In the end, as with any corpus, the accumulation of all the pieces inevitably supersedes any fragmentary knowledge we may have had when we began. Our hope is that the appearance of this corpus will lead to new insights and new comparative studies and be a stimulus for new work and new study in the period of the activity of Antonio da Sangallo the Younger and his circle.

Many people are to be thanked for their contributions to this project. First of all, I would like to express my gratitude to Victoria Newhouse, President of the Architectural History Foundation, for seeing the project through to its completion. Her encouragement and support came at critical times. We are both grateful to the director of the Uffizi in Florence, Anna Maria Petrioli-Tofani. My student Christoph Jobst took on the initial task of coordinating the research team, identifying the drawings to be worked on, providing the photocopies to each of the scholar-collaborators, and organizing the initial seminar on the architectural drawings that took place in Rome in 1985.

This corpus would never have been published if, in 1988, Nicholas Adams had not taken on the difficult task of editor. Thanks to his profound knowledge of the material, his organizational and diplomatic skills, and his great patience, the many problems confronting this project were overcome, and the frequently heterogeneous contributions to it have been melded into a unified whole. He also gave me important inspiration for this introduction. Not the least of my thanks are owed to my many collaborators on these volumes. The constant exchange of questions and findings raised this project beyond a compilation of isolated studies and made us aware time and again of being a genuine team; it gave us the benefit of an intellectual dialogue, without which scholarship cannot exist.

Christiane Denker Nesselrath provided important assistance for the organization of the early phases of the project. Pia Kehl was a valuable and indispensable help in the lengthy editing of the introduction. Wendy Wegener translated the first version with such sureness, empathy, and clarity that this collaboration would certainly have continued if her untimely death had not taken her from us.

Nicholas Adams's work as editor has been sup-ported by the National Endowment for the Humanities through the American Academy in Rome (1987/88) and the Institute for Advanced Study at Princeton (1992/93). Support has also been provided by the College of Arts and Sciences at Lehigh University and its enlightened dean, John Hunt (1988/89). Later, support was provided by Vassar College and its Research Fund (1990, 1992/93). Help also came from the Dipartimento di Storia in the Facoltà di Architettura at the University of Rome, which provided a summer's support. Special thanks are due Arnaldo Bruschi, Francesco Paolo Fiore, Pier Nicola Pagliara, and Anna Rosa Cerutti-Fusco. In Florence, Daniela Lamberini, of the University of Florence, made special trips to the Gabinetto dei Disegni to verify information. Student assistants provided their valuable interest. In addition to Janet Temos, who was responsible for coolly reorganizing the entire corpus in a moment of crisis, thanks are due Laura Stoland, James Mast, and Grazyna Wicik. Work on the final transition to book form was undertaken during 1992/93 within the friendly confines of the Institute for Advanced Study at Princeton, New Jersey. Nicholas Adams especially acknowledges Irving Lavin for his encouragement during that time.

A tool hardly used until recently for questionable datings is provided by Heinrich Wurm's study of the watermarks, using the latest scientific methods. His data base supplies information on which sheets bear identical watermarks. Wurm's watermark census, the index of which will be published in the last volume of this corpus, represents a pioneering effort in the long-ignored field of paper research. The work of Dr. Wurm and Dr. Jobst has been supported by funds arranged by the former curator of the Bibliotheca Hertziana, Ernst Plettner.

The volumes are graced with photographs of the drawings made available by the Bibliotheca Hertziana as well as new photographs that have been partially underwritten by Henry A. Millon at the Center for Advanced Study in the Visual Arts at the National Gallery in Washington, D.C.

C.L. FROMMEL

THE ARCHITECTURAL DRAWINGS OF
ANTONIO DA SANGALLO THE YOUNGER
AND HIS CIRCLE

Introduction.
The Drawings of Antonio da Sangallo the Younger:
History, Evolution, Method, Function

State of Research

Even before the first drawings entered the collection of the Grand Dukes of Tuscany in 1574, they may have been accessible through Antonio da Sangallo the Younger's heirs to the few interested in them. Some of the most beautiful were already acquired at that time by early collectors such as Giorgio Vasari.[1] Yet not until Percier referred to Antonio's plan U 314A for his reconstruction of the Villa Madama, around 1790, is their influence traceable.[2] Percier's student Paul Letarouilly (1795–1855) was in Rome between 1820 and 1824 and at that time began preparations for his *Edifices de Rome moderne*, which is linked in so many respects with Percier and Fontaine's *Palais, maisons et autres édifices modernes dessinés à Rome*.[3] Letarouilly must have been informed by Percier of the unexplored treasures in the Uffizi and probably used them from the beginning for his reconstructions of the early projects for St. Peter's or of the Palazzo Farnese.[4] Already in 1775 another early historian of Renaissance architecture, Seroux d'Agincourt, had acquired a volume with architectural drawings from Mariette's papers. It may still have been identical with one of the many volumes of Vasari's *Libro* and included among others Fra Giocondo's U 6A for St. Peter's and a series of studies after antique capitals and cornices that had been attributed wrongly to Antonio da Sangallo the Younger probably already by Vasari.[5]

Seroux sold the volume in 1798 to the Grand Duke of Tuscany and published one of the so-called Sangallo drawings and U 6A, whose attribution to Fra Giocondo was based solely on Antonio's inscription on the verso, in his *Histoire de l'art* of 1811 forward.[6]

That Seroux's volume included also drawings by Antonio himself is confirmed by other sources from these years.

Strangely enough, G. Gaye was totally unaware of the existence of Antonio the Younger's drawings in the Uffizi when, in 1840, he published a letter of 1574, in which Antonio di Orazio da Sangallo offered twenty-one volumes of his grandfather's drawings of fortifications to the grand duke.[7] The letter aroused general interest, and Carlo Pini and the Milanesi brothers, who were experienced archivists, began to work on the drawings soon after their rediscovery.[8] The first systematic description of Antonio's drawings followed in 1854, in the appendix to the Antonio da Sangallo *vita* in the eleventh volume of Le Monnier's edition of Vasari.[9] In this descriptive catalogue, which Gaetano Milanesi printed unchanged in the commentary to his Sangallo *vita* of 1880 (and thus probably regarded as his intellectual property), hundreds of Antonio the Younger's drawings were arranged and described typologically and topographically, and many of Antonio's inscriptions were transcribed. The sheets were at that time still in old albums that were much less systematically arranged but followed typological criteria. Volumes I and V contained most of the drawings for St. Peter's; Volume II, studies for churches and chapels; Volume III, studies for doors, fireplaces, capitals, and other details; Volume IV, secular buildings; Volume V, sacred buildings; Volume VI, studies from Antiquity; Volume VII, fortifications; and Volume VIII, geometric and mechanical studies. In each volume both the drawings and the pages, on which more than one drawing often were pasted, were numbered. In fact, the numbers mentioned in the catalogue of

1854, which probably predate the nineteenth century, are still found on many of the drawings. Thus the arrangement of Antonio's designs in twenty-one volumes, as they were described by his grandson in 1574, had been changed rather early. In 1865, when the architect Albert Jahn began working with the drawings in order to collect "materials for a critical illumination of the architectural works of the Italian Renaissance," the entire collection of architectural drawings in the Uffizi, bound and unbound, was divided among forty-nine volumes, but in Pini and Milanesi's arrangement by artist.[10]

The achievement of Carlo Pini and the Milanesi brothers cannot be overestimated. They were the first to rely on verifiable autographs to determine individual handwritings, and they already exhibited a surprising sureness in distinguishing between Antonio the Younger and his collaborators. Carlo Pini, the first curator of the drawings, subsequently published a huge collection of samples of artists' handwritings from the fourteenth to the seventeenth century, which still today is indispensable for the attribution of drawings.[11]

Even before Jahn, historically oriented scholars such as Guglielmotti had included drawings by Antonio da Sangallo the Younger in their specialized research.[12] But a historico-critical methodology for examining architectural drawings began to develop only with Heinrich von Geymüller. Geymüller had received a degree in engineering in Paris and studied architecture and architectural history at the Berlin Bauakademie, thus combining the tradition of French pioneers such as Percier and Letarouilly with the more historical German approach represented above all by his correspondent of many years, Jakob Burckhardt.[13] In 1864 he may have seen Letarouilly's unpublished bequest in Paris. Subsequently he spent two years in Italy, where on 5 February 1866 he proudly identified the plan in red chalk on U 20A as "the first completely certain drawing by Bramante for St. Peter's in Rome."[14] For his systematic study of the early designs for St. Peter's he could take advantage of the preliminary studies by Pini and Milanesi. Like Jahn before him, he found the drawings reordered in folders according to masters.[15] Peruzzi's designs were to be found in folders 1 and 2, those of Antonio the Younger in folders 4–7. From 1868 onward Geymüller and Pini drew on their growing expertise to develop a more and more precise identification of the Renaissance drawings.

Geymüller's masterly analyses (for example, of the large red chalk plan U 20A), his sure instinct, and his expertise have survived the oversubtle criticisms of more recent scholars who doubted his attribution to Bramante of the red chalk group (U 8A v., 20A, 104A, 7945A).[16] The care with which Geymüller proceeded is revealed by his doubts about the autograph nature of U 1A, despite the express testimony on the verso in Antonio's later handwriting. In other instances, Geymüller's views have been revised. Nevertheless, the specialization of recent years has only refined his method and hardly any of the more recent authors who have devoted themselves to this material is gifted with a comparable eye. The quality of the reproductions in his monographs on St. Peter's of 1875–80 and on Raphael of 1884 has never been achieved again.[17]

The discoveries of Pini, Milanesi, Geymüller, and others then went into Ferri's 1885 catalogue of the architectural drawings of the Uffizi, to this day the only one and of inestimable value for our corpus. Ferri even tried, not altogether convincingly, to define Antonio as a figural draftsman.[18]

While the monographs of Gustav Clausse of 1910 and Lukomsky of 1930 on Antonio da Sangallo the Younger contributed only slightly to our knowledge of his drawings, we remain indebted to Bartoli's large and superbly illustrated work of 1914–22 on the drawings of antiquities in the Uffizi by Renaissance architects for a further substantial contribution to our knowledge of the various hands, above all those of the Sangallo circle. Astonishingly, it then took until the eve of the Second World War before another important scholar, Gustavo Giovannoni, took on Antonio's drawings and, in particular, those of his later career. Even Geymüller had not considered anything after 1537, since he thought that the level of the later drawings declined. As Salmi reports in his foreword of 1959, Geymüller had himself encouraged Giovannoni to undertake his great Sangallo monograph, certainly on the basis of the acute individual studies that Giovannoni had published from the time of his *Saggi sull'architettura del Rinascimento* of 1935. When Giovannoni died in 1947 the work was by no means finished. He acknowledges in an introductory chapter that he was inspired directly by Bartoli, and that his book should really be entitled "L'opera di Antonio da Sangallo nei disegni degli Uffizi, riveduti e commentati." In actuality, his text relies primarily on an identification, novel in many regards, of the graphic projects, of which he catalogued more or less precisely over a thousand. Unfortunately, the work trails far behind Geymüller and Bartoli in the number and quality of the illustrations as well as in its philological apparatus, so that Gio-

vannoni's insight can be appreciated only partially by the reader.

A long series of monographic investigations on Antonio's individual works and projects followed in the wake of Giovannoni's book, for the most part from the pens of scholars who were directly or indirectly his pupils. The Bibliotheca Hertziana, too, became the breeding ground for further studies of the work of Antonio the Younger after 1953, when Franz Graf Wolff Metternich founded a center for studies of Renaissance architecture and in particular of New St. Peter's. Researchers like Heinrich Thelen set new standards for the study of the architectural drawings with his edition of Borromini's drawings.[19]

By the time Wolfgang Lotz stepped in as Metternich's successor as director of the Bibliotheca Hertziana in 1963, he had already dedicated a fundamental study to the representation of space in the architectural drawings of the Renaissance. Since then, the criticism of drawings has new criteria at its disposal for study, particularly as regards the evolution of the representation of architectural space and the process of design from the Late Middle Ages, criteria that Lotz himself demonstrated in the case of Antonio's drawings. The extent to which his conclusions, particularly for the Bramante and Sangallo circle, are still valid today will be among the issues to be explored in studies within this volume. In the English translation of his 1977 article, Lotz still concurred with Ackerman's judgment: "None of his [Antonio the Younger's] nearly one thousand architectural drawings in the Uffizi can be dated with certainty before 1517 or 1518."[20]

It would lead us too far afield to try to do justice to all the individual studies that have appeared in the wake of the research of Giovannoni, Metternich, Lotz, and others during the last few decades on the most important complexes of Antonio's architectural work.[21] Many of these studies draw support, much more carefully than even Giovannoni, from long-neglected archival material, so that in the meantime the majority of Antonio's buildings have been thoroughly researched. It is this very splintering of our formidable current state of knowledge, however, that makes the synthesis of a corpus all the more desirable, and so it is only to be welcomed that the majority of our collaborators have, for the most part, been recruited from among these authors. In short, the course of research in the last thirty years on Antonio da Sangallo the Younger was propitious for our undertaking, and at present the time is ripe for an edition of the corpus.

The Collection of Antonio da Sangallo the Younger

The architectural drawings of Antonio da Sangallo the Younger survive in greater numbers than those of any earlier architect. Yet, like Michelangelo, Antonio the Younger seems to have regarded only a part, probably the smaller part, as worth saving.[22] The collection of the drawings, therefore, poses enormous questions. Were they saved to document a building process? As works of graphic art? As a collector's item? Why are there so few finished drawings of the buildings as they were completed? Why so many hasty sketches?

For the architects of the Renaissance, and especially for the members of the Bramante and Sangallo circle, architecture had become a science. It presupposed not only a high measure of artistic creativity and technical ability, but also humanistic and archaeological knowledge as well as minute calculation.[23] In these terms, drawing of mathematical precision was necessary not only for the incorporation of older structures within the new, as was common practice especially in Rome, but also for the construction of fortifications and for making visual records of antiquities, where the architects would have to search out individual elements of a monument in cellars, courtyards, or gardens and recompose them to the precise fraction of a *palmo*.[24] Drawing, therefore, was knowledge. Antonio also preserved purely conceptual sketches—not so much as documents of a self-conscious inventor than as protocols of his thought processes, possibly useful to him or his followers at some later point.

Antonio the Younger and his drawings thus occupy a key position in the history of European architecture; he may even have hoped that the Fabbrica di San Pietro—to which he belonged for at least thirty-seven years and which he directed for twenty-six years—and his own workshop as well would outlive him to create a genuine tradition in the sense of the medieval workshops. There talents could be trained in practical matters of construction as he himself had been trained following the works and drawings of the great masters. The drawings thus would provide a record, the *archivio* of his thoughts that he refers to from time to time.

As part of the process of ordering his thoughts, then, Antonio the Younger had also attempted to identify and order his sheets. The first time might have been in the critical years after the Sack of Rome in 1527, when commissions slowed. In the same years he also found the time to attempt a translation and commentary of Vitruvius.[25]

In the lines of the 1531 draft for the foreword we

hear the self-conscious voice of a man who during his life had not only tried to understand and interpret Vitruvius but also to translate him into practice. One of the greatest obstacles to understanding Vitruvius's often obscure text was the loss of the illustrations: "La settima e la più importante (delle cause . . .che. . .non è anchora stato inteso questo nostro auctore di Vitruvio) si è che per la brievità dello scrivere lui promette mostrare li corpi formati col disegno e soscritti, quali non si trovano, o che la longhezza del tempo li abia fatti perdere o che di se perché li ignoranti non avessino a sapere quanto che lui." According to Antonio, Vitruvius wanted to prove his abilities to the emperor, who always gave the big commissions to others, but he took care not to lay open his inventions to imitation by others. Vitruvius's followers had nevertheless made his principles their own. Antonio believed further that it was possible to rediscover Vitruvius's theories in imperial architecture and that no one was better suited to do so than he himself.

This lofty goal thus demanded that he make a patient and detailed comparison among Vitruvius's doctrines, the surviving buildings, and the few other pertinent antique texts. Both texts and buildings had to yield their secrets, each testing the other in a continual process of exchange. Both leave their traces in Antonio's drawings and so he might have preserved them, not least of all for that moment when he would find the time for the completion of his Vitruvius commentary.

That he got down to the business of ordering and identifying his drawings toward the end of Clement VII's pontificate is revealed by inscriptions such as "Modani dela vigna del papa" on U 718A v., or "per la vigna del papa" on U 1356A v.[26] Around 1518/19, during the time they were executed, Antonio would hardly have indicated the villa of Cardinal Giulio de' Medici as "del papa," and after the death of Clement VII he would certainly have added his name to the pope's title. The handwriting tells us that the inscription "Finestre del chardinale farnese" on U 1001A is even to be dated to a time before 1528.[27] If he failed to inscribe many other sheets of a similar character, that is certainly because he rarely found time for such retrospective activity in the busy world of his architectural practice. The more complex and numerous his tasks, however, the more he may have made it a habit to identify his sheets immediately, if only to inform his many collaborators who then had to fill out the sketches or carry them out. Thus after 1538 he notes on U 57A "per santo pietro per sopra li pilastri delle

navette tonde quando se avera a fare li architravi grandi."[28] Occasionally his memory fails him, as for example in the later inscription on U 257A r., a facade design for St. Peter's from 1518, which he refers to as "faccia delo emiciclo tondo di s.to pietro," surely because during these years he had above all else been occupied with the south transept.[29] With the ground plan fragment on the verso of the same sheet he restricts himself to the uninformative formula "modani di più cose." On the plan project U 1146A, most likely by his co-worker Riniero da Pisa, for the reinforcement of the dome piers at Loreto, he even admits, "non so dove e non so di chi."[30] If Antonio's identifications, noted mostly on the less important sides (generally called the verso today), are often repeated by a later hand on the more important side (generally called the recto), that is certainly because his heirs preserved the sheets in albums.

From projects in which he himself had taken part, Antonio the Younger also retained a few designs by Bramante, Fra Giocondo, and Raphael, such as U 1A, 6A, 136A, 169A, 287A, and 1356A. These too were inscribed and identified, mostly after 1530, and inserted into his collection.[31] Nevertheless it is likely that not all of the sheets were identified, and it is conceivable that he possessed further projects by Bramante and Raphael, such as U 20A, 242A, and, possibly, 560A.[32] In individual cases it can now no longer be decided, since other drawings by Bramante, such as U 8A v., or 104A, in which Giuliano da Sangallo also had a hand, could have ended up in the Uffizi by way of his heirs.[33] Among the many drawings of antiquities that Antonio collected, annotated, and corrected at various stages in his career are also to be found some sheets by as yet unidentified co-workers or assistants from his early period. The drawings of his cousin and close collaborator Giovan Francesco da Sangallo may, after his death in 1530, have devolved directly to Antonio the Younger.[34] Giovanni Battista, who outlived his elder brother Antonio the Younger by two years, left the Vitruvius translation to the Brotherhood of the Misericordia.[35] Most of his numerous drawings in the Uffizi nevertheless were created for Antonio the Younger, and for that reason were found in the latter's papers—like the many drawings by Labacco, Giovan Francesco, Riniero da Pisa, Baronino, and others in the Sangallo circle.

Antonio the Younger's bequest probably would have come down to us in less complete form if collectors and art dealers had not begun just then to take an interest in architectural drawings. Even before 1550, Jacopo Strada tried to purchase the architectural

drawings of famous masters like Raphael and Giulio.[36] At about the same time, Vasari included in his *Libro de' Disegni* the drawings of such great architects as Brunelleschi, Alberti, Bramante, the Sangalli, Peruzzi, Sanmicheli, Michelangelo, and Palladio .[37] He may have owned, and partially identified and framed, clean drawings by A. da Sangallo such as U 66A, 67A, 172A, 173A, 178A, *189A, 199A, 259A, 829A, and 862A. But in the process he was not always able to distinguish between the two Antonios.[38]

Antonio da Sangallo the Younger died 3 October 1546. Pier Luigi Farnese, Duke of Parma and son of Paul III, immediately moved to acquire Sangallo's "cose, e spetialmente i disegni e i libri."[39] In vain Pier Luigi exerted his influence to have Giovanni Battista, who was attentive to his desires, named ward of the children and thus administrator of the inheritance. Pier Luigi had grown up from childhood in intimate association with Antonio the Younger's planning of the family palace in Rome, and had entrusted him in 1537 with the construction of his new residence at Castro.[40] Nevertheless, he was far more concerned with the projects "di San Pietro in poi" than with the designs for the numerous Farnese buildings. This fact can be interpreted in various ways, since from about 1509 Antonio had been part of the workshop of St. Peter's. But probably Pier Luigi meant neither the early phase under Bramante nor the years together with Raphael, but rather the time since around 1520 when Antonio the Younger headed all the major projects of the Papal State and thus also its fortifications.[41] Among the drawings of interest to the duke were Antonio's fortification projects for Castro, Parma, and Piacenza, whose dissemination Pier Luigi, in his own interest, could hardly have wished to see.[42] But even if he was not motivated primarily by political reasons to take this step, Antonio's drawings must have represented for Pier Luigi the very embodiment of Vitruvian teaching, the sum of all the knowledge that a modern architect and engineer could acquire, a treasure that for him as well as for his architects and engineers was more precious than the commentaries of a Fra Giocondo, a Cesariano, or a Serlio. After all, if it were a question of an overriding political need, surely the pope would also have been involved.

Until Antonio the Younger's only son, Orazio, reached his majority, his business affairs were administered by a distant relative, the sculptor Alberto da Sangallo, and he and Orazio were probably the ones who together held the collection of drawings left after Antonio's death.[43] In any case, the drawings were in the family's possession until 24 September 1574 when Orazio's only son and heir, also named Antonio, suggested the possible donation of one hundred drawings to the Grand Duke of Tuscany, Ferdinand I: "Havendo trovato alchuni disegni di fortezze di città, tanto del Suo felicissimo stato, quanto ancora di altri luoghi."[44] He adds that they were distributed throughout twenty-one volumes, in which Antonio the Younger's drawings had been pasted after his death, apparently without a strict typological order. Probably with this gesture Antonio's grandson wanted to win the favor of the grand duke, whom he served for years as a diplomat and to whose fame he dedicated his historical writings. Perhaps he also hoped to move Ferdinand to the purchase of the rest of the drawings. When he picked fortification projects for Florence and other locations as part of the initial donation, he revealed that the informative content of the sheets still enjoyed top priority: Antonio the Younger's ideas for the modernization of fortifications had not yet lost their topicality.[45]

The majority of Antonio's remaining drawings probably were added to the grand duke's collection soon afterward. Others entered the collection about 1574 with part of Vasari's *Libro de' Disegni*.[46] The coincidence with the donation of Antonio's grandson hardly was casual. Apparently this was the moment when the grand dukes became interested in architectural drawings. Another volume of Vasari's *Libro*, which had come with Crozat, Mariette, and the Gaddi to Seroux d'Agincourt, was acquired only in 1798. Yet other drawings—surprisingly, some dealing with fortifications along with letters written to Antonio and books in his possession—came from the collection of the Gaddi and their followers. This probably had been miscellany kept in the possession of Antonio's grandson.[47] Finally, some designs for fortifications apparently were found in an album of Francesco De Marchi's in the Biblioteca Magliabecchiana in Florence.[48]

Architectural Drawing before Antonio da Sangallo the Younger

Architectural drawing is as ancient as monumental architecture. But only in the course of Antiquity did the methodology known to us from Vitruvius's treatise come to maturity.[49] The practice of making not only ground plans—as documented, for example, by the Carolingian plan for St. Gall—but also elevations

*Sheets illustrated in the present volume (pages 275–494) are indicated by an asterisk preceding the Uffizi number. Sheets not asterisked will be reproduced in Volumes Two and Three of this corpus.

and sections, could not have been completely lost during the time prior to the beginning of the Gothic. Villard de Honnecourt's builders' lodge book presents the broad spectrum of possibilities in drawing during the early thirteenth century, which included the complementary representation of interior and exterior walls.[50] Thus it is not very credible to argue, as has repeatedly been done, that Gothic builders had largely dispensed with the aid of drawing.[51] After the artistic means for representing spatial depth had mostly been forgotten, Gothic architects perfected above all purely orthogonal, geometrically constructed methods of designing.

Giotto and the great Sienese artists were the first to re-create the prerequisites for a pictorial style of architectural drawing. Even though orthogonal sketches remained the basis for all architectural designing, in Tuscany they increasingly were supplemented by models and by presentation drawings of the highest pictorial quality.[52] Significantly, especially in Florence with its feeling for plasticity and its democratic constitution, the use of models provided not only patrons and the interested public but also builders and even the architect himself with a concrete representation of a project; and models could hardly be completed without orthogonal preparatory drawings.[53] By means of shading and the characterization of materials through color, presentation drawings—prime examples are those of the campanile of the Duomo and the chapel of the Piazza del Campo in Siena—gained a previously unknown clarity.[54] At the same time, methods for linear perspective were devised: to give, for example, a more plastic appearance to the portal zone in the designs for the facade of the Cathedral of Orvieto.[55] Even architects made some use of perspective, as when Antonio di Vincenzo clarified his copies of a cross section and ground plan of the Cathedral of Milan in 1389 by means of perspective details.[56] But even now linear perspective had a merely secondary function—like color and modeling—in the architectural drawings of the Trecento, whether in orthogonal elevations or in cross sections. Jacopo della Quercia may have been the first to make extensive use of perspective in his presentation drawings of 1408 onward for the Fonte Gaia.[57] By 1367, such a mass of drawings and models had already been collected in the Florentine builders' lodge that it became necessary to destroy everything not relevant to the current project.[58] This is all the more noteworthy because numerous presentation drawings and working designs, as was already common in Antiquity and the High Gothic, were drawn on walls and floors.[59]

As a sculptor and as chief architect of the Florentine cathedral, Brunelleschi knew all the currently used methods of representation.[60] When he built a model of the cathedral dome to scale, or showed the Baptistery in correct perspective for the first time, or designed an elevation to scale for the Loggia degli Innocenti, using the "braccio piccolo," he was continuing the tradition of the Trecento. And when he restricted his presentation project for Santo Spirito to a ground plan, and in his other buildings, too, left an astonishing number of decisions to verbal explanation, he did so on the basis of personal experience and preference, not because he was unable to do otherwise.[61] We only have to read Manetti's description of Brunelleschi's studies from Antiquity to learn of his familiarity with orthogonal representation. Apparently he simply sketched the orthogonal course of individual walls "grossamente" on squared-off strips of parchment and added measurements and clarifying symbols, certainly with the intention of making clean copies of everything later at home.[62] Those elevations that he restricted to the most important elements must have been similar to Giuliano's presumed copy of his design for S. Maria degli Angeli.[63]

Architectural drawing became increasingly more important during the first decades of the Quattrocento; by 1464 Filarete was able to assert that "il disegno è fondamento e via d'ogni arte che di mano si faccia. . ."[64] In his description of the design process, Filarete distinguished between several stages of design: sketches not drawn to scale—the "disegno in di grosso"—in which the architect illustrated his concept for his patron; the "disegno proporzionato," provided with a grid divided into *braccia* and thus with exact measurements; and the "disegno rilevato," or wooden model—intended for presentation as well as execution—which was constructed directly from the scale drawing.[65] In all of this, probably only the grid on the drawing paper, which Brunelleschi and Alberti had already used,[66] went beyond normal building practices.

For the illustrations in his treatise, Filarete typically preferred perspectival elevations and cross sections—such as had served in Giovanni di Gherardo's 1425 representation of the dome of the Florence cathedral—as a graphic equivalent to wooden models.[67]

While Filarete thus reflected the building practices of his time, Alberti tried to put the training and methods of the architect on a more systematic basis.[68] Because the real achievement for him lay in the "lineamentum"—not, that is, in the material realization, but in the artistic concept—he gave twice as much

importance to the methodology of designing.[69] The creative architect should, therefore, restrict himself to purely orthogonal means of representation—that is, to ground plans, elevations, and cross sections—and then translate these into a wooden model ("factis asserula seu quavis re") that would include information about the interior organization, such as the thickness of the ceilings ("parietum faciem et tectorum firmitatem"), and thus would be partially open.[70] The budding architect should thoroughly measure and analyze the best buildings, and even use models, so as to learn the principles of good construction.[71] An architect has to rely on a knowledge not only of geometry and arithmetic but also of painting—which he uses as the equivalent of drawing—in order to be able to put his ideas on paper, test them, and prepare for their translation into a model.[72] He should, however, leave the visualization of architecture through perspective and chiaroscuro to a painter and keep his models free of all painterly enticements.[73]

We do not know to what extent Alberti followed these prescriptions himself. The random survival of graphic efforts from his hand, such as the simple plan of a bath complex or the rapid sketch for the volutes of S. Francesco in Rimini, by no means conveys an adequate impression of his abilities as a draftsman, as must have been required by the design of the complex system of S. Andrea in Mantua, if nothing else.[74]

In any case, many decades were to pass before his principles were accepted. Francesco di Giorgio, Giuliano da Sangallo, and Bramante, his most important successors, certainly proceeded differently. Surviving material—above all studies from Antiquity, illustrations in treatises, and Bramante's Prevedari engraving—permit only indirect conclusions about building practices. These practices are probably most immediately reflected in the drawings of Cronaca, who in contrast to the other three masters was a pure architect and, probably for this reason alone, primarily made use of orthogonal representation.[75] But purely technical, and often quite artless, orthogonal designs were not yet deemed worthy of preservation, whereas shaded perspective views were certain to arouse admiration.

Francesco di Giorgio (1439–1501) was already following Alberti's advice to learn from good architecture, and on his numerous journeys he sketched and reconstructed the monuments of Antiquity.[76] Coming as he did from the then *retardataire* school of Siena, however, he did not have sufficient preparation to do justice to Alberti's requirements. Even though he captured the monuments astonishingly well in some of the

sketches he made at the site—for instance, S. Stefano Rotondo on U 330A v.—his clean drawings of the Colosseum, Pantheon, Basilica of Maxentius, and S. Costanza are seen in a conditioned way and schematically simplified. In his reconstructions of destroyed complexes, such as the Capitoline and the Serapaeum, he took less from Antiquity than from his own time.[77] It is not by chance that the path toward an analytical understanding of the ancient monuments followed by his foremost student Peruzzi was far longer than that of his junior by four years, Antonio da Sangallo the Younger.[78] Be that as it may, in his representations of ancient buildings, Francesco di Giorgio had already tried to convey a maximum of information by showing—in the Turin Codex, for example—not just ground plans but also perspectival sections and overall views, albeit usually without a scale or measurements.

By origin, the younger Florentine Giuliano da Sangallo (ca. 1445–1516) was certainly closest to Alberti and may even have known him personally.[79] On the first page of the *Libro* he asserts proudly that he began making studies from Antiquity as early as 1465.[80] He may have had a hand at that time in the construction of the Palazzo Venezia, which was under the direction of the papal architect Francesco del Borgo, a close follower of Alberti.[81] At any rate, some reworked copies of his drawings from these early years have survived in two sketchbooks. They must have been similar to the ground plan of S. Costanza on U 4372A, probably an anonymous copy of a lost original by Giuliano, which he then recopied in simplified form on folio 16 of the *Libro*.[82] Although Giuliano used both these sketchbooks until the last years of his life, the *Taccuino Senese* corresponds to an earlier phase in his development: It contains a disproportionately large number of projects from the time before 1500, and its generally harder style of representation never reaches the new level achieved in architectural drawing in Rome after 1504. Not by chance, about 1503/4 Antonio copied his earliest drawings after the antique from the *Taccuino* and not from the *Libro*, which probably did not yet exist (see Figs. 7, 8).[83]

Whereas Giuliano documented his own inventions in the *Taccuino* merely with cursory ground plans, he depicted the ancient monuments and Andrea Bregno's Cappella Piccolomini—much admired since its construction—in elevations in partial perspective, with some hatching and a hard linear style that shows the drawings to be close in time to the purely orthogonal sheets of his compatriot Cronaca. His theoretical studies of orders—and especially of the Doric entablatures "in Boario"—from which the young Antonio may

have profited, and which look far more archaic than comparable studies by the Bramante circle from about 1506, probably must also fall in the time before 1504 (see Fig. 13).[84] Only the Colosseum he showed with a ground plan, perspective section, perspective elevation, and pictorial view, thereby approaching Alberti's demand for thoroughness (see Fig. 11).[85] But even these cannot stand comparison with Antonio's probably later precise structural measurements of the same building of about 1504/5 (see Fig. 10).[86] Only in the details of the *Taccuino* did Giuliano—again like Cronaca—give minute measurements, breaking the Florentine *braccio* down into *punti* (0.000203 m), that is, 1/2880 (see Fig. 13).[87]

In Bramante's circle, the *Taccuino senese* was bound to seem antiquated before long, and this may have led Giuliano to rework his drawings of Antiquity in a more exacting style soon after his arrival in Rome, that is, sometime after the spring of 1504. Compared with the *Taccuino*, the earliest part of the Codex Barberini, the so-called *Libro Piccolo* (fols. 1–17), is distinguished by its greater care and more corporeal sensuousness. It can be dated securely before 1508 by copies in the Codex Escurialensis.[88] When, soon afterward, Giuliano reworked his drawings of ancient triumphal arches—among them even some from the *Taccuino*—in the *Libro degli archi* (fols. 18–27), he chose a larger format to which he adapted the *Libro Piccolo* by adding strips to the margins. These reworked drawings reveal a closeness to his design of 1505 for a gallery for the papal trumpets but especially to his designs for Loreto of ca. 1506/7, with their greater contrast of light and shade.[89] He could well have made the fantastic reconstructions of ancient monuments that he developed on empty pages of the *Libro Piccolo* while he was in Florence in 1507–13 and dependent on his own means, without a partner to criticize him. He may also have made the copies after Ghirlandaio that were found in the third fascicle (fols. 28–37) at that time.[90] Only in the fourth fascicle (fols. 38–47), which he probably began in Rome before 1510, did he approach the spirit of Bramante, as in his drawings of the tomb of Theodoric of about 1506/7 (see Fig. 18).[91] Not until he returned to Rome in the spring of 1513 and began working closely with his now grown son, Francesco, did he make the drawings in the last part of the *Libro,* for which he adopted Bramante's more rational and precise methods of representation.[92] As in his contemporaneous designs for the Torre Borgia and the facade of S. Lorenzo, he increasingly combined painterly chiaroscuro with strict orthogonality,[93] and in studies like those of the Serapaeum he achieved such precision that even Antonio the Younger used them as models,[94] as just now can be observed in an exchange of ideas he had with his more advanced nephew.[95]

The chronology of the *Libro* presented above is obscured by the fact that, like Francesco, Giuliano filled empty pages, marginal strips, and smaller areas of the earlier fascicles with later drawings, just as he recorded his July 1513 measurements of the Colosseum on the much earlier folio 7 r. of the *Taccuino,* or added capitals on folio 33 v.[96] In those last years, then, he was no longer concerned with systematization or coherence. Such details as the Doric entablature in his designs for S. Lorenzo show that he never wholly adapted to Bramante's world, and his nephews must have moved farther and farther away from him at that time in their understanding of architecture, especially ancient architecture.

There is no doubt that Alberti's postulates were realized by Bramante (1444–1514) as soon as he moved from Milan to Rome. Bramante had already shown in 1481, in his Prevedari engraving, that he was more capable of representing a complex interior than any of his contemporaries.[97] Indeed, in all probability he had already worked out this representation earlier for himself in orthogonal sketches or even in models. In any event, the Prevedari engraving even shows vaults and the thickness of walls, just as Alberti had recommended. He was familiar with the orthogonal triad not only from Alberti's treatise, to which he was indebted in so many ways, but also from the cathedral builders' lodge in Milan.[98]

How Bramante's Milanese clean drawings may have looked is shown by a presentation drawing in the Louvre of about 1505 for a church facade possibly made by his pupil Cristoforo Solari.[99] Its main story is drawn in strict orthogonals with some perspective visual aid offered only in the pediment zone. Giuliano, in contrast, still used a perspective elevation in the presentation drawing—also from about 1505—of his design for the papal musicians' gallery. Only around 1513, in his design for the Torre Borgia, did he decide to use an orthogonality comparable to that of Cronaca's drawings or the project in the Louvre.[100]

Thus, already during his time in Milan, Bramante seems to have followed Alberti's distinction between a "painterly" view, such as the Prevedari engraving, and a primarily "architectonic" presentation drawing. Some impression of the character of his conceptual sketches may be gained from the contemporaneous drawings of his friend Leonardo.[101] Leonardo alternated, according to object or idea, between orthogo-

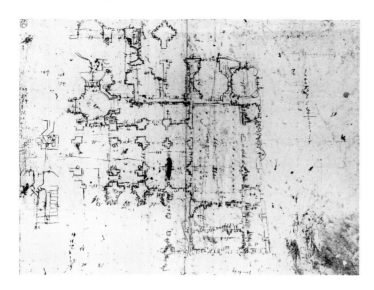

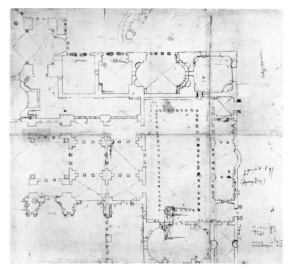

1 Donato Bramante(?). Ground plan of the Baths of Diocletian, detail (U 104A r.; ca. 1505).

2 Antonio da Sangallo the Younger. Ground plan of the Baths of Diocletian (U 2134A v.; ca. 1505/6).

nal elevations and perspective views; he combined ground plans with interior or exterior bird's-eye views; and sometimes he even included the ground plans in perspective foreshortenings.[102] He was also familiar with the use of the compass.[103] Bramante may have been equally free in his sketches of ideas and projects when they were merely intended to contribute to the solution of an immediate problem.

Before 1500 Bramante had studied Roman monuments only sporadically, as his Milanese buildings indicate. According to Vasari, he made up for lost time during his first years in Rome.[104] On U 104A r., probably his only extant drawing after the antique, he measures the ground plan of the Baths of Diocletian with an exactness still unknown in Francesco di Giorgio's studies or in Giuliano's in the *Taccuino senese* (Fig 1).[105] Although he invariably rounds off his *palmi romani,* one senses throughout that he was no longer satisfied with schematic approximations. Rather, he examines the mutual relationship of individual rooms, the articulation of the walls and staircases, and the requirements of structure wholly in Alberti's sense—surely because in his contemporary projects for St. Peter's he wanted to profit from the principles involved in the plans of the baths. On U 104A v. he sketched an elevation scheme of the entrance facade and various details in pure orthogonal projection, and in a ground plan sketch he at once translated the compositional principle of the baths surrounded by a courtyard into a project for St. Peter's all his own.[106]

The fact that Giuliano da Sangallo summed up two detail measurements of the great peristyle in his own hand indicates that he at least participated in its analysis. Thus the sheet probably was made during his close collaboration with Bramante at St. Peter's in 1505. Bramante's pioneering achievement soon was superseded by Antonio's much more exact measurements, which seem to take their point of departure from U 104A r. and can hardly date after 1506 (Fig. 2).[107] The ground plan of a relatively well-preserved building like the Baths of Diocletian would in no way have sufficed for Bramante's purposes; elevations, cross sections, and views had to be added, as they presumably also existed in the planning of St. Peter's.[108]

Bramante must have made such precise and systematic measurements from the beginning of his stay in Rome. The Doric entablatures of the Tempietto, Palazzo Caprini, or the Cortile del Belvedere, dating from 1501–4, presuppose a hitherto uncommon precision, both for the projects and for the preliminary studies, which must have included not only important Doric entablatures but also the specifications given by Vitruvius and Alberti, and must have gone far beyond comparable drawings of Doric orders in Giuliano's *Taccuino.*

The full extent of the revolutionary changes that Bramante effected even in the realm of architectural drawing is evidenced by the new precision and systematization cultivated by Peruzzi, Antonio da Sangallo, and Giancristoforo Romano from about 1506

on.[109] It was then—that is, at the very moment when preparations were being made for the construction of St. Peter's—that the seeds sown by Alberti's *De re aedificatoria* really began to grow.

Antonio's First Endeavors and his Collaboration with Giuliano and Bramante

Giorgio Vasari, the only close and well-informed contemporary to comment on Antonio da Sangallo's artistic beginnings, reports that he learned carpentry "nella sua fanciullezza." He must then have been around ten years old, and Vasari reports that his architectural talent soon became apparent and that he then followed both uncles to Rome.[110] Given his birth on 12 April 1484, Antonio the Younger would most likely have first entered into training under Antonio the Elder, who was occupied primarily between 1496 and 1498 with the coffered ceiling of the "sala nova" of the Palazzo della Signoria,[111] an experience that stood the younger Antonio in good stead for the rest of his life.

How important Antonio the Elder was for the boy's formation is shown above all by the affinity of their drawing styles and handwritings (see Fig. 7b, n). The sketchy, free, sometimes expressive manner of the two Antonios seems, compared with Giuliano's style, to have been formed primarily by Filippino (Figs. 3, 4).[111a] We do not know when Antonio the Elder's relationship with Filippino began; it certainly existed in 1494, and it is conceivable that Filippino, who had just returned from a sojourn of many years in Rome, gained a growing influence over Antonio the Elder during Giuliano's absence. Since the effect of this influence survived long after Filippino's death in 1504, Antonio the Elder must have been instructed relatively early by Filippino, who was almost the same age.

From early 1497 on, young Antonio must have become also the student of Giuliano, who had just returned from a two-year absence and shared his home and workshop with his brother.[112] Not only was the young Antonio able to profit from Giuliano's profound knowledge of ancient architecture and the Vitruvian orders, a knowledge captured in the latter's *Taccuino senese*, but he was able to garner his first experience in design and execution at the building sites of S. Maria delle Carceri in Prato, Palazzo Gondi, S. Maria Maddalena dei Pazzi, and the Sangalli's own house in Borgo Pinti.[113]

It is unlikely that the young Antonio followed Giuliano to Loreto in 1499, but it is conceivable that he accompanied Antonio the Elder to Rome in

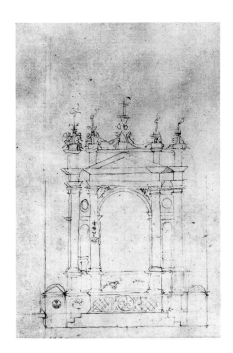

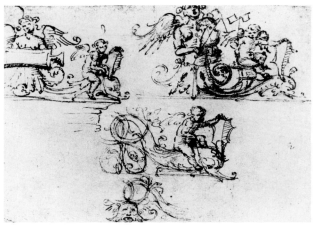

3 Antonio da Sangallo the Elder. Sketch for the high altar for the Madonna di S. Biagio at Montepulciano (U 1568A r.; ca. 1520).

4 Filippino Lippi. Decorative motifs with putto and a dolphin from the Golden House of Nero (private collection).

1499–1502, in order to participate in the construction of the coffered ceiling in S. Maria Maggiore and the Rocca of Civita Castellana—both works that would have a further influence on Antonio's early endeavors.[114] On 14 January 1504, the then nineteen-year-old was once again living in extremely modest circumstances with his parents in Florence, where Giuliano since 1500 and Antonio the Elder since 1502 were again active.[115]

In the few autobiographical remarks that Antonio the Younger weaves into the 1531 foreword to his planned edition of Vitruvius, it is significant that he nevertheless does not acknowledge at all his uncles as his teachers: ". . .abiamo consumato li studii nostri in Roma dalla eta nostra di anni XVIII al principio del pontificato di papa Julio nel MD. . .[lacuna]. . .e sempre stato alli servitii de' detti pontefici in le loro fabriche al tempo di papa Julio sotto Bramante sino a l'anno. . .[lacuna] del pontificato di Lione, dipoi in compagnia di Rafaelo da Urbino fino all'anno. . .[lacuna] di Lione. . .[lacuna]."[116]

Notably, he does not maintain that he first came to Rome under Julius II, but rather speaks only of the beginnings of his studies. Nor does he mention any other teacher, only his uninterrupted work on the papal buildings, which extended into Leo X's first year, under Bramante, and subsequently continued in collaboration with Raphael. With this, he is mistaken about a span of almost two years, for he probably did not come to the court of Julius II until shortly before his twentieth birthday. His imprecise memory for dates is also revealed by other gaps in his foreword. That he was still primarily under Giuliano's influence during his first years in Rome is shown by his early drawings; Vasari was also correct in this respect.

The same can be said for Vasari's report that Antonio did not become Bramante's collaborator until Giuliano returned to Florence in the spring of 1509. When Antonio, together with an apparently older compatriot, Sebastiano di Marco da Sangallo, constructed the triumphal arch for the return of Julius II from Bologna in March 1507, he was surely following a project of Giuliano's.[117] Well qualified as he was for such a task, Giuliano was perhaps even entrusted with the artistic direction of the ceremonial procession, even though, according to Vasari, he too accompanied the pope to Bologna.[118] The two carpenters were probably still under Giuliano's direction in July 1507 when they worked on the papal Rocca of Nettuno, which was begun about 1501, probably by Giuliano's brother Antonio the Elder.[119] At any rate, in 1507 Antonio the Younger was not yet a member of the builders' lodge

of St. Peter's and the Cortile del Belvedere. As late as December 1508, when Giuliano returned from Florence at the request of the pope in order to complete the fortification of the Vatican and Borgo, it was he and not Bramante who vouched for Antonio's work in the Rocca of Ostia and saw to it that Antonio was working at the Vatican just when the pope was staying in Ostia.[120] Antonio's work on the new Vatican apartments of Julius II—"pro portis finestris et altris lignaminibus"—is documented for June 1508[121] and continued probably until 1509. He could have designed the fireplace for the Sala di Costantino and the coffered ceiling on U 1623A, 1646A, and 2153A at that time, perhaps even as a substitute for Giuliano, who was mostly absent from the end of 1507 until the end of 1508 (Fig. 5).[122] The executed version of this fireplace differs from Antonio's design primarily in the

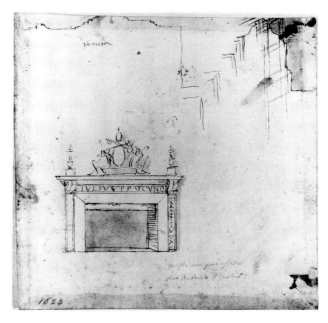

5 Antonio da Sangallo the Younger. Project for the chimneypiece of the Sala di Costantino (U 1623A v. [lower part] and 1646A v. [upper part]; ca. 1508).

atectonic relation of the consoles to the entablature, which brings it closer to Giuliano's more decorative style—and thus Giuliano may have partially corrected Antonio's project.[123] Only toward 1511–13, after Antonio had changed the logogram for *braccio*,[124] did he complete the sketch—erroneously attributed to Labacco—of Julius II's fireplace in the Magliana, whose irregular measurements in *braccia fiorentine* and *minuti,* and overly steep proportions, indicate a copy rather than an original design (Fig. 6).[125] This fireplace looks so much more rigorous than that of the Sala di Costantino that it could have been designed by Bramante himself after Giuliano's departure in the spring of 1509.

From the fact that Antonio was working in the papal apartments of the Vatican as well as at the *rocche* of Ostia and Nettuno ca. 1507/8, and, what is more, largely in Giuliano's entourage, we may conclude that he was not promoted to Bramante's assistant until Giuliano left in the spring of 1509 and was before that Giuliano's closest collaborator. While the pope commissioned large new structures to Bramante, he appears to have entrusted Giuliano with the completion of the interiors and fortification of residences already existing or begun. These included the Castel Sant'Angelo, whose loggia was erected by Giuliano in 1504/5,[126] the Magliana, and the Rocca in Civita Castellana, where Giuliano had probably already succeeded his brother by 1506.[127] As a close collaborator, Antonio may also have, as a rule, lived in his uncle's house near St. Peter's[128]—much as Giuliano and his brother had lived together in Florence and as Antonio, Gian Francesco, and surely also Aristotile and Antonio's brothers later lived together "in chasa nostra a San Rocho," the half-finished house that Antonio had purchased in 1512.[129] At Giuliano's house, artists such as Michelangelo, and no doubt Bramante and Andrea Sansovino, came and went; there Giuliano stored his drawings from Antiquity and drew large parts of the Codex Barberini; and there, between the spring of 1505 and the spring of 1506, he created his first projects for St. Peter's, possibly with the help of his brother,[130] and in the following years the designs for the facade of Loreto.[131] The young Antonio thus had the uncommonly good luck to have resided since his twentieth year at one of the focal points of European art and to have participated in the execution, and probably also the projecting, of Giuliano's buildings. Bramante, for his part, may have discovered and encouraged Antonio's exceptional talent very early, though at the same time respecting the interests of Giuliano, who stood increasingly in his shadow.

But what kind of design methods might Antonio

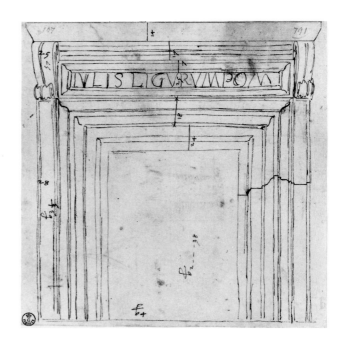

6 Antonio da Sangallo the Younger. Elevation of chimney-piece at La Magliana (U 1058A r.).

the Younger have learned in the workshops of his two uncles? The earliest drawings, whose attribution to Antonio has long been agreed upon by scholars, stem from the time after 1508.[132] Yet if we analyze the changes in his handwriting during those years we discover a development that can also be traced backward, to his beginning period in Rome and even beyond, and that allows the attribution of other drawings.[133] Letters such as *g, ch, d,* or *z,* and numbers such as *3* still retain in 1507/8 some of the characteristics from his beginnings, which in the case of the *3* disappear fully only after 1513. Comparison of a few specimens from various times during these years will show this with greater clarity (Fig. 7).

At the beginning there is a much discussed group of drawings at the Uffizi that have been attributed to

7 (opposite) Handwriting of Giuliano, Antonio the Elder, and Antonio the Younger da Sangallo, ca. 1503–ca. 1514: **a** Giuliano 1505 (U 8A v.) **b** Antonio the Elder (U 1642A)

Antonio da Sangallo the Younger: **c** ca. 1503/4(?) (*U 1564A r.) **d** ca. 1504/5 (U 1576A v.) **e** ca. 1504/5 (U 2049A v.) **f** ca. 1505/6 (U 2047A v.) **g** ca. 1506/7 (U 1482A r.) **h** ca. 1507/8 (U 992A r.) **i** ca. 1508/9 (U 1273A r.) **j** ca. 1509 (*U 975A r.) **k** ca. 1510 (*U 1484A v.) **l** with Labacco ca. 1512 (U 1193A r.) **m** ca. 1514 (U 1000A r.)

n Antonio the Elder 1508 (ASF, X di Balia, Responsive, 92, c. 133).

a

b

c

d

e

f

g

h

i

j

k

l

m

n

various hands. These parchment sheets, which belong together by virtue of their similar format and drawing technique, obviously belonged to a *Taccuino* modeled on Giuliano's.[134] It is not by chance that the probable earliest drawings in this group reproduce models by Giuliano.

Thus the four ground plans of ancient centralized buildings on U 2045A v. correspond, significantly, not to Giuliano's models in the Codex Barberini but to the less careful drawings on folio 16 of Giuliano's earlier *Taccuino senese* (Figs. 8, 9).[135] This alone is an important argument for dating them to the period before 1508. And if two of the three ground plans on U 2045A v. deviate slightly from those on folio 8 of Giuliano's *Libro,* it is because Antonio probably was following lost models closer to the less polished drawings in the *Taccuino senese.* These models could also have depicted the ground plan, view, and section of the octagon of Capua Vetere, which are in the center of U 2045A r. Since Antonio could hardly have been in Capua Vetere at the time, the reconstruction of the elevation, with its attic story and lantern, has to be ascribed to Giuliano. It is striking, however, that nowhere else there does Giuliano combine on one sheet, with the same consistency, the ground plan, elevation, and cross section of a single building, whereas this is precisely the organizational method developed later on by Antonio.

The two elevations on U 2045A r. follow the method of representing architecture that had been used since the fourteenth century: the elevations—in this case, a cross section or the front plane of the octagon—shown in orthogonal projection, with all of the components leading into depth shown in perspective.[136] This method of representation, which could be called "perspective elevation" and "perspective section," had the advantage of combining a primarily architectural orthogonal drawing with a primarily pictorial perspective, making it intelligible even to the layman while at the same time conveying exact measurements and wall thicknesses.[137]

These literal copies of Giuliano's drawings from Antiquity could have been made by Antonio while he was still in Florence—that is, before the spring of 1504. The same can be said of *U 1564A. The centering drawn on the recto derives from folio 27 r. of the *Taccuino senese* and conceivably includes the earliest specimens of Antonio's handwriting (see Fig. 7c); the roasting spit on the verso is technically much more detailed than that on folio 50 r. of the *Taccuino.*[138]

The speed with which Antonio subsequently outdistanced Giuliano is shown most of all by his com-

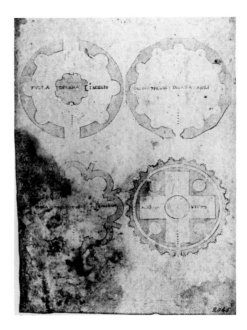

8 Antonio da Sangallo the Younger. Plans of antique centralized buildings (U 2045A v.; ca. 1503/4[?]).

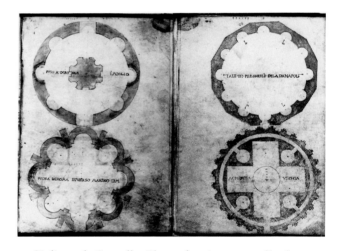

9 Giuliano da Sangallo. Plans of antique centralized buildings (Siena, Biblioteca Comunale, *Taccuino,* Codex S.IV.8, fol. 16 r. and v.), detail.

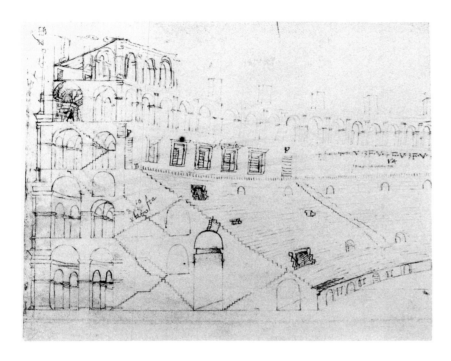

10 Antonio da Sangallo the Younger. Perspective section of the Colosseum (U 1555A v.; ca. 1504/5).

11 (below) Giuliano da Sangallo. Perspective section of the Colosseum (Siena, Biblioteca Comunale, *Taccuino,* Codex S.IV. 8, fol. 5 v.).

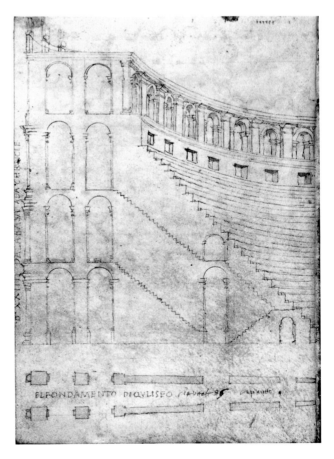

prehensive survey of the Colosseum, to which he devotes seven sheets of this early group.[139] Here, too, he appears to have started from the *Taccuino senese,* where, on folios 6 and 7, Giuliano with rare consistency combined a ground plan, cross section, elevation, and perspective view.[140] But Antonio was now no longer satisfied with copying. He studied the building *in situ* with such acuity and thoroughness that he was able to record the archaeological remains more precisely and intelligently than had any of the draftsman before him. Thus, on U 1555A r. he no longer shows the ground plan as a circle made slightly oval, as Giuliano does, but rather constructs an oval with two radii and four centers, placing the wall openings, piers, and stairs with much greater precision than did his uncle; similarly radical improvements are found in the cross section on U 1555A v. (Figs. 10, 11). While Giuliano crowds his overly tall cross section onto the sheet and is satisfied with a schematic characterization of the passageways, vaults, stairs, and auditorium, Antonio takes pains with every detail. He continues the complex system of stairs up to the top story and even reconstructs the illumination of the various corridors. One perceives that he has studied the building not only morphologically but also functionally and constructively, entirely in the spirit of Alberti. Not only does he reproduce the elevation on U 2043A r. with greater clarity than does Giuliano, but he also gives measurements of all the details. The sketches on

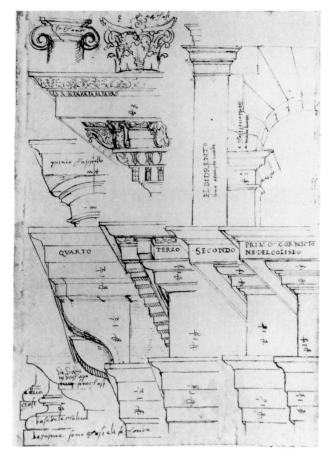

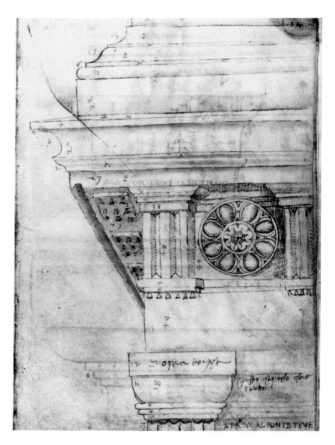

12 Antonio da Sangallo the Younger. Isometric view of details of the Colosseum (U 2043A v.).

13 Giuliano da Sangallo. Entablature of a Roman mausoleum (Siena, Biblioteca Comunale, *Taccuino*, Codex S.IV. 8, fol. 14 r.).

U 1576A r. and v., with their handwritten commentaries, prove that he worked all this out by himself, then transferred the results to clean drawings like U 2043A v., whose linear technique and partial perspective are again directly reminiscent of comparable sheets in Giuliano's *Taccuino* (Figs. 12, 13). This transferral may explain the lack of spontaneity that still characterizes, for example, his sketch of a passageway on U 1546A. There Antonio already exhibits a sureness, especially in his rendering of spatial structures, that goes even beyond Giuliano. In his diagram of the Colosseum stairs on U 1627A v. he shows himself again as a true architect who tried to penetrate into the ancient principles of spatial construction. On the same sheet, incidentally, he is already concerned with the Mausoleo del Divo Romolo,[141] the Basilica Aemilia, and a multinaved centralized building, and he sketches a head of Caesar there with a virtuosity

that can be explained only by a direct knowlege of the art of Leonardo.

The archaic handwriting, especially on U 1576A, speaks for Antonio's having begun his survey of the Colosseum soon after his arrival in Rome, that is, perhaps as early as 1504 (see Fig. 7d). Through Giuliano, he must already have come to know and admire Bramante; it may even have been Bramante who stimulated his interest in this analytical method. In any case, no earlier, comparably systematic survey of a large ancient building has yet been found, and thus it still served a decade later as point of departure for the sheets in the Codex Coner dedicated to the Colosseum.[142]

That Antonio da Sangallo, though remaining Giuliano's student and collaborator during his first years in Rome, was at the same time seeking a deeper and more comprehensive knowledge of Antiquity is shown

by other studies in his early group of drawings—for example, the ground plan and section of the Portumnus temple in Porto d'Ostia on U 1414A (Fig. 14), which manifest the same analytical sureness as the detail studies of the Colosseum on U 1546A.[143] The varying handwritings prove, as they do on U 2046A v.,[144] that Antonio returned to these early Roman studies in 1507/8, adding to the ground plan of the basement, the sketches on the verso, the measurements, and the colonnade, and even illustrating the last in detail in a partial elevation at the lower edge of the sheet.

Significantly, on U 2049A r., one of the few sheets with original designs in this early group of drawings, he used a largely orthogonal method of representation.[144a] At the left he sketched the tomb of a prelate that obviously goes back to prototypes from the Roman Quattrocento and shows no influence whatever from the great inventions of 1505, such as A. Sansovino's tombs for prelates in S. Maria del Popolo and Michelangelo's tomb for Julius II. The vocabulary of the triumphal arch at the right likewise still recalls Giuliano and especially the schematic ground plan with its subsequently applied column bases and perspectively foreshortened barrel vault. On the other hand, his treatment of the orders shows a monumentality rare at the time even for Giuliano. The free, sketchy lines—surprisingly sure for a twenty-year-old carpenter—which frequently circumscribe a form more than once, reveal Antonio's graphic schooling in Filippino's manner, especially in the figural and ornamental parts (see Fig. 4).

The verso of the same sheet confirms Antonio's close connection with Giuliano da Sangallo and the Florentine tradition. The "porta del chardinale cieserjno," probably from the palace of the younger cardinal, Giuliano, deceased in 1511, directly recalls the exterior portal of the Salone in the Cancelleria from shortly after 1500 (Fig. 15).[145] Antonio shows the portal at the right in orthogonal elevation and at the left in an isometrically extended section, with detail measurements in sixtieths (*minuti*) of a *braccio fiorentino*. No model for this combination of two views is yet found in the *Taccuino senese,* and it reveals once again the primarily structural thinking of the architect.

He may have drawn U 2046A r. a short time later.[145a] The handwriting, as well as the isometric representation of the coffers of the Basilica of Maxentius and of an entablature from the Forum of Augustus, show greater mastery than in U 2049A. In contrast, the centralized building on the recto, crowned by a Leonardesque rider, is again entirely in the spirit of

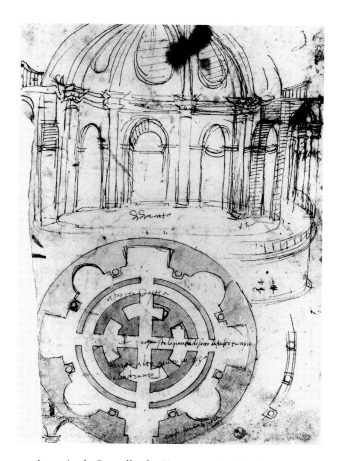

14 Antonio da Sangallo the Younger. Temple of Portumnus at Ostia Antica (U 1414A r.; ca. 1504/5).

Giuliano: The dome is reminiscent of Loreto, and the arrangement of the triumphal arch is inspired by the Cappella Gondi. That neither of these two sheets shows any reflection of Bramante's first Roman buildings is a further, important argument for dating them in 1504/5.

The most mature sheet in this group, U 2047A, contains details of the Temple of Antoninus and Faustina on the recto and the shaft of a capital from SS. Cosma e Damiano on the verso. It reveals yet again that by 1505/6 Antonio had already developed his new isometry with a precision and mastery unsurpassed even by the Codex Coner eight years later.[146] The shape of the logogram for *braccio* and the *3* prove that Antonio added the measurements only after 1510.

Entablatures had already been represented orthogonally, perspectively, and isometrically before Giuliano,[147] and all three methods of representation are found in the *Taccuino senese.* But, as in his studies of the Colosseum, Antonio's primary concern was a

15 Antonio da Sangallo the Younger. Elevation and isometric section of a portal of Palazzo Cesarini (U 2049A v.; ca. 1504/5).

maximum of reliable information. From the start he preferred an isometric representation of details to a perspectival one, if for no other reason than that it distorted less. Whereas he had still shown the detail of the Colosseum in isometric view, he now changed on U 2049A v. to an isometric section, which he would continue to prefer for details in the years following.

Neither Francesco di Giorgio nor Cronaca made cross sections of details, and in the *Taccuino* Giuliano also shows details in orthogonal, perspective, or isometric elevation, but hardly ever in cross section. Thus he may have added the only two exceptions (sections on folios 24 and 25 of the *Taccuino*) later, in the process strangely foreshortening the section rather than the view, as Antonio did.[148] His more precise drawing technique and measurements alone show that the more or less consistent perspectival sections of details in the *Libro* originate from a later date than Antonio's early studies.[149]

Of course, Antonio could have developed the isometric cross section himself, especially since sections of profiles must have been customary in building practice since the Gothic period. It is conceivable, however, that Bramante, who was a master of perspective, at least occasionally used it. Although the details of the few drawings attributed to him are exclusively orthogonal, the entablature in cross section in his Prevedari engraving of 1481 shows how familiar he was with this method of representation.[150] His friend Leonardo da Vinci had experimented with all kinds of sections, especially in his technical and anatomical detail studies.

That Bramante used isometric cross sections in the process of designing is suggested also by a number of copies presumably made by Aristotile da Sangallo, who was taught perspective by Bramante.[151] On U 1739A, Aristotile recorded a Doric entablature with exact measurements, probably in *palmi romani,* and the inscription "di bramante," a drawing that cannot be connected with any known building by the master (see Fig. 44).[152] It is thus apparently related to one of his unexecuted projects, perhaps for the courtyard of the Palazzo Apostolico in Loreto, for the model of which Antonio di Pellegrino was paid in February 1510.[153] The Doric entablature that Aristotile copied on U 1745A with the informative inscription "ritratta da disegni non so se misurata" is almost identical with that of the Cortile del Belvedere and may also go back to a design by Bramante.[154] It is unlikely that Aristotile would have translated orthogonal drawings by Bramante into isometric or perspectival drawings, if for no other reason than that Aristotile drew most of his details in orthogonal projection.[155]

By no later than 1505/6, Bramante himself must have perfected the purely orthogonal representation of details, which he used, for example, on U 104A v.[156] This method, too, was based on a long tradition and was already applied with astonishing consistency by such a master as Cronaca.[157] Giancristoforo Romano, the young Peruzzi, the young J. Sansovino, Menicantonio, and Raphael all made use of it, and Antonio was to prefer it increasingly after he entered Bramante's workshop.[158] Bramante seems to have done with the details what he did when he visualized parts of his project for St. Peter's on U 20A in perspective and, in 1509/10, had the pendentives drawn with technical precision in ground plan and cross section.[159] This is suggested as well by his large study for a Corinthian capital on U 6770A, where he supplemented the elevation partly in perspective on the recto with a purely technical section on the verso, intended for

the preparation of working drawings and wooden templates.[160]

Similarly, because of the handwriting and the subsequently applied wall articulation on U 2134A (see Fig. 2) and U 2162A—two related surveys of the ground plan of the Baths of Diocletian—the sheets can hardly be dated after 1506. They undoubtedly presuppose Bramante's measurement on U 104A r. (see Fig. 1).[161] In any case, Antonio used a scored grid here, as did Bramante on U 20A and 7945A, and in so doing improved on Bramante's survey by applying Bramante's own methods.[162] The precision with which Antonio proceeded is evident in the detail studies on these two sheets. At that time he may already have prepared a clean drawing of the ground plan as a whole, which then possibly served as a model for Bernardo della Volpaia, Francesco da Sangallo, and Giovan Francesco da Sangallo.[163] Now as before he used the Florentine *braccio*, not the *palmo romano* favored by Bramante, proving once again that he had not yet become one of Bramante's immediate collaborators. Unlike the *palmo*, the *braccio* had the great advantage of almost exactly equaling two *piedi antichi*, thereby making whatever ancient modulus might have existed readily discernible.[164]

An even more obvious affinity to Bramante is revealed by the survey of the tomb of Theodoric on U 1563A (Figs. 16, 17).[165] Though the schematic ground plan on the verso still recalls Giuliano's studies of ancient centralized buildings, in his strictly orthogonal elevation Antonio takes a big step beyond Giuliano, who, probably at about the same time, drew the mausoleum on folios 37 v. and 38 r. of the *Libro* in a far more cursory style (Fig. 18).[166] In fact, this is the earliest surviving drawing anywhere showing not merely a facade but an entire building in strict orthogonal projection.

But is such a step conceivable from the same Antonio who shortly before had been working entirely in Giuliano's manner? The graphic style and numerals are reminiscent of Antonio's copies after Francesco di Giorgio on *U 1482A, *1483A, or the isometric cross section on U 1413 v., from 1507/8 (see Fig. 21).[167] The survey thus could have been made on the occasion of Julius II's trip to Bologna, between the arrival of the pope in Imola at the end of October 1506 and his departure from Bologna at the end of February 1507.[168] Since Bramante and Giuliano accompanied the pope,[169] we can assume that the young Antonio did likewise.[169a] In any case, a few months after the laying of the cornerstone of St. Peter's, Bramante must have been keenly interested in the Ravenna buildings,

regardless of whether he undertook the survey himself or entrusted it to a helper who knew his methods.

A number of the sheet's characteristics speak against its being a totally independent survey by Antonio and in favor of its being a copy after Bramante. In contrast to all of Antonio's early drawings from Antiquity, it is measured in *palmi romani*, without a logogram to make this evident. Some of the numbers are accompanied by dots, as on Bramante's U 104A r. of about 1505 (see Fig. 1). Antonio seldom uses these, though significantly he does so on U 1413A v. of about the same time (see Fig. 21).[170] Finally, in the elevation Antonio twice changed a 3 to a 2, although he had previously drawn these parts correctly—perhaps because he had misread the numbers in an unfamiliar source.

But it is the separation of the elevation and the ground plan and the restriction of the ground plan to the basement story that speak most strongly against an independent survey. The three main stories of this complex building could be projected exactly onto a surface only by means of their three corresponding ground plans, as Antonio so brilliantly demonstrated in his study of the same mausoleum on U 1406A from 1526 (Fig. 19).[171] The vertical extension of a ground plan into an elevation had been known since the Gothic period and is found occasionally before 1500 in the works of Antonio de' Vincenzi, Piero della Francesca, Francesco di Giorgio, Leonardo, and Cronaca.[172] Antonio himself had already used this method of drawing elevations on U 1414A r. (see Fig. 14). When, on U 124A, Bramante's assistant Antonio di Pellegrino drew a ground plan and cross section of the pendentives of St. Peter's to the same scale but, like Antonio, separated them on the recto and verso, he too must have been copying a source in which the section was drawn vertically from the ground plan.[173]

Bramante made use of this procedure not only in his late design for a dome—known through Serlio—where the ground plans of several levels are likewise related in scale to the elevation, but also in his preceding projects. Thus the combination of an elevation with two different ground plans drawn to the same scale, which is seen in the depiction of the porticus of the Cortile della Pigna in the Codex Coner, must also reflect Bramante's method of representation.[174] It is not coincidental that already about 1507/8 Antonio added the plan of the socle story on U 1414A r., and that this method was then developed primarily by Bramante's students (see Fig. 14).[175]

Outside Bramante's circle, the derivation of an elevation from a ground plan was handled much less

16 Antonio da Sangallo the Younger, after
Bramante(?). Plan and details of the tomb of
Theodoric at Ravenna (U 1563A v.; ca. 1506/7).

17 Antonio da Sangallo the Younger, after
Bramante(?). Elevation of the tomb of Theodoric
(U 1563A r.; ca. 1506/7).

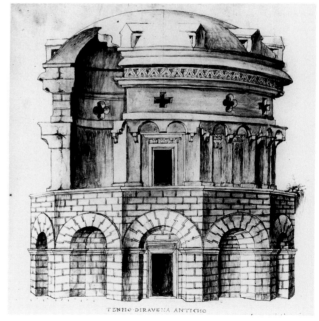

18 Giuliano da Sangallo. Plan and elevation of the tomb of Theodoric (Cod. Vat. Barb. lat. 4424, fols. 37 v., 38 r.).

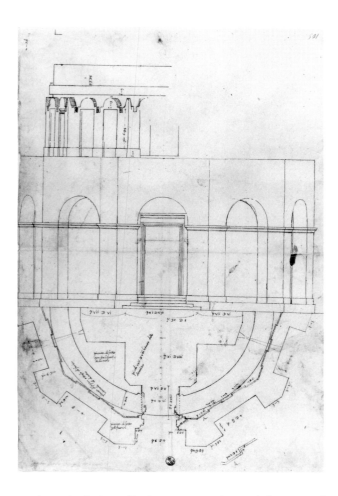

19 Antonio da Sangallo the Younger. Plan and elevation of the tomb of Theodoric (U 1406A r.; ca. 1526).

consistently: for instance, in the Codex Strozzi, which shows an affinity to Cronaca; in the few examples in which Giuliano made a ground plan and elevation to the same scale;[176] and in the view of the Colosseum that the young Peruzzi, probably before 1504, extended vertically from the ground plan on U 8026A.[177]

Nevertheless, the elevation of Theodoric's tomb on U 1563A r. also profited from these partial perspective views (see Fig. 17). By again combining modeling, which had become increasingly realistic since the Trecento, with an orthogonal elevation, Antonio unified pictorial vividness with objectivity in a synthesis that was to be particularly important for the architecture of the High Renaissance.

Antonio, too, had previously drawn only flat facades, interior walls, and details in pure elevation — as on U 2049A r.—restricting himself more or less to abstract outlines. He had reserved crosshatched shading—which Bramante used so skillfully in designs like U 6770A r. (for the capital) or U 226A (for the centering of St. Peter's)[178]—primarily for figural elements and quick sketches like U 1414A r. (see Figs. 12, 14). Because both the elevation of the tomb of Theodoric on the recto and the isometric cross section of details on the verso show a much more awkward use of three-dimensional hatching than in his drawings of the following years, he can only at that time have become acquainted with this new method of representation.

In his representation of Theodoric's tomb, Giuliano was himself obviously coming to grips with new methods of representation (see Fig. 18). Whereas in the *Taccuino senese,* and still in his 1505 design for the papal musicians, he had used chiaroscuro relatively sparingly and created spatial depth mainly through linear perspective,[179] he now suggests depth mainly through light and shade—no differently from his designs for the facade of Loreto, which can be dated 1506/7.[180] If the drawing of Theodoric's tomb was also made shortly after the trip to Bologna in 1506/7, he could even have been under Bramante's direct influence. At any rate, his information goes beyond Antonio's study: A cross section of the building is shown on the left side, niches are recorded in the ground plan, the central window is indicated in the elevation, and he makes his own suggestion for reconstructing the frieze zone. He could have learned the combination of cross section and elevation from Bramante, who combined the two in his project for the dome.[181] In Giuliano's work, however, it occurs only in the illustrations immediately preceding the fourth fascicle of the *Libro.* This combination of interior and exterior views also goes back to the Gothic period; it may have

been introduced in Rome by Bramante, and would later be developed by his students. All of this confirms once again the surprising importance of Gothic methods of representation, particularly for Bramante and his circle.

The sharp break that this first intense examination of Bramante's work must have occasioned in the totality of Antonio da Sangallo's thought found new expression in his drawings of the following years. The handwriting in some copies after Francesco di Giorgio's Codex Magliabechiano II.1.141 shows the connection between his early group of drawings and those securely dated in 1508/9.[182] Although the *ch* and *z* are still reminiscent of the script of his early years, the *d*—and above all the character of his script in general—is already markedly closer to Antonio's later handwriting (see Fig. 7e–l). Francesco di Giorgio's machines may have been useful for the increasingly intense building activity under Julius II, but Antonio was not at all satisfied with making mere copies. He improved the mechanisms, intensified the chiaroscuro through hatching (which already looks more routinized than in the elevation of Theodoric's tomb), and on *U 1482A he even added a skillfully sketched figure.

A similar script and hatching reappear on some of his drawings from Antiquity, such as the largely orthogonal elevation of the "zecha anticha a san chosimo e damiano" on U 992A (Fig. 20), the sketches of the Volta Dorata on U 1273A (see Fig. 7i), the later corrections on U 1414A (see Fig. 14), and the masterly isometry of the entablature of the Basilica Aemilia on U 1413A v. (Fig. 21), which more than any other drawing anticipates the entablatures in the Codex Coner.[183] After 1510, when he had gone over to Bramante, Antonio added the base and capital and a purely orthogonal view of the architrave and frieze on the recto.[184]

A date of 1508 for U 1413A v. likewise is suggested by the closeness of the script and method of representation to Antonio's designs for the fireplace in the Sala di Costantino (see Fig. 5) and the coffered ceilings on U 1623A, 1646A, and 2153A, where he already handles chiaroscuro with the same mastery as in his mature studies.[185] Not without reason did Vasari include U 1623A r. in his *Libro*.[186]

The sketch of the ground plan of the Rocca of Civitavecchia on *U 975A could have been made at the very end of his collaboration with Giuliano. In any case, a date prior to the beginning of its construction in April 1509 is confirmed not only by the totally different ground plan, but also by the antiquated *ch* (see Fig. 7j). He had already outgrown this when, around

20 Antonio da Sangallo the Younger. Elevation of the "zecha anticha" (Forum of Vespasianus), (U 992A r.; ca. 1507/8).

21 Antonio da Sangallo the Younger. Isometric view of the entablature of the Basilica Aemilia (U 1413A v.; ca. 1507/8).

22

1510, he made sketches, among other details, for the centering of a coffered vault (*U 1484A v.; see Fig. 7k).[187]

When Giuliano returned to Florence in the spring of 1509, there was no longer any obstacle to Antonio's transfer to Bramante's studio. Bramante at first placed at his side his old, experienced assistant, Antonio di Pellegrino. Together with him Antonio began, in the winter of 1509/10, to oversee the construction of the centering for the arches of St. Peter's.[188] Antonio di Pellegrino apparently died sometime between November 1510 and March 1511, and Antonio became Bramante's chief collaborator.[189] Vasari, informed by his friend Aristotile, reports that Bramante suffered from gout during these last years of his life and increasingly left the drawing of his projects to Antonio:

> . . . dal perletico impedito le mani, non poteva come prima operare; a porgergli aiuto ne' disegni, che si facevano: dove Antonio tanto nettamente, et con pulitezza conduceva; che Bramante trovandogli di parità misuratamente corrispondenti, fu sforzato lasciargli la cura d'infinite fatiche, che egli haveva a condurre, dandogli Bramante l'ordine, che voleva; et tutte le invenzioni, et componimenti, che per ogni opra s'havevano a fare. Nelle quali con tanto giudizio, espedizione et diligenza si trovò servito da Antonio, che l'anno MDXII. Bramante gli diede la cura del corridore, che andava a' fossi di Castel Santo Agnolo. . . .[190]

Antonio accordingly had to translate Bramante's ideas in drawing. Thus, at least the projects of 1511–13 are probably from his hand.

Bramante's bequest probably went to Raphael and was lost together with the latter's architectural drawings.[191] This may be the reason why so few sketches by Antonio from these decisive years have survived. Their dating in the last years of Bramante's life again is based primarily on characteristics of the handwriting, especially on changes in the 3, since the projects themselves rarely justify limitation to 1511–13.

Antonio's exact measurement of the choir arm of St. Peter's on U 43A was probably made then—that is, after the completion of the walls, but before the start of the vaulting, which Bramante himself carried out around 1512/13.[192] The alternative, on the recto, to the executed choir arms, in which the double pilasters of the apse are replaced by single pilasters, may have been copied from or inspired by Bramante's wooden model of April 1506, a model that is documented only by a later collaborator of Sangallo's on U 4A v. and U 5A r.[192a] The ground plan design on U 1304A, which is

so obviously inspired by Bramante's choir and which was intended, if not for S. Biagio, then for a similar building, may date from the same time.[193]

After 1510—that is, after he changed the loop in his logogram for braccio but certainly before 1513, Antonio sketched the dome of the Pantheon on the recto of U 69A and the scaffolding for the vaulting of the apse of St. Peter's on the verso.[194] The Pantheon sketch undoubtedly served as a preparatory drawing for the dome project. It thus reappears in abbreviated form on U 85A in Giovan Francesco's hand, beside three alternative suggestions for the dome by Antonio.[195] None of these "Tre modi per santo pietro" even remotely approaches the lavishness of Bramante's final project for the dome, which probably already reflects the spirit of the Medici pontificate—another argument for dating them immediately prior.[196] Only the first alternative includes a ring of columns around the drum; the second merely has pilasters; and in the third, the one closest to the Pantheon, the drum is missing altogether. Obviously, under Julius II Bramante and his technically experienced assistant took greater account of the load-bearing capacity of the piers.

The way the ideas of the handicapped Bramante were translated into graphic form is perceived even more immediately on U 1191A (Fig. 22).[197] At the left, Antonio copied the interior entablature of the Pantheon from an elevation made by Bramante's chief stonemason, Menicantonio (". . .la prese per bramante menicantonio") and derived from it, at the right, an idea, never executed, for the interior entablature of S. Biagio. Apparently Bramante directly followed the admired model—just as in the case of the capitals and the cupola of St. Peter's—and assigned his collaborator the task of calculation and measured conversion of these details, a problem that he was able to communicate to him verbally, without making his own sketches.

The two elevation sketches for the portal zone of SS. Celso e Giuliano on U 1859A belong to the same period (Fig. 23).[198] In the more routinized and energetic chiaroscuro hatching of the portal, Bramante's lessons are even more clearly recognizable than before.

Antonio's studies on *U 977A for a portal, the mastio, and the tombs of Civita Castellana must have been made toward the end of Julius II's pontificate. The handwriting, at any rate, can hardly be reconciled with that of 1506–9, when work on the uncompleted Rocca was probably already resumed.[199] Nevertheless, when he drew the portal he remained true to the style of his uncles, and certainly not only because of Bra-

22 Antonio da Sangallo the Younger. Interior entablatures of the Pantheon and S. Biagio (U 1191A r.; ca. 1510).

23 (below) Antonio da Sangallo the Younger. Sketch for the facade of SS. Celso e Giuliano (U 1859A r.; ca. 1510–13).

mante's instructions. In his first independent buildings, such as the palace of Tommaso Inghirami, the modernization of the Castel Sant'Angelo and the Rocca of Capodimonte, and the castle of Veiano, which he probably began during the reign of Julius II, he shows himself to be a true Sangallo, as if he valued this identity and wished to avoid being mistaken for an epigone of Bramante.[200]

Still, Bramante must have freed him in many respects from Giuliano's Quattrocentesque limitations. In his few datable drawings of Antiquity from 1509–13, he broke away from Giuliano's traditional schemes of representation. Thus on U 575A and 1168A, he encompassed a single building from several different angles, and reconstructed a portal in several variants—with incomparably greater looseness, sureness, and competence than in the sketches from his first years in Rome (Fig. 24). How intensively he worked to achieve a precise understanding of those very monuments that were important for Bramante's late style is demonstrated further by his sketches of the Arch of Titus on U 1255A.[201]

24 Antonio da Sangallo the Younger. Reconstruction of antique buildings (U 1168A v.).

Vasari does not state whether Antonio the Younger remained true to Bramante until the latter's death or whether, as his numerous personal commissions seem to suggest, he made himself independent at the start of the new pontificate. If the latter, his role as draftsman under Bramante could have been taken over by his cousin Giovan Francesco from the spring of 1513 on. Giovan Francesco, as his sketches on U 85A show, had been active in the building lodge of St. Peter's for some years, and, as Vasari again reports, he was working closely with Giuliano Leno.[202] He then served Raphael in a similar capacity, and it is conceivable that Giovan Francesco, rather than Antonio, drew Bramante's last designs, that is, not only for the dome but also for the altar house, the entire project for the expansion of St. Peter's, and for the Casa Santa in Loreto.

Antonio's Early Maturity: From the Death of Julius II to the Sack of Rome

Leo X (1513–21) immediately gave a new direction to the art and building policy of Rome and initially entrusted the realization of his lofty aims mainly to Bramante, Raphael, and the Sangalli—Giuliano and Antonio the Younger. While Julius II had concentrated on a few buildings commensurate with the new imperial pretensions of the papacy, the Medici pope and his advisers sought the renewal of ancient Rome in its entirety.[203] And while Julius II was still following the tendencies of his predecessors when he cut axial lanes through the city, such as the Via Giulia and the Via della Lungara, and gave them new points of emphasis, like the Palazzo dei Tribunali, now the attempt was made to revive the streets and urban focal points of ancient Rome by means of classicizing buildings. Thus, only a few months after Leo's election, Giuliano proposed a project that would extend the old Medici residence up to the Piazza Navona after the model of the imperial palace at Constantinople; and it was probably also Giuliano who designed even the wooden theater for the Capitoline, in which the two nephews of the pope were made citizens of Rome.[204] At the same time, or soon afterward, Antonio began the palaces of the Baldassini, Farnese, and del Monte, likewise within the context of the ancient cityscape, and in these, as in a project of his own for the Medici palace, he went considerably beyond Giuliano's reconstructions of ancient houses.[205]

Only by following the course of the ancient streets could the destruction of ancient monuments, such as the Meta of the Borgo, be avoided;[206] indeed, they could be given a new significance within the framework of the city. It was not without reason that the most important piece of urban planning by Leo X from about 1516/17 was the restoration of the two ancient streets radiating from the Piazza del Popolo.[207] Antonio had just then been appointed as second papal architect, giving him direct influence over the shaping of the city.[208] Raphael and Antonio considered not only distinguishing the accompanying Piazza del Popolo with an ancient obelisk, rescuing the ancient mausoleum at the junction of the two streets, and making the exedra of the Horti Aciliorum the focal point of a side street, but also architecturally articulating the crossing point with another street of ancient origin at the Piazza Nicosia.

The same principles determined thinking about the construction of new villas and churches: the orientation of the Villa Madama toward the Ponte Milvio; the erection of the Villa Lante for Baldassarre Turini on the foundations of the putative villa of Martial; Antonio's wish to transform part of the imperial fora into a villa; or his thought of reconstructing Santa Croce after the Templum Etruscum and building S. Giovanni dei Fiorentini after the Pantheon.[209]

This new Leonine building policy was so deliberate and steady that it must have emanated directly from the papal court and can hardly be connected merely with the name of one or even several artists. It led the pope consequently to commission Raphael to survey systematically and reconstruct not only the monuments of ancient Rome but also its streets, gates, and walls—"ad aeternam urbem in pristinam maiestatem reparandam," as Calcagnini defined the objective of the project in 1519/20.[210]

An equally ambitious, though less comprehensive antecedent to Raphael's project existed already at the beginning of Leo's pontificate. It has been transmitted to us in the form of the Codex Coner and was probably also commissioned by Leo X in 1513/14.[211] The new rulers were unable to form a conception of ancient Rome from such unillustrated topographies as those of Flavio Biondo and Francesco Albertini, or from the editions of Vitruvius. And even the architects in charge may have found it difficult to retain an overview of the scattered and heterogeneous studies of Antiquity from the preceding years. Both sides must thus have been in agreement in their desire to bring these and further studies together in a systematic collective work and, if the occasion should arise, to make this accessible in print to a larger circle. Who among the artists gave the initial impetus and how the project came into being are so far unknown. It is certain, however, that Bramante, Giuliano, Antonio, and Gio-

van Francesco made their drawings available, and that Antonio, at least, contributed with advice and corrections.[212] Even though the draftsman of the Codex, Bernardo della Volpaia, was a Florentine and could have come from Giuliano's school, Giuliano hardly was the real instigator of the project. Otherwise it would be a mystery why Bramante is represented by so many buildings but Giuliano by two ground plans at most,[213] and why Bernardo would have taken over several drawings by Antonio and identified them by name but neglected to attribute the few copies he made from Giuliano.[214] Like the learned inscriptions, the preference for a perspectival or partially perspectival method of representation indicates that the Codex was intended for a circle of humanistically educated laymen, not that it was a *retardataire* method of working. It was precisely when he showed entire monuments, at any rate, that Bernardo tried to achieve a much more consistent and clear perspective than did Giuliano or the early Antonio. The measured elevation of the Cortile del Belvedere on folio 45, for instance, is redrawn on folio 43 in a semiperspectival "orthographia." Since he could have entered the missing measurements of depth even more clearly in the cross section on folio 46, he must have been concerned primarily with the spatial and plastic effects of the facade.[215] This effort not to neglect the clarity of his monuments at the expense of precise information is also demonstrated by Bernardo's numerous studies of the Colosseum and Pantheon.

Antonio and Giuliano would scarcely have found time for such an undertaking during this period of intense activity in building and planning. The choice thus fell to Bernardo, who already before this must have attracted attention as a careful draftsman and experienced recorder of antiquities. That Antonio played an important role from the beginning in the formation of the work is shown by the system of measurement employed, the *braccio fiorentino* divided into sixty *minuti*. But it is established above all by his correction of the entablature of the temple of the Dioscuri on U 1181A.[216] There, as in many of his surveys of entire buildings, and like Giuliano in the *Libro*, Bernardo still makes the orthogonals converge, whereas later, on folio 85 of the Codex Coner, he takes over not only Antonio's corrections but also his isometric method of representation. Antonio's correction was based on a survey by his brother Giovanni Battista, who probably did not come to Rome until the spring of 1513,[217] and since Bernardo drew most of the details isometrically, he could not have begun to make clean drawings for the Codex before 1513.

Similar corrections by Antonio, not only with respect to the architectural fabric but also to the method of representation, may be hidden in other sheets of the Codex Coner.

Bernardo used models by Antonio not only for those examples he specifically attributed, such as the Doric entablature on folio 82, which was discovered under St. Peter's in 1507 and then reburied, but for his drawings of the Colosseum, the Baths of Diocletian, and the Pantheon.[218] In the case of the Pantheon, this is proved by the very measurements, which correspond to those on U 85A and 69A r.[219] For his drawing on folio 136, Bernardo went back to Giovan Francesco da Sangallo's independent measurement of a base of the Septizonium on U 1324A—"Basa delle cholonne per me di sette in soli."[220] And his Doric entablature from the Theater of Marcellus (fol. 76) may be based on Giovan Francesco's drawing on U 1705A, even though the measurements do not correspond exactly.[221] In other cases, too, Bernardo seems to have looked over and developed available drawings.

All of this, as well as the authority still accorded the Codex by Michelangelo and Palladio, speaks for its having been more than just the ambitious undertaking of a talented individual. It suggests that the assistance of so many important masters was dedicated to a higher cause. Despite all the inconsistencies and awkwardnesses in the book, even Bramante may have played a part in its conception. Bramante had instructed Aristotile and Labacco in architectural perspective, and this certainly included the bird's-eye view often used by Bernardo, which Bramante had seen in Leonardo's work and made use of for a coin depicting the Cortile del Belvedere.[222] Besides, Bramante's joint responsibility included the participation of his assistants, while Antonio's involvement in the perspective representations must have been minimal. In any case, it is hardly a coincidence that Bernardo interrupted the project soon after Bramante's death, and that he included the project for SS. Celso e Giuliano but not Raphael's Chigi Chapel or Antonio da Sangallo's first palaces. Indeed, the new project for Rome, to which Raphael turned his attention toward 1519, was to concentrate even more concretely on the reconstruction of the ancient city.[223]

The high standard achieved in clean architectural drawings in Bramante's circle is demonstrated by Antonio's first fully independent designs. No other architect profited as much from the desire for building that spread throughout Rome after the death of Julius II. He quickly rose in status from carpenter and

master builder to one of the most celebrated architects in Italy, courted not only by the Medici, Farnese, Riario, del Monte, Colonna, and Santa Croce, but also by the building lodges of Orvieto and Foligno.[224] Even before the election of Leo X he may have received occasional commissions, such as the palaces of Fedra Inghirami and Cardinal Fieschi and the *rocche* of Capodimonte and Veiano, which are more archaic in appearance than the buildings begun after 1513/14.[225]

On the basis of its archaic 3, Antonio's ground plan on U 1298A for the Palazzo Baldassini can be accepted as his earliest surviving independent project for a building, datable to no later than 1513, if not to the year before.[226] Like all his Roman projects, it is measured in *palmi romani*. As in the Palazzo Ricci-Inghirami and the Rocca of Capodimonte, he retains a pre-Bramantesque vocabulary, for example, in his choice of columnar arcades for the courtyard. His four years of instruction under Bramante, on the other hand, are reflected in the strict axial symmetry he imposes on the irregular building site. The two main axes cross at the center of the square courtyard, and the *andito*, courtyard loggia, rear exit, and stairs follow a tightly controlled movement.

How a related facade elevation might have looked can be seen in the slightly later presentation drawings for the portal of the Cancelleria on U 188A (Fig. 25) and for the Palazzo Farnese in Gradoli on U 1320A, where perspectival aids, such as those still offered by Giuliano in his contemporaneous project for the Torre Borgia on U 134A, have largely been eliminated.[227]

That orthogonal cross sections were then already a firmly established component of planning is demonstrated by Antonio's section for the Palazzo Farnese on U 627A, certainly the earliest among the numerous designs made by the young master for this, his most important work, and probably dating from 1513/14 (Fig. 26).[228] One immediately senses there the sure hand of a practiced designer fully in command of the techniques of orthogonal projection. Taking the format of the sheet into account, Antonio truncates the frontal and receding loggia in the middle, shades the cross-sectioned arcades and vaults with short, Bramantesque hatchings, and in so doing gains space on the right border to indicate the correspondence to the exterior articulation of the building. Not until executing the drawing and perhaps after having discussed it with the cardinal had he decided to offer a more monumental alternative for both upper courtyard stories. The sheet in its entirety may thus be interpreted as a presentation drawing for the cardinal.

25 Antonio da Sangallo the Younger. Cancelleria, project for the portal (U 188A r.).

Not until a slightly later time did he turn to working out the three-naved "atrium" and its connection with the courtyard, for which he elaborates several proposals on U 1000A r., following Vitruvian rules and so precisely and extensively labeled that he seems to have wanted to be able to hand on the sheet to the cardinal for a joint consultation.[229] No previous architect had laid a similar value on the horizontal continuity between the individual building elements, and thus it is no coincidence that the section, which illuminates these continuities, has such a particular importance for Antonio. As in the design for the portal cornice for the Palazzo Baldassini on 1000A v., his search for antique perfection finds resolution in the monuments of the imperial period (U 1221A v.).[230]

When Antonio has to deal with the elevation relief, such as the semicircular balconies on U 627A or the window aedicules of U 1000A r. and 1001A r., he makes use of the proven Bramantesque chiaroscuro hatchings and occasionally even light suggestions of perspective. On U 1199A he calculates the Doric frieze of the courtyard order in *minuti*, that is, in the sixtieth part of the Roman *palmo*. Antonio must have become acquainted with calculations of this sort and with theoretical drawings under Bramante, who was the first to have reconstructed the Doric entablature precisely and made it, in various forms, an integral part of the architectural vocabulary.[231]

Finally, the detail plan for the stairway on U 1002A has survived, which he planned with greater care than was usually taken with stairs up to that time. The primarily technical character of the drawing, the notation of the angle of inclination of the runners, the

27 Antonio da Sangallo the Younger. Project for the Colossal order of Palazzo Farnese (U 918A r.; before 1520[?]), detail.

26 Antonio da Sangallo the Younger. First project for Palazzo Farnese, section (U 627A r.; ca. 1514).

scaling, and the detailed commentary remotely recall Antonio di Pellegrino's drawing U 124A for the pendentives of St. Peter's[232] and assume similarly complex calculations; here, too, we are dealing with another aspect of the Bramante school.

Once again, the progression of Antonio's handwriting indicates that this first stage of planning for the Palazzo Farnese must have extended over several years—at least from about 1513 until 1515, if not, indeed, beyond that. Thus the study on U 918A for the base zone of the *piano nobile,* with its Colossal order, probably was not drawn until 1516–20, when construction had already reached this level (Fig. 27).[233]

The various stages in this first planning phase of the Palazzo Farnese can be recognized in some less easily datable drawings of the same years. Thus the sketches on U 1259A for the Palazzo Medici on Piazza Navona and on U 895A for the Palazzo Fieschi correspond to the stage reached in 1513/14.[234] The elevation of the Torre del Monte on U 1898A is reminiscent, down to the fine hatching, of U 627A.[235] Conversely, a date of 1513/14 for a detail of the Doric order of the Palazzo Farnese on U 1199A is supported by the relationship of the handwriting to Antonio's correction of Bernardo della Volpaia on U 1181A. The design on U 1050A for the Bramantesque church of S. Egidio in Cellere, if Antonio's script there is not misleading, can hardly be dated before 1513/14.[236] Its design procedure is already remarkably similar to that of the project on U 171A for S. Maria di Monserrato of 1517/18.[237] Still, it

is just such projects as these that testify to the difficulty of determining a date merely by stylistic criteria.

More completely preserved are the designs for St. Peter's that Antonio prepared after he was named Raphael's deputy and collaborator in the direction of the St. Peter's office in the fall of 1516.[238] Raphael had already presented his own alternative project around 1514 and in the only surviving preparatory study, U 1973F, had proved himself the genuine heir of Bramante.[239] There he is concerned, just as Bramante had been in U 20A and 7945A, to elucidate spatially the effect of the interior, in this case the view in spatial terms from the central nave into the side aisles and the adjoining chapels. How much more directly Raphael had made Bramante's method his own than the latter's long-standing assistant had done is also shown by the remaining designs from these first years of Raphael's activity as an architect: the sketches for a kind of nymphaeum on the Lille study for the Madonna Alba from around 1511/12, where plan and elevation seem directly related;[240] the study for Agostino Chigi's stable from around 1512, where he marks the plan in powerful red chalk strokes and immediately checks it in elevation;[241] the two plans for the Chigi Chapel, where, like Bramante, he makes use of a finely meshed grid and proceeds from the radiating space of the dome, letting the borders float, rather than proceeding from the body of the structure itself;[242] the presumed construction drawing for the dome of the Chigi Chapel, where, possibly, he draws two levels of

29

the plan and the section interpenetrating each other;[243] his project for S. Lorenzo from 1516, preserved only in the copy on U 2048A, where the orthogonal elevation again stands in direct relation to the plan;[244] or the slightly later Oxford project for a villa, where he searches for a solution of the plan on the verso, which would allow him to outline the facade orthogonally on the recto and to enliven it spatially with wash.[245]

These designs of Raphael's, created before his collaboration with Antonio, convey an idea of the difference between the two approximately contemporary masters, and this individuality also characterizes Raphael's 1518 project, certainly designed independently of Antonio and known only through copies, absolutely the earliest surviving example in which plan, elevation, and section are related to each other with complete consistency in the terms defined by Alberti.[246] As illustrated in the section, it deviates from all previous projects precisely in the direct correspondence between the exterior articulation and the interior construction and in this respect approaches Antonio's earlier studies for the Palazzo Farnese.

Most likely in equal measure independent of Raphael, Antonio at the same time had proposed to preserve Bramante's Colossal exterior order and its complex rhythms in his purely orthogonal facade project, U 257A.[247] He then responds to Raphael's 1518 project with the plans U 252A (left half) and 254A, but most importantly with the related elevation U 70A, which already shows itself in its space-creating hatchings and the numerous corrections and detail sketches to be the outcome of thorough discussions in which the pope and his architecturally knowledgeable cousin Giulio de' Medici may have taken part (Fig. 28).[248] Significantly, the perspectival detail sketches do not concern themselves so much with the effect of the interior of St. Peter's as with the subsidiary rooms and their connection with the rest of the system, and thus with problems similar to those on the sketch U 1000A r., for the Palazzo Farnese. If the groundwork for all the methodological and graphic qualities of this study was already laid in Antonio's earlier drawings, it appears that the collaboration with Raphael nevertheless liberated his creative energies in a way he would never again experience.

In the further course of the planning, Antonio was able to impose a 9-*palmi* order on the exterior, mediating between Bramante and Raphael, and with it to give clearer expression to the principle of correspondence, as shown by his virtuoso section U 54A and his many plan and elevation studies for the southern

transept, which are polished down to the last detail.[249] On the plan U 35A, which, like U 34A and 36A, he carried out with the help of a grid, and in the scaled plan U 37A, he draws the various options on top of one another, just as Bramante had done on U 20A. On U 35A he also emphasizes the favored solution by graphic means.[250]

Antonio's share in the planning of the Villa Madama was no less decisive.[251] After Raphael and his presumed collaborator, Antonio's cousin Giovan Francesco, had failed to realize the first project due to the unstable terrain, the Medici had called in Antonio himself. He immediately demonstrated his technical and methodological competence by having the entire site remeasured (in height and breadth) and by proposing a more practicable terracing, thereby deriving a slightly reduced yet more axially symmetrical project. How indispensable was the combination of plan, elevation, and section for the solution of such problems is attested by his designs U 179A and 1518A—the products, as sober as they were consequential, of a bold calculator.[252]

The two masters must also have collaborated closely in the area of ancient studies. During the same year, when they were planning St. Peter's and the Villa Madama, Leo X commissioned Raphael to survey the ancient city of Rome.[253] In the letter in which Raphael presents the project to the pope, in fact, he talks about the destruction of ancient monuments during the eleven or twelve years since his arrival, mentioning, among other things, the "archo che era alla entrata delle therme Diocletiane."[254] Its destruction probably was connected with the restoration of the entrance, which had been carried out in 1518 by Francesco di Giuliano da Sangallo—as he himself remarked on U 284A—[255]on the commission either of Ascanio de' Sacchi, who owned a "barco. . .in loco terme diocletiani," or of Cardinal Ippolito d'Este, who had leased part of it until his death in September 1520.[256]

The survey of ancient Rome involved the two papal architects if for no other reason than that it served chiefly in the restoration of the city rather than for archaeological purposes. Before the physical specifications of the new city could be determined, "good" architecture worth preserving had to be incorporated and reconstructed. In Raphael's own words, the *paragone* with ancient monuments should spur both builders and architects to outdo Antiquity with its own means.[257]

Julius II had already, of course, begun the process of restoring his papal metropolis to its ancient glory. His architects, chief among them Bramante, had

28 Antonio da Sangallo the Younger. Project for facade, section, and other details of St. Peter's (U 70A r.; ca. 1519).

already developed methods of representation similar to those described by Raphael in his letter, as a means of handing down the ancient exemplars to posterity at least in graphic form. Such methods as the scaled triad of ground plan, elevation, and section; the use of a compass; and the reconstruction of destroyed parts by analogy to those surviving can, in fact, already be found before 1515 in the work of both Antonio da Sangallo and of Raphael, even before their intensive collaboration.[258]

What set Raphael's project for Rome apart from the Codex Coner and all earlier studies of ancient monuments, and made it the object of admiration among his contemporaries, was its historico-topographical method.[259] In determining the physical specifications for restoring ancient Rome, Raphael did not start, as did Bernardo della Volpaia before him and Serlio afterward, with building types and orders, but with areas, the first of which, the area between the Arch of Titus and the Porta Capena, he supposedly had worked out before he died.[260]

Although the sources link only Raphael to the

Rome project, he had Antonio's help for both the reconstruction of the streets and the surveys of individual monuments. Thus Raphael also must have counted on the relevant planning material collected over the years by Bramante and the Sangalli. Only when he had gained an overall view of which monuments were adequately surveyed, which were imprecisely or partially surveyed, and which were missing altogether, would he have ordered new, time-consuming surveys. And like Raphael himself, the busy Antonio probably played a delegating and interpreting role in the gigantic project rather than actively taking part in the surveys himself. The few drawings from Antiquity by Antonio that can reasonably be dated in these years were frequently made in connection with concrete building projects.[261] The systematic studies of the Theater of Marcellus, which he carried out together with his brother Giovanni Battista and probably also Peruzzi, in any case, stem from the time after Raphael's death.[262]

Thus the sources so far are inadequate for a more precise determination of Antonio's share in the Rome

project.[263] How closely it was tied not only to Raphael but to the pontificate of Leo X is shown by later developments. Neither Clement VII nor Paul III, neither Antonio's nor Raphael's students, carried the historico-topographical method further. Significantly, Fabio Calvo's *Simulachrum* of 1527 is based entirely on the ancient sources compiled by the Ravenna humanist for Raphael's project.[264] It was Pirro Ligorio who later resumed the work under changed circumstances.

How complex the development of architectural drawing was in the circle of Bramante and his immediate students, and how early Antonio da Sangallo's influence was felt, can also be seen by a glance at other masters of these dynamic years. A group of drawings in the Uffizi, which at one time were attributed to Jacopo Sansovino and then by Günther to a Sienese working about 1525, can be compared with the Codex Coner, for the group similarly includes, besides ancient monuments, only projects by Bramante, and only those, moreover, in the representational style established by Bramante during his years in Rome.[265] The draftsman makes use of perspective sections, opens the interior spaces at wide angles, only rarely draws pure elevations, and, like the young Antonio, favors isometric sections for details. Although he is still attested to being a collaborator of Antonio's in 1532, his bundle of drawings in the Uffizi may have originated before Bramante's death; indeed, some of the sheets—the projects for the Baptistery, the Oratorium Crucis, and SS. Celso e Giuliano, for example—may have been copied directly from projects made by the Bramante workshop.[266] This is also suggested by the fine graphic technique, with its light and dark contrasts and suggestions of spatial depth, which similarly characterize Aristotile's presumed copies after Bramante's projects.[267] In any case, his method of representation can hardly be reconciled with the more rational thinking that became current after 1514.

In contrast, most of the surviving drawings of the French stonemason and architect Jean de Chenevières must have been made during the pontificate of Leo X.[268] Like Bernardo della Volpaia, he too could have taken over the bird's-eye perspective favored in his overall views from Bramante.[269] Coherent pieces of workmanship, such as the double-sided doorframes of the Cancelleria, are drawn in elevation as well as in cross section, as he had probably been taught to do in a French building lodge.[270] Generally speaking, his tight, not very pictorial method of representation and his use of the French foot remain true to his native

training. His ground plans after existing buildings—predominantly projects by Antonio da Sangallo, together with the Cancelleria—are characterized by a Sangallesque precision, just as his only two presumably attributed buildings, S. Luigi dei Francesi and the Palazzo Regis, are directly inspired by Antonio. Oddly enough, none of his drawings from Antiquity seems to go back to models by Antonio. Before becoming an independent architect, which he became by 1518 at the latest, he could have worked as a stonemason under Bramante and Antonio and have learned the new principles of construction from them. If the Munich design for S. Giovanni dei Fiorentini is really from his pen, he would then already have been making use of the complementary combination of facade and section in the two halves of a drawing, such as could be found at that time principally in the work of Antonio and Raphael.[271]

This method of representation—which is still popular today—was also taken over after 1518 by the Bolognese sculptor and architect Domenico da Varignana.[272] In the drawings on folios 1 to 62 of his Codex Mellon, orthogonal elevations and perspective views, such as already were used by Giuliano da Sangallo, predominate. When he showed the interior of SS. Celso e Giuliano in a wide-angle, diagonal view toward the piers of the dome, he was perhaps, like Aristotile and Pseudo-Sansovino, copying a lost project by Bramante. The rooms of a Roman bath on folios 51 v., 52 v., and 54 r. may also go back to models from the time before 1514; here, a perspectivally foreshortened ground plan completes the perspectival section, a procedure that is already found in Leonardo's Milan sketches and that once again may have been brought to Rome by Bramante.[273]

Domenico avoided the perspectival and the isometric cross sections of details that are so characteristic of the early Antonio the Younger, and he failed to include even a single building of Antonio's, though he did copy Raphael's unexecuted project of 1518 for St. Peter's. This alone is an indication that the two papal architects, despite close collaboration, represented independent points of view. After having, on folio 59 r., continued to join the elevation of the round temple in Tivoli with a perspectival section—as ineptly as had Chenevières the ambulatory in Antonio's model—Domenico began, on folio 63, undoubtedly again inspired by Raphael, to make a complementary division of the elevation into facade and section.

No one developed Raphael's strict method of design and representation more fully than his star pupil, Giulio Romano.[274] From the color-differentiated

design for the courtyard of the Palazzo Branconio of 1519 and the pen sketch for the Palazzo Adimari of 1520 to Andreasi's probably faithful copies of his designs for the Palazzo del Te of ca. 1525, his projects in the Codex Chlumczansky, his designs for the Porta del Te, and his late house in Mantua, he kept—though by no means exclusively—to the orthogonal elevation. He endowed it with a previously unknown sensuousness, even permitting himself in the process an occasional concession to perspective.

Equally obvious is the dependence upon Raphael and Antonio of the so-called Italiener C, recently identified as Riniero Neruccio da Pisa.[275] He drew ancient monuments almost exclusively, as a rule representing them in strict orthogonal projection—with the exception of the rooms of a bath on folios 15 v. and 16 r. and v., which, with their combination of perspective section and perspectival ground plan, go back to similar, if not indeed the same, models used in the Codex Mellon.[276] Although he seems not to have made clean copies of the drawings in the Vienna sketchbook until after 1519, he copied a number of other sheets after models from Bramante's circle, especially those by Giancristoforo Romano and Peruzzi, which date from the period before 1510.[277] The same master obviously drew the Vienna designs for S. Giovanni dei Fiorentini, which both in their formal language and in their method of representation are so closely allied to Antonio's projects of 1518–20 that they have sometimes been attributed to him.[278] In fact, Riniero worked closely with Antonio as a stonemason and architect for Loreto and left him—for example, in 1535—some of his own drawings of ancient architecture.

How differently Bramante's immediate followers drew is demonstrated by Peruzzi's extensive corpus.[279] Not only in his drawings from Antiquity but also in his presentation drawings, he preferred throughout his life—in diametric opposition to Raphael and Antonio da Sangallo—a perspectival method of representation, such as he had already used before his encounter with Bramante. His few orthogonal views of ancient buildings may thus have been copied from models of the Sangallo circle, especially since they are measured in *braccia fiorentine*, in contrast to his independent surveys.[280] Peruzzi's predilection for perspective is all the more remarkable because he had already learned the precise representation of details in complementary elevations from Bramante by about 1506,[281] and in the process of designing he in no way renounced the use of orthogonal elevations and sections.[282] About 1507 he copied Antonio's isometric cross section of the Doric entablature found in St. Peter's, and in the fol-

lowing period he was frequently to employ the isometric section—the "projectura quadra," as he called the procedure on U 409A r.[283] Toward the end of his life, in his project for St. Peter's on U 2A, Peruzzi combined perspectival section and perspectivally foreshortened ground plan, which had been familiar to him since his early years in Rome, with a Bramantesque bird's-eye view.[284]

Thus the more intensively one studies the beginnings of Roman architectural drawing, the clearer becomes Bramante's unique importance. While only a few isolated strands of development lead back to Francesco di Giorgio, Cronaca, or Giuliano, Bramante alone seems to have united all the various possibilities of representation: the orthogonal triad, the complementary elevation, the drawing of one story within another, and the numerous methods of perspective and isometry. As a painter—a follower of Piero and Mantegna, and a friend of Leonardo's—he was familiar with all the tricks of perspective. As a follower of Alberti and an adviser to the Milanese cathedral building lodge, he was familiar with all of the orthogonal methods, and although only a few original drawings of his have come down to us, his students and admirers prove how broad and unorthodox the spectrum of his means of representation must have been.

If collaboration with Raphael meant a major enrichment of Antonio da Sangallo's formal language, with its otherwise monotonous tendencies, the repercussions for his design method and his drawing style still remained astonishingly minimal: The clean copy U 122A for St. Peter's differs from the earlier Cancelleria project mainly in the spare use of wash.[285] And if the design U 7976A, a drawing for base and pedestal of the large interior order at St. Peter's, is drawn more precisely than Bramante's capital study U 6770A, Antonio still nevertheless follows similar formal and geometrical principles insofar as he translates the antique prototype into repeatable formulae with the use of compass and ruler.[286]

Similar design principles also characterize Antonio's projects for S. Giovanni dei Fiorentini, S. Marcello, S. Maria di Loreto in Rome, S. Marco in Florence, and the Cathedral of Foligno, in which something of Raphael's spirit lives on.[287] Yet when, after Raphael's death, Antonio was promoted to first architect of St. Peter's and Peruzzi to be his deputy, this was fruitful mainly for their joint study of Antiquity.[288] Stylistically Antonio drew far more inspiration from unorthodox masters such as Michelangelo and Giulio Romano. He had drawn Michelangelo's model for S. Lorenzo early in 1518 on U 790A r., in Rome.[289]

The effect of the inserted attic and the bundled verticals of the model, or of the bracketing of the arcades of the Medici Chapel, is not slow to make itself felt in his projects for the facade of St. Peter's (U 72A), S. Luigi dei Francesi (U 868A), or S. Giovanni dei Fiorentini (176A, 1364A).[290] Even the abstract volutes of the "finestre inginocchiate" of the Palazzo Medici in Florence found a direct reflection in 1526 on the rear wall of the loggia of the papal palace in Loreto (U 923A), and in the same year he must have copied on U 816A and 817A projects by Michelangelo for the Laurenziana Staircase.[291] The effect of Giulio's fondness for rustication and encrustation also becomes noticeable immediately (*U 1041A, 786A).[292]

Peruzzi's influence does not even seem to have affected Antonio's graphic representations. Thus, for example, the unaccustomed perspective of his chimneypiece design U 170A for Hadrian VI is much nearer to Giuliano's last drawings than to Peruzzi.[293]

From about 1525, certainly encouraged by Peruzzi, Giovan Francesco, and Giovanni Battista, and also with the idea of a Vitruvius commentary in mind, he renewed his critical study of the great Roman monuments and their architectonic structure, this time in a far more theoretical way. Thus he made with Giovanni Battista a precise survey drawing and reconstruction of the Baths of Caracalla and studied the imperial fora and the Porticus Pompei with a keen sense for archaeology.[294] But most of all he concentrated on the Pantheon, the matriarch of all Renaissance architecture. Its exceptional size and complexity perhaps explains why there had been no reliable measuring of the entire building to that date,[295] although Antonio and his cousin Giovan Francesco had measured various details of the Pantheon, or copied them from other models, during Bramante's lifetime,[296] and in the Codex Coner most space was given to the Pantheon and the Colosseum.

When, toward 1525, Antonio began a more systematic treatment of antique architecture, he must have determined that he was missing a great mass of critical information about the Pantheon, particularly regarding certain details and the relationship between the interior and exterior elevations.[297] The structural thinking that we can see again and again from his studies for the Palazzo Farnese, St. Peter's, and the Villa Madama, which can be followed in such a full way in the case of no earlier architect, speaks clearly from the questions he poses on U 1157A v. Thus he inquires after the precise height of the floor inside and out ("chome sachorda") and after the continuity of the cornice ("chome safronta"). He seems to have

solved these problems immediately, as the probably contemporary studies on U 1157A r. testify (Fig. 29). In the same context he must have noted on the earlier measured drawings U 1061A, 1191A r., 1219A, and probably also 85A v. his observations on the proportions of the Colossal interior order of the Pantheon.[298]

He must have then summarized all these surviving studies, surely the smaller part of those actually made, in a section, which would have differed only minimally from Peruzzi's Ferrarese section, the earliest measured, purely orthogonal section of the whole building that we possess (Fig. 30). Indeed, the use of the *braccio fiorentino* divided in 60 *minuti* and the correspondence of numerous measurements support the idea that Peruzzi simply copied Antonio's lost section and completed it with a few details in *piedi* and *palmi romani*, noted on the margin.[299]

Not until Antonio had achieved complete clarity about the total structure of the building in this way could he turn to the numerous inconsistencies that could not escape a student of Bramante and even led Michelangelo to his theory of the three architects.[300] If he gave himself no rest seeking more consistent solutions on U 306A, *841A, 874A, 1060A, 1241A, 1339A, or 3990A,[301] this was less a regression into Gothic thinking than a thoroughly creative acknowledgment of the teaching of Bramante, who of course had attended with similar rigor to correspondence and axiality in the Tempietto and in his design for the dome of St. Peter's.[302]

29 Antonio da Sangallo the Younger. Studies after the Pantheon (U 1157A r.; ca. 1525).

34

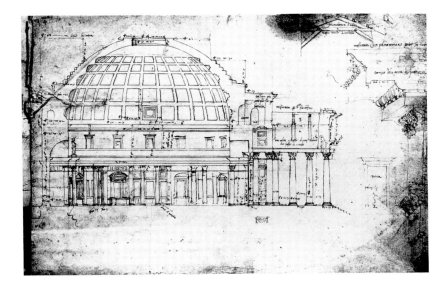

30 B. Peruzzi (after Antonio da Sangallo the Younger?). Section of the Pantheon (Ferrara, Biblioteca Comunale, MS. Classe I, n. 217; after 1525[?]).

31 (below) Antonio da Sangallo the Younger. Project for the Cappella Medici at Montecassino (U 172A r.; ca. 1535).

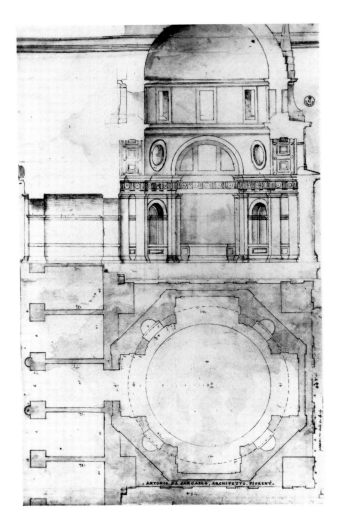

Antonio da Sangallo the Younger's Late Period: 1527–46

After 1527, in his projects for the Cappella Cesi in S. Maria della Pace (U 708A), for S. Maria di Montemoro (U 173A), for S. Girolamo degli Spagnoli (U 904A), for the Medici chapels in Montecassino (U 172A; Fig. 31) and in S. Maria sopra Minerva (U 178A), and finally for St. Peter's (U 66A, 256A, 259A), Antonio raised the level of his presentation drawings to a perfection previously unknown.[303] In contrast to Peruzzi, he stayed true to the more effective orthogonal projection, even for complicated structures like St. Peter's, and used wash, slightly lighter than in his early drawings, to create light and shadow and thus increase spatial effects. He must have retained this procedure for his definitive project for St. Peter's from 1538 onward, of which his co-worker Labacco then copied his most accurate copperplate engravings.[304] In the project for Montecassino (U 172A), or in the late dome project for St. Peter's (U 261A, 267A), he drew the plans of several stories one above the other, as had been the practice of Late Medieval construction teams and the Bramante circle and as he himself had already done about 1526 in a study of the Tomb of Theodoric (see Fig. 19).[305] This method thoroughly corresponded to Antonio's method of rational planning.[306]

This process of technical perfecting falls, not by accident, in the troubled years before and after the Sack of Rome, which meant a burdensome caesura in Antonio's life: In 1526 he entered into a relationship with the Florentine patrician Isabella Deti, a woman

of difficult character who drove him to maintain an all-too-extravagant lifestyle.[307] In May 1527, the Sack destroyed the aestheticism of the previous decades. Periods of belligerent unrest made fortification architecture a priority throughout the Papal States for the first time since Alexander VI and demanded a good part of Antonio's energies from then on.[308] Finally, toward the end of 1534, his most important patron, Alessandro Farnese, became pope and inundated him with commissions; these he had to deal with for the most part single-handedly after Peruzzi's death in 1536.

How far-reaching was the impact of these events on the nature of the deeply religious master can be seen in his handwriting alone. After 1527 the ductus becomes more hasty, more habitual, sketchier, and seems occasionally hard, rushed, even nervous (Fig. 32e–i), and particularly in the overburdened years after 1537 these traits appear in a heightened form (Fig. 32j–m).[309] Thus, he typically draws abbreviating hyphens as a ligature over the vowels without a break, while before 1527 he usually used them in an isolated fashion (Fig. 32a–g).[310] Most of all, he changes the *h*, making it approximate the form of the standard modern lower case by opening the lower part and doing without the fatly looped upper stem. It is possible that this change was motivated by confusion between a *ch* and a *g*, which in his earlier hand sometimes look identical. The lower curve of the *3*, which formerly he had often drawn dragging down, he now also tries to make approximate the norm. Drawings such as the geometric study on U 1456A, where both forms of the *h* appear side by side (Fig. 32e), may have been made during the transitional years 1527–29.

The distinctions in the handwriting samples datable between years from 1510 to 1527 are less obvious. On the earliest, *U 1484A v., from around 1510, and on related sheets such as U 1191A, one senses a youthful swaying of direction, which later tends to go slightly to the right (see Figs. 7h, l, 22, 32a–d).[311] The *g* and *h* are still provided with thick, occasionally even left-swelling curves. The lower strokes of the *s* and *f* occasionally open out to small loops. Before 1514 the *3* frequently ends with a rounded hook. Individual letters possess not only larger upper and lower lengths, but have a more sweeping, unrestrained, youthful character. The difference of the controlled, more rational inscriptions from 1514/15 on the designs for the Palazzo Farnese is already unmistakable (see Fig. 7m).[312] The listing on *U 1344A r., dated November 1526, then characterizes a yet more decisive attack and a diminution, concentration, and simplification of

forms, again mainly of the *h*, whose upper loop frequently is left off (Fig. 32d). Nevertheless, it is anything but easy to provide a sequence for the drawings of the period after 1513 and before 1528 solely on the basis of the handwriting of this or that phase.

It can hardly be a coincidence that, on the basis of their handwriting, most of Antonio the Younger's theoretical studies can be dated to the period after the Sack of 1527, as the drop in building commissions gave him time to consider a commentated edition of Vitruvius.[313] His preoccupation with Vitruvius led him not only to draw the "homo quadratus" on U 1249A r., as a norm for the Doric,[314] but also to study antique monuments systematically and with a hitherto unknown precision.

In doing so, he replaced the *braccio fiorentino*— which he had retained up to 1525 mainly because it corresponds nearly exactly to 2 *piedi antichi*, and the measurements of the older drawings of antiquities had been calculated with this unit—with the *piede antico*.[315] Thus it became even easier to recognize the modulus and a building's relation to Vitruvius's teaching right away. Now he no longer concentrates on a few exemplary buildings nor on the most beautiful detail as he had during his years of training and apprenticeship, but rather he analyzes the various orders and the building types (theater, bath, and temple) to which Vitruvius devotes Books III–V. On U 1427A v., he even gives indications for a future classification of his drawings of antiquities, not necessarily based on Vitruvius or Alberti, but rather following format and building type (temple, triumphal arch, triumphal column).[316] This ambitious undertaking could find support in the numerous drawings of antiquities that Antonio the Younger himself had prepared, copied, inherited, or received from collaborators such as Giovan Francesco and Giovanni Battista from the time of his Roman beginnings. For the more monumental buildings he had to turn to his own measurements and those that he and Giovanni Battista had carried out in the mid-1520's with a more critical approach.[317]

This intense preoccupation with Vitruvius and the antique also led Antonio to calculate his orders and his architectural detail in *piedi romani* and antique moduli and, in his domestic architecture, to attend more strictly to the sequence of vestibulum, atrium, cavaedium, peristylium,[318] perhaps even inspired by his deceased cousin Giovan Francesco, whose villa design from ca. 1518 anticipated the interior disposition of Antonio's later houses (see Fig. 37).[319] Antonio must have also prepared a great part of his

32 Antonio da Sangallo the Younger's handwriting 1518–46: **a** 1518 (U 1228A v.) **b** ca. 1520/21 (U 33A)
c ca. 1523 (U 717A r.) **d** 6 November 1526 (*U 1344A r.) **e** ca. 1528–30 (*U 1456A) **f** 1530 (U 706A v.)
g 1531 (proemio, fol. 3 r.) **h** ca. 1534 (*U 1282A r.) **i** 1535/36 (*U 1014A r.) **j** 1538/39 (*U 1342A r.)
k ca. 1540 (U 62A v.) **l** ca. 1541/42 (*U 902A r.) **m** 1545 (U 991A r.).

numerous copies after Taccola and Francesco di Giorgio shortly after 1527, and have concerned himself with mathematical and astronomical problems that he needed for the commentary on Vitruvius's Books IX and X.[320] The changes in his handwriting are thus also contemporary with an entirely more conscious and reflective conception of his artistic tasks.

Oddly enough, a change in his drawing style corresponding to the change in his script comes about only gradually. The sketches for the Palazzo Pucci in Orvieto (ca. 1528–34), the Cesi Chapel (1529/30), the Fortezza da Basso of 1534, the palace of Luca Massimo and his own house in the Via Giulia from around 1535, or for the entrance of Charles V into Rome in 1535/36, are not fundamentally distinct from those of the period before 1527.[321] The same holds true for his figurative style, which does nonetheless lose something of its charm.

Not until the innumerable studies for the definitive project for St. Peter's from 1538 and the following years does Antonio the Younger's drawing style increasingly take on that sketchy hastiness that had been heralded years before in his handwriting and in a few studies such as U 78A for St. Peter's (ca. 1535) or U 918A for the Palazzo Farnese (before 1520?) (see Fig. 27).[322] Painstaking details or spatial clarifications become rarer, the contrast between the hastily composed sketches and the mathematically dry clean copies increases.[323] In the case of the latter, distinguishing between the hand of the master and those of his collaborators is almost impossible, especially since Antonio usually reserved the scaling and the commentary for himself. He now no longer arranges his sketches and their accompanying inscriptions carefully and evenly across the sheet, as he may have learned to do from Bramante; rather, he fills in every gap without a second thought for aesthetic considerations. This new, occasionally chaotic-seeming spontaneity expresses itself most overtly in the designs for the Porta Santo Spirito of 1541/42, where drawing and commentary even overlap each other. Nevertheless, these last studies possess a new graphic appeal, an individual fecundity, like none of his earlier sheets. Indeed, it is conceivable that his two great rivals in Rome of the thirties, Peruzzi and Michelangelo, and painters like Perino del Vaga inspired him to this new freedom. At the same time, it also represents a return to the spontaneity of his own pre-Bramantesque early period (see Fig. 14).

Since there is no project for which all stages of the design survive, only the totality of Antonio's drawings can convey an idea of his design method and its possible changes, as well as the method of his workshop. Basically, most of his projects fall into a sequence matching the six design stages we already can discern in Bramante. Measurement of the site and existing structures, if any, as well as the first sketches of ideas stand at the beginning (see Figs. 5, 23, 27). Such projects, not yet drawn to scale, were presented to the patrons or even developed with their cooperation.[324] The first sketch plans often are accompanied by elevation sketches of the facade, the courtyard, or the interior to serve as a control.[325] Antonio certainly did develop elevation and plan together.[326] If he usually limited himself to a few elevation details and spent relatively little energy on checking the spatial effect, that was due mainly to his sure knowledge of tried-and-true systems and types of spaces to which he returned again and again. In any case, the clean copy of the plan already presumed precise studies of the individual building parts and wall systems. He checked over the mutual relationships between the interior and exterior constructions and the coherence of the individual spatial components with sections and related detail plans (see Fig. 28).[327] From these studies he developed the presentation drawing for the patron, which frequently offered alternatives for choice and was easily translated into a wooden model (see Figs. 26, 31).[328] Not until the patron had decided on the realization of this or that project did Antonio develop the plan to the point where it could be carried out. Thus, studies for the atrium, stairwell, and window aedicules follow upon the presentation drawing U 627A for the courtyard of the Palazzo Farnese. And similarly the flood of detailed studies for St. Peter's does not begin until around 1519/20 and again after 1538, after Leo X and Paul III had decided on specific projects for execution. Thus, one must also distinguish between presentation models, such as models prepared for competition,[329] and working models, like Antonio's wooden models of 1521 and 1538 onward for St. Peter's.[330] The sixth and last stage, namely, the preparation of working drawings (see, for example, *U 7976A for bases and pedestals of the Colossal interior order of St. Peter's, or U 788A for the cornice of a portal of the Scala Regia) and their translation into working drawings or templates drawn on a scale of 1:1 for the use of the laborers, did not come until the final decision on the working project, directly before construction.[331]

These six stages, of which the second and fourth could be broken down further, had been anticipated by fifteenth-century practice. A glimpse at the drawings of an architectural autodidact like Michelangelo

nevertheless shows that Antonio the Younger's contemporaries by no means all planned using the same method.[332] He himself seems to have refined this method rather than ever fundamentally changing it in the course of his nearly forty years as a practicing architect. No design of an entire facade from the period before 1535 is calculated completely in *dita*, that is, twelfths of a *palmo,* as are U 1111A and 1286A;[333] and only from around 1538–40 did Antonio completely convert to calculating details such as orders or door and window mounts in antique feet and in thousandths of moduli.[334]

Antonio the Younger's Collaborators

Like Bramante, Antonio the Younger involved only a few highly qualified collaborators in his design process.[335] Until 1530, these are mainly Antonio Labacco, his cousin Giovan Francesco, his brother Giovanni Battista, and probably also his other brother Francesco; after 1530 they are Giovanni Battista and Bartolomeo Baronino and occasionally Giovan Francesco's brother Sebastiano, known as Aristotile.

As early as 1512 Labacco had worked under Antonio on preparations for the Lateran Council (see Fig. 7l), and in 1552 he still acknowledged Antonio as "mio maestro."[336] Under Bramante's and Antonio's guidance—that is, probably between 1509 and 1514—he learned the newest methods of reconstructing and depicting ancient ruins, many of which were just then beginning to come to light.[337] He must have stored his drawings carefully, and even copied many of the drawings from Antiquity made in the Sangallo circle, so that they could later be published in his book of engravings of 1552.[338] This also explains why astonishingly few of his drawings after the antique (U 1190A, 1338A, 1664A, or 1850A) ended up in Antonio's collection.[339] Only some of his admirable engravings follow the rational triad of plan, elevation, and section, and among these the studies of the Mars Ultor Temple and the Forum of Augustus are based on studies made after 1520 by the Sangallo circle.[340] Parts of others, such as the purely perspective reconstruction of the Basilica Aemilia—already destroyed by 1506—may go back to the time before 1514, when Labacco, like Aristotile, learned from Bramante the method of representing both buildings and ground plans in perspective.[341] This is also suggested by the details in the drawing of the Basilica Aemilia on U 1190A, where the numbers and the method of representation are directly reminiscent of Antonio's and Giovan Francesco's drawings from the time before 1514 (Fig. 33).[342] The combination of an elevation

with two ground plan levels and the section of a column base from the Mars Ultor temple, which recalls Peruzzi's Bramantesque detail studies of about 1506, probably also go back to Bramante.[343] A glance at Serlio's woodcuts after similar models is enough to reveal the incomparably more profound training of this long-standing collaborator of both masters.[344]

Labacco was so closely bound to Antonio that all his life he wrote numerals resembling Antonio's from the time before 1513; as a consequence, sheets such as U 1058A have falsely been ascribed to him (see Figs. 6, 32a).[345] In the ground plans U 720A and 171A for S. Maria di Monserrato of 1518, Antonio the Younger's earliest project to date, for which Labacco's participation has been documented, the hands of the two are hardly separable, and so Labacco may have participated on numerous other drawings, surviving as well as lost. In ca. 1519 he must have built Antonio's model for S. Giovanni dei Fiorentini. Perhaps because he participated in its design and undertook some changes in the printed version, he claimed this later as his own invention.[346] Probably he also made the model of Antonio's project of 1521 for St. Peter's. In the 1520's he assisted Antonio in projects for the transformation of S. Giacomo degli Spagnoli[347] and accompanied him to Piacenza, Modena, Mantua, and Ancona to inspect fortifications (U 1151A). His copies of construction drawings for mills probably were not made until after 1527. The large wooden model of about 1538 for St.

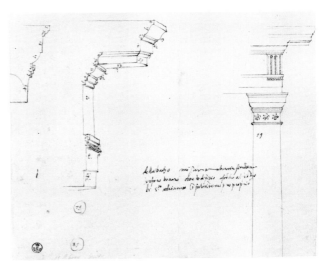

33 Antonio Labacco. Entablature of the Foro Boario with explanation by Antonio the Younger (U 1190A r.).

39

Peter's was the high point of Labacco's numerous activities.[348] Even after Antonio's death he seems to have remained active in the planning of the Palazzo Farnese.[349]

In contrast to Labacco, Giovan Francesco (1484–1530) can be grasped as an independent architect.[350] Like his cousin Antonio, he probably came to Rome and to papal service in the spring of 1504 in his uncles' following. And if he has not yet been documented during the pontificate of Julius II, he must nevertheless have belonged to that circle of talents who, in close collaboration first with Giuliano and then with Bramante and Antonio, matured into independent artists.

According to Vasari, Giovan Francesco, together with Giuliano Leno, profited from selling building materials.[351] In December 1514, he was named as *misuratore* and *soprastante* of the crew on site on the basis of his experience "in geometria et arithmetica" and thus became Raphael's immediate collaborator. In his earliest drawings, which he may have made before 1514, the 3 is, as with the young Antonio, still graced with a hook (Figs. 34, 35b).[352] Before 1518, and probably already around 1513/14, he normalized it as his cousin had done (Fig. 36). Perhaps some of these early sheets date back as far as ca. 1505. In any case, U 1326A (see Fig. 35b), which with its fine hatching and angular handwriting is slightly different from the rest of the early group, and U 1650A v. seem to have been copied after drawings by Antonio the Younger from the time before 1507 (see Fig. 15).[353] While Antonio in most of his early drawings already concerns himself with a structure in its entirety, the drawings that survive from Giovan Francesco's early period are mostly detail studies of existing buildings. Even in these early sheets, Giovan Francesco surpasses most of his contemporaries and even his cousin Antonio in precision and painstaking reproduction, and thus Giuliano and Bramante may have made use of his talent not only for drawings after the antique but also for clean copying of their own projects. The beautiful elevation fragment U 2143A r. of the so-called Basilica Aemilia may also be his, distinguished from Giuliano's earlier sheet in the "Libro degli Archi." of the Codex Barberini by its greater exactness of the Doric detail and its reduction of the perspectival aspects.[354] Significantly, a purely orthogonal mode of representation already predominates in these early drawings, as Antonio the Younger himself also preferred, and as became more and more established in the Bramante circle after about 1506, as opposed to the combination of section and perspective. U 1704A and 85A confirm how closely Giovan Francesco was working with Antonio even before 1514 (see Fig. 34).[355] Since his drawing style shows no trace of Filippino's influence and is perceptibly closer to that of Giuliano, indeed, at times even approaches Aristotile's pictorial chiaroscuro, he must have undergone a wholly different training. The precision and theoretical awareness of even his early drawings nevertheless clearly go beyond Giuliano.[356]

The drawings of the years 1514–20 differ from the foregoing ones in their normalized 3, and from the later ones in the horizontal stroke in the *ch,* as is found on U 273A, 863A, 909A, 1292A, and 1898A, all datable around 1518/19 (see Figs. 35d, e).[357] Thus if Giovan Francesco's early handwriting as found on U 1329A, 1377A, 1704A, or 1852A is united with Antonio's later handwriting, this means that Antonio annotated his cousin's drawings after his death in 1530.[358] The putative early sheet U 1652A, recording antique details that had been found and reburied in Bramante's lifetime, shows Giovan Francesco's late handwriting with the calligraphic *d* and thus must be a copy that Giovan Francesco made of another drawing after 1520.[359]

After Giovan Francesco had proved himself in Bramante's workshop, Raphael entrusted him to prepare his designs in executable form, probably not only for

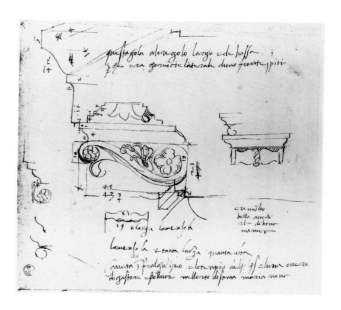

34 Giovan Francesco and Antonio the Younger da Sangallo. Studies after the antique (U 1704A r.; ca. 1512).

40

35 Handwriting of Antonio Labacco and Giovan Francesco da Sangallo: **a** Labacco 1529 (U 1793 v.) **b** Giovan Francesco ca. 1505 forward (U 1326A r.) **c** Giovan Francesco ca. 1512 and Antonio the Younger ca. 1512 and after 1530 (U 1704A r.)

Giovan Francesco: **d** ca. 1515 (U 1898A v.) **e** ca. 1518 (U 863A v.) **f** after 1520 (U 1346A v.) **g** 1524/25 (U 1331A r.) **h** ca. 1525 (U 1399A r.) **i** 1526 (*U 1396A r.).

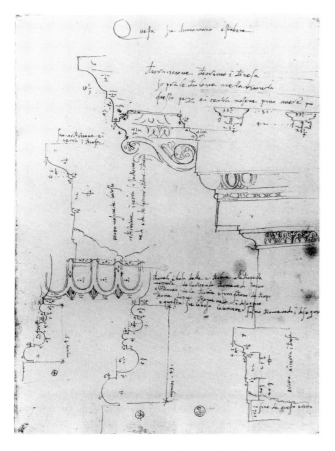

36 Giovan Francesco da Sangallo. Studies of the Pantheon
(U 1387A r.).

the Palazzo Alberini, Villa Madama, and Palazzo Pan-
dolfini, but also for the remaining projects of those
years. Giovan Francesco could thus also have drawn
the model for Raphael's second project for St. Peter's,
which has been preserved in the Codex Mellon.[360]
Raphael also assigned him the execution of the Palaz-
zo Pandolfini. Thus, Giovan Francesco, who was
equally experienced in theory and in craftsmanship,
may have played a greater role in the material trans-
lation of Raphael's architectural ideas than has hith-
erto been supposed. At the same time, he was making
drawings for his cousin Antonio, not only for projects
in which both papal architects participated, but even
for one, S. Giovanni dei Fiorentini, in which they
were competing.[361] As the partner of Giuliano Leno,
a supplier of materials, he had his own interest in
view in all these costly undertakings, especially dur-
ing the building of St. Peter's, and during the years of
his most intensive collaboration with Raphael he
worked also as an independent architect.

The drawings of antiquities from these years
between 1514 and 1520, however, do not reveal that
Giovan Francesco was then working for Raphael. On
U 1163A, 1329A, 1705A, and 1716A he makes as much
use as before of the perspective and isometric sec-
tion.[362] Among these, U 1163A and 1329A represent
antique cornices that lay in the house near S. Rocco
that Antonio had rented in 1512; thus they are unlike-
ly to have been copied from older models.[363]

Not much later, he draws the orthogonal studies
after the Pantheon on U 1387A expressly as his own
achievement (see Fig. 36).[364] Like almost all of his
drawings of antiquities, they are measured in *braccia
fiorentine*, which, like his cousin, he must have calcu-
lated as 2 *piedi antichi* exactly.[365] Likewise ca.
1515–20—that is, about the same time as Francesco
da Sangallo's sheet U 284A—he copied the ground
plan of the Baths of Diocletian on U 2163A, probably
after a lost model by Antonio.[366]

The *ch* with crossbar also turns up on Giovan
Francesco's only surviving design from this second
phase, U 3963A, a design for a villa from about 1518
(Fig. 37).[367] Although in this project he sticks with the
perspectival concessions as used by Giuliano, at the
same time he anticipates the schema of the Vitruvian
plan that Antonio would prefer after 1527.[368] Despite
the dryness, one senses here, as in his contemporary
Palazzo Balami or in his version U 292A of Antonio's
contemporary project U 1303A for Bonifacio da
Parma,[369] something of the close collaboration with
Raphael, first of all on the Villa Madama. Indeed there
is likewise a dominating axis in depth that binds
together the individual areas of the villa. Around
1513–20, he may also have invented the machinery on
*U 1528A, *3950A, and *3951A, on which he was par-
ticularly dependent both as a building contractor and
as an active master builder.

After Raphael's death, Giovan Francesco became
Antonio's most important co-worker and is docu-
mented as such on the projects for S. Giacomo Scos-
sacavalli and S. Giacomo degli Spagnoli, on the
Palazzo Ferrari, and on the Roman mint and north
Italian fortification projects (see Fig. 35f–i).[370] The
smallest number of drawings of antiquities have been
preserved from this last decade,[371] and these—notably
U 1375A, 1378A, 1382A–1386A, 1388A, 1393A, 1394A,
and 2057A—are dedicated to a great extent to theo-
retical considerations or to entire structures—possibly
in connection with the studies of Vitruvius with which
he himself then to a greater degree was occupied and
which for some time he studied even together with
Michelangelo.[372] Thus, for example, he reconstructs

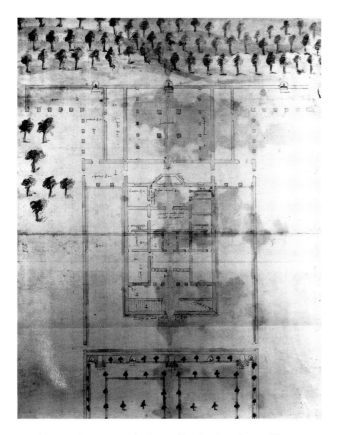

37 Giovan Francesco da Sangallo. Project for a villa
(U 3963A r.; ca. 1518).

the tectonic frame of an antique "Basiglicha" on
U 1378A,[373] and likewise occupies himself on U 1385A
not only with Bramante's never-completed "chonchra-
vo" but also with the design principles of antique
tomb monuments and capitals.[374] He is now so sure
of his ability that on U 989A he applies Vitruvian stan-
dards to criticize the portal of the Vigna of Giovanni
Gorizio, designed by the young Antonio while still
entirely under Bramante's influence.[375] On *U 1846A
he provides the portal of the Rocca of Civita Castel-
lana with a pediment, which also had been designed
by Antonio before 1514.[376] He also seems to have fol-
lowed his own taste on some of the projects he drew
for Antonio, at least in the details—most clearly seen
in the plan U 1399A and probably also in the elevation
U 201A for the Palazzo Ferrari, which he drew free-
hand (in contrast to most of Antonio's projects) and
provided with perspectival optical aids.[377]

If we can thus hardly place Giovan Francesco
among the most important architects of the Renais-
sance, he nevertheless belongs to that group of indis-

pensable spirits who stood tirelessly at the side of the
greats and made an essential contribution to the
knowledge of Antiquity.

Antonio's brother Giovanni Battista was not born
until 1496 and was certainly too young to have fol-
lowed him to Rome as early as 1504.[378] Like Antonio
himself, he too may have entered into training under
his uncle Antonio the Elder and continued, from 1508
on, under Giuliano, who had then returned to Flo-
rence. After his brother and his cousins had begun
such successful careers in Rome, his academic and
artistic training probably became even more thorough.
In any case, in contrast to his brother and his two
uncles, in his early drawings Giovanni Battista already
made use of a calligraphic script, as was used by Bra-
mante, Raphael, and Peruzzi and at that time was
becoming more and more widely diffused (Fig. 38b–e).
The difference in the handwriting of Giuliano's son
Francesco, who was only two years older, mainly con-
sists in the latter's more squiggly g,[379] and thus it is
even conceivable that the two youngest members of
this talented family pursued their training together
(Fig. 38a).

When in March 1513 a Medici became pope, it
seemed that a Golden Age had finally dawned for the
"setta sangallesca," now expanded to at least seven
masters. Giuliano and his brother returned immedi-
ately to Rome and certainly took Francesco and Gio-
vanni Battista along with them. As early as 1513/14
Giovanni Battista delivered a measured representation
of the entablature of the Temple of Castor and Pollux
to his brother that far exceeded that of Bernardo della
Volpaia in its precision.[380] It may have looked similar
to U 1705A, distinguished from contemporary sheets
by Giovan Francesco mainly by the abbreviation used
for the *braccio*.[381] Although it is precisely the stylized
calligraphy that renders attribution more difficult, as
well as some dialect forms in the inscriptions that
don't seem Tuscan, Giovanni Battista remains to this
day the most plausible author of design U 1320A for
the facade of the Palazzo Farnese in Gradoli from
around 1514/15 (Fig. 38b).[382] In its abstraction and its
punctilious concession to perspective, with the unit of
measurement drawn on the upper margin, this design
stands in fact between Giuliano and Antonio the
Younger, as one would expect of Giovanni Battista
around 1515.[383] The two measured plans U 1358A and
2137A for the Palazzo Alberini, in whose planning also
Giovan Francesco took part, both datable toward
1518, probably stem from the same calligraphic hand
(Fig. 38c, d).[384] And this hand returns shortly after
Raphael's death on the garden design U 789A for the

a

b

c

d

e

f

g

h

i

38 Handwriting of Francesco di Giuliano and Giovanni Battista da Sangallo: a Francesco ca. 1514/15(?) (Cod. Vat. Barb. lat. 4424, fol. 1 v.)

Giovanni Battista: b ca. 1515(?) (U 1320A v.) c ca. 1518 (U 1358A v.) d ca. 1518 (U 2137A v.) e ca. 1520 (U 789A v.)
f ca. 1523–25 (U 1319A v.) g 1526 (*U 979A v.) h after 1534 (U 1657A v.) i 1546–48 (Vitruvius).

Villa Madama, up to now attributed to Francesco da Sangallo and secured for Antonio's workshop by virtue of Antonio's own annotations (Fig. 38e).[385] This sheet then forms the bridge to the design U 1319A for a window of the Sala Ducale from around 1521–24, the earliest drawing that can be attributed indubitably to Giovanni Battista on the basis of its calligraphic marginal comments (Figs. 38f).[386] The sheet also demonstrates what graphic virtuosity the twenty-eight-year-old had acquired in the meantime—a virtuosity whose mathematical precision eschews almost every personal note and thereby anticipates the style of Antonio's later working designs. The presumable designs of the previous years permit at least the suspicion that Giovanni Battista had an important share in Antonio's works from 1513 on, perhaps even more important than that of the less tractable Labacco and the more independent Giovan Francesco.

Giovanni Battista is documented as Antonio's assistant from 1521.[387] How close he must have stood to Giovan Francesco, whose drawings were attributed to him up to recent times, is shown by the roughly contemporary measurement of the garden portal of Johannes Goritz on U 1653A v.[388] But, while on U 989A the older Giovan Francesco considers Antonio's early work with practiced criticism, and Antonio himself then later apologetically added, "Non sta bene fu delle prime jo facesse non avevo anchora inteso vitruvio bene,"[389] Giovanni Battista contents himself with the laconic remark: "Credo penda troppo ancor secondo vitruvio." Strangely enough, the elevation of Antonio's "Imagine del Ponte," made not before 1524 on the verso, also has the character of a survey drawing, although Giovanni Battista must have had access to the project itself. Accordingly, Antonio's closest relatives and collaborators by no means limited themselves to blind following, but rather assessed his work on the Vitruvian standard and may thereby have contributed to his subsequent more intensive study of Vitruvius. Like Giovan Francesco, Giovanni Battista knew how to gain material advantage from his many connections, as when he appeared in the diocese of Montefiascone between 1521 and 1526 as an administrator for the Farnese.[390]

A valuable reference point for the development of Giovanni Battista's handwriting is the series of notes from 19 April 1526 on *U 979A, which he made during a journey with Antonio to north Italian fortresses (Fig. 38g). In comparison to his script of the 1530's, but particularly to that of his Vitruvius translation and his letter to Paul III from ca. 1546, it appears more supple, rounded, and flowing.[391] The consistent and

occasionally mannered hooking of the upper and lower lengths—for example of the *f*, *g*, *q*, or *s*—is less pronounced. In short, its character is palpably closer to the inscriptions on U 789A and 1319A (Fig. 38e, f).

After Giovan Francesco's death in 1530, Giovanni Battista acquired a more powerful influence on his brother's design process. This is best illuminated by the studies for the tomb of Clement VII in S. Maria sopra Minerva from 1534 onward.[392] Antonio left the working-out of his sketch U 185A to Giovanni Battista—from the measurement of antique sarcophagi through to the clean copy U 183A (Figs. 39, 40). In general, Giovanni Battista seems to have made a name for himself with tombs such as the entirely independently designed Margani tomb of 1532 in S. Maria in Aracoeli, the only surviving work from his hand,[393] or the design U 186A for a freestanding monument, perhaps even that of Piero de' Medici, whose preparation he was in any case charged with at the time.[394] In all these projects, his somewhat drier and pedantic drawing style remains far behind his brother's with regard to figuration, although, as the complex motifs on *U 1659A v. show, he must have occupied himself even with contemporary painting as in around 1534 with Michelangelo's preliminary studies for the *Last Judgment* or the *Fall of the Rebel Angels*.[395]

What burden of work fell to Giovanni Battista is shown alone by the great number of studies of antiquities that he prepared in close collaboration with Antonio, which in great part also landed in the latter's possession. A sure point of reference for their date, aside from the signature, is offered above all by the use of the *piede antico* after ca. 1525. This is not to say that all drawings measured with the *braccio* are to be dated before 1525, despite agreement on a conversion ratio of 1:2.[396] But the measurements of the Baths of Caracalla on U 1381A or the reconstruction of the Colosseum on U 1126A, 1856A, 1883A, and 3969A[397] can hardly be separated from Antonio's late studies on U 1135A, 1656A, and 4117A.[398] The same holds for the relationship of the measurements of the Theater of Marcellus and of the Forum Holitorium on U 626A, 1657A, and 1668A to Antonio's late studies on U 1090A, 1107A, 1122A, 1225A, 1233A, and 1270A.[399]

What sort of distance Antonio da Sangallo maintained with his younger brother—who was, as his nickname "il Gobbo" (The Hunchback) reveals, little favored by fate—is shown by the annotations on a few drawings of antiquities. Thus, for example, Giovanni Battista notes on U 1057A, the perspectival section of the entablature of the Basilica Aemilia: "questa

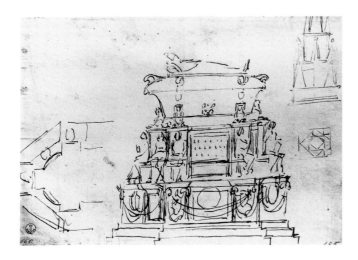

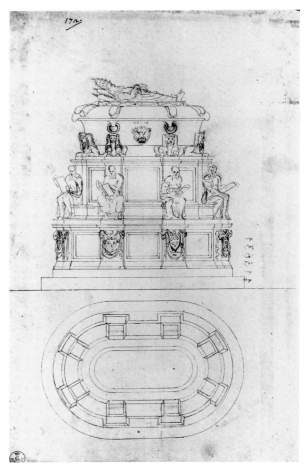

39 Antonio da Sangallo the Younger. Sketches for the tomb of Clement VII (U 1129A r.; after 1534).

40 (opposite) Giovanni Battista da Sangallo. Project for the tomb of Clement VII (U 183A r.).

e di mia mano non ne penso che sia bona io non o se non e di mia mano si che none so quale voi dite havermi date ma nonme ne richordo averne di vostra mano."[400] Perhaps Antonio had believed his own measurement of this entablature made before 1510, which had disappeared in the meantime, was to be found in his brother's possession.[401] The "voi" of the address itself argues for a dating of the sheet, at least of the annotation, in the period after 1520.

A similar process can be observed in the measurement of the Theater of Marcellus, where on U 1966A Giovanni Battista comments: "A basso credo havate le misure cioe del membretto e del primo cornicione el chapitello primo"(Fig. 41).[402] He may possibly be referring here to the survey drawings *U 760A, *761A, 932A, and 1296A, which can be attributed to Antonio del Tanghero in the years after 1517;[403] the drawings, by a pupil of Pietro Rosselli and thus another co-worker in the St. Peter's construction crew, were already in Antonio's possession and their schema obviously was borrowed by Giovanni Battista on U 1966A (Fig. 42). There Antonio the Younger converts Antonio del Tanghero's measurements—noted in *palmi* and *dita* and thus hardly on Antonio's orders—into *minuti*, that is, sixtieths of a *palmo*, in order to be able to compare the proportions with Vitruvius's rules.

That Antonio always held the threads of these ambitious studies in hand, and that Giovanni Bat-

tista's intellectual contribution was relatively minor despite all his training is proved by his own studies of Vitruvius, probably not begun until after his brother's death.

A few unannotated clean drawings for projects of Antonio's, such as U 836A for the Cappella Cesi, U 879A for the Cappella del Corpus Domini in Foligno, or *U 914A, *1256A, and *4159A for the entrance of Charles V, may also be by Giovanni Battista.[404] Their detailed base zone, which Antonio himself usually omitted, recalls the clean drawings probably drawn by Giovanni Battista. Further, the difference between these and his spontaneous sketches is much sharper than in the case of the other members of his family. On the survey drawings of antiquities prepared on site, too, any sense for the aesthetic ordering of the sketches on the sheet is missing, that self-evident formal consciousness that particularly distinguishes Antonio's and Giovan Francesco's early sheets.

The role played in the Sangallo workshop by Gio-

46

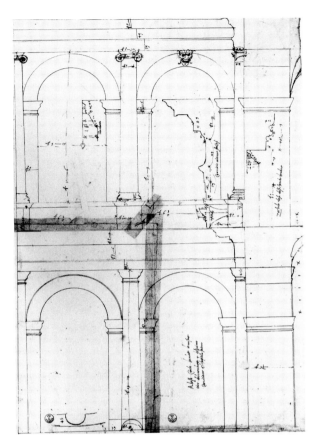

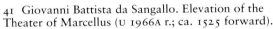

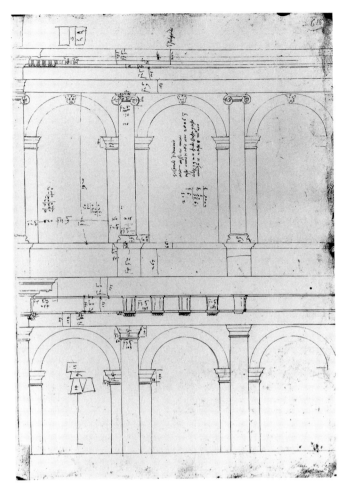

41 Giovanni Battista da Sangallo. Elevation of the Theater of Marcellus (U 1966A r.; ca. 1525 forward).

42 (opposite) Antonio del Tanghero. Elevation of the Theater of Marcellus (U 932A v.).

van Francesco's brother Sebastiano—who was born in 1481 and early in life acquired the epithet Aristotile because of his learned eloquence and physiognomy—is still unclear.[405] As assistant to Perugino, a friend of Ridolfo Ghirlandaio's, the enthusiastic draftsman of the cartoon of Michelangelo's *Battle of Cascina,* and for a time even Michelangelo's assistant in the painting of the Sistine Chapel, he had decided initially to become a painter. With this goal in mind, probably about 1508, he began his initiation under Bramante into the secrets of perspective, especially of perspective stage design. Like Antonio and his brother, he undoubtedly lived at the time in Giuliano's house near St. Peter's, where he became involved with architecture: ". . . si dilettò. . .nella sua giovinezza, come hanno fatto gli altri di casa sua, delle cose d'architettura, e con molta diligenza alle cose di prospettiva: nel che fare gli fu di gran comodo un suo fratello chiama-

to Giovan Francesco. . . "[406] Although Giovan Francesco was three years younger, he must have taken care of his brother until his own death in 1530. Not only did he facilitate his brother's access to architecture, perspective, and Antiquity, but he helped him in all material questions. Thus Aristotile's well-informed friend Vasari reports that Giovan Francesco entrusted to his brother the bookkeeping of his lucrative business in building materials, which he transacted together with the papal *provveditore* Giuliano Leno. In 1520 Aristotile succeeded Giovan Francesco as building supervisor of the Palazzo Pandolfini when the latter returned to Rome after a few months, and he was still assisting and representing Giovan Francesco in 1526–28 in the building lodge at St. Peter's.[407] According to Vasari, he had soon discovered that he was lacking the "invenzione" to become a painter and therefore decided "che il suo esercizio fusse l'architet-

47

tura e la prospettiva, facendo scene da comedie, a tutte l'occasioni che se gli porgessero. . . "[408] In 1528 he followed the papal court to Orvieto, where he is documented for the first time as a close collaborator of Antonio's in the planning of the Palazzo Pucci.[409] He had grown up with Antonio ("essendosi allevato con Antonio da piccolo") and the latter employed him, until his own death, at a variety of building sites, first at the Fortezza da Basso and in Castro, later in Perugia and in the building lodge of St. Peter's.[410] Soon after Antonio's death he returned to Rome, even though Michelangelo is supposed to have counted on his collaboration in 1546/47 for the planning of the Capitoline.[411]

From all this we learn that in the workshop of his two uncles Aristotile began a training like his brother's and cousins', but because his training and abilities in drawing—especially in perspective—were so much more advanced, architecture at first was merely a sideline. Only when he became aware of his limitations as a painter, and perhaps only from the 1520's on, did he begin to augment his occasional commissions for stage scenery and ceremonial apparatuses by becoming the established architectural collaborator of his more successful relatives.

The majority of Aristotile's surviving drawings depict Roman and Florentine monuments of the period between 1480 and 1545, his focus being mainly on smaller structures, details, and ornamentation. Tombs, window frames, fireplaces, and chapels interested him more than monumental buildings such as St. Peter's, the Villa Madama, or the Palazzo Farnese. Thus he particularly liked drawing *palazzetti* and chapels, such as the Farnesina, Palazzo Caffarelli, Palazzo Regis, and various projects by Giovanni Mangone, with whom, accordingly, he had dealings.

More distinctly, however, than in the work of other draftsmen of those decades, Antonio da Sangallo's buildings from the period after 1520 dominate Aristotile's drawings, their number equaling those of Bramante and Michelangelo combined.[412] Most of his drawings appear to stem from this mature period, when Aristotile had become a regular collaborator first with his brother, then with Antonio. The only studies that may be datable in the period before 1520 are those of San Agostino, the Rocca of Civita Castellana, the Tempietto, the Farnesina, and the isometric section of a Bramantesque entablature on U 1745A.[413] Surprisingly, from the period of his close collaboration with Antonio, only one drawing, the survey of the Pucci property in Orvieto on U 1070A, is connected with Antonio's design activities (Fig. 43).[414] Only on

two—the surveys of the Vatican obelisk on U 1754A and of the Porta Marzia in Perugia on U 1043A—is their collaboration documented by notes in Sangallo's own hand.[415] The rest of Aristotile's drawings after Antonio are relevant to the present corpus only when they preserve lost designs, as in the case of S. Maria di Loreto, the Palazzo Ferrari, and possibly also the Palazzo Sacchetti, or lost models, as is likely the case on U 176A and 1371A.[416]

Aristotile's drawing style differs from that of his brother and cousins in its painterly chiaroscuro, which probably was influenced by Ghirlandaio. He places himself under no constraint, employing every conceivable form of elevation, perspective, and—in his details—isometry (Fig. 44). Even in those designs presumably his own, which range from facades and chapels to tombs, fireplaces, and coffered ceilings, he remained true to the semiperspectival method of representation that he had learned from his uncle Giuliano.[417]

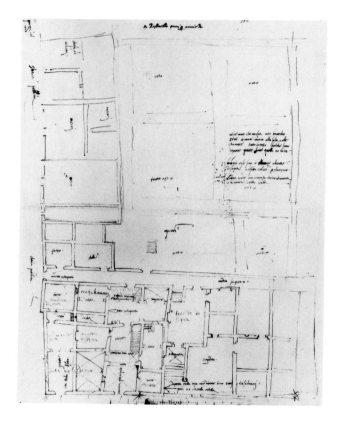

43 Aristotile da Sangallo. Plan of the old Palazzo Pucci at Orvieto (U 1070A v.; ca. 1528–30).

44 Aristotile da Sangallo. Doric entablature "di bramante" (U 1739A r.).

Antonio's only project connected with Giuliano's son and heir, Francesco, born in 1494, is the latter's drawing for the entry of Charles V into Rome in 1536 (*U 1671A r.).[418] Already before the spring of 1509, when Francesco di Giuliano returned to Florence with his father, he must have taken an active part in the Roman art scene and made architectural drawings. After Giuliano's return in the spring of 1513, Francesco became his most important collaborator, as his drawings in the *Libro* attest.[419] Two of them are copies after Antonio;[420] Antonio, for his part, seems to have copied the ground plan of the baptistery near S. Giovanni in Laterano from the *Libro* in 1514.[421] In general, the precision and orthogonal representation in these drawings—probably Francesco's earliest—are closer to the method of his two cousins than to that of his father. Francesco thus could have played an important role in Giuliano's turn toward the Bramante circle. Around 1518 he directed the enlargement of the entrance to the Baths of Diocletian, as he himself reports on U 284A.[422] The letter of 21 December 1538 on U 307A r., where Antonio not only explains

the orientation of the Pantheon, but also speaks about the care of his mother Smeralda and expresses the hope that his brother Giovanni Battista would also contribute his modest share to this end, must have been addressed to Franceso.[423]

Francesco di Giuliano is not, by the way, to be confused with Antonio's younger brother Francesco, born around 1490, who is probably identical with the *soprastante* of the crew on site at St. Peter's in 1521 and the master builder recorded in Rome after 1552.[424] His hand may be that of the as yet unidentified master who has been confused with both Giovanni Battista and Bernardo della Volpaia. Around 1520, he copied Raphael's designs for his house on the Via Giulia on U 310A and 311A for Antonio.[425] Probably for Antonio as well, he drew the ground plan design U 980A for two row houses by Antonio del Bufalo.[426] After 1520, together with Peruzzi, he measured the column shafts of Old St. Peter's on U 108A, 125A, 1079A–1084A, and 1851A (Fig. 45a).[427] As *soprastante*, Francesco was Antonio the Younger's and Peruzzi's immediate subordinate, which would explain both their collective measuring and Peruzzi's comments on U 108A v., or Antonio's comments on U 1084A. The measurements of the Forum Holitorium on U 3965A, which apparently were made after 1525 in connection with Sangallo's survey, probably originate from the same hand.[428]

One of Antonio's last and most capable collaborators was undoubtedly Bartolomeo Baronino, born in 1500.[429] His handwriting is secured by U 873A for S. Giacomo degli Incurabili from the period around 1540 (Fig. 45b).[430] As Antonio's most important assistant, he was actively engaged at the same time on the planning of the second phase of construction of the Palazzo Farnese (Fig. 45c).[431] After Antonio's death and before his murder in 1554, he would make his career as the designing architect of the Palazzo Capodiferro Spada and as the executive construction master of the Villa Giulia.

Other masters were connected with Antonio, such as Rinieri Neruccio da Pisa, Lorenzetti, and Pietro Rosselli, mainly through their activity for the construction crews at Loreto and at St. Peter's. The highly talented Lorenzetti, shortly after the death of his teacher Raphael, asserted himself as an independent architect of the Caffarelli and della Valle Capranica palaces and can be documented as *soprastante* of the crew on site at St. Peter's from 1540.[432] The sensible drawing U 1572A, probably made under Paul III, which is secured for him by his handwriting on the verso, shows him completely independent of the

45 **a** Francesco di Bartolommeo da Sangallo(?), columns of Old St. Peter's (U 1082A v.; 1520 forward), detail **b** B. Baronino, handwriting (U 873A r.; ca. 1540) **c** B. Baronino, project for the staircase of Palazzo Farnese (U 1769A r.; ca. 1540)

L. Lorenzetti, handwriting: **d** 1541 (Archivio della Rev. Fabbrica di S. Pietro) **e** 1534 forward (U 1572A v.).

46 L. Lorenzetti. Project for balustrade and niche decoration (U 1572A r.; 1534 forward).

Sangallo circle (Figs. 45d, e; 46).[433] A series of other draftsmen from Antonio's intimate circle, whose sheets he commentated personally, remain to be identified.[434]

After Bramante's death the most important architects of the High or Late Renaissance passed directly or indirectly through the school of Antonio da Sangallo the Younger, as is proved alone by Vignola, Alessi, and Palladio. Even Giacomo della Porta, Carlo Maderno, Borromini, Bernini, and Carlo Rainaldi are indebted to him. Thus he marks one of the great points of intersection in the history of architecture— no matter how one may judge this or that project. And thus the present corpus not only presents the historian with insights into the methods and ideals of an epoch long past, it may also indicate for those who create today a way to their most powerful roots.[435]

NOTES

For all frequent titles, see the Reference List following the Notes.

1. Ragghianti Collobi 1973; Ragghianti Collobi 1974, p. 4ff.

2. B. Friedrichs kindly provided me with the reference to Percier's reconstruction of the Villa Madama at the Institut de France (Ms 1009, p. 27, fig. 42).

3. C. Percier and P.F.L. Fontaine, *Palais, maisons et autres édifices modernes dessinés à Rome. . .*(Paris, 1798); P.M. Letarouilly, *Edifices de Rome moderne. . .*(Paris, 1849–66).

4. Letarouilly, *Edifices de Rome*, text, p. 257ff.; P.M. Letarouilly, *Le Vatican et la Basilique de Saint-Pierre de Rome* (Paris, 1882; published from the posthumous papers by A. Simil).

5. See n. 1.

6. G.B.L.G. Seroux d'Agincourt, *Storia dell'arte col mezzo dei monumenti*, II (Milan, 1825), p. 140, pl. 72, no. 24.

7. Gaye, III, 391ff. On the history of the Gabinetto dei Disegni in general, see A. Forlani Tempesti, "Il Gabinetto dei Disegni e delle Stampe degli Uffizi" (with bibliography), *Musei e Gallerie d'Italia* 41–42 (1970): 37–59.

8. C. Ravioli, *Notizie sui lavori di architettura militare sugli scritti o disegni editi ed inediti dei nove da Sangallo. . .*(Rome, 1863), p. 31ff.

9. A. Jahn, "Die Sammlung der Handzeichnungen italienischer Architekten in der Galerie der Uffizien zu Florenz," *Jahrbuch für Kunstwissenschaften*, ed. A. von Zahn, 2 (1869): 143–54; G. Vasari, *Le vite. . .*, ed. F. Le Monnier, XI (Florence, 1854), pp. 23–86; Vasari-Milanesi, V, pp. 475–552.

10. Jahn, see n. 9.

11. C. Pini and G. Milanesi, *La scrittura di artisti italiani (sec. XIV–XVII)* (Florence, 1876).

12. A. Guglielmotti, *I Bastioni di Antonio da Sangallo disegnati sul terreno per fortificare e ingrandire Civitavecchia l'anno 1515* (Rome, 1860).

13. Jakob Burckhardt, *Briefwechsel mit Heinrich von Geymüller*, ed. C. Neumann (Munich, 1914).

14. H. von Geymüller, *Architektur und Religion* (Basel, 1911), p. 109f.

15. H. von Geymüller, *Notizen über die Entwürfe zu St. Peter in Rom aus bis jetzt unbekannten Quellen* (Karlsruhe, 1868); Italian translation in *Il Buonarroti* 3 (1868): 170–76, 215–23.

16. See, for example, D. Frey, *Bramantes St. Peter-Entwurf und seine Apokryphen* (Vienna, 1915); B. Degenhart, "Dante, Leonardo und Sangallo," *Römisches Jahrbuch für Kunstgeschichte* 7 (1955): 101–292; H. Saalman, "Die Planung Neu St.-Peters," *Münchner Jahrbuch der bildenden Kunst*, 40 (1989): 103–40.

17. H. von Geymüller, *Die ursprünglichen Entwürfe für Sanct Peter in Rom* (Vienna, Paris, 1875–80); Geymüller, *Raffaello Sanzio studiato come architetto* (Milan, 1884); Geymüller, "Documents inédits sur les manuscrits et les oeuvres d'architecture de la famille des San Gallo. . .," *Mémoires de la Société nationale des Antiquaires de France* 45 (1885): 1–31.

18. *Inventario. 2. Disegni esposti*, ed. A.M. Petrioli-Tofani (Florence, 1987), p. 479ff.

19. H. Thelen, *Francesco Borromini: Die Handzeichnungen*, I (Graz, 1967).

20. Lotz 1977, p. 31f.

21. See the bibliography in Bruschi 1983, in addition to the bibliography of this corpus.

22. On Michelangelo's attitude to his own drawings, see M. Hirst, *Michelangelo and his Drawings* (New Haven, London, 1988), pp. 16–21.

23. Look, for example, at a drawing such as U 1199A for the courtyard of Palazzo Farnese (Frommel 1981, p. 135ff., fig. 21).

24. Frommel 1973, II, p. 5; Pagliara, in Frommel/Ray/Tafuri, p. 181; Günther 1988, pp. 60, 62, 171, 265, 322ff.

25. See below, p. 36f.

26. Frommel, in Frommel/Ray/Tafuri, pp. 330f., 338; on Sangallo's annotations, see also Giovannoni, p. 20ff.; Günther 1988, p. 316f.

27. Frommel 1973, II, p. 118.

28. Wolff Metternich 1972, fig. 53; Frommel, in Frommel/Ray/Tafuri, p. 288f.

29. Frommel, in Frommel/Ray/Tafuri, pp. 245ff., 266.

30. Giovannoni, p. 10.

31. Frommel 1973, II, p. 329f.; E. Bentivoglio, in Frommel/Ray/Tafuri, p. 130; Frommel, ibid., pp. 330f., 360ff.; Wolff Metternich/Thoenes, pp. 13ff., 52f.; Antonio's inscription on U 6A v., "Opinione e disegnio Di fraiocondo per santo pietro De roma" (ibid., fig. 52), may still go back to the time before 1530.

32. Frommel, in Frommel/Ray/Tafuri, p. 226ff.; Wolff Metternich/Thoenes, p. 81ff.

33. Wolff Metternich/Thoenes, p. 73ff.; Frommel 1989, pp. 161–68.

34. In any case, we would like to assume this from Antonio's annotations, which seem to have been added after 1527 (e.g., U 1163A, 1329A, 1372A, 1377A, 1852A; Bartoli, pp. 76, 93, 98, 101, figs. 413, 499, 534, 553). It is nevertheless conceivable that these sheets reached Antonio during Giovan Francesco's lifetime; see below, p. 40.

35. Giovannoni, p. 399f.; see below, p. 43ff.

36. Golzio 1936, p. 176.

37. Ragghianti Collobi 1974, pp. 53, 57, 97f., 101ff., 111f., 127, 136, 138f., 149, 150ff., 156.

38. Ibid., pp. 102f., 127.

39. A. Ravioli, "Antonio da Sangallo il Gio.," *Atti e Memorie della RR. Deputazioni di Storia per le Provincie Modenesi e Parmensi* 2 (1864): 14f.; Günther 1988, p. 24.

40. Frommel 1981, p. 145ff., below in this volume, pp. 75–80 (Giess).

41. See below, pp. 61–74 (Adams and Pepper).

42. Ibid.

43. A. Bertolotti, "Nuovi documenti intorno all'architetto Antonio da Sangallo (il Gio.) e alla sua famiglia," *Il Buonarroti,* ser. 3, 4 (1890–92): 280f.; Frommel 1973, II, p. 293.

44. Gaye, III, p. 391ff.; Giovannoni, p. 9; Günther 1988, p. 244.

45. See below, pp. 61–74 (Adams and Pepper).

46. See above, p. 1.

47. Ravioli (see n. 8), pp. 12f., 32ff.

48. Ibid., pp. 32, 34.

49. *Vitruvii de architectura libri decem,* ed. C. Fensterbusch (Darmstadt, 1964), pp. 11, 20ff.

50. Frommel 1983, p. 154f.

51. Tigler, p. 141ff. (with bibliography); exhibition catalogue, *Les bâtisseurs des cathédrales gothiques,* ed. R. Recht (Strasbourg, 1989), p. 227ff.

52. Schofield, pp. 120–31 with sources and bibliography.

53. Ibid., p. 123ff.

54. Degenhart/Schmitt, cat. 38, 54; Schofield, p. 128.

55. Degenhart/Schmitt, cat. 11f.; Schofield, p. 128.

56. Lotz 1956, p. 194, fig. 1.

57. Degenhart/Schmitt, I, p. 204ff.

58. Ibid., I, p. 94.

59. Schofield, p. 130f.

60. Lotz 1977, p. 3ff.

61. A. Manetti, *The Life of Brunelleschi,* ed. H. Saalman (University Park, Pa., 1970), p. 124f.; Italian edition, ed. D. De Robertis and G. Tanturli (Milan, 1976), p. 122.

62. Ibid. (1970), p. 64ff.; Günther 1988, p. 22ff.

63. S. Borsi, p. 348ff.

64. Tigler, p. 146.

65. Ibid., p. 149ff.

66. Ibid., p. 165ff.

67. H. Saalman, "Gio. di Gherardo da Prato's designs concerning the cupola of S. Maria del Fiore in Florence," *Journal of the Society of Architectural Historians* 18 (1959): 11–20.

68. Lotz 1977, p. 4ff.; Alberti, ed. P. Portoghesi, IX, p. 856ff.

69. Alberti, I, 1, p. 18f.

70. Ibid., II, 1, p. 96ff.

71. Ibid., IX, 10, p. 856ff.

72. Ibid., IX, 10, p. 860f.

73. Ibid., II, 1, p. 98f.

74. H. Burns, "Un disegno architettonico di Alberti e la questione del rapporto fra Brunelleschi ed Alberti," in *Filippo Brunelleschi. La sua opera e il suo tempo.* Acts of the International Congress, Florence, 1977 (Florence, 1980), p. 105ff.; F. Borsi, *Leonbattista Alberti* (Milan, 1975), pp. 133, 207; Günther 1988, p. 105; on the interpretation of the drawing for Alberti's first buildings, see also H. Ettlinger, "The sepulchre on the facade: a re-evaluation of Sigismondo Malatesta's rebuilding of S. Francesco in Rimini," *Journal of the Warburg and Courtauld Institutes* 53 (1990): 133–43; Schofield, p. 122f.

75. A. Lepik, "Das Architekturmodell in Italien von 1353 bis 1500," PhD. diss., Augsburg, 1989; Günther 1988, p. 67ff.

76. G. Scaglia, *Checklist and History of Francesco di Giorgio's Manuscripts and Drawings* (Bethlehem, Pa., 1992), p. 53ff.

77. Günther 1988, p. 29ff., figs. 15–17, 20–23.

78. Frommel 1993.

79. Tönnesmann, p. 88ff.; P.N. Pagliara, "Grottaferrata e Giuliano della Rovere," *Quaderni dell'Istituto di Storia dell'Architettura,* n.s. 13 (1989): 32, rightly calls Giuliano the "principale erede delle teorie albertiane attivo in quel momento [i.e., before 1500]."

80. S. Borsi, p. 41ff.; Tönnesmann, p. 90ff.

81. S. Borsi, F. Quinterio, C. Vasic Vatovec, *Maestri fiorentini nei cantieri romani,* ed. S. Danesi Squarzina (Rome, 1989), p. 156ff.

82. *Filippo Brunelleschi 1377–1446. La Renaissance de l'architecture moderne,* ed. Direction de l'Architecture (Paris, 1978), fig. 121; S. Borsi, p. 108f.

83. See below, p. 14.

84. S. Borsi, pp. 267ff., 286ff., 292ff.; Günther 1988, p. 128ff.; see below, p. 16.

85. S. Borsi, p. 254ff.

86. See below, p. 15.

87. S. Borsi, p. 40; Günther 1988, p. 230.

88. For the various fascicles of the *Libro,* see S. Borsi, p. 116ff.; for the dating of the *Libro Piccolo* before 1508, idem, p. 115; A. Nesselrath, "Codices e Vaticanis selecti phototypice expressi, vol. XXXIX," *Zeitschrift für Kunstgeschichte* 52 (1989): 284ff.

89. S. Borsi, pp. 423ff., 472ff.; Frommel 1986, p. 284; F. and S. Borsi, p. 316ff.

90. Günther 1988, p. 118.

91. Ibid., p. 121ff.; see below, p. 21.

92. Ibid., p. 123ff.; see below, p. 9.

93. S. Borsi, pp. 453ff., 481ff.

94. Günther 1988, p. 137.

95. Ibid., pp. 123ff., 193f., 199ff., 252.

96. S. Borsi, p. 257; Günther 1988, p. 123f.

97. F. and S. Borsi, p. 160ff.

98. Frommel 1991 ("Bramante," Düsseldorf).

99. C.L. Frommel, "Il progetto del Louvre per la Chiesa dei Fogliani e l'architettura di Cristoforo Solari," in *Quaderno di studi sull'arte lombarda dai Visconti agli Sforza. Per gli 80 anni di Gian Alberto Dell'Acqua,* ed. M.T. Balboni Brizza (Milan, 1990), pp. 52–63.

100. S. Borsi, pp. 423ff., 453ff.

101. Schofield, p. 131ff.

102. Pedretti, p. 23; Schofield, p. 131ff.

103. H. Burns, in Frommel/Ray/Tafuri, p. 420f.

104. Vasari 1550, p. 596.

105. Frommel 1989, pp. 161–68.

106. Frommel 1991 ("Bramante," Naples); Frommel ("St. Peter's").

107. See below, p. 18ff.

108. Frommel ("St. Peter's").

109. Frommel 1993.

110. Vasari 1550, p. 865ff.; Vasari 1568, p. 313; Giovannoni, p. 91; Bruschi 1983, p. 4

111. Satzinger, pp. 131f., 161ff.

111a. Ibid., p. 116.

112. Ibid., p. 164.

113. Marchini, p. 84ff.; Tönnesmann, pp. 17ff., 108ff.; S. Borsi, p. 14ff.; H. Biermann, "Palast und Villa: Theorie und Praxis in Giuliano da Sangallos Codex Barberini und im Taccuino senese," in *Les Traités d'Architecture de la Renaissance,* ed. J. Guillaume (Paris, 1988), pp. 138–50.

114. Satzinger, p. 131f.

115. G. De Angelis D'Ossat, p. 100.

116. Florence, Biblioteca Nazionale, Cod. Magl. XVII.20, fol. 3 v.; A. Gotti, *Vita di Michelangelo Buonarroti narrata con l'aiuto di nuovi documenti* (Florence, 1875), II, p. 179; Giovannoni 1959, p. 395ff.; Günther 1988, p. 243f.; Satzinger, p. 78f.

117. Jobst, p. 140. From this earliest document of Antonio's Roman activity, the important passages for the present work are: ". . . Sebastianus quondam marcj de giano de sangallo de florentia et antonius bartolomej etiam de sangallo carpentarj jn civitate lavinia prope palatium apostolicum" owe the Roman citizen Martino de Alpino from Rione S. Eustachio 47 ducats "ex causa pretij venditionis certi lignaminis videlicet tabularum trabium et travicellorum ac diversarum lignaminum ab eodem martino habitorum. . .de mense martij tempore accessus et reditus smi.dni.nri.pape ad urbem ex civitate bononie que lignamina dicti sebastianus et antonius. . .habuerant etc pro conficiendo certo arco triunfali ad gloriam laudem et ornatum dicti s.d.n.. Actum jn civitate lavinia prope palatium apostolicum jn apoteca dictorum sebastiani et antonij presentibus rafaello berti del sarto de florentia architectore johanne francisco quondam johannis de florentia alias tirib. . . carpentario et joanne jacobo rusmini [?] de adinis [?] de caravagio ferrario testibus" (ASR, Coll. Not. Cap., v. 60, fol. 81 r.).

118. Vasari 1550, p. 630.

119. Marchini, p. 96. Since the Rocca of Nettuno was apparently begun in 1501—that is, about the same time as the Rocca of Civita Castellana—it was most likely designed by Antonio da Sangallo the Elder.

120. G.L. Hoogewerff, "Documenti, in parte inediti, che riguardano Raffaello ed altri artisti contemporanei," *Atti della Pontificia Accademia Romana di Archeologia, Rendiconti* 21 *(1945/46),* p. 262, docs. 10, 11; the payment in the spring of 1509 to a stonemason named Giuliano is certainly related to Giuliano del Toccio (Fabriczy, p. 11); payments for Antonio's work on the papal bark were not made until April 1510 (Frey, p. 16, doc. 71; cf. Giovannoni, p. 385).

121. C.L. Frommel, "Eine Darstellung der 'Loggien' in Raffaels 'Disputa'. Betrachtungen zu Bramantes Erneuerung des Papstpalastes in den Jahren 1508/09," in *Festschrift Eduard Trier zum 60. Geburtstag* (Berlin, 1981), pp. 113ff., 121f.

122. Frommel 1973, p. 41, pl. 186a, b; Frommel 1981, p. 114, figs. 7, 8. Antonio could conceivably have participated in the execution of the richly decorated coffered ceiling in the papal bedroom, which—like the window aedicules of the Cortile del Papagallo—could go back to Giuliano's design (see C.L. Frommel, "Disegno und Ausführung: Ergänzungen zu Baldassarre Peruzzis figuralem Oeuvre," in *Kunst als Bedeutungsträger.* Commemorative volume for Günther Bandmann [Berlin, 1978], p. 216, fig. 2; Frommel 1984, p. 124f.). Giuliano may have been in Rome again between December 1507 and February 1508 (*Il carteggio di Michelangelo,* ed. B. Barocchi and E. Ristori, I [Florence, 1965], pp. 57, 61).

123. In his securely attributed buildings and projects, Giuliano also frequently used richly decorated entablatures and consoles with no load-bearing function.

124. See below, p. 23.

125. Giovannoni, pp. 69, 104; L. Bianchi, *La Villa Papale della Magliana* (Rome, 1942), p. 39ff., pl. 9ff. The detail of a fireplace on the verso also speaks for a reworking and, like the geometric studies, is the work of the young Antonio. So far, Bramante's participation in the Magliana before 1513 has not been proved (M. Dezzi Bardeschi, "L'opera di Giuliano da Sangallo e di Donato Bramante nella fabbrica della villa papale della Magliana," *L'Arte* 4 [1971]: 111–73). It is conceivable, however, that immediately after Giuliano's departure, Bramante assumed responsibility and entrusted Antonio with the execution. Giuliano's samples of an inscription for Julius II in the *Taccuino senese* probably date from the first years of his pontificate (see S. Borsi, p. 467).

126. Marchini, p. 97.

127. Giovannoni, p. 343ff.; Frommel 1986, p. 265; Satzinger, p. 119f.

128. Fabriczy 1902, p. 23.

129. On 17 June 1512 Sangallo purchased from the papal builder Giorgio da Coltre—who also owned the neighboring house and had perhaps built up these narrow parcels on the new street on speculation—for 70 ducats "certam domum principiatam sine solarijs et tecto cum muris comunibus ab utroque latere. . .latitudinis quatuor cannarum versus viam publicam et longitudinis XI cannarum scilicet a dicta via usque ad partem posteriorem versus flumen tiberis jn conspectu montis de austa prope sanctum roccum." The property owed taxes to S. Maria del Popolo (ASR, vol. 60, fol. 632; Frommel 1973, II, p. 298). The sketch for a ground plan on U 7975A r., which could date from about 1512/13, is perhaps connected with the completion of these houses.

130. Satzinger, p. 78.

131. Frommel 1986, p. 283f.

132. Bruschi 1983, p. 3ff.; Frommel 1986, p. 264ff.; cf. Degenhart, pp. 273–78, figs. 365–375. Among his attributions to Antonio, only that of U 2046A is correct.

133. For a similar change in Peruzzi's early handwriting, see Frommel 1993.

134. Ferri, p. XL f.; Fabriczy, p. 111f.; Bartoli, p. 30ff., figs. 145-154, 393-396, 401f.; Giovannoni, p. 383; Vasori, no. 119f.; S.

Borsi, 495–99; Günther 1988, p. 113f.

135. Fabriczy 1902, pp. 104, 111f.; Ashby, pp. 19, 21; Egger, p. 161f.; Huelsen, pp. xx, 15f.; Bartoli, pp. 31f., 74; Vasori, p. 28ff.; S. Borsi, pp. 71, 214f., 497; Günther 1988, pp. 257, 313.

136. See above, p. 6f.

137. Lotz 1956, p. 199ff.

138. S. Borsi, pp. 284f., 332.

139. U 1555A r. and v., 1576A r. and v., 1627A v., 2043A r. and v.; Bartoli, cf. S. Borsi, fig. 495ff.; Günther 1980, p. 113f., fig. 3f.

140. S. Borsi, p. 254ff.; Günther 1988, p. 123f., figs. 9f., 18, 23.

141. Francesco da Sangallo's later copies on fol. 43 v. of the *Libro*, in S. Borsi, p. 214f.

142. See below, p. 26f.

143. Vasori, p. 153ff.; Günther 1988, p. 114, fig. 6.

144. See below, this page.

144a. H. Saalman (see n. 16), p. 226, fig. 20.

145. Huelsen, text, p. 4; Letarouilly 1846 (see n. 3), p. 88, fig. 63.

145a. Bartoli, p. 31, fig. 150.

146. Bartoli, p. 31, fig. 153; Günther 1988, p. 113, n. 87.

147. Degenhart/Schmitt, I, pp. 2, 478–82, Teil 4, pls. 327–336, cat. nos. 434, 435, 463; Günther 1988, p. 27, fig. 11.

148. S. Borsi, pp. 124, 140.

149. Idem, pp. 50, 84f., 91, 93, 196, 224, 230; see above, p. 7f.

150. See above, p. 8f.

151. See below, p. 47ff.

152. Ghisetti Giavarina, p. 70, cat. 17.

153. F. and S. Borsi, p. 317ff.

154. Ghisetti Giavarina, p. 72, cat. 26.

155. Ibid.

156. Frommel 1989; see above, p. 9.

157. Günther 1988, appendix I, pls. 1–12.

158. Frommel 1993, p. 150ff.

159. Wolff Metternich/Thoenes, p. 81ff., figs. 94, 98.

160. Ibid., p. 118, fig. 121f.

161. Bartoli, p. 35, fig. 178f.; Bartoli's attribution to Antonio the Elder can be ruled out on the basis of his handwriting alone (fig. 21b, o); his secured drawings in Günther 1988, p. 114f., fig. 7, and Satzinger, fig. 69. I owe the sample of his handwriting of 1508 to R. Paciani.

162. Wolff Metternich/Thoenes, p. 94ff., fig. 100.

163. Bartoli, pp. 97, 126, figs. 525, 722; Günther 1988, pp. 199f., 378, fig. 35f.

164. For Sangallo's system of measurement, see Günther 1988, pp. 174f., 184f.; above, p. 8.

165. Buddensieg, p. 108.

166. Lotz 1977, p. 19f.; S. Borsi, p. 197f.; see above, p. 8.

167. See below, p. 24.

168. Pastor, IV, part 1, p. 737f.

169. R. Tuttle, "Julius and Bramante in Bologna," in A. Emiliani, ed., *Le arti a Bologna e in Emilia dal XVI al XVII secolo*, Atti del XXIV Congresso C.I.H.A., Bologna, 1979 (Bologna, 1982), 3ff.; see above, p. 11.

169a. On 20 October 1506, a "magister Antonius fiorentibus" was paid "per fare aconciare lo aromario de' libri del coro. . .et per lo telajo dello altare de Sancto Jo [hanni?] apresso lo campanile" (Rome, Archivio degli Agostiniani, Sagr. S. Agostino [1505–18, fol. 12v.]). If "magister Antonius" is identical with Antonio the Younger, he would have remained in Rome during these months.

170. See below, p. 22.

171. Ferri 1885, p. 120.

172. Lotz 1977, p. 4, fig. 1; Francesco di Giorgio Martini, *Trattati di architettura*, ed. C. Maltese (Milan, 1967), pl. 221f.; Pedretti, fig. 83f.; Günther, Appendix I, pl. 1.

173. Wolff Metternich/Thoenes, p. 165ff., fig. 164f.

174. Bruschi 1969, p. 387, fig. 251.

175. Frommel/Ray/Tafuri, pp. 135, 167, 280, 333f.

176. S. Borsi, pp. 196, 205, 254, 260; Günther 1988, p. 73ff., fig. 5ff.

177. Frommel 1993, fig. 31.

178. For U 226A, see Wolff Metternich/Thoenes, p. 190, fig. 189.

179. S. Borsi, p. 423ff.

180. See above, p. 8; the sketch on *U 1552A for the fortification of the church, which is close to the work of the young Sangallo, may also date from that time (S. Borsi, p. 509f.).

181. Wolff Metternich/Thoenes, p. 170ff., fig. 169; S. Borsi, 196.

182. Cf. Scaglia 1992 (see n. 76), p. 167ff.

183. Bartoli, p. 65, fig. 245; see below, p. 26f.

184. Bartoli, p. 73, fig. 391; for the dating of Giovan Francesco's copy on U 1716A r. (Bartoli, p. 101, fig. 555) in 1514–20, see below, p. 42.

185. See above, p. 11.

186. See above, p. 5.

187. C.L. Frommel, "Il cantiere di S. Pietro prima di Michelangelo," in J. Guillaume, ed., *Les Chantiers de la Renaissance. Actes des colloques tenus à Tours en 1983–1984* (Paris, 1991), p. 180, fig. 8f.

188. Frommel 1976, p. 67f.

189. Ibid., p. 120f.

190. Vasari 1550, p. 867.

191. On the fate of Raphael's and thus probably also Bramante's architectural drawings, see K. Oberhuber, *Raphaels Zeichnungen Abteilung IX . . .* (Berlin, 1972), p. 18f.

192. Frommel, in Frommel/Ray/Tafuri, pp. 256f., 294f.; Günther 1982, p. 81f. With its diameter of ca. 29 p., this vault is much smaller than those of St. Peter's.

192a. See Frommel ("St. Peter's").

193. Frommel 1986, p. 265, fig. 3.

194. Bartoli, p. 65, fig. 343; Wolff Metternich 1972, p. 55f., fig. 82, who relates the sketch to the "beam construction of the emergency roof carried out in 1542"; cf. C. Thoenes in Wolff Metternich/Thoenes, p. 194; Frommel ("St. Peter's").

195. Bartoli, pp. 71f., 83, figs. 381, 386f., 446, 449f.; Wolff Metternich 1972, p. 65, fig. 119, with an attribution to Sangallo and B. della Volpaia; the explanatory inscriptions on the recto were added—as in so many cases—by Antonio only later.

196. Frommel, in Frommel/Ray/Tafuri, p. 258; Wolff Metternich/Thoenes, p. 169ff.; Frommel ("St. Peter's").

197. Bartoli, p. 71, fig. 376f.; Günther 1988, p. 47f.

198. H. Günther, "Das Trivium vor Ponte S.Angelo. Ein Beitrag zur Urbanistik der Renaissance in Rom," *Römisches Jahrbuch für Kunstgeschichte* 21 (1984): 180. In the few preserved drawings of the period before 1515, in which Antonio used the abbreviation for the *palmo romano*, he always put a crossbar on the tail of the *p* (this essay, fig. 7b; Frommel 1973, pl. 177d; Frommel 1981, fig. 23f.); thereafter until ca.1520 this abbreviation turns up only occasionally (idem, fig. 35; Frommel/Ray/Tafuri, figures pp. 285f., 293, 335), and Antonio prefers a *p* with an upper stroke (Frommel 1981, figs. 21, 27, 29).

199. See above, p. 12.

200. Frommel 1986, p. 262ff.

201. Bartoli, pp. 75, 88, figs. 407, 468f.; Jobst, p. 123f., which can be dated more precisely in 1512/13 on the basis of the script; U 2055A is not by Antonio the Younger.

202. Vasari-Milanesi, VI, p. 434f.

203. For the building policy of Leo X, see Tafuri in Frommel/Ray/Tafuri, p. 76ff.; C.L. Frommel, "Papal policy: The planning of Rome during the Renaissance," in R.I. Rotberg and T.K. Rabb, eds., *Art and History: Images and Their Meaning* (Cambridge, 1988), p. 55ff.; Günther 1988, p. 56ff.; Tafuri, p. 97ff.

204. A. Bruschi, in F. Cruciani, *Il teatro del Campidoglio e le feste romane del 1513* (Milan, 1968), p. 158ff.; Günther 1988, pp. 174, 338.

205. Frommel 1986, p. 271ff.

206. See Raphael's complaint in his letter of 1519/20 to Leo X (Golzio, p. 83).

207. Günther 1985; Frommel, *Palazzi Romani* (in press).

208. Frommel 1986, p. 280ff.

209. Frommel, in Frommel/Ray/Tafuri, p. 325f.; C.L. Frommel, "Villa Lante e Giulio Romano artista universale," in *Giulio Romano*. Atti del Convegno Internazionale di Studi, Mantua, 1989 (Mantua, 1991), p. 130. On the basis of the inscriptions and handwriting alone, Antonio's project on U 1283A (Bartoli, p. 84, fig. 452), which directly recalls *U 1484A v., must be dated before 1517. G.A. della Rovere, prior to 1512–16, had already leased large parts of the Forum of Augustus to Marcantonio Cosciari, with the obligation to spend 400 ducats "in reparatione dicti palatii" (Lanciani, I, p. 185f.; J. Delaville Le Roux, "Liste des prieurs de Rome de l'ordre de l'hôpital de S. Jean de Jerusalem," in *Mélange G.B. De Rossi* [Rome, 1892], p. 268; Günther 1988, p. 254). The property reached "usque ad parietes magnos iuxta viam publicam ab uno latere, ab alio vicum protendendem ad ortum dicti prioratus. Item totam et integram partem terminatam a dictis parietibus magnis et a prefata via ab alio orto dicti prioratus." The three "columne magne" could not be touched. In addition, Cosciari took responsibility "facere stratam seu viam pro orto ipsius d. prioris iuxta arcum hoc (sancti Basilii) et ecclesiam sancte Marie de Angelis," evidently a small church situated near the Curia (R. Lanciani, *Forma urbis Romae* [Rome, 1893–1901], pl. 22). For S. Croce in Gerusalemme, see C.L. Frommel, "Progetto e archeologia in due disegni di Antonio da Sangallo il Giovane per Santa Croce in Gerusalemme," in S. Danesi Squarzina, ed., *Roma, centro ideale della cultura dell'Antico nei secoli XV e XVI. . .* (Milan, 1989), pp. 382–89.

210. Golzio, p. 282.

211. Günther 1988, pp. 172ff., 336ff.

212. See below.

213. Günther 1988, pp. 337f.; Wolff Metternich/Thoenes, p. 93, fig. 97; see above, p. 26.

214. Günther 1988, p. 173.

215. Bruschi 1969, figs. 218, 220f.

216. Buddensieg, p. 90ff.; Günther 1988, p. 200. Antonio's calculation on the verso of U 3966A, which Buddensieg (idem, p. 95) convincingly attributed to Bernardo, may be even a little earlier. It would confirm a collaboration during Bramante's lifetime. Obviously, Bernardo translated this orthogonal elevation for the Codex (fol. 64) into his particular perspective.

217. See below, p. 43.

218. Günther 1988, p. 336ff.

219. See above, p. 23.

220. Günther 1988, p. 338.

221. Ibid., p. 296.

222. Frommel, in Frommel/Ray/Tafuri, p. 358.

223. See below, p. 30ff.

224. Frommel 1986, p. 268ff.

225. Ibid., p. 266f.

226. Frommel 1973, II, p. 25, pl. 14b. For the dating of the Palazzo Baldassini in 1514, see Frommel 1983, p. 138.

227. Giovannoni, p. 307f., fig. 24; Frommel 1973, I, p. 77. This design must have been made at any rate before the palace was confiscated in the summer of 1517, probably even soon after 1512, when Antonio was working on the Cancelleria and when, as especially the three-quarter columns indicate, he was still close to Bramante and studying the Arch of Titus (see above, p. 24). Antonio could only have inscribed such a presentation drawing afterward. For this phase in the construction of the Cancelleria, see Frommel, *Palazzi Romani del Rinascimento;* for U 1320A, see below, n. 382.

228. Frommel 1983, p. 134ff., fig. 22.

229. Ibid., p. 138ff., fig. 23f.

230. Bartoli, p. 69, fig. 365.

231. Denker Nesselrath, pp. 8–45.

232. Wolff Metternich/Thoenes, p. 165ff., fig. 164f.

233. Frommel 1983, p. 153. The pre-1527 dating is based on the early form of the *h*; the logogram for *palmo* points to the period before 1520 (see n. 198).

234. Frommel 1973, II, pp. 183, 227, pls. 75, 177d.

235. Frommel 1983, p. 276, fig. 25; see there the unpersuasive conclusion that Giovan Francesco's remarks on the verso point to a date after 1516. In Antonio's U 4163A, one probably has to view his accompanying ground plan for the Palazzo del Monte provided with many *botteghe*.

236. Frommel 1986, p. 269ff.

237. Ibid., p. 277ff.

238. K. Frey 1910, p. 56.

239. Frommel, in Frommel/Ray/Tafuri, pp. 23ff., 214ff.

240. J. Shearman, ibid., p. 116.

241. Frommel 1973, II, p. 168ff.; Ray, in Frommel/Ray/Tafuri, p. 119ff.

242. Bentivoglio, in Frommel/Ray/Tafuri, p. 130f.

243. Frommel, ibid., p. 135.

244. Tafuri, ibid., p. 167ff.; Frommel 1986, p. 275f.

245. Shearman, in Frommel/Ray/Tafuri, p. 323f.

246. Frommel, ibid., p. 270ff.; Frommel 1986, p. 280ff.

247. Frommel, in Frommel/Ray/Tafuri, p. 266.

248. Ibid., pp. 248, 267, 274f.

249. Ibid., p. 276ff.

250. Ibid., p. 268ff.

251. Ibid., p. 311ff.; Frommel 1986, p. 288ff.

252. Frommel, in Frommel/Ray/Tafuri, p. 333f.

253. C. Thoenes, "La 'lettera' a Leone X," in *Raffaello a Roma*. Acts of the Congress, Rome, 1983 (Rome, 1986), pp. 373–81 (with bibliography).

254. Golzio, p. 83.

255. "Questa era lentrata principale di questa terme laquale io francesco di giuliano da sangallo feci iroma lanno 1518" (Günther 1988, p. 199f., fig. 35). The original form of the entrance is indicated by Peruzzi on U 574A (Wurm, p. 425).

256. ". . . quendam locum vulgariter nuncupatum el barco situm Rome in loco terme diocletiani cui ab uno pars cohopertum dictarum termarum ab alio via publica ab alio platea seu campus dictarum termarum ab alio vinea domini ascanii de sacchis de perusio . . ." Ascanio, who owned the "barcho," leased it on 7 May 1522 to Cardinal Innocenzo Cibo, a nephew of Leo X, for 50 gold ducats a year (Rome, Archivio Capitolino, sez. LXVI, vol. 40, fol. 84 r.).

257. Golzio, p. 83f.

258. See above, pp. 8f., 18f.

259. See E. Maddaleni Capodiferro's elegy on the death of Raphael: ". . . Reddebat te ipsam tibi, tot regionibus, Umber, Dimensis, portis, moenibus atque viis . . ." (Golzio, p. 80).

260. Ibid., p. 113. For the census of the *regiones*, see F. Albertini, *Opusculum de mirabilibus novae et veteris urbis Romae* (Rome, 1510), fol. K.

261. Thus, his interpretation of Santa Croce as a "templum etruscum" (U 899A) is related to his work on Santa Croce in ca. 1520 (see n. 209); his plan U 949A of the Alexandrine Baths (Bartoli, p. 92, fig. 491) to the project for a palace for Enckevoirt; his drawing of Trajan's Column, U 1153A, to the construction of S. Maria di Loreto (Bartoli, p. 85, fig. 458); his survey drawing of obelisks on U 1172A to urbanistic plans (Günther 1985, p. 289); and his plan U 1283A to a project for a villa for M.A. Cosciari (see n. 209).

262. See below, p. 45f.

263. Cf. Thoenes 1986 (see n. 253), p. 375f.; Günther 1988, p. 252ff.

264. P.N. Pagliara, "La Roma antica di Fabio Calvo. . . ," *Psicon* 8/9 (1976): 65–87; P.N. Pagliara, in *Raffaello in Vaticano* (Milan, 1984), p. 92ff.; P.J. Jacks, "The Simulacrum of Fabio Calvo: A view of Roman architecture all'antica in 1527," *Art Bulletin* 72 (1990): 456f.

265. Bartoli, p. 110ff., figs. 616–629; Frommel 1976, p. 73; Vasori, p. 189ff.; Günther 1982; K. Weil-Garris Brandt, "Michelangelo's Pietà for the Cappella del Re di Francia," in *"Il se rendit en Italie." Etudes offerts à André Chastel* (Rome, Paris, 1987), p. 98, n. 77, fig. 3, with the important comment that the project for moving the Vatican obelisk mentioned on U 4335A refers to Paul II and thus makes it possible to date the group considerably earlier; see above, p. 23.

266. Frommel 1993, p. 150ff.

267. See below, p. 47ff.

268. Frommel 1973, II, p. 17; Frommel 1987, p. 181.

269. For instance, his views of the Cancelleria on fol. 10 r. of Cod. Icon. 195, of Antonio's first model for St. Peter's on fols. 2 v. and 3 v., or of the Cortile del Belvedere on Windsor 10496.

270. Cod. Icon. 195, fols. 7 r., 10 v., 11 r. and v.

271. Ibid. For the attribution of this design to Giulio Romano, see Tafuri in catalogue, *Giulio Romano* (Milan, 1989), pp. 45, 302.

272. H. Nachod, "A recently discovered architectural sketchbook," *Rare Books* 8, 1 (New York, 1955); Frommel 1973, II, p. 6; S. Storz, in Frommel/Ray/Tafuri, p. 418ff. (Storz is preparing a critical edition of the sketchbook); C.L. Frommel, "Il progetto di Domenico da Varignana per la facciata di S. Petronio," *S. Petronio.* Acts of the Congress, Bologna, 1990 (in press).

273. See above. The surveys of the baths of Diocletian and Constantine (?), drawn by the same procedure, presuppose Bramante's and Antonio's surveys of 1506/7 (A. Nesselrath, "I libri di disegno di antichità. Tentativo di una tipologia," in *Memoria dell'antico nell'arte italiana*, ed. S. Settis [Turin, 1986], p. 107f.).

274. *Giulio Romano* (see n. 271), p. 288ff. The partially perspectival "TENPIO GRECHO" on U 131A, inspired by the Baths of Diocletian, is reminiscent in its pictorial shading of Raphael's late stage set (Frommel, in Frommel/Ray/Tafuri, p. 225ff.) and probably stems from the period after 1520, as the statues indicate (cf. Günther 1988, p. 128; S. Borsi, p. 502ff.).

275. Günther 1988, p. 203ff.

276. Ibid., appendix IV, pls. 32a, 39a.

277. Frommel 1993, p. 150ff.

278. Günther 1988, pl. 62ff.

279. Wurm; Frommel 1993.

280. See, for instance, Wurm, pp. 456, 458ff., 466, 469 f., 473, 477f.

281. Frommel 1993, p. 150ff.

282. Wurm, pp. 141f., 173, 193f., 214, 224, 237, 246, 315, 338, 353, 361, 487, 512.

283. Frommel 1993, p. 149.

284. C.L. Frommel, "Baldassare Peruzzi als Maler und Zeichner," *Beiheft des Römischen Jahrbuches für Kunstgeschichte* 11 (1967–68): 24; Wurm, p. 494.

285. Frommel, in Frommel/Ray/Tafuri, p. 286.

286. Ibid., p. 277f.

287. Giovannoni, pp. 205ff., 214ff., 232ff., 254ff.; Tafuri, in Frommel/Ray/Tafuri, p. 217ff.; Frommel 1986, p. 295ff.; Jobst, p. 50ff.; M. Tafuri, "Due progetti di Antonio da Sangallo il Giovane per la chiesa dei Fiorentini a Roma," in *Architettura storia e documenti*, 1987, pp. 35–52; Tafuri in vol. 2 of the present corpus. On this occasion Antonio probably also designed the projects on U 502A, which he derived from his designs for St. Peter's (Tafuri, in Frommel/Ray/Tafuri, p. 217).

288. K. Frey 1910, p. 63ff., Günther, p. 252ff., who probably gives too early a date for the beginning of this collaboration.

289. Frommel 1986, p. 278, n. 61; Günther, p. 254, fig. 14.

290. Giovannoni, figs. 75, 200; Frommel, in Frommel/Ray/Tafuri, figure p. 283; Frommel 1987, p. 173f.

291. Giovannoni, figs. 133, 137; R. Wittkower, "Michelangelo's Laurenziana," *Art Bulletin* 16 (1934): 161, fig. 26.

292. Giovannoni, figs. 48, 154.

293. Ibid., fig. 34.

294. Bartoli, p. 964, figs. 521–524; Günther 1988, p. 378 (with the attribution of U 1656A and 4117A to Giovanni Battista). Antonio's U 1133A (Bartoli, p. 96, fig. 520) corresponds to the state of knowledge of ca. 1514, as is shown by a comparison with B. della Volpaia's plan (Günther, V, fig. 36). This early survey drawing was in any case adequate as a model for the exedrae of the garden loggia of the Villa Madama (H. Burns, in Frommel/Ray/Tafuri, p. 392). Not only the analytical character of the more mature sheets, but also the parallels to Peruzzi's drawings from Antiquity suggest a date after 1520 and before 1528 (cf. Günther, p. 252ff.).

295. Günther, figs. IV, 8, V, 13, VII, 6, 7, Pt. 2, 6b, 13, 16a, 29b, 30, 72a, 73, 106–111, fols. 32v.–34 of the Codex Mellon (see n. 372), or the survey drawings of the Raphael circle (J. Shearman and A. Nesselrath, in Frommel/Ray/Tafuri, 418ff.; for the Pantheon drawings of the Sangallo circle see vol. 3 of this corpus.

296. Bartoli, pp. 77, 83, figs. 378ff., 449. The relationship of the measures in *palmi* on U 1191A r. (this essay, fig. 22), the copy after Menicantonio's survey drawing of the colossal interior order (see above, p. 23), to the measures in *braccia* on Giovan Francesco's approximately contemporary drawing U 85A v. is particularly revealing. A twelfth of a *palmo* is replaced by two-sixtieths of a *braccio*, thus one *palmo* equals two-fifths of a *braccio*, whereby for the sake of simplicity any degree of imprecision over 5 percent is accepted. Apparently, Antonio corrected Giovan Francesco's U 85A v. with the more precise measures that he took from his own measurement U 1387A r.; on the dating of Giovan Francesco's drawing, see below, p. 42.

297. See U 1157A v. (Bartoli, p. 65, fig. 344; Günther 1988, p. 298, both without mentioning the verso): "In prima misurare tutto lo di sopra e vedere quan/to e dalla chornicie di marmo a quello di mattonj / vedere dentro le finestre quanto e dalla chornicie alla

soglia / e quanto dalla chornicie di sopra a quella delle finestre / larchitrave di dentro / vedere chome sachorda lo piano dentro chon quello del porticho / vedere la chornicie della porta chome safro / ta cho chornicie che gira dentro / vedere chome safronta cholla chornicie del porticho / quella della porta / misurare le spaliere nelle chapelle / schizare le feste che sono tra pilastri / misurare la chornici del portichale dentro e fuora / e misurare lo frontespitio / schizare li chontraforti sopra lentrata/ misurare la chornicie e fregio della porta / misurare quanto sono e quadri primj e chosi li pettorali / misurare quanto e alto insino in terra"; cf. the corresponding questions on u 1299A r. (Günther 1988, p. 271).

298. Bartoli, pp. 71f., 83, figs. 381, 386f., 446, 449f.

299. H. Burns, "A Peruzzi Drawing in Ferrara," *Mitteilungen des Kunsthistorischen Institutes in Florenz* 12 (1966): 245–70; Wurm, pl. 473; see above, p. 33.

300. T. Buddensieg, "Criticism and Praise of the Pantheon in the Middle Ages and the Renaissance," in *Classical Influences on European Culture A.D. 500–1500* (Cambridge, 1971), p. 265f.; on Antonio's criticism of antique triumphal arches, see C. Jobst, "Die kritischen Studien nach antiken Triumphbögen von Antonio da Sangallo dem Jüngeren. Das Verhältnis von Säulenordnung und Mauerwerk," *Annali di architettura* 2 (1990): 45ff.

301. Bartoli, pp. 73f., 76, figs. 388, 414.

302. Frommel 1983, p. 154ff.; Frommel 1991 ("Bramante," Düsseldorf).

303. Giovannoni, figs. 71, 72, 76, 190, 199, 204, 207, 230.

304. Ibid., fig. 88f.

305. Ibid., fig. 85; see above, p. 19.

306. See above, p. 28f.; Frommel 1991 ("Bramante," Düsseldorf).

307. Giovannoni, p. 90.

308. See below, pp. 61–74 (Adams and Pepper).

309. The earliest samples of the altered handwriting are found on the plan u 836A, dated by the notes on the verso to 1530, for the Cesi Chapel (Giovannoni, p. 379, fig. 229), in the foreword to the Vitruvius Commentary, dated to the beginning of 1531 (see p. 11) and in the drawings of an antique find, *u 1212A, dated after 1 April 1531. The designs u 968A, 969A, 1074A, 1116A for the Palazzo Pucci and *u 958A for the Cappella dei Tre Magi in Orvieto may even be placed back in the time around 1528/29 (Giovannoni, p. 294ff., figs. 299ff., 343).

310. The list on *u 1344A r., dated November 1526, betrays the luxury of his new domestic quarters, the like of which he, as a frugal bachelor, would hardly have imagined for himself (compare *u 1484A).

311. Bartoli, p. 71, fig. 376f; see above, p. 20.

312. Frommel 1981, figs. 21–29.

313. For Antonio's studies of Vitruvius, see especially P.N. Pagliara, "Studi e pratica vitruviana di Antonio da Sangallo il Giovane e di suo fratello Giovanni Battista," in *Les Traités d'Architecture de la Renaissance*, ed. J. Guillaume (Paris, 1988), pp. 179–206, as well as Pagliara in vol. 3 of this corpus. Of the Vitruvius studies discussed by Pagliara, only u 903A is in the handwriting of the period before 1527, but closer to 1525–27 than earlier (idem, p. 190, fig. 14). Antonio there compares Fra Giocondo's interpretation of the Doric frieze on the left half of the sheet with that of "lovechio" on the right. By the "old one" he perhaps means Fabio Calvo, born 1450, who translated Vitruvius's treatise into Italian for Raphael (V. Fontana and P. Morachiello, *Vitruvio e Raffaello. Il "De Architectura" di Vitruvio nella traduzione inedita di Fabio Calvo, Ravennate* [Rome, 1975]). When Antonio

described Durantino's 1524 translation of Vitruvius, in his late handwriting, as his own copy, adding to the full name his position and the year 1520 ("architettore del papa 1520"), he was probably documenting his appointment as first papal architect (Pagliara 1988, p. 185). The almost identical inscription in his lost Vitruvius edition of 1513 and in other books in his possession probably should be interpreted similarly; Ravioli (see n. 8), p. 34; Pagliara 1988, p. 184ff.

314. Giovannoni, p. 23; the *piede antico* used here and its subdivisions apparently are based on Giovan Francesco's tables on u 1427A r. (Günther 1988, pp. 227, 229), which he had drawn up around 1514–20 on the basis of antique sources.

315. On the use of the *braccio fiorentino* and *piede antico* and their exact correspondence, see Günther 1988, p. 225ff. Oddly enough, on the survey drawing of obelisks, datable toward 1520, he calculates the *piede* as $^{424}/_{420}$ of a *braccio fiorentino*, while, on the later u 1427A v., he overlooks this small difference of 1 percent.

316. "Lo mezo disegnio di termine longo b[raccia] 700 piedi 1400 / Le piante grande si mettono al libro secondo queste misure / Lo coliseo longo alto b[raccia] 85^4/24 b[raccia] 333 p[iedi] 666 / La ritonda alta b[raccia] 75 longa b[raccia] 140 [in the margin] li templi con questa / La colonna storiata alta b[raccia] 66 / [here in the margin] li archi con questa" (Günther 1988, p. 227); on Antonio's Vitruvius commentary, see P.N. Pagliara in vol. 3 of this corpus.

317. Also among the assistants of the 1530's was the stonemason Rinieri Neruccio da Pisa, who as Loretan construction director was Antonio's subordinate (see above, p. 33). Thus in 1535 Sangallo copied Riniero's survey drawing of the Temple of the Sibyls in Tivoli (Günther 1988, 206ff., figs. 2, 6)—albeit without trusting every detail. Otherwise he would not have measured the building once again four years later on u 1216A, when he also came up with divergent figures (idem, p. 241). For his part, if he is identical with the "Italiener C," Riniero copied Antonio's new survey drawing of the Baths of Caracalla after 1527 (idem, p. 341, pl. 35f.).

318. See, for example, u 1074A and 116A for the Palazzo Pucci from 1528 onward (Giovannoni, fig. 303 F), *u 1092A and 1224A of ca. 1535 for his house on the Via Giulia (idem, figs. 309, 312), or *u 745A from ca. 1537 for Castro.

319. See below, p. 42.

320. See below, pp. 81–97 (Scaglia).

321. Giovannoni, figs. 229ff., 299ff., 309, 314f., 344.

322. Ibid., figs. 66–69, 375; Frommel/Ray/Tafuri, p. 253.

323. See, for example, Giovannoni, fig. 83.

324. Schofield, p. 121ff.

325. See, for example, u 702A, 703A, *750A, 868A, 878A, 877A, 925A, *1087A, *1092A, *1269A, 1363A, 1365A, 1368A (Giovannoni, figs. 10, 139, 145, 176, 179, 200, 208, 210, 228, 231, 309, 327, 329).

326. Cf. J.S. Ackerman, "Architectural Practice in the Italian Renaissance," *Journal of the Society of Architectural Historians* 13 (1954): 3–11.

327. Particularly, the detail studies for the Palazzo Farnese (Frommel 1981, figs. 23, 29, 32, 33, 35) and for St. Peter's (Frommel, in Frommel/Ray/Tafuri, pp. 268f., 274ff.)

328. Thus also u 1320A for the Palazzo Farnese in Gradoli or u 252A and 122A for St. Peter's (Frommel/ Ray/Tafuri, pp. 267, 286).

329. Thus Labacco's engraving of Antonio's central plan project for S. Giovanni dei Fiorentini may derive from a wooden model (Tafuri, in Frommel/Ray/Tafuri, p. 222f.; Frommel 1986, p. 296, n. 142); Schofield, p. 121ff.

330. Giovannoni, p. 143ff.; Frommel, in Frommel/Ray/Tafuri,

pp. 299–302.

331. Giovannoni, fig. 121.

332. J.S. Ackerman, *The Architecture of Michelangelo*, 5th ed. (Chicago, 1986); G.C. Argan and B. Contardi, *Michelangelo architetto* (Milan, 1990).

333. Frommel 1973, pl. 138a, b.

334. Pagliara 1988 (see n. 313).

335. On Antonio's workshop, see especially Giovannoni, p. 96ff.

336. Frommel 1986, p. 279f., n. 70; on Labacco's *Libro*, see idem, p. 283, n. 88; Günther 1988, p. 248ff.

337. Frommel 1986, p. 279f.

338. Ibid.; cf. Vasori, p. 189.

339. Buddensieg, p. 95; Günther 1988, p. 248.

340. Günther 1988, pp. 261, 272ff., 282, figs. 23, 39ff., 54f.; see p. 45.

341. Ibid., p. 249ff., fig 8.

342. Ibid., fig. 10.

343. Ibid., p. 272, fig. 42.

344. Ibid., p. 257ff., fig. 22.

345. See above, p. 12.

346. Frommel 1986, p. 296, n. 142.

347. Giovannoni, p. 244.

348. See above, p. 35.

349. Günther 1988, p. 65.

350. On Giovan Francesco, see Frommel 1973, II, p. 362; Buddensieg, p. 104f.; Frommel 1986, p. 276, n. 55; C.L. Frommel, "Giovanfrancesco da Sangallo, architetto di palazzo Balami-Galitzin," in Spagnesi, ed., *Antonio da Sangallo*, p. 63ff.; Günther 1988, pp. 127, 296ff., 338; Frommel 1991, p. 181.

351. Vasari-Milanesi, VI, p. 435.

352. Bartoli, pp. 69, 83, 99, 101ff., figs. 369, 446, 550, 553, 561, 563, 571; Günther 1988, pp. 125f., 257, 296ff.

353. Günther 1988, p. 127, n. 144; see above, p. 17.

354. Bartoli, p. 23f., fig. 98; cf. S. Borsi, p. 144ff.; Günther 1988, p. 115, n. 104.

355. Bartoli, p. 99, fig. 540; for U 85A, see above, p. 23.

356. Cf. Günther 1988, p. 296ff.

357. Frommel/Ray/Tafuri, figures pp. 178, 222, 327; as on U 909A for the aedicule of S. Giacomo (Giovannoni, p. 244), one also finds Giovan Francesco's handwritten comments on U 1898A v. for the Torre del Monte, without, however, the occurrence there of the *ch* (Frommel 1973, p. 125f.; Frommel 1986, p. 276, n. 55; this essay, fig. 33d).

358. Bartoli, pp. 93f., 99, 101, 106, figs. 499, 540, 553, 584.

359. Ibid., p. 100, fig. 545.

360. See above, p. 30.

361. Frommel 1986, p. 296ff.

362. Bartoli, p. 101ff., figs. 553, 556, 570.

363. On Sangallo's house near S. Rocco, see above, n. 129.

364. Bartoli, p. 99, fig. 537.

365. See above, n. 315.

366. See above, p. 19.

367. Buddensieg, p. 108; F.E. Keller in vol. 3 of this corpus.

368. See above, p. 36.

369. For the palace of B. da Parma, see B. Adorni, "Progetti e interventi di Pier Francesco da Viterbo, Antonio da Sangallo il Giovane e Baldassarre Peruzzi per le fortificazioni di Piacenza e di Parma," in Spagnesi, ed., *Antonio da Sangallo*, p. 365ff.; since this project has not as yet been dated, nothing prevents an earlier dating.

370. Giovannoni, figs. 189, 191, 286; Frommel 1973, II, pp.

30ff., 175ff., pls. 17a, b, 71a, b; Frommel 1986, p. 298f., n. 149.

371. Bartoli, pp. 95, 99f., 102, figs. 507ff., 539, 541,545, 559; Vasori, pp. 161–72, 175ff.

372. Günther 1988, p. 297.

373. Bartoli, p. 95, fig. 508; see P.N. Pagliara in concluding volume of this corpus.

374. Frommel, in Frommel/Ray/Tafuri, p. 361; Günther 1988, p. 297.

375. Giovannoni, pp. 11, 26, fig. 50; Günther 1988, p. 297.

376. See above, p. 23.

377. See above, p. 42.

378. P.N. Pagliara, "Cordini, Giovanni Battista," *Dizionario Biografico degli italiani* 29 (Rome, 1983), pp. 23–28; P.N. Pagliara, "Sangallo, (Giovanni) Battista," *Macmillan Dictionary of Architecture* (New York, 1992), with further bibliography.

379. S. Borsi, p. 44 (upper half).

380. See above, p. 27.

381. Bartoli, p. 102, fig. 562.

382. Frommel 1973, I, p. 133, pl. 167b; F.E. Keller, "Residenze estive e 'ville' per la corte farnesiana nel Viterbese nel '500," in *Farnese dalla Tuscia Romana alle Corti d'Europa*. Acts of the Congress, Caprarola, 1983 (Viterbo, 1985), p. 74ff; F. Fagliari Zeni Buchicchio, "Contributo all'attività di Antonio da Sangallo il Giovane a Civitavecchia, Gradoli e Castro," in Spagnesi, ed., *Antonio da Sangallo*, p. 250ff. That here we are not dealing with a drawing of the consolidation phase of the years 1537/38, as formerly suspected, but rather with a design from the time of the beginning of construction, is demonstrated mainly by the deviant measurements of the windows and the different sizes of the corner bosses. These, as well as the low upper story, still correspond stylistically to the Palazzo Baldassini of ca.1514 (Frommel 1973, pl. 10a), while the small-block rustication carried out above the socle story on the side facing the valley is found in Antonio's buildings from the time after 1515 such as the Palazzo Farratini in Amelia (M. Bertoldi, M.C. Marinozzi, L. Scolari, C. Varagnoli, "Note sul palazzo Farrattini ad Amelia," in Spagnesi, ed., *Antonio da Sangallo*, pp. 297–308) or the upper part of the ground floor of the Palazzo Farnese (Frommel 1973, pl. 41a). If on U 1320A there are two references to preexistent walls, this means simply that older construction material was integrated, as the documents as well as the asymmetrical and completely atypical plan witness. It remains to be determined whether dialect forms such as "fazzata" or "cornisone" on U 1320A can be attributed to a Florentine.

383. On Giuliano's drawing of Brunelleschi's S. Maria degli Angeli, see above, p. 6. The plan U 1285A, which Antonio later provided on the verso with a purely classificatory inscription ("facciate per diversi palazzi e case"), and which was possibly intended for the palace of Cardinal Francesco Soderini in Borgo Nuovo, is likewise abstracted and could also have been drawn by the young Giovanni Battista (Giovannoni, pp. 49f., 322). Francesco's palace facade, drawn significantly later in a similar technique on U 1772A, provides support for the idea that we have here to do with a specifically Florentine mode of representation.

384. Frommel 1973, II, p. 5, pl. 6a, b; Pagliara, in Frommel/Ray/Tafuri, p. 179ff.

385. Frommel, in Frommel/Ray/Tafuri, p. 322, figure p. 317.

386. Giovannoni, p. 67; D. Redig de Campos, *I Palazzi Vaticani* (Bologna, 1967), p. 120f.

387. Pagliara 1983 (see n. 378), p. 24.

388. Ibid.

389. Giovannoni, p. 26, fig. 50; see above, p. 43.

390. I owe this information to F. Fagliari Zeni Buchicchio.

391. P.N. Pagliara, "Alcune minute autografe di G. Battista da Sangallo," *Architettura Archivi* 1 (1982): 25–50.

392. Pagliara 1992 (see n. 378).

393. Pagliara 1983, p. 25; Pagliara 1992 (see n. 378).

394. Pagliara 1983, p. 25; Pagliara 1992 (see n. 378).

395. Not one of the motifs coincides with Michelangelo's known studies.

396. See above, p. 36.

397. Bartoli, pp. 93, 96f., figs. 493–497, 520f., 526f.

398. Bartoli, pp. 94, 97; figs. 503f., 529–531; Günther 1988, p. 261ff., figs. VII, 19, 50.

399. Bartoli, p. 77ff., 80f., figs. 417f., 433–438; Günther 1988, p. 377, figs. 26, 84, 82.

400. Bartoli, p. 98, fig. 533.

401. See above, p. 22.

402. Bartoli, p. 97, fig. 532; Vasori, p. 174f.; Günther 1988, p. 377.

403. Bartoli, p. 62, figs. 335–338; Giovannoni, p. 67, fig. 45f.; Günther 1988, pp. 231, 298; on the attribution of these sheets to Tanghero, see G. Scaglia, "Antonio del Tanghero's work in Rome in 1518 with Pietro Rosselli, Michelangelo Buonarroti, and Antonio da Sangallo il Giovane," *Antichità Viva*, 1992.

404. Giovannoni, pp. 239, 379, fig. 229.

405. Ghisetti Giavarina.

406. Vasari-Milanesi, VI, p. 434.

407. C.L. Frommel, "Palazzo Pandolfini," in *Atti del Convegno Internazionale Raffaellesco*, Florence, 1984, ed. M. Sambucco Hamoud and M.L. Strocchi (Florence, 1987), p. 201.

408. Vasari-Milanesi, VI, p. 437.

409. Ghisetti Giavarina, p. 17ff.

410. Ibid., p. 23ff.

411. Vasari-Milanesi, VI, p. 449.

412. Ghisetti Giavarina, cat. 1, 2, 6–9, 11–13, 45, 49f., 56, 73, 97; the author's attribution of most of these drawings to Tommaso Boscoli is not convincing.

413. Ibid., cat. 4, 38f., 76f., 91ff.; see above, p. 18.

414. Ibid., cat. 7.

415. Bartoli, p. 107, fig. 593; Vasori, p. 179ff.; Ghisetti Giavarina, cat. 35.

416. Ghisetti Giavarina, cat. 8.

417. Ibid., cat. 37, 43, 48, 59, 61, 67f., 78, 82ff., 86, 95.

418. Ragghianti Collobi 1973, p. 73, fig. 87. On Francesco da Sangallo, see Degenhart, p. 256f.; A.P. Dadd and R. Roisman, "Francesco da Sangallo: a rediscovered early Donatellesque 'Magdalen' and two wills from 1574 and 1576," *Burlington Magazine* 129 (1987): 784–92, with Francesco's testaments, in which, however, only "modelli" are mentioned.

419. Borsi, figure p. 44 (compare Antonio's U 2047A v.; see above, pp. 8, 17) and figure p. 215 (compare U 1627A r.; see above, n. 141); for his part, Antonio had access to Giuliano's *Libro*. Compare, for example, *U 1665A r. and v.: "spoglia cristi dal libretto di Giuliano"; Vasori, p. 172ff.; Günther 1988, p. 857.

420. *Libro*, fols. 1v, 43 (S. Borsi, pp. 44, 213ff.; see above, p. 17, n. 141).

421. S. Borsi, p. 202f.; Frommel 1973, II, p. 118, pl. 50b.

422. See above p. 30. He may also have drawn sheets such as U 930A (Bartoli, p. 80, fig. 431), where the cursive script differs from Giovanni Battista's drawings of antiquities by the squiggly *g* and the abbreviation for the *braccio*.

423. Bartoli, p. 65, fig. 342; Günther 1988, fig. VII, 86.

424. De Angelis D'Ossat; Pagliara 1983 (see n. 378), p. 23. Francesco's hand is certainly represented among those drawings

Antonio preserved that have yet to be identified.

425. Frommel 1973, II, p. 264ff., pl. 110; Tafuri, in Frommel/Ray/Tafuri, p. 236ff.

426. Giovannoni, p. 322, with outline in fig. 20.

427. Bartoli, pp. 54, 104, figs. 295ff., 574; Wurm, p. 117f.

428. Bartoli, p. 109, fig. 603f.; cf. Peruzzi's probably later copy on U 477A r. (Günther 1988, p. 282, fig. 52).

429. J. Hunter, "The 'Architectus Celeberimus' of the Palazzo Capodiferro at Rome," *Römisches Jahrbuch für Kunstgeschichte* 21 (1984): 397–403.

430. M. Heinz, "Das Hospital S. Giacomo in Augusta in Rom . . . ," *Storia dell'Arte* 41 (1981): 31–49; see also Baronino's receipt in the Archivio d. Rev. Fabbrica di S. Pietro.

431. Frommel 1981, p. 149ff., figs. 5, 32, 42, 45, 48.

432. N. Nobis, *Lorenzetto als Bildhauer* (Bonn, 1979).

433. Ferri 1885, XLI; Lorenzetti's handwriting is secured by receipts from the construction crew at St. Peter's (Nobis [see n. 432], p. 237ff.); see this essay, fig. 45d.

434. See, for example, the group put together by Bartoli (pp. 32–35, figs. 155–182), which stem from the same draftsman as the scale of measurement on *U 829A v.

435. Frommel 1986, p. 280ff.

REFERENCE LIST

Alberti, L.B. *L'architettura (De re aedificatoria)*, ed. P. Portoghesi, trans. G. Orlandi (Milan, 1966).

Ashby, T. "Sixteenth-Century Drawings of Roman Buildings Attributed to Andreas Coner," *Papers of the British School at Rome*, 2 (1904).

Bartoli, A. *I monumenti antichi di Roma nei disegni degli Uffizi di Firenze*, 6 vols. (Rome, 1914–22).

Borsi, F., and S. Borsi. *Bramante* (Milan, 1989).

Borsi, S. *Giuliano da Sangallo. I disegni di architettura e dell'antico* (Rome, 1985).

Bruschi, A. *Bramante architetto*, Bari, 1969.

Bruschi, A. "Cordini (Cordiani?), Antonio, detto Antonio da Sangallo il Giovane," *Dizionario biografico degli italiani* 29 (Rome, 1983), pp. 3–23.

Buddensieg, T. "Bernardo della Volpaia und Giovanni Francesco da Sangallo: Der Autor des Codex Coner und seine Stellung im Sangallo-Kreis," *Römisches Jahrbuch für Kunstgeschichte*, 15 (1975): 89–108.

Clausse, G. *Les San Gallo* II (Paris, 1902).

De Angelis D'Ossat, G. "L'autore del Codice londinese attribuito ad A. Coner," *Palladio* n.s. 1 (1951): 94–98.

Degenhart, B. "Dante, Leonardo und Sangallo," *Römisches Jahrbuch für Kunstgeschichte* 7 (1955): 101–292.

Degenhart, B., A. Schmitt. *Corpus der italienischen Zeichnungen 1300–1450*, Part I, 4 vols. (Berlin, 1968).

Denker Nesselrath, C. *Die Säulenordnungen bei Bramante* (Worms, 1990).

Egger, H. *Codex Escurialensis. Ein Skizzenbuch aus der Werkstatt Domenico Ghirlandaios* (Vienna, 1905-6).

Fabriczy, C. von. "Giuliano da Sangallo," *Jahrbuch der Königlich Preussischen Kunstsammlungen* 23 (1902), Beiheft: 1–42.

————*Die Handzeichnungen Giulianos da Sangallo. Kritisches Verzeichnis* (Stuttgart, 1902).

Ferri, P.N. *Indice geografico-analitico dei disegni di architettura civile e militare esistenti nella R. Galleria degli Uffizi in Firenze* (Rome, 1885).

Frey, K. "Zur Baugeschichte des St. Peter. Mitteilungen aus der

Reverendissima Fabbrica di S. Pietro," *Jahrbuch der Königlich Preussischen Kunstsammlungen* 31 (1910), Beiheft: 1–95.

Frommel, C.L. *Der Römische Palastbau der Hochrenaissance,* 3 vols. (Tübingen, 1973).

———"Die Peterskirche unter Papst Julius II. im Licht neuer Dokumente," *Römisches Jahrbuch für Kunstgeschichte* 16 (1976): 57–136.

———"Sangallo et Michel-Ange (1513–1550)," in *Le Palais Farnèse* (Rome, 1981), I, 125–224.

———"Il complesso di S. Maria presso S. Satiro e l'ordine architettonico del Bramante lombardo," in *La scultura decorative del Primo Rinascimento,* Atti del I Convegno Internazionale di studi, Pavia, 1980 (Pavia, 1983), pp. 149–58; lightly abridged version published in *Lotus* (1992): 6–22.

———"Il Palazzo Vaticano sotto Giulio II e Leone X. Strutture e funzioni," in *Raffaello in Vaticano.* Catalogue of the exhibition, Vatican City, 1984–85 (Milan, 1984), pp. 118–35.

———"Raffael und Antonio da Sangallo der Jüngere," in *Raffaello a Roma,* Acts of the Congress, Rome, 1983 (Rome, 1986), pp. 261–304.

———"S. Luigi dei Francesi: das Meisterwerk des Jean de Chenevières," in *"Il se rendit en Italie." Etudes offertes à André Chastel* (Rome and Paris, 1987), pp. 169–93.

———"Bramante e il disegno 104 A degli Uffizi," in C. Carpeggiani and L. Patetta, eds., *Il disegno di architettura.* Acts of the Congress, Milan 1988, (Milan, 1989), pp. 161–68.

———"Peruzzis römische Anfänge: Von der Pseudo-Cronaca-Gruppe zu Bramante," *Römisches Jahrbuch der Bibliotheca Hertziana* 27–28 (1991–92): 137–81.

———"Bramante und die Anfänge der italienischen Architekturzeichnung diesseits und jenseits der Alpen," in J. Poeschke, ed., *Kunstgeschichte im europäischen Kontext: Italienische Renaissance und nordeuropäisches Spätmittelalter, Akten des Kolloquiums,* Düsseldorf, 1991 (in press).

———*Palazzi Romani del Rinascimento,* (in press).

———"St. Peter's 1505–1535," in *Renaissance architecture,* catalogue of the exhibition, Venice, 1994 (in press).

———"Ulteriori riflessioni su Bramante disegnatore," in *Il disegno di architettura.* Acts of the Congress, Naples, 1991 (in press).

Frommel, C.L., S. Ray, M. Tafuri, eds. *Raffaello architetto* (Milan, 1984).

Gaye, G. *Carteggio inedito d'artisti dei secoli XIV. XV. XVI,* 3 vols. (Florence, 1839–40).

Ghisetti Giavarina, A. *Aristotile da Sangallo e i disegni degli Uffizi* (Rome, 1990).

Giovannoni, G. *Antonio da Sangallo il Giovane* (Rome, 1959).

Golzio, V. *Raffaello nei documenti nelle testmonianze dei contemporanei e nella letteratura del suo secolo* (Vatican City, 1936).

Günther, H. "Werke Bramantes im Spiegel Gruppe von Zeichnungen der Uffizien in Florenz," *Münchner Jahrbuch der bildenden Kunst* 33 (1982): 77–108.

———"Die Strassenplanung unter den Medici-Päpsten in Rom (1513–1534)," *Jahrbuch des Zentralinstituts für Kunstgeschichte* 1 (1985): 237–93.

———*Das Studium der antiken Architektur in den Zeichnungen der Hochrenaissance* (Tübingen, 1988).

Huelsen, C. *Il libro di Giuliano da Sangallo, Codice Vaticano Barberiniano latino 4424,* 2 vols. (Leipzig, 1910).

Jobst, C. *Die Planungen Antonios da Sangallo des Jüngeren für die Kirche S. Maria di Loreto in Rom* (Worms, 1992).

Lotz, W. "Das Raumbild in der Architekturzeichnung der italienischen Renaissance," *Mitteilungen des Kunsthistorischen Institutes in Florenz* 7 (1956): 193–226.

———*Studies in Italian Renaissance Architecture* (Cambridge, Mass., London, 1977), pp. 1–65.

Loukomsky, G.K. *Les Sangallo* (Paris, 1934), pp. 69–125.

Marchini, G. *Giuliano da Sangallo* (Florence, 1943).

Pastor, L. von. *Geschichte der Päpste seit dem Ausgang des Mittelalters* (Freiburg, 1885ff.).

Pedretti, C. *Leonardo architetto* (Milan, 1978).

Raffaello in Vaticano. Catalogue of the exhibition, Vatican City, 1984–85 (Milan, 1984).

Ragghianti Collobi, L. "Il 'Libro de' disegni' del Vasari. Disegni di architettura," *Critica d'Arte* 20 (1973), n. 127: 3–120.

———"Nuove precisazioni sui disegni di architettura del 'Libro' del Vasari," *Critica d'Arte* 20 (1973), n. 130: 31–54.

———*Il Libro de' Disegni del Vasari,* 2 vols. (Florence, 1974).

Satzinger, G. *Antonio da Sangallo der Altere und die Madonna di San Biagio bei Montepulciano* (Tübingen, 1991).

Schofield, R. "Leonardo's Milanese Architecture: Career, Sources and Graphic Techniques," *Achademia Leonardi Vinci* 4 (1991): 111–57.

Spagnesi, G., ed., *Antonio da Sangallo il Giovane: la vita e l'opera.* Atti del 21 Congresso di Storia dell'Architettura, Rome, 1986 (Rome, 1986).

Tafuri, M. *Ricerca del Rinascimento. Principi, città, architetti* (Turin, 1992).

Tigler, P. *Die Architekturtheorie des Filarete* (Berlin, 1963).

Tönnesmann, A. *Der Palazzo Gondi in Florenz* (Worms, 1983).

Vasari, G. *Le vite de' più eccellenti architetti, pittori et scultori italiani, da Cimabue insino à tempi nostri,* 2 vols. (Florence, 1550).

———*Le vite de' più eccellenti pittori, scultori e architettori italiani,* 3 vols. (Florence, 1568).

Vasari-Milanesi, *Le opere di Giorgio Vasari,* ed. G. Milanesi (Florence, 1880–1906).

Vasori, O. *I Monumenti antichi in Italia nei disegni degli Uffizi,* ed. A. Giuliano (Rome, 1980).

Wolff Metternich, F. *Die Erbauung der Peterskirche zu Rom im 16.Jahrhundert,* Part I (Vienna, 1972).

———*Bramante und St.Peter* (Munich, 1975).

Wolff Metternich, F., C. Thoenes. *Die frühen St.-Peter-Entwürfe: 1505–1514* (Tübingen, 1987).

Wurm, H. *Baldassarre Peruzzi: Architekturzeichnungen* (Tübingen, 1984).

The Fortification Drawings

NICHOLAS ADAMS

SIMON PEPPER

Fortification drawings figure prominently in the portfolios of Antonio da Sangallo the Younger, testifying to the important—at times dominant—role of military building in his architectural practice. They also reveal aspects of his approach to fortification design that could not have emerged from a study confined to the surviving defensive structures. Although Antonio da Sangallo the Younger's built *oeuvre* is often seen to mark the arrival of the fully developed, and increasingly standardized, bastioned system of the sixteenth century, the corpus of drawings demonstrates the more varied and far more interesting picture of an inventive and imaginative designer who was participating at a number of levels in the Renaissance revolution in military architecture.[1]

Gunpowder had been used in European warfare since the early fourteenth century, and in 1453 Turkish bombards destroyed the walls of Constantinople with massive stone projectiles, giving the gunners their most spectacular early achievement. The critical change came somewhat later in the fifteenth century, however, as the French adoption of iron shot gave a much enhanced destructive performance from lighter and more mobile guns.[2] The improved weapons not only threatened the tall towers and slender curtain walls of conventional medieval fortifications, but represented an entirely new and exciting range of possibilities for the defense of works designed, or modified, to accommodate artillery and smaller firearms. By removing towers, thickening and lowering walls, and sinking the reinforced works in deep ditches, designers could render fortifications much less vulnerable to cannon fire. But this was only half the problem. Real skill was needed to combine these essentially passive measures with the design of protected gun emplacements for a variety of large and small weapons capable of engaging enemy siege batteries and sweeping all external surfaces with defensive crossfire.

Backed by the near-constant pressure of war and threats of war, this challenge proved a potent source both of inspiration and of actual building commissions for Italy's leading architects: Francesco di Giorgio, Leonardo da Vinci, Michelangelo Buonarroti, Michele Sanmicheli, Baldassarre Peruzzi, and the older members of the Sangallo family, Antonio and Giuliano.[3] Among this distinguished company, Antonio da Sangallo the Younger stands out. Contemporaries acknowledged his outstanding technical expertise. As Vasari put it: "No other architect among the moderns was more trusted or more knowledgeable about putting buildings together."[4]

To the veteran military engineer Francesco De Marchi he was one of the "valentissimi huomini nell'arte di fortificare."[5] To this we should add his ability to handle and bring to completion major fortification projects in unprecedented numbers. Indeed, Antonio the Younger's only serious contemporary Italian rival as a designer and constructor was Michele Sanmicheli, who worked exclusively for Venice in the republic's extensive fortification program. Antonio's patronage was more diverse, but he shared with Sanmicheli the benefit of lessons learned in the traumatic years around 1500, and it was their good fortune to have reached architectural maturity by the 1530's and 1540's, when fortification projects of unprecedented size and number presented themselves as the new rulers of Italy established their regimes behind strong walls.

Pope Julius II (1503–13) provided early commissions for Antonio at the fortress-palace of Civita Castellana, the walls of the Vatican Borgo (starting 1505), and the central Roman stronghold of Castel Sant'Angelo (starting 1512), all of which were modernized to resist and accommodate the new artillery.[6] Under Pope Leo X (1513–22) he began a long association with the Medici dynasty when he undertook the design of fortifications for Civitavecchia (1512–20), the principal naval base on the west coast of the Papal States.[7] Later he was to work on a variety of ecclesiastical and civil buildings for another Medici pope, Clement VII (1523–34), for whom he began in 1532 what was eventually to prove a major program of fortification at Ancona, the chief papal port on the Adriatic.[8] Clement's turbulent reign also provided the architect with valuable military experience. The best-known military commission from this period was the tour of inspection of papal fortresses along the northern borders of the church states—then threatened with invasion by the imperial army that eventually sacked Rome—which he undertook in 1526 in collaboration with Sanmicheli. Antonio also served Clement in the papal-imperial camp outside Florence during the siege of 1529–30. No Italian can have been a total stranger to warfare during the protracted Hapsburg-Valois conflict; but Antonio the Younger's experience of active service in the long and bitter siege of Florence must have given him a new perspective on the grim practicalities of fortification design.

The year 1534 marked an important threshold in Antonio's career. In March of that year he was engaged to design and build the Fortezza da Basso by Alessandro de' Medici, the recently installed Imperial Duke of Florence.[9] Alessandro was assassinated shortly afterward, to be succeeded by Cosimo I, for whom Antonio brought this enormous project to a state of near completion within the amazingly short period of two years. With the election in October 1534 of Alessandro Farnese as Pope Paul III, Antonio was engaged as chief designer of the ambitious and eventually largely abortive scheme to refortify the Aurelian walls, the circuit dating from the third century A.D., which still constituted Rome's outer defenses.[10] Antonio had been associated with the cardinal since 1517, when work began on his Roman palace. Later he had built for the family at Montefiascone. Paul III's pontificate, however, brought him numerous further commissions. Besides retaining his appointment as chief papal architect ("architetto di tutte le fabbriche pontificie," a title awarded him by Clement in May 1534), he was engaged in the following years in major works at Castro, Parma, and Piacenza, all Farnese fiefs, and at the papal undertakings at Ancona, Ascoli, and Perugia. The last twelve years of Antonio's life saw him engaged in massive projects, often built under conditions of extreme haste.

Military construction made special demands on the architect. More than any other type of building, fortifications required considerable labor forces[11] to excavate the broad ditches and to shift the very large quantities of earth and rubble that were packed behind the outer masonry skins to resist the impact of cannonballs and the destructive effect of explosive mines. The logistics of these operations posed formidable difficulties in the supply, organization, equipping, and provisioning of what can only be called small armies of unskilled building labor. Moreover, fortification demanded the conventional skills of the masons who constructed the internal network of countermine galleries and casemates, and who crafted the gun embrasures and vents to high standards of accuracy. Viewed simply as construction, these projects represented no mean professional achievement in the successful coordination of many hundreds of workers and dozens of skilled building tradesmen. It was surely no coincidence that both of the most prolific Italian fortification builders of the period, Antonio the Younger and Michele Sanmicheli, were supported by relatives in their workshops, as well as by the bureaucracies of the Vatican and the Venetian republic. Although the organizational details of collaboration within the workshop are not yet fully understood, it seems clear that Antonio's successful handling of this substantial workload stemmed both from the support given him by the *setta* and from his own ability to work with the politicians, administrators, military advisers, and the host of others involved in what must have been one of the most public forms of public architecture.

The bulk of Antonio's surviving drawings date from the later, post–1534, period of his activity, when the works were at their most ambitious and when the workshop had evolved methods and routines that made drawing a key to project development and the control of distant building operations. The preservation of these drawings became an essential aspect of a workshop that had to manage a number of major projects on widely separated sites. During the 1530's and 1540's, fortification work (to say nothing of other projects) was progressing—often simultaneously—at Ancona on the Adriatic coast, at Florence and Perugia in central Italy, at Rome and Castro in the south, and at Parma and Piacenza in the Po valley to the north

(Fig. 1). Under these conditions it became essential to preserve drawings, to keep copies of drawings sent out to members of the family working on different sites, and to archive the survey data brought or sent back from numerous tours of inspection.

The best-known of these tours is the survey of the papal fortresses of the Romagna in 1526, which was carried out jointly by Antonio da Sangallo and Michele Sanmicheli, together with other associates.[12] Partly because a series of annotated sketches supposedly from this project was published by Luca Beltrami,[13] and partly because it apparently brought together two of the rising stars of Italian military architecture, the Romagna survey has assumed great importance in the scholarly literature. This undertaking is poorly supported by original documents, however. Beltrami cites a letter (dated 1 April 1526) from Niccolò Machiavelli—then in Florence—to the Florentine ambassador to the Holy See, referring to the expected arrival of Antonio the Younger, who had been commissioned by "our lordships" (that is, the Florentines) to survey the fortified towns of Lombardy. Sanmicheli's involvement is attested by Vasari, and Beltrami associates him with a number of the drawings (not all of which can now be identified) on the evidence of Venetian spellings and usages in the annotations. However, to call the product a "relazione" (Beltrami's title) is somewhat misleading, since the timetable of the visits, the precise terms of reference, and the final recommendations are all unknown. What remains is a series of what possibly are field survey drawings with notes, typical products of the bread-and-butter work of Renaissance military architecture, much of which involved life on the move, inspecting and surveying fortifications, recommending improvements to old walls, and indicating the locations and fields of fire of new works. (It may also be possible that some the drawings were recopied at a later date.) Leonardo da Vinci's notebooks record similar work for the Appiani at Piombino and for Cesare Borgia in the Marches.[14] Baldassarre Peruzzi left annotated survey drawings of towns in the Sienese *dominio* directly comparable to those of Antonio the Younger.[15] Machiavelli accompanied Pedro Navarro on a similar survey of the medieval walls of Florence in 1526, and wrote what is probably the most coherent and literate technical report to come down to us from this period, recommending the construction of a number of simple new works, reinforcements, and modifications, which formed the basis for their successful defense in the siege of 1529–30.[16]

A peripatetic working life, added to the volume of

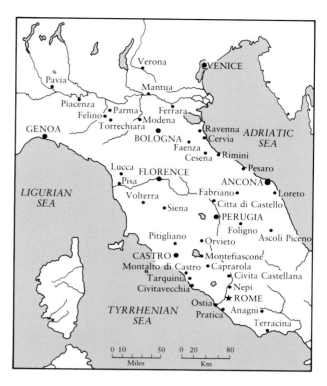

1 Map of Central Italy showing the sites visited by the Sangallo circle as part of their defense and fortification work.

projects handled by the Sangallo family, made some sort of central office organization essential. Antonio himself was based in Rome when not on the road, but the largest projects demanded the presence of local representatives capable of interpreting the drawings. Aristotile (Antonio's nephew, Bastiano da Sangallo) represented the family at Perugia and Ancona, and at Perugia he was assisted by Jacomo Melighino. As building works began at the Fortezza da Basso in Florence, Nanni Unghero joined the team as permanent site architect, and was later reinforced by Aristotile as family representative. Gobbo (Antonio's brother, Giovanni Battista da Sangallo) worked on a number of the drawings—but whether in Florence or Rome is impossible to say. Giovan Francesco da Sangallo was closely involved in the Piacenza project, but whether in that city or elsewhere is not known. Central control remained always with Antonio the Younger, however, who seems himself to have carried out all of the critical initial site visits and strategic surveys (see, for example, U 1023A, 1028A). Drawings were sent to him for approval, and he was enough of the boss to comment angrily when sufficient information was not included. As he noted on U 1043A, one of the draw-

ings for the Porta Marzia, Perugia: "I can not finish this unless I know the height facing [that corresponds to] the 17 *palmi* of the scarp of the bastion. For God's sake make a note of the actual heights of these things and how they measure up one to another."[17]

Antonio's ultimate authority in these matters was probably a mixed blessing. Subordinates often proved unwilling to take decisions without the approval of a man who frequently had too many decisions to make. Pressure of work, slow communications, and the inability to be in more than one place at a time, all led to delays and frustrations and a catalogue of the standard complaints about busy architects in the documentary record.[18]

Evidently the workshop also developed standardized procedures, such as the use of ready reckoners for calculating superficial areas (U 1466A, 3949A), standard color coding conventions, and sheets of scaled dimensions (U 804A, 1461A) to avoid the kind of confusion that could easily arise in different cities that used the same words for units of measure of markedly different value. There was also a small office industry dedicated to the production of copy drawings.[19] Pricking was, of course, the standard copying technique. Whole sets of multiple copies have survived; some sheets of city-wall surveys were marked with place names, or the names of gates, while others were left simply as the blank outline of walls. A few sheets have been so extensively pricked that they obviously served as "masters" (U 271A, 272A).

Among the surviving sheets, much the smallest category is the finished presentation drawing. The illustrated rendering, possibly by Bartolomeo de' Rocchi, of the bastion of San Paolo al Cassero at Ancona (Fig. 2) is by far the most polished example of formal architectural draftsmanship associated with any of Antonio the Younger's projects. It may well have been intended for publication in a treatise, since it includes not only the three-dimensional arrangements of the bastion flanks in a quasi-axonometric projection, but also the formal architectural treatment of the quoins, cordon, and parapets, as well as a section through the rampart that shows the internal countermine gallery and its lighting and ventilation flue.[20] Among the drawings that have survived, Antonio's drawing office never matched this level of finish. Presentations to patrons or building committees would almost certainly have been by means of models, which nonarchitects still find easier to understand than drawings, and on which sixteenth-century clients were willing to spend very large sums.[21]

This being said, still the Sangallo circle produced

2 Ancona, the bastion at the Porta al Cassero, U 4225A. The drawing, which makes extensive use of wash, is attributed to Bartolomeo de' Rocchi in the Uffizi catalogues.

many impressive examples of fine draftsmanship as the more detailed aspects of a project's development were explored and resolved. Even these fine drawings, however, were often incomplete. The city facade of Perugia's Rocca Paolina (U 1510A) is drawn in great detail up to the cordon, where a light wash is used to bring out the relief of the quoining and the architectural detail of the main gate. But the second level is left quite blank inside the elevational outline. Notes specify the materials to be used, but little more. Another Perugia drawing, the oversized plan of the lower fortress, or hornwork (U 272A), still contains alternative proposals that had yet to be resolved in the design of the hornwork. It is shown here as it was eventually built, with two demi-bastions. Rough overdrawing in gray chalk indicates, however, that a third central bastion was contemplated by Antonio or others—the drawing may not be in his hand. Most of this drawing is accurately delineated, dimensioned, annotated, and color coded to identify old and new masonry. But despite the detailed annotation, the exploratory nature of parts suggests that this was an office design drawing, retained and updated as decisions were reached, and perhaps used as the basis for planning discussions, rather than a drawing that could be employed on site by masons unfamiliar with the discussions.

One of the most interesting sequences of near-complete variations is provided by the plans for the interior of the Fortezza da Basso, Florence. U 315A and 316A show the colonnaded ranges of stables and bar-

racks running around the open parade ground surrounding the central keep, which was clearly devised in the first place to provide a heavily fortified retreat for the unpopular puppet duke, Alessandro de' Medici. Both plans show the fortress interior in an advanced state of elaboration, but the very extensive pricking on U 315A and minor differences in content suggest that this was an earlier base drawing, while U 316A represents a later stage of development. The picture is further revealed in studies for the elevational and sectional treatment of the barracks and stables. U 768A and 1282A show that Antonio envisaged these highly functional, warehouse-scale structures fronted by a vaulted arcade, with an attic story above. A later drawing, U 931A, shows the enlargement of these already massive blocks. A second tier of arcading now sits above the first, serving a second major floor of accommodation with a mezzanine level. With an enlarged roof space and basement, and the equivalent of four intermediate floors, the blocks recall major urban structures such as markets, loggias, and civic palaces. The two-tier arcades, with semicircular arches between piers bearing pairs of attached Doric columns, enclosed ambulatories that were to be handled as a series of shallow domed vaults. The corners of the piers and pilasters under each dome were beveled to create a circular space outside each doorway or staircase. There is a striking similarity between the architectural handling of these blocks for soldiers, horses, and military stores, and the "Osteria" that Antonio was to design only a few years later for the Farnese court at Castro. Although the barracks were never built in this form, and the drawings remained incomplete, these design development drawings convey the level of polish envisaged for what would have been one of the most magnificent fortress interiors of the sixteenth century. A view into one of the few interiors to have been built to Antonio the Younger's specifications gives a remarkable sense of what the character of the whole would have been like (Fig. 3).

Another large group has been categorized as survey drawings. These include a number of rudimentary site plans or views, probably sketched while the artist was standing or sitting on a vantage point—hence their roughness—and annotated to identify landmark buildings and key topographical features of military significance. Hatching or crumbly rock-like symbols are used as shorthand for steep slopes; but often words are employed to save time sketching on site: *piu basso*, or *alto* (U 1028A, 301A r.). Often these survey drawings are composed largely of notes, miniature essays

on the defensive potential of the sites that may well have formed the raw material for more formal documents. However, the term *survey drawing* also embraces measured and dimensioned plans of existing fortifications. Drawings of this kind recorded the minutely detailed survey of Rome's Aurelian walls that was carried out in 1534 in the preliminary stages of what promised to be Antonio's most ambitious urban refortification project.

Few cities had been accurately mapped at the beginning of the sixteenth century. Antonio the Younger was obliged to do his own plane-table surveys of Florence, possibly in 1531 or even earlier.[22] Plane-table surveying involved taking sightlines to a series of landmarks from at least two locations of known distance apart, allowing the landmarks to be plotted by intersection. In its simplest form, the plane table was a horizontal surface or drawing board mounted on a tripod or some other support so that the surveyor could move around it taking sights between a central pin and another on the end of a string. U 771A, 772A, 773A, 774A, and 776A (all of Florence) survive as a series of sightlines radiating out from the center of the drawing, like the spokes of a cartwheel (see also U 1020A). For the Florentine survey, Antonio combined compass bearings with the older plane-table technique and took most of his bearings to buildings, bell towers, or the gate towers that dominated the medieval walls. For the rural site of the Farnese fortress city of Castro, where suitable landmarks for plane-tabling were lacking, Antonio seems to have relied entirely on compass bearings for his site maps.[23]

The term *study* has been used to embrace a third, very varied category of drawing in which ideas are developed, possibilities explored, alternatives compared and used as the basis for discussions with colleagues and collaborators. Typically, such studies begin as a doodle along the edge of a sheet, on which a more fully resolved sketch is to be found, leading in some cases to a detailed drawing—perhaps even dimensioned or scaled. Entire sheets of doodles may indicate substantial, almost obsessional consideration of a particular idea. One such notion that clearly fascinated Antonio was the star-shaped fortress trace, formed from overlaid squares or triangles, and apparently derived from the fifteenth-century treatises or sketchbooks of Antonio Filarete, Francesco di Giorgio, and Giuliano da Sangallo (U 758A, 759A, 1344A v., 1520A, 1665A v.). Antonio the Younger ponders, turns, and extends these diagrams as he explores their potential as the controlling geometry for schemes that

65

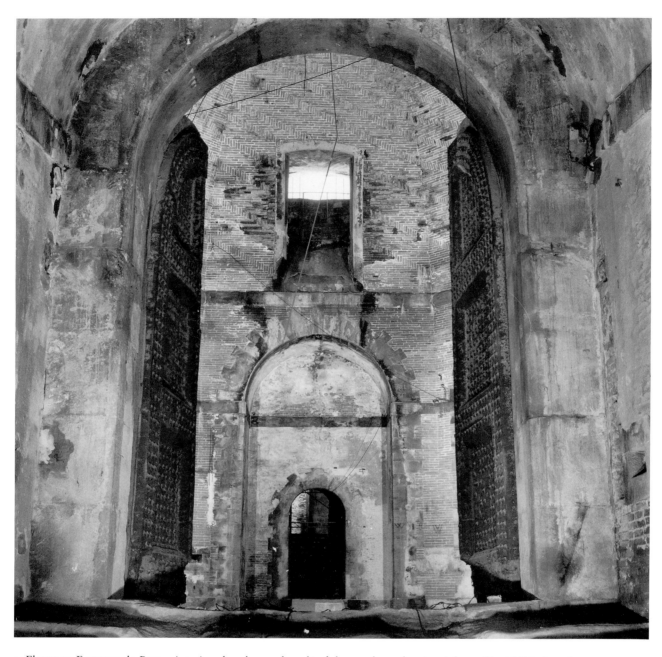

3 Florence, Fortezza da Basso, interior chamber and vault of the northeast bastion (photo: David Friedman).

integrate star-shaped walls with a polygonal central keep and a series of pointed outworks that extrapolate the original fifteenth-century germ of an idea into an elaborate sixteenth-century system of defense in depth.[24] Here Antonio may be playing privately with an idea, as designers have always done. Only rarely are the incised stylus lines of scaled drawings used in these studies. Pen and ink, rapidly applied freehand and often heavily overdrawn with later proposals, characterize these studies, which were obviously executed in haste as one idea led to another (see U 751A, 1016A). Often the graphic or verbal language is arcane and private, and sometimes ambiguous. A squiggle may indicate a steep slope or rock outcrop, a single line a wall or sightline, a rough circle may mark either depression or peak. The omnibus term *study* is really far too imprecise for the variety of doodles, exploratory sketches, ideograms, or developmental drawings that often appear together on the same sheet. But because our descriptive vocabulary is limited, we have been compelled to fall back upon such a term for many of the published fortification drawings.

Antonio da Sangallo the Younger as Military Architect

The basic component of what Sir John Hale called "the International Style par excellence of the Renaissance" was the angle bastion.[25] In its simplest form, the bastion was little more than a solid platform projecting in front of a fortress or town wall. Guns mounted on its flanks could sweep the neighboring curtains, so that any assault on the main walls would have to pass through a crossfire from two adjacent flanking batteries. Guns mounted on the two outer faces fired away from the walls to engage the enemy's siege batteries. The angled, triangular, or pointed plan shapes that were to give the characteristic star patterns of early modern fortifications were the only forms capable of eliminating the blind spots in the defensive fire plan that were always to be found outside squared or rounded works.[26] Round towers were of course well known to be stronger than square ones. As Vitruvius had explained, blows directed at angles could shatter them but "in the case of round towers they can do no harm, being engaged as it were, in driving wedges to their center." Thus, although exposed upper works were often beveled or curved in section to deflect incoming round shot, the straight-sided, angled plan forms of bastions and their outworks derived purely from the need to leave no sector of the enceinte uncovered by guns.

The Fortezza da Basso yielded a classic application of the bastion. After experimenting with stellar plans, concentric rings of circuits and outworks, and solutions that provided for a fort-within-a-fort, Antonio settled for a simple but sophisticated five-bastioned enceinte. One curtain and the bastions at each end of it faced the city. At its center a miniature bastion and cavalier projected forward to cover the gateway. The masonry of this block—which also housed the guardhouse and castellan's quarters—was richly decorated in a low-relief pattern of diamonds and balls to provide an architectural focus for the city facade (Fig. 4). The bastions that swept this facade, however, had extra low-level embrasures in the pointed salients for the guns that might have to be turned on rebels from inside Florence. This extra provision compensated for inner bastions that were more acutely pointed—and thus less spacious for handling artillery—than the broader bastions facing outward to the north, greatly adding to the city's defenses in this region.

The flat site occupied by the Fortezza da Basso astride the northern walls of Florence had none of the

4 Florence, Fortezza da Basso, northwest bastion, exterior wall (photo: David Friedman).

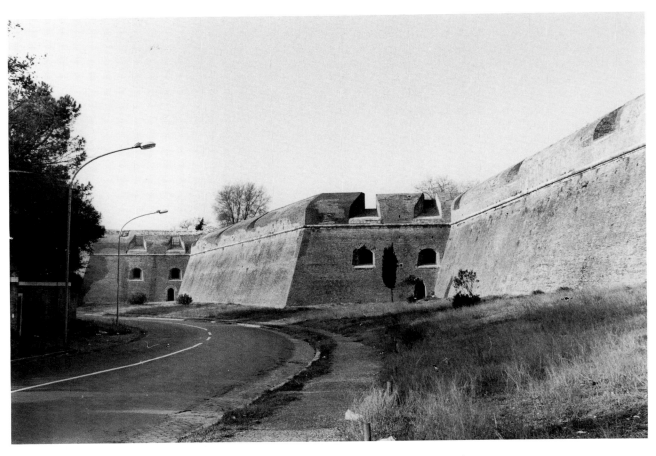

5 Rome, Bastione Ardeatina, view along the flank of the walls (photo: Maurizio di Puolo).

topographical constraints that so often modified the crystalline purity of the Italian system. Elsewhere Antonio created new and original solutions to suit particular sites. The so-called "double bastion" at the Porta Ardeatina, Rome, was one of a series of designs for the complete refortification of the city following the sack of 1527 and the renewed Turkish threat of the 1530's (Fig. 5). By doubling the flanks in a number of the bastions, and by stacking weapons on two tiers of flank batteries and a third open platform, or cavalier, Antonio was able to achieve an enormous potential concentration of flanking fire along the curtains. Doubled flanks also allowed the spacing between salients to be increased, thus reducing the cost of the new fortifications along the extensive Roman walls.

A number of his drawings provide evidence of a fascination with some of the more advanced features, as well as what are often supposed to be *retardataire* features, of fortification design. He was evidently captivated by the formal and technical potential of what became known a century later as the tenaille trace, a zigzag plan with the principal gun positions located in the reentrants. From these protected recesses guns fired out to "clean" each adjacent wall and, of course, to beat the ground between each pair of faces. (In the more pronounced zigzags illustrated in many of Antonio's studies, where the angles were about 90 degrees, each face also swept the approaches to its neighbor.) On restricted sites the tenaille trace often worked better than a bastioned layout, and it was used in the mid-sixteenth century in the controversial design for the Spanish fort dominating Naples from the heights of Sant'Elmo, as well as in more modest defensive works, such as coastal towers or encampments. Antonio evidently planned to employ the tenaille trace for the projected central keep of the Fortezza da Basso and the ramparts surrounding it (U 758A, 759A r. and v., 781A, 1118A, 1389A). The plan of the keep is generated by the same diagram of two superimposed squares, one rotated through 45 degrees, that gave the mid-fifteenth-century treatise author Filarete the basic geometry for his ideal city of Sforzinda. Some of the

more developed drawings for the Florentine project show that this idea, combined with a conventional bastion plan for the outer defenses, survived to a late stage in this scheme. The project reveals Antonio at once exploring practical alternatives to the basic bastion, and making references back to Filarete's geometry and aspects of transitional fortification design that one would not expect to have interested a mid-sixteenth-century expert of Antonio's standing. Here too is the same preoccupation with concentric rings of defensive works (U 759A, 1665A v.) that we find in Francesco di Giorgio's late-fifteenth-century designs and in Leonardo's imaginative concentric circular project for the keep at Piombino.

The defense of ridges and other narrow sites represented yet another special problem in fortification design. On the Pincio ridge at Rome, at Perugia, and later still at Castro, Antonio encountered precisely these conditions and responded by designing what were probably the earliest hornworks (known by the Italians as *tenaglia*, in English "pincers"). These were narrow-fronted projections defended by the crossfire of two half-bastions; their horn- or pincer-like shape in plan gave the work its name. None of these early hornworks can now be seen. That designed for the Pincio ridge at Rome never went beyond the drawing board. But the hornwork at the end of the long corridor descending from the heights of the Rocca Paolina was a highly original solution to a difficult planning problem and, on the evidence of plans and views, one of the most impressive features of that hated symbol of papal authority.

Antonio, together with Francesco di Giorgio, Leonardo, and Dürer, shared an interest in low-level pillboxes, or caponiers, placed in ditches to provide flanking fire for structures that were too high, or rounded, or otherwise ill-adapted to the normal triangular bastion solution. Francesco di Giorgio, indeed, illustrates a number of schemes in which all of the flanking fire is delivered from caponiers, and it is clear from written sources that these low-level defensive works were commonly employed in northern Europe well into the sixteenth century.[27] In the Castro drawings caponiers appear attached to the lower works (U 754A, 813A); the Florentine drawings yield examples projecting from the base of the proposed keep at the Fortezza da Basso, wrapped around bastions to give extra low-level flanking fire along both faces (U 893A, 1389A), and located in the counterscarp (or outside wall) of the ditch to sweep the floor from a position that enemy artillery would be quite unable to reach (U 1507A).

Defensive artillery needed to be protected against incoming enemy shot and provided with openings that gave adequate fields of fire (Fig. 6). Parapets that deflected enemy shot from bare rounded surfaces, or absorbed cannonballs in thick upper earthworks, quickly became a feature of the new military architecture, robbing it—in the eyes of some—of much of the picturesque appeal of the towers, turrets, and corbelled *merlatura* that gave the characteristic broken profile of medieval fortifications.[28] Yet in the transitional stages of the new military architecture, the design of improved parapets and efficient new gun embrasures represented the quickest means of modernizing an earlier generation of fortifications. Antonio's studies from the 1520's include a number of closely specified drawings of new parapets designed, as he put it, "alla Francese." These provided wide external and internal splays giving a generous sideways traverse for the gun, and a gentle angle of depression (muzzle-loaders were not generally fired steeply downward). The constricted opening between

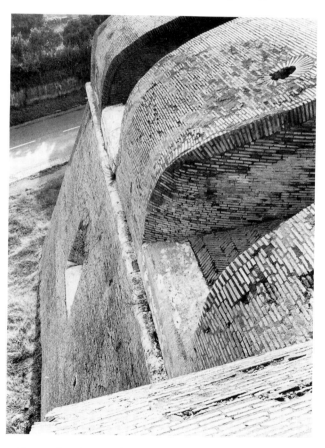

6 Rome, Bastione Ardeatina, detail of embrasures and scarp (photo: Maurizio di Puolo).

7 Rome, Bastione Ardeatina, detail of embrasure and ventilation chimneys (photo: Maurizio di Puolo).

the protective merlons left little room for the penetration of enemy shot, and just enough space in the embrasure to prevent damage from the muzzle blast of the cannon (Fig. 7). The most detailed of these drawings specified modifications to the late-fifteenth-century Venetian fortress at Ravenna, which Antonio the Younger and Sanmicheli surveyed in 1526 (U 884A, 885A v.). Here triple embrasures were to be built into the parapet of the curtain wall, each forward-pointing opening planned in conjunction with two slightly smaller sideways-directed openings. The arrangement provided an unusually wide field of fire from each group of embrasures for a fortress that had been built just before the era of the bastion and lacked proper flanking batteries.

This proposal and others like it demanded sound knowledge of the dimensions and handling qualities of contemporary artillery, and there is no doubt that Antonio sought to keep abreast of developments in gun design and performance. The annotation to U 825A

records his presence at a test firing in Civitavecchia on 10 October 1538; a number of drawings contain detailed and carefully scaled sketches of gun barrels, often shown in section to reveal the different internal profiles of bores and breeches (U 821A, 822A, 825A, 841A, 855A r. and v., 858A). These are among the earliest examples of what was to become a graphic convention for gun illustrations in artillery manuals.

Yet another new—and much less visible—feature of sixteenth-century military architecture was the underground system that had been evolved to meet the threat of explosive mines planted beneath bastions or walls by enemy sappers. A countermine consisted of a communication gallery running inside the walls at ditch-bottom level, from which a number of *pozzi*, or well shafts, dropped into the foundations. Listening posts would be established at the bottom of these *pozzi*, where the sounds of enemy digging could be heard, and from which countermeasures could be launched. At their most dramatic, these countermoves

involved driving a defensive shaft silently to a position in front of the enemy mine, packing the end with gunpowder, and exploding this "depth charge" by fuse to destroy the enemy works. Antonio's drawing of the *pozzi* at the Ardeatine bastion in Rome also shows the dog-leg air-lock security system that protected what otherwise might serve as a silent means of entry should an enemy succeed in digging his way into the countermine (U 1362A). U 801A shows a ring of *pozzi* and galleries apparently inserted beneath an older round tower. The designs for the Farnese fortress at Piacenza illustrate another advanced system for underground defense, with the lighting and ventilation flues shown in one of the most complete sets of detailed drawings in the collection (U 802A, 1392A, 1396A, 1424A).

The effectiveness of Antonio's designs under the test of battle can only be guessed, because most of his greatest schemes were never defended against modern siege trains. Castro fell to treachery in 1641 after suc-cessfully resisting a lengthy siege. Following its capture, the city and its walls were torn down and—like the ruins of Carthage—sown with salt. The deserted site is now marked by a small pylon with the legend "Qui fu Castro." The long resistance of Castro, and its unusually thorough destruction, may well be testimony to the efficacy of the design as well as to the vindictive passions aroused by the Farnese.

Antonio's urban citadels represent success of a different kind. The Fortezza da Basso and the Rocca Paolina helped to set a new, if unwelcome, fashion in repressive construction, which caused the former to be denounced by one outraged republican as a "heel on the throat of Florence's liberty." It mattered not at all that the last Florentine republic and the rebellious Baglioni regime at Perugia had already been firmly suppressed, and that duke and pope each argued that firm government backed by a fortress garrison was the best guarantee of liberty for both of these strife-ridden

8 Perugia, the Rocca Paolina, the Porta Marzia as incorporated into the curtain of the upper fortress.

9 Civita Castellana, Rocca, the interior courtyard (photo: Getty Center Photographic Archive, Max Hutzel Collection).

10 Perugia, Rocca Paolina, the interior corridors (photo: Camerieri and Palombaro).

communes. Here, as elsewhere, the fortress represented oppression. The Rocca Paolina was one of the first targets of the patriots in 1848–49 and again in 1860, when the only Perugian casualties were those struck by falling masonry as the mob tore down the hated symbol of papal domination.

Parts of Antonio's military structures won praise in their own time. The decorated masonry on the gatehouse of the Fortezza da Basso—with its appropriate low-relief cannonball and Medici *palle* motif—was the only military work to be described by Vasari as "fa bellissimo vedere."[29] No doubt Vasari, had he known of it, would have applauded Antonio's effort to preserve the Etruscan Porta Marzia at Perugia and incorporate it into one of the flanks of the Rocca Paolina (Fig. 8). The elegant interior cortile of the fortress at Civita Castellana (which was not, of course, by Antonio) conveys some idea of what the great colonnaded ranges planned for the barracks and stables of the Fortezza da Basso might have been (Fig. 9). As it is, the remains of the Rocca Paolina are his military masterpiece. The cortile and the governor's palace were destroyed in the Risorgimento, and now lie beneath the Municipio and the gardens at the end of Perugia's Corso Vannucci. The hornwork was demolished too. The lower levels of the upper fortress survived their second redevelopment, however, and today form part of a complex of museum and exhibition spaces at the upper end of the escalator that, following closely the line of the corridor to the hornwork, carries visitors up from the bus station and parking decks in the lower town. By walking through these mysterious but magnificent Piranesian spaces one can still grasp something of the awe-inspiring qualities of Antonio da Sangallo the Younger's military buildings, and appreciate the three-dimensional planning skills needed to incorporate the ruins of the Baglioni properties, even the curve of the medieval street on which they stood, into the interior of the fortress (Fig. 10).

NOTES AND REFERENCES

1. Recent works include J.R. Hale, "The Early Development of the Bastion: an Italian Chronology c. 1450–1534," in J.R. Hale, L. Highfield, B. Smalley, eds., *Europe in the Late Middle Ages* (London, 1965), pp. 466–94; Hale, *Renaissance Fortification: Art or Engineering?* (London, 1977); Horst De la Croix, "Military Architecture and the Radial City Plan in Sixteenth-Century Italy," *Art Bulletin* 42 (1960): 263–90; De la Croix, "The Literature of Fortification in Renaissance Italy," *Technology and Culture* 6 (1963): 30–50; Pietro Manzi, *Architetti Ingegneri Militari Italiani dal secolo XVI al secolo XVIII, saggio bibliografico* (Rome, 1976); Simon Pepper and Nicholas Adams, *Firearms and Fortifications: Military Architecture and Siege Warfare in Sixteenth-Century Siena* (Chicago, London, 1986); and, more generally, Franco Cardini, *Quell'antica festa crudele: guerra e cultura della guerra dell'età feudale alla Grande Rivoluzione* (Florence, 1987); Geoffrey Parker, *The Military Revolution: Military Innovation and the Rise of the West, 1550–1800* (Cambridge, London, 1988).

2. For the general development of early artillery, see Charles Ffoulkes, *The Gunfounders of England* (Cambridge, 1937); A.R. Hall, *Ballistics in the Seventeenth Century* (Cambridge, 1952); B.H.St.J. O'Neil, *Castles and Cannon* (Oxford, 1960); Michael Lewis, *Armada Guns: A Comparative Study of English and Spanish Armaments* (London, 1961); J.F. Guilmartin, *Gunpowder and Galleys: Changing Technology and Mediterranean Warfare at Sea in the Sixteenth Century* (London, 1974); B.P. Hughes, *Firepower: Weapons Effectiveness on the Battlefield, 1630–1850* (London, 1974).

3. Roberto Papini, *Francesco di Giorgio Martini, Architetto,* 2 vols. (Florence, 1946); Marco Dezzi Bardeschi, "Le rocche di Francesco di Giorgio nel Ducato di Urbino," *Castellum* 8 (1968): 97–138; Gianni Volpe, *Rocche e fortificazioni del Ducato di Urbino* (Urbino, 1982); Francesco Paolo Fiore, *Città e macchine del '400 nei disegni di Francesco di Giorgio Martini* (Florence, 1978); Fiore, "Francesco di Giorgio e il rivellino 'acuto' di Costacciaro," *Quaderni dell'Istituto di Storia dell'Architettura,* n.s. 1–10 (1987): 197–208; Eric Langeskiöld, *Michele Sanmicheli* (Uppsala, 1938); Camillo Semenzato, "Michele Sanmicheli architetto militare," in *Michele Sanmicheli. Studi raccolti dall'Accademia di Agricoltura scienze e lettere di Verona per la Celebrazione del IV centenario della morte* (Verona, 1960), pp. 75–93; Ignazio Calvi, *L'architettura militare di Leonardo da Vinci* (Milan, 1943); Ludwig H. Heydenreich, Bern Dibner, Ladislao Reti, *Leonardo the Inventor* (London, 1981); Pietro C. Marani, "Leonardo, Fortified Architecture and Its Structural Problems," in Paolo Galluzzi, ed., *Leonardo da Vinci, Engineer and Architect,* catalogue of the exhibition, Montreal Museum of Fine Arts, 22 May–8 November 1987 (Montreal, 1987), pp. 303–16; Marani, *L'architettura fortificata negli studi di Leonardo da Vinci* (Florence, 1984); William Wallace, "'Dal disegno allo spazio': Michelangelo's Drawings for the Fortifications of Florence," *Journal of the Society of Architectural Historians* 46 (1987): 119–34; Renzo Manetti, *Michelangiolo: le fortificazioni per l'assedio di Firenze* (Florence, 1980); Pepper and Adams, *Firearms and Fortifications,* pp. 32–57; Nicholas Adams, "Baldassare Peruzzi and the Siege of Florence: Archival Notes and Undated Drawings," *Art Bulletin* 60 (1978): 475–82; Adams, "Baldassare Peruzzi as Architect to the Republic of Siena, 1527–1535: Archival Notes," *Bullettino senese di storia patria* 88 (1981): 256–67; Adams, "Postille ad alcuni disegni di architettura militare di Baldassarre Peruzzi," in M. Fagiolo and M.L. Madonna, eds., *Baldassarre Peruzzi: pittura, scena e architettura nel Cinquecento* (Rome, 1987), pp. 205–24; Gustave Clausse, *Les San Gallo* (Paris, 1900–1902); Giuseppe Marchini, *Giuliano da Sangallo* (Florence, 1943); Giancarlo Severini, *Architetture militari di Giuliano da Sangallo* (Pisa, 1970); Domenico Taddei, *L'opera di Giuliano da Sangallo nella fortezza di Sansepolcro e l'architettura militare del periodo di transito* (Florence, 1977); Giorgio Carli, *Firenzuola: la fortificazione ad opera di Antonio da Sangallo il Vecchio* (Florence, 1981). Nicholas Adams, "L'architettura militare di Francesco di Giorgio," in *Francesco di Giorgio Architetto,* ed. M. Tafuri and F.P. Fiore (Milan, 1993), pp. 126–63.

4. "[N]e fu mai fra i moderni altro architetto più sicuro ne più accorto in congiugnere mura." Giorgio Vasari, *Le vite de' più eccellenti pittori scultori ed architettori,* ed. G. Milanesi, 9 vols. (Florence, 1878–85), V, p. 459.

5. Francesco De Marchi, *Dell' architettura militare, Libri tre* (Brescia, 1599), Bk. I, chap. XVI, fol. 4 v. In Bk. III, chap. XXXIIII, fol. 78 (in connection with the invention of the double-flanked bastion), De Marchi misnames him as "Maestro Gio: da S. Gallo" but makes up for this when he describes him as "homo famosissimo in tempo di Papa Paolo Terzo."

6. For an overview of Antonio's career, see Francesco Paolo Fiore, "Episodi salienti e fasi dell'architettura militare di Antonio da Sangallo il Giovane," in G. Spagnesi, ed., *Antonio da Sangallo il Giovane: la vita e l'opera*, Atti del 22 Congresso di Storia d'Architettura, 19–22 February, 1986 (Rome, 1986), pp. 331–47. We have also relied on the entry by Arnaldo Bruschi on "Cordini (Cordiani?), Antonio" in *Dizionario biografico degli italiani*, vol. 29 (Rome, 1983), and, of course, on Gustavo Giovannoni, *Antonio da Sangallo il Giovane*, 2 vols. (Rome, 1959).

7. Arnaldo Bruschi, "Bramante, Leonardo, e Francesco di Giorgio a Civitavecchia: La 'città con porto' nel Rinascimento," in *Studi Bramanteschi* (Rome, 1974), pp. 535–65, and Alberto Guglielmotti, *I Bastioni di Antonio da Sangallo disegnati sul terreno per fortificare e ingrandire Civitavecchia l'anno 1515* (Rome, 1860).

8. Carlo Mezzetti and Fausto Pugnaloni, *Dell'architettura militare: l'epoca dei Sangallo e la cittadella di Ancona* (Ancona, n.d.).

9. J.R. Hale, "The End of Florentine Liberty: The Fortezza da Basso," in N. Rubinstein, ed., *Florentine Studies* (London, 1968), pp. 501–32; Mauro Gianneschi and Carla Sodini, "Urbanistica e politica durante il principato di Alessandro de' Medici, 1532–37, "*Storia della Città* 10 (1979): 5–34.

10. De la Croix, "Radial City Plan," for the Roman conferences. See also: C. Quarenghi, *Le mura di Roma* (Rome, 1880); E. Rocchi, *Le piante iconografiche e prospettiche di Roma del secolo XVI* (Rome, Turin, 1902); M. Borgatti, "Il bastione Ardeatina a Roma," *Rivista d'artiglieria e genio* 2 (1916): 207–23; and Simon Pepper, "Planning versus Fortification: Sangallo's Project for the Defence of Rome," *Architectural Review* 159 (1976): 162–69.

11. For labor, see Daniela Lamberini, "La politica del guasto: l'impatto del fronte bastionato sulle preesistenze urbane," in *Architettura militare nell'Europa del XVI secolo*, Atti del Convegno di Studi, Florence, 25–28 November 1986 (Siena, 1988), pp. 219–42; Lamberini, "Le mura e i bastioni di Pistoia: una fortificazione reale del '500," *Pistoia Programma* 7 (1980): 5–30; J.R. Hale, "Francesco Tensini and the fortification of Vicenza," *Studi Veneziani* 10 (1968): 231–89.

12. Not all the personnel involved in this undertaking are known, but Giuliano Leno, Pier Francesco da Viterbo, and Antonio Labacco also worked with them in Parma and Piacenza (Vasari-Milanesi, V, pp. 458–59).

13. Luca Beltrami, *Relazione sullo stato delle Rocche di Romagna, stesa nel 1526 per ordine di Clemente VII da Antonio da Sangallo il giovane e Michele Sanmicheli* (Milan, 1902).

14. Martin Kemp, *Leonardo da Vinci: the Marvellous Works of Nature and Man* (Cambridge, Mass., 1981), pp. 227–34; V.P. Zubov, *Leonardo da Vinci* (Cambridge, Mass., 1968), pp. 24–26.

15. Nicholas Adams, "Baldassarre Peruzzi and a Tour of Inspection in the Valdichiana, 1528–29," *Revue d'Art Canadienne/Canadian Art Review* 5 (1978): 28–36.

16. Niccolò Machiavelli, "Relazione di una visita fatta per fortificare Firenze," in S. Bertelli, ed., *Arte della guerra* (Milan, 1961), pp. 295–302.

17. "Qui non posso terminare se non so dove lalteza / delli 17 palmi si afronta collo zocholo del / baluardo[.] Colmalanno che dio vi dia / Segniateli come stanno in opera le loro / alteze come si afrontano luna collaltra. . ."

18. For example, the appeal from Bernardino Castellario della Barba, Bishop of Casale (papal legate in Perugia), for a decision on earthwork or masonry construction in part of the Rocca Paolina (Archivio di Stato, Parma, Carteggio Farnesiano, Estero 283, 30 October 1540).

19. U 885A, Ravenna, transcription: "take a copy of this drawing and send it back so that a model can be made, as I haven't got a copy." See also Daniela Lamberini, "Funzione di disegni e rilievi delle fortificazione nel Cinquecento," in *L'architettura militare veneta del Cinquecento* (Milan, 1988), pp. 48–61.

20. See very similar if somewhat cruder contemporary drawing in G. Maggi and J. Fusti Castriotto, *Della fortificatione delle città* (Venice, 1564), Bk. II, chap. 26, p. 65. Many of Francesco di Giorgio's drawings are, in effect, axonometrics and must have been produced near the beginnings of this sophisticated explanatory device.

21. Antonio the Younger's background in fine joinery and inlay work would, of course, have superbly equipped him for this craft. Pietro Cataneo, *I Quattro Primi Libri de Architettura* (Venice, 1554), Bk. I, chap. 1, fol. 1, argues at some length for the value of the more sophisticated projection techniques in reducing the time and money spent on models.

22. Doubt has recently been cast on the presumption, following Hale, "Fortezza da Basso," that these plane-table survey roses dated from the preliminary stages of the 1534 project. Antonio the Younger was in Florence in 1531 and also shortly before the siege of 1529–30, working on fortifications on the perimeter. The survey could have been on either of these occasions. See Silvano Salvadori and Francesco Violanti, "Antonio da Sangallo il Giovane: la genesi del progetto della Fortezza da Basso," *Bolletino degli Ingegneri* 19, nos. 8–9 (1971): 26–36; Mario Bencivenni, "La rilevazione del perimetro urbano fiorentino in alcuni disegni di Antonio da Sangallo il Giovane," *Storia Architettura* 5, no. 2 (1982): 25–38.

23. See Hildegard Giess, "Die Stadt Castro und die Pläne von Antonio da Sangallo dem Jüngeren," *Römisches Jahrbuch für Kunstgeschichte* 17 (1978): 47–88, and ibid., 19 (1981): 85–140.

24. De la Croix, "Radial City Plan," pp. 268–71.

25. Hale, "Bastion," p. 466.

26. Pepper and Adams, *Firearms and Fortifications*, p. 4; see also De la Croix, "Radial City Plan," p. 267, who adapts a drawing from Gabriele Busca, *Della architettura militare* (Venice, 1601), chap. 34, p. 126, fig. 3, to make the point that this is not a modern postrationalization.

27. Martini-Maltese, *Trattati*, II, pp. 433–34; Maggi and Castriotto, *Delle fortificatione delle città*, Bk. I, chap. 10, fol. 20; Busca, *L'architettura militare*, p. 187.

28. Simon Pepper, "The Meaning of the Renaissance Fortress," *Architectural Association Quarterly* 5 (1973): 22–27. See also the history of the rebirth of the *merlatura* in the nineteenth-century restoration of Monteriggione in Giovanni Barsacchi, "Profilo urbanistico," in Paolo Cammarosano, ed., *Monteriggioni: Storia, architettura, paesaggio* (Milan, 1983), pp. 103–8.

29. Vasari-Milanesi, I, p. 129.

Castro and Nepi

HILDEGARD GIESS

With his solemn bull "Videlicet immeriti," Pope Paul III (1534–49) created the duchy of Castro on 31 October 1537 and along with Nepi and Ronciglione gave it to his son Pier Luigi (1503–47) as an hereditary fief. In so doing he realized a centuries-old ambition of the Farnese family to realign and expand its territories, elevate its rank, and increase its power. The conferment of the fief included the requirement to care for its defense. The urban planning involved in this work is described by Giorgio Vasari in his life of Antonio da Sangallo the Younger.[1]

Nepi

Situated on a rocky plateau about 40 kilometers north of Rome, the town of Nepi was already a strong fortress in Etruscan times. One of its ancient walls is still visible today. Toward the end of the fifteenth century, an imposing *rocca* was built there, in part under the direction of Antonio the Elder: a ducal palace protected by sloping walls and four round corner towers. It incorporated parts of an earlier polygonal complex and a large round tower (*maschio*). The *rocca* served Pope Alexander VI (1492–1503) as an occasional stopover and his daughter Lucrezia (1480–1519) twice as a residence. By 1537 it had become obsolete as a fortification, but in Antonio's judgment it was still "asai bella" and its residential wing "torna bene per opera e asai comodo" (see U 953A). New fortifications were sketched by Antonio and partially built (see U 954A r., 955A r., 966A r., and 1787A r.). Along with the construction of the new bastions, the *maschio* apparently was made higher so that it could be incorporated into the complex of fortifications. Bartolomeo

Baronino was sent to Nepi from Rome in 1537 "per misurare il chiostro de dicta rocca, per mattonarla e fare una Ci[s]terna."[2] The present ruinous condition of the *rocca* makes it impossible to determine whether, in addition to the paving of the court and the building of a cistern, minor renovations were undertaken on the residential wing under Antonio's direction. An inscription over the portal of the court facade of the palace, about which we know from Gregorovius,[3] documented its occupant: "P. Aloisius Far. Dux Primus Castri."

The new complex of fortifications required the destruction of a small church. In the process, holy relics of martyrs were discovered for which Antonio designed a large new church (see U 551A r., 865A r., 866A r., and 886A r.).

Meanwhile, the town was reshaped[4] and work begun on a new Palazzo del Comune.[5] Its construction, following plans sent from Rome, was under the direction of Giovanni Battista da Sangallo. The new main street was paved with bricks,[6] and private houses clearly showing the influence of the Sangallo workshop were built along it.

In 1545 Nepi reverted to the Papal States. Even though Pier Luigi's sons, Ottavio (1524–85) and Cardinal Alessandro (1520–89), exercised a kind of protectorate over the town and the Farnese continued to use the *rocca* as an occasional residence (Cardinal Ranuccio [1530–65] from December 1545 to April 1546, Orazio Farnese [1526–53] during the Christmas of 1545,[7] and Ottavio Farnese from October to December 1574), they did little to preserve what was there, much less to realize the grand projects proposed by Antonio.

Castro

The duchy of Castro was situated at the northern edge of the Papal States, between Lago di Bolsena and the sea. A large number of its castles were old family properties on which, documents show, Antonio had already worked (rebuilding of Capodimonte, S. Egidio di Celere, Gradoli, Caprarola, and Isola Bisentina). In 1537 Antonio made one or more trips to the area in order to plan his many new projects. We may assume that only a small number of the drawings made for that purpose have survived. For the *rocca* of Montalto, situated near the sea, we have only a single sheet (U 730A r.), which served primarily, like that for Nepi (U 935A r.), as an initial survey. Gradoli needed new reinforcing walls (U 189A v.). But the old country town of Castro, which had given its name to the duchy, was to be redesigned and adorned with new buildings so that it could assume the function of a ducal residence.

Contemporary accounts indicate that the existing buildings were in deplorable condition. The reign of Pier Luigi thus gave rise to a lively activity. Antonio improved the appearance of the town by ordering its streets and constructing a piazza. He designed projects for the defense of the town and palaces for the duke, the *comune*, and private individuals. As in Nepi, a large church with a cloister was planned. But little of this was constructed or completed. In 1545 Pier Luigi was made Duke of Parma and Piacenza. With that, his interest, and that of his courtiers, in the building of Castro dwindled. Nor did his sons, Orazio and later Ottavio, who took up the succession, make any further significant investments there; in the town, which was afflicted by malaria, construction ceased altogether.

A plan of the town dated 14 October 1644 thus provides a good picture of its appearance in the second half of the sixteenth century. It was drawn up by a military architect, Capitano Soldati, who was given the task of refortifying Castro.[8] Although the war between the pope and the Farnese duke, which lasted several years, was brought to an end through the intervention of international powers, and the town was returned to the duke after its fortifications were demolished on 18 July 1644, hostilities soon threatened to break out again. In fact, five years later, after papal troops recaptured Castro, its inhabitants were expelled and the town was razed. Capitano Soldati's plan shows the topography of Castro and its surroundings with admirable precision (Fig. 1). We see a rocky peninsula, viewed from the northeast, of which an area averaging 300 meters in width and about 650 meters in length is taken up by the town proper. To the south and west we see the boundary line formed by the Olpita stream and, in the foreground, steep slopes falling away to the ditch created by the Filonica brook, whose course is not indicated. Two phases of settlement are clearly distinguishable in the town. First, there is an irregularly developed older core composed of compound blocks of houses with outer staircases. The layout of streets and the allocation of space in this core appear to have been determined not only by the unevenness of the terrain, which varies in height by as much as 60 meters, but also by the arbitrariness of the developers. Second, there are rectangular plots of ground separated by side streets, which indicates a reorganization of the housing blocks and arteries of transportation traceable to Antonio's town planning.

From time immemorial, Castro had had two main entrances, whose design and defense now became Antonio's concern. The Porta di sopra was located at the land bridge on which most of the roads of the Papal States and of Tuscany converged and where the town, deprived here of its natural defenses by the steep slope, needed special fortification. Soldati drew in a large pincer formation. Its earthworks had probably just been built, and construction of its masonry had already begun on the front corner of the left bastion. Behind it we see the old town wall with a portal at approximately its center and two round towers at the left. The wall is depicted very schematically, but recognizably, in Antonio's drawings and serves him as a topographical point of reference (U 751A r., 752A r. and v., 753A r., 754A r., 813A r., and 945A r.). Behind the wall, the 1644 plan shows the walls and trenches of a fortification complex. They probably date from after the middle of the sixteenth century and have no connection with Antonio's designs. As in Nepi, Antonio offers two solutions for the problems presented by the defense of Castro: a broadly extended complex (U 945A r.), whose further development is not documented, and a large pincer formation not unlike that of 1644 (U 813A r.). The design of the pincer formation begins a series of projects that take this motif in ever new variations (U 752A r. and v., 751A r.). Sketches that focus on a central bastion (U 751A r. and 813A v.) eventually lead to a design for the *puntone* (U 295A r.), which is accompanied by a calculation of costs. This *puntone* reappears on the sheet of measurements for the entire complex of the town's fortifications (U 294A r.); Antonio probably presented U 295A to his client as his final proposal.

In 1541 and 1542, Duke Pier Luigi sought out specialists to advise him on fortifying Castro. This must

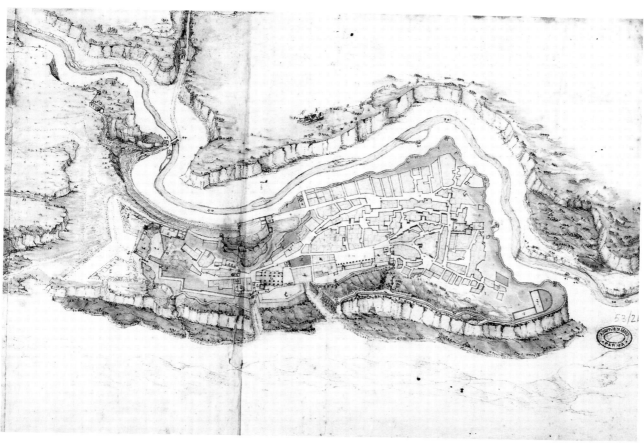

1 Castro, town plan by Capitano Soldati, dated 14 October 1644 (ASP, Mappi e Disegni, vol. 53, no. 25).

have caused interruptions in Antonio's work on the project. In contrast to Nepi, none of his designs for Castro was realized.

The second entrance to the town, which opened on the road to Rome, was located at the steep slope above the Olpita. Here, recesses and projections of the terrain offered advantages. Soldati's ground plan shows clearly the double-gated complex, the Porta di sotto, or Porta Lamberta, which, despite having already been vaulted in 1545,[9] was still under construction in 1556. Antonio's grand design (U 750A r.) probably served as a model for it, but it was changed in execution, especially in its architectural decoration. A third portal, the Porta Santa Maria, was located near the center of the short west side of the town. Antonio proposed defending it with a bastion (U 294A r.). It was walled up in the 1560's and is therefore indicated only cursorily by Soldati (some masonry within a small arch). A small "porta forella" must have been located at the northern edge of town, approximately to the right of the large bastion in the plan of 1644.[10]

It is mentioned on U 745A r., 746A r., and 747A r., but it remains an open question whether in 1537 the gate had not long since been walled up, its name serving in these drawings merely to identify the street. In Soldati's plan the most important public buildings and complexes are numbered. Even though no accompanying register has been found, other sources permit exact identifications. No. 4 shows the direction of the main street, which runs from the Porta Lamberta along the regulated plots, takes first a right and then an acute-angled turn, and after widening to an open, more or less trapezoidal area (the Piazza del Capitone) bypasses shapeless blocks of buildings and ends in a rectangular square. This last is the new town center, which is connected to a second center, that of the cathedral, by means of newly straightened streets.

Antonio created the brick-paved Piazza Maggiore, which measures 22 by ca. 66 meters, by tearing down approximately two rows of houses[11] to enlarge an already existing free space and smoothing the ground. Attaining these proportions (1:3) meant contending

with difficult terrain on parts of the long sides of the piazza. The short west side was already occupied by the "Palazzo del Podestà" and the "Macello" (see U 297A r., *a*, and 732A r.). The facade of the Zecca was erected on the opposite side, just in front of a number of preexisting houses (see U 189A r. and 297A r., *g*). The house of Scaramuccia next to it was rusticated (see U 299A r.); an arcade with thirteen arches and connecting shops was to border the long north side of the square. The use of the space behind the shops was initially in dispute. Antonio first planned a large, seven-bayed palace with a double staircase (U 297A). When the ground plan for the loggias was finally decided upon (U 732A), however, he asked the duke whether the adjoining land should be used for guest houses ("case delle osterie"), private houses, or something else ("altra resolutione particulare"). Did Pier Luigi intend for a time to erect a *rocca* (on another site)? The sketches on U 733A may be evidence of this. Subsequent plans of the piazza (U 299A r. and 742A r.) provide for the construction of two palaces. One has seven bays and follows the ground plan of U 297A. Transformed and enlarged in conformity to the duke's wishes, it was to be a complex worthy of his rank; Antonio (still?) calls it the Osteria. By order of the duke, it is adjoined by a five-bayed palace (for Capitano Meo), which, by filling the available space, guarantees a regular configuration on the north side of the piazza. Because of the steep terrain, this plan would have required expensive substructures and the construction of a new access street by the cliff (see U 297A r., 299A r., 732A r., 742A r., and 750A v.). Soldati's plan shows the completed loggias and shops, as well as the entrances to the palaces, which were not built. The long south side was to be occupied by existing, modernized, and new buildings (see U 743A r., *a* and *b*). Here, two side streets interrupt the line of facades.

Commissions from courtiers and citizens now competed with those of the duke (see U 743A r., 744A r., 745A r., 746A r., 747A r., 748A r., and 749A r.). Most of the names found in Antonio's drawings appear frequently in Farnese correspondence. Alessandro Tomassini of Terni, "Capitano alexandro dalternj" (see U 743A r., *g*), was a comrade-in-arms of Pier Luigi whose expertise was called upon in all important matters of fortification (Rome, Nepi, Castro, and Civita Castellana).[12] He was later to accompany his lord to Piacenza. In order to tie Tomassini even more closely to him, Pier Luigi induced him in 1547 to transfer his holdings in Terni and Perugia to his son, and compensated the captain with papal gifts in the new duchy.[13] Sforza Monaldleschi della Cervara, "lo signor

sforza," also served in the military under Pier Luigi and would remain a member of the Farnese court. In 1553 he returned to Castro as adviser to the duke's widow, Gerolima, the governor of Castro, though he resided in Capodimonte.[14] Cavaliere Sebastiano Gandolfo, "messer bastiano," whose family came from the neighboring Ischia di Castro (which accounts for Antonio the Younger's familiar designation), followed a different course. He appears rather to have played the role of secretary at the Farnese court. In 1541 he was at the Vatican copying papal bulls pertaining to Pier Luigi. A letter of June 1543 written by Annibale Caro describes him as Amphitryon in Ischia. In February 1548 Alessandro Manzuoli reported to Pier Luigi from Nepi, where he was staying at the court of the newly installed Cardinal Ranuccio, that he had had a conversation with Cavaliere Gandolfo, to whom he had extolled the merits of a highly talented young architect (Vignola!).[15] Gandolfo, too, followed his lord to Piacenza.[16]

Another courtier, Cavaliere Antonio Maria de Cassis da Sassolo, "Cavaliere Saxuolo" (U 743A r., *a* and *b*), already had connections with the region of Castro at an earlier date through marriage in Canino.[17] In the fall of 1545 he transferred the ducal stud farm to Piacenza,[18] without, however, completely cutting his ties to Canino. Among his numerous debts, which his wife listed in a letter written to Piacenza, were 97 *scudi* "per la casa di Castro."[19] "Messer mattia [Gherardi] delle poste per la citta die Castro et gradoli Istia et Montalto" (see U 748A r. and v. and 743A r., *d*) was entrusted by the Farnese with the handling of their mail. His duties increased with theirs. He not only shuttled between Rome, Castro, and Piacenza but was sent in December 1546 to Ottavio Farnese, who was then commanding the Italian troops in the army of the emperor.[20] His familiarity with the papal court permitted him to invite Paul III to his estate in Borghetto (the Lake of Bolsena) on the occasion of a journey through the duchy of Castro planned by the latter for May 1547.[21] Unlike the other courtiers, he was apparently on solid financial footing, which made it possible for him to construct his house in Castro quickly.[22] Only "messer agniolo de Castro" (see U 745A r., 746A r., and 747A r.) belonged to an old established Castro family, the name of which was given a certain notoriety in the second half of the sixteenth century by the notary Dominicus Angelus. An Angelus Camerarius appears in 1545 in the listings of the Castro town council.

Was a new Palazzo del Comune planned for Castro as it was for Nepi? There is no evidence for this.

The old building was located opposite the Palazzo del Podestà (see U 297A r., *a*), at the point where the main street led into the newly created piazza. It must already have been dilapidated in 1537, because extensive restorations of the facade and interior, continuing with interruptions from 1543 until 1571, are mentioned in the municipal records.[23] It was nevertheless decided in 1587 to construct a new building. It would be surprising if this had not already been contemplated during the first euphoric building campaign of 1537. I would venture to identify a project for a palace facade, which has always been associated with Castro because of its formal similarity to the Osteria, as a model for a Palazzo del Comune (see U 1684A). When Gardner-McTaggart was taking measurements of the ruins of Castro, he came upon "the substructures of a large building, which appears never to have been completed" and which can be dated on the basis of its masonry to the sixteenth century.[24] It is located on the Piazza del Capitone, which before 1537 was the main square of Castro. Gardner-McTaggart has kindly informed me that the masonry is exposed only in places; the outlines of the foundations are otherwise marked by mounds of earth and rubble that eventually disappear into the ground. The visible substructures are divided by means of 0.75-meter-thick walls into five approximately equal sections, 5.40 meters in width. The overall measurement (not taking into consideration the greater thickness of the outer walls) is 31.5 meters. This would correspond in length to the facade of U 1684A. No definite statement can be made, however, without further excavation. Moreover, the visible masonry is not executed with the vaulting technique used by the Sangallo workshop for the Osteria; it may, instead, have been constructed by a local workshop. The foundations of the church of San Francesco, for example, were begun under the direction of a local builder, Fra Leone, who was paid a monthly fee of 1 *scudo* by the duke.[25] The utilization of these foundations was afterward to present a considerable problem for Antonio (see U 737A r., 739A v., and 740A r.). In Nepi, only the lower story of the Palazzo del Comune was completed in the sixteenth century. In Castro, did it get only as far as the foundations?

Soldati's plan shows, on the projecting terrain in the northwest, an L-shaped ground plan with a circular segment. This marks the spot where construction of the church and cloister of San Francesco was begun. The Porta di sopra planned by Antonio required the demolition of a small Franciscan church. Antonio worked on the design of a magnificent new structure on U 736A r., 737A r., 738A r., 739A r. and v.,

740A r., and 811A v. Above the steep slope, a path leads around the new cloister and the entire area of the town. In times of war, it probably served a military function. Because of this path, a distance of 30 *palmi* (ca. 6.70 m) was needed between buildings, a necessity with which Antonio had to cope in designing San Francesco. His first sketch for the project is found on the back of sheet U 811A, showing, in addition, designs for the fortifications of the nearby Orsini residence of Pitigliano, and a cursory ground plan surveying the cloister of San Francesco in that town. Antonio probably had no special interest in the simple building, the ruins of which are today the home of a farmer. We can assume that his survey was made at the request of Duke Pier Luigi, for whom the construction of the Pitigliano cloister and church served as a kind of legal precedent. In 1493, after a visit by Pope Alexander VI, Count Nicola III Orsini had received permission to destroy a small Franciscan cloister, which was preventing the extension of his fortress, and to rebuild it on another spot. This rebuilding of the church and cloister must have occurred soon afterward, even though the exact date is not known. According to a now lost inscription in the choir, in 1522 Ludovico Orsini (Pier Luigi's father-in-law) had the church restored and decorated at his own expense.[26] The year 1522 is accepted in modern literature as the date of the founding of the church and cloister. For stylistic reasons alone this date must be rejected as must also the occasional ascription of the buildings to Antonio. The small cloister of San Francesco might have satisfied an Orsini of Pitigliano as an endowment, but Pier Luigi, the son of a pope, had greater ambitions for the buildings of his duchy. The inscriptions on Antonio's drawings bear witness to discussion between client and architect (U 732A r., 742A r., and 739A v.), and they show as well that the requests of the former were consistently for an increase in size and splendor. The plans traveled back and forth between Antonio, the duke's representative, and the builders in Castro; Aristotile da Sangallo spent several months there,[27] and Battista, too, traveled from Nepi to Castro.[28] Nevertheless, Antonio's main focus and creative activity, and the efforts of his workshop, were not centered there but on the buildings in Rome. Political circumstances resulted first in a cessation of construction, then in the destruction of Antonio's work. A Castro legend came into being, based on Antonio's drawings preserved in the Uffizi, that it represented an ideal Renaissance town. Castro lacked the requisite topographical and sociological conditions for this; yet the activity of the Sangallo workshop

there may well have created models and set a new standard for architecture and architectural sculpture capable of profiting the entire region. The town of Castro, destroyed by the armies of the pope in 1649, was never resettled.

Privately funded excavations in the 1960's uncovered parts of the town, including about a third of the piazza. For about two years measurements were taken, architectural decorations were studied, and reconstruction drawings were made. In the 1970's H.B. Gardner-McTaggart took very thorough measurements of the entire Castro settlement. Today little remains of what was then visible; some architectural sculptures fortunately were transferred to the museum of Ischia di Castro. Others, despite their weight, fell victim to the "souvenir hunters" of the region. Nature, too, is taking back with new growth what had been torn from her. A lone group of youthful Castro fans has placed on the rocks by the road ascending to the town an inscription which, according to legend, in the seventeenth century marked the place where the town of Castro stood before its destruction: "Qui fu Castro."

NOTES

1. Giorgio Vasari, *Le vite de' più eccellenti pittori scultori ed architettori*, ed G. Milanesi, 9 vols. (Florence, 1878–85), V, pp. 436, 465.

2. ASR, Soldatesche e Galere, vol. 86, Fabriche delle fortezze e munitione 1537, fol. 43 r.

3. F. Gregorovius, *Lucrezia Borgia* (Stuttgart, 1874), p. 134.

4. Vasari-Milanesi, V, p. 465.

5. R. Fagioli, *Documenti sulla Costruzione del Palazzo Comunale di Nepi, Lunario Romano XIX, Palazzi Municipali del Lazio* (Rome, 1984), pp. 41–59.

6. On the building activity in Nepi, see the letters written by Governatore Pietro Paolo Mostij to Cardinal Alessandro Farnese on 23 September 1545 and 4 October 1545 (ASP, Casa e Corte Farnesiane, ser. II, Carteggio Estero, busta 163, Nepi).

7. Letters from Cardinal Alessandro Farnese to Duke Pier Luigi, 24 December 1545 (ASP, Casa e Corte Farnesiane, ser. II, busta 11, fasc. 4) and the governor of Nepi to Pier Luigi, 27 April 1546 (ASP, Casa e Corte Farnesiane, ser. II, Carteggio Estero, busta 163, Nepi).

8. Archivio di Stato, Parma, Mappe e Disegni, vol. 53, no. 24.

9. Letter from the auditor Lucio Monaldini of Castro to Pier Luigi, 10 June 1545 (ASP, Casa e Corte Farnesiane, ser. II, busta 10, fasc. 1).

10. On the location of the "porta forella," see H.B. Gardner-McTaggart, "Castro. Eine Orswünstung in Tuscanien," *B.A.R. International*, Ser. 262 (1985): 63–64.

11. Gardner-McTaggart, p. 115.

12. Cardinal Alessandro Farnese's credentials for Capitano Alessandro da Terni, 28 December 1547, and a letter from the castellan of Nepi to Cardinal Farnese, 29 December 1547 (ASP, Casa e Corte Farnesiane, ser. II, Carteggio Estero, busta 163, Nepi).

13. Letter written in Rome by Fabio Coppellato to Pier Luigi, 23 April 1547 (ASP, Casa e Corte Farnesiane, ser. II, busta 15, fasc. 6).

14. On the private clients, see also H. Giess, "Die Stadt Castro und die Pläne von Antonio da Sangallo dem Jüngeren," *Römisches Jahrbuch für Kunstgeschichte* 19 (1981): 110–17.

15. A. Ronchini, "I due Vignola," *Atti e Memorie della RR. Deputazioni di Storia Patria per le Provincie Modenesi e Parmensi* 3 (1865): 362.

16. Letter from Ottavio Farnese to Pier Luigi in Piacenza, 17 April 1546. In it he asks his father to send Cavaliere Gandolfo to Rome to settle various financial matters, including the arrangement of a dowry for Madonna Claudia (his daughter?) (ASP, Casa e Corte Farnesiane, ser. II, busta 12, fasc. 5).

17. F.T. Fagliari Zeni Buchicchio, "Contributo all'attività di Antonio da Sangallo il Giovane a Civitavecchia, Gradoli e Castro," in G. Spagnesi, ed., *Antonio da Sangallo il Giovane: la vita e l'opera*, Atti del 22 Congresso di Storia dell'Architettura (Rome, 1986), p. 257.

18. Letter from Orazio Farnese to Pier Luigi, 30 September 1545 (ASP, Casa e Corte Farnesiane, ser. II, busta 10, fasc. 5).

19. 2 March 1546 (ASP, Casa e Corte Farnesiane, ser. II, busta 12, fasc. 4).

20. Letter written in Rome by Fabio Copellato to Pier Luigi in Piacenza, 15 December 1546 (ASP, Casa e Corte Farnesiane, ser. II, busta 14, fasc. 5).

21. Letter from Bernardino della Croce (secretary of Paul III) to Pier Luigi, 25 April 1547 (ASP, Casa e Corte Farnesiane, ser. II, busta 16, fasc. 1).

22. Fagliari Zeni Buchicchio, pp. 252, 253.

23. Gardner-McTaggart, pp. 121–25.

24. Ibid., p. 138.

25. Letter from the auditor Lucio Monaldini of Castro to Pier Luigi, 10 June 1545, requesting a different assignment of the fee previously paid to Fra Leone (ASP, Casa e Corte Farnesiane, ser. II, busta 10, fasc. 1).

26. Casimiro da Roma, *Memorie istoriche delle chiese e conventi dei frati minori della Provincia di Roma* (Rome, 1764), pp. 261–64.

27. Vasari-Milanesi, VI, p. 446.

28. Fagioli, *Documenti sulla Costruzione del Palazzo Comunale di Nepi*, pp. 49, 50.

Drawings of Machines, Instruments, and Tools

GUSTINA SCAGLIA

The sources of many of the drawings of machines, instruments, and tools by Antonio da Sangallo the Younger and by members of his circle have been traced to specific manuscripts or treatises by Mariano Taccola, Francesco di Giorgio [Martini], and an anonymous artist known as the Anonimo Ingegnere Senese. This essay concerns the dating and the identification of the persons responsible for drawings on the sheets that are included in this volume.

The identity of the person responsible for the drawings on each sheet is often questionable. Drawings of machines and instruments that are done with a strict line for frames and curved lines for the parts, sometimes with help of a straightedge and a compass, yield relatively little artistic personality. It is difficult to assess an artist's style when a drawing lacks figures of men or animals as engine operators. Another impediment occurs when the graphic elements are minimal—for example, penstroke shading of components, or wave lines to illustrate water gushing from a tube.

All copyists, including Antonio the Younger and members of his circle, as well as the Anonimo Ingegnere Senese who worked ca. 1470–80, accurately reproduced mechanical components and never changed the viewpoint of the mechanisms. Copyists merely straightened lines in their own way, sometimes misconnecting the components and their positions in space. This copywork leads to special difficulties. For example, Antonio the Younger's copies could have had as their source one or the other manuscript, and possibly both. In addition, Antonio copied twice from his sources and used different pen techniques for each set.

Written inscriptions on the drawings are rare. The calligraphies of only a few artists have been securely identified, notably those of Antonio the Younger (1484–1546), Giovanni Battista da Sangallo (1496–1548), Francesco da Sangallo (1494–1576), Giuliano da Sangallo (1445–1516), and Antonio dell'Abaco (Labacco).[1] The calligraphies of Giovan Francesco da Sangallo (1484–1530) and Aristotile da Sangallo (1481–1551) have also been identified.[2] Furthermore, the history of the attributions is puzzling. Of those sheets attributed by P. Nerino Ferri in his catalogue of the Uffizi drawings (1885), only a few have seriously been reconsidered as a result of opinions formulated when the drawings were exhibited.[3] Ferri, too, is far from infallible. While those drawings of engines after Taccola or Francesco di Giorgio with an inscription in Antonio the Younger's hand are identifiable as his, Ferri assumed that even those without his inscription were autograph as well. On close comparison, these may now be distinguished. Many sheets once attributed to Antonio the Younger are in fact by a series of anonymous hands, the Anonymi, who are a separate group of copyists from the one known as the Anonimo Ingegnere Senese, and they are so listed as copyists in the Appendix to this essay.

Antonio the Younger, the Anonymi, and the Anonimo Ingegnere Senese

In order to understand the nature of copywork and to lay out the nature of some of the confusion that has crept into the question of attribution, let us examine drawings by two of the Anonymi and by the Anonimo Ingegnere Senese. Sheets of drawings seem to have

circulated easily within several workshops. Thus, the Anonymus called Copyist 6 in the Appendix was responsible for a group of drawings on eight folio sides (now numbers U 4047A r., 4054A r., 4057A r., 4061A r.), which Antonio the Younger seems to have had at his disposal, since he wrote a note on U 4057A r. Note that a foliation "A/1" on one of the folios annotated by Antonio the Younger (U 4052A v.) has a follow-up "B/v." on Copyist 6's folio (U 4057A r.) and both sheets are the same size. In another example, a comparison of the way Antonio the Younger illustrated water flowing under boats (U 818A r.) might lead one to connect his work with that of Copyist 12 (U 4079A r., 4080A r., 4081A r. and v.). The pen technique appears to be identical. But on close inspection the hands may be distinguished. For these and many other drawings, Antonio the Younger and Copyist 12 seem to have employed the identical source, the copybook of the Anonimo Ingegnere Senese (Ms Additional 34113, British Library, London).[4] This copybook of the 1470's reproduced Taccola's Notebook drawings executed in between the 1420's and 1453 (*De ingeneis, Books I and II and Addenda*, Ms CLM 197, part II, Bayerisches Staatsbibliothek, Munich), which remained in Siena until the 1530's.[5]

Antonio the Younger's copywork is important evidence for the transmission of technical knowledge that had been illustrated since ca. 1420. In addition, his original sketches and drawings of mills and canals that he had actually seen or built and noted the locations of can be dated by the documents of his travels to various places. I believe the drawings of machines reflect his work as a builder and millwright. His drawings also include copies after Francesco di Giorgio's (1439–1501) drawings of gristmills, pulverizers, pumps, bale-lifters, and hoists, some of which Francesco di Giorgio had copied from Taccola's manuscripts. Antonio the Younger's copies after Taccola, which are based on the copybook of the Anonimo Ingegnere Senese that Antonio had seen and utilized, include the field of military engineering. These copies include marine devices and battlefield structures such as mobile towers, fire-launching wagons, and scaling ladders. Antonio's own invention in military engineering is limited to drawings of cannon. In civil engineering, Antonio's copied drawings generally are borrowed from Francesco di Giorgio's drawings of hoists, mills, obelisk movers, column lifts, and mechanical drills, which were illustrated in Francesco's two treatises (*Trattato I:* Codex 148 Saluzzo, Biblioteca Reale, Turin; Codex Ashburnham 361, Biblioteca Medicea Laurenziana, Florence; and *Trattato II:* Codex Magliabechiano II.1.141, Biblioteca Nazionale, Florence).[6] However, Francesco di Giorgio had selected these mechanisms from his previous manuscript, ca. 1475, *Opusculum de architectura* (Ms Lat. 197 b 21, British Museum, London),[7] and first described how the mechanisms work in *Trattato I,* ca. 1480.

Francesco di Giorgio's drawings of obelisk movers and column lifts generally comprise the combination of a screw, a toothed gear, and a rack, a device absent from Taccola's series of machines in his Notebook before 1453. This screw-gear-rack device evolved sometime after 1453 and before ca. 1475, when Francesco di Giorgio first illustrated it in his *Opusculum de architectura*. About the screw-gear-rack device, Antonio the Younger often comments that it would move slowly, but he nevertheless persisted in copying the mechanisms. These had seized the imagination of artists since Francesco di Giorgio represented them, but for reasons that we cannot explain Antonio the Younger drafted many of them as well as Taccola's machines, showing the most ancient cogwheel-lantern gears, rope pulleys, winches and capstans, and treadwheels operated by men or animals. In military engineering, Antonio and the Anonymi repeatedly copied even Taccola's imaginative illustrations of scaling ladders and the like, which were not employed on the battlefield in the fifteenth and sixteenth centuries.

Antonio the Younger, Giuliano da Sangallo, and Giuliano's Trip to Siena

It has been possible to learn something about the sources of Antonio's drawings. On twenty-two folio sides, Antonio's drawings are copies of Taccola's machines, taken not directly from Taccola's Notebook, which remained in Siena until ca. 1530, but from the copybook of the Anonimo Ingegnere Senese (Ms Additional 34113), which is an almost complete set of drawings after Taccola's Notebook. The Anonimo was Sienese, and his copybook remained in Siena probably until the mid-sixteenth century when it was in Florence, according to notes on some sheets added to the Anonimo's copybook bearing dates of 1562 and later for projects in Florence and Pisa.[8] We do not know who brought the Anonimo's copybook to Florence. Did Antonio the Younger utilize the Anonimo's copybook in Siena? There is only some circumstantial evidence, no documentary evidence, that Antonio the Younger ever went to Siena. It is possible that he utilized drawings that one of his relatives, Giuliano da Sangallo, had executed in Siena.

Giuliano da Sangallo certainly went to Siena, ca. 1500, since he illustrated the Piccolomini altar in the

Duomo of Siena without any of Michelangelo's four statuettes of Saints Peter, Paul, Pius, and Gregorius (*Taccuino:* Codex S.IV.8, fol. 20 r., Biblioteca Comunale, Siena).[9] Fifteen figures were contracted for in 1501 and the contract was ratified in 1504 when four statuettes were completed. Michelangelo had probably gone to Siena (1501) to measure the niches where his statuettes were to be fitted; it is not known when they were delivered. When Giuliano da Sangallo was in Siena and drafted a view of the Piccolomini altar *in situ,* he also worked with the copybook of the Anonimo Ingegnere Senese in someone's workshop or else in the workshop of the Anonimo himself. Giuliano derived from the copybook (fol. 158 v.) a gear-rack-screw and crank mechanism, also called a cranequin, not illustrated in other copybooks. Giovan Francesco da Sangallo copied a stone-block hauler (U 3951A r.) from Giuliano's *Taccuino* sometime before 1530. By his own statement, Antonio the Younger noted that he copied certain drawings from the "Libretto di Giuliano" (U 1665A r.), which he may have done before or after Giuliano's death in 1514 or earlier, ca. 1500. According to other data, Antonio's copywork may have continued into the 1520's. Obelisk haulers and column lifts illustrated in Giuliano da Sangallo's *Libro* (Codex Barberini lat. 4424, Biblioteca Apostolica Vaticana),[10] which are the ones first represented by Francesco di Giorgio, seem to have been reproduced by Giuliano from the copybook of the Anonimo Ingegnere Senese (Ms Additional 34113).

Thus Giuliano da Sangallo's copies of the Sienese material on machines—obelisk movers and column lifts—before 1514 are graphic evidence that these had entered the repertory of Florentine artists' copybooks by that year. A note that may be considered with regard to a possible visit to Siena by Antonio the Younger is one about differences in grain measures between those of Siena and Florence (U 1486A r.), which he might have learned without going there and recorded casually. When this note and Giuliano's copies of Francesco di Giorgio's obelisk movers and column lifts are weighed in the balance with Antonio the Younger's copied drawings of other Sienese machine drawings from Francesco di Giorgio's *Trattato II,* ca. 1500, there is a good possibility that Antonio and Giuliano were together in Siena sometime before 1504. The chronology of Antonio's work after he went to Rome (ca. 1507) does not allow for any travel to Siena. Nor does the style of Antonio's machine drawings offer a clue for dating them.

The occasion for Antonio's and/or Giuliano's trip to Siena may have been when Michelangelo's stat-uettes were delivered. Since it is not known exactly when the statuettes were installed, the dating ca. 1504 may be too early for Antonio the Younger's copies of Francesco di Giorgio's machine drawings in *Trattato II* and for Antonio's copies after the copybook of the Anonimo Ingegnere Senese. Other circumstantial evidence to be presented later in this essay may bring the date to the 1520's.

Antonio the Younger, the Anonimo Ingegnere Senese, and Francesco di Giorgio's Trattato II

Antonio the Younger copied the Anonimo Ingegnere Senese's large-size copies of Taccola's small sketches of military devices. On twenty-two folio sides, Antonio the Younger's drawings, copied from the Anonimo's copies of Taccola's drawings and from Francesco di Giorgio's *Trattato II,* are in two styles, although the paper of both has the same watermark. I cannot explain why Antonio's drawing styles are different for the assorted material he executed at approximately the same time, and especially those drawings he copied from a single copybook by the Anonimo Ingegnere Senese. Antonio composed these drawings in two of several sketchbooks, and he sometimes copied twice the same engine drawings from the Anonimo's copybook and others after Francesco di Giorgio's *Trattato II.* Of Antonio's two styles or pen techniques, the one characterized by penstroke shading may have been his first style, if we consider that his careful copywork of an engine and all of its parts and, sometimes, his transcription of Francesco's notes preceded his work in free penline technique.

Examples of Antonio's very free penline style include U 848A r., marine and battlefield devices; 1443A r. and v., column lifts, obelisk hauler; 1451A r. and v., drills, mobile towers; 1452A r. and v., mobile towers, shelter with sickles, soldiers, battle equipment, cannon, and equestrian soldier; 1471A r. and v., mills; 3976A r. and v., underwater weapons, pincers, rider on an ox; 4059A r. and v., climbing pole, grappling hooks, clubs, sling, and a shield as arrow-quiver; and 4078A r., obelisk hauler, hoists, crane.

Antonio the Younger's other style of machine drawing is penstroke shading, and the watermark is consistent on the rare occasions when it is preserved. The sheets include U 818A r., ship-sinking devices; 1432A r., ship-sinking; 1438A r., treadwheel ship; 1440A r. and v., rope hoist, bale-lifter, and water scoop; 1450A r. and v., gear car, bale-lifter, ship-sinking device, pile drivers, ferry crane; 1476A r., ship-sinking; 1481A r. and v., ships with cannon, trebuchets; 1482A r. and v., hoists; 1483A r. and v.,

hoists; 4060A r. and v., ship-sinking; 4064A r. and v., scaling ladders; and 4065A r. and v., scaling ladders.

Considering what has been written above, that Antonio's graphic source was the Anonimo Ingegnere Senese's copybook, a few more of Antonio's drawings are proof of that statement. He followed the Anonimo's compositions exactly for sets of pincers (U 3976A r.), for clubs and shield as arrow-quiver (U 4059A v.), and for grappling hooks (U 4059A r.). A treadwheel ship (U 1438A r.) is not among Taccola's Notebook sketches, but the Anonimo had developed one (fol. 116 r.) for his own copybook like that illustrated by Antonio the Younger. Inspired by Taccola's examples while copying them, the Anonimo conceived a new ship-sinking device, and Antonio the Younger copied it (U 4060A v.). Drawings of hand positions for releasing arrows (U 1470A r.) may have been suggested to Antonio by the Anonimo's copy (fol. 90 v.) of Taccola's hand position for balancing a pot on a stick. A soldier's shelter with sickles on its sides that Antonio illustrated (U 1452A r.) is not now in Taccola's Notebook, but the Anonimo illustrated one (fol. 131 r.) that Antonio copied. A car with a pair of gears (U 1450A r.) is Antonio's finished drawing of the Anonimo's sketch in his copybook (fol. 154 v.). One folio (157 v.) of the Anonimo's copybook on which he had sketched drills from Francesco di Giorgio's *Trattato I* furnished Antonio the Younger with those drills and a variety of military devices that Antonio arranged on one folio (U 1451A r.). These drills are in addition to the military devices that the Anonimo copied from Taccola's Notebook, and the Anonimo reproduced them on various sheets of his copybook. Evidently, Antonio drafted on one sheet what he had selected from various sheets by leafing through the Anonimo's copybook.

Fifteen folio sides of the drawings copied by Antonio the Younger were derived from a supplementary chapter of Francesco di Giorgio's illustrated and unique version of *Trattato II* (Codex Maglibechiano II.1.141). Antonio's drawings of these machines from Francesco's supplementary chapter are again in two styles. Penstroke shading for drawings and an exact transcription of Francesco's texts are characteristics of one set of Antonio's folios (U 1482A r. and v., 1483A r. and v., hoists). Free penline is Antonio's second style, again with a consistent watermark (U 1443A r. and v., column lifts, pump, obelisk hauler; 1471A r. and v., mills, pump, windmill; 4078A r., hoists, crane, and obelisk hauler). Antonio numbered these machines from 1 to 7 (U 4078A r.), 9 to 14 (U 1443A r. and v.), 15 to 18, 27, 28 for fourteen mills and pumps

(U 1471A v.), and 19 to 26 (U 1471A r.). Francesco di Giorgio did not number his machines in the supplementary chapter of his *Trattato II*, and Antonio's mills numbered 26, 27, and 28 are not illustrated in Francesco's *Trattato II*. Presumably, Antonio conceived them from his imagination and practice in mechanics.

This set of Antonio the Younger's drawings after the supplementary chapter of Francesco's *Trattato II* increases the probability that Antonio was in Siena at some time, and he was there when he made these drawings and transcribed their texts (U 1482A r., 1483A r.). He worked with the actual manuscript of *Trattato II*, which he may have heard about from Leonardo da Vinci. I have already commented on Antonio's travel to Siena in the company of Giuliano da Sangallo before ca. 1504. The illustrated *Trattato II* was transcribed and illustrated ca. 1500 in the scriptorium of Monte Oliveto Maggiore near Siena. The scribes' style of calligraphy and initial letters are like those of Francesco's *Trattato I* transcribed and illustrated in two versions in the same scriptorium. In 1504, Leonardo da Vinci copied texts and drawings from *Trattato II* for his Codex Madrid II (Ms 8937, Biblioteca Nacional, Madrid), and entered notes on seven folios of a copy of *Trattato I* (Codex Ashburnham 361), which also was executed by scribes at Monte Oliveto Maggiore.[11]

Antonio the Younger, Benvenuto Della Volpaia, and Bernardo Della Volpaia

The date of Antonio the Younger's drawings based on the Anonimo Ingegnere Senese's copybook in Siena is imprecise because it is uncertain when Antonio was in Siena, but the copywork from Francesco di Giorgio's *Trattato II* makes it certain that Antonio utilized *Trattato II* in the monastery. In regard to the dating, it is useful to explore other artists' engine drawings, especially those engineer-artists with whom Antonio is known to have had special links. Engine drawings identical with those of Antonio the Younger were drafted by another Florentine engineer, Benvenuto Della Volpaia, in 1521 and 1524 (Codex Ital. Cl. IV, 41, 5363, Biblioteca Marciana, Venice).[12] Antonio's mill pulverizer in Pisa (U 1445A r.) is identical with one with different measurements that Benvenuto sketched in rough outline, described, and dated in 1524 (fols. 50 v., 51r.). Benvenuto's drawings of rope-and-pulleys lifts appear in many of Antonio's drawings (U 1076A v., rope-and-pulleys lift; 1444A r., rope-and-pulleys lift). Antonio and Benvenuto had a mutual interest in the study of pulleys and their force.

For a pump design (U 1485A r.), Antonio named the engineer "Bartolino"—probably Giovanni Bartolini. Benvenuto Della Volpaia also named him (fol. 41 v.) in connection with an animal-driven hoist he described and dated in the year 1521. Antonio and Benvenuto (on fol. 42 r.) both illustrated and located a bucket-and-chain pump in the Ospedale degli Innocenti, Florence (U 1488A r.).

Antonio the Younger's link with the Della Volpaia family was natural in their native city of Florence. One member, Bernardo Della Volpaia, might have had a working relationship with Antonio, according to the recent disclosure of their drawings of architecture amid the archaeological sites in Rome.[13] Benvenuto illustrated a number of different marble-cutting saws, none like Antonio's (U 1496A r.). Antonio's compasses for making an ellipse (U 1102A r.) and other compasses (U 4043A r.) are like those of Benvenuto Della Volpaia (fols. 43 r., 43 v.), whose family were outstanding instrument makers. Benvenuto seems to have copied four obelisk haulers and column lifts from the copybook of the Anonimo Ingegnere Senese, which furnished Antonio the Younger with many of the same examples. Significantly for the role of the Anonimo's copybook, three of four hoists and an edge-runner mill for crushing olives or grapes by Benvenuto (fols. 51 v., 52 r.) are illustrated also by the Anonimo, and they have no precedents in other copybooks known to me.

Antonio the Younger's and Giovan Francesco da Sangallo's Drawings of Machines in Cesena, Pitigliano, San Leo, Orvieto, Pisa, Ancona, Arezzo, Rocca di Selvino, Viterbo, and Florence; Vasella as a Millwright in Rome

Turning to mechanisms that Antonio the Younger drafted directly at the building sites, he used a free penline and summary outlines of all the mills and mill pulverizers that he annotated with reference to where he saw or built them. He saw the mill in Cesena (U 819A r., 1442A r., 1461A v.) when he went there in 1526.[14] One mill in Pitigliano near Lago di Bolsena was seen or built by Antonio when he went there in 1526, and a similar one was noted in San Leo near Arezzo (U 852A r., 1442A r.). A mill in Orvieto (U 1467A v.) was seen when Antonio went there to build the Pozzo di San Patrizio in 1525–37. A mill in Rimini (U 819A r.) was drafted by Antonio when he visited there in 1526. A waterwheel for the canal in Ancona (U 1446A v.) was seen and probably worked on when Antonio was there in 1527–32. A mill in Arezzo (U 1467A r.) was seen when Antonio visited in

1526. The mill pulverizer in Pisa (U 1445A r.) was illustrated by Antonio when he traveled there in 1529, and Benvenuto Della Volpaia's drawing of it is dated in 1524.

Giovan Francesco da Sangallo sketched a hand-cranked gristmill made of iron (U 3951A v.) that he saw or built in the Rocca di Selvino near Pitigliano, property of the Count of Santafiore. Giovan Francesco illustrated the workmen's scaffold (U 1528A r.) installed in the Church of the Madonna della Quercia, Viterbo, which Antonio the Younger contracted to build (1518) and Giovanni Battista da Sangallo worked on (1524). Antonio's sketch of a builder's bridge (U 847A v.) is annotated with his statement to the effect that he believed the mosaic workers would have used it for their work on the vault of San Giovanni in Florence. Antonio's second sketch of a builder's bridge is annotated to inform us that he illustrated it according to how the pope thought the bridge was positioned. Evidently these sketches refer to Antonio's conversation with a pope in Rome or Florence, and we cannot know whether the pope was Leo X (1513–21) or Clement VII (1523–34). The date for Antonio's sketches is probably in the 1520's.

Antonio worked in Ancona in 1527–32 where he may have conceived his plan for a very large circular mill with four pairs of cogwheel lanterns (U 1268A r.), drawing it with a straightedge and compasses. Antonio may have built the bucket-and-chain pump in the drawing by Giovan Francesco da Sangallo and annotated "di Farnese" (U 1528A r., 1528A v.) in the town of Farnese (near Pitigliano and Castro), or else in Palazzo Farnese in Gradoli (perhaps founded in 1520), or perhaps in Palazzo Farnese in Rome, construction of which Antonio the Younger began in 1511. Antonio sketched a small part of a silk-spinning wheel, which he had seen, because he states in his note that it was owned by the Spinelli in Florence (U 1118A v.). Giovan Francesco da Sangallo sketched a fulling mill for the cloth industry (U 3950A v.), but did not note its location.

Antonio the Younger's other drawings go beyond the record of technologies he had actually seen or built. These drawings came from his lively imagination. One of his ingenious gristmills done in a free penline (U 1113A r.) is fabulous, and another of similar pen technique (U 1436A r.) shows how a team of two men operated a treadwheel so that it could turn four mills on a single shaft simultaneously. Antonio's drawing of a horse-driven treadwheel for a gristmill (U 1480A r.) is a slight variant of one conceived with similar imagination by Francesco di Giorgio (*Trattato*

I, fol. 38 r.; *Trattato II*, fol. 97 v.). Twice Antonio the Younger sketched horse-driven gristmills (U 1487A r., 1495A r.), and his comment for three mills (U 1487A r.) is that they all have the same force. As an experienced mechanic, he had a critical sense of mechanical force, which was the new science of his time.

When Antonio the Younger illustrated gristmills with undershot waterwheels (U 1447A v.), he criticized one that Cesare Cesariano had illustrated in his 1521 edition of Vitruvius (p. CLXX v.).[15] This clearly furnishes the date of Antonio's drawing on this sheet as being after 1521. Antonio copied Cesariano's mill (the Anonimo Ingegnere Senese's copybook shows a similar one, fol. 76 r.) beside one of his own design that he declared would work much better. He could say so because he had long practice in the field. Antonio situated a windmill perhaps in Orbetello (U 1448A r.). It resembles one that Leonardo da Vinci illustrated when he, too, was near Orbetello (Codex Madrid II, MS 8937, fol. 43 r.). Its mechanism is a variant of one that Antonio copied (U 1471A r.) from Francesco di Giorgio's supplement in *Trattato II*, dating ca. 1500. Therefore in many cases it is difficult to distinguish where Antonio's observation of actual or built machines ends and his mind's eye takes over, and equally difficult to learn which ones he built and which he merely recorded in the course of his work as architect.

Mills with a weight-wheel of balls on chains, sometimes called a flywheel ("palle sciolte" is Antonio the Younger's term for the device), were illustrated several times by Antonio, one of which he said was built by a certain Pasquino (U 1445A v.). The central mast of these mills holds wheels variously combined, but the types with weight-wheels comprise one with horse drive (U 1446A r.) and another type with crank handles (U 852A r., in Pitigliano; 1442A r., in Pitigliano and in San Leo). These sites had been visited by Antonio in 1526 and he may have built the mills with crank handles. If not as a builder, Antonio may have worked with drawings. For example, one of two weight-wheel gristmills that Francesco di Giorgio illustrated in the supplementary chapter of his *Trattato II*, and had shown earlier in *Trattato I* (fol. 33 v.), was reproduced in the Anonimo Ingegnere Senese's copybook (fol. 249 r.). Antonio the Younger had copied directly from these two manuscripts (*Trattato II* and the Anonimo's copybook). Benvenuto Della Volpaia (Codex Ital. Cl. IV, 41, 5363, fol. 85 r.) adapted the weight-wheel for a machine to cut circular forms.

The weight-wheel as a flywheel force seems to be a northern European invention. Notes by one of the

Anonimi known as Copyist 16, formerly considered the drawing of Antonio dell'Abaco (U 4095A r.), state that the weight-wheel (*vertibolo*) "was first built in Germany, then reconstructed in the same form in Rome." In fact, the earliest illustration of the weight-wheel with balls on chains is in the Hussite Anonymus manuscript (Ms CLM 197, part I, Bayerisches Staatsbibliothek, Munich), which, at some unknown time, was bound with Taccola's Notebook.[16]

I may comment on another mechanism built in Rome and illustrated by one of the Anonimi known as Copyist 16 (U 4094A v.). He noted that the mill to grind pigments, which he illustrated, had been used by Vasella. The latter was probably a descendant of the twelfth-century Vassalletto who constructed the cloisters of San Paolo-fuori-le-Mura in Rome.[17] We may visualize these skilled craftsmen, including Antonio the Younger and his family, as those who developed and improved on the mechanisms they used. I doubt that drawings were useful for such improvements and adjustments; rather, the mechanism as built was examined for defects of form or size so as to attain its proper and efficient functioning.

Antonio the Younger's Sources for the Mechanical Studies

Pumps are another subject of Antonio the Younger's technology. One cranked manually was seen probably in Castro in 1531 (U 294A v.). His name for the waterflow channel, *stantuffo*, is new in technical writing by the Sienese standards of Francesco di Giorgio, who described and illustrated dozens of pumps. None of Francesco's is like Antonio's, which function with a ball (*palla*) as a substitute for a valve. A mill wheel (U 847A v.) is also joined to a *stantuffo*. Another type of pump with a gear in an elliptical rack (U 847A r.) is new in the sense that Francesco di Giorgio did not illustrate a device like this one. Antonio illustrated the device in four versions (U 847A r., one of two shown here has a cogwheel drive; 1409A v., as details; 1493A r.). He described it on the first folio as including the metal balls in place of valves and having only four teeth on the gear. He showed four in that drawing, but there are twelve on the racks that move the *stantuffo* up and down. The purpose of the *stantuffo* is to prevent the water from flowing back. The other pump with a gear in an elliptical rack (U 1493A r.) has more teeth on the gear, but Antonio did not explain the design, which also includes a weight-wheel of balls on chains.

Another pump drawing (U 1485A r.) is a lever-operated suction pump, whose design Antonio's note

ascribes to "Bartolino," probably Giovanni Bartolini, as named by Benvenuto Della Volpaia. One pump has three tubes and valves (U 1092A v.), and another one four tubes and a treadwheel (U 1445A v.). Antonio noted that the capacity of the three-tube pump was like that of the Toledo waterworks in Spain. This is a remarkable note, because the first person to mention the waterworks of Toledo was the Sienese engineer Taccola (*De ingeneis*, Book I, fol. 31 v.).[18] His manuscript introduced the pump in Toledo to Francesco di Giorgio, as shown in his *Codicetto* (Codex Urb. lat. 1757, Biblioteca Apostolica Vaticana) and in his *Opusculum* (Ms 197 b 21, fol. 60 v.) where the name "Toledo" appears on the citadel. Then the pump drawing came to the attention of the Anonimo Ingegnere Senese and others, including one of the Anonymi known as Copyist 12 (U 4080A r.), who copied the whole pump without writing the city's name. Actually the three-tube pump of Toledo has an equivalent form fully illustrated in a Florentine copybook dating from 1548–52 (Codex Palat. 1417, Biblioteca Nazionale, Florence), where it is said to be operating on the Danube River in Hungary.[19]

Antonio the Younger illustrated a force pump with two side tubes (U 1409A v.) and named it "Tesibica machina" or pump of Ctesibius, as described by Vitruvius (X.vii.1–5). Antonio based his design on pumps that he built or proposed for construction. Cesariano's edition of Vitruvius in Italian translation published in 1521 includes his extensive analysis of the "Ctesibica machina" (pp. CLXXI v., CLXXII r.), but Cesariano did not illustrate it. Cesariano's hydraulic chapter was the source for one of Antonio's undershot waterwheels (U 1447A v.). Ctesibius was a well-known name among Vitruvianist scientists long before Cesariano prepared his book. For example, the Anonimo Ingegnere Senese's copybook dating ca. the 1470's (Ms Additional 34113) includes the first Italian translation of Philon's *Pneumatica* on the theory of pumps, and Philon often speaks of Ctesibius.[20] The Ctesibian-Philonian tradition had been continued by Heron of Alexandria.

Antonio the Younger's drawing of a Vitruvian chorobates (VIII.v.1–2), or leveling instrument (U 1409A v.), has a close equivalent in one by Cesariano (p. CXXXVIII r.), but it is not a copy. However, Antonio did copy (U 1461A r.) the hodometer from Cesariano's illustration of a wagon (p. CLXXIIII r.). Antonio copied (U 1444A r.) Cesariano's illustration of a tripod hoist and rope-and-pulley system (pp. CLXV r., CLXVI r.). He used some of Cesariano's text and quoted Cesariano's phrase for his own illustration

of the Vitruvian lead pipe joint (U 1492A r.). Significantly, Antonio used Tuscan words for the mechanical components, not Cesariano's terms in Lombard Italian. This copywork of Antonio the Younger should not obscure the fact that he had original ideas when he twice illustrated how a series of ten pulleys on an inclined plane can be arranged for use in threshing grain (U 1437A r., 4058A r.).

Antonio the Younger studied other chapters of Cesariano's edition of Vitruvius, and he also read other technical literature. This fact is not immediately discernible by looking at his several sketches of shafts with ropes twisted around them by a rod shown in place (U 1447A r., with details; 1447A v., 1458A r., 1485A r.). Antonio's reading about this ordinary device is clarified by his notes for this projectile-throwing device, which are sometimes in Latin, and he cited by name the author Plautus, *De catapulta*.[21] Antonio's notes and sketches are paraphrases, extrapolations, and interpretations of Vitruvius (X. xii.1–2, On the Preparation of Catapults and Balistae) in Cesariano's edition (pp. CLXXVII r. and v.). Antonio even chose Cesariano's Lombard terms, such as "modioli," "cupitelli," "anse rudenti," "conii," and "sucule." Cesariano did not illustrate the device described by Vitruvius, which is the simplest form of snapper or catapult. Antonio reconstituted one from his experience and following Cesariano's wording. It is a workman's iron or wooden tool used to turn rope around a shaft. It is like the snapper that Taccola illustrated in his Notebook (Ms CLM 197, part II, fol. 127 r.). Antonio the Younger's additional borrowings of texts or drawings from Cesariano on a total of ten sheets include his sheets U 1213A r. and 1460A r.

Antonio the Younger also studied illustrations of geometry in the manuscript of Fra Giocondo (U 1456A r., 1457A r., 1463A r. and v.). By citing "Gieometria di Fra Jochundo," Antonio recorded his source, and this inscription is another example of the way he classified his drawings.

Giovanni Battista da Sangallo copied drawings of Brunelleschi's lantern crane (U 1665A r.) from the manuscript he called the "Libretto di Giuliano," which is Giuliano da Sangallo's *Taccuino* (Codex S.IV.8, fol. 12 r.). Antonio the Younger's design of centering for a vault (U 1564A r.) is from the same *Taccuino* (fol. 27 r.). Antonio's drawing of a roasting spit (U 1564A v.) is a variant of one in Giuliano's *Taccuino* (fol. 50 r.). Giovan Francesco da Sangallo also copied from Giuliano's *Taccuino*, specifically his method of stone-block transfer (U 3950A r.).

A Roman author whose terminology for ancient

military weapons Antonio the Younger quoted (U 1470A r.) was Vegetius, *Epitoma rei militaris,* first published (1487) in Rome, edited by Giovanni Sulpizio. Antonio cited also the translation of Vegetius (U 1461A r.). Francesco di Giorgio also quoted Vegetius, but he knew the text in a manuscript.

Antonio the Younger's notes about an oil press, written in Latin with his own Italian glosses (U 1469A r.), came from Palladius (*De re rustica*) and Columella (*Rei rusticae*), two authors he mentioned by name and whose books and chapters he cited by numbers. Antonio took notes from the first edition (1496), which he owned. From that edition, he selected phrases from Cato's *De re rustica* about the oil press. The structural parts that Antonio sketched were surely drawn from oil presses he saw, or else he himself had built one. The components do not appear to be reconstructed from a verbal description. He illustrated a roller-mill (*trapetum*) for crushing olives or grapes (U 1469A v.). He placed that mill beside a beam press for the same purpose, which Cato had described. However, Antonio's lengthy quotations in Latin for the *trapetum* are taken from a source that I have not found, and I can only report that it is not in the 1496 edition. Another press and edge runner for olive oil or grape wine that Antonio illustrated (U 7975A r.) was drafted directly before the structure itself.

Waterworks among Antonio the Younger's drawings include the overshot waterwheel of a mill in Ancona (U 1446A v.), which he may have built. His sketch of a bucket-chain and pump with horizontal waterwheel (U 1494A r.) has a parallel in a more complete illustration by one of the Anonymi known as Copyist 9 (U 4073A r.). A bucket-chain pump by Giovan Francesco da Sangallo for the Farnese (U 1528A r.) has been mentioned. It is very similar to one by Antonio the Younger (U 1494A r.) and to one in the Ospedale degli Innocenti, Florence (U 1488A r.). Such similarities of components may be expected when a pump worked smoothly. It was illustrated also by Benvenuto Della Volpaia. A pump that Antonio sketched loosely (U 1486A r.) is like one he copied (U 1443A r.) from Francesco di Giorgio's *Trattato II*. Two bucket-chain pumps (U 4052A r. and v.) have no precedents in the literature or copybooks.

Antonio the Younger's title on the latter sheet is "Difitii dacqua" (Waterworks), which indicates that he classified his drawings by function of machines. Antonio also titled one of his categories (U 1438A r.) "Ordinary Devices," and another category (U 1496A v.) is "Various Kinds of Engines." Among the types frequently illustrated by the Anonimo Ingegnere

Senese (Ms Additional 34113, fols. 182 v., 239 r.) are Antonio's drawings of bucket-wheels—one with eight hammers (U 4048A v.), another with conical buckets hinged to it (4048A r.). Aristotile da Sangallo's script is on a traditional bucket-wheel (U 881A r.), which probably was built in Ferrara. Antonio the Younger combined the traditional Archimedean water screw with a gear-rack unit in one drawing (U 1468A r.) and with an overshot waterwheel in another (U 1477A r.).

Drawings of Flintlock Triggers, a Bar-breaking Tool, a Cranequin, Lathes, Screw Drills, a Smoke Jack, a Minting Press, Compasses, Astrolabes, and Tilting and Pivoting Lifts

Antonio the Younger's drawings of tools and instruments include two forms of flintlock triggers (U 4041A r., 1441A v.), the second of which is close to several illustrated by Leonardo da Vinci (Codex Madrid I, Ms 8936, fols. 18 v., 94 r., 98 v., 99 v., Biblioteca Nacional, Madrid). Antonio copied his bar-breaking tool (U 1472A r.) from one of several by Leonardo exactly alike (Codex Atlanticus, fols. 6 r., *a*, 6 v., *a*, 16 r., *c*, 16 v., *b*, Biblioteca Ambrosiana, Milan). Leonardo's departure to France in 1514 may be a way of dating Antonio's examples sometime before that year. Antonio said he saw the crossbow with a screw device, or cranequin (U 1106A r.), in Venice, noting that it was made by Maestro Jacomo Bonacostia da Ferrara, his physician. This is the only documentary evidence of Antonio's travel to Venice, which seems to have occurred in 1526 when he inspected the forts in various parts of Romagna. As for the names of other technologists, Giovanni Battista da Sangallo noted the name of Maestro Andrea da Palestrina (U 3970A v.).

Assorted mechanisms by Antonio the Younger include three lathes for screws and files (U 1445A r., 1441A r., 1564A r.); a medal-making press (U 1441A r.); and screw drills (U 1445A r.). Giovanni Battista da Sangallo's minting press (U 3970A r.) is like one by Baldassarre Peruzzi (U 504A v.). Antonio the Younger developed a double roasting spit, or smoke jack (U 1564A v.), which differs from one by Leonardo (Codex Atlanticus, fol. 5 v., *a*) and by Giuliano da Sangallo in his *Taccuino* (fol. 50 r.). As stated above, Giuliano was in Siena sometime before 1504, in which year Leonardo was in Siena at the scriptorium of Monte Oliveto Maggiore, where he annotated the *Trattato I* of Francesco di Giorgio. That Leonardo's drawings were known also to Giovan Francesco da Sangallo is documented by Giovan Francesco's sketches that he placed beside his sketches of antiquities in Rome (U 3956A r. and v.). On both sides of that folio

Giovan Francesco illustrated bird's wings moved by mechanical joints, which he copied from Leonardo's drawings of the flying machine sometimes called an ornithopter.

Compasses for elliptical and other shapes (U 1102A r., 4043A r.) are precision instruments that the Della Volpaia family produced. Antonio the Younger's forms of compasses strongly resemble those illustrated by Benvenuto Della Volpaia (Codex Ital. Cl. IV, 41, 5363). Antonio classified his drawings as "Astrolabes and Quadrants" (U 1455A v.). He reproduced expertly in facsimile the three parts of a Moorish astrolabe datable in the tenth century that he called Egyptian (U 1454A r. and v.). This is an extraordinary demonstration of Antonio's skill in transcribing from the astrolabe its Arabic-Kufic script and numerals. His accuracy in this foreign writing is such that the signature of the instrument maker has been deciphered and his exact location of work identified in Baghdad. Antonio reproduced, in a drawing, a mid-fourteenth-century quadrant with Roman numerals, Arabic numerals, and the zodiac signs named in Latin (U 1455A r.). On the matter of Antonio's transcription of foreign languages, I may mention his facsimiles of Etruscan script (U 2080A r., 2081A r., 1025A r.), which are written clearly enough for Etruscologists to read.

A stone-block lift with treadwheel and rope pulleys on a boat was operating in Genoa, according to Antonio the Younger's drawing of it (U 794A r.). The same type of boat illustrated by Lorini in 1612 is said to have been used to build a seawall. Antonio seems to have visited Genoa in 1536, and he also illustrated sluice gates in Genoa (U 901A r., 1503A r.). Antonio developed a pivoting and tilting lift for raising stone blocks from a boat (U 1479A r. and v., 1501A r., 4042A r.). This type of lift constitutes a technical advance over the traditional pivot that did not tilt (U 1439A v.).

Antonio the Younger's Drawings of Hoists and Cranes

A series of hoists and cranes by Antonio the Younger are based on Brunelleschi's mechanical inventions of 1418. These and some variants of Brunelleschi's work may be discussed together. There are two variants of a traveling crane by Antonio (U 1449A r.), a crane as variant of Brunelleschi's invention in Antonio's drawing (U 1449A v.), and Antonio's drawings of hoists operated by a treadwheel or turned by a horse or turned manually (U 1440A r., 1504A r.). Antonio's drawing (U 1504A r.) is a variant of Brunelleschi's three-speed hoist with reversible screw operated by an ox, its rollers on angle hooks fixed to the wheel shown

as details. Antonio's drawings of hoists with rope pulleys (U 1440A r., 1504A r.) show rope winders balanced on two sides of a rope roller to prevent swerving. I believe that these and other examples of rope winders (U 1449A v.) were developed by Antonio himself, and they are clearly improved over Taccola's version. It will be remembered that Antonio the Younger adapted the Anonimo Ingegnere Senese's one-sided rope winder (Ms Additional 34113, fols. 24 r., 88 r., 88 v.). Antonio's examples are based upon his study of improvements to be made on the mechanism's rope guides. He numbered, from 1 to 7, the crane, traveling crane, and details (U 1449A r. and v.). Above the first mechanisms, Antonio centered the title "Tirari" (Hoists, Cranes, Lifts, and Haulers), another classification of drawings for his collection. As stated previously, this sheet also shows other hoists that Antonio copied (U 1482A r., 1482A v., 1483A r. and v.) from drawings and texts in Francesco di Giorgio's *Trattato II*, which Antonio utilized in the scriptorium of Monte Oliveto Maggiore.

Traveling cranes like the examples by Antonio the Younger (U 1449A r.) and another in Giovan Francesco da Sangallo's drawing (U 3951A r.) were illustrated previously by Buonaccorso Ghiberti (1451–1516) in his *Zibaldone* (Ms Banco rari 228, fol. 95 v., Biblioteca Nazionale, Florence), and drafted also by Leonardo (Codex Atlanticus, fol. 49 v.).[22] Antonio's drawing of a variant of Brunelleschi's crane or load positioner (U 1449A v.) is one that had been copied many times since it first appeared in Francesco di Giorgio's *Opusculum de architectura*, and Antonio copied another from Francesco's *Trattato II*, fol. 92 v., when that treatise was in the scriptorium. What is presumed to be a drawing of Brunelleschi's authentic crane was first illustrated by Buonaccorso (*Zibaldone*, fol. 106 r.), then by Leonardo (Codex Atlanticus, fol. 379 r., a). Brunelleschi's authentic three-speed hoist with reversible screw was first illustrated by Buonaccorso (*Zibaldone*, fols. 102 r., 103 v.). Then Leonardo sketched it and some details of rollers on angle hooks in new forms. These rollers differ slightly from those that Buonaccorso illustrated for Brunelleschi's "secret hoist" (*Zibaldone*, fol. 95 r.). Considering that two Florentines, Buonaccorso and Leonardo, illustrated what are believed to be reliable drawings of Brunelleschi's hoists and cranes, it is surprising that Antonio the Younger, also a Florentine, illustrated a variant of the hoist with reversible screw (U 1504A r.). We cannot know where Antonio saw the rollers on angle hooks that differ from those on the designs of Buonaccorso and Leonardo.

Antonio the Younger's new drawing of a three-speed hoist driven by an ox (U 1504A r.) is wrongly constructed. The hoist has only two wheels instead of three, and both wheels have the staves of lanterns. At this point it is important to note another fact: that none of the Florentine artists—Buonaccorso, Leonardo, or Antonio the Younger—indicates with notes on his drawings that the hoist and cranes are Brunelleschi's inventions, nor does anyone say that the machines were used to complete the cupola of Florence Cathedral. There is one exception, which concerns the work of building the lantern. Giovanni Battista da Sangallo's drawing (U 1665A r.) includes the note about the revolving crane used to build the lantern on the cupola, without mentioning Brunelleschi by name. On Antonio the Younger's copy of the drawing, he noted that he took it from Giuliano da Sangallo's *Taccuino* (fol. 12 r.). Antonio used Giuliano's sketchbook for other drawings (U 1564A r. and v.).

Antonio the Younger closely analyzed (U 826A v.) the load positioners (*ulivella*) for stone blocks operating on Brunelleschi's hoist, drawings of which he saw in Giuliano's *Taccuino*, fols. 48 v., 49 r. Giovan Francesco da Sangallo illustrated a winch and traveling crane with rope-and-pulley system for lifting stone blocks and another lift with gears and rope pulleys (U 3951A r. and v.). Giovanni Battista da Sangallo illustrated and analyzed the whippletree that pivots the wheels of a four-wheel wagon (U 3975A r.). Something of that kind was also observed by Leonardo (Codex Atlanticus, fol. 4 v.; Codex Madrid I, fols. 58 r., 93 v.).

Antonio the Younger's Drawings of a Turnstile Gate, a Roman Water Pipe, and an Obelisk Mover; Giovanni Battista da Sangallo's Drawings of Water-Pool Rotundas

Antonio the Younger developed the mechanism of a turnstile gate for a fort (U 1473A r.). Francesco di Giorgio first illustrated one in a slightly different form (*Trattato II*, fol. 83 r.) and described its movements and parts in detail. Antonio studied Francesco's treatise when it was in the scriptorium, so it is clear that he adapted his version from the Sienese prototype, which also was copied by one of the Anonymi known as Copyist I (U 4074A r.). The turnstile gate enabled the gatekeeper to see who left and entered the fort after or before crossing the moat. Antonio shows two elevations and two plans of a turnstile gate with mechanized door (*saracinesca*) formed as circular towers rotating on platforms with rollers underneath.

Archaeological objects are mentioned and one is illustrated by Antonio the Younger (U 1212A r.). On his drawing of a tripartite waterpipe sealed with lead, which Antonio considered a tomb, he noted it was one of three discovered in 1531 near the Temple of Antoninus Pius and Faustina. About the present one, he said it was found beneath a column of the temple's porch. This discovery in 1531 was the result of investigations that he and others made when they explored the sites of antiquities and made drawings of the terrain, the temples, and site plans of the Imperial Fora where churches and the monastery of San Basilio had been built into the Roman structures.

Antonio the Younger illustrated a method for moving the Vatican obelisk (U 854A r.). Antonio and Michelangelo encountered difficulties with the project in 1535, according to the inventor-engineer Camillo Agrippa, whose book on the Vatican obelisk was published in 1583. Agrippa had come to Rome from Milan in October 1535, when Antonio and Michelangelo first considered the project. Agrippa designed a pump for the fountain of the Medici Villa in Rome, which Oreste Biringuccio illustrated ca. 1578–83, naming both Agrippa and the place (Codex Album S.IV.1, fols. 137 v., 138 r. ["Agrippa"], 135 v., 136 r. ["Medici"], Biblioteca Comunale, Siena).[23]

Giovanni Battista da Sangallo illustrated a water-pool rotunda (U 4046A r.) like those of Pozzuoli, Baia, and Lago d'Averno in the Campi Flegrei, which were built in the second and third centuries on or near thermal springs. Romans and Italians went there for cures until 1538 when volcanic eruptions destroyed the terrain. In our time, A. Maiuri believed that he had found traces of water outlets in the pavement of one rotunda, but the exact function of the structures is unknown,[24] and no trace of a hypocaust system has been reported. These rotundas were built long after Vitruvius described baths like the small and earliest ones in Pompeii and Herculaneum. The imperial thermae furnished with water brought on aqueducts were built in Rome after Vitruvius's time. They are structurally different from the Pompeian laconicum that Vitruvius described.

Giovanni Battista shows people standing in the water, the pool surrounded by steps, and there are suspensurae under the pavement. Separately he shows the hot-air channels of a hypocaust (Vitruvius, V.x.2) under the pool's pavement; a furnace is not noted. Giovanni Battista's rotunda cannot reflect Vitruvius's small round laconicum for only a few people, because the latter had no water pool; it was heated by hot air conducted from the hypocaust to places between the laconicum's double walls (V.x.5). In any case, the Neapolitan rotundas are unrelated to the thermae in

Rome or the Pompeian laconicum. Giovanni Battista's drawing is largely fanciful, based on his study of Vitruvius.

Giovanni Battista illustrated the same rotunda as a water pool and details of water vessels in the margins of a Sulpizio-Vitruvius (ca. 1486) that he owned (Incunaboli 50, F 1, Biblioteca della Accademia Nazionale dei Lincei e Corsiniana, Rome).[25] Not surprisingly, all of Giovanni Battista's versions of water-pool rotundas include three vessels for water (U 4046A r.). In this, he follows a traditional interpretation of Vitruvius's paragraph (V.x.1) about three bronze caldrons containing hot, tepid, and cold water. Even in Fra Giocondo's edition (1511) of Vitruvius, a single illustration of three caldrons over the furnace is in the chapter on Baths (V.x.1). The Vitruvianists of the sixteenth century introduced the idea of rooms with temperatures of heat known as caldarium, tepidarium, and frigidarium in the building complex of the imperial thermae. In his drawings, Giovanni Battista expressed his understanding of Vitruvius. If part of his illustrations relates to the popular use of the rotundas in the Campi Flegrei, the detail of a hypocaust does not belong there where thermal springs provided the healing waters. In Rome, everyone could see that water for use in the thermae had been brought on aqueducts from the distant hills.

In conclusion, each drawing by a member of the Sangallo families sheds new light on his engineering interests and work. The members of this circle built or were involved in building structures such as mills, canals, pumps, tools, and the project of moving the Vatican obelisk. They worked closely with local craftsmen and mechanics, and sometimes named the persons with whom they were allied as architects. Antonio the Younger's library included two major printed works of 1496 and 1521, which he quoted or criticized, and he copied some of their illustrations. Giovanni Battista da Sangallo's library included a copy of the first Latin edition of Vitruvius. Antonio the Younger had enormous facility in transcribing foreign scripts such as Arabic and Etruscan, and he was able to understand Latin and transcribe it. Antonio copied extensively from drawings in other engineers' manuscripts, for example, those of Francesco di Giorgio and his compatriot and contemporary, the Anonimo Ingegnere Senese. His drawings and notes transcribed from those manuscripts are decisive factors for stating that he was in Siena sometime after ca. 1500. A note or two by Antonio indicates that he copied drawings from the *Taccuino* of Giuliano da

Sangallo, and other copywork from that sketchbook has been discovered by comparing drawings. Antonio's habit of classifying his collection of drawings reflects his personal wish for order in the material he kept in his workshop. His comments about a machine's efficiency and productivity came from his scientific and technical experiences, which he and others developed as engineers in a new political climate.

NOTES

1. C. Pini and G. Milanesi, *La scrittura di artisti italiani* (Florence, 1876): U 307A r. (Antonio da Sangallo the Younger); U 1793A r. (Antonio alias Abacho in Roma). For the script of Giovanni Battista da Sangallo, see P.N. Pagliara, "Alcuni minute autografe di G. Battista da Sangallo," *Architettura Archivi—fonti e storia* I (1982): 25–50. See also the Introduction by C.L. Frommel in this volume.

2. T. Buddensieg, "Bernardo Della Volpaia und Giovanni Francesco da Sangallo," *Römisches Jahrbuch für Kunstgeschichte* 15 (1975): 89–108, especially for an example of Giovan Francesco's script. Aristotile da Sangallo's script is suggested in many captions of illustrations reproduced by C.L. Frommel, *Der Römische Palastbau der Hochrenaissance* (Tübingen, 1973). See also above, figure p. 4.

3. P. Nerino Ferri, *Indice geografico-analitico dei disegni di architettura civile e militare esistenti nella R. Galleria degli Uffizi in Firenze* (Rome, 1885).

4. Ms Additional 34113 is an unpublished manuscript described by A.E. Popham and P. Pouncey, *Italian Drawings in the Department of Prints and Drawings in the British Museum, The Fourteenth and Fifteenth Centuries* (London, 1950), p. 38. It is also discussed by F.D. Prager and G. Scaglia, *Mariano Taccola and His Book "De ingeneis"* [Codex Palat. 766] (Cambridge, Mass., London, 1972), pp. 199–201.

5. Mariano Taccola, *De ingeneis, Books I and II and Addenda* (The Notebook) [Ms CLM 197, part II], ed. G. Scaglia, F.D. Prager, U. Montag (Wiesbaden, 1984). Taccola's *Books III* and *IV* are in another manuscript (Codex Palat. 766, Biblioteca Nazionale, Florence), which is reproduced in the book by F.D. Prager and G. Scaglia cited in n. 4.

6. Francesco di Giorgio Martini, *Trattati di architettura ingegneria e arte militare*, ed. C. Maltese and L. Maltese Degrassi (Milan, 1967). Vol. I comprises the edited texts of *Trattato I* in Codex 148 Saluzzo (Biblioteca Reale, Turin) and Codex Ashburnham 361 (Biblioteca Medicea Laurenziana, Florence), and the illustrations are from Codex 148 Saluzzo. Vol. II comprises the edited texts of *Trattato II* in Codex S.IV.4 (Biblioteca Comunale, Siena) and in Codex Magliabechiano II.1.141 (Biblioteca Nazionale, Florence) and the latter's illustrations are reproduced. Also see one version of *Trattato I* in Francesco di Giorgio, *Trattato di architettura di Francesco di Giorgio Martini: Il Codice Ashburnham 361 della Biblioteca Medicea Laurenziana di Firenze* (Florence, 1980).

7. The unpublished manuscript that I cite as Ms 197 b 21 was described by A.E. Popham and P. Pouncey (as in n. 4) before its classmark was changed to this one. I have discussed it and its twenty-eight copies in *Checklist and History of Francesco di Giorgio's Manuscripts and Drawings* (Bethlehem, Penn., 1992).

8. Internal evidence such as notes by a sixteenth-century owner on sheets added to the Anonimo Ingegnere Senese's section indicate beyond any doubt that the Anonimo's manuscript was transferred to Florence, perhaps in the Della Volpaia workshop. Notes

on the added sheets are dated in 1562 (project for the sacristy of SS. Annunziata, Florence), in 1602 (Certosa d Pisa), in 1612 (instrument for inscriptions in porphyry), sketches of machines by Maestro Bernardo and by Lorenzo Della Volpaia (d. 1566), and sketches of the Florentine Cathedral's orb and cross when it was being restored in 1601. About the sketches of the orb and cross, see G. Scaglia, *Alle origini degli studi technologici di Leonardo*, Lettura Vinciana XX (20 April 1980), (Vinci, 1981), p. 13.

9. (Giuliano da Sangallo), *Il taccuino senese di Giuliano da Sangallo* [Codex S.IV.8], ed. R. Falb (Siena, 1902; reprint, 1984).

10. (Giuliano da Sangallo), *Il Libro di Giuliano da Sangallo. Codice Vaticano Barberiniano latino 4424*, C. Huelsen, ed. (Leipzig, 1910; reprint, 1984).

11. Leonardo da Vinci, *The Madrid Codices, National Library, Madrid. Facsimile Edition of Codex Madrid I (Ms 8936), Codex Madrid II (Ms 8937)*, ed. L. Reti (New York, 1974). For references to Leonardo's Codex Atlanticus (Biblioteca Ambrosiana, Milan), I have shown the original numbers printed in *Il Codice Atlantico di Leonardo da Vinci* (Milan, 1894). The reprint (1976) does not show numbers on the plates, so the reader must find them elsewhere: C. Pedretti, *The Codex Atlanticus of Leonardo da Vinci. A Catalogue of its Newly Restored Sheets* (London, New York, 1978–79).

12. An unpublished manuscript for which the main publications are: C. Maccagni, "Notizie sugli artigiani della famiglia Della Volpaia," *Rassegna periodica di informazioni del Comune di Pisa* 3, no. 8 (August 1967): 3–13; idem, "The Florentine Clock- and Instrument-makers of the Della Volpaia Family," *XIIᵉ Congrès International d'histoire des sciences, Paris, 1968. Actes*, Tome XA, *Histoire des instruments scientifiques* (Paris, 1971), pp. 65–71, including a checklist of surviving instruments by the Della Volpaia family. Biographical sketches of each member of the Della Volpaia family are published by P.N. Pagliara in *Dizionario biografico degli italiani* (Rome, 1989).

13. T. Buddensieg's attribution, as published in n. 2, above.

14. Chronology of Antonio the Younger's work and travels in Gustavo Giovannoni, *Antonio da Sangallo il Giovane*, 2 vols. (Rome, 1959), I, pp. 110–11.

15. (Cesare di Lorenzo Cesariano), *Di Lucio Vitruvio Pollione de Architectura Libri Dece* (Como, 1521; reissued New York, London, 1968).

16. Bert S. Hall, *The Technological Illustrations of the So-called "Anonymus of the Hussite Wars," Codex latinus Monacensis 197, part I* (Wiesbaden, 1979).

17. For the Vassalleto family in the twelfth and thirteenth centuries, see G. Giovannoni, "Opere dei Vassalletti marmorari romani," *L'Arte* 11, fasc. 4 (1908): 2–23; Peter C. Claussen, *Magistri doctissimi romani. Die Römischen Marmorkünstler des Mittelalters*, Corpus Cosmatorum, I (Stuttgart, 1987), pp. 101–44, with bibliography.

18. Prager and Scaglia, *Mariano Taccola*, p. 192.

19. Scaglia, *Checklist and History*, Item no. 20, with an attribution to Cosimo Bartoli.

20. Philo of Byzantium, *Pneumatica. The First Treatise on Experimental Physics*, ed. F.D. Prager (Wiesbaden, 1974), pp. 112–24 (The Italian Philo), written by the Anonimo Ingegnere Senese in Ms Additional 34113.

21. Antonio the Younger's source for this work is unknown. It is probably to be sought in the literature collected by humanist-scientists and translators at the papal library, for example, Fabio Calvo da Ravenna and others. Cesariano's translation (see n. 15) of the Vitruvian chapter on the catapult in Book X ("De le ratione de le catapulte et scorpioni") cites the name of persons who studied the catapult, and quotes some parts of Josephus, *De bello Iudaico*, Bk. III, chap. 14.

22. The technical drawings from Buonaccorso's sketchbook are reproduced in F.D. Prager and G. Scaglia, *Brunelleschi: Studies of His Technology and Inventions* (Cambridge, Mass., London, 1970), pp. 65–109.

23. Antonio the Younger probably knew Lorenzo Castellani, the hydraulic engineer in Rome whose pumps are illustrated and identified with his name in the sketchbook of Oreste Biringuccio (Codex Album S.IV.1, Biblioteca Comunale, Siena). There is no biographical information about Lorenzo Castellani, only his authorship of *Aritmetica pratica composto dal molto rever. Padre Christoforo Clavio. . .e tradotta dal Latino in Italiano dal Signor Lorenzo Castellano patritio romano* (Rome, 1586). About Oreste Biringuccio, who was the main artist-author of Codex Album S.IV.1, see L. Heydenreich, "Uber Oreste Vannocci Biringucci," *Mitteilungen des Kunsthistorischen Institutes in Florenz* 3, no. 7 (1931): 434–40. Heydenreich did not discuss any of the numerous engine drawings by Oreste and other engineers in Codex Album S.IV.1. I have studied some of them: "Drawings of Forts and Engines by Lorenzo Donati, Giovanbattista Alberti, Sallustio Peruzzi, The Machine Complexes Artist, and Oreste Biringuccio," *Architectura. Zeitschrift für Geschichte der Baukunst* 18, no. 2 (1988): 169–97; "Drawings of Cinquecento Palaces and Palace-fort, a Church by Lorenzo dei Pomarelli, and a Chapel for the Confraternità di San Luca in Rome," *Palladio. Rivista di Storia dell'architettura e Restauro*, Year 2, no. 6 (1990): 25–42.

24. A. Maiuri, *I Campi Flegrei dal sepolcro di Virgilio all'antro di Cuma*, Itinerari dei musei, gallerie e monumenti d'Italia, 5th ed. (Rome, 1970).

25. P.N. Pagliara, "Vitruvio da testo a canone," in *Memoria dell'antico nell'arte italiana*, ed. S. Settis (Turin, 1986), vol. 3, pp. 5–85, with bibliography, and figs. 25, 26. See also P.N. Pagliara, as in n. 1, above. He first discussed Giovanni Battista's two manuscripts of Vitruvius translations (Ms 43 G. 1 and Ms 43 G. 8) in Biblioteca Corsiniana, Rome ("L'attività edilizia di Antonio da Sangallo il Giovane. Il confronto tra gli studi sull'antico e la letteratura vitruviana. Influenze sangallesche sulla manualistica di Sebastiano Serlio," *Controspazio* 4, 7 [1972]: 19–55). I have studied the Vitruvian chapter on baths, drawings by various artists, and the thermal spas in the Campi Flegrei: "'Stanze-stufe' e 'Stanze-camini' nei 'Trattati' di Francesco di Giorgio da Siena," *Bollettino d'Arte* 71, 39–40 (1986): 161–84; "A Vitruvianist's 'Thermae' Plan and the Vitruvianists in Roma and Siena," *Arte Lombarda* 84–85 (1988): 85–101.

Appendix

The attributions for the drawings used in the Uffizi are listed below in brackets; the names that C. Briquet used for watermarks are shown under the Uffizi drawing number; the short titles listed as sources for the illustrations refer to the complete reference shown in the notes to the essay, for example: *Trattato I and II*, as in n. 6; *Opusculum*, as in n. 7; Notebook of Taccola, as in n. 5; Codex Atlanticus, as in n. 11; Ms Additional 34113, as in n. 4 (limited space does not permit the addition of all folios from this manuscript).

Uffizi *scheda*	Artist	Machine	First illustrated in:
1334A v.	Anonymus [Giovanni Battista da Sangallo]	Sluice gate	
1385A v.	Anonymus [Giovanni Battista]	Pivoting crane; ox-driven hoist	(cf. Antonio the Younger, U 1439A r. and v., 1445A r., 1504A r.)
1433A r.	Copyist 1 [Antonio the Younger]	Gristmill	*Trattato II*, fol. 98 r., Martini-Maltese, pl. 331
1434A r.	Copyist 2 [Antonio the Younger]	Obelisk hauler	*Opusculum*, fol. 23 v. (variant)
1474A r. (*Couronne*)	Copyist 3 [Antonio the Younger]	Crane (variant of Brunelleschi's)	*Opusculum*, fol. 11 v.
1475A r.	Copyist 4 [Antonio the Younger]	Scaling ladder	*Opusculum*, fol. 34 v.
1499A r.	Anonymus [Antonio the Younger]	Planetary sphere	
1867A r. and v.	Anonymus [Antonio the Younger]	Mechanized saw; note refers to Messer Agostino [Chigi]	
3944A r.	Anonymus [Giovanni Battista]	Quadrant; artist's script differs from 3945A r. and v., 3946A r.	
3945A r.	Anonymus [Giovanni Battista]	Quadrant front with sliding scale and border (*mobile distate*)	(cf. Antonio the Younger, U 1454A r., 1455A r.)
3945A v.	Anonymus	Quadrant (incomplete)	
3946A r.	Anonymus [Antonio the Younger]	Quadrant dated 1572, inscribed: COSM. MED. MAGN. ETR. DVX	(cf. quadrant by Egnatio Dante for S. Maria Novella, Firenze)
4040A r.	Copyist 5 [Antonio the Younger]	Pile driver	*Opusculum*, fol. 19 v. (variant)
4044A r.	Anonymus [Antonio the Younger]	Geometrical compass or divider	(cf. Antonio the Younger, U 4043A r.)

Uffizi *scheda*	Artist	Machine	First illustrated in:
4045A r.	Anonymus [Antonio the Younger]	Wire drawer or a wire or nail embosser	(information received from T. Settle and P. Breni)
4045A v.	Anonymus [Antonio the Younger]	Alphabetic letters; arches	
4047A r. (*Arbalète*)	Copyist 6 [Antonio the Younger]	Winch on ramp; siphon; scaling ladders; column transport (originally fol. 51)	Notebook, fols. 59 v., 60 r., 125 r.
4047A v.	Copyist 6 [Antonio the Younger]	Armed boat; bellows pump; pump; shield	Notebook, fols. 61 r., 61 v., 62 v., 60 v., 61 v.
4049A r.	Copyist 1 [Antonio the Younger]	Column lift; column lift	*Trattato II*, fols. 93 v., 94 r., Martini-Maltese, pls. 322, 323
4050A r.	Copyist 7 [Antonio the Younger?]	Bath: hypocaust plan; bath	*Trattato I*, fol. 23 v., Martini-Maltese, pl. 42
4051A r.	Copyist 8 [Antonio the Younger]	Gear drive for a bucket into a well	(no precedent)
4051A v.	Copyist 8 [Antonio the Younger]	Cogwheel drive for a bucket into a well	(no precedent; cf. U 4055A r.)
4053A r.	Copyist 7 [Antonio the Younger?]	Five chimney flues; oven	*Trattato I*, fols. 22 v., 23 r., Martini-Maltese, pls. 40, 41; *Trattato II*, fol. 13 r., Martini-Maltese pl. 189
4054A r.	Copyist 6 [Antonio the Younger]	Bellows pump; ship-sinking; caisson; pump; siphon; armed cart; dam	Notebook, fols. 53 v., 52 r., 54 r., 63 r., 66 v.
4054A v.	Copyist 6 [Antonio the Younger]	Boats; weight motor; dippers, oven; weight motor; wheel	Notebook, fols. 41 v., 53 r., 56 r., 55 v.?, 53 r., 53 r.
4055A r. (*Flèche*)	Copyist 9 [Antonio the Younger]	Pump 4; pump 4	(no precedents)
4056A r.	Copyist 1 [Antonio the Younger]	Gristmill 18; gristmill 19; gristmill 22	*Trattato II*, fols. 97 r., 97 v., Martini-Maltese, pls. 329, 330
4057A r. (*Sirène*)	Copyist 6 [Antonio the Younger]	Bucket-chain pump; gear-rack pump (with note); original foliation B/2	*Opusculum*, fols. 53 v., 53 r.
4057A v.	Copyist 6 [Antonio the Younger]	Dipper; aqueduct; waterwheel and sluice gate; original foliation B/v	*Opusculum*, fols. 58 r., 58 v.
4061A r. (*Arbalète*)	Copyist 6 [Antonio the	Aqueduct; aqueduct; aqueduct; lake drainage;	Notebook, fols. 113 v., 114 r., 112 v., 113 r.,

Uffizi *scheda*	Artist	Machine	First illustrated in:
	Younger]	bellows pump; fishpond	106 r., 105 v., 99 r.
4061A v.	Copyist 6 [Antonio the Younger]	Bridges on boats; on barrels; column transport; oxen; pile driver; dam; siphon	Notebook, fols. 107 r., 122 v., 117 v., 54 v., 115 r.
4062A r. (*Arbalète*)	Copyist 10 [Antonio the Younger]	Underwater weapon; underwater weapon	Notebook, fols. 8 r., 8 r.
4062A v.	Copyist 10 [Antonio the Younger]	Underwater weapon; underwater weapon	Notebook, fol. 7 v.
4063A r.	Copyist 10 [Antonio the Younger]	Four underwater traps; aqueduct	Notebook, fols. 9 r., 117 v.
4063A v.	Copyist 10 [Antonio the Younger]	Two underwater traps; trebuchet	Notebook, fols. 6 r., 8 v.
4068A r. (*Arbalète*)	Copyist 10 [Antonio the Younger]	Pile driver; trebuchet on boat; armed ship; armed ship	Notebook, fols. 100 r., 68 v., [. . .], 60 r.
4068A v.	Copyist 10 [Antonio the Younger]	Bale-lifter to boat; armed ship; ship trailing another; armed ship	Notebook, fols. 4 r., 60 r., 91 v., 47 v.
4069A r. (*Arbalète*)	Copyist 10 [Antonio the Younger]	Ship-sinking; bale-lifter; ship-sinking; incendiaries; traps; rocket on boat	Notebook, fols. at random
4069A v.	Copyist 10 [Antonio the Younger]	Ships; boat with fire; ship-sinking; drill for boat-piercing	Notebook, fols. 41 v., 47 v., 51 v., 62 r., 69 v.
4070A r. (*Arbalète*)	Copyist 10 [Antonio the Younger]	Harbor defense; armed boat; armed boat; ship at dock	Notebook, fols. 12 r., [. . .], 88 r., 87 v.; *Opusculum*, fol. 45 r. (first armed boat)
4070A v.	Copyist 10 [Antonio the Younger]	Bridge in canyon; bridge on boats; ship near city	Notebook, fols. 83 r., 134 v., 91 v.
4071A r. (*Anchre*)	Copyist 10 [Antonio the Younger]	Bridge on barrels; underwater weapon	Notebook, fols. 118 v., 6 r.
4071A v.	Copyist 10 [Antonio the Younger]	Armed boat; underwater weapon; cross and chain; arrow; harbor defense	Notebook, fols. 6 r., 9 v., 5 v., 3 v., 98 r.
4072A r.	Copyist 10 [Antonio the Younger]	Armed boat; cannon on boat; forge, anvil, and harbor chains on boat	Notebook, fols. 10 v., 51 r., 83 v. (without forge); Ms Additional 34113, fol. 115 v. (with forge, anvil, chains)
4072A v.	Copyist 10 [Antonio the Younger]	Ship in dock; boats; drill; boat with drill	Notebook, fols. 87 v., 5 r., 11 r., 11 r.
4073A r.	Copyist 9 [Antonio the Younger]	Bucket-chain pump 4; gristmill 4	(cf. Antonio the Younger, U 1494A r.; Anonymus, U 4084A v., also #4 on U 1498A r.

Uffizi *scheda*	Artist	Machine	First illustrated in:
4074A r.	Copyist 1 [Antonio the Younger]	*Camini*-rooms, fireplaces; flues; turnstile gate; gristmill	*Trattato II*, fols. 12 v., 13 r., 14 r., 83 r., [. . .], Martini-Maltese, pls. 188, 189, 191, 303
4075A r.	Anonymus [Antonio the Younger]	Two identical roasting spits (?), and detail	Leonardo (?), Codex Atlanticus, fol. 5 v., *a* (identical)
4076A r.	Anonymus [Antonio the Younger]	Vise, and detail	(precedent unknown)
4077A r.	Copyist 11 [Antonio the Younger]	Hoist; roof-beam joints	*Trattato I*, fol. 51 r. (similar hoist); *Opusculum*, fol. 20 r. (similar hoist); Antonio the Younger, U 1439A r.
4079A r. (vellum)	Copyist 12 [Antonio the Younger]	Hoist with reversible screw	(cf. Antonio the Younger, U 1439A r., 1504A r., variants)
4080A r. (vellum)	Copyist 12 [Antonio the Younger]	Pump of "Toledo"	*Opusculum*, fol. 60 v.
4080A v.	Copyist 12 [Antonio the Younger]	Pump with half-rack, lantern, and cranks	*Opusculum*, fol. 52 v.
4081A r. (vellum)	Copyist 12 [Antonio the Younger]	Bucket pump with gears	
4081A v. (vellum)	Copyist 12 [Antonio the Younger]	Waterwheel with disks, gear, and reversible screw	*Opusculum*, fol. 61 r. (variant)
4082A r.	Copyist 13 [Antonio dell' Abaco]	Tower hauler; column hauler; crane, variant of Brunelleschi's	
4082A v.	Copyist 13 [Antonio dell' Abaco]	Bale-lifter; hoist; hoist	
4083A r.	Copyist 13 [Antonio dell' Abaco]	Bucket wheel A and camshaft; bucket-chain gristmill	(cf. Copyist 9, U 4073A r., variant gristmill)
4083A v.	Copyist 13 [Antonio dell' Abaco]	Gristmill; pump A	(cf. Copyist 16, U 4095A r.)
4084A r.	Copyist 13 [Antonio dell' Abaco]	Suction pump (2) and details	(no precedent)
4084A v.	Copyist 13 [Antonio dell' Abaco]	Bucket-chain pump; C-crank pump	(cf. Copyist 9, U 4073A r.)

Uffizi *scheda*	Artist	Machine	First illustrated in:
4086A r.	Copyist 14 [Antonio the Younger]	Lathe for screws; column hauler (with note)	(cf. Antonio the Younger, U 1445A r., 1564A r. (lathe); *Opusculum*, fol. 5 v. (hauler)
4086A v.	Copyist 14 [Antonio the Younger?]	Column hauler	*Opusculum*, fol. 5 v.
4087A r.	Copyist 15 [Antonio the Younger?]	Roof-beam joints (with notes)	Ms Additional 34113, fols. 52 v., 53 r., 53 v.
4094A r. (*Anneau*)	Copyist 16 [Antonio dell' Abaco]	Mill built in river; mill for grinding pigments, by Vasella in Rome (see n. 17)	(no precedent)
4094A v.	Copyist 16 [Antonio dell' Abaco]	Mill built in river (with note)	(no precedent)
4095A r. (*Anneau*)	Copyist 16 [Antonio dell' Abaco]	Gristmill; gristmill with weight-wheel (*vertibolo*) "first built in Germany now built in Rome"	(cf. Copyist 13, U 4083A v.)
4095A v.	Copyist 16 [Antonio dell' Abaco	Gristmill; mill with undershot waterwheel; gristmill with hand crank	
7836A r.	Anonymus [B. Ammannati]	Traveling crane and structural details	(cf. Antonio the Younger, U 1439A v., 1449A r.; Anonymus, or Giovan Francesco da Sangallo, U 1385A v.

Commentaries on the Drawings

Note on the Organization of the Entries

The entries follow the numerical sequence employed at the Gabinetto dei Disegni e Stampe at the Uffizi, Florence. Each drawing is identified by its Uffizi number which is followed by an indication of the subject collection it comes from. In the case of the drawings by Antonio da Sangallo the Younger and his circle, all are from the architectural collection ("Architettura") and are thus identified by the letter A. We have used the designation "U" (for Uffizi) only for the first drawing in a sequence or a drawing referred to singly.

While every effort has been made to regularize the forms of transcription used by the authors, some variations are inevitable. For example, on sheets with multiple subjects, notably those dealing with machinery, it has been the practice for the sake of clarity to link the transcription of the short identifying captions provided by the Sangallo workshop with the identification of the drawing by the scholar.

The designation "recto and verso" is used in the heading when we have reproduced both recto and verso, having judged that both faces of the sheet merit reproduction. In cases where only a brief text is found on the verso the scholars have been asked to transcribe the text but no reproduction of that face is provided. In those instances a sheet is referred to as "recto" only. Mathematical inscriptions have not been transcribed unless judged of special relevance.

Division of the sequence of drawings by subject, both for the purposes of the entries and for the format of the volumes, is a result of the vast size of this undertaking. In some instances drawings that contain annotations related to subjects ostensibly covered in this volume have had to be reserved for a subsequent volume. By and large, we have tried to follow the principle that the main subject of the sheet determines its location within the corpus. Despite our best intentions this principle of order has not always been respected.

The first lines of each entry give the author, subject, and approximate date of the sheet. Next follows a summary of specifications. Dimensions (height and width) are expressed in millimeters, measured from the bottom left corner; irregularly cut sheets are so described; if opposite sides of a sheet differ in length, both measures may be given, separated by a slash (/). References to "white paper" are assumed, since it was the standard medium used by the Sangallo workshop. Restorations to the sheet may be noted. A table of watermarks, compiled by Heinrich Wurm, will be published in Volume Three.

In the Inscriptions, brackets around three dots indicate an illegible word or phrase. A slash (/) is used to mark a new line. Semicolons indicate discrete words or groups of words.

The authors are identified by initials at the end of each entry. In the case of division between the authors by a slash (/), it assumes collaboration between the authors. In the cases where initials have been divided by a comma (,) the entries have been combined by the editors. In the case of the entries by Fagiolo and Morolli, the description of the drawing was undertaken by Morolli and its interpretation by Fagiolo.

N.A. = Nicholas Adams
E.B. = Enzo Bentivoglio
F.Z.B. = Fabiano T. Fagliari Zeni Buchicchio

U 112A recto and verso

ANTONIO DA SANGALLO THE YOUNGER

Project for the exterior face of the arch before St. Peter's
(recto). Notation concerning the statues and their
decoration for the arch before the Palazzo di San Marco
(verso). Rome, before April 1536.

Dimensions: 274 x 272 mm.
Technique: Pen and brown ink.
Paper: Well preserved, lightweight.

INSCRIPTION, Recto: (at top) *per la porta di santo pietro in
cima le scale / tetto;* (bottom) *Le due storie acanto li epitafj in
tondo / se fanno a stare le armi del papa e sue allo / epitaffio
sopra la porta come a stare / allo epitaffio di sopra come a
stare / le cinque statue in cima quali anno a essere;* (at right)
Larchitrave la dodecima / parte dellalteze delle / cholone
Verso: *Due storie a canto allo epitaffio alto palmi 10 lungo /
Due storie dalle bande dell archo alte palmi 13 ½ large / Le
storie sotto l'archo palmi 10 e uno terzio / alte palmi 15 / laltre
storie pure sotto larcho longa palmi 31 lalte palmi 15 / Le dua
statue in sulle colonne / Le quattro statue sopra le colonne
dinanzi / Le due statue in sulle colonne di dietro / Le cinque
statue in cima la phaccia dinanzi / Le cinque statue in sula
faccia de rieto / in li epitaffi dinanzi lettere / in li epitaffi di
rietro lettere*

The three ancient entrances to the Vatican basilica
(recto), framed by four columns, are decorated to
form a kind of triumphal arch (on the right) and a
facade with the volute joining the central parts to the
wings (on the left). Both solutions specify the areas where
inscriptions, decorations, and statues are to go. The most
significant measurements specified in the drawings are
those that belong to the diameters of the columns (7
and 6 *palmi*) and that which notes the height of the
roof, which is measured from the summit of the attic.

The drawing at the right (closest to what was ulti-
mately built) is similar, though in simplified form, to
the projects of Michelangelo for the facade of the
Church of San Lorenzo, Florence.

This sheet was once identified as a drawing for the
western apse of the Church of St. Peter's (Giovannoni)
and dated 1520–21. Antonio's project was, it seems,
substantially built, as we learn from the testimony of
the rare printed program entitled *Ordine, Pompe,
Apparati, et Ceremonie delle solenne intrate di Carlo
V. Imp. sempre Aug. nella città di Roma, Siena, et
Fiorenza* (1536) and from successive views. Francesco
Cancellieri (*Storia de' solenni possessi de' Sommi Pon-
tefici,* Rome, 1802, pp. 93–104) described and com-
mented on the entry of Charles V, borrowing
information from the sixteenth-century text. However,
Cancellieri introduces an error regarding the number
of columns: "Nell'entrare delle 3 porte di S. Pietro è
fatto un ornamento di 2 Colonne di granito." Vincen-
zo Forcella (*Feste in Roma nel Pontificato di Paolo
III,* Rome, 1885, pp. 35–50) notes instead that there
are four columns. In point of fact, the original source,
erroneously referred to as being in the Biblioteca
Alessandrina rather than the Biblioteca Vallicelliana in
Rome, describes the original display by Antonio da
Sangallo the Younger quite precisely: "four granite
columns (those existing) with gilded capitals, and
above that a structure with a cornice, bases, and a
frontispiece, historiated and decorated with a frieze of
beautiful pictures and above that statues of victories
holding their arms, with a Saint Peter on the top who
gives his benediction and in the middle the following
inscription: CAROLO.V.AVG.CHRISTIANAE. REIP.
PROPAGATORI."

Concerning the notations on the verso, it is possible
to refer back to the sixteenth-century booklet (cited
above) that proves that these images were present on
the "arco superbissimo" arch in front of the Palazzo
of San Marco: "in each of the fields are two Emper-
ors, and four prisoners. . . . On the peak of the fron-
tispiece there is a figure representing Rome and to
either side there are the arms of the Pope and of Cae-
sar with trophies. . . on the section of the concave
facade is painted a large story [*Historia*] of the Tri-
umph of Africa, on the face is the Battle of Goletta. In
total there are eight other images of stories on each of
the four sides: two above and two below the cornice."
Giovannoni specifies that U 914A, 1772A, and 4159A
are also for the same arch. Bruschi adds U 1269A (for
Giovannoni it is probably for the arch at Porta San
Sebastiano) and removes U 914A. In Bruschi's opinion,
the "freedom of the theme allowed experimentation
in unusual directions. . .with the reuse of old themes
but also the flowering of new proposals, often impor-

tant for future sixteenth-century developments."

BIBLIOGRAPHY: Giovannoni (1959) I: 141, 143, 310, 311; Bruschi (1984) 14.

E.B.

U 189A *recto*

Antonio da Sangallo the Younger
Castro, elevation of the facade of the Zecca, 1537.
Dimensions: 424 x 297 mm.
Technique: Pen and brown ink, light brown wash, stylus.
Paper: Yellowed, irregularly cut, edges reinforced and straightened.
Drawing Scale: palmi romani (20 *palmi* = 127 mm).

INSCRIPTION: *per la zecha di Castro; si pofare come / questa banda / o come laltra / secondo la co/modita delle / pietre grande / o pichole;* (in Roman letters, by later hand) *M. ANTONIO DA SA SANGALLO*

The representation of the Zecca in Castro derives from the facade of the Zecca in Rome though without following it precisely. The splendid triumphal-arch motif of the Roman palace is adapted here to the narrower central bay. For the dovetailing of the rustication above the lintel, see Antonio the Younger's copies on U 779A r. and 888A r. Alternative rustication patterns are shown.

From what remains of the Zecca in Castro we learn that the upper story followed the design rather closely. In the large coat of arms and the two smaller ones, Pier Luigi Farnese's *gonfaloniere* device was added between the lilies. The lower story was made higher, with the round-headed entrance, no windows, and rustication like that in the right half of the drawing. On U 297A r., g, the Zecca is shown with a round-headed entrance whose height was to be equal to that of the loggia. But the facade of the Zecca, narrow because of its location, did not permit this. The relationship of the two stories was so altered during construction that the lower story lost its pronounced character as socle. No trace has been found of an inscription such as that noted on U 297A r., g. For the reconstruction of the facade by Hofman and Willems, see Giess (1981).

BIBLIOGRAPHY: Ferri (1885) 23; Giovannoni (1959) I: 298; Aimo, Clementi (1971) 61–63; Fiore (1976) 83; Giess (1981) 90–95, 135.

H.G.

U 271A *recto*

Antonio da Sangallo the Younger
Perugia, Rocca Paolina, upper fortress, summer 1540.
Dimensions: 1678 x 902 mm (ca.).
Technique: Pen and brown ink, pin, brown wash, red wash, red chalk, pencil, stylus, straightedge.
Paper: Heavy, made up from at least four overlapping sheets, on modern support, extensively folded and repaired (see figs. A, C). Two varieties of watermark indicate assembly of drawing from different batches of paper.
Drawing Scale: Roman *palmi* (100 *palmi* = 158 mm).

271 R
Original pagination
SCALE 5x5 units
50 (palmi) = 7.9 cm.

———— = original joins
- - - - - = modern joins
X = watermark location

Fig. A

271 R.
Key to transcription

Fig. B

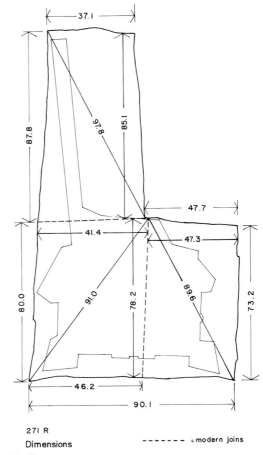

basamento; *scarpone;* (24) *scarpone;* (25) *muro di tevertini;* (26) *Qui non si trova fonda/mento per questo si ritira / in dietro al muro antico;* (27) *Ripa;* (28) *orto di cecho porcho / quale ruina;* (29) *portone / di Santo Savino;* (30) *strada;* (31) *loggia;* (32) *case de privati*

Verso (not reproduced; darkened areas indicate that the sheet was used as a support for other drawings numbered 235, 97, 232).

271 R
Dimensions - - - - - - - = modern joins

Fig. C

INSCRIPTION, Recto—see fig. B: (1) *Qui finiscie la muraglia / della terra nel corritoro; muro della terra;* (2) *questa scala viene sotto el piano del coritoro / coperto;* (3) *Andito di corritoro* (left toward corridor); *Loggia del pa/lazzo donde si par/te el corritoro* (at edge of street); (4) *pozzo; questo si e lo migliore pozzo / di perugia e lo piu abondante / de aqua viva quale viene / conpreso nelli palazzi;* (5) *Arco di marzo; archo;* (6) *palazzo;* (7) *alla porta della archo;* 232 (number written upside down); *alla punta del baluardo di terra al alto in la cima;* (8) *197 Dal angolo ablangolo;* (9) *scarponi; in basamento; scarpa;* (10) *scarpetta;* (11) *Palazzo del Signore gentile;* (12) *insola di Case [. . .];* (13) *strada va alla piaza sopra [. . .]; io* (on the white); (14) *[. . .] di case;* (15) *La strada vechia se a allargare della [. . .] / perche scopre tutte la torre di mezo ach[. . .]rire / ne al palazzo per ditta strada;* (16) *strada vechia / stretta* (Note: *A* and *B* serve as setting-out points for dimensions); (17) *Questo non e / fatto a Cavaliere / la terra di / [. . .] mezo lo fonda/mento; Questo fondamento si / e sopra terra palmi 10;* (18) *queste mura sono alte sopra alpiano / della piaza nuova palmi 20 & la piaza nuova e piu alta che non era / prima palmi 15;* (19) *palazzo del Signore braccio in parte / e parte dalla sapientia nuova;* (20) *strada nuova che va in piaza / de signori; insola di case;* (21) *insola di case;* (22) *Chiesa de Servi;* (23) *scarpa* (inner red wash); *in*

The construction of the Rocca Paolina, Perugia, represents a key phase in the reestablishment of papal control within the Church States following the disaster of the Sack of Rome (1527). Faced by rebellious Perugian nobles, led by the Baglione family, Paul III ordered the construction of a fortress and armed palace to serve as administrative-military headquarters for the papacy. The general model was the Vatican Palace–Castel Sant'Angelo, connected as in the Roman example by a flying corridor.

Work began June 1540 over the houses of the Baglione family and a vast section of the city. Local administrative control was maintained by the papal legate the Bishop of Casale, Bernardino Castellario,

called Monsignor della Barba, who had been responsible for overseeing the fortress at Ancona begun in 1532 under Clement VII and completed under Paul III. Although earlier projects for a fortress in Perugia had existed, drawn by Pier Francesco da Viterbo and (possibly) Maestro Francesco da Macerata from as early as 1537, it has not been possible to determine their influence on the work of Antonio the Younger. A note on U 272A refers to a small bastion that may have formed earlier work by Maestro Francesco; it seems not, however, to have been part of a plan of the scale of Antonio's fortress. (It is possible that U 1899A, attributed by Giovannoni to Bartolomeo de' Rocchi, may reflect an early plan.) Given the comprehensive nature of the early graphic record, Antonio da Sangallo the Younger seems to have been largely responsible for the design of the original fortress. In addition, Antonio also undertook a survey of the defenses of the city.

Work moved speedily at first. On 28 June 1540 the destruction of the Baglione houses was begun and in August of the same year another twenty-five houses were demolished. According to contemporary writers, during his visit to Perugia of September 1540 Paul III seems to have expressed displeasure at the civic nature of the upper level of the project as it was developing: "Seeing the palace already begun with its high walls and iron-grated windows he said that it was not enough, I want you to make a fortress here." In place of Antonio the Younger's original design, recalling the Vatican and Castel Sant'Angelo complex with a palace-like facade directed toward the city (see U 1021A, 1510A), and a balance of civil and military values, a more powerful military effect was created. Antonio's role in the creation of the architecture of this phase of construction is unclear. Camerieri and Palombaro (1988) argue that Antonio made no contribution to this phase, but the fact is that evidence is lacking one way or the other. The absence of drawings from this second phase may mean only that they have been consumed in the construction process. Almost all the drawings date from the first period of site examination and project development, but there is no evidence for a second designer and it seems more likely that Antonio (or members of his shop) provided further drawings, now lost, before he moved on to other work around the summer of 1541. In the succeeding entries we will attempt to place the drawings, both topographically and chronologically.

U 271A recto is an enormous plan of the upper section of the Rocca Paolina as originally planned in 1540. It shows the section that would have faced the town, centered on the present-day Via del Forte, with its two bastions, the Porta Marzia (see U 1043A), sections of the preexisting houses of the Baglione family, and the corridor descending along the south face. The annotations reveal much of the plan of the earlier city and the Baglione palaces.

This sheet is a superb example of a kind of drawing that must have been relatively common on fortification and architectural sites during the Renaissance. It provides an overall plan of the fortress and the significant major measurements that would have been elaborated, possibly at a vast display table on site, with detailed drawings of individual elements. Heavy annotation was a necessity due not only to the complexity of the subject, but also to the fact that the drawing would have to be consulted by a variety of workmen. Drawings such as U 271A and its complement, U 272A, are so big (almost 1 m x 1.75 m) and fragile (note that the former is made from four smaller sheets glued together in an L shape) that they tend to be lost, either through the construction process or in later mishandling.

The verso reveals traces of glue and pen-and-ink numbers executed in the eighteenth or nineteenth century; the numbers refer to drawings that were once attached to the sheet.

BIBLIOGRAPHY: Ferri (1885) 110; Bacile di Castiglione (1903) 354 n. 1, 359; Giovannoni (1959) I: 355; Grohmann (1981a) 90–104; Camerieri, Palombaro (1988) 44, fig. 25.

N.A./S.P.

U 272A *recto*

ANTONIO DA SANGALLO THE YOUNGER
Perugia, Rocca Paolina, plan of the lower fortress, called San Cataldo, summer 1540.

Dimensions: 1907 x 450 mm (ca.).

Technique: Pen and brown ink, pin, straightedge, brown wash, red wash, gray wash, red chalk; modern pencil additions strengthen original annotations. Drawing pricked at major angles.

Paper: Heavy, made up from eight overlapping sheets; original sheets 442 x 733 mm, extensively folded, repaired, and fragmented at edges.

Drawing Scale: Roman *palmi* (100 *palmi* = 154 mm).

INSCRIPTION, Recto—see fig. B: (1) *Scarpone deli corritore dove* [. . .]; (2) *sopra al / cordone*; (3) *24 in fondo*; (4) *in sula resta di fondo 57*; (5) *Per la pendentia*; (6) *In sula pendentia / del puntone*; (7) *Dal piano terreno / fino allaqua sono / palmi 150 / Largo palmi 114 / e palmi 26 /* (written in modern pencil at side) *de aqua viva*; (8) *pozo vivo*; (9) *questo si a/riforsare*; (10) *in sulla resta di fondo* (written in modern pencil at side);

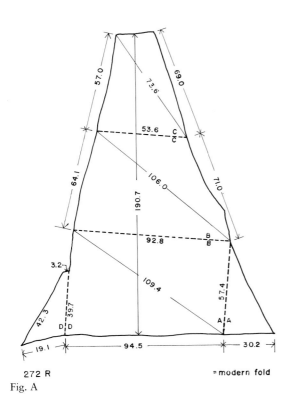

272 R = modern fold

Fig. A

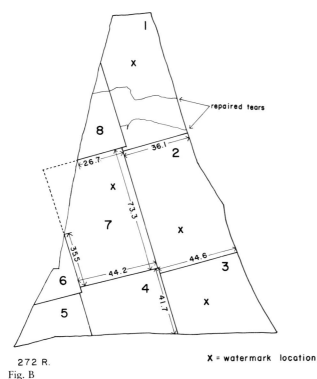

repaired tears

272 R.

Fig. B X = watermark location

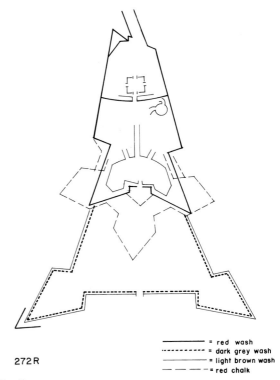

272 R

Fig. C

—————— = red wash
- - - - - - = dark grey wash
·········· = light brown wash
— · — · — = red chalk

(11) *in sula cordone;* (12) *Questa facciata* [. . .] *della torre;*
(13) *Questa faccia va* [. . .] *al cantone della torre di fuore
diverso Santo arcolano /* [. . .] *in la fasciata* [. . .] *fare
girolamo bartini discosto dal cantone del baluardetto astutto /
Maestro francesco da macerata cioe allo spigolo del cantone
del fianco palmi* [blank]; (14) *muro* [. . .] *ano vvero della
cittj* (similar to 21); (15) *al pie / della scarpa in / la rocha;* (16)
Dove si trova / adesso palmi 14; (17) *pie della scarpa in sulla
Resta;* (18) *Mulino subterraneo;* (19) *Stantia per farina;* (20)
stalla per lo ca/vallo del mulino; (21) *muro vechio della terra;
Terra pieno;* (22) *muro vechio;* (23) *rinculate Coperte;* (24)
voltette per stare lartiglieria al coperto e rinculate; (25) *intorno
per centtro del cava/liere;* 66 *in sul cordone* (below wall); 66 *in
sul cordone;* (26) 217 *in sul cordone* (inner edge of wall); (27)
Piazza alta piu / chella bassa palmi 25; (28) *Questa Piazza
Bassa si e piu basa che quella di sopra / palmi* 25; (29) *fosso
basso Canne* 3 (outside walls); *scarpa di muro* (on red wash);
Muro (on the lighter gray outside); (30) *scarpa del bastione di
terra* (outer wall, lighter gray); *Bastione di terra in cima* (inner,
darker gray); (31) *Dallangolo della scarpa insulla resta del
baluardo / della rocha segniato A fino allangolo / del bastione
segniato B cioe in cima / dove se trova adesso sie palmi* 514;
(32) [. . .]*sione* (inner, darker); *scarpa del bastione* (outer,
lighter); (33) *muro fatto in questa punta* (outer, lighter); *scarpa
di muro* (in the red); (34) *palmi* 220 *in cima alluno angulo
allritto;* (35) *Dalla punta deluno de baluardi in cima alla punta*

dellaltro cio li bastioni di terra per linia retta sie palmi 834; (36) *Bastioni* (inner); *scarpa di terra* (outer); (37) *Bastioni di terra* (inner); *scarpa di terra* (outer); (38) *208 in cima* (inner) [. . .] *di terra* (outer) [. . .]; (39) [. . .] (possibly erased?); (40) *Bastione in cima;* (41) *Bastione di terra 151* (inner); (42) *scarpone di terra dove si apogia el muro* (outer); [. . .] *faccia del bastione in cima alta palmi 40* (outer gray); *scarpone di terreno dove si appoggian el muro* (outer); (43) *Muro* (within wall); *166 palmi dal cantone del fiancho fino / dove* [. . .] *della facia de / baluardo di terra cioe della cima* (on red); (44) *Bastione* (inner gray); *Muro* (outer gray); *scarpa del muro* (red); (45) *Terreno / forte cioe / tassello fino / al cordone* (left); *Terreno forte cioe tassello / fino al cordone / e sempre inmontando / verso il maschio* (right); (46) *santo cataldo* (bomb shelter, inner); (47) *Buttafuochi; Buttafuochi;* (48) *99 allangolo sopra alcordone;* (49) *questa piazza si e bassa / che quella di mezo palmi 40;* (50) *344 sopralcordoni*

Verso (not reproduced; darkened outlines indicate that the sheet was used as a support for other drawings numbered *755, 320, 321*). *Linia va alla punta del palazo vechio del signiore Gentile quale baluard/etto di Santo Sallustio che ha fatto mastro Francesco da Macerata; dal maschio; 90 palmi; angoli; gola; san angelo—166 al di sopra del mura alto 36 palmi*

272R

Fig. D

U 272A complements 271A and shows Antonio the Younger's proposal for the lower half of the Rocca Paolina, the fortress of San Cataldo, linked by the flying corridor to the upper fortress. Some preexisting structures are marked, annotated, and shown more faintly below the solid brown wash that defines his alternative proposal: A hornwork lies within a crownwork (in brick), which is in turn subsumed within a larger hornwork (in earth). The proposal fans out across the hill well below the present-day Piazza Partigiani, the location of the termination of the Rocca Paolina as it was built. The great earth hornwork would have been reinforced with brick at the corners as is shown by the red wash at the salient angle. It is remarkable in a drawing of this scale, one that almost assumes a definitive state to the project, that Antonio is still showing alternative proposals.

Colored wash, now greatly faded, is used to code the materials proposed for the construction. Red is used for brick or masonry, brown is used for earth, gray is used for masonry or earth. A key to the colors is provided. As in U 271A, the annotation is extensive. A well (8), an underground mill (18), a stable for the horse that operates the mill (20), and a storehouse for flour (19) are shown. Protection is provided by the bombproof vaults for the gunners serving the cannon (24). Of particular interest is a reference (13) to an onsite work ("un baluardetto") by Francesco da Macerata, who preceded Antonio the Younger at Perugia (see U 271A).

Antonio the Younger's hand is not evident on all parts of the drawing. Much of the actual drawing probably was done by Jacopo Melighino, who was on site with Antonio in June 1540. It would be interesting to know who designed the crownwork (in red chalk). The hand is not that of Antonio the Younger, although there is no reason to think that it was not his idea.

Like U 271A, this sheet was also once used as a backing sheet for other drawings (see numbers on the verso).

BIBLIOGRAPHY: Ferri (1885) 110; Bacile di Castiglione (1903) 359–60; Giovannoni (1959) I: 81, 355, 413; II: fig. 367; Grohmann (1981a) 104; Ghisetti-Giavarina (1986) 399; Camerieri, Palombaro (1988) 43, fig. 27.

N.A./S.P.

U 294A *recto*

ANTONIO DA SANGALLO THE YOUNGER
Castro, measured plan of the walls, ca. 1541.
Dimensions: 290 x 430 mm.
Technique: Pen and brown ink.
Paper: Yellowed, folded twice, reinforced at the creases.
Drawing Scale: canne and *palmi romani.*

INSCRIPTION: (large sketch, upper right) *alla casa coperta* / *acanto al chusarino*; *la punta del baluardo* / *puo uscire piu che la casetta* / *p[almi]40; casarino* / *della capretta; torritta; alla* [. . .*ri?*] *va; alla casetta* (twice); (across center fold, reversed) *porta;* 106 [*canne*] *el tutto;* 1400 [*palmi*] *el tutto;* (in the small sketch) *fianchi piomba/tori p[almi] 10 in giu*

The entire circumference of the city is roughly sketched in. Following the terrain, the city is measured in sections oriented by means of letters and numbers. The numbers correspond to the eight divisions of the compass, each section divided into 20 degrees. T stands for Tramontana (north), G for Greco (northeast), ŏ or + for Levante (east), S for Scirocco (southeast), O for Ostro (south), L for Libeccio (southwest), P for Ponente (west), and M for Maestro (northwest). (The same division of the compass is found on U 771A–774A.) On the long sides, the measurements closely follow the upper edge of the steep slope, which affords natural protection for the city (see "Castro and Nepi" and Soldati's plan, fig. 1). Only at one point, about the middle of the lower edge, is the line following the upper ledge of rock crossed out with hatching and a lower terrace measured instead. On the opposite long side, particular care is taken with the measurement of the outcropping of rock, where the defenses of the Porta di sotto were to be placed (see U 750A r., upper half). The land bridge and the Porta di sopra (smaller short side) are defended by a great bastion whose flanks are in turn protected by two smaller bastions (see U 295A). On the opposite short side, the terrain drops off more gently and more irregularly, and the line of fortification is not yet fully established. The "baluardo" referred to here is intended as protection for the Porta di Santa Maria, which was later walled up.

BIBLIOGRAPHY: Ferri (1885) 23; Vasari-Milanesi (1878–85) V: 500; Fiore (1976) 81; Polidori, Ramacci (1976) 80; Giess (1978) 75, 76, 80; Clementi (1986), 347; Fiore (1986) 341.

<div align="right">H.G.</div>

U 294A *verso*

ANTONIO DA SANGALLO THE YOUNGER
Castro, machines for water movement, ca. 1541.
Dimensions and Paper: See U 294A recto.
Technique: Pen and brown ink.

Left half: (a) Note (upside down, refers to recto) *Pianta di Castro.* Right half: (b) Pump with crank-wheel. (c) Pump, detail of water channel (*standufo*) and ball (*palla*). (d) Pump, detail of pipe (*canna*).

INSCRIPTION: (at *c*) *Non succiando lo* / *standdufo non veria* / *su so e necessario* / *lanimella in fondo* / *li standuffi Si nota li* *den/ti del fuso sino nove* / *intorno e sieno tre denti* / *per standufo In le canne* / *che vanno in la fistola* / *sia una palla di* / *preta* / *o metallo che giochi in cambio* / *danimella;* (at *b*) *Busi* *senza ani/melle alti fino* / *al di sotto dello stan/dufo* / *quando* *sie* / *alzato su quanto puo*

This hand-cranked pump possibly was located in Castro. Antonio's notes can be translated as follows: "If the *stantuffo* does not raise the water sufficiently, a valve will be needed at the bottom of the *stantuffo*. Note the wheel has up to nine teeth, three each for a *stantuffo*; the tube that goes in the pipe should have a rolling stone or metal ball in place of a valve. Holes without valves are as high as the underside of the *stantuffo*." The technical elements, at *c* and *d*, may or may not have the modern meaning of "compressor"; the terms had various uses among hydraulic engineers. For example, another drawing (U 847A v.) names the *stantuffo* as the perpendicular line attached to a wheel, and its note indicates two of them attached to the wheel. In another case (U 847A r.) it is mentioned again for a gear rack in ellipse, which has the ball in place of a valve mentioned above.

BIBLIOGRAPHY: Ferri (1885) 23, 91.

<div align="right">G.S.</div>

U 295A *recto*

ANTONIO DA SANGALLO THE YOUNGER
Castro, fortification of the land bridge, the "Puntone," with cost estimate, ca. 1541.
Dimensions: 229 x 217 mm.
Technique: Pen and light brown ink, corrected and redrawn with dark brown ink, scored with a straightedge.
Paper: Stiff, slightly yellowed, cut at edges, modern support.
Drawing Scale: canne di Castro.

INSCRIPTION: *Puntone di Castro* (piece of paper, glued on later); *per fare questo puntone con questi due mezi* / *baluardi* *vanno longi Canne 150* / *alti Colli fondamenti Canne 10 grossi* / *raguagliati grossi piedi 7½ (palmi 10* canceled) / *raguagli/ati* *Canne di Castro (romaneschi* canceled) 7500 *a ratione* / *di julij* 7½ *la canna monta scudi 5625*

In response to suggestions for fortifying the land bridge of Castro by means of a pincer formation (see U 813A r., 752A r. and v., and 753A r.), the solution proposed on U 751A r. is adopted here: a great central bastion to which are added two *mezi baluardi* (see also U 294A r.). It is datable after 3 October 1541,

when experts were consulted in Castro (see "Castro and Nepi"). The fortification is given the abstract, ideal form of a pentagon, without consideration for the terrain, and its costs are calculated on this basis: The length of the wall, 150 *canne*, is multiplied by its height of 10 *canne* and, because of its thickness of 7½ *piedi*, by a further factor of 5 (*raguagliati*, for which I am indebted to Dr. Fagliari Zeni Buchicchio). The total equals 7500 *canne* of masonry at 7½ *giuli* = *scudi* 5625, at the rate of 10 *giuli* per *scudo*. In his text Antonio substituted *canne di Castro* for *canne romaneschi*. Practically, the difference could not have been great, since the length of a Castro foot in 1611 was ca. 333 mm, in today's measurements (see Andrews, 1978, p. 410). The length of the scale recorded for Castro in Valentano (ca. 3.70 m) cannot serve as a substitute here for a *canna di Castro*, because the Castro land bridge is not much wider than 100 meters (see Antonio's calculations on U 913A r. and the figures given in Gardner-McTaggart).

BIBLIOGRAPHY: Ferri (1885) 23; Vasari-Milanesi (1878–85) V: 502; Giovannoni (1959) I: 81; Fiore (1976) 81; Andrews (1978) 410; Giess (1978) 75, 80; Fiore (1986) 341.

H.G.

U 297A *recto*

ANTONIO DA SANGALLO THE YOUNGER
Castro, projects for the north side of the piazza, 1537 and
 later.

d e f g

 a b c

Dimensions: 289 x 439 mm.

Technique: Pen with light and dark brown ink, red chalk, stylus.

Paper: Slightly yellowed, folded twice, badly worn at the edges and creases, cut, reverse side glued on.

Drawing Scale: palmi romani.

INSCRIPTION: (lower left, almost totally blurred) *palazo del podesta*; (a) *palmi 296*; Canne 30 (30 canceled); *porta* (three times); (upside down, but not by Antonio) *la volta grossa duj palmj*; *Cortile in volta di mattoni*; *Destri* (twice); *scarpa* (twice); *muro*; (d) *matonata in coltello*; (e) *Scalino* (twice); (g) *P LUIS*; *zecha*

In addition to numerous corrected preliminary sketches, the sheet includes some precisely measured detail drawings that must have immediately preceded construction.

At *a*: The long side of the piazza is subdivided into thirteen arches, the central one leading into the courtyard of a palace. Shops are set into the remaining twelve, whose clear width is reduced from 20½ to 18. The distance between the centers of the arches is reduced from 20½ to 20, i.e., the width of the arches does not correspond to the space obtained by the subdivision but rather is reduced by Antonio the Younger to dimensions conforming to his scheme of proportion (see U 750A v. and 1199A r.). In addition to the ground floor (a large courtyard with laterally adjoining rooms and two staircases), the ground plan of the palace indicates underpinning required by the drop of the terrain (see U 732A). The four piers in the open courtyard, together with their accompanying crosses, refer to the stables below. The hatching over the lateral rooms and the crosses behind and over the middle six shops and seven arches indicate the upper story. (For further planning of the palace, see U 299A, 742A, and 750A v.)

At *b*: The first elevation of the arcade and *piano nobile* shows that Antonio derived his ideas from the Piazza dell'Annunziata, Florence, substituting piers for the fifteenth-century columns. At *c*: a Doric arcade and a changed form of window. At *d*: a cross section through half of the loggia, with the exact measurements of the actual structure and its cellar (added later).

At *e*: stairs leading from the piazza, and two half ground plans of a pilaster base and a facing pilaster base. At *f*: ground plan of the bases of a pilaster and a facing pilaster, with precise measurements for their construction.

At *g*: elevation of a Doric arch and its entablature, with precise measurements. Beside it is a sketch of the lower story of the Zecca (see U 189A) with a round-headed portal, apparently an attempt to align the opening with the height of the loggia molding.

BIBLIOGRAPHY: Ferri (1885) 23; Giovannoni (1959) I: 200, 202; Aimo, Clementi (1971) 59, 60; Fiore (1976), 82, 83, 86; Polidori, Ramacci (1976) 82; Giess (1981) 98–108, 136.

H.G.

U 299A *recto*

ANTONIO DA SANGALLO THE YOUNGER
Castro, project for the Osteria and the palace of Capitano
 Meo, ground floor, after 1537.
Dimensions: 508 x 680 mm.

Technique: Pen and brown ink, light brown wash and some red wash over the pentimenti; pin, stylus, straightedge and compass; numerous pentimenti.

Paper: Stiff, slightly yellowed and spotted, folded twice, modern support in middle.

Drawing Scale: 50 *palmi romani* = 94 mm.

INSCRIPTION: *Duca di Castro* (later hand); *Strada nova*; (left palace, the Osteria) *la porta al piano della / Strada Nuova; Tinello sotto e sopra / Cucina; Destri; stalla larga palmi 42 sotto lo piano / del cortile; questo Cortile si puo voltare / in volta in sulli pilastri e farne / la stalla alpiano della strada nuova / de retro e sara larga p[almi] 64 / e venira come li segni; salita che sara la scala / al piano della sala / sia tutto ricetto come / tiene questa carta / grande qui appresso; aria; destri; archetto; Questo Camerone sara grande / quanto piglia questa Croce / quale piglia due archi; Questa sala sara longa quanto piglia questa / Croce quale piglia 3 archi; Questo salotto piglia due archi; Strada / Bottega della osteria* (six times); *Androne della osteria; Porta della osteria; Arcone Colla Catena* (four times); (in the open space in front of the Osteria, below left) *La sala viene larga palmi 50 / facendola quanto e largo lo porti/cho e le botteghe e longa / palmi 62; Ma chi la volessi fare tanto piu / longa quanto lo porticho del / Cortile si puo fare e ven/eria larga p[almi] 62 e longa p[almi] 76;* (to left) *palazo del podesta; Palazo del podesta; strada; piaza;* (Palazzo of Capitano Meo) *Cortile scoperto; Cortile; Si potra pigliar / lume da questa / banda; Destri; La sala di sopra sara / quanto e grande qu[est]a Croce quale/ piglia 3 archi; Lo salotto sia largo quanto piglia / questa Croce quale piglia / due archi; Bottega del Capitano Meo* (four times); *Androne del cap[itan]o Meo; Capitano Meo da questa / stella in la cioe archi / cinque; Volta a vela; Arcone colla Catena* (twice); (below right, in the open space) *Porticho della piazza di Castro; Bisognia avertire che a quelli archoni / quali sono perlo traverso delle loggie sopra / delli quali ci va sopra li muri delle sale / bisognio farli tanto grossi quanto potranno / venire fino al piano de mattonati e in / ciascuno murarci una Catena di / ferro di peso di 7 libbri el palmo almeno / e ce ne vole 6 cioe dove e scritto Catena; Piazza;* (to the right) *Casa di Scarmuccia; Strada che va al vescovado; La zecha*
Verso: *Duca di Castro* (twice)

This drawing shows a plan for the construction of the north side of the piazza of Castro, following U 297A and 732A. There were to be located arcades and shops and behind this, two palaces: the residence of the duke (the Osteria) and that of Capitano Meo (official residence?). Pentimenti and inscriptions show that technical problems pertaining to the loggias were already under discussion while the buildings were being designed. There are drawn and written references to three different stories: the basement ("Strada nova" and "stalla"), the ground floor, and the *piano nobile* ("piano della sala"). Reference is made also to a superstructure over the Strada nova. See also the continuation of the project on U 742A ("la carta grande

qui appresso"). For Bergmann's attempt at a reconstruction, see Giess (1981), pp. 104, 105. The loggias and shops and their cellars were built in 1540–45 in accordance with this plan.

BIBLIOGRAPHY: Ferri (1885) 23; Vasari-Milanesi (1878–85) V: 500; Giovannoni (1959) I: 200, 202; Aimo, Clementi (1971) 49, 60; Polidori, Ramacci (1976) 83; Fiore (1976) 82, 83, 86; Giess (1981) 101–6, 136; Gardner-McTaggart (1985) 113.
<div align="right">H.G.</div>

U 301A *recto and verso*

ANTONIO DA SANGALLO THE YOUNGER
Rome, studies for the fortification of the north slope of the Campo Marzio from Castel Sant'Angelo to the Porta Pinciana, for the Porta San Sebastiano and Porta Latina, and the elevation of a Doric gate, 1537.
Dimensions: 292 x 440 mm.
Technique: Pen and brown ink.
Paper: Folded in half and restored edges and patches.
Drawing Scale: measurements on the verso in Roman *palmi* and quarter *palmi*.

INSCRIPTION, Recto: *Castello; cittadella; Lausto; Basso; via Lata; Collina; muraglia; questo e necesario pigliarlo per tore lo locho al nimico che ofenderebbe al basso; Capozucha; abate De / Bufalini; tempio; trinita; muraglia vechia; valle; questo fianchegi la muraglia / sino aporta pinciana; muraglia / vechia; mura/lia ve/chia*
Verso: (*a*, upper left) *valle presso aporta latina; porta / Latina; nelalto; valle; nel monte / Cavaliere /che aiuti; nelmonte / Cavaliere / che aiuti;* (*b*, upper right) *tempio; trinita;* (*c*, lower left) *per la porta; q[uar]ti 86; quarti 50;* (*d*, lower right) *Santo Sebastiano*

The recto contains a proposal, not in scale and rather freely drawn, for the new defenses of the Campo Marzio on the north slope of the left bank of the city. Antonio the Younger here indicates the major topographical elements on the site that will be taken into consideration as part of the design for the new defenses. The Porta Flaminia, with the antique walls and the complex of Santa Maria del Popolo, remains outside as is done at the Porta San Paolo and for Testaccio on the south slope; both of these areas were sparsely inhabited. Here the bastioned front begins on the right bank at the Castel Sant'Angelo, which is surrounded simply by a moat and without the additional defenses that Antonio would later design. It then continues up to the Tiber and a long straight curtain meant to contain a citadel in the bend of the river, much like the one envisioned by Antonio's uncle Giuliano da San-

gallo for Pisa. Across the Tiber, a pair of bastions protect a recently opened gate on the Via Ripetta; one is next to the gate, the other stands on the Mausoleum of Augustus ("Lausto"). From here the design presents two options, the first internal, the second external. According to the inscription, the latter is preferred. The more internal, in fact, would advance only to the level of the Mausoleum of Augustus and, after opening onto a gate between two doubled flanks on Via Lata, would be defended by a bastion on the ridge of Trinità dei Monti, corresponding to the Orti Luculliani; it would continue, using the Aurelian walls, toward the Porta Pinciana where the last bastion is located. This is an interesting proposal because of its reduced scale, but an improbable one for several reasons: (1) the difficulty of doubling the flank of the first bastion due to the lack of space between the mausoleum and the Via Lata; (2) the difficulty of constructing the semicircular reentrant between the second bastion and the Aurelian walls; above all, (3) because it would be exposed to bombardment from the heights not included in the circuit. The proposal for a more extended system presents the advantage of a large advanced bastion, with a circular cavalier and a raised interior section, on a site owned by the Capizucchi, that could defend the Porta Flaminia and the hills in front, while a diagonal linking scarp would provide a better solution for the embrasures in the semicircular reentrant. Note that the so-called Capozucha bastion did not extend, as Rocchi asserted (1902), up to the approaches of Monte Parioli, but only to those of the Pincio, which can be confirmed by noting the presence of the Aurelian "muraglia" toward the Porta Flaminia beyond its most external face.

On the verso, at *b*, the solution is further improved by the articulation of the new Porta Ripetta, the bastion at the Mausoleum of Augustus, and the bastion moved to the limit of the Pincio in the form of pincers, or "the tail of a kite" (bird with a forked tail), as Castriotto was to call it shortly thereafter, taking credit for having thought of it first at Sermoneta. In fact, Antonio proposed it for Castro around 1537 (U 751A, 752A, 753A, 813A), and it was built with variations on his plan at Rocca Paolina, Perugia (Camerieri, Palombaro, 1988). At *d* is a small sketch for the defenses of the Porta Appia, or of "Santo Sebastiano," more complete and precise, even in the outline of the ancient walls, than that of U 892A v. The bastion beyond the curve of the walls would defend the nearby Porta Latina as well, beyond which, as in *a*, the new walls would be detached to form a pincer

around the external ridge in front of the Porta Metronia. This solution, examined in two successive, overlaid sketches, would include once again the introduction of hidden embrasures on an angle within a trapezoid or semicircular withdrawn area, as in the external side of the Pincio, and of an intermediate platform beyond two recessed cavaliers, one inside and the other outside the Aurelian walls. On the other hand, study *c* "per la porta" must refer to the new Porta Flaminia on Via Lata or Ripetta, needed for the new Campo Marzio fortifications, since both the Porta San Sebastiano and the Porta Latina have double, ancient arches, and it is unthinkable that Antonio would have wanted to replace them with something new. It is equally difficult to accept the idea that Antonio was already working on solutions for the Porta Santo Spirito in 1537 on this sheet, even if the width of the arch of the Porta Santo Spirito as ultimately built (27 *palmi*) is close in width to the arch indicated in the drawing (28 *palmi*). In the actual building the flanks are wider. As can easily be seen, even the intercolumniation is different here (13:5 with respect to the diameter of the columns, whereas in the Porta Santo Spirito the ratio is 15:4, due in part to the insertion of a lateral niche). Furthermore, the proportion of the columns, including base and capital, is 5:37,5 *palmi* here—that is, 1:7,5—whereas it is 1:8,5 in the Porta Santo Spirito itself. These more narrow proportions led Giovannoni (1959) to identify the gate mistakenly as Ionic or Corinthian, similar to other examples such as the studies for triumphal arches in honor of Charles V made by Antonio in 1536 or the study for the Porta Lamberta in Castro (U 750A r.) around 1537.

In his design for the Porta Flaminia, or Porta Ripetta, Antonio has also solved the problem of the Doric entablature jutting out over the columns, with a frieze of metopes (15 quarters of a *palmo*) and triglyphs (10 quarters of a *palmo*), in a brilliant and original way. A detail (in plan) illustrates the solution of the special projecting triglyph with glyphs (16⅔ quarters of a *palmo*) and its connection to the partial triglyph (6⅓ quarters of a *palmo*) that enables its insertion in the frieze. Base and attic were to complete the triumphal order of the gate, which thus was well articulated but more pared down than the actual Porta Santo Spirito. See also U 941A, 1359A, 1360A, 902A, 1096A r. and v., 1290A.

BIBLIOGRAPHY: Vasari-Milanesi (1878–85) V: 486; Ferri (1885) 167–68; Huelsen (1894) 330–31; Rocchi (1902) I: 185–89; II: pls. XXXIV–XXXVI; Giovannoni (1959) I: 82, 361; Fancelli (1986) 235, 238, 241; Fiore (1986) 338.

F.P.F.

U 315A *recto*

ARISTOTILE DA SANGALLO
Florence, Fortezza da Basso, plan of courtyard and interior
 quarters, summer 1534.

Dimensions: 839 x 1078 mm.
Technique: Pen and brown ink, straightedge, pin, stylus.
Paper: Four pieces joined together, trimmed left-hand edge,
 tears at top, piece missing at center.
Drawing Scale: Florentine *braccia* (100 *braccia* = 151 mm).

INSCRIPTION: (a) *li fossi son larghi sesanta bracia;* (b)
TERRALGLIO; (c) *Mulino;* (d) *prima guardia;* (e) *Lire; fosso;
tertia guardia; fosso; guardia seconda; Braccia cento / fiorentine*
Verso: *Domino Messer Antonio da Sanchallo / A Roma*

Both U 315A r. and 316A r. present a problem of attri-
bution. Giovannoni suggests that they were outlined
by Battista but annotated by Antonio the Younger.
Hale (p. 515 n. 2) suggests that they are by Aristotile
since he is twice cited in connection with the construc-
tion of the Fortezza da Basso. The drawings also carry
a modern penciled attribution to him. The ruled line
outline of the fortress could be his or that of another
member of the shop.

Both U 315A and 316A illustrate critical early plans
of the Fortezza da Basso with the entire enceinte
shown in outline. Both include a rudimentary propos-
al for an inner keep with a stellar trace. Most atten-
tion has gone to the internal disposition of the
guardhouses at the entrance, the barracks, the monu-
mental corner stairs, the stables, and the grand *piazza
d'armi.* Note the use of attached columns on the
colonnade piers and the vaults over each bay and the
octagonal mill with alternating rectangular and semi-
circular niches recalling Antonio the Younger's pro-
posal for San Giovanni dei Fiorentini in Rome. The
security arrangements are also noteworthy; first guard,
second guard, internal ditch with ramped bridge, and
third guardhouse would all have had to be passed
before entry to the courtyard.

The verso inscription suggests that this drawing
was sent from Florence to Antonio the Younger in
Rome for approval. U 316A r. would have been kept
on site as a record of the drawing.

BIBLIOGRAPHY: Ferri (1885) 57; Giovannoni (1959) I: 349,
415; II: fig. 374; Hale (1968) 521, fig. 20.

 N.A./S.P.

U 316A *recto*

ANTONIO DA SANGALLO THE YOUNGER
Florence, Fortezza da Basso, plan of courtyard and interior
 quarters, summer 1534.

Dimensions: 840 x 1040 mm.
Technique: Pen and red and brown ink, stylus, black chalk; in
 modern pencil *(Picconi) Antonio da Sangallo.*
Paper: Four overlapping pieces, modern folds.
Drawing Scale: Roman *palmi.*

INSCRIPTION: (a) *prima guardia;* (b, from top) *tertia guardia;
fosso; fosso; aria; segonda guardia;* (c) *Mulino;* (d, red ink) *dal
mezo alla Stella dello angolo sie p[almi] 185 br[accia] 16 d[ita]
9;* (e, red ink) *da luna si ella allato sie p[almi] 8;* (f) *centro;
questi circuli rossi sono per trovare justa / questa linia
diagonale; centro;* (g) *Lo br[accio] si e una / Lira ale misure 50
/ a lire br[accia] e di* (arithmetical calculation); *p[almi] 38
br[accia] d[ita] 6; palmi 22 br[accia] 10; p[almi] 28; p[almi]
22; p[almi] 24; p[almi] 22 br[accia] 3; p[almi] 1 br[accia] 17
d[ita] 6; p[almi] 6 br[accia] 5 d[ita] 6; p[almi]1 br[accia] 17
d[ita] 6; p[almi] 3; 90; dalluna stella allatra / sie braccia 90;* (h)
*Lo tuto dal linia si e la de li angoli allaltra / p[almi] 201
br[accia] 7 [. . .erased];* (i, outer line of rooms) *stalla;* (j)
centro; centro; centro; (k) *tutta due insieme palmi 371 braccia
13 dita 6*

316 R

This is a ground floor plan of the Fortezza da Basso, Florence, with entire enceinte shown in outline, including a rudimentary proposal for an inner keep with a stellar trace; for dating, see U 315A r.

In the opinion of Giovannoni the drawing is the work of Giovanni Battista; the annotation, he claims, is by Antonio the Younger. In our opinion the drawing may be by another (possibly Giovanni Battista), but the drawing, as a whole, reflects Antonio the Younger's ideas. There is relatively little character in the ruled lines to help us with an attribution.

BIBLIOGRAPHY: Ferri (1885) 57; Giovannoni (1959) I: 349, 415; Marconi et al. (1978) 232–33.

N.A./S.P.

U 463A *recto*

ARISTOTILE DA SANGALLO
Perugia, study of rampart or bastion footing of the Rocca Paolina possibly facing the Piazza dei Servi, 1540–42.
Dimensions: 334 x 261 mm.
Technique: Pen and brown ink.
Paper: Thick, trimmed irregularly on partial new support.
Drawing Scale: piedi and *dita.*

INSCRIPTION: (left) *achanto alla porta;* (right, top to bottom) *da servi; misurando la apiombo; a servj*

Although the subject of the drawing cannot be determined with absolute certainty, it could well be a section through the Rocca Paolina facing the Piazza dei Servi. If so, it would be the only record of what must have been a relatively attractive facade. The elegant torus molding at the base recalls the molding at the Porta San Viene, Siena (1528–32) by Baldassarre Peruzzi. The drawing is certainly by Aristotile da Sangallo, who was active at Perugia; the dating is only approximate.

BIBLIOGRAPHY: Giovannoni (1959) I: 354, 416.

N.A./S.P.

U 724A *recto*

ANTONIO DA SANGALLO THE YOUNGER
Amelia, fortifications, 1518–34.

a
b
c
a

Dimensions: 288 x 435 mm.

Technique: Pen and brown ink.
Paper: Partially yellowed, with fold marks.
Drawing Scale: Roman *palmi.*

INSCRIPTION: (a) *per amelia; rupe; forte; monte; cavaliere alto ma discosto / un tiro darchibuso; novo; vecchio; por[ta]; da qua i[n] la ripe alte;* (b) *ricresciuto palmj 5 /dove e punteggiato;* (c) *Longo Canne 30 / grosso Canne 1½ [canne] 45 / [canne] 30 / [canne] 1350 / 3 giulij / [giulij] 4050*

Datable 1518–34 in view of the still modest form and dimensions of the bastions, this page shows a plan, which was never carried out, for fortifying the part of the Amelia walls most exposed to enemy attack. In the general plan (*a*) five bastions have been proposed, several of them incorporating existing towers. Only the central bastion (*b*), corresponding to the tower with the city gate, has been given detailed treatment with measurements in *palmi*. They include the total measurements of the perimeter (30 *canne*), the thickness (1½ *canne* = 15 *palmi*), and the cubic mass (1350 cubic *canne*), together with the estimated cost (4050 *giuli*). From this it can be deduced that the average height of the construction would have been 6 *canne*, bearing in mind that the unit of thickness corresponds to 2 *palmi* (15 *palmi*: 2 *palmi* x 7.5 units of thickness; 1350 cubic *canne*: 30 *canne* x 45 *canne*; 45 *canne*: 7.5 x 6 *canne*).

BIBLIOGRAPHY: Vasari (1846–70) X: 53; Ferri (1885) 5; Cansacchi (1938) 8–15; Giovannoni (1959) I: 82, 418.

F.Z.B.

U 725A *recto*

ANTONIO DA SANGALLO THE YOUNGER
Pratica, urban plan, after 1539.

a

b c

Dimensions: 278 x 191 mm.
Technique: Pen and brown ink superimposed at (*a*) on markings in gray chalk.
Paper: Partially yellowed, folded.
Drawing Scale: canne (*a*) and Roman *palmi* (*b, c*).

INSCRIPTION: *per mes[ser] luca di massimo / per ardea*

The sheet contains initial ideas for a new urban plan for Pratica, near Rome. (The inscription is incorrect.) On the long sides of the piazza an arcade faces a square stronghold with four circular towers on the

corners. On the short sides there is a church across from the guardroom of the castle where the new curved entranceway should be noted (*a*). In addition, the subdivision of the two secondary side blocks and the larger one between them has been indicated (*b, c*). See also U 838A and 944A as well as the drawing in scale of existing conditions and a more advanced plan in U 843A.

BIBLIOGRAPHY: Vasari (1846–70) X: 54; Ferri (1885) 9; Giovannoni (1959) I: 80; Dell'Acqua, Gentilucci (1986) 312, 314 n. 18, 628.

F.Z.B.

U 727A *recto*

ANTONIO DA SANGALLO THE YOUNGER
Bologna, fortifications, survey of southwest curtain, 1531(?).
Dimensions: 310 x 403 mm.
Technique: Pen and dark brown ink, red chalk for alternative proposals.
Paper: Folded in eight (for mailing?).
Drawing Scale: Bolognese feet.

INSCRIPTION: (top half, left to right) *Sanmichele in boscho; monte vicino / alla terra; per bolognia alla porta che va a parma si do* [. . .] *nela santo felicie la muraglia vechia sta come lo nero / Bisognia fare come sta lo rosso; questa sie la cortina quale / e offesa di dentro da/l monte;* (across horizontal centerline fold, then left to right) *porta san mamolo / va* (blank); *Santa maria / del barachiane; tertia toretta; mezo fralle due torrette; seconda; prima; monte / da farsi; alla prima / torretta; cortina longa / va alla rochetta; Cosi*

This drawing shows a series of studies of parts of the Bologna walls and proposals for the updating of specific areas. In this case (lower right, in red chalk) the Porta Santo Stefano is to be reinforced by a large triangular bastion, marked "Cosi." For a reconstruction of Antonio's proposal for the southern side of the city, see Tuttle, fig. 12.

The format of the drawing is typical of Antonio the Younger's method of analysis of the ramparts, by lengths, and is seen as well in drawings for Rome (U 892A r.) or Perugia (U 1502A r., 1506A r.). The dating of the Bologna sheets presents something of a problem. The series of studies of the Bologna walls (U 727A, 727A v., 728A) have been linked by Tuttle to the Rocche della Romagna inspection of 1526. Yet, as acknowledged by Tuttle, positive evidence for this date is lacking. Antonio the Younger is documented in the area on a number of other occasions—for example, in September 1531, at the request of Francesco

Guicciardini, for problems associated with the River Idice and for discussion of the *rocchetta* (see U 727A v.). (The reference to discussion of the fortifications was kindly provided by Richard Tuttle, oral communication, June 1989.) In any case, the detailed section-by-section analysis undertaken in this drawing is not what we would expect from an inspection or quick evaluation. Finally, the geometric play on the verso (see below) is typical of the period of Antonio's work on the Fortezza da Basso, the Castel Sant'Angelo, and the Rocca Paolina (ca. 1530–40).

BIBLIOGRAPHY: Ferri (1885) 13; Guicciardini (1927) 76, 82, 84, 86, 87, 105, 106; Giovannoni (1959) I: 77; Tuttle (1982) 194–97, fig. 10.

N.A./S.P.

U 727A *verso*

ANTONIO DA SANGALLO THE YOUNGER
Bologna, fortifications, renovation to walls; geometric experiments with fortress form, 1531(?).

a
b
c d
e

Dimensions and Paper: See U 727A recto.
Technique: Pen and brown ink, red chalk.

INSCRIPTION: (top middle) *Di bolognia;* (to left) *lo baluardo della / rochetta si per stare / grande e lo fosso into/rno e murato intorno /* [. . .] *no fianchi / e diffore;* (on curtain) *porta;* (lower right) *la rochetta faciendolo / cosi se ne sta una tertia / parte colla muraglia*

A rich sequence of notations related to Bologna are found on this sheet: (*a*) a section through a rampart with a curved parapet; (*b*) a plan section of the small-arms embrasures, angled steeply downward from the internal gallery shown in *a*; (*c*) a sketch of the pentagonal *rocchetta* of Julius II with its original round corner towers; (*d*) scheme for the refortification of the *rochetta*, incomplete, but evidently comprising six bastions; (*e*) a smaller alternative refortification proposal, comprising four bastions. Marani claims that this sketch is derived from Leonardo da Vinci (Codex Atlanticus, fol. 135) though, in fact, the stellar plan was quite widely used, particularly in field fortifications (*see* Naples, Fortress of Sant'Elmo).

As noted by Marani and Tuttle, these studies show Antonio the Younger's method of design: outlining the

geometrical plans (stellar, polygonal), then introducing details that respond to the practical exigencies. It is a method that he perfects at Florence, Perugia, Rome, and elsewhere. In this sequence of relatively rough sketches we also see his hasty style in which ideas literally burst over the boundaries. So, for example, the sketch of the rampart contains elements of a vertical section and a horizontal section.

BIBLIOGRAPHY: Giovannoni (1959) I: 82–83; Tuttle (1982) 194–97, fig. 11; Marani (1984) 27–28, fig. 7.

N.A./S.P.

U 728A *recto*

Antonio da Sangallo the Younger
Bologna, fortifications, sections through the ditches, 1531(?).
Dimensions: 204 x 310 mm.
Technique: Pen and brown ink.
Paper: Darkened at edges.

INSCRIPTION, Recto: (left to right along ditch levels) p[orta] Santo mamolo; Barachiane; porta Santo Stefano; malcantone; fondo del fosso; Canpongnia; Malcantore in sula porta Santo donato alla porta ma/scharella; Canpognia; argine; Bocha del terreno / e fondo del fosso; pelle dallaqua; (below left) Lo fosso della terra alla porta a Santo mamolo / si e fondo piedi 21 di bolognia quali piu de / sie due tertii di brazo fiorentino ce da dicta porta / e fondo di fosso fino al fondo del fosso dove scie / Laqua del rosso(?) di bolognia sie piedi ala pelle / e superfitia dellaqua sono piedi 71½ quali sono / Braccia fiorentine 47⅓ si puo a fondare lo fosso / a Santo mamolo b[raccia] 17⅓ restaria b[raccia] 30 apartiene / in li sostegni che saranno molti; (new hand) V livello di fossi di Bologna
Verso: V livello di fossi di Bolognia

The building of trenches and the erection of new walls often created problems with the water table for the architects. (Antonio faced similar problems at the Fortezza da Basso; see U 791A r.) In this sheet Antonio compares levels to see to what depth the ditch may be dug. Tuttle describes this as "a carefully measured survey of the ditch surrounding the city. In it Antonio recorded the gradual southerly descent of the *fossa* at successive points around the eastern perimeter, from the highest point at the Porta San Mamolo to the lowest near the Porta Galliera" (p. 195). The highly specific problems dealt with here, at a time when work seems to be under way, tends to cast doubt on the sheet's traditional association with the 1526 survey of the Rocche della Romagna when we would have expected time to have been of the essence. Antonio the Younger's interest in hydraulic problems

in 1531 (see U 727A) provides a probable date in which fortification and hydraulic work in the Bologna area are on his mind.

BIBLIOGRAPHY: Ferri (1885) 14; Giovannoni (1959) I: 78; Tuttle (1982): 194–96, fig. 9.

N.A./S.P.

U 729A *recto and verso*

Antonio da Sangallo the Younger
Ascoli Piceno, topographical study (*recto*). Section of wall with *puntone* or *casamatta* (*verso*). 1532.
Dimensions: 284 x 222 mm.
Technique: Pen and dark brown ink; verso, red chalk.

INSCRIPTION, Recto: (left) *fosso profondo con ripi / tagliati a piombo;* (at central peak) *monte; A; A; piano; castellario;* (below) *Sant'Antonio; C; monti; C; Colletti;* (to right from top) *B; porta romana; monti; Selve di abito / presso alla terra / a tre miglia; ascoli; San pietro in / castello; tiratoio; tronto F[iume]; Colletti; Ascoli e di diametro uno miglia / da porta romana alla porta / che va al mare;* (below) *Li fossi quali ascoli astorno sono profondi e quasi / per tutto sono tagliati apiombo largi circha 100 passi / e profondi nel piano circha 20 passi & dove / e segniato A el piu locho atto al campo e che ci sia / per la comodita del mare e piano e monte facile / laltro locho sie dove segniato B laltro locho / e dove e segniato C ma e impossibile perche cinto / da fossi profondi e impracticabili*

Li fossi anno le ripe de una pietra quali e dicano / tufo e alquanto piu forte che el piperigno e quasi / simile spetie ma piu forte [. . .] quoto e in qualche / loco a incima per capello tevertino non di questo tufo / e per tucto el paese e a sopra poca torpa nel circha / anno passo in la maggiori parte

Antonio the Younger is recorded at Ascoli Piceno on two occasions: 1532 while working at Ancona, and around 1540 when work was proceeding on the fortress in Ascoli. Pier Francesco da Viterbo was also on site in 1536. Unpublished documents in the Archivio di Stato, Parma, suggest it was possible that the Sienese architect Giovanni Battista Peloro was there in 1541 (ASP, Carteggio Farnesiano, estero 324).

This drawing is similar to other topographic studies associated with fortifications undertaken by Antonio the Younger (such as U 1028A r.). Yet it is not certain that this drawing was undertaken in connection with fortification work. Antonio's two major concerns are the rivers and the nature of the bedrock. No site is proposed for a fortress; indeed, issues of fortification do not appear to be raised directly at all. It could even be that Antonio was called on to consider problems of flooding or river maintenance as well as defense as

at Foligno (U 800A r.), Lucca (U 827A r.), or Modena (U 797A v.). Note that the paper used for U 729A is quite different from that used for the drawings of Ascoli Piceno dated by us ca. 1540 (see U 1511A, 1512A, 1516A).

The drawing on the verso is an extremely crude sketch of a short length of medieval wall, with towers, possibly forming part of the Ascoli Piceno survey on the recto. The drawing, in Antonio's hand, probably represents a preexisting work rather than his original design.

BIBLIOGRAPHY: Rosa (1869) 190–91; Ferri (1885) 10; Giovannoni (1959) I: 76–77, 418; Fabiani (1957–59) I: 241–44.
N.A./S.P.

U 730A *recto and verso*

ANTONIO DA SANGALLO THE YOUNGER
Montalto, reconstruction drawings for some parts of the Rocca, 1537.
Dimensions: 428 x 292 mm.
Technique: Pen and light brown ink for drawings, measurements, and scale (workshop), stylus with a straightedge, inscriptions by Antonio in dark brown ink.
Drawing Scale: piedi and dita; scale in *palmi romani* (10 *palmi* = 34 mm).

INSCRIPTION, Recto: *per monte alto montare dentro alla prima porta con scala / a bastoni alpiano della porta nova e fare la porta / dove e la porta vechia ma piu alta in sudetto piano e / piu in Cantonata in verso la Torre che venga in mezo / dello spatio del rivellino di poi entri in uno ricetto fino alla / porta della sala e della porta della sala in la sieno / le scale per andare di sotto e di sopra; schala abastoni; la porta venga in que/sto mezo; ricetto; serrare(?); porta; schala che va / abasso; [s]cala che va / di sopra / nasce in sala;* (room at top) *sala*
Verso: *Montalto*

The Rocca of Montalto still exists as a conglomerate of parts dating from the Middle Ages to the twentieth century. Eighteenth-century drawings of a ground plan, a cross section, and an elevation for a survey and a reconstruction project (ASR, Mappe e Disegni, Coll. I, cart. 33, no. 118) make it possible to interpret U 730A. At that time, and already in Antonio's day, the Rocca consisted of a tall medieval tower adjoined by a long residential wing with a truncated tower and a shorter residential wing. In front of the tall tower and residential wing was a bastion whose slightly battered basement was set off from the vertical masonry by a cordon. At about the center of the wall was an unadorned round-headed portal reached by a draw-bridge over a moat. Recognizable, upper right, is the opening of the portal, the bastion surrounding the tower, and a (planned?) broad staircase compensating for the difference in height between the ground floor and the rooms in the upper story. The inscription states that a new high door (or one placed higher?), centered within the space created by the bastion in front of it, was to give access "in questo mezo" to a *ricetto*, from which a door would lead into the *sala*. The staircase was to flank this door. An exact plan for the *ricetto* and staircase, however, was not yet prepared.

The upper-level plan, designated as the *sala*, can be identified with a room of the same name in the eighteenth-century plans. In the latter, however, it does not lie behind the bastion, which was measured by the Sangallo workshop, but rather adjoins the transverse wing omitted on U 730A r. The curious placement of only two windows at the ends of the room and the central niche (a fireplace?) in the left (the sole) outer wall is explained in the eighteenth-century drawing by the introduction of a staircase leading from the *sala* to an upper bastion. This anomaly, not carried over by the Sangallo workshop, is explained by Antonio the Younger in an inscription: "[s]cala che va di sopra nasce in sala." U 730A r. thus gives only some indication of the state of the Rocca di Montalto and Antonio's first thoughts on its redesign. Comparison with the eighteenth-century plans show that no significant reconstruction was completed.

On the verso is a rapid measured annotation concerning the walls of Montalto.

BIBLIOGRAPHY: Vasari-Milanesi (1878–85) V: 507; Ferri (1885) 95; Cobianchi, Petrucci (n.d.).
H.G.

U 732A *recto and verso*

ANTONIO DA SANGALLO THE YOUNGER AND WORKSHOP
Castro, northwest corner of the piazza, loggia of the Osteria, after 1537.
Dimensions: 279 x 399 mm.
Technique: Pen and brown ink, drawn with straightedge and freehand.
Paper: Slightly yellowed, spotted, folded twice, new support in several places.
Drawing Scale: palmi romani.

INSCRIPTION, Recto: (in a later hand) *Misure di Castro*; (inscriptions and numbers by the workshop) *Strada Nova*; *Voto*; *Pieno*; *Macello*; *Loggia*; *Piaza*; *Palazo del po[des]ta*;

strada; (by Antonio) *aria caro sapere quanto questa strada e piu / bassa chel piano della piaza; Apresso aro Caro Sapere se Sua excellentia / vol dare questo sito alle Case delle osterie o pure / farne altre Case private a private persone / o se altra resolutione particulare Se desidera sapere quanto / alle osterie me ne sia data aviso/aria Caro Sapere quanto la piaggia sia piu bassa qui chello piano della piaza;* (below) *Circha aquesto disegnio non so altro che mi dire / se non che staria bene che si facessi questo archo sopra / la strada va al macello Come sta nel primo disegnio che sara/nno archi 13 e verra uno anche in mezo et Cosi ara / la perfectione sua altrimenti sara imperfetto et lo imputato / sara jo se non se fa*
Verso: *Monstra dele Mesure di Castro; Castro;* totaling of the measurements of the fourth project for San Francesco (U 737A r.)

After determining the ground plan of the loggia, Antonio addressed the problems arising from the incorporation of the existing structures into the piazza and from the downhill terrain, which was to be closed off by a new street. The passage to the *macello* had to be vaulted and a structure built over it on the piazza side (see U 299A r. and 742A r.) so that the palace facade would again have thirteen bays (as was planned on U 297A r.) and a center arch. The duke still had to be consulted about the nature and purpose of the structures that would adjoin the loggia and shops.

BIBLIOGRAPHY: Ferri (1885) 23; Vasari-Milanesi (1878–85) V: 500; Giovannoni (1959) I: 200; Aimo, Clementi (1971) 59; Polidori, Ramacci (1976) 82; Fiore (1976) 87, 91; Giess (1981) 101, 136; Gardner-McTaggart (1985) 115, 347.

H.G.

U 733A *recto*

ANTONIO DA SANGALLO THE YOUNGER
Castro, sketches of the palace(?), 1537.

 e

 d

c

 b a

Dimensions: 153 x 177 mm.
Technique: Pen and brown ink, red chalk (script).
Paper: Slightly yellowed, cut at the edges and repaired, earlier (center?) fold at the side.
Drawing Scale: palmi romani.

INSCRIPTION: (not by Antonio) *palazzo nuovo di Castro;* (by Antonio, in red chalk) *Palazo per castro;* (a) *portico*

This tiny sheet was certainly once part of a larger one,

possibly containing plans to which these detailed sketches belonged: *a*, a portico with adjoining inner rooms; *b* (drawn partly within *a*), a tower-like corner projection with two small windows; *c* can be identified with the 20-*palmi*-wide Strada nova, which ran along the cliff below the Osteria and gave access to the 40-*palmi*-deep stables (see U 299A r., 732A r., and 742A r.); *d*, a monumental loggia with a complicated adjoining staircase; and *e*, a pier belonging to it, with an engaged column and pilaster, all of startling dimensions. The piers initially were intended to be 10 *palmi* wide (ca. 2.34 m) and 24 *palmi* (ca. 5.36 m) or 30 *palmi* (ca. 7.02 m) apart. These dimensions were reduced to 8 and 20 (see those of the loggia of the Osteria: 6 and 16). The column of measurements for half the palazzo, set down by Antonio at the upper left, should total 205 *palmi,* not 179 as he mistakenly wrote. In the city itself there would have been no room for a building 410 *palmi* (ca. 96 m) long. Perhaps Pier Luigi planned to erect a Rocca as a ducal residence near the "porta di sopra" or on the plateau lying opposite the city, which on U 945A was still included in the network of fortifications. I know of no other drawings for this project. For the ducal residence, see my essay "Castro and Nepi" in the present volume.

BIBLIOGRAPHY: Ferri (1885) 23; Vasari-Milanesi (1878–85) V: 500; Fiore (1976) 84, 86; Giess (1981) 137.

H.G.

U 736A *recto*

ANTONIO DA SANGALLO THE YOUNGER
Castro, San Francesco, first project and further studies, 1537.
Dimensions: 424 x 578 mm.
Technique: Pen and brown ink, topographical notations in red chalk, scored with straightedge and compass.
Paper: Slightly yellowed, folded twice, backed along the crease.
Drawing Scale: palmi romani (100 *palmi* = 90 mm).

INSCRIPTION, Recto: (center, not by Antonio) *per Santo fran[cesc]o di Castro; Prato Cotone;* (pertaining to the cloister) *Rifettorio; Cucina; Convento / palmi 192 / per ogni verso / el tutto;* (pertaining to the church) *el tutto li dentro sie p[almi] 140;* (in red chalk) *casa;* (upper right, inverted) *polifilo/ marcho agapalto(?) / Margarita felsofica; messer Joanntonio Capellano di Santo / Ambrogio de Milanesi so dove sta / fra Cornelio Condivi di dare lettere / delli suoi sostituti;* (at left edge) *1^1o alta 10 picnostilo; areostilo; Diastilo; Sistilo; picnostilo; Eustilo*
Verso: *per Santo Francesco di Castro e altre Cose pure di Castro*

In order to make better use of the terrain, the locations of the church and cloister of San Francesco on U 811A v. have been reversed. The measurements of the buildings are adjusted to the topography; the 30-*palmi* interval may be a later addition. The cloister, whose rooms again surround a large rectangular courtyard, is preceded—on the model of the Badia, Fiesole—by a loggia serving as a belvedere. The ground plan of the church is likewise rectangular, with a semicircular apse, and is divided into three aisles with side chapels. The chapels on the right may have presented a problem in lighting. The facade corresponds to the articulation of the interior. The ground plans of piers at left have new measurements, an indication that the ground plan of the church has been redesigned. For later designs, see U 738A r., 739A r. and v., 740A r., and 737A r.

Antonio turned the sheet at an angle to make numerous other sketches and notations. Near the top of the sheet is a sketch for a processional wagon. Near the left edge are sketches for the coffering of a ceiling (possibly preliminary studies for the Sala Regia), many numerical calculations not pertaining to San Francesco, and a compilation of the ratio of the diameter to the height of the columns according to Book 3, chapter 3, of Vitruvius. The inscription also contains notes that refer to the *Hypnertomachia Polifili* ("polifilo") and the *Margarita philosophica* (Strasbourg, 1504) by Gregor Reisch ("Margarita felsofica").

BIBLIOGRAPHY: Ferri (1885) 23; Vasari-Milanesi (1878–85) V: 501; Giovannoni (1959) 203; Giess (1981) 118–20, 138; Gardner-McTaggart (1985) 141.

H.G.

U 737A *recto*

ANTONIO DA SANGALLO THE YOUNGER
Castro, San Francesco, fourth project, after 1537.
Dimensions: 381 x 525 mm.
Technique: Pen and brown ink, lightly washed, punctures, scored with straightedge and compass.
Paper: Slightly yellowed and spotted, folded twice, edges reinforced.
Drawing Scale: palmi romani (60 *palmi* = 87 mm).

INSCRIPTION: (upper left, not by Antonio) *S[an]to franc[esc]o di Castro*; (below this) *Questo si e lo disegnio rifatto secondo li fonda/menti fatti per fra lione quali servono li maggiori / e principali*; (next to the church) *Tutta la chiesa colle / sua mura e scarpa / si e larga 133½*; *Lo Convento si e palmj 131½*; *Lo tutto insieme si e 265*; *Convento*; *Chiesa*; (for the church) *Sacrestia*; *Coro per li frati*; *altare grande*; *quanto*

tira/ questa Croce / sara lo Campa/nile; *Capella* (six times); *Corpo della chiesa / della nave di mezo*; *portico publico della / chiesa*; *palmi 265 el tutto*; (at top, for the cloister) *palmi 179½*; *Rifettorio*; *Lavamani*; *Cucina*; *Capitolo*; *Loggia prima overo / peristilio*; *Portinaro*; *Publico inanti(?) / alla porta / del convento*; (at the right edge) *Queste sono le misure per questo / verso quale in tutto fanno la so / ma di p[almi] 242½ Come sta lo di/segnio mandato da Castro a Roma / ultimamente Come stanno li fonda/menti fatti; tutto lo Convento si e / palmi 131½ Come / si vede per le sue misure / Le stantie quale sono della / scala e loggia prima / in qua sotto e sopra se inten/de essere lo apartamento / di sua excellentia per ritirar / si al tempo della sua de/votione / Le altre dalli in la se intende / essere delli frati sotto / et sopra*

Antonio the Younger's careful drawing and the elevated tone of the inscriptions suggest that this sheet was intended for presentation. As in the preceding design on U 740A r., the ground plan takes into account the wishes of the duke represented on U 739A v. and makes use of the already existing foundations of Fra Leone. At the same time, the sequence of rooms in the cloister is improved and the church is given an entirely new character: By reducing the bays to three, by abandoning the pilaster arrangement of the chapels, and by introducing deep, semicircular niches at the ends of the side aisles, the longitudinal direction is deemphasized and a unified interior space created. A monumental entrance hall has replaced the fourth bay. It is related to the studies for SS. Celso e Giuliano (U 4037A r.) and can also be connected with the contemporaneous projects for San Tolomeo in Nepi (see U 551A r., 865A r., and 866A r.). The beginning of the construction of the church is documented by inscriptions (U 739A r. and v.). Gardner-McTaggart's measurements demonstrate that it was built according to a project deviating only slightly from U 737A r. Presumably, the only part of the cloister to be completed was the basement, which later served as a magazine (see "Castro and Nepi"). The walls of the church and cloister were probably raised to a certain point, but without excavation their height cannot be determined.

BIBLIOGRAPHY: Ferri (1885) 23; Vasari-Milanesi (1878–85) V: 501–2; Giovannoni (1959) I: 203, 204; Fiore (1976) 88; Giess (1981) 124–27, 139; Gardner-McTaggart (1985) 140–47.

H.G.

U 738A *recto*

ANTONIO DA SANGALLO THE YOUNGER
Castro, San Francesco, second project, after 1537.

Dimensions: 480 x 597 mm.

Technique: Pen and brown ink, red chalk, punctures, scored with straightedge and compass.

Paper: Yellowed and spotted, ragged lower edge, the other edges cut, folded twice.

Drawing Scale: palmi romani (50 palmi = 98 mm).

INSCRIPTION, Recto: *Sacristiola; Canona; Sacrestia; Ricetto; Campanile; Coro; Altare; per S[an]to franc[es]co di Castro;* (cloister, top) *prato Cotone; p[almi] 92; Rifettorio; Lavamani; Cucina; Destri; Stantia da scaldarsi;* (measurements of the cloister) *palmi 88; Sopra questo porticho si puo / fare stantie e Camere per lo S[igno]re; Camera per servitori; Tinello per la famiglia e sopra / stantie per lo S[igno]re; Cucina abasso per lo Signore;* (at edge) *per avere Carestia / di stantie / a questo piano e nechessario / fare le stantie subterranee / e si fara[nno] le oficine che man/chano al piano di sopra si / faranno a questo piano di sotto / ma bene che sieno subterranee / si puo spianare qui fino sul tu/fo e verrano sopra terra da / questa banda ma da questa / banda saranno Cantine e cellar/ij per essere exposto a tramontana; Sopra a questa scala puo essere / destri per le stantie del S[igno]re; Dal Convento alla ripa p[almi] 30 / quale puo essere al tempo di pacje / de frati per legnia e simil cose*

Verso: *S[an]to francesco di Castro*

The present design is similar to U 739A, except for a few variations (reduction of the *sacristiola* and *canona* by 5 *palmi* in order to leave the 30-*palmi* road free; see "Castro and Nepi"). The church and cloister are reduced in width and a pronounced emphasis is given to their length through changes in all their measurements. Cupolas are added to the side aisles (see U 736A), and a campanile is introduced (possibly at the duke's request). The rooms of the cloister are differentiated, and an apartment is planned for the duke. The working area is situated on the sloping terrain, partly cut into the tufa and partly built aboveground. The project is further elaborated in U 740A r. and 737A.

BIBLIOGRAPHY: Ferri (1885) 23; Vasari-Milanesi (1878–85) V: 501; Giovannoni (1959) I: 203, 204; Fiore (1976) 88; Giess (1981) 120–24, 138–39.

H.G.

U 739A *recto and verso*

ANTONIO DA SANGALLO THE YOUNGER

Castro, San Francesco, second project (*recto*). Sketches for the foundations (*verso*). After 1537.

Dimensions: 478 x 595 mm.

Technique: Pen and brown ink, red chalk, punctures, stylus, straightedge, compass.

Paper: Yellowed and spotted, torn off at the lower edge, the remaining edges trimmed slightly, repaired.

Drawing Scale: palmi romani (50 palmi = 98 mm).

INSCRIPTION, Recto: (not by Antonio) *per s[an]to fran[ces]co di Castro;* (pertaining to the church) *Sacrestiola; Canona; Sacrestia; lavamani; (. . . .canceled); Campanile; S[an]to fran[cesc]o di Castro; Capella di / S[an]ta Lucia / in tal di fu cominciata;* (cloister) *Rifettorio; Lavamani; Cucina; pozzo per li destri; Stanza per scaldarsi; Camino grande; Dispensa; Capitolo; dispensa per el S[igno]re; principio; sopra questo si puo fare / Camere per lo S[igno]re; Camere per servitori; Tinello per la / famiglia; Cucina abasso / per el S[igno]re; palmi 85; palmi 51;* (at the edge) *serrato; ripa; per avere poche stantie / a questo piano e nec/essario a fare le stantie sub/terranee per avere le o/ficine che manchano come / forno barberia lavatoro / di panni per legnia e chantine / cellarij e cose simili / e cosi ci sara tutto lo bisognio / per li frati come per lo S[igno]re; Sopra alla prima bancha / della scala puo essere / destri per servitio di quelli / del S[igno]re su ad alto; Sotto questa scala / puo servire alla Cucina / per dispensetta della Cucina / e si potria andare anchora / per detta schala in le Cantine / subterranee a libito di chi / se ne a servire; Ripa; porta; serrato fino alle ripe; 134 di prima*

Verso: *S[an]to fran[ces]co di Castro / per mandarlo la; Bisognia per largeza aquistare 30 p[almi] / perche non vadia fino alle ripe acio ci resti / la strada / se eleva alla Chiesa le Capelle 12 palmi / per banda / A li chiostri si leva dua palmi restono / p[almi] 16 luno / alli archi si toglie p[almi] uno per archo / alle stantie 5 p[almi] restono 25 / in tutto si eleva p[almi] 36 / Bisognia adopiare le stantie del ducha / e mandare el cortile in su e quello si / guadagnia agiungerlo al coro pure /dalla finestra del dormitorio fori / Lo vano della chiesa resta come qui sotto et / Cosi el Convento; diminuire el Convento solo la chiesa stia come prima e pigliare tre canne inverso la terra / El fondamento cavato serve per lo secondo fondamento cioe quello della facciata lo novo come qui / fondamento prima cavato / fondamento da cavarsi; Lo fondamento cavato per fra Lione sta cosi*

This sheet shows the same project as U 738A and was intended for delivery to Castro. The articulation of the facade is apparent: It has six wide pilasters, the middle four slightly accentuated by the addition of two quarter pilasters. After discussing this plan with the duke, Antonio the Younger, on the verso, deals with the duke's requests (to keep the chapels and enlarge his apartment) and military requirements (a 30-*palmi* road; see "Castro and Nepi"). In Castro work had already begun on the foundations under the direction of a local overseer, Fra Leone. These now had to be incorporated into a new design. On the verso are three sketches of the foundations and two small sketches of an entablature.

BIBLIOGRAPHY: Ferri (1885) 23; Vasari-Milanesi (1878–85) V: 501; Giovannoni (1959) I: 203, 204; Giess (1981) 120–24; Frommel (1986) 301.

H.G.

U 740A *recto*

ANTONIO DA SANGALLO THE YOUNGER

Castro, San Francesco, third project, after 1537.

Dimensions: 281 x 426 mm.

Technique: Pen and brown ink, faded red chalk or gray pencil, scored with straightedge and compass.

Paper: Discolored, severely damaged, on new support, folded twice.

Drawing Scale: palmi romani (60 *palmi* = ca. 56 mm).

INSCRIPTION: *Lopera rossa sie lo mezo / di fralleone e lo negro sie lo / mezo dello secondo;* (church and cloister) *scoperto; Canona; Sacrestia; Rifettorio; Lavamani; Cucina; Campanile; portinaro; camera; Tinello; Cucina; Dispensa; Camera dei Cuocci; Mura; scarpa; el tutto palmi 280¹/₂*

The ground plan of the third project for the church and cloister of San Francesco follows the second project (U 738A r. and 739A r.), taking account of the duke's wishes. Fra Leone's foundations are used (see U 739A v.), the church is shortened by one bay to make room for the 30-*palmi* road, and the courtyard of the cloister is reduced to double the space available for the ducal apartments. Niches are added to the facade between the first and second, and fifth and sixth pilasters. The working plan for San Francesco is found on U 737A r.

BIBLIOGRAPHY: Ferri (1885) 23; Vasari-Milanesi (1878–85) V: 501; Giovannoni (1959) I: 203; Giess (1981) 124, 139.

H.G.

U 742A *recto*

ANTONIO DA SANGALLO THE YOUNGER

Castro, project for the Osteria and the palazzo of Capitano Meo, upper story, after 1537.

Dimensions: 418 x 582 mm.

Technique: Pen and brown ink, light brown and (over the pentimenti) red wash, punctures, in part not related to the drawing, scored with a straightedge.

Paper: Stiff, slightly yellowed, folded once, cut, considerably repaired.

Drawing Scale: Roman *palmi*.

INSCRIPTION: *Questa parte non se finita per non avere / le misure per fino alla strada nova; Cucina; Andito per la Cucina;*

Ricetto longo p[almi] 30; largo p[almi] 20; porta (partially obliterated); *Cortile scoperto / Largo palmi 67; Longo palmi 67; Amficamera; Camera; Loggia longa p[almi] 67; Larga p[almi] 20; sopra la strada per / poter passare / in lo palazo del / podesta volendo; Palazo del podesta; Camerone; Longo palmi 50; Largo palmi 40; Sala; Longa p[almi] 66; Larga p[almi] 50; Quando Vostra excellentia volessi / che questa sala fussi maggiore / si puo pigliare la loggia e con ditta / sala andare fino in sul cortile / e saria longa palmi 75;* (another hand) *Sua exc[ellen]za / vole la sala vada sino al cor/tile e si levi la loggia; Salotto; Largo p[almi] 40; Longo p[almi] 50; Camino;* (in the open space) *Casa per losteria quale piglia / archi 8 con quello della strada / delli macelli; Piazza di Castro;* (palazzo of Capitano Meo) *Cucina; Camino; Cortile scoperto; Longo p[almi] 64; Largo p[almi] 38; qui sotto si puo fare / la stalla; Loggia / larga p[almi] 18; Amficamera; Larga p[almi] 38; Longa p[almi] 42; Si puo avere / lume di / qua volen/do pi/gliare; Camera Longa p[almi] 45; Larga p[almi] 38; Sala / Longa p[almi] 66; Larga p[almi] 50; Camino [. . .]; Catena; Salotto / Largo palmi 40; Camino; Catena;* (in the open space in front) *Casa per lo Capitano Meo / quale piglia archi cinque; Bisognio avertire a Questi 6 tramezi / quali cavalcano sopra alli arconi del / portico di sotto che quelli arconi si facino / gagliardi e di mattoni e tanto grossi quanto / possono venire fino al piano del mattonato / delle sale e Camere e in ciascuno archo / si mette una Chiave di ferro che pesi almancho / l[ibbri] 7 lo palmo Colli suoi buoni puletti dalli capi;* (at the side) *Casa di scar/amuccia; Strada quale / va al vescovado*

The ground plan of the upper story of the two palaces on the new piazza (see "Castro and Nepi") should be viewed in connection with U 299A r. (ground floor). Pentimenti and inscriptions indicate the course of the project, the purpose of which was to beautify and enlarge individual rooms and the buildings as a whole by extending the building over the Strada nuova. As on U 297A r. and 299A r., the ground plan of this story contains indications of two other stories: a basement level and the Strada nuova, and a new pilaster arrangement in the enlarged courtyard of the ground floor. A final plan of the north side of the Castro piazza apparently was not drawn up. Construction came to a halt after shops and loggias were built on the ground floor (1540–45).

BIBLIOGRAPHY: Ferri (1885) 23; Vasari-Milanesi (1878–85) V: 500; Giovannoni (1959) I: 200, 201; Aimo, Clementi (1971) 59, 60; Fiore (1976) 83, 88; Giess (1981) 103–6, 136, 137.

H.G.

U 743A *recto*

ANTONIO DA SANGALLO THE YOUNGER
Castro, seven sketches for private houses, 1537.

a b

c d

e f

g

Dimensions: 419 x 279 mm.
Technique: Pen and brown ink, corrections in red chalk.
Paper: Slightly yellowed, cut, folded several times, reinforced
 at the edges.
Drawing Scale: palmi romani.

INSCRIPTION, Recto: (b) *Cavaliere Saxuolo; archo* (twice);
*strada; scoperto; sotto larcho p[almi] 13; strada; Cantina;
mura;* (c) *messer matteo / Tresauriere;* (d) *di messer matia;
vano 25½; 30 vano;* (e) *strada delle ripe; strada; di messer
bastiano;* (f) *A studiolo / B stufa;* (g) *Strada maestra; strada;
vicino; Capitano alexandro / dalternj; none sra(?); strada canta
le ripe; misure a palmi romaneschi*
Verso: *Case private di Castro di piu persone*

These first sketches of houses for the duke's entourage
are primarily intended to explore the possibilities of
the available building sites as determined by the lay-
out of the streets and the buildings of the old city. The
property of "Cavaliere Saxuolo" (*a* and *b*) is situated
on the new piazza, opposite the palaces of the duke;
Antonio plans to support the upper story with a side
wall and to extend two arches over a side street (on
Soldati's plan, the first on the left, at the piazza; see
"Casto and Nepi," fig. 1). More detailed drawings are
not available. Part of the lower story was built, as well
as the supporting wall and at least one of the arches.
In 1587 the walls were incorporated into a newly
planned Palazzo del Comune. For information on the
client, see "Castro and Nepi." Sketch *c* (measurements
corrected in red chalk) cannot be linked to any known
project. Sketch *d* is too rudimentary to be connected
with the house of Messer Mattia delle Poste, which
was built later (see U 748A). Sketches *e* and *f* ("messer
bastiano"), on the other hand, are developed further
on U 744A. For sketch *g*, another project that did not
progress beyond its beginning stages, we have no fur-
ther information. For the client, "Capitano alexandro
dalternj," see "Castro and Nepi."

BIBLIOGRAPHY: Ferri (1885) 23; Vasari-Milanesi (1878–85)
V: 489; Giovannoni (1959) I: 204; Giess (1981) 111–14, 137;
Gardner-McTaggart (1985) 205–6; Fagliari Zeni Buchicchio
(1986) 257.

H.G.

U 744A *recto and verso*

ANTONIO DA SANGALLO THE YOUNGER
Castro, project for house of Cavaliere Sebastiano Gandolfo,
 1537.
Dimensions: 218 x 287 mm.
Technique: Pen and brown ink, corrections in red chalk, scored
 with straightedge and compass, punctures not related to
 the drawing.
Paper: Folded twice, reinforced at edges and center.
Drawing Scale: Roman *palmi* (20 *palmi* = 41 mm).

INSCRIPTION, Recto: *strada maestra palmi 66½; strada*
(twice); *palmj 84; Sala / aterreno; quanto tiene questa /crocie
sara la sala / longa p[almi] 37 larga p[almi] 37; di messere
bastiano; sopra lo studiolo / e sopra la stufa / sia tutta una /
stantia cioe anfi/camera; studiolo / 6—12; stufa 12; Cucina;
destri* (twice); *strada canto a ripa;* (in a different ink) *palmi
vinti*
Verso: *Seb.Gandulphus Ill.mi D.P. Aloysij Primi Ducis Castri
Alum[nus?] a secretis his modicis edibus sua pecunia a solo
structis hospitium ami[cis dedi?]cavit et virtutum cultoribus*

The first ground plan sketch, U 743A r., *f*, still shows a
cul-de-sac, which has already been extended to the build-
ing site and permits a symmetrical division of the
property. U 743A reveals the grandiose demands of the
owner: a *studiolo* and a *stufa*, worked out in more
detail on U 744A (for the *stufa*, see U 986A). The three
elliptical openings in the wall probably indicate water
reservoirs (supplying rainwater from the roof?). The
position of the staircase has been changed. A terrace
decorated with balusters, two staircases, and two
"destri" is added to the rear facade. This is the first
design for the rooms of the upper story. The inscrip-
tion on the verso was probably meant to appear on
the well-proportioned, five-bayed facade. For infor-
mation on the client, see "Castro and Nepi." Nothing
is known about the construction of this building.

BIBLIOGRAPHY: Ferri (1885) 23; Giovannoni (1959) I: 204;
Pagliara (1972) 36 n. 80; Frommel (1973) I: 77; Liebenwein
(1977) 136; Giess (1981) 114, 115, 137; Gardner-McTaggart
(1985) 206, 207; Clementi (1986) 380.

H.G.

U 745A *recto*

ANTONIO DA SANGALLO THE YOUNGER AND
WORKSHOP
Castro, house of Messer Angelo, third project, after 1537.
Dimensions: 569 x 427 mm.
Technique: Pen and brown ink, scored with a straightedge;
 punctures following U 747A r., the similarity not reflected
 in the drawing.
Paper: Slightly yellowed, fold, reinforced at edges and creases.
Drawing Scale: Roman *palmi* (50 *palmi* = 179 mm).

INSCRIPTION, Recto: (from bottom) *Strada maestra;
Vestibulo; Atrio; Questa sara tutta Sala quanto / tiene questo
atrio elvestibolo / el tramezo quale sara longa / palmi 55 et
larga palmi 34; peristilio; Cavedio; Scoperto; Stradella; Scarpa
perfino al piano della strada maestra* (twice); *Scarpa perfino al
piano della strada di sopra maestra; Strada va a porta forella;
piaggia pendente perfino alle ripe*
Verso: *Di messer agniolo da Castro per la citta di Castro*

This sheet is a clean drawing following U 747A r. The
window on the landing of the staircase has been omit-
ted. The ground plan is unusual, not only because of
the sequence of rooms (center) with antique labels, but
also because of the numerous *destri* and the second
staircase to the upper story. Possibly this was an ambi-
tious program outlined by the client. A precise plan of
the upper story is still lacking. No information exists
about the execution of the house.

BIBLIOGRAPHY: Ferri (1885) 23; Vasari-Milanesi (1878–85)
V: 503; Giovannoni (1959) I: 204; Frommel (1973) I: 48, 55,
85; II: 364; Giess (1981) 116–18, 138; Gardner-McTaggart
(1985) 110–11.

 H.G.

U 746A *recto*

ANTONIO DA SANGALLO THE YOUNGER
Castro, house of Messer Angelo, first project, after 1537.
Dimensions: 511 x 421 mm.
Technique: Pen and brown ink, corrections in red chalk, scored
 with a straightedge, punctures intended for U 747A r.
Paper: Two sheets glued together, folded twice, reinforced at
 edges and center, slightly yellowed.
Drawing Scale: Roman *palmi.*

INSCRIPTION, Recto: *Strada maestra; La sala viene tanta
grande quando e insieme lo / vestibulo Collatrio cioe viene
longa p[almi] 49½ / larga p[almi] 34; stradella va alle ripe;
strada laterale va a porta / forella; Vestibulo; Atrio; peristilio;
Cavoedio / subdivo; scarpa* (three times); *Ripa scivolante fino
alle ripe / del tufo; Bisognia ingrossare / latrio p[almi] 4½ che*

*sara / p[almi] 33 / diminuire lo / Cortile p[almi] 4½ che /
restera p[almi] 17½*
Verso: *Di messer agniolo da Castro / per la citta di Castro; di
messer agniolo da castro; Bisognia se alongi la faccia[ta] / pari
a quella di messer matteo / e pigliare la strada che ve al
pre[xente e la strada farla in la casaccia / del vescovado a
scontro o dirittura / dellaltra di messer matteo*

This project, with its almost square ground plan and
100-*palmi*-wide (ca. 22.34 m), seven-bayed facade, is
for the largest private palace in Castro. The support-
ing walls surrounding it, necessitated by the topogra-
phy, are echoed in the rustication on the right corner
of the house. This drawing must have been preceded
by sketches showing a similar sequence of rooms, the
central rooms here labeled according to Vitruvius (see,
however, the more sensible design of the similarly
named rooms on U 969A r., Palazzo Pucci, Orvieto).
A spiral staircase is added, as well as an unusual num-
ber of *destri* whose side shafts presumably served to
collect rainwater for washing. Measurements have
been corrected in an attempt to give the rooms har-
monious proportions (for example, the atrium initially
had a ratio of 28½ : 34; by reducing the cortile by 4½
and the wall of the peristyle by ½, Antonio arrived at
33½; the result is recorded as 34 x 34!). The staircase
is broadened. The notations on the verso are evidence
of Antonio's intervention in the urban planning, pre-
sumably on the land between the cathedral and the
piazza (topographical notations also on the recto).
The project is continued on U 747A r. and 745A r. For
information on the client, see "Castro and Nepi."

BIBLIOGRAPHY: Ferri (1885) 23; Vasari-Milanesi (1878–85)
V: 503; Giovannoni (1959) I: 204; Giess (1981) 116–18, 138;
Gardner-McTaggart (1985) 110-11.

 H.G.

U 747A *recto*

ANTONIO DA SANGALLO THE YOUNGER AND
WORKSHOP
Castro, house of Messer Angelo, second project, after 1537.
Dimensions: 554 x 411 mm.
Technique: Pen and brown ink, scored with a straightedge,
 punctures.
Paper: Slightly yellowed, mildew spots, folded once, reinforced
 at the edges.
Drawing Scale: *palmi romani* (25 *palmi* = 89 mm).

INSCRIPTION, Recto: *Strada maestra; Vestibulo; Atrio;
Questa sara tutta sala quanto / tiene questo atrio el vestibulo /
el tramezo quale sara longa / palmi 55 e larga p[almi] 34;*

peristilio; *Cavedio*; *Scoperto*; *aria*; *Scarpa perfino al piano della strada maestra* (twice); *Scarpa perfino al piano della strada di sopra maestra*; *Strada va a porta forella*; *piaggia perfino alle ripe*; (not by Antonio and in a different ink) *di messer Agnolo da Castro per la citta di Castro*
Verso: *Di messer agniolo da Castro per la citta di Castro*

The present drawing includes the corrections made in U 746A. Most of the rooms now have simple commensurable proportions: vestibule, 17:34; side rooms, 32:24; atrium, 34:34, the side rooms of which are deepened from 22½ to 23½. One can assume that this extra *palmo* was to be added to the peristyle in the central rooms, so that its measurements would change from 16:34 to 17:34. Side rooms are left: 16:24 and 16:16. The proportions of the *cavedio*, 18:36, were arrived at by measuring its depth only up to the corner pilaster; the vertical masonry on U 746A r. has here been replaced, apparently, by a lower parapet. U 745A r. shows the subsequent ground plan.

BIBLIOGRAPHY: Ferri (1885) 23; Vasari-Milanesi (1878–85) V: 503; Giovannoni (1959) I: 204; Giess (1981) 116–18, 138; Gardner-McTaggart (1985) 110–11.

 H.G.

U 748A *recto*

ANTONIO DA SANGALLO THE YOUNGER
Castro, house of Messer Mattia delle Poste, project from the
 beginning of 1538.
Dimensions: 409 x 502 mm.
Technique: Pen and brown ink, scored with a straightedge,
 punctures in part not related to the drawing.
Paper: Slightly yellowed and spotted, folded once, modern
 support at the creases and edges.
Drawing Scale: palmi romani.

INSCRIPTION, Recto: *Dalluno mattonato allaltro / palmj 24; La sala sara grande quanto questa / stantia el tramezo ellandito qual / viene longa palmi 44 et / larga p[almi] 34; questo muro sia a ingrossare da questa / banda p[almo] uno; A; A; A Cavalatori; Vicino* (six times); *Coritoro per la cucina; Cucina; Cortile; scoperto; strada*
Verso: *Case; Di messer mattia della posta per la citta di Castro et gradoli Istia et montalto*

Compare U 748A r. to the very cursory sketch of 1537 on U 743A r., *d*, which may have been intended for another site. By adroit planning, Antonio managed to create a small palace capable of satisfying the lofty demands on a badly shaped site. It is one of the new buildings on the piazza, adjacent to the unfinished

house of Cavaliere Sassuolo (see U 743A r., *a* and *b*). The property was purchased in December 1538, and on 12 September 1540 the palace was described as "facto e fabricato." For information on the client, see "Castro and Nepi."

BIBLIOGRAPHY: Ferri (1885) 23; Vasari-Milanesi (1878–85) V: 503; Giovannoni (1959) I: 204; Giess (1981) 115–16, 138; Gardner-McTaggart (1985) 109–12; Fagliari Zeni Buchicchio (1986) 252–53, 256 n. 30, fig. 7.

 H.G.

U 749A *recto*

ANTONIO DA SANGALLO THE YOUNGER
Castro, house of Signor Sforza, design sketch, 1537.
Dimensions: 290 x 218 mm.
Technique: Pen and brown ink, scored with a straightedge,
 punctures.
Paper: Partially yellowed, reinforced at the edges.
Drawing Scale: palmi romani (30 *palmi* = 87 mm).

INSCRIPTION: *per lo S[igno]re Sforza per Castro; palmj 65; (Tutta sala Come tira / questa Croce* canceled); *La sala sara longa palmi 35 / larga p[almi] 36; La sala sara quanto / tira questa Crocie / loncha palmi 48 / larga 35; Camera; palmj 90* ½; *Camera / 27 / 23* ½; *Studiolo p[almi] 9/16; Cucina; palmi 63*

A trapezoidal site, apparently intended to maintain a straight road, is divided in such a way that a normal palace with five bays can be built on it (see U 744A and 748A). The particular wants of the client included a *studiolo* on the ground floor (next to the warm kitchen) and, on the *piano nobile*, a *sala* as large as possible. This plan does not yet correspond to the present staircase. For information on the client, see "Castro and Nepi." We have neither information nor remains bearing on the construction of the house.

BIBLIOGRAPHY: Ferri (1885) 23; Vasari-Milanesi (1878–85) V: 503; Giovannoni (1959) I: 204; Giess (1981) 113–14, 138; Gardner-McTaggart (1985) 207; Clementi (1986) 380.

 H.G.

U 750A *recto and verso*

ANTONIO DA SANGALLO THE YOUNGER
Perugia, project for the fortress of San Cataldo, 1540 (*upper
 half of recto*). Castro, project for the Porta Lamberta,
 1537 (*lower half of recto*). Castro, project for the facade
 of the palace on the piazza; arcade, proportional scheme
 (*verso*).
Dimensions: 544 x 420 mm.
Technique: Pen and brown ink, black chalk on verso.

Paper: Two sheets glued together. Paper folded several times, yellowed and spotted, modern support at a number of points.

Drawing Scale: *palmi romani* (recto, lower half, and verso).

INSCRIPTION, Recto: (top) *Questa viene bassa / tagliata nel tufo / la maggior parte*; *surta*(?) (twice); *in piano sia Porlo de sotto / in quanto bono*

Verso: (above, not by Antonio) *disegno per castro / del Duca di Castro*; (left) *di mezo palmi 22 a mezo*; (to right) *Disegnio per castro / Delducha di Castro*

The attaching of these two sheets may have been undertaken by someone who did not recognize that they were for two different sites, Perugia and Castro.

The drawings for Perugia show the lower fortress of San Cataldo in a state prior to that seen in U 272A. It is shown without the great *tenaglia* that is so remarkable in the later sheet. The unshaded outline of the walls suggests that it is a preparatory drawing and thus it may be dated to the early summer of 1540. The drawing is executed freehand.

Those sections on the recto that are from Castro show a drawing of the defenseworks in perspective as well as a partial ground plan. Both are set on the cliffs of Castro. For the site, see "Castro and Nepi" and Soldati's plan (fig. 1) as well as U 813A r. and 945A r. Bastions and casemates protect the entrance to the city. The principal subject is the second gate, which resembles a triumphal arch (see U 1269A r. for Charles V's entry). Antonio the Younger's project was not realized in this form, but it served as the basis for the construction between 1545 and 1550 of the Porta Lamberta, which was only minimally decorated.

On the verso, left, there is a drawing for the facade of the palace on the piazza (see U 297A r., 299A r., 732A r., and 742A r.). It was drawn freehand by Antonio the Younger and given measurements afterward. For the arcade story, see U 297A r., *d* and *g*, and the penciled sketch at the right. The measurements for the *piano nobile* are not yet definitive; the height of the pilasters, like that of the arches, is given as 26 *palmi*, whereas the height of the bases and capitals is indicated by various numbers set side by side. For the shape of the windows, see U 1684A r. and 1364A r. In the attic story, the numbers added afterward (4 – 6 – 4) bestow a rhythm to the openings of the arcade not provided by the drawing. The transom window had to be eliminated after the measurements had been calculated. The sketch at the right, barely recognizable, includes numbers for the proportional scheme on which the construction of the arcades was based (see

also U 1199A r.). To approximate the golden section, Antonio made use of calculations based on the Fibonacci sequence (Giess, 1981). See also the reduction on U 297A r., *a*, of the original width of the arches from 22½ *palmi* to 22.

BIBLIOGRAPHY: Ferri (1885) 23; Vasari-Milanesi (1878–85) V: 501; Giovannoni (1959) I: 56, 200, 201; Polidori, Ramacci (1973) 81; Aimo, Clementi (1976) 60; Fiore (1976) 81, 82, 86; Giess (1978) 76, 80; Giess (1981) 106–8, 137; Gardner-McTaggart (1985) 65–68; Clementi (1986) 374–77.

N.A./S.P., H.G.

U 751A *recto*

ANTONIO DA SANGALLO THE YOUNGER
Castro, sketches for the fortifications of the land bridge, after 1537.

Dimensions: 286 x 374 mm.

Technique: Pen and brown ink.

Paper: Heavily spotted, glued onto stiff paper, damaged at edges.

INSCRIPTION, Recto: (not by Antonio) *Castro*
Verso: *Castro* (exposed by hole cut in the upper sheet of the paper)

Variations of the bastions on the land bridge of Castro are shown; two small bastions are added at the sides of a larger central bastion. The old city wall with a gate is sketched in also. See also U 813A r. and v., 752A r. and v., 753A r., 294A r., and 295 r. For a discussion of the topography, see "Castro and Nepi."

BIBLIOGRAPHY: Ferri (1885) 23; Vasari-Milanesi (1878–85) V: 502; Giovannoni (1959) I: 200; Fiore (1976) 81; Giess (1978) 73, 79; Fiore (1986) 341.

H.G.

U 752A *recto and verso*

ANTONIO DA SANGALLO THE YOUNGER
Castro, studies for the fortifications of the land bridge, after 1537.

Dimensions: 367 x 292 mm.

Technique: Pen and brown ink.

Paper: Folded twice, slightly yellowed, reinforced in places.

INSCRIPTION, Verso: *Santo francesco*; *Casa*; *Castro*

Following U 813A r., Antonio varies both form and the relative position of the bastions based on a pincer-like plan. The recto shows the left forward bastion. The verso shows the right forward bastion. Both sides

include rough sketches of the terrain, the city wall, the small church of San Francesco, and a house. For a discussion of the topography, see "Castro and Nepi." Additional projects: U 751A r., 753A r., 813A v., *b*, 294A r., and 295A r.

BIBLIOGRAPHY: Ferri (1885) 23; Vasari-Milanesi (1878–85) V: 502; Giovannoni (1959) I: 200; Fiore (1976) 81; Giess (1978) 73, 79; Fiore (1986) 341.

H.G.

U 753A *recto*

ANTONIO DA SANGALLO THE YOUNGER
Castro, study for the fortification of the land bridge, after 1537.
Dimensions: 597 x 437 mm.
Technique: Pen and brown ink, black chalk.
Paper: Yellowed, torn and cut at the lower edge, backed in several places, folded twice.

INSCRIPTION, Recto: (not by Antonio) *Castro*
Verso: *Castro*

This sheet contains several superimposed drawings. The first, in black chalk, shows the topography of the site (formation of the terrain and the city wall) and two bastions of unequal size with rounded points. This sketch is followed by a similar one in ink. A third shows variations of the pincer motif and develops it with a system of casemates. Its position relative to the city wall indicates that it has been pulled back, that is, reduced in size compared to that on U 813A r. and 752A r. (see also U 752A v., 751A r., 813A v., *a*, 294A r., and 295A r.). For a discussion of the topography, see "Castro and Nepi."

BIBLIOGRAPHY: Ferri (1885) 23; Vasari-Milanesi (1878–85) V: 50; Fiore (1976) 81; Polidori, Ramacci (1976) 81; Giess (1978) 73, 79; Fiore (1986) 341.

H.G.

U 754A *recto*

ANTONIO DA SANGALLO THE YOUNGER
Castro, sketch for the fortification of the land bridge, after 1537.
Dimensions: 259 x 241 mm.
Technique: Pen and brown ink.
Paper: Slightly spotted.

INSCRIPTION, Recto: (top to bottom) *Castro* (not by Antonio); *Questa si tagli tutta / la porta*; *Questa stia come sta lo novo*; *per Castro di farnese*; *Questa vada come / il vechio*;

Questo sieno Casematte / Basse in fondo del fosso; *Casematte*; *Questa vadia allinia / della valle*; *Questa sta meglio*; *si potria fare come / il puntigliato Come / Casematte*
Verso: *Disegni per Castro*; [. . .] *di volti / Per santo pietro*

The first drawing, at the top, shows, in awkward perspective, a defensework with three sections of wall joined at obtuse angles. Projecting casemates are placed at the four corners. The related ground plan, the third sketch from the top, includes a portion of the old city wall ("il vechio") and two round towers; this identifies it as the fortification for the Castro land bridge ("si tagli tutta la porta," refers to the old Porta di sopra). This ground plan shows a casemate placed squarely in front of the shortened central portion of wall. The related ground plan, at the bottom, is drawn with dashed lines ("puntigliato"). This sketch does not belong to the series of projects that includes U 751A r., 752A r. and v., and 753A r.; see also 813A v., *a*.

BIBLIOGRAPHY: Ferri (1885) 23; Vasari-Milanesi (1878–85) V: 502–3; Giovannoni (1959) I: 81; Fiore (1976) 81; Giess (1978) 76, 80; Fiore (1986) 341.

H.G.

U 755A *recto*

ANTONIO DA SANGALLO THE YOUNGER
Rome, plan for the fortification of Castel Sant'Angelo, 1542.
Dimensions: 570 x 488 mm.
Technique: Pen and diluted ink, prepared with stylus and ruler.
Paper: Heavy, folded in four, cut and restored on the corners.
Drawing Scale: Roman *piedi*.

INSCRIPTION: *Corritore*; *Cittadella*; *spazio per abitazione / e giardini*; *spazio per abitazione / e giardini*; *questo disegnio si e misu/rato a piedi e la sua circon/ferenzia si e piedi 2876 / quali sono palmi 3834²/₃ / quali sono Cannj 383 p[almi] 4²/₃*

The drawing most probably represents the final plan by Antonio the Younger for the new fortifications of Castel Sant'Angelo, Rome. Even if the link-up with the new Vatican defenses is not shown, the configuration of the proposed irregular pentagon that is proposed closely mirrors the study in U 1016A r., *d*, where the Vatican defenses do appear, and the design can thus be dated 1542 or shortly thereafter. Much as in that study, the emphasis is placed characteristically toward the Tiber where the existing Alexander VI tower is left to function as an advance ravelin for the Sant'Angelo bridge. The tower allows Antonio to withdraw the curtains, on the sides, leaving room for the riverbank and Via Alessandrina. A correction on

the flank of the left bastion confirms it as the position where the entranceway was planned, guarded by the embrasures in the gorge of the tower ravelin. The largest bastion is the one at the top that defends the longest curtains (380 *piedi* = ca. 113 m) of the pentagon, which thus becomes compressed toward the river and dilated toward Prati. In this way Antonio solves the need for internal space in the circuit without having to use the hexagonal enclosure proposed in U 910A, leaving "space for houses and gardens" on the two sides of the oldest nucleus of the castle. The Castel Sant'Angelo is shown in its entirety, including the addition of the small tower (on the left) that was never built. Penstrokes in diluted ink indicate the lines of crossfire on the exterior. In order to allow for them the Passetto was interrupted and ended by an underground passageway, reachable by means of a sturdy circular staircase. Following Camillo Orsini's temporary fortifications in 1556 the castle pentagon was continued from 1561, by Francesco Laparelli in a permanent form in brick. The destruction of Alexander VI's tower and other changes would follow around 1628 under Pope Urban VIII. See also U 1012A r. and v., 1016A r. and v., 1020A v., 910A, 939A.

BIBLIOGRAPHY: Firenze, Bibl. Medicea Laurenziana, Codex Ashburnham 1828 App., fols. 159 v.–160 r.; Ferri (1885) 167; Borgatti (1890a); Rocchi (1902) I: 193–94; II: pl. XXXVII; Borgatti (1931) 433, 468 n. 7; Cecchelli (1951); Marconi (1968) fig. 90; D'Onofrio (1971); D'Onofrio (1978); Spagnesi (1992).

F.P.F.

U 756A *recto*

GIOVANNI BATTISTA DA SANGALLO
Florence, Fortezza da Basso, ground floor plan, south front, summer 1534.
Dimensions: 420 x 579 mm.
Technique: Pen and brown ink with brown wash, stylus, pin, compass, straightedge.
Paper: Heavy.
Drawing Scale: 100 *braccia* = 87 mm.

INSCRIPTION: (twice) *stalle b*[*raccia*] *160 per cavalli 106* (or *126?*)

This drawing shows how the construction of the Fortezza da Basso was to take advantage of the pre-existing medieval wall and the Porta Faenza. The drawing appears to be by Giovanni Battista da Sangallo and shows casemates with five gun embrasures in the salients of the two bastions. Antonio the

Younger experimented extensively with different ways of arranging cannon within the bastions by the use of twin or triple embrasures (U 1509A) and double casemates (U 802A), but these salient gun positions are unusual in that they provide small-arms or light artillery fire from a constricted part of the bastion that was normally unarmed.

The gate was, of course, the weak point in any enceinte. Here it is placed close to the flank of the central *mastio*, and inside Antonio the Younger created a cranked, air-lock security. In later drawings, such as U 315A and 316A, the security system is much more elaborate.

BIBLIOGRAPHY: Ferri (1885) 57; Giovannoni (1959) I: 348, 349; II: 376; Hale (1968) 521, fig. 21.

N.A./S.P.

U 757A *recto*

ANTONIO DA SANGALLO THE YOUNGER
Florence, study of entry for the Porta a Faenza, 1531.
Dimensions: 266 x 410 mm.
Technique: Pen and brown ink with light brown wash, pin, stylus.
Paper: Thick with holes made by incised lines, folded in four, tape repairs on verso.
Drawing Scale: Florentine *braccia* (25 *braccia* = 99 mm).

INSCRIPTION: *b*[*raccia*] *24 aluna*; (right) *mura dela tera*; *tore dela porta / a faenza*

This is generally considered to be a study of the internal works of the Fortezza da Basso at a time when it was proposed that the fortress straddle part of the ramparts at the Porta a Faenza (see U 760A). The use of wash, it has been suggested by most previous scholars, denotes the preexistent bastion which includes the tower of the Porta a Faenza. This tower was to be conserved to make the *mastio*; entry to the fortress is therefore found in the side of the bastion and not in the curtain. The drawing was traced at first by a stylus, then inked and filled in with wash. A later ink intervention modified the orientation of the left-hand access, making it oblique with respect to the great central room. The use of wash shading and a vague zoomorphic inspiration is said by Manetti to recall Michelangelo's fortifications for Florence.

Dating and attribution of this drawing present a problem. Hale gives it to Antonio the Younger and implies a date around 1535, while Manetti seconded by Marani favor Giovanni Battista and a slightly later date of 1536–37. To us, both script and forms (notably

the embrasures) seem typical of Antonio the Younger. In our opinion, however, the drawing is not to be associated with the construction of the Fortezza da Basso in the middle years of the decade of the 1530's but with the strengthening and refortification of Florence that took place just after the siege of the city (1529–30) in 1531, when Antonio the Younger was there.

In the first place, nothing on the sheet (recto or verso) makes reference to the Fortezza da Basso. Moreover, this kind of drawing (wash with pen and brown ink) is found extensively on only one other sheet, U 761A, which can certainly be dated to the earlier phase of work on the walls. Finally, as noted above, the refortification of the post-siege city demanded precisely the kind of construction and survey work of the entire city defenses shown in part on the verso. For further discussion, see U 757A V.

BIBLIOGRAPHY: Ferri (1885) 57; Giovannoni (1959) I: 81, 348; II: fig. 379; Hale (1968) 522, fig. 25; Marconi et al. (1978) 231; Manetti (1980) 126–29, fig. 7; Marani (1984) 112–13, fig. 70.

N.A./S.P.

U 757A verso

GIOVANNI BATTISTA DA SANGALLO WITH ANTONIO DA SANGALLO THE YOUNGER
Florence, hill of San Miniato, proposed defenses, 1531.
Dimensions and Paper: See U 757A recto.
Technique: Pen, brown and red ink, straightedge.

INSCRIPTION: (middle) *insino / alo campangha / di sanmynjato / soto;* (in red) *dal / una stella alaltra / fa murato sono / la mura alta nalpiu / baso br[accia] 6; insino / dala schala di sanmynjato;* (bottom right, hand of Antonio the Younger) *questo e fatto sono li segni / chi stanno cosi;* (bottom left) *Discegni di / fiorenza*

Concerning the dating, see U 757A r. The San Miniato hill had presented defensive problems during the siege of Florence, as Michelangelo's service reveals, and these alternative proposals to ring the hills would have solved Florentine problems.

Strategically these proposals should be linked to Antonio the Younger's proposals to encircle the Borgo in Rome (U 1016A, 1017A) as well as the defenses for Castro, Perugia, and other hilly sites. A trace is outlined with various alternative proposals in outline or dotted line. In fact, the script is that of Giovanni Battista as may well be the drawing. (Antonio's handwriting may be seen only in the lower left.) In these

kinds of topographic analyses Antonio the Younger makes extensive notation of the surrounding topography and tends not to use a straightedge (see U 1028A).

BIBLIOGRAPHY: See U 757A recto.

N.A./S.P.

U 758A recto

ANTONIO DA SANGALLO THE YOUNGER
Florence, experimental plans for the Fortezza da Basso, March–April 1534.
Dimensions: 259 x 208 mm.
Technique: Pen and brown ink.
Paper: Darkened at edges.
Drawing Scale: Florentine *braccia*(?); notation on fortress at lower right (numbered "1") shows cortina labeled 200 and bastion 100 without indication of units.

INSCRIPTION: (at upper right) *La porta aSangallo sie cosi; sangallo; laripa; coronnara*

According to Vasari and Condivi, Alessandro de' Medici first tried to entice Michelangelo back to Florence from Rome to work on the fortifications. On 10 March 1534 Alessandro Vitelli wrote to Antonio da Sangallo the Younger to invite him to come to Florence for consultations "on a certain project." Antonio the Younger seems to have arrived shortly thereafter; on 29 May 1534 he was appointed "caput magistrorum fortilitii illustrissimi ducis" by the *capitani*. Between then and 15 July, when the foundation stone was laid, all the major decisions on location, shape, size, and strategy had been taken for what was to become the Fortezza da Basso. Excavations are recorded as early as May. Assisting Antonio the Younger on site were Nanni Unghero (Giovanni Alessio), who had been in Florentine employ since at least 1531, and Aristotile da Sangallo. The *provveditore* was Gherardo di Bertoldo Corsini. Work on the Fortezza da Basso proceeded remarkably quickly, with the labor force reaching as high as 1500 per day. The first garrison was installed in December 1535.

The location sketch (top right) is part of Florence's walls, apparently part of the Porta San Gallo. Giovannoni calls this a "bozzetto appena iniziale," but the drawing is, in fact, much more interesting than that. It shows a five-sided fortress inside the walls with the Prato road leading through the Porta San Gallo. This proposal makes extensive use of the preexisting walls. Below is a series of numbered geometrical variations on the idea of the polygonal fortress: triangle, square, two interlocked squares, five-pointed star, six-pointed

star, and six-sided polygon. In the center are two polygonal fortress designs, one with a circular core, the other with a hexagonal core. These may either be courtyards (as at Caprarola) or variations on *mastio* experiments (as at Rome, Castel Sant'Angelo). Both proposals reflect the angle of the walls at the Porta San Gallo. In any case, the sheet reveals the level of geometric play (recalling Francesco di Giorgio and Antonio Filarete) inherent in the development of the polygonal fortress at an early phase of plans for the Fortezza da Basso.

BIBLIOGRAPHY: Varchi (1838–41) I: 108; Ferri (1885) 57; Vasari (1906) V: 462; Giovannoni (1959) I: 348; Hale (1968) 513–20, fig. 14; Moschella (1970); Salvadori, Violanti (1971); Bencivenni (1978); Manetti (1980).

N.A./S.P.

U 759A *recto and verso*

ANTONIO DA SANGALLO THE YOUNGER
Florence, Fortezza da Basso, sketch plan; experimental stellar fortress plans, spring–summer 1534.
Dimensions: 440 x 273 mm.
Technique: Pen and light brown ink, stylus, compass (note circular form incised in recto upper figure, indicating central rotunda or drum, also found on verso).
Paper: Darkened at edges.
Drawing Scale: verso in *canne.*

INSCRIPTION, Recto: *Schizi per fiorentia; cavalieria*

Fortress plan studies fill both sides of the sheet. The verso shows an early sketch plan of the Fortezza da Basso in pentagonal form with its *mastio* in place and a series of experimental geometrical variations on the fortress plan related to the Fortezza da Basso. A six-pointed stellar scheme is shown (above), with cranked curtains and a central rotunda keep. To the right is an alternative detail of a concave curved flank/curtain. In the center, left, are studies of the embrasures in a central rotunda. At the center is a geometrical outline of a six-pointed stellar trace. Below that is a conventional five-bastioned trace.

Antonio the Younger is still feeling his way through to a layout that becomes defined in U 758A and later in U 315A. Many of the elements on U 759A reappear on other sheets. See, for example, U 1052A (for the curved bastions), 1118A (for the reentrant), 1467A (for studies of the batteries), 1344A v. and 1520A (for the central keep).

BIBLIOGRAPHY: Ferri (1885) 57; Giovannoni (1959) I: 348, 349.

N.A./S.P.

U 760A *recto and verso*

ANTONIO DA SANGALLO THE YOUNGER
Florence, plan of the Fortezza da Basso (*recto*). Proposal to divert the Mugnone(?) (*verso*). April–May 1534.
Dimensions: 282 x 414 mm.
Technique: Pen and brown ink.
Paper: Darkened at edges.
Drawing Scale: probably Florentine *braccia.*

INSCRIPTION, Recto: (in center) *vestibolo; atrio*
Verso: *facii; Mangionine*

The main drawing (recto) is an early study for the location and form of the Fortezza da Basso. Here, Antonio the Younger still experiments with the idea of a fortress within a fortress. However, the inner fortress is now too big properly to be called a *mastio,* or keep. It is defended by six small bastions, and contains two courtyards with arcades, together with extensive accommodation. The entire complex is now planned for a site outside the city walls at the Porta a Faenza. The medieval gate thus becomes the main entrance from the city of Florence, to the south. The inner fortress is no longer central (as in U 759A) but projects into the open country to the north. The small section through the rampart (bottom right) shows that Antonio's design has begun to take on reality as a three-dimensional object.

Although the drawing has been attributed by Giovannoni to Aristotile, we concur with Hale and others who give the sheet to Antonio.

The verso shows a series of penstrokes to test or clean a nib, and a study of techniques to divert the Mugnone, the creek that enters the Arno near the Fortezza da Basso. The drawing seems to show what may be an attempt to shore up the banks of the Mugnone to help with the problem of local flooding.

BIBLIOGRAPHY: Ferri (1885) 57; Giovannoni (1959) I: 349, 419; Hale (1968) 521, fig. 19; Marconi et al. (1978) 232.

N.A./S.P.

U 761A *recto*

ANTONIO DA SANGALLO THE YOUNGER, WITH OTHERS(?)
Florence, bastion at the Porta alla Giustizia, 1531.
Dimensions: 290 x 424 mm.
Technique: Pen and brown ink, stylus, straightedge, light brown wash, red chalk to show lines of fire.
Paper: Thick, darkened at edges, center fold, ink stain left.
Drawing Scale: passo (50 *passi* = 83 mm).

INSCRIPTION, Recto: (left, top to bottom) *Arno*; *Torre della / munitione*; *pescaia*; *arno*; (across ramparts) *porta all justititia*; (later hand, possibly Aristotile da Sangallo) *per la porta alla justitia di firenze*; *porta gibellina / murata*; (below right) *passi 50*
Verso: *per la porta alla justitia / di fi/orenze*

Sited on the so-called Cittadella Vecchia, an area that had been damaged both by the Arno and by the imperial-papal siege of 1529–30, Antonio the Younger's bastion for the Porta alla Giustizia, Florence, may have been influenced by Michelangelo's work on the same site (*see* Florence, Casa Buonarotti, 19). The curving faces and interwoven geometries seem more characteristic of Michelangelo than of Antonio the Younger, and suggest perhaps a strong influence from the surviving foundations. Antonio's work would have had an intricate entrance and a complicated demi-bastion with orillons facing the countryside from which a smaller arrowheaded bastion projected toward the Arno. Red chalk is used to show the lines of fire from the embrasures, but the convention is not the one usually employed by Antonio. In the opinion of Hale this drawing reflects one of Antonio the Younger's first proposals (March or April 1534) for the strengthening of Florence's defenses. A more likely date, however, is provided by Gianneschi and Sodini, seconded by Manetti, who associate the drawing with payments of late 1530–31 for work undertaken in the Porta alla Giustizia area by Antonio the Younger and Nanni Unghero. To this period we would also add U 757A r. and v. Due to the use of the straightedge, it is difficult to identify the author. Antonio the Younger's handwriting is visible on the sheet, but it is possible that Nanni Unghero was actually responsible for the drawing. A later notation, identifying the site, may be by Aristotile da Sangallo.

BIBLIOGRAPHY: Ferri (1885) 57; Giovannoni (1959) I: 390; Ackerman (1964) II: 47; Hale (1968) 507, fig. 7; Gianneschi, Sodini (1979) 7–8; Manetti (1980) 55–58, fig. 6.

N.A./S.P.

U 762A *recto*

ANTONIO DA SANGALLO THE YOUNGER
Florence, Fortezza da Basso, study of rustication, 1535.
Dimensions: Original sheet irregularly cut, modern support 296 x 226 mm.
Technique: Pen and brown ink, stylus, compass, straightedge.
Paper: Heavy on new support, folded on dotted lines.

On the small bastion and cavalier in the center of the south curtain of the Fortezza da Basso, facing the city of Florence, is found one of the most remarkable pieces of sixteenth-century rustication. Diamond-pointed stones alternate with low-relief balls (*punte di diamante e di palle schiacciate*). Clearly designed to present the city with an image uniting the Medici symbol (the *palle*, or balls) with a symbol of their wealth and character, Antonio's design is both attractive and rugged. This facade became, in effect, the distinguishing mark of the fortress and was much praised by Giorgio Vasari ("fa bellissimo vedere").

The drawing shows Antonio the Younger in the process of working out the pattern that was later to be executed in stone. The drawing seems to presuppose a faceted surface and thus may respond to a plan like that of U 315A. The design is ingenious for it allows Antonio the Younger to maintain the pattern across the splayed segments of the wall by varying the size of the undecorated stones.

BIBLIOGRAPHY: Ferri (1885) 57; Vasari (1906) I: 129; Giovannoni (1959) I: 348; Hale (1968) 523, fig. 34.

N.A./S.P.

U 768A *recto and verso*

ANTONIO DA SANGALLO THE YOUNGER
Florence, Fortezza da Basso, studies for colonnade and piers (*recto*). Door architrave (*verso*). 1535.
Dimensions: 408 x 567 mm.
Technique: Pen and brown ink, stylus, pin, compass, straightedge.
Paper: Darkened at edges, heavily repaired.
Drawing Scale: Florentine *braccia*.

INSCRIPTION, Recto: *Cosi viene uno quadro / e due tertij de alteza*; *Lo braccio in 20 minuti*; *Lo piu sie b[raccia] 13*
Verso: *Rocha di fiorenza*

The elaborate barracks planned to ring the *piazza d'armi* of the Fortezza da Basso, Florence (and seen in U 315A), is studied in three sheets in addition to the present one: U 931A r., 1282A r., 1659A r. In U 768A r., Antonio the Younger sketches an elevation to resolve the proportional relations of the different components of the Doric arcade, and in a series of plans he explores the nature of the beveled corners of the arcade piers.

On the verso is a sketch for a door, possibly for the Fortezza da Basso.

BIBLIOGRAPHY: Ferri (1885) 57; Giovannoni (1959) I: 348, 350, 420.

N.A./S.P.

U 769A *recto*

Antonio da Sangallo the Younger
Città di Castello, portal, 1530(?).
Dimensions: 150 x 282 mm.
Technique: Pen and brown ink.
Paper: Trimmed at edges, modern support.

INSCRIPTION: *Di citta di Castello*

The drawing shows the outline of a section of the walls of Città di Castello. In the center of the section of the walls is a portal (or possibly a bastion or a platform) with what seems to be a pair of protective caponiers or curved wall barbicans to either side. Lines of fire appear to indicated from the flanks behind the curved shoulders. Above is what appears to be a section through the ditch before the gate. The drawing was not cited by Giovannoni.

BIBLIOGRAPHY: Ferri (1885) 28.

<div style="text-align:right">N.A./S.P.</div>

U 770A *recto*

Antonio da Sangallo the Younger
Città di Castello, Vitelli tower, before 1540.

c

a b

Dimensions: 210/206 x 290 mm.
Technique: Pen and brown ink.
Paper: Partially yellowed.
Drawing Scale: Roman *palmi*.

INSCRIPTION: *Schizo p[er] fare una torre p[er] lo Signiore alexa[n]dro / vitelli la vole con[n] la scarpa e i[n] cima la scarpa la porta / e vole abbia dua poste di bechatelli luna / sopra allaltra*

The site is certainly not the one originally chosen for the square tower that Alessandro Vitelli wanted to build. In the section elevation (*a*) the horizontal measurements are indicated but not the height. Only in the partial section (*c*) do we have the height of the scarped lower part (44 *palmi*), which comprises two vaulted chambers, one on top of the other, connected with the upper levels by a stairwell (*b*). The internal stories, above the portal and entrance bridge, were probably to be built in wood.

BIBLIOGRAPHY: Vasari (1846–70) X: 62; Vasari-Milanesi (1878–85) V: 505; Ferri (1885) 28; Giovannoni (1959) I: 73 n. 1, 420.

<div style="text-align:right">F.Z.B.</div>

U 771A *recto and verso*

Antonio da Sangallo the Younger
Florence, compass survey, 1526(?).
Dimensions: 205 x 278 mm (original sheet).
Technique: Pen and brown ink, stylus, red chalk.
Paper: Darkened at edges, partial new support. Watermark is partially cut at bottom (unidentifiable).

INSCRIPTION, Recto: (from left, clockwise) *18 al puntone;* M[*aestro*] *1½ a San Nicholo;* S[*cirocco*] *4 a San Francesco champanile;* S[*cirocco*] *5½ al champanile di Santo miniato;* S[*cirocco*] *6⅔ alangolo del palazzo;* S[*cirocco*] *9 Santa Margherita a montici;* S[*cirocco*] *14 Lanfredini;* S[*cirocco*] *14½ alla torre delle mura;* S[*cirocco*] *18½ San Giorgio;* S[*cirocco*] *19½ al champanile de S[igno]ri;* + [*Levante*] *9 al champanile di San Giorgio;* + [*Levante*] *13½ a San piero Gattolini;* + [*Levante*] *14½ alle Campora;* + [*Levante*] *19 Santo Donato schopeto;* G[*reco*] *1 a bellosguardo;* G[*reco*] *3 a belvedere;* G[*reco*] *3⅔; 4 alla porta di Camaldoli e a un palazzo;* G[*reco*] *6 al palazzo in su lato sopra monte uliveto;* G[*reco*] *7½ alla chasa nera;* G[*reco*] *9 a Sanfriano; al champanile di monte uliveto* M[*aestro*] *1⅔ alla porta a faenza;* + [*Levante*] *4 aSangallo*
Verso: (from right-hand side reading clockwise) G[*reco*] *17⅔ al chanto di Sangriano;* T[*ramontana*] *7⅔ la invidia; porta al prato* T[*ramontana*] *10; porta a faenza* M[*aestro*] *1⅔; Porta aSangallo 3⅔; porta apinti 1½; torre a tre canti* L[*ibeccio*] *11⅔; Crocie 0–0; Munitione;* M[*aestro*] *½ Sanicholo;* M[*aestro*] *7 San miniato;* P[*onente*] *1½ San giorgio*

This is one of a group of four plane-table compass surveys of the walls of Florence (U 771A, 772A, 773A, 774A). They have been connected, by Hale and most other scholars, with the decision to locate the Fortezza da Basso in the northwest corner of the city of Florence in spring 1534. The lone dissenting voice is Bencivenni (1982) who argues that the surveys belonged to an earlier period, possibly 1526–27, when proposals to renovate Florence's defenses were made by Niccolò Machiavelli and Pedro Navarra. In support of his argument Bencivenni notes that the focus of the drawings is on the left side of the Arno and seems largely unrelated to the potential sites (on the right bank) for the Fortezza da Basso. Moreover, Bencivenni notes that there is no evidence of any of the siegeworks from 1529–30 on any of the drawings. Finally, the monastery of San Donato Scopeto, outside Porta Romana, destroyed during the siege, is marked on three of the drawings.

We agree with the analysis provided by Bencivenni. In 1534 events moved too quickly and with the kind of assurance that hardly required such extensive sur-

veys. For a city plan or the like such surveys would have been essential. In addition, there seems to have been no special interest in the general problems of Florence's walls in 1534. Hence, an earlier date, possibly 1526, seems likely. Note also the pre-1530 form of "h" as written by Antonio (see essay of C.L. Frommel).

U 771A r. uses the cupola of Santa Maria del Fiore as a viewing point. Significant architectural and topographic landmarks are then noted (the campanile of the Church of San Francesco, the campanile of San Miniato, the Porta San Gallo) with their distances and direction from the cupola. Antonio seems to proceed logically from east to west (Bencivenni). On the left bank the drawings show special interest in the nearby hills.

Bencivenni has been able to establish for each drawing a viewing point from which the observations were taken: U 771A, the cupola of Santa Maria del Fiore; U 772A, the Porta San Niccolò and San Miniato; U 773A, the Porta San Giorgio; U 774A, the Porta San Frediano. Antonio made use of a plane table with a radiating arm fixed at the center, as one can see from the central hole in which the arm was fixed. The sheets are rather roughly treated, rotated, or approached from different directions in order to take sitings; chalk is used to mark precise points. The inscriptions cross one another at points, suggesting that siting and inscription were executed in the same motion.

The plane table survey simply plots the direction of the landmarks from a central observation point. Two such survey sheets from a known distance apart allow all the landmarks to be plotted by triangulation. Compass bearings permit a double check on accuracy and, where all the landmarks cannot be seen from the two observation points, allow accurate location by means of a bearing and a measured distance. The combination of the two methods (seen here) produces the best results.

Plane tables for compass readings and other similar devices were used by L.B. Alberti, Leonardo da Vinci, and others for city surveys. Raphael's famous letter to Leo X (1519) concerning a map of the city's antiquities described the use of a similar instrument. In short, by Antonio the Younger's time the plane survey was a relatively well-established technical tool. For example, he used it at Castro as can be seen on U 294A r.

BIBLIOGRAPHY: Ferri (1885) 57; Giovannoni (1959) I: 348; Hale (1968) 513; Moschella (1970); Salvadori, Violanti (1971); Bencivenni (1982) 34, fig. 2.

N.A./S.P.

U 772A *recto*

ANTONIO DA SANGALLO THE YOUNGER
Florence, compass survey, 1526(?).
Dimensions: 172 x 280 mm.
Technique: Pen and brown ink, stylus.
Paper: Partially darkened. Watermark is cut at edge, but identical to U 771A.

INSCRIPTION: (right-hand drawing, counterclockwise from top) + [Levante] 2½ al palazzo piu dentro che Lanfredini / inverso firenze delle dua torri B; S[cirocco] 18½ al chasamento infral palatio sopradicto / a Sanminiato; S[cirocco] 3½ amezo la facciata; S[cirocco] 2½ al champanile di San Miniato; O[stro] 15¼ amezo la faciata; O[stro] 14 al champanile di San Fran[cesc]o; a la chupola M[aestro] 7; M[aestro] 1 allo champanile delli signori; (left-hand drawing, counterclockwise from bottom) T[ramontana] 12½ al champanile de signori; (hole) alla torre del chantone / di santofriano 6½; al champanile di monte Uliveto 2½; G[reco] 19 amezo lo palatio in nel lato sopra mo/nte Uliveto segnato D; + [Levante] 8 laltro palazzo delle due torri / segniato B; + [Levante] 8 fralle due torre de Lanfredini; S[cirocco] 17½ al chantone del palazzo di San Miniato; S[cirocco] 14 al champanile di San Miniato; S[cirocco] 12½ al champanile di San Fran[cesc]o; S[cirocco] 3 auna cierqua / tonda da uciellare dietro a San Franc[esc]o / di la dalla valle; al puntone O[stro] 3¼; 2 alla torre della munitione

U 772A is one of a group of four survey drawings of Florence and its surrounding territory (U 771A, 773A, 774A). For a consideration of issues of technique, purpose, and dating, see U 771A.

BIBLIOGRAPHY: Ferri (1885) 57; Giovannoni (1959) I: 348; Hale (1968) 513; Moschella (1970); Salvadori, Violanti (1971); Bencivenni (1982) 29, fig. 4.

N.A./S.P.

U 773A *recto*

ANTONIO DA SANGALLO THE YOUNGER
Florence, compass survey, 1526(?).
Dimensions: 214 mm (diameter).
Technique: Pen and brown ink, stylus, red chalk.
Paper: Modern support.

INSCRIPTION: (counterclockwise from left) T[ramontana] 7 al champanile di monte uliveto; 13½ (canceled) al palazzo in sul monte sopra monteuliveto / segniato D; G[reco] 16 alla torre di bello sguardo / e San donato schopeto; G[reco] 7 alprimo palazzo presso alle Campora; G[reco] 3 amezo la faciata della Campora 16⅔ al champanile di S[an] Gagio; + [Levante] 14 alla torre in sul lato presso S[an] Gagio;

S[cirocco] 18 al Cholle; S[cirocco] 14 al baronciello; S[cirocco] 10 alli Lanfredini; S[cirocco] 6 al palazzo segniato B; S[cirocco] 4¹⁄₂ a Santa Margherita a Montici; (sheet rotated) S[cirocco] 0 alla torre bianca presso S[an] Miniato; (sheet rotated) O[stro] 4¹⁄₂ al casamento segniato A; (sheet rotated) O[stro] 9 allangolo del palazzo di S[an] Miniato; O[stro] 7¹⁄₂ al campanile di San Miniato; O[stro] 2 al champanile di San Fran[cesc]o; L[ibeccio] 9 alla torre delle munitione; L[ibeccio] 2²⁄₃ alla porta alla chrocie; P[onente] 19 alla torre atre Canti; P[onente] 11¹⁄₂ alla porta a Pinti; P[onente] 4 alla porta aSangallo; P[onente] ¹⁄₂ a Santa Maria alla cupola; P[onente] 0 al champanile de signori; M[aestro] 12 alla porta a faenza; M[aestro] 1 alla porta al prato; T[ramontana] 18¹⁄₄ alla torre della invidia; T[ramontana] 15 alla torre

U 773A is one of a group of four survey drawings of Florence and its surrounding territory (U 771A, 772A, 774A). For a consideration of issues of technique, purpose, and dating, see U 771A.

BIBLIOGRAPHY: Ferri (1885) 57; Giovannoni (1959) I: 348; Hale (1968) 513, fig. 9; Bencivenni (1982) 30, fig. 7.

N.A./S.P.

U 774A recto

ANTONIO DA SANGALLO THE YOUNGER
Florence, compass survey, 1526(?).
Dimensions: 138 x 138 mm (modern support).
Technique: Pen and brown ink, stylus, red chalk.
Paper: Original sheet trimmed to octagonal shape, partially yellowed, attached to modern support.

INSCRIPTION: (counterclockwise from upper right) *Strada pasa apiedi di monte Uliveto T[ramontana] 2¹⁄₂; Champanile di monte uliveto G[reco] 19; casa nera presso al detto G[reco] 5; palazzo in sul lato sopra monte / uliveto G[reco] 5; bellosguardo + [Levante] 9; S[an] Donato schopeto + [Levante] 0; torre presso San Gagio S[cirocco] 14; S. pierogattolini S[cirocco] 13¹⁄₂; (sheet rotated) S[cirocco] 6 Colle; S[cirocco] 5. Capponi (Caponi canceled); S[cirocco] 3. in fra le dua case del baronciello; S[cirocco] 1²⁄₃ Lanfredini; O[stro] 17¹⁄₂ palazo delle due torri merlate; O[stro] 14¹⁄₂ torre biancha presso S[an] Miniato; O[stro] 13¹⁄₂ porta S. giorgio; O[stro] 11 al canpanile di S[an] miniato; O[stro] 8¹⁄₄ canpanile di S[an] Fran[cesc]o; O[stro] 5 porta San nicholo; O[stro] 0 Canpanile de Signiori; L[ibeccio] 11¹⁄₂ Cupola; L[ibeccio] ¹⁄₂ porta Sangallo; P[onente] 11¹⁄₂ porta a faenza; (sheet rotated) porta al prato M[aestro] 16¹⁄₂; torre della invidia M[aestro] 11¹⁄₂*

U 774A is one of a group of four survey drawings of Florence and its surrounding territory (U 771A, 772A,

773A). For a consideration of issues of technique, purpose, and dating, see the entry for U 771A.

BIBLIOGRAPHY: Ferri (1885) 57; Giovannoni (1959) I: 348; Hale (1968); Moschella (1970); Salvadori, Violanti (1971); Bencivenni (1982) 31, fig. 9.

N.A./S.P.

U 776A recto

ANTONIO DA SANGALLO THE YOUNGER
Florence, Fortezza da Basso, plan section of entry to fortress; elevation of scarped wall; piece of curtain wall, May–June 1534.
Dimensions: 261 x 204 mm.
Technique: Pen and brown ink.
Paper: Very thin, darkened at edges.
Drawing Scale: Florentine *braccia.*

INSCRIPTION: (top) *dita 16;* (bottom) *nella Cortina; schalino*

A detailed study for the entry system at the Fortezza da Basso, Florence, using the Porta a Faenza. The drawing probably was executed by Antonio the Younger about the same time as U 760A as it shows the entry to the fortress through the old medieval portal. Later it was proposed to block the entry by a ravelin (U 783A r.) and later still entry was moved from the Porta a Faenza (U 316A). In the lower right may be a sketch for the arcade system used at the *piazza d'armi* (see U 315A, 316A).

Entry was, of course, a critical matter in the design of fortresses. Antonio the Younger's multiple-air-lock systems for the Fortezza da Basso were particularly ingenious (see U 315A, 316A).

BIBLIOGRAPHY: Ferri (1885) 57; Giovannoni (1959) I: 348.

N.A./S.P.

U 777A recto

ANTONIO DA SANGALLO THE YOUNGER
Fortification study, section through scarped wall for an unknown location, ca. 1535.
Dimensions: 224 x 218 mm.
Technique: Pen and brown ink.
Paper: Darkened at edges.

INSCRIPTION: *Terra*

This drawing seems to be an attempt on Antonio the Younger's part to contrive an elegant rampart, with a base molding and two alternative placements for the upper cordon (or, possibly, a double cordon). The base

molding is relatively unusual in military architecture, possibly because it requires a flat site. A vertical flue seems to run from the gallery to the casemate above.

Identification and dating are extremely difficult. Although the angle of the scarp recalls the ramparts at Piacenza, which the Sangallo circle studied extensively (see U 802A, 808A r. and v., 1392A, 1395A, 1396A), none of the Piacenza drawings has the distinctive double cordon. Giovannoni compared U 777A to drawings for the Fortezza da Basso, such as U 1282A, but there too the distinctive cordon is missing. Another similar study is found for the Rocca Paolina (U 463A). We would favor a dating around 1535 when Antonio seems to have been interested in these matters.

BIBLIOGRAPHY: Giovannoni (1959) I: 83, 420.

N.A./S.P.

U 778A *recto*

ANTONIO DA SANGALLO THE YOUNGER
Polygonal fortress; bastion; cranked curtain joining two
 bastions, location unknown, ca. 1526.
Dimensions: 122 x 232 mm (maximal).
Technique: Pen and brown ink, stylus, compass.
Paper: Medium to heavy weight, on new support to form
 rectangle and close holes.
Drawing Scale: Ravennate *braccia* (100 *braccia* = 26 mm).
 Note: Construction lines show geometric basis for the
 stellar trace of the fortress (right).

INSCRIPTION: (top left, cranked curtain) *b*[raccia] *400*; (left) *cie passi 40 / b*[raccia] *100 / di ravenna*; (bottom) *per una grande / forteza*

This sheet shows an interesting mixture of site-specific comments and general, even theoretical, studies. The sheet was rotated by Antonio the Younger in order to fill it. The study of an intermediate bastion between larger works (bottom), the cranked curtain (top left), and the stellar work (right) all seem to be theoretical works; while the drawing scale (equivalence between *passi* and Ravennate *braccia*) is highly particular and suggests a date of 1526 along with the other Ravenna sheets (U 884A, 885A, 887A).

The sketch for the large fortress (bottom) appears related to a Sangallo shop drawing (U 1390A r.). The stellar work (right) relates to other drawings by Antonio the Younger (U 1118A, 1344A, 1520A). The study of the placement of the intermediate bastions is also referred to (U 1118A).

Although inward (concave) cranked curtains were

illustrated in some sixteenth-century treatises, nothing quite like these outward (convex) cranked curtains was ever built, to our knowledge. Such cranks would, of course, increase the exposure of the flanks to enemy fire and, at the same time, introduce a blind spot in front of each flank, which could not be swept by its neighbor.

BIBLIOGRAPHY: Giovannoni (1959) I: 83, 348, 420.

N.A./S.P.

U 779A *recto*

ANTONIO DA SANGALLO THE YOUNGER
Fortification study (Florence, Fortezza da Basso?), casemate
 before a wall; study of firing-line embrasures in a round
 tower, 1534–35.
Dimensions: Original sheet irregularly cut, modern support
 202 x 138 mm.
Technique: Pen and brown ink.
Paper: Darkened at edges.

INSCRIPTION: *a punte 16*; *abreccia*; (later hand, in pencil) *Gobbo?*

This sheet is one of a series of studies of gun embrasures for round towers undertaken by Antonio the Younger; see also U 759A, 784A, 1118A. Here the parapet and the upper embrasures through the wall are studied. Elsewhere (see above) the embrasures at the foot of the rotunda receive attention. In all cases, the problem is to achieve a field of fire that is as wide as possible, without using projecting bastions. The great thickness of the walls renders this task more difficult. The context for these studies is probably the early proposals to incorporate a central keep at the Fortezza da Basso.

Giovannoni notes that the point is accentuated here, thus leading to the type adopted in the seventeenth century by the Germans at locations such as Landsberg. The later pencil attribution to Il Gobbo refers to the inscription.

BIBLIOGRAPHY: Giovannoni (1959) I: 83, 348.

N.A./S.P.

U 780A *recto*

ANTONIO DA SANGALLO THE YOUNGER
Florence, Fortezza da Basso, perspective sketch of low-level
 embrasures, spring 1534.
Dimensions: 78 x 172 mm.
Technique: Pen and brown ink.

Paper: Darkened at edges with remains of a hinge at the top, possibly from an album.

This sheet almost certainly shows details from the base of the central keep originally projected, though not executed, at the Fortezza da Basso in Florence. See for comparison U 1344A v., 1520A r. In all probability the drawing represents an early phase of the project.

BIBLIOGRAPHY: Ferri (1885) 57; Giovannoni (1959) I: 348.

N.A./S.P.

U 781A *recto*

ANTONIO DA SANGALLO THE YOUNGER
Florence, Fortezza da Basso, studies for the defense of a
 circular or polygonal keep, ca. 1534.
Dimensions: 113 x 215 mm (maximal, original sheet).
Technique: Pen and brown ink, stylus.
Paper: Darkened at edges, cut and remounted.

One of a series of studies, probably done early in 1534, for star-shaped fortresses. It is probably associated with early proposals for the Fortezza da Basso, Florence, where Antonio the Younger was initially attempting to incorporate a central circular or polygonal keep. Here the keep is surrounded by a series of wedge-shaped, pyramidal projections equipped with pointed or circular caponiers at their salients. Another outer ring of works strengthens the system. For these Antonio the Younger explores the use of further caponiers (shaped like miniature bastions) at the salients, and curved flanking batteries set into the reentrant angles. Among the other stellar trace studies associated with the Fortezza da Basso is U 758A.

BIBLIOGRAPHY: Ferri (1885) 57; Giovannoni (1959) I: 348, 420.

N.A./S.P.

U 782A *recto*

ANTONIO DA SANGALLO THE YOUNGER
Florence, Fortezza da Basso, April–May 1534.
Dimensions: Original sheet irregularly cut; modern support
 191 x 268 mm.
Technique: Pen and brown ink.
Paper: Darkened at edges.
Drawing Scale: bastions are 35 units (none given) = 25 mm.

This drawing shows the main body of the Fortezza da Basso, Florence, as an irregular pentagon in the same form and on the same scale as it finally appeared in

U 315A r. The internal arrangements, however, are different and seem to focus on a central rectangular *piazza d'armi* with a corner staircase and a range of major accommodations opposite the main gate (U 760A). This layout may refer to the early proposal for a palace-castle inside the fortress. At this stage, moreover, Antonio incorporates a number of outworks. The gate to the city is defended by a huge triangular ravelin. See U 783A r. for a similar proposal. Smaller ravelins are placed in front of the curtains joining all but one pair of bastions (although the missing unit seems to be implied).

Proposals involving ravelins of this sort represent advanced military planning for the 1530's, for although detached ravelins had long been used as barbicans to defend gates, their use between bastions to reinforce the entire enceinte was not to become commonplace until the seventeenth century. It should be noted that Antonio the Younger's sketch, U 1344A, foresaw this development when he indicated two complete encircling rows of ravelins and redoubts.

The Porta a Faenza is not noted on the sheet. Either it has been ignored by Antonio or it has been included in the fortress, as was to happen in the final proposals (U 315A).

BIBLIOGRAPHY: Ferri (1885) 57; Giovannoni (1959) I: 349; Hale (1968) 520, fig. 16.

N.A./S.P.

U 783A *recto*

ANTONIO DA SANGALLO THE YOUNGER
Florence, Fortezza da Basso, April–May 1534.
Dimensions: Original sheet irregularly cut; modern support
 224 x 185 mm.
Technique: Pen and brown ink.
Paper: Darkened at one edge, possibly hinged at one time.
Drawing Scale: braccia(?); bastion marked 27; rampart
 marked 50.

INSCRIPTION: (at left) *porta della / Citta;* (bottom right) *questo puntone / sie basso la piaza / a pian terreno piu / alta p[iedi] 13 chella cam/pagna / per lo ponte chontra / in rosso si discende / e per quello iscontra si / ascenda*

This sheet shows a schematic layout for the Fortezza da Basso early in its evolution, when it was envisaged that the fortress might straddle the city wall. A short section of city wall with a city gate is shown at left on the drawing. The interior, though sketchy, seems to indicate an almost urban solution involving the symmetrical layout of pavilions, courtyards, and outer

ranges of accommodations around a theatrical, ter-raced central space. The fortifications remain essen-tially unchanged from U 782A, although the ravelin protecting the fortress gate has become larger and the outworks have been dropped. Although very effective as a protective device, a ravelin on this scale com-pletely obscures the gate and robs the fortress of its formal city facade. The subsequent abandonment of the ravelin and development of the gatehouse complex into a highly decorated miniature bastion, overlooked by a raised cavalier (or platform), as in U 315A r., indi-cates a continuing concern for the formal urbanistic contribution of the fortress. (Whether that concern derives from Antonio the Younger or not we cannot say.)

BIBLIOGRAPHY: Ferri (1885) 57; Giovannoni (1959) I: 349; II: fig. 375; Hale (1968) 520–21, fig. 15.

N.A./S.P.

U 784A *recto*

ANTONIO DA SANGALLO THE YOUNGER
Plan section of a fortified rotunda; studies of embrasures; perspective sketch of rotunda with *puntoni*, location unknown, ca. 1535.
Dimensions: (modern support) 187 x 186 mm.
Technique: Pen and brown ink, stylus, compass, straightedge.
Paper: Irregularly cut original sheet pasted on to modern backing sheet.

The drawing shows (above) a circular gun tower or rotunda with triple embrasures. The central group of embrasures affords a traverse of almost 90 degrees. The perspective view (below) shows a modeling of the wedge-shaped *puntoni* projecting between each group of embrasures. Giovannoni, probably thinking of works illustrated by Viollet-le-Duc, cites these *puntoni* as models for small bastions, or caponiers, used in sev-enteenth-century Germany. Elsewhere Antonio the Younger certainly designed flanking works of very similar appearance. Here the *puntoni* are solid mason-ry with a purely passive defensive role.

It has not been possible to identify the location for which this drawing was prepared. Both studies recall the central rotunda of the early Fortezza da Basso studies (see U 779A, 813A v.).

BIBLIOGRAPHY: Giovannoni (1959) I: 83, 348, 420.

N.A./S.P.

U 791A *recto and verso*

ANTONIO DA SANGALLO THE YOUNGER
Florence, Fortezza da Basso, studies of ditchworks, June–July 1534.

a
 b
 d
c

Dimensions: 287 x 236 mm.
Technique: Pen and brown ink.
Paper: Folded, modern repairs.
Drawing Scale: Recto has dimensions marked but the drawing is not to scale; verso, 275 *braccia* = 50 mm.

INSCRIPTION, Recto: (a) *Dallaqua del pozo achanto /ˆla porta fino sopra la torre / mezo brachio sie b[raccia] 32¾ / (dal di so* canceled); (b) *Casa; aqua; Canale / de tenzelle; piano di terra; aqua darno;* (c) *bisognia dare / ⁴/₅ di braccio per / onio e a no/za di dare lo / (i* canceled) *a (n* canceled) 22 *in/zi* (page trimmed at edges); *Le tre fossi delli tre balu/ardi sono longi b[raccia] 947;* (d) *Lo fosso del baluardo / grande sie longo 321 / largho b[raccia] 31*
Verso: (top to bottom) *questa sta bene / ultimente agiustata; dal centro della / porta al angolo 461; La cortina si ritira in terra in b[raccia] 660 b[raccia] 19*

Recto and verso may be dated to the early stages of construction of the Fortezza da Basso, Florence. On the recto (top left), a section records levels of the water table across the site in relation to the River Arno. The problems caused by water flooding the foundations and ditch excavations are well document-ed and dated to June–July 1534. What appear as very crude bastion plans are in fact dimensional diagrams of the excavations for the two representative bastions drawn on the verso. The centerline (dimensioned "96" and "84" in one case, and "94" in the other) repre-sents the outer face of the works. The excavation inside this line is for the foundations, and that outside it for the ditch. The other dimensions and depths allow the volume of the excavation to be calculated. The drawing is entirely in the hand of Antonio the Younger and seems to have been done on site.

BIBLIOGRAPHY: Ferri (1885) 57; Giovannoni (1959) I: 81, 349.

N.A./S.P.

U 792A *recto*

<small>ANTONIO DA SANGALLO THE YOUNGER</small>
Plan section through the flank of a bastion showing (above)
the merlon and parapet of the open battery and (below)
the countermine gallery, sally port, and various casemates
equipped with small-arms embrasures, location unknown,
ca. 1545.

Dimensions: 264 x 207 mm.

Technique: Pen and brown ink, straightedge, stylus.

Paper: Darkened at one edge.

Drawing Scale: 10 units = 46 mm.

<small>INSCRIPTION:</small> *Contramine; Muro della terra; Scharpa*

Giovannoni cites this drawing for the use of internal
defenses, such as countermines hidden within the
walls. In fact, this sheet is particularly interesting for
its attempt to resolve some of the three-dimensional
problems of fortification design by representing in
plan, and to scale, the layout of component parts on
different levels. In effect the drawing is a kind of three-
dimensional plan. The merlons of the flank battery are
drawn over the layout of the lower countermine
gallery. The gallery is given running dimensions
between enlargements that form casemates from
which gunners could serve a number of small low-
level embrasures. Use of the phrase "muro della terra"
suggests that the bastion was to be added to a preex-
isting wall.

Although the location is not known, the technique
is similar to that employed in the drawings for the
fortress in Piacenza such as U 802A or 803A. For that
reason and because of the sophistication of the draw-
ing technique we have dated the sheet relatively late.

<small>BIBLIOGRAPHY:</small> Giovannoni (1959) I: 81, 348, 421.

<small>N.A./S.P.</small>

U 794A *recto*

<small>ANTONIO DA SANGALLO THE YOUNGER</small>
Genoa, study of a barge, early 1536. The barge is shown above
in plan view, measured, and below in side view with
treadwheel and pulleys-and-ropes lift for stone blocks.

Dimensions: 156 x 226 mm.

Technique: Pen and brown ink.

Paper: Center fold.

<small>INSCRIPTION:</small> *A palmi genovesi quali / sono magiori uno
bon dito / che romaneschi; puntone; Puntone grande / di
Genova; Rota alta palmi 30 / Lo stile palmi 3; Largo palmi 40
in mezo / longo palmi 114*

Antonio's measurements of the barge are in Genoese
palmi, as stated, and the word *puntone* identifies the
lift at the stern. That he visited Genoa is clear from
his description of the stonework on the Church of San
Domenico (U 901A r.) and sluice gates there. A better
explanation of the barge's function and an illustration
identical to Antonio's appears in a work by the Flo-
rentine architect Buonaiuto Lorini who called it "bar-
cone per condur le pietre. . .barconi piatti" and told
how the treadwheel served to slide and pull a stone
block from the dock near a quarry, and how the lift
raised it, suspended it on the lewis (*livella*) or clamps
(*tanaglie*), and lowered it into the water where a dock
landing or sea wall was to be built. A man working
deep in the water would guide the block to its place
in the wall. The description of the barrel in which the
diver is housed is among illustrations attributed to
Bartolommeo Ammannati (U 7678A v.).

For Antonio the Younger's trip to Genoa, see
U 795A.

<small>BIBLIOGRAPHY:</small> Lorini (1596) IV: 164–69; Ferri (1885) 80.

<small>G.S.</small>

U 795A *recto*

<small>ANTONIO DA SANGALLO THE YOUNGER (AND OTHERS?)</small>
Genoa, project for refortification, early 1536.

Dimensions: 432 x 570 mm.

Technique: Pen and brown ink, light brown wash, red chalk,
stylus, pin, straightedge.

Paper: Thick, darkened at edges, folded in eight, originally
connected to U 796A.

<small>INSCRIPTION:</small> (left to right) *guardiola; Al di fuora del
castelletto; guardiola; Castelletto*

U 795A originally was attached to U 796A. Together
they formed a long sheet on which Antonio the
Younger proposed a series of modern bastions for the
area of Castelletto along the northern flank of the city.

In letters dated 24 and 25 January 1536, published
by Ronchini, Antonio the Younger announced his
intention of going to Genoa. In all likelihood he went
there shortly thereafter, though positive documenta-
tion for the visit seems to be lacking. Forti's proposal
that the Genoese sent detailed topographic maps to
Antonio in Rome is highly unlikely; the degree of
detail that would have been needed would have
required a prohibitive amount of work.

In fact, the Genoese seem to have had some diffi-
culty in securing an architect for their new fortifica-
tions in the 1530's. Although Antonio must have come

<small></small>

to the city, he could not stay to superintend the work. The Genoese also tried to get Pier Francesco da Viterbo without success. Finally they hired Giovanni Maria Olgiati, who was then working in Pavia and who came in February 1536. But if Antonio's sketch reached the stage we see in U 795A and 796A, it is likely that he prepared a relatively full proposal. Forti has hypothesized that Olgiati had access to these sheets, since the bastion of Acquasola, at the far left in U 795A, as built by him is almost identical with Antonio's proposal.

Both U 795A and 796A show the typical kind of product of the refortification projects practiced by the Sangallo workshop. The old walls and the main lines of the new works are marked with a stylus, and then ink is used over the top. (The stylus is also used to fix the new bastion face in relation to the new embrasures for effective flanking.) It is likely that the trace of the old walls was provided on this sheet for Antonio when he arrived in Genoa. Not only does it not seem to be the hand of Antonio the Younger, but the paper is notably unlike any other paper used by the Sangallo workshop. Antonio then sketched in flanking coverage along the length of the walls, which is provided by means of bastions and demi-bastions that project in front of the old walls and retreat behind them. The bastions are irregular in plan, the example on U 795A being five-sided. A mixture of straight flanks and curved orillons is employed. This kind of adaption of angle-bastion technique was practiced relatively commonly in Italy during the mid-sixteenth century. For example, Antonio provided similar proposals for Ancona (U 1526A). In that drawing, however, both trace and proposals seem to be in his hand.

BIBLIOGRAPHY: Ronchini (1864) 473–76; Ferri (1885) 80; Giovannoni (1959) I: 80; Forti (1971) 33; Dellepiane (1984) 48; De Moro (1988) 154–55.

N.A./S.P.

U 796A recto

ANTONIO DA SANGALLO THE YOUNGER (AND OTHERS?)
Genoa, project for refortification, early 1536.
Dimensions: 425 x 572 mm.
Technique and Paper: See U 795A r.
Drawing Scale: 300 *piedi antichi* = 154 mm.

INSCRIPTION: (left to right around trace) *porta di* [. . .]; *A el portone de cavaliere de palavissini; Al B del cavaliere di pa/lavissini; guardiola; guardiole; porta dela le volta murata; strada;* (bottom center) *questi sono 300 piedi antichi e / con questo sie misurato tutto / questo disegnio*

The back of this sheet was used to support drawings as the glue marks make clear. Numbered drawings displayed there include *78, 79.* For further commentary, see U 795A r.

BIBLIOGRAPHY: See U 795A recto.

N.A./S.P.

U 797A *recto and verso*

ANTONIO DA SANGALLO THE YOUNGER
Modena, survey of the mills along the Canale Pradella, 1526(?).
Dimensions: 205 x 340 mm.
Technique: Pen and brown ink.

Recto. (a) Paddle of undershot wheel (*quante palle 20 / piedi 6*). (b) Cogwheel in plan view (*diamitro di denti per / quanti denti; per / quanti denti 56.* (c) Inscription, see below. (d) Water channel.
Verso. (a) Inscription, see below. (b) Inscription (upper right), see below. (c) *Di Modena* (center right). (d) Outline of dock with six canals between Porta di Bologna and Porta Bozuara.

INSCRIPTION, Recto: (c) *Quanti denti / a la rocha otto; La macina piedi 4;* (d) *La sua pendenta del chanale / caduto piedi 8 / da superficie a superficia / dell aqua*
Verso: (a) *Modena dalla parte piu bassa alla / piu alta; la superfitia dell aquaro / a quella del navilio sie piedi xiii;* (b) *Cie un altro mulino quale a dipendentia / piedi dua e mezo lo quale a la (destra canceled) ruota / piedi 10 le pale uno piede luna longe in tutto 12 / in fuora large per laltro verso piedi 3 lo / resto e come li altri;* (h) *Piu le ruote; Porta di mezo; Primo canale; Secondo canale; Porta Bozuara; Tertio canale; Stafa; Quarto; Quinto; Sexta; Casa inruina; Porta di Bologna; Canne 50;* (on small plan) *Canne 50; Convento Santo Sibastiano*

The components illustrated on the recto probably belong to one structure, a canal where the water drops 8 feet from one level to another. On the verso, just above the phrase "di Modena," Antonio noted another mill and cited measurements for its parts. His drawing at the left outlines a curvature with measurements of the lowest level of the water to that of the dock. Six canals are cited, a house in ruins, the Convent of San Sebastiano, the Porta di Bologna, and the Porta Bozuara. Alongside the ramparts of Modena there is today the Canale Pradella, which is likely to reflect some aspects of the structures Antonio the Younger described and measured on both sides of the present sheet.

No date is known for Antonio the Younger's visit

to Modena. The spidery, controlled script would suggest a date earlier rather than later in his career. It could be that the study was undertaken at the time of the Romagna inspection trip of 1526 or possibly around 1530 when he was in the Bologna area and concerned with the canals. The drawing shows the Canale Pradella at the point where it passes through Modena. There is no indication as to why Antonio the Younger undertook this survey. He seems to have been especially interested in the mills and the nature of the height of the vertical drop between canal and mill wheel—a common enough preoccupation. There seems no evidence for relating this sheet to the drawings for Genoa as noted by Giovannoni (I, p. 421).

BIBLIOGRAPHY: Ferri (1885) 94; Giovannoni (1959) I: 70, 80, 421.

N.A./S.P., G.S.

U 799A *recto*

ANTONIO DA SANGALLO THE YOUNGER
Parma, survey and early proposals for fortification of the
 Rocca, April 1526.
Dimensions: 307 x 384 mm.
Technique: Pen and brown ink.
Paper: Folded in half, darkened at edges, modern support.

INSCRIPTION: *questa linea tira alla piaza / a pie del ponte dove se a fare lo Cavaliere / dove e una torretta bassa Canne dua / dove e cierta erba in cima; ponte; fosso; piedi veronesi; ala scarpa piedi 4; questa linea tira alla piaza / quale e a pie del ponte / dove e una toretta alta circha / a piedi 20 [. . .] in d'una cierta / erba dove se a da fare una Cavaliere; Rocha di parma; Lo piedi minuti (17½ canceled) 11 / Lo brazo parmisano sie 17½ c[anne] 120 parmisane / sono b[raccia] 120* Verso: *La Rocha di Parma*

Antonio the Younger is known to have been in Parma during April 1526, probably as part of the Romagna fortress inspection team (Giovanni Battista da Sangallo, Giuliano Leno, Michele Sanmicheli). The only drawing for Parma to have survived from that trip is U 799A recto, in effect, an analysis of a short stretch of wall (identified by Adorni) between the *cannoniera* near the Rocchetta of Porta Nuova and the area near the bastion on the road south of the city. The walls of the city had been damaged during the war of Parma in 1521, and in February and December 1524 monies were appropriated by Pope Clement VII to pay for renovation.

Antonio the Younger's full proposal is not known. (We are skeptical that the plan published by Adorni [1986, fig. 14] represents Antonio the Younger's proposals of 1526.) The drawing under discussion seems to suggest that Antonio the Younger was, as usual, interested in elevating the point of defensive fire (the proposal for a cavalier) and improving and modernizing the ramparts (the mention of the low towers). In any case, this sheet is effectively a series of private notes on the fortifications that would have been worked into a more formal proposal.

The reference to "Veronese feet" is also said by Adorni to be an indication of the presence of the architect Michele Sanmicheli.

BIBLIOGRAPHY: Ferri (1885) 109; Giovannoni (1959) I: 78, 421; Adorni (1974) 142 n. 5, 159; Adorni (1986) 364, fig. 16.

N.A./S.P.

U 800A *recto*

ANTONIO DA SANGALLO THE YOUNGER
Felino and Torrechiara, plan of defenses, 1526(?).
Dimensions: 282 x 218 mm.
Technique: Pen and brown ink.
Paper: Thick, darkened at edges.

INSCRIPTION: (Torrechiara, top) *monte cavaliere alla terra altretanto quanto alta la terra / dal piano presso a uno stadio; monte quale / e cavaliere e / loltano; colle basso;* (upside down) *fiume della parma; valle; valle;* (within enceinte) *Torchiara; valle; verso parma; piano; colle / basso; chiesa; entrata nova;* (Felino, below) *terra; filine del signiore / Lorenzo salviati; questa / guarda verso / parma; piano;* (middle) *Filine delli pala/visini presso a parma / a dieci miglia; questo monte dove fu fondato lo castello / sie cavaliere a tutto lo paese forse canne 100 / aciettoche da questa banda di la della valle / a uno mezo miglio apresso anno altro cavalliere / monte alto quanto lui*

The twin castles of Felino and Torrechiara dominate one of the approaches to Parma, which is about ten miles to the south in the Parmese Apennines. Torrechiara was reconstructed between 1448 and 1460 by Pier Maria Rossi, Count of Berceto, who is reputed to have been his own architect. In 1552 it was held by the daughter of Pallavicino Pallavicino. Felino, on the other side of the valley, had been reconstructed between 1460 and 1483, seriously damaged in 1483 by Ludovico il Moro, but rebuilt on the same lines soon afterward. It was held by the Pallavicini when Antonio the Younger made his survey. Adorni believes that Antonio's visit was part of an attempt to create a regional defensive strategy (1974, p. 143). Certainly the map has a large number of strategic annotations

regarding the height of nearby sites, but in general the concerns are local rather than regional.

The plans, despite their rather rugged appearance, are extraordinarily accurate. Antonio the Younger records the splay and the triangular projection at Felino (bottom right) which Perogalli takes to be an early proto-bastion. This says much for Antonio the Younger's observation and accuracy in recording.

Dating of this sheet is problematic. Adorni (1986, p. 364) dates the sheet to 1526 and suggests that this proves papal interest in regional strategies. This may be correct. Our only reservation has to do with the script and the character of drawing, which seem rather looser and seemingly more self-confident than the script on, say, U 799A.

BIBLIOGRAPHY: Ferri (1885) 109; Giovannoni (1959) I: 77, 78, 421; Perogalli (1972) 94; Adorni (1974) 143, 159; Adorni (1986) 364, fig. 17.

N.A./S.P.

U 801A *recto*

ANTONIO DA SANGALLO THE YOUNGER
Pavia, plan of bastion; plan of a countermine, 1545(?).
Dimensions: 144 x 175 mm.
Technique: Pen and brown ink.
Paper: Darkened at edges.

INSCRIPTION: (on sheet attached to top) *Piacentia e pavia*; (on sheet) *Carmona*; *Contramine / di charmona / pozi sei e chiavacha / dalluno allaltro cosi / avicho da quelli di cirrcho / a quello di mezo*; *a pavia*; *Baluardo di pavia*

The activities of Antonio the Younger in some of the smaller towns of northern Italy still lack archival documentation. In the case of Pavia our only evidence is this sheet; local historians have not noted his presence there. The annotation that connects Piacenza and Pavia is provided by an additional sheet and thus cannot be used to link Antonio the Younger's activity in the two towns. Nonetheless, a dating from the later period of Antonio the Younger's activity in Piacenza is not impossible given the summary haste he uses in the drawing.

The form of the *baluardo* (below) is unusual, as is the circular layout of the countermine gallery and *pozzi* (well shafts) in the round tower (above). Possibly the drawing represents a proposal to modernize a medieval round tower by means of countermines and the addition of caponier-type gun casemates in the corners where the tower joins the curtain. Possibly the bastion is simply one that interested Antonio the

Younger on his passage through the town. The bastion noted here may be one near the bastion of Santo Stefano at the point where the River Carona enters the town.

BIBLIOGRAPHY: Ferri (1885) 109.

N.A./S.P.

U 802A *recto*

ANTONIO DA SANGALLO THE YOUNGER
Piacenza, plan and section through casemates, countermines, and ventilation system of a bastion flank, 1526.
Dimensions: 274 x 189 mm.
Technique: Pen and brown ink, red chalk, stylus, pin, straightedge.
Paper: Darkened at the edges.
Drawing Scale: 10 *canne* = 87 mm.

INSCRIPTION, Recto: (wall lower left) *muro vechio*; (on scale) *canne .x. di pie di .vi. in tutto piedi .LX.*
Verso: *piacentia* (in red chalk); (later hand) *Piacentia*

The drawings of Antonio the Younger and the Sangallo shop for Piacenza can be divided into two groups on the basis of the form of the "h" as recognized by Frommel. One group, U 802A r., 803A r. and v., 804A r. and v., 805A r., 1392A r., 1396A r., and 1397A r., can be dated before 1530 and thus are probably to be associated with inspections that are recorded as taking place in 1526. A second group, by Antonio the Younger alone, U 803A r. and v., 807A, 808A r. and v., are to be dated after 1530 on the basis of Frommel's dating criteria and thus to 1545 when Antonio was again recorded in Piacenza.

In the opinion of Adorni (1982, p. 160), the drawing illustrates a preparatory study for part of the bastion of San Benedetto on the fortress of Piacenza. It shows a plan section through the flank battery, casemates, countermines, and ventilation system of the bastion. A small section shows the countermine galleries and ventilation flue. Red chalk is used on the plan by Antonio the Younger to define an alternative embrasure system connecting the casemates adjacent to the orillon. Yet another arrangement is shown farther along the bastion face. The notation "muro vechio" refers to the preexisting curtain (see Adorni, 1982, p. 173). The San Benedetto bastion is the only one to have been built with orillons. The form of withdrawn flank with double casemate and embrasure (*cannoniera*) and orillons is relatively rare in Antonio the Younger's work. Further consideration of the San Benedetto bastion is found on U 1392A, 1396A, 1397A

(attributed to Giovan Francesco), 803A, 807A, and 808A (where the double *cannoniera* has become one). For the historical background, see U 808A r.

BIBLIOGRAPHY: Ferri (1885) 111; Giovannoni (1959) I: 80, 421; II: fig. 393; Marconi et al. (1978) 152; Adorni (1982) 151–67, 171; Adorni (1989) 362.

N.A./S.P.

U 803A *recto and verso*

ANTONIO DA SANGALLO THE YOUNGER
Piacenza, rough plan of half a bastion showing principal gun embrasures, handgun embrasures, and flank battery (*recto*). Rough plan and section of the curtain and its centrally placed cavalier (*verso*). Ca. 1545.
Dimensions: 188 x 285 mm.
Technique: Pen and brown ink; on verso, red chalk.
Paper: Darkened at edges.
Drawing Scale: braccia.

INSCRIPTION, Recto: (from top) *Piacentia; Lo tramezzo delle dua / cannoniere de basso sie / tanto basso che dal para/petto di sopra tirando un / filo tochi laqua braccia 100 di/scosto dal baluardo; Le Cannoniere da baso pendino / tanto che diviene b[raccia] 50 discosto / dal baluardo; Dalla piaza di sopra aquella di sotto / sie braccia 9 / La banchetta ala b[raccia] 2 / Lo parapetto fino allo piano delle / archibusiere b[raccia] 2 d[ita] 4 / dal piano delle archibusiere i[n] / terna al merlo b[raccia] 1 d[ita] 3*
Verso: *Trabochi 145 sono b[raccia] 870; Braccia di palmi due luno e dita 24*

On the recto is a preparatory study for a bastion for the fortress at Piacenza. U 803A shows the principal gun embrasures on the face, handgun embrasures (corner of face and flank), and the flank battery. The nature of these embrasures is defined more closely in U 808A. Antonio the Younger's use of stepped masonry on the inner, exposed sides of the two principal flank embrasures should be noted as a device to reduce the risk of enemy roundshot being deflected into the battery. The verso shows a preliminary study of the layout and access system for a cavalier along the wall and a section through the fortress wall. For further information, see entry for U 808A. Notations concerning measurement equivalents show the trouble the Sangallo shop had in rationalizing the systems used on different sites (see also U 804A r.). The fragmentary sketch lines are typical of the mature Antonio the Younger. For a discussion of the dating of this sheet, see U 808A.

BIBLIOGRAPHY: Ferri (1885) 111; Giovannoni (1959) I: 81, 421; Adorni (1982) 171; Adorni (1986) fig. 3.

N.A./S.P.

U 804A *recto and verso*

CIRCLE OF ANTONIO DA SANGALLO THE YOUNGER
Piacenza, dimension equivalents and fortification sketches, 1545.
Dimensions: 203 x 291 mm.
Technique: Pen and brown ink.
Paper: Darkened at edges.

INSCRIPTION, Recto: *minuti 17½ / ½ b[raccia] di palma* (272 mm between stars); *questi sono channe 100 di palma / sichondo la propucione dal disegnio / e sono bracia 6 per ognuna; Braccia 120 piasentine / sono piedi 191; minuti 15; mezo braccia di piagentinia; minuti .ii.; piedi ½ di piasenza vena 6 per channa / da luna alaltra stella venghano / a essere 12 mezi una canna*
Verso: *Misure di parma / piacentia*

The recto of this sheet demonstrates one of the difficulties of shifting site, as the Sangallo shop often did. New measuring systems had to be perfected so that the architect could communicate with the masons. It was a problem that the workshop faced frequently but it became critical because of their reliance on drawing. The architect in Rome needed to know the scale the *capomaestro* was using on site and vice versa. As the notations explain, the sheet establishes a scale for Piacentine measurements: in the middle 171 mm = the *canna* of 100 *palmi*. The sheet also shows the value of the *braccio*, the *palmo*, the *piede*, the *minuto*, and the *canna* in Piacenza.

The verso shows a series of quick sketches of the sections of the walls at Piacenza (or possibly Parma). An elevation of a section of the wall with an embrasure is shown on the short axis to the right. The specific location cannot be identified, and the hand, though related to the Sangallo shop, has not been identified satisfactorily.

BIBLIOGRAPHY: Ferri (1885) 111; Adorni (1982) 171.

N.A./S.P.

U 805A *recto*

GIOVAN FRANCESCO DA SANGALLO
Piacenza, preparatory study of bastion with cavalier and access ramps, 1526–29.

Dimensions: 173 x 246 mm.
Technique: Pen and brown ink.
Drawing Scale: palmi (face of bastion, 102 *palmi* = 79 mm).

INSCRIPTION: *Baluardo* (upside down, possibly in hand of Antonio the Younger); *D terra / Lo murato a ingrossare / piedi 18 intorno intorno; piedi 5 alto lo parapetto / piedi 2 alto questo bancho; piedi 120 / parapetto dela Chavaliere; Tiri in Canpagnia; parapeto; piaza dellartigliria; parapetto; tiri in chanpagnia*

This is a preparatory study of a bastion with cavalier for the fortress at Piacenza. It contains elements that are comparable to elements in U 803A, and which become elaborated later, in U 808A v., which concerns the bastion, and in U 806A, which involves the piazza. The handwriting is comparable to U 1392A and thus it has been attributed to Giovan Francesco. In this sequence of drawings Giovan Francesco seems particularly concerned with finding a way to return to the defenders the advantage of height that tended to be lost with the development of the low-profile angle bastion. The drawings are, however, exploratory in nature and do not form a group of working studies.

Although the bastion is not identified, it is possible that it was to have been located at an angle of the walls; note that the flank embrasure is inclined back as if it were to cover a receding curtain.

Nothing, in our eyes, confirms the attribution of this drawing made by Giovannoni to a collaboration between Rocchi and Antonio the Younger; both script and hand seem characteristic of Giovan Francesco. The word "Baluardo," written upside down, seems to be in the hand of Antonio the Younger. In our opinion this notation was made later, possibly in the 1540's when Antonio took up the problems of Piacenza once again.

BIBLIOGRAPHY: Ferri (1885) 111; Giovannoni (1959) I: 76, 80, 421; Maggi (1966) 60; Adorni (1982) 171.

N.A./S.P.

U 806A *recto*

ANTONIO DA SANGALLO THE YOUNGER
Piacenza, fortress, plan of cavalier, 1545.
Dimensions: 190 x 292 mm.
Technique: Pen and brown ink, stylus, pin.
Paper: Darkened at edges; the heading (top center) is cut from elsewhere and pasted on to this drawing.
Drawing Scale: 10 *palmi* = 22 mm (located center of top line).

INSCRIPTION: *Cavaliere di piacentia; parapetto banchetta;*

Spalla del / Cavaliere; terraglio; parapetto / continuato (continuous parapet, i.e., *en barbette*); *questo / parapetto / volessere piu / alto chella piaza / b[raccia] 2; questa piaza del cavaliere vole essere / piu alta che el terraglio della Cortina / tanto che volendo tirare sopra allo / parapetto della Cortina e difendere / el baluardo possa vedere libera espedi/ta tutto la faccia del baluardo dalluno / angulo allaltro e piu presto davantagio / La spalla del chavaliere volessere piu alta / che questa piaza b[raccia] 4; Scale abastoni*

Although the title "Cavaliere di piacentia" was pasted in place and possibly cut from another sheet, the identification is correct: U 806A is a further development of the cavalier on U 803A v. and is presented in a more complete version on U 808A v.

Here Antonio the Younger's note expresses the need for height to sweep the face of the neighboring bastion. The provision of these cavaliers between the bastions is registered on other drawings (see U 778A, 1390A).

BIBLIOGRAPHY: Ferri (1885) 111; Giovannoni (1959) I: 78, 80, 81, 421; Adorni (1982) 171.

N.A./S.P.

U 807A *recto*

ANTONIO DA SANGALLO THE YOUNGER
Piacenza, fortifications, details of embrasures, 1545.

Dimensions: 280 x 424 mm.
Technique: Pen and brown ink, stylus, pin.
Paper: Heavy, darkened at edges.
Drawing Scale: 12 units = 32 mm (vertically along center fold).

INSCRIPTION, Recto: (a) *parapetto grande resta br[accia] 8;* (b) *parapetto grosso braccia 3;* (c) *Larchibusiera scoperta lo suo piano / di sotto stia come quella che fatta / cioe la sua pendentia / Le archibusiere scoperte in la bocha di fuora / sieno alte d[ita] 4 / La prieta della archibusiere coperte sieno / messe piu bassi chelle pietre delle scoperti d[ita] 3 / e nello stretto della archibusiere seno largo d[ita] 2 / e in detto stretto sia alta d[ita] 8;* (d) *Dal mezo deluna delle archibusiere / allaltra sia braccia 9½;* (e) *Queste archibusiere vanno tutti a tre coperte / e la bucha di fuora sia messa che non sia / piu alta*

che d[ita] 4 / Le priete di tutte a tre queste sie non messe in
piano / colle rufiane dellarchibusiera scoperta quali / viene piu
bassa d[ita] 3 chella pietra della scoperta / e dette archibusiere
nello stretto di dentro sieno / alte d[ita] 8; (f) Coperta;
Scoperta; Coperta; (g) Coperta; Coperta; Coperta; (later hand)
parapetto et merlatura di piacentia
Verso: Parapeti e merlatura di piacentia

The drawing shows a plan section of a pair of triple
embrasures. The embrasures are double splayed (that
is, splayed in and outside of a constriction) and the
triple loophole allows a good traverse without expos-
ing the gun (and the gunner) to the dangers of return
fire through a very wide embrasure. Similar experi-
ments can be seen in drawings for Ravenna (U 885A).
Here, different dimensions are specified for the uncov-
ered embrasures on the left, and the covered and more
restricted set on the right.

BIBLIOGRAPHY: Ferri (1885) 111; Giovannoni (1959) I: 80,
422; Adorni (1982) 171.

N.A./S.P.

U 808A *recto*

ANTONIO DA SANGALLO THE YOUNGER
Piacenza, plan section of the bastion; fortress plan, 1545.

```
e           c
   a
   a   b
   a       d
```

Dimensions: 416 x 574 mm.
Technique: Pen and brown ink, gray chalk sometimes
 reinforced with pen, stylus, straightedge.
Paper: Heavy, folded vertically, darkened at edges.
Drawing Scale: 10 braccia = 12 mm (or is it 22 mm?).

INSCRIPTION: (a) *piaza per la cannoniera / dellangolo alta al
piano / della banchetta / della archibuseria; La muraglia tutta
delli baluardi / ce alta sopra la superfitia dellaqua / b[raccia]
26 o[ncie] 7 cioe 22 fino al principio / della merlatura e la
merlatura / sie b[raccia] 4 o[ncie] 7 / Dalle pelle dellaqua fino
alle boche / di fuora della Cannonera sia b[raccia] 9 / Dalla
pelle dellaqua alla piaza della / Casamatta sia b[raccia] 12 /
Dalla piaza della Casamatta / fino alla piaza di sopra sia /
b[raccia] 9 Lo suo parapetto sie b[raccia] 2 / Le banchette de li
archibusiere / e piaza delle tre Cannoniere di / sopra sieno piu
alte di ditta piaza / b[raccia] 2; Dal piano delle banchette fino
al piano / delle archibusiere sie b[raccia] 2 o[ncie] 4 / Dal
piano di dette archibusiere fino in / cima al merlo b[raccio] 1
o[ncie] 3 in tutto fanno / la somma delli dette b[raccia] 26
o[ncie] 7; qui staria Bene una montagnia / di tera alta piu chel*

piano delle / piaze almancho b[raccia] 10 perche faciessi /
Cavaliere a tutta la campagnia / e maximo di lontano quali
po/tessi tirare per tutto sopra alli para / petti delli baluardi e
Cortine / dove bene li venisse; (b) Piaza per tirare per fianco
per lo fosso / e per la canpagnia per la apertura / quale viene
sopra alle due Cannoniere / da baso e sopra al pilastro quale e
per tra / mezo scalle due cannonere; (c) quando sara messo al
suo locho lo pa/rapetto de la piaza di sopra dimezo / la
Casamatta dove a stare lartiglieria / quale atirare dalla piaza
da lalto per lo / fosso e per la canpagnia si dara laltezza al /
pilastro quale sta sialluna cannoniera / allaltra della Casamatta
e tirando / uno filo dal di sopra del ditto parapetto / da dalto
pendente sopra al detto pi/lastro e vadia a tochare la superfitie
/ dellaqua del fosso discosto b[raccia] 100 discosto / dal
fianco del baluardo e sotto detto / filo sia laltezza del detto
pilastro; (d) in li parapetti saranno / le archibusiere scoperte /
dal mezo delluna / al mezo dellaltra sara / b[raccia] 9½ e
ciascuna ar/chibusiera scoperta ara / due rufiane che tirino /
per fianco e ditte rufiane / saranno coperte; (a sequence of
shorter notes runs from the lower right, along the scarp, to the
longer text at the upper left) Casamatta / subteranea; cientro
di questa / parte; cientro di questa parte; (around rim)
parapetto continuato / alto piu chella piaza di sopra b[raccia]
2; piaza al pari della bancheta; (along embrasures of the main
flank) Banchetta alta / piedi 3 cioe braccia 2; scharpa; (on the
scarp) b[raccia] 129 qui insulvivo; (scale, upside down)
Braccia .x. di palmi romani eschi due / per ciascuno braccio /
Lo trabocho sie .vi. di queste braccia; cannoniera; (along
bottom of sheet) La scarpa sie / el mancho o[ncie] 3 p[iedi] 0;
superfitie dellaqua; A questo modo viene in la Cortina;
Terraglio; piano della Canpagnia; argine; strada; (e, upper left,
at right angle) Piacenza / Baluardi e Cavalieri e merlatura /
delle mura della citta di piacentia / misurati a braccia
piagentine e a oncie / quali uno braccio sie palmi dua roma /
neschi che tanto quanto uno cubito e lo ditto / braccia e
partito in o[ncie] 12 che viene a essere / longa dite dua antiche

U 808A r. was constructed by Antonio the Younger
from two sheets; the main sheet was folded in half ver-
tically and a smaller sheet was attached to the upper
left. The drawing shows a plan section through one-
half of a bastion. The walls are battered, and this very
accurate piece of the drawing marks the base of the
scarp as well as the outer edge of the parapet. Embra-
sures and casemates on different levels are shown also.
A conventional section is taken through the wall,
ditch, and counterscarp. To the left, top, is a sketch of
a fortress trace and a series of notes concerning the
fortress and bastions of Piacenza. The scale is provid-
ed in *braccia* and *oncie* of Piacenza.

U 808A r. is one of the most complicated of Anto-
nio the Younger's architectural drawings. The sheet

seems to show a simple plan section through the bastion, but in fact the sections are taken at different levels through the bastion as the notations make clear. For example, there is a "mountain of earth" to be used for a cavalier to overlook the countryside; there is also a "subterranean casemate" in the reentrant. Thus the drawing uses an extraordinary economy of means to bring all the information together. Earlier studies of the Piacentine bastions include U 802A r., 803A r., 804A r. and v., and 805A r., as well as those executed earlier by Giovan Francesco (see U 1392A r., 1366A r., 1397A r.).

Antonio's participation in the works at Piacenza is well represented by drawings but poorly documented on the historical record. It seems likely that he visited Piacenza in April 1526 as part of the noted inspection trip of the Romagna fortresses, but there is no record of what, if anything, was undertaken on that occasion in the field of military architecture. In our opinion, no drawings can be associated with that visit. At that time the Piacenza works were under the care of Pier Francesco da Viterbo. Adorni (1982, 1986) proposed that the bastion represented on U 808A r. dates from 1529 and the fortress drawing from 1545, but we are not so certain that a distinction of that sort can be made. Drawings by Baldassarre Peruzzi (U 459A, 460A, 461A) survive from the late 1520's but they reflect quite different issues, and the drawings of Antonio the Younger cannot be related to the matters addressed by Peruzzi. Possibly preliminary work was undertaken on the bastion by Antonio the Younger and Giovan Francesco which was only partially completed or still under way at the later date. (This would explain why the drawings were pasted together so precisely.)

In our opinion, the handling of the drawings for Piacenza, and notably U 808A r., seems assured and confident and is, probably, to be dated later than 1526 to a time when Antonio the Younger had gained more experience in fortification architecture. (The form of the "h" corresponds to the later date.) In November 1545 Antonio (along with Michelangelo) supplied drawings to Paul III for a new fortress to be built at Piacenza. Work began on a pentagonal fortress in May 1547. Although Antonio's designs seem not to have been followed point by point by the architect-engineers Domenico Gianelli, Battista Calvi, and Benedetto Zaccagni in U 808A, we have the most complete proposal for the shape of the fortress in Antonio's hand as well as the most detailed plan section of a typical bastion.

The drawing was attributed by Giovannoni to Rocchi without justification; the small sheet seems wholly

by Antonio the Younger and the annotations are clearly his. The larger drawing is difficult to attribute since a straightedge has been employed. The design ideas, however, and the technique of overlaying the layouts of different levels are characteristic of the Sangallo workshop.

BIBLIOGRAPHY: Ferri (1885), 111; Giovannoni (1959), I: 76, 77, 80, 81; II: fig. 391; Maggi (1966) 61; Marconi et al. (1978) 152; Adorni (1982) 160, 172; Adorni (1986) 356, fig. 2.

N.A./S.P.

U 808A *verso*

ANTONIO DA SANGALLO THE YOUNGER
Piacenza, plan of cavalier and section through bastion flank, 1545.
Dimensions and Paper: See U 808A recto.
Technique: Pen and brown ink.

INSCRIPTION: (above) *pendentia del pi/lastro; pendentia della Ca/noniera; banchetta; piaza; Casamatta; piaza;* (below) *questa spalla di questo Cavaliere / volessere piu alta chella sua / piaza b[raccia] 4; Spalla del cavaliere; scarpa; parapetta; banchetta; scarpa e scale della banchetta; parapetto Continuato; questi parapetti voglio / no esere piu alti chessa pia/za braccia 2; piaza del cavaliere; Questa piaza di questo Cavaliere volessere / piu alta chel di sopra delli parapetti delle cortine / tanto che Collartiglieria si possa difendere e vedere / tutte le faccie dinanzi delli baluardi e piu pre/sto davantaggio; scala bastioni; schala; strada in sul terraglio*

The top half of the sheet shows a cross section through the casemate of what is probably the flank battery of a bastion. The bottom half of the sheet shows a plan for a cavalier, or raised gun platform. Both appear to be from Antonio the Younger's design of 1545 for Piacenza. The sheet was folded in half and the top half is darkened, suggesting that it was exposed more extensively to light and abrasion.

The cavalier is well worked out in its details (see also U 803A and 806A), but it appears to be slightly different from U 803A v. and 806A r., which are rough sketches of a similar cavalier. Though the scheme is the same in U 808A v., the face dimensions appear to have been reduced.

Cavaliers were, by the mid-sixteenth century, commonly placed inside, behind, or between bastions. This one is clearly designed to be placed between bastions, in a central position on the curtain. It incorporates a high parapet to the front (*spalla,* or shoulder) and lower curved parapets to each side over which guns could fire *en barbette* to sweep the faces of the adjacent bastions. (Fire is *en barbette* when it is direct-

ed over the top of the parapet rather than through embrasures cut into it.)

We initially identified the upper drawing as a section through the lower cavalier. But it is so clearly set down below the general level of the ramparts and the bastion (here described as "piazza" level) that it must relate to some other part of the works, probably to a bastion flank battery.

For the historical background, see U 808A r.

BIBLIOGRAPHY: Giovannoni (1959) II: fig. 394; Adorni (1982).

<div align="right">N.A./S.P.</div>

U 809A *recto and verso*

ANTONIO DA SANGALLO THE YOUNGER
Pisa, city walls and bastions (*recto*). Pisa, fortress (*verso*).
1533.
Dimensions: 290 x 440 mm.
Technique: Pen and brown ink, gray chalk; on verso, gray chalk.
Paper: White paper, extremely thin, possibly from a notebook, worn at edges, folded in quarters, darkened.

INSCRIPTION, Recto: (across top in gray chalk) *Santo / doni/no; Torre che pende in fuore; stanpaci; Batteria; Batteria; questa mura/gli pendi fronte / in fuora;* (below in brown ink) *saria necessario alle cose di pisa cavare li fossi in/torno alla terra dalla porta a mare fino alla rocha / e cosi da arno dal canto alla porta allo piazzia fino alla / porta di lucha di poi [. . .] lo solo e portavi quasi per tucto excie/tto che dalla porta allione per fino quanto tiene la cittadella vechia / fino adarno che li bisogniria cavare / Apresso bisognia cavare li fossi della rocha che sono ripieni che la / rocha non e sopra terra bracia 18 al presente bisogniria fare / uno fossetto che havessi laqua del fosso si no al piano dellaqua darno / perche in tutte le Casemate di fosseto cie 3 braccia daqua / e bisogniria perche la terra si scossasi e asciugassi per poverta / manegiare di poi noti bisogna rifare lo muro ruinto / del fosso che arno non ci possa entrare e rifarlo atachato colla / punta del baluardo che si fara piu al sicuro perche e piu discosto / dalarno e la canoniera del fianco potra difendere ditto muro / e tagliando uno principio duna torre diento puntone di terra / che ci scie in fuora el fiancho difendere o battera tutto arno che / [. di . ?];* (left half, inverted) *Barbacani; arno qui bisogna / rifare lo mu/ro; taglio; muro basso da ruinare; rotta; rotta; ponti; Principio dela torre / datagliarsi; Bisogna fare una porta in sulla prima pila / del ponte per potere guardare la faccia del pontone / Segniato A e perche la porta che va al prexente non va / difesa nissuna che facendola come segniata saria / difesa bisogna sbasare la torre della porta alle / prachgie quanto e fatto di mattoni e sbasare uno Canpa/nile a*

presso a quella che Colli archibusi non fa stare / nisuno alle difese della rocha e bisognieria alzare / tutta la muraglia della rocha che agiro inverso; (continues below) *La citta e sbasare quella parte che de inverso arno perche al prexente sie piu* (bassa canceled) *alta e delle case si leva dalle difese tutti quelli che stanno diverso arno / e diverso fiorenza*

Apresso bisognieria alzare 4 braccia el cavaliere grande e farci le sue Canno/niere nel parapetto e cosi alzare la torre principiata nel puntone acanto al porta e / (hole in page) *cose che quando si volesse spondere che [. . .] saria di fare;* (in chalk) *questo frusta el fossatino a star pari;* (in chalk) *questa pende forte in fuora*
Verso: (in later hand) *Pisa*

The sheet contains a series of observations about the state of the defenses at Pisa. Antonio the Younger proposes to cut the ditches from the Piagge, on the north side of the Arno, to the present-day Porta Mare by way of Giuliano da Sangallo's fortress. A stretch of the medieval wall is shown in plan and, very lightly, two bastions that may be part of the fortress built by Giuliano da Sangallo for Pisa. On the verso is a plan of Giuliano's fortress. Elsewhere in the text there are specific suggestions about how to empty the flooded ditches and proposals to enlarge the defenseworks. The rough nature of the drawings, the shorthand notes, and the casual mixture of media suggest that this was an on-site set of notations that would have been worked up as part of a complete report once the architect returned to the workshop.

The only dated visit of Antonio the Younger to Pisa is early in his career, but the impression is that this drawing involves problems separate from (and in addition to) the fortress. The hasty character of the script and Antonio the Younger's apparent mastery of his approach to the subject convince us that this drawing can be dated to the 1530's, following Gianneschi and Sodini. In the summer of 1533 Nanni Unghero was dispatched to the site because of damage to the Cittadella Nuova and work was, thereafter, undertaken to repair the banks of the Arno. Although no documentary evidence places Antonio the Younger in Pisa, this drawing would seem, nonetheless, to belong to this period; the text confirms his special interest in the control of the Arno. It is possible that another hand can be seen (Nanni Unghero's?) in the sketch at the center of the sheet.

BIBLIOGRAPHY: Ferri (1885) 112; Giovannoni (1959) I: 76, 422; Masetti (1964); Marconi et al. (1978) 222–23; Gianneschi, Sodini (1979) 11–15; Tolaini (1979).

<div align="right">N.A./S.P.</div>

U 811A *recto and verso*

ANTONIO DA SANGALLO THE YOUNGER
Pitigliano, study for the fortifications; Convent of San
 Francesco (*recto*). Castro, Convent of San Francesco,
 topographical sketch (*verso*). 1537–45.

a c
 d
b

Dimensions: 217 x 292 mm.
Technique: Pen and brown ink, red chalk on verso.
Paper: Partially yellowed, folded.
Drawing Scale: recto in *piedi*; verso in *palmi romani*.

Recto. (a) Large bastion. (b) Fortification. (c) Top of tower. (d)
 Cloister and Church of San Francesco, Pitigliano.

INSCRIPTION, Recto: (a) *Cavaliere; valletta; Cavaliere; fosso;
Disegnio / mio / in locho emine[n]te; fosso; parapeto piedi 16 /
coritoro piedi 8 / terra pieno 32 / piaza; terrapieno; Conte
nichola; fosso; rocha vechia;* (b) *pitigliano;* (d) *Convento di
Santo francesco di piti/gliano; A di p[iedi] 30; A chiesa; B
sacrestia; C rifettorio; D lavamani; E Convento; F Cantina; G
Cucina; H stovigliera; I Cortile dalavare pannj; K Cortile
servito per loro uso; L orto; Sopra al rifettorio e cucina e
sacrestia e chiostro / quello longo piedi 10 longo 15*
Verso: *prato Cotone per orto; Convento di S[an]to francesco
dafarsi in Castro; chiesa; strada da farsi / diritta / strada nova*

On the recto, above, is Antonio the Younger's pro-
posals for the fortifications that were eventually built
at Pitigliano upriver from the ancient fortress. (See
U 812A.) Below is a plan for the fortification for the
entire town.

 At *c* on the recto the top of the church tower is
drawn in lightly; it is an invention of Antonio's. He
made a quick survey of the Convent of San Francesco
in Pitigliano (*d*), possibly by pacing off the measure-
ments. This insignificant structure probably interested
him only as a precedent for Castro (see "Castro and
Nepi").

 The verso shows the sketch for the cloister and
Church of San Francesco in Castro (possibly made on
site) with a rough outline of the immediate zone (see
"Castro and Nepi" and Soldati's plan illustrated
there). There are notes concerning existing structures
(in red chalk) and the most important measurements
of the terrain. The church and cloister have the same
spatial relationship to one another as those of San
Francesco in Pitigliano. The ca. 12.6-meter-wide
church interior, with its large semicircular apse and

shallow, rounded side chapels, anticipates that of the
slightly later Church of Santo Spirito in Sassia, Rome.
There are also plans for the access streets and a rough
assessment of buildings. For additional projects, see
U 736A r., 738A r., 739A r., 740A r., and 737A r.

BIBLIOGRAPHY: Vasari (1846–70) X: 81; Vasari-Milanesi
(1887–85) V: 520, 518; Ferri (1885) 23, 114; Giovannoni
(1959) I: 82, 203, 422; Fiore (1976) 88; Giess (1981) 118,
138; Curti (1985) 43–55; Fiore (1986) 342, 638.

<div align="right">H.G./F.Z.B.</div>

U 812A *recto*

ANTONIO DA SANGALLO THE YOUNGER
Pitigliano, study of the fortifications, 1537–45.
Dimensions: 248/251 x 142/143 mm.
Technique: Pen and brown ink.
Paper: Partially yellowed, folded.

INSCRIPTION: (above) *Pitigliano / P[er] lo Conte di
pitigliano; questo sta / nello alto e sul tufo; revellino i[n]anzi /
allaltro revellino vechio / fatto per me; fosso fatto; fosso; rocha
vechia; p[er] pitiglianio i[n] la sua / fronte dove e attachato /
alla collina p[erche] dalla/ltre bande alli fossoni / chrandissimi
e profo[n]di;* (below) *questo si faria / i[n]co[n]tro al cavaliere /
che sta qui i[n]anzi; questo fosso e fatto e serviria; questo saria
/ daffare perche copi/rria piu la terra / da questa ba[n]da*

This sheet is closely related to U 811A r. and shows the
plan for the fortifications built before 1545, upriver
from the ancient fortress of Pitigliano. The text also
refers to Antonio the Younger's previous intervention
in an earlier ravelin ("revellino vechio") that he had
constructed.

BIBLIOGRAPHY: Vasari (1846–70) X: 80–81; Ferri (1885)
114; Giovannoni (1959) I: 82, 422; Curti (1985) 43–55.

<div align="right">F.Z.B.</div>

U 813A *recto and verso*

ANTONIO DA SANGALLO THE YOUNGER
Castro, fortifications of the land bridge, survey of the terrain
 and first project, 1537 (*recto*). Castro, projects for the
 fortifications, after 1537 (*verso*).
Dimensions: 424 x 287 mm.
Technique: Pen and brown ink, corrections in red chalk; on
 verso, pen and brown ink at left, red chalk at right.
Paper: Slightly yellowed, folded twice, cut at edges and
 reinforced.
Drawing Scale: canne and *palmi romani* (recto).

INSCRIPTION, Recto: (left, top to bottom) *prato; strada di*

<div align="right">143</div>

farnese; *strada e cava vechia; monte; strada vechia di pitigliano; valle; monte piu lontano; valletta; monte verso pitigliano;* (center, by the pincer formation) *Santo francesco; 280 [palmi] fino al taglio;* C[*anne*] 59; Ca[*nne*] 33; Ca[*nne*] 22 *fino al sito a san francesco; da san francesco Canne 32; secondo / prima;* Ca[*nne*] 45 *alla punta nova; punta nova;* (upper right) *porta; salto mast*[. . .]

The recto forms part of an on-site survey and contains the first project for protecting the land bridge of Castro (see "Castro and Nepi," fig. 1). We can recognize the course of the Olpita stream, the location of the Porta di sotto (Lamberta) with the steep slope above it, the formation of the ground opposite the city, and the streets leading from neighboring towns to the upper gate. Above, shown in perspective, is the small Church of Santa Maria dei Servi. The old wall of the city is also visible, with two round towers, as well as the Church of San Francesco (scheduled for demolition), which marks the point from which the measurements were taken. Two acute-angled bastions with orillons are planned for the new fortifications; they are arranged in a pincer formation, spanning the entire width of the terrain. This double-bastion project is shown in many variations on U 752A r. and v., and on 753A.

Of the three concept sketches produced later by the workshop, the two on the verso at the left (a starform, radiating bulwark) are not related directly to the topography of Castro. They can be regarded, however, as a further development of the sketch on U 754A r. At the right, the sketch in red chalk—a large acute-angled bastion with orillons—shows, at the end of the curtain at the right, the characteristic rocky promontory above the Porta di sotto (see recto). This identifies it as the land bridge of Castro (see also the sketch on U 751A r. and the project on U 295A r.).

BIBLIOGRAPHY: Ferri (1885) 23; Vasari-Milanesi (1878–85) V: 502; Giovannoni (1959) I: 83, 200; Fiore (1976) 80, 81; Polidori, Ramacci (1976) 80; Giess (1981) 74, 76, 79; Clementi (1986) 374; Fiore (1986) 341.

H.G.

U 814A *recto*

ANTONIO DA SANGALLO THE YOUNGER (AND OTHERS)
Verona, walls of the city, proposed bastions and countermines, 1526(?).
Dimensions: 457 x 593 mm.
Technique: Pen and brown ink, red chalk, straightedge.
Paper: Heavy, folded in eighths, darkened at top (glue?).

INSCRIPTION, Recto (see key): (a) *piedi 30 / in fondo / adi scarpa / lo sesto;* (b) *diametro del va/cuo piedi 84 / che sono pertichi 14;* (c) *pertichi no 25;* (d) *24 pie / in fondo;* (e) *terraglio 36;* (f) *scharpa 24;* (g) *anchora a verona cie anchora / delli baluardi e ci sono magiore / di questi;* (h) *cannoniera / doppia;* (i) *Dua Cannoniere / anno bocho;* (j) *allimenti di sopra armi / queste schopietterie;* (k) *queste misure sono in fondo;* (l) *Baluardo che fa / fare piero francesco;* (m) *fiume; qui solamente sono / fatte le co*[. . .] (script terminates abruptly); (n) *questo baluardo / solo alli butta fuochi / solamente nel petto / dove* (so canceled) *dove li fianchi / non possiano vedersi;* (o) *piano;* (p) *piedi in romesi partito in oncie 12;* (q) *valle;* (r) *valetta;* (s) *monte alto;* (t) *monti piu alto / chel baluardo;* (u, later hand) *baluardo di verona murato;* (v) *le chontramine / sono pichole; contramina; coritoro; contramina / in fondo*

Verso: *Baluardo Di verona murato*

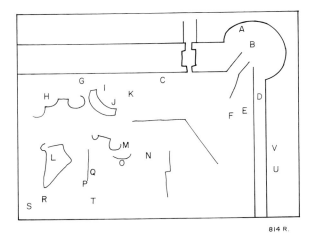

814 R.

The drawing shows a plan of the walls of the city of Verona in the area of Porta San Felice with a series of detailed studies of the bastion being built by Pier Francesco da Viterbo (*l*), countermines (*v*), and embrasures along the wall (*h, i, j*). The works are laid into a topographic context (*q–t*). (Giuliana Mazzi, who is preparing a study of the urban history of Verona, kindly provided information concerning the history of the walls of the city.)

The purpose of the drawing is not known. It seems to be purely a study drawing of the defensive system. There appears to be nothing that is proposed afresh on this sheet; the notes refer to work either under way or completed. A number of hands may be seen on the sheet. The detailed freehand studies of the topography and the embrasures clearly belong to Antonio the Younger. Similar topographic fragments are used by

him to analyze the situation in Perugia and elsewhere (see U 1028A, 977A). Authorship of the main curtain is less certain and the use of a straightedge makes identification difficult; the shading in pen and ink is uncharacteristic of Antonio the Younger. Later hands are also present on the sheet. The notation "baluardo di verona murato" suggests that the author of that note may possibly have known of a time (or a place) when the walls were in earth.

The identification of the distended baluard (l) as a work by Pier Francesco da Viterbo (1470–1537) is especially interesting. Pier Francesco was in Verona in mid-December 1525 where he met with the Duke of Urbino, Francesco Maria delle Rovere, then *Capitano generale* of the Venetian Republic, and it is tempting to think that Antonio might have seen this bastion while on his trip through the Romagna in 1526 when this sheet may have been done. We cannot be certain, however, that U 809A shows an accurate representation of the Pier Francesco da Viterbo bastion, due to the many changes in design.

The workshop for the Porta Felice bastion was opened in 1525, closed quickly, reopened in 1528; closed, but reopened in 1532 when new plans were made for the area. The many changes in plans are criticized by delle Rovere in his *Discorsi militari* (1583, p. 3). It is not clear which stage is recorded in this drawing. Nonetheless, we can be sure that anything by the distinguished Viterbese architect would have interested Antonio; they were both praised for their skill by military experts such as delle Rovere (*Discorsi militari*, p. 17).

BIBLIOGRAPHY: Ferri (1885) 225; Celli (1895) 49; Giovanonni (1959): I: 77; II: fig. 392.

N.A./S.P.

U 818A *recto*

ANTONIO DA SANGALLO THE YOUNGER
Studies of techniques for sinking ships.
Dimensions: 280 x 212 mm.
Technique: Pen and brown ink.
Paper: Center fold.

INSCRIPTION: (above) *Machine per rompere una nave sotto aqua;* (below) *Questa machina e per scaricare la botte / piena di saxi col rampino di ferro / a una sponda della nave e come ve / attachata el peso della botte fa voltare / la nave sotto sopra e annegala*

The present sheet is one of a series on marine warfare, all executed in a uniform technique of penstroke shad-

ing: U 1432A r., 1438A r., 1450A r. and v., 1476A r., 1481A r. and v., 4060A r. and v., 4064A r. and v., 4065 r. and v. In style and subject Antonio the Younger's work belongs in a single copybook with mechanisms carefully arranged on each sheet. These machines were first illustrated by Mariano Taccola in his Notebook (*De ingeneis Books I and II and Addenda*, Ms. CLM 197, part II, Bayerisches Staatsbibliothek, Munich), then copied by the Anonimo Ingegnere Senese in his copybook (Ms Additional 34113, British Library, London). Antonio utilized the latter manuscript (fols. 106 v., 121 r.) for the series, which is his first sketchbook. For his second, which includes drawings again from the Anonimo's copybook, its characteristic style and themes are discussed at U 848A r., where the first folio appears. On the basis of the form of the "h," as discussed by C.L. Frommel, this sheet should be datable before 1530.

See also "Drawings of Machines" for a discussion of the dating of Antonio's copies from manuscripts in Siena and the probable years for such travel.

BIBLIOGRAPHY: Ferri (1885) 91; Prager, Scaglia (1972) 199–201; Taccola (1984).

G.S.

U 819A *recto*

ANTONIO DA SANGALLO THE YOUNGER
Studies of mills, probably 1526.
Dimensions: 290 x 215 mm.
Technique: Pen and brown ink.
Paper: Center fold.

Lower half: (a) Cesena, mill pulverizer in the Rocca. Upper half: Rimini, mills in the Rocca (*rottele; in la rocha di Rimini*).

INSCRIPTION: (a) *In la rocha di Ciesena sie una rota / quale si macina uno mulino e pesta / polvere; Questi sono nove pestoni / li mortai sono di legnio; La rochetta de pestoni sie dua piede / La rota grande sie piedi 10 / La rochetta colle gretole (sulla canceled) quale / va alla rotta dentata in costa per la / macine sie piedi 3 La rota den/tata in faccia piede quattro / Lo rochetto sia otto gretole ed e grosso / dita u[na] / La machina sie piedi 3; (b) Rochetto grande per 2 d[ita] una / Rota dentata in piano 3 d[ita] una / Rochetto 12 della gretole 8 / Rota / macina d[ita] 5*

Antonio's note placed the mill pulverizer (*a*), with nine wooden mortars and pestles, its gear 2 feet, its great wheel 10 feet, in the fortress at Cesena, near Rimini. The staves (*gretole*) of the lantern (*rochetta*) turn on

the cogwheel (*rota dentata*) for the millstone (*macine*) and the greatwheel (*rota grande*). The cogwheel's diameter is 4 feet, the millstone's 3 feet, and the lantern has eight staves. Antonio illustrated another mill pulverizer with horse-driver in Cesena (U 1442A r.), one like it in Arezzo (U 1467A r.), and a mill in Cesena (U 1461A v.). His note on this sheet placed another mill in the fortress in Rimini, its parts being a great wheel, a cogwheel, a lantern with eight staves, and a millstone. These two mills probably were sketched when Antonio the Younger and Michele Sanmicheli visited fortresses in the Romagna.

BIBLIOGRAPHY: Ferri (1885) 24.

G.S.

U 820A *recto*

ANTONIO DA SANGALLO THE YOUNGER
Section through a cannon barrel; elevation of a cannon and its carriage, ca. 1537(?).
Dimensions: 129 x 151 mm.
Technique: Pen and brown ink.

INSCRIPTION: *2 a Li 12; quarti 6; li fuochi anno in li / capi due femine / e uno maschio e rito / intorno e in altro / e posi piede; Lo barile e longo p[almi] 2*

A group of nine sheets in the Uffizi reveal Antonio the Younger's interest in and knowledge of artillery and foundry techniques. Five of the sheets seem to be records of artillery in the papal arsenals of Civitavecchia, Piacenza, Bologna, and Ostia. These sheets seem to follow a standard form that suggests that they may have been part of an inventory of papal arms (see U 821A, 822A, 823A, 849A, 855A). We have dated U 820A to follow these sheets; during the pontificate of Paul III the renovation of the papal fortresses was undertaken and inventories of their arms were made. In addition to the brief study seen here, other sheets include U 821A, 822A, 823A, 824A, 825A, 849A, 855A, 858A.

U 820A shows two sketches. The lower one shows a cannon on its carriage. The emphasis at the join between carriage and barrel suggests that the sketch may have been intended to clarify the pivot point. Above is a section through the barrel. The notes refer to the techniques used to cast cannon around a series of hoops. In neither sketch is the location or the maker of the cannon specified. Both sketches are relatively rough and seem to have been done from an actual cannon. U 820A may be a rough sketch for U 858A, which seems to show the same cannon; there

a compass has been used to control the outline of the barrel section.

The use of this type of sectional drawing (across the mouth of the barrel) is not found in earlier treatises that deal with artillery and cannon, such as that of Francesco di Giorgio. It later becomes extremely popular, occurring in numerous artillery manuals and treatises from the 1550's onward. The application of these techniques of representation to technological matters is one of Antonio's notable contributions.

BIBLIOGRAPHY: Ferri (1885) 105.

N.A., G.S.

U 821A *recto*

ANTONIO DA SANGALLO THE YOUNGER
Five studies of cannon from Ostia, ca. 1537(?).
Dimensions: 221 x 149 mm.
Technique: Pen and gray ink.
Paper: Partially yellowed, modern support.
Drawing Scale: Roman *dita*.

INSCRIPTION: (from top) *Ostia; a faccie 24; Colubrina palla dita 7²/₅; cannone palla 9¹/₄; palla; palla*

This sheet shows five pieces of artillery from the papal fortress at Ostia. Measurements in Roman *dita* are given only for the topmost cannon, specified as a 24-sided culverin, and the second from the top.

This sheet is part of a group of five sheets that show cannon from the papal fortresses drawn freehand in profile, measured and arranged in parallel lines (see U 822A, 823A, 849A, 855A). Other drawings related to artillery and cannon include U 820A, 824A, 825A, 858A. It is not known why or under what circumstances Antonio the Younger was asked to draw these cannon. It is possible that, in addition to his architectural advice on the papal fortress he was asked to use his graphic skills to record the nature and extent of the papal arsenals. The representation of these cannon in a regular manner seems consistent with some large bureaucratic plan. These sheets are, in effect, the notes for a more complete report that may have been submitted to Pope Paul III or his officers.

BIBLIOGRAPHY: Ferri (1885) 105.

N.A., F.Z.B.

U 822A *recto*

ANTONIO DA SANGALLO THE YOUNGER
Three studies of cannon from Civitavecchia, ca. 1537(?).
Dimensions: 172/177 x 228 mm.
Technique: Pen and brown ink.
Paper: Partially yellowed, fold marks.

INSCRIPTION: (top to bottom) *orso; sacro orsino di mastro andrea; a faccia 16*

This design, which can be dated ca. 1537, gives measurements for three artillery pieces in Civitavecchia. Of the three, we know that the top one was made by "mastro Andrea piemontese," a foundryman for Pope Julius II, as shown by the inventory consigned on 27 November 1511. The same piece is still listed in inventories dated 19 July 1512 and 23 March 1529.

The drawing, part view and part section, would have been useful to officials who needed to know the size and nature of the artillery pieces in the papal forces. From sketches such as these (or their fair copy reproductions) they could also have known the size and weight of the ball that such weapons could have used. This sheet is related to a group of four similar sheets that represent cannon (see U 821A for a fuller discussion of the purpose of such drawings). Other drawings include U 822A, 823A, 849A, 855A. Four other sheets dealing with cannon and artillery are U 820A, 824A, 825A, 858A.

BIBLIOGRAPHY: Ferri (1885) 92; Fagliari Zeni Buchicchio (1988) 312–13, 328–29, 364–66.

N.A., F.Z.B.

U 823A *recto and verso*

ANTONIO DA SANGALLO THE YOUNGER
Five studies of cannon from Piacenza, ca. 1537(?).
Dimensions: 143 x 384 mm (modern support).
Technique: Pen and brown ink.
Paper: Partially fragmented, thick, partially yellowed, on modern support.
Drawing Scale: Roman *dita*.

INSCRIPTION, Recto: *arteglieria di piace[n]tia; questa e bellina; misurate a dita antiche*; (in a later hand) *Arteglieria di piace[n]za*
Verso: (script in original hand) *Artiglieria di piace[n]tia*

These five artillery pieces from Piacenza have been sketched as part of the papal inventory (see U 820A, 821A) and this sheet has been dated with the others, although specific evidence for the date of this sheet is lacking.

This sheet is one of a group of five that represent the cannon in parallel lines (see U 821A, 822A, 849A, 855A). Other sheets also deal with artillery (see U 820A, 824A, 825A, 858A).

BIBLIOGRAPHY: Ferri (1885) 111.

N.A., F.Z.B.

U 824A *recto*

ANTONIO DA SANGALLO THE YOUNGER
Possibly the annotations from U 823A.
Dimensions: 39 x 59 mm (original sheet); 133 x 150 mm (modern support).
Technique: Pen and brown ink.

INSCRIPTION: *Artiglieria; Civitavecchia* (slightly smudged); *Appartiene al No. 823* (modern blue pencil)

According to a note on the verso in a later hand, the sheet "belongs to U 823A." This seems unlikely, not only because the papers are of different thickness but because U 823A refers to artillery for Piacenza, not Civitavecchia. The inscription added to the sheet after 1854 might refer to other designs, no longer identifiable, related to artillery for Civitavecchia. Concerning Civitavecchia, see U 822A and 825A. For a fuller discussion of Antonio the Younger's artillery drawings, see U 820A and 821A. There are nine sheets that deal with artillery. In addition to the present sheet, see also U 820A, 821A, 822A, 825A, 849A, 855A, 858A.

BIBLIOGRAPHY: Vasari (1846–70) X: 84; Ferri (1885) 28; Fagliari Zeni Buchicchio (1988) 312, 328.

N.A., F.Z.B.

U 825A *recto and verso*

ANTONIO DA SANGALLO THE YOUNGER
Civitavecchia, artillery trial, 1538.
Dimensions: 339 x 291/289 mm.
Technique: Pen and brown ink on the recto, red pencil on the verso.
Paper: Partially yellowed; fold marks.
Drawing Scale: *dita* and *piedi*.

INSCRIPTION, Recto: (top left) *a facie 20; piedi 13 D[ita] 2¹/₂; Colubrina di mastro/ andrea*; (central text) *questa Colubrina o fatto la prova / a civita vechia addi 10 dottobre / 1538 / in bocha la meza sie Dita 8¹/₂ / di rieto sie Dita 11¹/₂ la meza / quale e longa dita 210¹/₂ quale / i[n] dette Dita 210¹/₂ aquista Di/ta 3 viene aquistare uno me/zo dito ogni Dita 35¹/₁₂ di no/do p[er] andare aquistare la i[n]terse/gatione della linia del mezo / della Canna dove el primo / pu[n]to in biancho*

aquistare / 17 meze dita e p[er] questo dire/mo 17 vie 35 1/12 fa
Dita 536 5/12 / lontano dalla bocha e li elprimo / pu[n]to in
biancho quale viene pie/di 33 Dita 8 e 5/12 di dito di/scosto
dalla bocha lo secondo pu[n]to i[n] biancho si e dis/costo dalla
bocha piedi 2000 / aquista[n]do come e ditto uno mezo / dito
ogni Dita 35 1/12 aquista / D[ita] 456 quali sono piedi 28 1/2 / e
tanto a dato basso della sua mira / del centro della Canna;
(below, left) *piedi 13 D[ita] 2 1/2; p[ie]di 33 D[ita] 8 5/12; piedi*
2000; piedi 28 1/2; p[er]che lartiglieria / i[n] se e grossa 3 dita /
piu da capo che i[n] bocha / cioe la meza bisognia / partire el
dito in dieci / e dite tre dita i[n] mo/duli 30; A piedi mille i[n]
piano / A 1100 bisognia mettere i[n] sulla bocha / de dite
moduli 27 / A piedi 1200 metti i[n] sulla bocha 24 / A piedi
1300 metti (space) *21 / A piedi 1400 metti* (space) *dita 18 / A*
piedi 1500 metti moduli 15 / A piedi 1600 metti moduli 12 / A
piedi 1700 metti moduli 9 / A piedi 1800 metti moduli 6 / A
piedi 1900 metti moduli 3 / A piedi 2000 la mira sua da di
Pu[n]to i[n] biancho / cioe el secondo pu[n]to i[n] biancho
apu[n]to; (top right) *Colubrina Pisana / a faccie 8; Cannone /*
Di mastro vi[n]cie[n]tio; Cannone; opus andree

On this sheet, datable 1538, the measurements for four
artillery pieces for Civitavecchia have been noted. Two
of the cannon (left, bottom right) were cast on 28
November 1511 by Maestro Andrea, Julius II's Pied-
montese foundryman. A third (middle right) is a later
work by a certain Vincenzo. The last (top right) is
generically known as an eight-faced Pisan culverin. On
10 October 1538 Antonio the Younger tested Andrea's
culverin on distances ranging from 1000 to 2000
piedi. Not all of the calculations made at the time
check out accurately, however, and errors include the
following: *dita* 536 5/12, equal to 33 *piedi* and 8 5/12 *dita*,
should be *dita* 596 5/12 equal to 37 *piedi* and 4 5/12 *dita*;
furthermore, at a distance of 2000 *piedi*, there would
be a drop of 450 5%/71 *dita*, equal to 28 *piedi* and 2 5%/71
dita, not 456 *dita* equal to 28 1/2 *piedi*. See also U 822A
and 824A.

This sheet is an extremely important demonstration
of the interest in trajectory among sixteenth-century
military architects and field commanders. It appears
to be the first visual record of such a test. Writers such
as Niccolò Tartaglia, for example, took special interest
in these matters (see *Nuova Scientia*, 1537).

BIBLIOGRAPHY: Vasari (1846–70) X: 83–84; Ferri (1885)
92; Fagliari Zeni Buchicchio (1988) 311–13, 328–29.

F.Z.B., N.A.

U 826A *verso*

ANTONIO DA SANGALLO THE YOUNGER
Study of proportions of column shaft; stone-hanger, or lewis;
 plan view of capital; plan of tower (left half).
Dimensions: 215 x 290 mm.
Technique: Pen and light brown ink.
Paper: Folds, part of large sheet, previously folded.

INSCRIPTION, Left half: (stone-hanger, or lewis) *Per lulivella*
ordinarie / la chiave di mezo non / sta come questa seg/niata A
ma sta co/me questa segniata / K grossa tanto da pie / quanto
da capo; (referring to capital on right half) *Capitelli quadri*
grandi / di Santo Pietro anno tre / ferrature dulivelle cioe / una
in mezo in crocie & / uno per banda ordinaria / Bisognia
trovare come stanno per una e necessarie / stessi cosi come e
fermato / qui apresso / Come sono anto/ri inserito / come se
vede qui; (tower) *Per trovare la ritondita della tore e diamitro /*
suo se abia per geometria quanto sia / dallo A B e da B C e di
C D / e si metta in piano colla A B D col B A / elle dira quanto
se aha sopra alla A / ritornando da B verso la A e per quella /
deferentia troverai quello va cercando

On the right half of the verso is a note concerning
payment for wine dated 21 January 1542. Regrettably
the note is not related to the drawings for a stone-
hanger, or lewis, for positioning stones in masonry
under construction. Antonio's analysis of the lewis, in
sixteen parts identified by letters A to K, is unprece-
dented. See, by contrast, drawings such as the one
illustrated by Buonaccorso Ghiberti, which are among
the devices ("livella da levare pessi") that Brunelleschi
rediscovered for use with the hoist and crane of his
invention (Ms Banco rari 228, fol. 119 r., Biblioteca
Nazionale, Florence). Antonio's notes are so worded
as to raise the question of why he analyzed the lewis.
Nothing is known about the building devices Antonio
used to construct St. Peter's. He first wrote in general
terms, using an objective tone as a simple observation:
"For the ordinary lewis the middle piece is not set as it
is in A but rather as in K, and its thickness is the same
at top and bottom." His tone changes where he refers
to the lewis used for the St. Peter's capitals, saying,
"The large square capitals of St. Peter's have three
iron pieces [where] the lewis [was applied], a cross
shape in the middle, an ordinary one on each side.
One must look for the way one of them is placed, and
they necessarily were placed as illustrated nearby. Here
is the way they were inserted." In this case, the square
capitals must have been those of Old St. Peter's stand-
ing on nave and aisles. Evidently, Antonio studied the
location and forms of iron pieces and illustrated what
he found, an archaeological activity like others he made

that led to his illustrating the pipe found on the Roman Forum (U 1212A r.) and round holes on the steps of the odeum (U 1472A r. and v.). On seeing the round holes, he noted how persons sat in the theater, and observed such a small detail as a "marble support in the assembly room." The great tower mentioned on that sheet may be the same one illustrated on the present sheet, marked with letters A, B, C, D.

BIBLIOGRAPHY: Ferri (1885) 91; Prager, Scaglia (1970) 65–83, figs. 24, 25; Von Stromer (1977).

G.S.

U 827A *recto and verso*

ANTONIO DA SANGALLO THE YOUNGER
Lucca, plan of the wall system, 1532.
Dimensions: 302 x 209 mm.
Technique: Pen and brown ink; underdrawing of charcoal(?).
Paper: Relatively heavy, modern support.

INSCRIPTION, Recto: (in center) *Lucha;* (around the walls) *strada che va* (in modern pencil) *a pistoia* (in ink); *sostegnio; fossato; fosso; fosso; muro vechio; Lucha; monte S.* (*gialiano* canceled) *giuliano; a pereltua; monte; porta in verso librafata; po[. . .] e sito dellaqua / de Sito e para(?); chella super sito delaqua; porta di pietra S.M.; altro*
Verso: *pistoia sie quadrangulata e in sulli angoli sie le porte / li passi sono linfrascrittis seravalle si e per la via / di lucha a tre miglie quale che vi e ne da / lucha a montare mezo miglio e si tro/va in mezo la vale e in su lasella uno / monterozo asai grandetto dove e su uno / Castelletto mezo in ruina pure se abita / ce a e munitia in mezo le valle e da ogni banda a fossato e per quello di corso fiorentina presso larghezza / a da ogni banda scalzono le montagnie altissime ma sono Coltivate / e se bene sono ripite se per alte si possano passare in molti luoghi / E di Seravalle in fino a pistoia qua pende; Di poi a questo cie* (hole in sheet) *di Cestello murato quale e uno simile / a Seravalle ma piu porte e piu sterile quale [. . .] diverso mandare / lontano da pistoia 20 miglia*
Di poi sie el passo del bagnio del zabuco da pistoia allo a perusino so [. . .] / otto miglia Come aqua pende verso pistoia e li e lo [. . .] / mo quasi continuato equalmenti di poi aquapende fano al confine / 10 miglia e dal confino al bagnio sono due miglia

In character, this drawing recalls the kind of sheets produced during the Romagna inspections (see U 889A): a brief sketch with extensive text. Yet the text on both sides is limited to some topographic observations the purpose of which is not clear. The sketches are so basic that we do not think they were part of a defensive proposal; rather, the text might

lead one to imagine that Antonio was interested in communication or water supply. The rough character of the drawing led Giovannoni to attribute the drawing to Bartolomeo de' Rocchi and Antonio the Younger. By contrast, we can detect nothing of what has been identified conventionally as Rocchi within this drawing, though the underdrawing for the plan of Lucca may be by a hand other than Antonio's. The topography, however, is sketched in a manner that is characteristic of Antonio (see U 1028A).

Any dating for this drawing is tentative. Although the drawing is rudimentary, the handwriting seems relatively mature (note the form of the "h"); we would favor a date around 1532 when Antonio was working for Alessandro de' Medici (1532–37).

BIBLIOGRAPHY: Ferri (1885) 85; Giovannoni (1959) I: 76, 422.

N.A./S.P.

U 830A *recto and verso*

ANTONIO DA SANGALLO THE YOUNGER
Perspective studies, ca. 1526–27.
Dimensions: 551 x 417 mm.
Technique: Pen and brown ink, straightedge, compass, stylus, pin. Note that ovals are drawn freehand between points.
Paper: Center fold, repairs, brown at edges.
Drawing Scale: cube base = 81 mm.

INSCRIPTION, Recto: (left) *primo; secondo;* (*secondo* canceled); *primo; quarto;* (*quarto* canceled); *tertio; per far uno mazochio;* (right) *in faccia; obliqua; questa sta / bene; in propria forma / meglio stanno quan/do sono scortate in pro/spettiva*
Verso: *Distantia e quale allochio in piano in latitudine; parete; parete; Distantia e quale dallochio in profilo / in altitudine; punto; Distanta; Modo per dipignere una figura in una / parete che para fora della parete; Prospettiva e tagli di piramida*

This is the largest and richest of the sheets devoted to perspective. There are demonstrations of the problems of placing solid volumes in space (cube, cone, checkerboard squares), as well as the construction of a *mazzocchio.* On the verso is a demonstration of illusionistic construction techniques in painting (see U 857A v.). For comparison, see the drawings of the *mazzocchio* (U 831A, 832A, 1464A r., 4120A) or that of perspective construction (U 1462A v.).

BIBLIOGRAPHY: Ferri (1885) 81.

N.A.

U 831A recto

ANTONIO DA SANGALLO THE YOUNGER
Studies of a *mazzocchio*, ca. 1526–27.
Dimensions: 485 × 386 mm.
Technique: Pen and brown ink, stylus, compass, dividers, straightedge.
Paper: Yellowed, reinforced at top.

INSCRIPTION: *Proprie forme per fare uno mazochio*

This is one of four sheets with representations in the hand of Antonio the Younger of the *mazzocchio* (see U 832A, 1464A r., 4120A). The *mazzocchio* was a light frame, generally made of wicker, around which cloth was wrapped to form a kind of headgear worn by gentlemen. In the drawing we see only an outline of this frame. A noted example of a *mazzocchio* can be seen on the seated figure in Paolo Uccello's *Flood* in the Chiostro Verde of the Church of Santa Maria Novella, Florence (1446–48). There the *mazzocchio* has become displaced and slipped down around the figure's neck.

Whatever its function as an item of clothing, the skeletal form of the *mazzocchio* was commonly used as a device to demonstrate techniques for the representation of regular and irregular bodies. Drawings in the Uffizi from the early fifteenth century by Uccello show its venerable status and employ a similar form of plan and elevation. Piero della Francesca made use of it in his treatise on perspective (*De Prospectiva pingendi*); there it is shown in the context of an exercise to prepare the student to represent architectural elements. Daniele Barbaro recommended the *mazzocchio* for similar purposes in his book on geometry (*Prattica della perspettiva*, 1569). As a tool for the demonstration of the geometer's art, the *mazzocchio* seems never to have lost its appeal. There are even a number of studies of *mazzocchi* by Leonardo da Vinci.

The purpose and date of these drawings are open to question. It is possible that Antonio the Younger had plans for a book on geometry, just like those he planned on machines. These representations of the *mazzocchio* are of a standard type, which would also suggest that Antonio was interested in the *mazzocchio* as a device for a manual or as an educational tool within the workshop rather than as a subject for independent investigation. None of the sheets is fully complete. For a consideration of the dating of the sheets, see U 1464A where there is independent evidence for dating.

While the attribution of this sheet is more or less secured by the handwriting, we cannot be so certain of the attributions of U 832A and 4120A. The latter bears a later attribution to Giovanni Battista da Sangallo.

BIBLIOGRAPHY: For further discussion of *mazzocchi*, see Kern (1915); Degenhart, Schmitt (1968) I: 2, 402–5; Davis (1980); Veltman, Keller (1986) 128–37. The sheets of Antonio the Younger are not discussed by Giovannoni.

N.A.

U 832A recto

ANTONIO DA SANGALLO THE YOUNGER
Studies of a *mazzocchio*, ca. 1526–27.
Dimensions: 564 × 421 mm.
Technique: Pen and brown ink, stylus, compass, dividers, straightedge.
Paper: Folded in four, glue marks on left side, ink smudges.

INSCRIPTION, Verso: (later hand) *Aristotele*

For a consideration of the sequence of drawings of the *mazzocchio* by Antonio the Younger, see U 831A. (Other representations of the *mazzocchio* include U 1464A r. and 4120A.) For a consideration of the dating of the sheets, see U 1464A where there is independent evidence for date.

This sheet is the most complex representation of the group. It shows plan, elevation, and an oblique view into the *mazzocchio*. For bibliographic references to the *mazzocchio* as a device for the demonstration of geometric principles, see U 831A.

N.A.

U 835A recto

ANTONIO DA SANGALLO THE YOUNGER
Study for arms of Paul III, after 1537.
Dimensions: 201 × 140 mm.
Technique: Pen and brown ink.
Paper: Edges browned.

INSCRIPTION: *Imprese di papa pagolo; Tardita; presteza; cameleonte; Dalfino; Sole; nugolo; Lo Sole che passa per uno buso delli / nugoli eli razi della superfitie del / Sole dal mezo in giu fanno lo mezo / Circhuolo dello iris sopra terra / & quello dela superfitia delSole dal / mezo in su fanno lo mezo circolo / delo arco Juris in piana terra / e dicha aristotele elli altri a modo / loro che questa sie la pura verita*

The combination of figures (dolphin and lizard) is found in rooms within the Castel Sant'Angelo often accompanied by the motto "Festina Lente." The

drawing of the sun shows how a rainbow is formed. The rays leave the sun and are focused by the cloud ("nugolo") to form the rainbow. Antonio cites Aristotle for his opinion.

The transcription provided by Giovannoni is incorrect. It is not known whether this sketch was also to provide a heraldic device.

BIBLIOGRAPHY: Ferri (1885) 34; Giovannoni (1959) I: 18.

E.B.

U 838A *recto*

ANTONIO DA SANGALLO THE YOUNGER
Pratica, survey sketches, after 1539.
Dimensions: 57/106 x 106/119 mm (upper sheet); 267.5 x 185/178 mm (lower sheet).
Technique: Pen and brown ink.
Paper: Partially yellowed but in two distinct parts mounted on same modern support.
Drawing Scale: Roman *palmi* with orientation according to degree and direction of the winds T[ramontana], G[reco], S[cirocco], O[stro], L[ibeccio], P[onente], M[aestro].

INSCRIPTION: (above) *Patricha de Mes[ser] / lucha di maximo*; (below) *muro antico*; *muro castellano*; *portico / moderno*

The sketches may be dated after 1539 when Luca Massimo became the sole owner of Pratica. The sheet above and to the right gives the measurements of a column that may have been part of the "portico moderno" described on the other sheet as having six bases and being behind the "muro castellano." A new system of defense with three bastions is also outlined on the sheet (lower left) as an alternative to the square or rectangular fortress proposed in U 725A and 843A. Regarding the dimensions of the new urban plan with respect to U 725A, the width of the main square in the center of the town has been increased from 120 to 130 *palmi* by reducing the side streets from 30 to 25 *palmi*. In U 843A the width of the main square once again is calculated as 120 *palmi*, whereas the narrowing of the side streets to 25 *palmi* has been maintained. See also U 944A for more general information.

BIBLIOGRAPHY: Ferri (1885) 186; Frommel (1973) II: 239 n. 5.

F.Z.B.

U 839A *recto*

ANTONIO DA SANGALLO THE YOUNGER
Casigliano, Palazzo-Castello Atti, before 1527.
Dimensions: 442 x 444 mm.
Technique: Pen and brown ink, straightedge, right angle.
Drawing Scale: Piedi romani (5 canne = 41 mm).

INSCRIPTION: (not in hand of Antonio, but sixteenth-century script) *Disegni di lodovico da Todi / Casigliano et Civita Castellana et Casa de C[esi?] in Narni*; (hand of Antonio the Younger) *in circuito pertiche 100 in circha / alto pertiche 3 grosse pedi 5 / in tutto pertiche 1500*

This drawing proves Antonio the Younger's participation as designer for Casigliano. The shift in date (see U 731A) is justified by the annotations. Ludovico Atti (d. 7 May 1527) was the father of Angelo Atti. The chronological relation between U 731A and 839A is complex and does not allow for certain resolution. The plan of the palace as a succession of spaces (*andito*, portico with three arches and stairs, courtyard with portal) is comparable to the entry of the Palazzo Baldassini, Rome, or the Palazzo Ferratini in Amelia.

The walls are strengthened by two angular towers. That to the southwest is scarped. The palace-castle is sited on a hill and is surrounded by a square-planned enclosure ca. 100 x 100 *piedi*. Four circular bastions with scarps mark the corners. The annotation of distance refers to the development of the construction.

BIBLIOGRAPHY: (not published).

E.B.

U 843A *recto*

ANTONIO DA SANGALLO THE YOUNGER
Pratica, plan of the town, after 1539.
Dimensions: 597 x 1033 mm.
Technique: Pen and brown ink, stylus, straightedge, dividers, pin.
Paper: Partially yellowed, folds, corners cut and integrated in modern support.
Drawing Scale: Roman 100 *palmi* (10 canne = 95.5 mm).

INSCRIPTION, Recto: *scoperto*; G[reco]; ŏ [Levante]; S[cirocco]; O[stro]; L[ibeccio]; P[onente]; M[aestro]
Verso: *Pratica di me[sser] luca di maximo*

The plan dates from 1539 when Luca Massimo was the sole owner of Pratica. Done in scale and including a wind rose, it reproduces all the data regarding the existing structures on the U 944A survey drawing. The new urban planning shown here has reached the definitive stage and is more advanced than U 725A. It

includes the almost square fortress with corner bastions, the entrance with guardroom, and the regularized antique walls with three large bastions. Thus protected, the town has been redefined in an orthogonal grid pattern with the layout clearly divided into two types: porticoed streets giving on to piazzas and side streets. Unlike U 838A, the existing "modern portico" on the short side of the piazza, opposite the guardroom, has not been reproduced, and the defensework with three bastions that would replace the "square" fortress is missing.

BIBLIOGRAPHY: Ferri (1885) 186; Dell'Acqua, Gentilucci (1986) 310–12, 626–28.

F.Z.B.

U 847A recto

ANTONIO DA SANGALLO THE YOUNGER
Six studies of pumps.
Dimensions: 295 x 415 mm.
Technique: Pen and brown ink.
Paper: Left half of previously folded sheet.

(a) Pump with double tubes and cogwheel drive (left half of sheet). (b) Pump with double tubes and metal balls as valves (*in cambio di animelle / sieno pallotti di metallo*). (c) Pump, detail of four balls in two valves (*Quello strutto nelle / giunture delle canne / sostiene che llaqua / non torna indietro*). (d) Note *lo rocchetto denti 24 / la rota denti 72.* (e) Pump, detail of four balls (*cierchi; cierchi; cierchi; capilarga / per potere dare a cierchi / e stringerli*). (f) Pump, detail of four-tooth gear in elliptical racks (*quattro denti / di 12 del fuso / allo standuffo 4 / per banda*). (g) Pump, detail of gear racks in support frame.

INSCRIPTION: (a) *La rota a denti 72 / Lo rochetto denti 24 / Li denti che mandano / su e giu li standufi sono / partiti in denti 12 et / delli 12 ne ano solo 4 / e lo resto senza denti*

Antonio the Younger's note (*a*) may be translated: "The wheel has 72 teeth, the lantern 24; the teeth that send the *stantuffi* up and down are divided into 12; they work on only 4, the space in between being without teeth." Another detail (*f*) shows four teeth of the twelve on the rod of the *stantuffo,* four teeth on each side. Though the precise meaning is not clear, *stantuffi* are mentioned and variously illustrated (U 294A v., 847A r. and v., 1468A r.) in relation to the metal balls that substitute as valves. The details of gear and rack seem to illustrate some part of the present pump from another viewpoint. Balls as valves and an elliptical

gear are present also in other pumps by Antonio (U 1409A v., 1493A r.). Gears in elliptical racks for pumps are never shown in Francesco di Giorgio's drawings, and they seem to have been developed in the sixteenth century, as noted at U 1493A r.

BIBLIOGRAPHY: Ferri (1885) 91.

G.S.

U 847A *verso*

ANTONIO DA SANGALLO THE YOUNGER
Studies of pumps, builder's bridges.
Dimensions and Paper: See U 847A recto.
Technique: Pen and brown ink.

Left half: (a) Pressure wheel or force pump (*rota palmi 20*) with rod (*standufi*), a central weight (*pietra*), and a man pulling another *stantuffo.* Right half: (b) Octagonal plan (*rulletti; ruota di sopra b[raccia] 10*). (c) Octagonal plan (*ruota di / sotto b[raccia] 5*). (d) Octagonal form with oculus. (e) Builder's bridge on a mast with stepped profile outside. (f) Builder's bridge on a mast with stepped profile inside, detail (*el papa dicie stava / cosi e giravasi into/rno e posava la scala / in sul cornicione*).

INSCRIPTION: (a) *Prema tonda / da due standuffi / Uno omo / pegna / la preta e facilmente / va in qua e in la;* (f) *E io credo stessi cosi; Per mettare el musaico di / Santo Giovanni di Fiorenze*

Antonio the Younger illustrated a third machine with *stantuffi* (see also U 294A v., 847A r.). His note (*a*) says that the man pushes the stone so that it goes easily from side to side, but he means to say the wheel forces pressure into one side then the other. His note for the builder's bridges (*e*) and (*f*) is self-explanatory. He states that they were used for mosaic work done on the vault of the Baptistery in Florence; two plan views and octagonal form with oculus illustrate that building. He comments that the pope (Leo X or Clement VII) thought the small rotating platform on the central mast was stepped down to rest on the interior cornice, and his sketch shows steps ascending from there to a platform inserted into the oculus. Antonio thought differently about the bridge. His second sketch shows a very large platform lower down on the mast, and steps rising from it to the oculus. Evidently the pope had thought about how mosaic work was done on vaults, and Antonio discussed the matter with him. Both forms are more imaginative than the ordinary flat bridge illustrated by Giovan Francesco (U 1528A r.) for work that Antonio the Younger con-

tracted for in 1518 in Viterbo.

BIBLIOGRAPHY: Ferri (1885) 481, 91; Schwarz (1990).
<div align="right">G.S.</div>

U 848A *recto*

ANTONIO DA SANGALLO THE YOUNGER
Studies of military strategems.
Dimensions: 170 x 240 mm.
Technique: Pen and light brown ink.

(a) Boat resting on a layer of beams. (b) Castle wall and traps around it (*passanti*; *fossi*). (c) Trebuchet. (d) Trebuchet with sling. (e) Floating buoys and beams (*per serare una bocha duno porto / presto*). (f) Floating trap (*per mettere in un porto*). (g) Floating trap (*per mettere nuno / porto per impedire / nave e vogliono essere / asai*).

Antonio the Younger's source for these sketches and the question of dating have been explained (see U 818A r.): The Anonimo Ingegnere Senese's copybook (Ms Additional 34113, British Library, London) provided him with Taccola's drawings and text in translation. A comparison of drawings *a* through *g* in U 848A r. with the copybook reveals the following: folios 117 r., 141 r., 132 v., 124 r., 117 r., 117 v. The present sheet and other seventeen folio sides once belonged to Antonio's second sketchbook: U 1443A r. and v., 1451A r. and v., 1452A r. and v., 1471A r. and v., 1472A r. and v., 3976A r. and v., 4059A r. and v. Antonio's style of free penline in the second sketchbook is developed after he had used penstroke shading consistently in his first sketchbook (U 818A r.). Despite the change in representational technique, the Anonimo's copybook was his source for both sketchbooks. One cannot be sure that Antonio's pen techniques might not have developed in reverse order, but his penline technique was used in sketches of mill pulverizers (U 819A r.) that he saw in Cesena and Rimini, where he traveled with Michele Sanmicheli in 1526. The same watermark appears on many sheets of Antonio's second sketchbook, for example those listed above by number.

BIBLIOGRAPHY: Ferri (1885) 117; Prager, Scaglia (1972) 199–202; Taccola (1984).
<div align="right">G.S.</div>

U 849A *recto and verso*

ANTONIO DA SANGALLO THE YOUNGER
Studies of eight cannon; three cannon from Bologna, ca. 1537.

Dimensions: 301 x 408 mm.
Technique: Pen and brown ink.
Paper: Yellowed at edge, partial modern support.

INSCRIPTION, Recto: *palla* (seven times)
Verso: *Artiglieria di bolognia*; *Artiglieria di bolognia*

U 849A recto and verso form part of a group of nine sheets in the Uffizi concerning artillery and foundry techniques (see U 820A, 821A, 822A, 823A, 824A, 825A, 855A, 858A).

For a general discussion of the drawings of artillery by Antonio the Younger, see U 820A. For a discussion of the drawings of cannon laid out in parallel rows, as here, see U 820A. The dating of this sheet, ca. 1537, follows the pattern adopted elsewhere.

BIBLIOGRAPHY: Ferri (1885) 14.
<div align="right">N.A.</div>

U 850A *recto*

ANTONIO DA SANGALLO THE YOUNGER
Twelve gores for a globe, ca. 1530.
Dimensions: 329 x 434 mm (modern support).
Technique: Pen and brown ink, wash, compass, straightedge, stylus, pin.
Paper: Original drawing cut from larger sheet, modern support.

INSCRIPTION: (top to bottom) *Miglia / 22500*; *Settentrione* [. . .]*desto polo artico*; *ponente*; *Equinotiale*; *Levante*; *M / Antonio*; (at bottom) *settentrio*; *Altro Settentrione* [. . .]*deste polo antartico*; *Mapamondo mia openione*

On this sheet Antonio the Younger has given "his opinion" about the form of a *mappamondo* for a terrestrial globe. The globe has been divided into a set of twelve gores; above and to the right is the gore cap, to the left may be an experimental gore cap. The total number of miles given (top center) for the world (22,500) was a relatively common figure for the circumference of the earth. The other number (1865) divides the earth into twelve segments (more or less) corresponding to the gores.

The division of the earth into twelve gores for the construction of a globe was first demonstrated by Martin Waldseemüller (1509), but later versions, such as those of Boulengier (1518) or Robertus de Bailly (1530), may have provided a model for Antonio. Unlike those examples, however, Antonio seems to have decided not to curve the parallels, rather an odd decision, since it would have produced a globe with a

<div align="right">153</div>

flat grid pasted to it rather than the proper effect of curvature.

Interest in maps and globes was extremely high during this period. In 1542 a copper terrestrial globe (now in the collection of the New-York Historical Society) was made by Euphrosynus Ulpius for Marcello Cervino in Rome, and Cardinal Pietro Bembo is known to have had a globe in his possession. G.B. Ramusio recounts that he visited Girolamo Fracastoro in Caffi in company with the architect Michele Sanmicheli (in the mid-1530's?) and debated geographical matters in front of a globe. In short, Antonio's interest in such matters should come as no surprise. Nonetheless this is the only sheet in his hand to deal with these matters. For these and other events in the history of the terrestrial globe, see Stevenson (1921), pp. 94–196. So far as I have been able to determine, this sheet is unpublished; it is not referred to by either Ferri (1885) or Giovannoni (1959).

Thanks are due to John Wolter of the Map Division at the Library of Congress, Washington, D.C., and David Woodward of the Department of Geography, University of Wisconsin, for help in the interpretation of this drawing.

BIBLIOGRAPHY: (not published).

N.A.

U 851A *verso*

ANTONIO DA SANGALLO THE YOUNGER
Geometrical studies.
Dimensions: 299 x 466 mm.
Technique: Pen and brown ink, stylus.
Paper: Edges extensively repaired.

INSCRIPTION: *dove batte la linia circulare / segniata A in la piramida / sega la piramida che tanto sara / a misura e pesa la parte di sopra / quanto quella di sotto;* (below the pyramid) *piramida;* (below) *La colonna 1024 / la tertia parte si / e la piramida 341 1/3*

The pyramidal figure seems to address problems related to the bisection of a pyramid. According to the sketch, if the "arc at *A*" strikes the line *BC* at a point *D*, the length of the two segments *BD* and *DC* are in the relation $\sqrt{2}$ and $2 - \sqrt{2}$ as is seen in the sequence:

$BD = BO = (\sqrt{2}/2)BC$ and $DC = BC - BD = [(2 - \sqrt{2})/2]BC$.

On the basis of this relationship the volumes of the two solids generated from the section of the pyramid (one pyramid and one pyramid base) are in the relation of $\sqrt{2}$ and $4 - \sqrt{2}$. Thus the statement "the part

above and below will be the same size and weight" turns out not to be true and thus testifies to the lack of knowledge of the proportionality of the sections of the pyramid based on relative distances from the apex. The statement would, in fact, be correct if it referred only to the lateral surfaces of the two solids.

The triangle (below, drawn in a fainter hand) with the calculations below refers to the computation of the volume of a pyramid with a square base of 8 units and a height of 16 units; in fact a form with the same base and same height has a volume that is as follows: $(8 \times 8) \times 16 = 1024$, and the pyramid would have a volume of $1024/3$ or $341 \frac{1}{3}$. Note that Antonio does not compute this sequence ($1024:3$) but rather does the proof: "$341 + \frac{1}{3} \times 3$."

Concerning the calculation (multiplications and additions), see the remarks of a general nature on U 857A.

Note here that the disposition of the calculations is generally more ordered than on other sheets (out of some thirty operations only three are disposed off the horizontal), and that the numbers are generally of three, four, and five digits. It seems as if the same logic guides the calculations: Multiplications by three refers to the problems of pyramid calculations, and the similarity of the results obtained through different procedures suggests controls. It is possible, in fact, to identify seven groups in which there are two specific operation sequences: (a) $2 \times A^3 = B$, and (b) (total) $\times 3 = B$. The first derives from the "cubo duplicato" (doubled cube); see U 856A v. The second suggests that the "total" may be the volume of a pyramid and thus that B expresses the volume of the prism with the same base (its so-called *colonna*); that the value of B may be obtained duplicating a cube may be explained by assuming that the height of the prism (and thus of the pyramid as well) is double the length of the square base.

BIBLIOGRAPHY: Ferri (1885) 81.

G.L.V.

U 852A *recto*

ANTONIO DA SANGALLO THE YOUNGER
Studies of mill and furnace.
Dimensions: 210 x 295 mm.
Technique: Pen and black ink.
Paper: Center fold.

(a) Furnace and instructions for making aluminum sulphate. (b) Wheel with iron balls on chains as weight-wheel for a hand-cranked pulverizer in Pitigliano. (c) Mill, detail of pulverizer.

INSCRIPTION, Left half: (a) *Le allume se cava e coce sicome la calcie in pezi / e se coce in 12 ore / Di poi si porta in mezo una piaza e se ne fa una / maxa longa 10 canne in circha larga quarto / alta meza canna E li si adaqua come li orti / tanto sia bagniata e spenta cosi in massa a scarsa / E di poi che macerata si porta in una caldaria / grande canne due in bocha fatta di muni / chal fondo di rame di getto grossa quattro dita largha / piedi 6 in circha alla quale se da el focho col fo/rnello pensile Chel piano del forno sie pieno di busi / dove cascha la bracie e piglia vento sone come dua / forni luno sopra laltro sotto la chaldara / Di poi che de cotto in ditte caldara / dita aqua si fa andare in cierti / canali con ramaioli E va a cierti / cassoni longi piedi otto large / 4 e alti 4 di tavoli grossi bi [. . .] / armati che tengino laqua E li lassa / fredare e lo allume se apicha al / ditto legnio grosso quattro dita / e laqua resta pura e lo / allume se apecha alle ditte asse*; Right half: (b) *In Pittigliano sie uno mulino da farina / con due macine quale volta uno cavallo / La ruota dentata sie piede 7 lo rochetto / dita 12 la macina dita piedi 4 valento / E piu ce uno mulino colle palle quale a una / rota nel fuso di piedi dua quale da in / uno rochetto di dita 12 la macina piedi 3 / Le palle piede uno Lo fuso e le traverse che regeno / le palle sie ogni cosa di ferro*; (c) *Apresso ce uno difitio da pestare la polvere quale / pesta con quattro mortari con dua manichi da rota / quale volta con gran faticha Saria bono se avessi una / rota che ci andasi dentro o sopra dal canto / di fora uno uomo saria facile e / buona*

Antonio the Younger's drawing of the furnace is similar to one by the Anonimo Ingegnere Senese (Ms Additional 34113, fol. 13 v., British Library, London), but Antonio's text owes nothing to that sheet, which is related to Francesco di Giorgio's *Trattato I*, fol. 44 r. (Maltese, I: pp. 175–76). In Pitigliano near Lago di Bolsena, Antonio noted measurements of the components of a horse-operated gristmill. He then described and sketched, in Pitigliano, a hand-cranked mill made of iron with iron balls on chains as weight-wheel. In Pitigliano, he also saw a mill pulverizer comprising four mortars and two cranks, which he sketched in part. He criticized its difficult operation, adding that a treadwheel moved by a man standing on its outside or inside would be better and would enable the wheel to turn more easily. Efficiency of treadwheel operation is a recurring theme in Antonio's notes and is frequently illustrated in his engine drawings. About the presumed origin of the weight-wheel in Germany and its development in Rome, there is some documentary evidence presented in my introductory essay. Antonio's penline technique for these drawings is comparable to sketches (U 819A r.) probably executed in 1526 in Cesena and Rimini. For a another approach to the problem of dating, see the essay of C.L. Frommel. Other drawings of Pitigliano (U 811A, 812A) are dated 1537–42.

BIBLIOGRAPHY: Ferri (1885) 36, 114.

G.S.

U 854A *recto*

ANTONIO DA SANGALLO THE YOUNGER
Studies for raising an obelisk, ca. 1535.
Dimensions: 430 x 290 mm.
Technique: Pen and light brown ink.
Paper: Center fold.

(a) Framework to transfer the Vatican obelisk (*per rizare la guglia*). (b) Obelisk in horizontal position on a wedge (*leva*), being raised on pulley-rope (*traglie*), and calculation of the arc (*del tondo*; *del tondo*) of its movement from and to its upright position. (c, top left) Pulley, detail. (d, top right) Framework with obelisk at an angle. (e) Framework with obelisk resting horizontally. (f) Framework of the platform(?) for sliding the obelisk.

INSCRIPTION: (bottom) *diamitro*; *Cosi e fatto lo Cosi e culi/seo di Roma*; *a trovare lo mezo duna linia / a una spretura de fusse*

In his book on the Vatican obelisk, Camillo Agrippa, a Milanese engineer and inventor of hydraulic engines, stated that when he came to Rome in September 1535, Antonio the Younger and Michelangelo were encountering great difficulty with plans to transfer the Vatican obelisk. Antonio's drawing may be dated to 1535 rather than ca. 1520 as suggested by Franz Graf Wolff Metternich. It is well known that Domenico Fontana successfully transferred the obelisk in 1585, and his book demonstrates the method by which it was moved. Fontana's illustrations and another by Giovanni Guerra hardly differ from Antonio the Younger's drawings and sketches, with the exception of the greater number of planks used in the frameworks. Antonio the Younger shows the obelisk standing on round balls instead of the flat blocks (called astragals) that are included in most drawings, which were later replaced by four lions, symbols of Sixtus V, after the transfer was completed. Drawings in the Lodewijk Houthakker Collection, Amsterdam, include one by an anonymous artist close to Domenico Fontana. It illustrates the transfer equipment at various stages of the work in fifteen details, one of them annotated "un pezzo della aguglia dis[. . .] carratate 34(?) della aguglia 1585." One of Camillo Agrippa's hydraulic engines built in Rome for the fountain of

Villa Medici is discussed in relation to Antonio's drawing of one by Giovanni Bartolini (U 1485A r.).

BIBLIOGRAPHY: Agrippa (1583); D'Onofrio (1965) 64, 81–92, figs. 25, 29, 33–35, 37, 38, 47; Wolff Metternich (1972) 54, fig. 76; Fuhring (1989).

G.S.

U 855A *recto and verso*

ANTONIO DA SANGALLO THE YOUNGER
Studies of six cannon (*recto*). Four cannon (*verso*). Ca. 1537.
Dimensions: 423 x 300 mm.
Technique: Pen and brown ink.
Drawing Scale: Roman *dita.*

INSCRIPTION, Recto: (top to bottom) *a faccie 16 tondo; Cannone a faccie 20 bello / di mastro giovanni; Cannone tondo anticho; cerchi 5; sacro a faccie 16 in cavate; Colubrina pisana a otto faccie / quale alla sale di forro grosso D 5 / e leroti anno li bochalazi di metallo; Cannone di mastro* (*uscentio* canceled) *andrea*
Verso: (in descending order) *a faccie 16; Tondo; Tondo; Tondo; Cannone di maestro andrea Tondo; a faccie 20 / di mastro giovanni di spruocha; Tondo; Tondo; a faccie 18; sacro di mastro bernardino*

Of the nine sheets dealing with cannon and artillery, U 855A recto and verso is the most elaborately annotated. These notes consider not only size but authorship. Antonio the Younger lays out the cannon parallel (see U 821A, 822A, 823A, 849A, 855A). For a discussion of this technique, see U 821A. He also uses the combined view and sectional technique of representation that allows him to show the size of the cannon bore as well as the exterior profile of the weapon. For a discussion of Maestro Andrea, the foundryman responsible for one of the cannon, see U 822A.

The sheet was once folded in half and Antonio worked on each half separately, turning the paper over to make his notes. His interest in the molded details of the cannon profile is especially remarkable; he is as careful here as with molding profile on the architectural orders.

U 855A r. and v. form part of a group of nine sheets by Antonio the Younger in the Uffizi concerning artillery and foundry techniques (see U 820A, 821A, 822A, 823A, 824A, 825A, 849A, 858A).

BIBLIOGRAPHY: (not published).

N.A.

U 856A *recto*

ANTONIO DA SANGALLO THE YOUNGER
Mathematical calculations.

Dimensions: 284 x 425 mm.
Technique: Pen and brown ink.
Paper: Extensively repaired, darkened at edges.

INSCRIPTION: (center) *la radicie di 200*; (right) *questo sa partire in quatro / parte equale*

The sheet contains geometrical figures and calculations. The orientation of the writing and the frequent crossing over of the script makes it difficult to follow the sequence. The lack of orientation makes it seem that Antonio the Younger picked up the sheet a number of different times. In the key, geometrical figures (thirteen in all) are indicated by a letter; numerical calculations are given a number.

The geometrical figures are as follows: *A* = triangle; *B* = series of squares with enlarged sides; *C* = rectangle divided into four (see *H*) with a side of 100 units; *D* = parallelepiped in perspective; *E* = overlay of triangle, rectangle, isosceles triangle, and right-angled triangle with the horizontal line double that of the isosceles and the vertical line reduced by a tenth along the vertical axis; *F* = square joined to a rectangle; *G* = square divided into four equal parts and with the right side divided into eight parts from segments that begin from the lower left edge; *H* = see similar figure *C* and phrase below, "questo sa partire in quatro parte equale"; *I* = duplication of squares (see Vitruvius, *De Architectura*, [1969], pp. 3, 4, 45); *L* = form similar to *G*: a square within another square that has one edge in common; from this line the base is formed for a division into eight segments which divide the right sides of the squares and an arc equal to a quarter of circumference into eight parts; *M* = grid 4 x 10 units; *N* = duplication of a square with sides of fifteen units (see Vitruvius, above at *I*); *O* = octagon divided into nine parts.

It is possible to define five groups of calculations:

GROUP 1:

1 = list of the cubes of the first ten natural numbers.
2, 3, 4 = cubes of 30, 20, 7.

GROUP 2:

5, 6, 7, 8, 9 = squares of 21¼, 22, 22½, 21, 21⅙.
10 = total of 225 + 225 = 450 (square doubled of 15; refers to the square of *N*).

GROUP 3:

11 = square of 21⅕.

GROUP 4:

12 = square of 14⅓ (incomplete; at the left can be read the number "200").
13 = square of 14⅐ (14⅐ is the approximate square root of 200).

GROUP 5:

14, 15, 16, 17 = cubes of 9, 8, 7, 6.

The presence of figures *1* through *N* and the calculations *10* and *12* and the inscription "la radicie di 200" suggest that Antonio the Younger may have used this sheet for calculations and geometric constructions found in Vitruvius, *De Architectura*, Book 9.

BIBLIOGRAPHY: Ferri (1885) 81; Vitruvius (1969).

P.N.P./G.L.V.

U 856A *verso*

ANTONIO DA SANGALLO THE YOUNGER
Mathematical calculations, possibly before 1530.

```
                    3
    1        2            7  8  9  B
                               10
                                  11
         4              13   12     D
                         15   E  17
                          C
 5       A             14  F  G  16
                                    H
    6                    I  L  18  19
```

Dimensions and Paper: See U 856A recto.
Technique: Pen and brown ink.

INSCRIPTION: *Lo cubo duplicato si e la radicie di due quadri duplicati / Lo cubo triplicato si e la radicie tre cubi triplicati / Lo cubo quatriplicato si e la radicie di quatro cubi quatriplicati / Lo cubo quincuplicato si e la radicie di 5 cubi quincuplicati cosi / si va infinito*

10
10 via 10 fan 100
————
100
10 via 100 fan 1000
2 quadri duplicati fanno 2000 / La radicie di 2000

The sheet contains ten figures, about twenty mathematical operations, and a few written comments; the sheet is particularly difficult to read because some notes have bled through from the recto. The page is also packed with calculations with geometrical figures and calculations overlapping one another. Despite the single orientation of the writing, not all calculations took place at the same time. The geometrical figures have been identified by letters, the calculations by number.

Geometrical Figures: A = two squares, one gridded; *B* = square with side of ten units; *C* = figures that refer to the second theorem of Euclid applied to a right triangle in which the arms are 8 and 4 units; *D, E* = construction of similar figures; *F* = duplication of a square (see Vitruvius, *De Architectura* [1969], pp. 3, 4, 45); *G* = quadruplication of a square with sides of 4 units (see Vitruvius, as above); *H* = as figure *C* with arms of 6 and 2 units; *I* = section of two regular octagons inscribed within one another and rotated 22 degrees 30 minutes in relation to one another; *L* = square with the figure "3½."

Calculations: 1 = square of 2⅔; *2* = multiplication 7⅑ x 2⅔ (left incomplete); note that 7⅑ is the square of 2⅔ (see *1*), thus the total of the two operations produces the cube of 2⅔; *3* = cube of 2½; *4* = square of 3⅖ (left incomplete); *5* = addition 64 + 64 = 128 (double the cube of 4); *6* = square of 5⁵⁄₇; *7* = calculation of double the cube of 6; *8* = double the cube of 5; *9, 10* = cubes of 7 and 8; *11* = the figures 200 and 14⅐ appear (14⅐ is the approximate square root of 200); *12* = cube of 14 (result incorrect); *13* = cube of 14⅐; *14* = cube of 2⅔ (left incomplete); *15* = cube of 2½; *16* = square of 3⅓; *17* = square of 2⅔ (see *1*); *18* = square of 3½ (left incomplete); *19* = square of 3⅓ (left incomplete).

Of greatest interest on this sheet is the extensive inscription (see above), which seems to refer to the famous problem of the duplication of the cube as explained by Vitruvius, *De Architectura* (1969), pp. 7, 56–64. It does not appear that there is an arithmetical solution to the problem unless one reads the term "quadri" (squared) as "cubi" (cubed) and the total, including figures *C* and *H*, as referring to the relation between the height of a cube and that of a

parellelepiped of single section.

BIBLIOGRAPHY: Ferri (1885) 81; Vitruvius (1969).

P.N.P./G.L.V.

U 857A *recto*

ANTONIO DA SANGALLO THE YOUNGER
Studies of the volume of a pyramid (possibly related to the
reconstruction of the Mausoleum of Halicarnassus or
duplication of squares described in Vitruvius), before 1530.

Dimensions: 533 x 337 mm.
Technique: Pen and brown ink, stylus and compass point used
to construct pyramid at left.
Paper: Heavy, partially repaired at top and sections of other
three sides.

INSCRIPTION: (top left) *aug. iur.*; (to left of *I*) *li gradi alti
p[almi]* 3¾; *tris et semis*; *tris semis*; *meza la fronte*; *mezo li
lati*; (bottom right, next to eye) *XIV c. VII*

The sheet contains fifteen geometrical figures and
about thirty mathematical operations (addition and
multiplication). The geometrical figures can be ana-
lyzed in four groups:

1) Figures *A, B, F, G.* These recall the figures on U
1448A and seem to refer to the same type of analysis
of a prism with a square base. The only difference
consists in the presence of measurements (in *F, G*) of
"16" and "4" (which appear twice). This would sup-
port the hypothesis that the figures of this group con-
stitute an intermediate phase between those of the first
and second groups of U 1448A.

2) Figures *D, H, L, N.* The square (*H*), with mea-
surements in letters, leads one to conclude that both
prisms *D* (with measurements) and *L* (with measure-
ments and letters along the edges) have as their base

a right isosceles triangle. The triangular prism (*L*) pre-
sents the division of three similar pyramids. Figure *N*
represents one of the three pyramids of this group
placed on a horizontal plane. The presence of this sub-
division of a prism with a base along half of a square
suggests that even this second series may be related to
the conclusion of the process seen in U 1448A.

3) Figures *I, M* (stepped pyramid), *O, P* (pyramid
on a base and Doric colonnade). These drawings
probably are related to attempts to reconstruct the
Mausoleum of Halicarnassus.

4) Figures *C, E, Q.* These represent a grid, the
duplication of a square of sides of 10 units, and an
eye.

The operations on the sheet are additions and mul-
tiplications using algorithms similar to the present
forms. The only difference is that in the calculations
rational numbers are used in mixed notation: integer
numbers and proper fractions (for the tenths). Other
differences involve the absence of the symbols for
addition (+), multiplication (x), and equals (=), which
though used by Fibonacci only became common dur-
ing the sixteenth century.

The disposition of the calculations on the sheet
does not allow one to establish a correlation with the
figures: The frequent appearance of 3½, 3¼, 6½
(double 3¼) allows one to suppose a relation with the
phrase "li gradi alti palmi 3¾," which refers to the
Mausoleum of Halicarnassus.

From the analysis of the algorithms it is possible to
note a remarkable facility in the handling of the cal-
culations with proper fractions and an excellent mas-
tery of the skills of positional technique.

BIBLIOGRAPHY: Ferri (1885) 81.

P.N.P./G.L.V.

U 857A *verso*

ANTONIO DA SANGALLO THE YOUNGER
Theoretical study for perspective construction of a frieze with
a figure within a space, before 1530.
Dimensions and Paper: See U 857A recto.
Technique: Pen and brown ink, straightedge, stylus.

INSCRIPTION: (upper drawing) *punto*; *questa vede mancho
del piano*; *parete*; *muro*; (lower drawing) *punto*; *piano dove se
a mettere le proprie forme*; *per fare la prospettiva che non
rovini in un subito sendo costretto / di non avere destantia
debita da tirarsi indietro e necesario / mettere le proprie forme
tanto dentro alla parete che habbino la(?) piu / distantia
almeno di quatro quadri quante grande la storia / el piu de piu
gratia / Ma bisognia fare la propria forma tanto grande che*

quando vengono / alla intersegatione della parete vengono di quella grandeza che / homo vole vengino nella storia; (right) *stantia; questo si e il piano terreno della stantia dove si sta / a vedere e dove se a a depigniere; queste quele asai(?) de[. . .]; muro; vedute overo punto;* (below, left) *piano dove se a mettere le proprie forme*

Here Antonio the Younger has studied how to construct a painted frieze with figures in perspective in a room of given dimensions. (The size is determined by the maximum distance of the observer.) The demonstration appears to be purely theoretical. In order to obtain good results following his rule the figures must seem to stand at least four times the height of the frieze behind the wall plane. For his further concern with perspective, see the representation of the *mazzocchio* (U 831A, 832A, 1464A, 4120A). See also U 830A v.

BIBLIOGRAPHY: Ferri (1885) 81.

<div align="right">P.N.P.</div>

U 858A *recto and verso*

ANTONIO DA SANGALLO THE YOUNGER
Cannon mouth in cross section, ca. 1537.
Dimensions: 208 x 262 mm.
Technique: Pen and brown ink, compass.
Paper: Fairly heavy, darkened at edges.
Drawing Scale: Roman *dita.*

INSCRIPTION, Recto: *in la Culletta meza / palla; in bocha uno / tertio di palla; libre 25 di palle per mezo / Cannone; per cannone libre 60; Dita 7½; Longha la cavia(?) D 112½ / palle 15*
Verso: Arithmetical figures and calculations; *quadrata moduli / 8441⁹/₄₂; quadrato 154 basa; colonna; quadrati mod* (paper cut); *1440¹⁹/₄₂ / de tutto qui / resta 8441¼; tucti moduli / 9881²/₃*

U 858A recto and verso form part of a group of nine sheets by Antonio the Younger in the Uffizi concerning artillery and foundry techniques (see U 820A, 821A, 822A, 823A, 824A, 825A, 849A, 855A). Dating is approximate (see U 821A).

This sheet, like U 820A, shows a section across the mouth of a cannon; though the numbers are not written at the same points of the mouth it is possible that the drawings are of the same cannon. U 820A would thus be a rough record of the shape of the mouth while U 858A, in which a compass was employed, seems somewhat more definitive. In addition to the section across the mouth there is a pair of briefly

sketched studies that represent the outer profile of the barrel.

BIBLIOGRAPHY: (not published).

<div align="right">N.A.</div>

U 859A *recto*

ANTONIO DA SANGALLO THE YOUNGER
Study for the statue of Marforio, Rome, 1536.
Dimensions: 240 x 155 mm.
Technique: Pen and brown ink, straightedge, stylus.
Paper: Darkened at edges.

INSCRIPTION: *per marforio*

This aedicule doubtless was proposed as a temporary display during Charles V's triumphal entrance into Rome (1536). The design is similar to that found on U 1269A verso.

BIBLIOGRAPHY: Madonna (1980) fig. 67.

<div align="right">M.F.</div>

U 880A *recto and verso*

ANTONIO DA SANGALLO THE YOUNGER
Foligno, plan of the canals; study of fortress (*recto*). Mills along the Tinia (*verso*). Probably before 1530.
Dimensions: 217 x 283 mm.
Technique: Pen and brown ink.
Paper: Edges darkened.

INSCRIPTION, Recto: *aqua morta; punta; aqua morta; qui voria andare laqua viva/ce Conguegiersi Colla morte / e tenia lo canale netto scupre; tinia; vechia forma in Confino nova / qui achanto alla forma vechia / alchuno consideria ce / la forma nova*
Verso: *Fuligno; ripieno e di altro / a e piu baso che in logo / (cut) mancho spesa asai; Torre di fulignio; forma dove corre la tinia vide altro / al piano del terreno laqua ae la bocha per tutto; fosso di via longo para sia foso che porta tutti sassi / nella tinea chella serra e fatomer inchollo / bisogni dove ritarda se non si unischa colla tinia / se non e sotto lo ponte di bevegnia; monte; ponte della tinia [. . .]; questo sciaquatore / bisognia se nova; sciaquatore che / muova sassi e petre la tinia; bevagnia; mulina; monte; maestro delli / fornicce; piemonte; lo sciaciatoro si puo fare al d[. . .] / comettor in la forma renversa / ala fera libera lativirisa; Topiano; forma nova*

The recto illustrates a method to excavate under the River Bevagna in order to reclaim the area around Foligno. The dating of this sheet is problematic. The handwriting would seem to place it before 1530. The

only documented trip to this area occurs much later. In 1538 Antonio the Younger was delegated the responsibility for the waterways around Trevi according to documents cited by Giovannoni and this area may have entered into his purview. During this period (late 1530's and early 1540's) the architect was frequently in this area (between Ancona, Ascoli Piceno, and Perugia). The trace of a four-bastioned fortress appears to bear no relation to the principal theme of the drawing.

The verso also addresses hydraulic problems in the area of Foligno. Antonio the Younger's topographic shorthand, most clearly visible in the fortification drawings, is used here to lay out the problems of the site. He seems to have in mind straightening the River Tinia and eliminating some of the tributary streams that fill the Tinia with stones.

BIBLIOGRAPHY: Ferri (1885) 80; Giovannoni (1959) I: 70.

N.A./S.P.

U 881A *recto and verso*

ANTONIO DA SANGALLO THE YOUNGER
Ferrara, outline plan of the walls; bucket wheel (*recto*). Study
 of three bastions (*verso*). 1526(?).
Dimensions: 154 x 239 mm (maximal).
Technique: Pen and brown ink.
Paper: Strengthened at corner.
Drawing Scale: passi.

INSCRIPTION, Recto: (top left) *Denti 62; denti 82; Ferra*
Verso: (left to right) *passi andantio; Ferrara; fosso largo / passi 80*

The rough outline plan of the city of Ferrara on the recto shows the trace of the walls and the form of the bastions around the outside. The state of the walls is not dissimilar to the plan of Francisco de Hollanda closer to mid-century, reproduced in Bury. Giovannoni considers this to be one of the plans done by Antonio the Younger with the aid of others, possibly Aristotile, though we can identify only the one hand.

The verso seems to be in the nature of a record of the bastions that Antonio found in Ferrara during his visit. The walls of Ferrara had been extensively updated by Biagio Rossetti and Alessandro Biondo around the turn of the century. A tentative identification of the bastions follows: (left) recalls the della Montagna bastion since it is the only bastion at the turn of the wall; (bottom, center) recalls the San Rocco bastion, which has a similar gorge defense; (right) faintly recalls the San Rocco bastion. For the form of these bastions, see Malagù and Ravenna.

If these sketches indeed show Rossetti's works, this would be one of the few demonstrations of Antonio's interest in military architecture built by another architect (see U 814A). The stiff character of the sketching would seem to support an early date of the drawing before his major work for Clement VII and Paul III when he was still gathering study material. Antonio the Younger assuredly had many occasions to visit Ferrara; a dating around 1526 (the trip to the Romagna) represents reasonable compromise, though, as in many other drawings that are associated with that time, we have no confirming documentation. Malagù dates the drawing to 1526 without evidence.

The undershot bucket-wheel with cogwheel and lantern turns in a stream, which is not illustrated. Judging from the size of the cogs and staves it is a very large mill. Mariano Taccola illustrated similar bucket-wheels in his Notebook (Ms CLM 197, part II, Bayerisches Staatsbibliothek, Munich). These drawings by Taccola were often copied. Antonio the Younger may have seen the bucket-wheel in Ferrara.

BIBLIOGRAPHY: Ferri (1885) 41; Giovannoni (1959) I: 76; Malagù (1960) 20; Bury (1979) 180–81; Taccola (1984) fols. 36 r., 59 r.; Ravenna (1985).

N.A./S.P., G.S.

U 884A *recto and verso*

ANTONIO DA SANGALLO THE YOUNGER
Ravenna, Fortezza Brancaleone, plan of embrasures; section
 through wall, 1526 or after 1530.
Dimensions: 217 x 221 mm.
Technique: Pen and brown ink.

INSCRIPTION, Recto: *grossi palmi 45; palmi 128 di ravenna / daluno torione allaltro*
Verso: *Cannoniere 500 per[. . .]; Cannoniero; moschiettiere in porto largi p[almi] 3 / alte uno ½ nello stretto larghi per ½ p[almi]; alto 2; Canonieri 500 per[. . .]; Li archibuscieri larghe in bocha / palmi 1½ alti per uno / dentro in lo stretto per 1½ / largi ½ p[almo] / per ravenna*

The sheet shows a section through the wall of Fortezza Brancaleone, Ravenna, and a plan of the small-arms embrasures (*archibusieria*). The verso appears to be a rough draft of U 885A; the embrasures correspond in almost all particulars. For a fuller discussion of Antonio the Younger's activities in Ravenna, see U 885A.

BIBLIOGRAPHY: Ferri (1885) 120.

N.A./S.P.

U 885A *recto*

ANTONIO DA SANGALLO THE YOUNGER
Ravenna, Fortezza Brancaleone, study of embrasures for light
 artillery and small arms; section through scarped walls
 and ditch, 1526 or after 1530.

Dimensions: 290 x 438 mm.

Technique: Pen and brown ink.

Paper: Medium heavy, frayed at edges, folded into sixteen.

INSCRIPTION, Recto: (left) *Le merli siano grossi palmi 15 /
e questo Corritoro vi sta darcho / palmi 30; dal mezo de luna /
cannoniera amezo / laltra sie palmi 40;* (alongside plan) *questa
sia aperta fino di so/pra e si puo adoperare un Cannone /
largha in bocha palmi 12 / in lo stretto p[almi] 4 die dentro
p[almi] 6; questa sia coperta largha p[almi] 3 / alta p[almi] 1½
per moschetti; questa sia scoperta per uno pe/zo mezano
larghe inbocha / palmi 10 nello stretto p[almi] 3 / di dentro
p[almi] 5; questa sia coperta larcho / in bocha p[almi] 3 alta
p[almi] 1½ per / moschetti; Questa sia schoperta / per pezi
mezani, / questa sia coperta larcha / in bocha palmi 3 alta
p[almi] 1½ / e didentro in lo stretto sia largha / p[almo] 1 alta
p[almi] 2; questa sia scoperta per nanzi / pezi cioe mezi
cannoni / mezi colubrini & sacii / e cosi seguita fino alla/ltro
torrione; siada notare che tutte le / Cannoniere che sono per di
/ ritto tanto connonieri / quanto moschettieri anno / due
archibusieri intra versate che tirono per fian/cho quali in la
bocha anno / due scioni alti palmi uno / larghe palmi uno o in
lo stre/tto di dentro alto palmi 1½ / larghe (palmi* canceled)
*uno mezo / palmo / palmo; per uno cannone o colub/rino
perche a bona rinchu/late che po correre in lato;* (right, rotated
90 degrees) *superfitia delaque; merlo; Coritoro; Fate pigliare
copia di questo e rima/ndatelo perche possa fare lo modello
perche / nonme no serbato copia;* (later hand) *la Rocca di
Ravenna*

Verso: *La rocha di ravenna*

Ravenna changed hands a number of times during the
early sixteenth century. In 1503 the city surrendered to
a papal army commanded by Francesco Maria I della
Rovere. In 1512 Marc'Antonio Colonna held out in
the Fortezza Brancaleone for four days after the Battle
of Ravenna; he surrendered to the artillery of the
French. Spanish and papal forces again occupied
Ravenna in 1523 and found considerable damage there
notably in the upper works which were constructed
largely out of temporary gabbions. The ditches were
also considered unhealthy. The state of the walls in
1523 may explain why during the visit of Antonio the
Younger special interest was shown in the embrasures.

The drawing shows a section along the wall of the
Fortezza Brancaleone in Ravenna that reveals the
embrasure plan and a section through the wall to

show the angle of fire. At either end of the embrasure
plan are the round bastions of the fortress. The plan,
as the annotation explains, reveals different-sized
embrasures adapted to different weapon sizes—anoth-
er limitation on the free transfer and disposition of
cannon. The elaborate examination of the form of the
embrasures, graded in size so that only certain
weapons could stand at certain locations, was under-
taken by Antonio the Younger at Piacenza as well (see
U 807A).

The drawing has been attributed by Giovannoni to
Rocchi with annotations by Antonio the Younger and
has been dated by him to 1526 based, presumably, on
Beltrami's extensive quotation of material concerning
the fortress of Ravenna dated to the 1526 visit to the
Romagna. This dating has been accepted by the most
recent writers on Ravenna (Giovannini and Ricci) and
there are reports that some work was done in
1527–28. However, the form of the "h" suggests either
a later still, undocumented visit, or a later revision, or
perhaps a fair copy of the original sketch. The draw-
ing seems to us to show only the hand of Antonio the
Younger.

Two notes, one on U 884A v. and the second on this
sheet, remind us that Antonio the Younger required an
elaborate shop organization to keep his practice. On
U 884A v. there is a note that the sheet is from the
fortress of Ravenna, as if the sheet might be misidenti-
fied. The second note requests that someone in the
shop make a copy of this drawing (U 885A r.) to be the
basis of a model or template version; there is, Anto-
nio notes, no other copy.

BIBLIOGRAPHY: Ferri (1885) 120; Beltrami (1902) 36–38;
Marinelli (1937) 81–109; Giovannoni (1959) I: 16, 76, 77;
De Lorenzi (1966) 154–58; Giovannini, Ricci (1985) 108–9.

N.A./S.P.

U 887A *verso*

ANTONIO DA SANGALLO THE YOUNGER
Ravenna, Fortezza Brancaleone, sketch plan of inner bailey,
 1526 or after 1530.

Dimensions: 425 x 293 mm.

Technique: Pen and brown ink.

Paper: Folded into quarters, brown stains.

Drawing Scale: piedi (Ravenna?).

INSCRIPTION: *Ravenna; Fuora; Di ravenna*

The plan shows the inner keep of the Venetian late-
fifteenth-century Fortezza di Brancaleone in Ravenna
as surveyed by the Sangallo team in 1526. For the his-

tory of Antonio the Younger's work in Ravenna, see U 885A.

BIBLIOGRAPHY: Ferri (1885) 120.

N.A./S.P.

U 889A *recto and verso*

ANTONIO DA SANGALLO THE YOUNGER
Cesena, proposal to complete the fortress, 1526 or after 1530.
Dimensions: 302 x 219 mm.
Technique: Pen and black ink.
Paper: Heavy.

INSCRIPTION, Recto: *Colle; La rocha di ciesena a manchamento di fianchi boni e dannosi lassato / serrare colle mura della terra dentro alla terra e la rocha / non a sochorso nessuno fuor della terra bisongnia chel soccorso / entri prima nella terra e dipoi vadia alla Rocha per una porti/cella nuovamente fatta presso alla porta della Rocha quale viene / nella Cortina infralla (cittadella canceled) forteza nova ella vechia*

La rocha vechia bisongnaria sbassare le sue mura fino al piano / terreno acioche la rocha la potessi dominare tale chella venissi / fino al piano dell'alteza del muro quale va dalla rocha nova / alla vechia e li fare uno puntone inverso la collina e due / torrioncelli che fianchegiassino ditto puntone colle sue cortine

Di poi bisogna cimare un monticello quale presso / alla Rocha vechia akavalcha 5 canne quale e facile a butarlo / in la valle perche da una banda e tagliato quasi a piombo

Circha allo accrescimento della terra sta tutto bene acietto che una parte / quale e sotto la rocha diverso la fiumana del Savio quali colli quali / son presso alla rocha vechia battano per di dentro la cortina

Lo restante staria bene se fussi bassato questo pezo di fuora cioe la / chiessa di Santa (space) con forse 100 case e lassandola star / cosi bisongnia fare quattro traverse alte accio si possa stare alle / difese ma nelle case sara dificile astarvi Verso: *Facendo detta terra nuova bisongnia scortare la terra dalla / porta che viene da rimini fino alla Casa chera del Cardinale / di pavia per discostarsi dal monte di Santa maria de frati di Santo bene/detto di monte Casini*

Ma io judicho che saria stato meglio adaver preso dentro ditto / monte di Sancta Maria e sariasi fatti due efetti si saria ritratto nella / aria bona e sariasi tolto lo allogiamento del chavaliere alli ni/mici e non si aria a tagliare laterra di detta banda e taglia/re la terra dalaltra banda dove ditto primo E cosi / la terra non arai Cavalieri quali la potesse battere dentro / ella rocha rimaria con due facie di fuora dalla terra

Ma chi potesse fare luna fortificazione elaltra cioe quello / che incomincio el vescovo de rossi lassando pero la parte della terra / quale esotto larocha e quella del monte saria milgliore

perche facen/do quella del monte non saria da questa banda necessario taglia/re quella parte del borgo fino alla Casa del cardinale anzi ve/neria bene allassarla come sta e si potria fare fare la meza / parti di detto muro del monte alli detti frati perche poi veneriano / in la terra cioe el muramento el cavamento de terreni si potria fare / fare alli villani del paese

E cosi si potria far passare un canal di fiume per lo mezo / della terra con uno forare da un monte di 300 canne / e fare le moline in la terra dentro e Cosi si faria / forte e bella e con pocha spesa perche le mura quali si fanno / adosso alli torrioni forti tagliati non e necessario farli troppo / forti ne troppi grossi

Although nothing allows for a secure dating, the drawing possibly forms part of the 1526 inspection of the Romagna undertaken by Antonio the Younger and others. Cesena had recently returned to papal control after a brief period under Cesare Borgia, and works to enlarge and reinforce the walls had been undertaken in 1517 by the *governatore*, the Bishop of Treviso, Bernardino Rossi. Antonio the Younger's proposal, in fact, centers on the Rocca Malatestiana, begun in 1380 by Galeotto Malatesta (additions during the pontificate of Paul II), which Antonio proposed to connect with the Rocca Vecchia, to the west, which holds the highest ground. Antonio the Younger's notes emphasize traditional sixteenth-century problems of flanking and high, thin walls. The *puntone* (top left) is expected to encase the old fortress. Antonio proposed to flank it with two smaller bastions. The rest of the note is concerned with the problems of high ground near the Rocca, which could be used to look down into the defensework. He also proposed the erection of a mill along the river—especially useful in time of siege—and advised on the kinds of workmen needed for the work of hauling the earth (the local peasantry, of course). All in all, the drawing offers a rich set of proposals. Yet none is fully worked out and this, as well as the rugged, sketch-like nature of the drawing, reasonably suggest a dating in connection with the Romagna trip of 1526. Opposed to the 1526 dating is the form of the "h," close to the post-1530 form as identified by Frommel. It is possible that, as in other instances, Antonio prepared a fair copy of these drawings in the 1530's to form part of a treatise or as a demonstration of his skills.

BIBLIOGRAPHY: Ferri (1885) 24; Beltrami (1902) 31; Bazzocchi, Galbucci (1915) 9; Marinelli (1937) 179–213; Giovannoni (1959) I: 78–79, 425; Marconi et al. (1978) 314; Montalti (1986) 19, 23.

N.A./S.P.

U 890A *recto*

ANTONIO DA SANGALLO THE YOUNGER
Cervia, plan of the fortress, 1526 or after 1530.
Dimensions: 237 x 235 mm.
Technique: Pen and brown ink, stylus, pin.
Paper: Smudged, surface dirt at top, darkened at edges.

INSCRIPTION: (top left) *Rocha vechia di Ciervia*; (to left of plan) *passi 36 piedi 1½*; (bottom of rocca) *passi 27 piedi 4*; (right) *fuore della terra*; (bottom middle) *porta che va a ciesena*; (*porta di ciesena* canceled); (at right) *La torre maestra sia di scarpa el quarto / ed e alta sopra terra piedi 36 / e sopra laqua de fossi pie[di] 40 / (La torre masie* canceled) / *La torre maestra sie di due cinti / di muro quel di mezo si e grosso / piedi 6 quello di fuora sie grosso / piedi 3½ (lo vacuo quali* canceled) *e va a scarpa di dentro come di / fuora e la torre di mezo va apio/mbo e sie luno muro e laltro sono cierti / Contraforti e ello restante deli vacuo sie / ripieno di terra e quando piovi rigonfia / e faruinare el muro di fuora; Le mura della rocha sono alte sopra / terra circha apiedi 30*

The drawings for Cervia seem, at first glance, to represent precisely the kind of consultancy work that Antonio the Younger is known to have undertaken in 1526 as part of the trip to the papal fortresses of the Romagna with Sanmicheli, Leno, and others. A version of the drawing was published by Beltrami; on that sheet are proposals for renovations along with the cost of bricks, the price of hod carriers, and the like. The whereabouts of Beltrami's drawing is not known. The only difficulty with the date of 1526 is that we lack confirming documentation for any specific stop. In the case of Cervia, for example, the fortress there was taken by the Venetians in 1527 and only returned to papal control in 1529 as a result of the Treaty of Barcelona. The form of the "h" would seem to point to a later date for the sheet, possibly as a fair copy for presentation and display in a formal portfolio or the like.

In this drawing Antonio the Younger has taken a survey of the preexisting medieval fabric of the fourteenth and fifteenth centuries and notes that since the walls are filled with earth they tend to expand when it rains, thus ruining the outer wall. There are no specific proposals for improvement of any aspects of the fortress on this sheet. See also U 891A r. and v.

BIBLIOGRAPHY: Ferri (1885) 24; Beltrami (1902) 35; Giovannoni (1959) I: 78, 425; Mancini, Vichi (1959) 171; Cervia (1980) 18.

N.A./S.P.

U 891A *recto and verso*

ANTONIO DA SANGALLO THE YOUNGER
Cervia, plan of the fortress, 1526 or after 1530.
Dimensions: 292 x 414 mm.
Technique: Pen and brown ink.
Paper: Heavy, folded in half, darkened at edges.

INSCRIPTION, Recto, Left half: *porta di ciervia; voto 60; voto 60; porta di ciervia; muro; da questa [. . .] / al spatio pa[ssi] 20; case*; Right half: (from top left) *porta diciesi; torre bone; casetta; contraforti; qui e spatio 20 passi; casa; voto / cie 4 casette / in p[. . .]; canale; magazino grande de disfare; porta di rame nuovo; da questa banda e voto p[assi] 20 4 casette 79*
Verso, Left half: *Di cervia*; Right half: *voto pieno di terra*; (below) *La torre sie masicia / fino sopra terra / piedi* (no number) / *el voto della torre sie / per uno in verso piedi 20 / per laltro 12 oncie e di / fatta in due volte; Di fuora; sopra terra piedi 36 / questa torre a di / scarpa el quarto / alta sopra laqua / piedi 40; li mura sono alto / piedi 30 sopra torre; caseno; Contraforti; fondamento; voto / pieno / dita*; (later hand, not Antonio the Younger) *Di Cervia*

Located along the Adriatic coast near Ravenna, Cervia was regarded in the sixteenth century as an important location both for its saltworks and its defensive position. (As an indication of its importance, it is reported by Mallet and Hale [1984, p. 127] that in 1474 a Venetian commander received one-quarter of the pay for his company in salt from Cervia.) In 1460 it had been fortified by Malatesta Novello (Mancini and Vichi). Antenore Leonardi, quoting Francesco Maria I della Rovere, Duke of Urbino, called it a "sito gagliardo." Clearly it controlled southern access to the Po plain and dominated its sea site. For the Venetians in particular, Cervia was considered a useful frontier buttress.

Antonio the Younger's proposals involve the renovation of the walls (on one half). He also drew a quick sketch of the fortress, expanded further on the verso. These sketches reflect an analytical stage in the architect's approach to Cervia. See also U 890A r. and v.

BIBLIOGRAPHY: Ferri (1885) 24; Giovannoni (1959) I: 76, 425; Mancini, Vichi (1959) 171.

N.A./S.P.

U 892A *recto and verso*

ANTONIO DA SANGALLO THE YOUNGER
Rome, survey of the Aurelian walls from the San Saba re-
 entrant to Porta San Sebastiano; studies for the Ardeatine
 bastion and the defense of Porta San Sebastiano, 1537.

	Recto	⋮	Verso
		⋮	a
a		⋮	
	b c	⋮	b
		⋮	
		⋮	c

Dimensions: 292 x 430 mm.
Technique: Pen and brown ink.
Paper: Folded in eight; vertical fold more noticeable; trimmed
 on three sides; restored lower left corner with patches;
 some yellowing.
Drawing Scale: Roman *palmi.*

INSCRIPTION, Recto: (a, following the trace of the walls
from top left to bottom right) *torre del cantone; torre merlata /
nello alto; al vivo; al vivo; alla scarpa 1½; va dentro alla
punta / del muro palmj 5 e all / torre ultima a punto; alla
punta del muro p[almi] 9; dal filo alvivo e no alla scarpa; torre
ruinata; muro; filo; filo; filo; (b) terra; questo si va sotto /
al piano delcordone p[almi] 19; li fili sono attachati / 5 palmi piu
alti che / cordone / li posi sono largi in cima p[almi] 4; (c)
baluardo; pieno; filo; scarpa; filo; filo; el filo*
Verso: (a) *almuro sopra albastione; (b) ciglio della scarpata;
questo e del balu/ardo; (c) porta S[an]to / bastiano*

The recto, which contains a survey of the Aurelian
walls from the San Saba reentrant to the San Sebas-
tiano gate, reveals Antonio's concern with the preex-
isting structures in planning the Roman defenses.
Above all, this sheet documents his survey methods in
a case where architectural and topographical surveys
had to be combined with precision. The survey, in
fact, has been done in polygons, that is, in dotted lines
oriented as indicated in capital letters; for example,
"T" = *Tramontana*, followed by a number that indi-
cates the declination or angle of the external lines. The
method is that described in the so-called Raphael Let-
ter to Leo X. The sectors shown are linked in
sequence and, as indicated in the design, by capital let-
ters that mark the junction points with the curtain,
while the circle with a cross indicates the measurement
of certain heights. The Ardeatine gate, which will be
incorporated into the bastion, and is still present in U
1517A, does not appear here, while the Porta San
Sebastiano is clearly shown.

Together with the survey are indications of plans
for the insertion of the double flank of the bastion in
the Aurelian curtain with the two funnel-shaped
embrasures and the circular openings of the ventila-
tion shafts in the countermine corridor; a detail, again
in plan, of the embrasures; a section of the bastion
with the inclination and thickness of the salient; the

scarp corridor of the approximate height of the terre-
plein, inscribed "terra"; and the countermine rooms
below.

The verso, in turn, contains a sketch in plan of the
development of the scarp corridor from the salient of
the bastion (*a*) to the first flank and the sally port
opening toward the terreplein. Below (*b*), the same
corridor is shown in detail at the level of the second
flank that connects with the Aurelian walls. Both
designs, though rapidly sketched, are highly informa-
tive and their measurements and solutions are con-
firmed in the grand design for the planned bastion
(U 1362A). The study for the bastioned defense of the
Porta San Sebastiano is shown below in dotted lines
(*c*), with one of the two bastions unbalanced, as in
other cases, so as to contain the thrust of the ancient
walls on which it would be superimposed. Work on
the Ardeatine bastion, begun in late 1537, was sus-
pended when almost finished in April 1542. This is the
first example of doubled flanks, if we exclude the
primitive attempt at Civitavecchia claimed by Gugliel-
motti (1860) and later critics, see Fiore (1986). In fact
the importance of the Ardeatine work was noted as
early as De Marchi (1599, I: XXXIX; III: XXXIV),
who was present during the planning stage of the
Roman bastion and who provides us with the first
measurements of the topography (I: XXXIX) as well
as a description of the countermine system (III:
XXXIV). The countermine system developed here is
the other notable innovation, making the wall actively
resistant to explosions by diluting their impact. The
Ardeatine bastion has often been cited in later military
annals as setting a precedent for power and monu-
mentality. See also U 1517A r. and v., 1289A r. and v.,
1362A r. and v., 1505A.

BIBLIOGRAPHY: ASR, Soldatesche e Galere, folder 15;
Corsiniana, Inc. 50 F 1, fol. 98 v.; De Marchi (1599) I: 39, fol.
11 v. et seq; III: 34, fols. 89 r. and v.; Marini (1810) I: 132–44;
Guglielmotti (1860); Quarenghi (1882); Ravioli (1882);
Huelsen (1894); Muentz (1886); Borgatti (1890) 391–96; Bor-
gatti (1916); Giovannoni (1959) I: 362; Cozzi (1968); Pepper
(1976) 164; Marconi (1978) 384–91; Fiore (1986) 339.

F.P.F.

U 893A *recto*

ANTONIO DA SANGALLO THE YOUNGER
Study of caponier forward from walls, unknown location,
 1530's.
Dimensions: 124 x 189 mm.
Technique: Pen and brown ink.
Paper: Darkened at edges.

INSCRIPTION: *fosso / cupo; Casa matta nel fosso / bassa bassa dove / si possa andare per / sotto terra della rocha*

The drawing shows the outline sketch plan of a pair of flanking bastions along a wall trace. In much greater detail, Antonio the Younger has added on the upper left a plan section of an L-shaped battered outwork, sited in the perimeter ditch and detached from the bastion salient. This caponier is connected to the wall through an underground passageway, as the text explains. Between the outwork and the bastion salient, the "fosso cupo" (an excavated sump within the ditch) prevents access directly to the caponier's embrasures. Casemates and embrasures fire back along the faces of the bastioned trace. The wall trace and the caponier are probably not drawn to the same scale.

Although Giovannoni notes the similiarity to other drawings by Antonio the Younger (U 295A, 754A, 893A), the drawing shows a relatively advanced defensive solution for the times, a forerunner of the eighteenth-century form of bastion protection known as a bonnet.

Conjectural dating is based on the relatively rugged, assured hand, and the interest shown for ditch defenses in a number of the drawings for the Fortezza da Basso, Florence.

BIBLIOGRAPHY: Giovannoni (1959) I: 81, 425.

N.A./S.P.

U 901A *recto*

ANTONIO DA SANGALLO THE YOUNGER
Genoa, hydraulic devices, 1536.
Dimensions: 280 x 250 mm.
Technique: Pen and brown ink.
Paper: Folded in half.
Drawing Scale: palmi genovesi.

(a) Doorway. (b) Sluice gate devices (from San Domenico). (c) Sluice gate in plan view (*caditore / scoperrta; caditoria / piccola; stanza di rovare*). (d) Sluice gate; stair. (e) Boat with roof. (f) Boat with roof (*queste sie attagano / a uno chiodo nel frontespitio*). (g) Inscribed for all sketches: *columbari conelva caterata / per lo calattotoi.*

INSCRIPTION: (a) *In Genova sie Santo Do/menico quale e / la faciata in la nave / in mezo due porte / come a la chiesa di/scesi quali anno le / pietre delli archi li co/nenti a dita di sega / ed una pietra bian/cha e latra negra / di poi di fuo[r]i ornamenti / alla tedescha*

This sheet once formed part of a sketchbook. His studies of sluice gates were probably also made in that book, and he sketched canals in Modena (U 797A r., 1503A r.). In Genoa he saw and illustrated a barge with treadwheel and hoist (U 794A r.) that transferred and lifted stone blocks to be put in deep water for a dock or seawall. For the date of his trip to Genoa, see U 795A.

BIBLIOGRAPHY: Ferri (1885) 90.

G.S.

U 902A *recto*

ANTONIO DA SANGALLO THE YOUNGER
Rome, study for the interior face of the Porta Santo Spirito, 1542–43.
Dimensions: 212 x 144 mm.
Technique: Pen and brown ink.
Paper: New support, cut and yellowed on the edges.
Drawing Scale: Roman *palmi*.

INSCRIPTION: *La porta di Santo Spirito / della chiesa si e alta / palmj 30 larga / p[almi] 12 / Arebbe dessere 5 & / 12 / La quinta parte di 12 / si e (²/₁₂ canceled) 2²/₅ / Lalteza si e dodici volte 2²/₅ / che di piu/ alto che / a ess/ere p[almi] [. . .] 30.0; La faccia dinanzi a s/carpa & cosi dalli / lati*

On the left of the sheet are extensive notes regarding the door of the church of Santo Spirito, Rome, that specify a proportion of 5:12 and measurements of 12 x 30 *palmi* (approximately 2.7 m x 6.7 m). This leads one to believe that in 1542 Antonio possibly was still thinking about the church and his plan (ca. 1538) to renovate it. At the same time, the notes lead one to believe that the drawing could refer instead to the gate of the Porta Santo Spirito bastion, and in particular to the bastion's internal facade (Fancelli, 1986), which faced the flank of the nearby church and was aligned with it on the same street. In fact, there is a close resemblance between the plans (U 1359A, 1360A) and the elevation visible on the present sheet. See in particular U 1360A, where the internal facade is rectilinear and opened to the right for a single arquebus, whereas the portal is recessed vis-à-vis the facade and preceded by a quadrangular space. This coincidence makes it unlikely that the design is a variation on the external facade of the gate; the notes also tell us that Antonio the Younger intended to give the facade a scarped profile, like the side walls (though these slope more sharply) as shown on the upper right side of the sheet. The interior measurements of the arched portal, 28 *palmi* wide and 15 *palmi* for the height of the pier, coincide in width with the above-mentioned plans and

in height with the total height of the gate: ca. 10 meters up to the level of the roof. The facade, in fact, is divided here in three levels of approximately 15 *palmi* each and the position of the last of the four arquebuses indicates the height of the roof. If the design, even in elevation, is close to Antonio's definitive ideas, we would have an interior facade slightly lower than the exterior one. This would accord with his notion of a triumphal Doric exterior front, between curtains of a clearly military character, and a simpler, rusticated, and Tuscanized facade looking in toward the city and its civilian architecture. Lastly, the presence of the plaque on the attic level should be noted, as it is cited, along with the one on the exterior, by Molza following Pirro Ligorio (Bentivoglio, 1985). See also U 941A, 1359A, 1360A r. and v., 1290A.

BIBLIOGRAPHY: Vasari-Milanesi (1878–85) V: 485; Ferri (1885) 167; Rocchi (1902) I: 177; Giovannoni (1959) I: 366; Bentivoglio (1985) 81; Fancelli (1986) 233–34, 236, 241, 245 n. 43.

F.P.F.

U 910A *recto*

ANTONIO DA SANGALLO THE YOUNGER
Rome, study for the fortification of Castel Sant'Angelo, 1542.
Dimensions: 254 x 167 mm.
Technique: Pen and brown ink.
Paper: Light, left corners restored, yellowed margins.

INSCRIPTION: *Castello Santo / angelo; strada*

In this study Antonio addresses the need for more space inside the castle precinct. He proposes a wide hexagonal circumference, with a true bastion around the tower of Alexander VI, which is allowed to emerge, nonetheless, on the salient guarding the bridge. The octagonal towers already constructed by Antonio the Elder at the angles of the castle are not shown and seem destined for destruction because they no longer serve a defensive purpose in this scheme. The castle would thus have regained its ancient plan, except for the one small tower, with the bent wall, built on the left corner toward the Tiber to guard the gate. A sloping terreplein, subdivided by ramps, would have linked the external bastioned walls with the castle and the interior drill ground, which was left open toward Prati and arcaded like the one planned for the Fortezza da Basso, Florence (see U 783A, 315A, 756A). A double arcade, originally planned, has been crossed out. The remaining single arcade is based on a sequence of internal pilasters around the pentagonal courtyard, which provides for both residential and papal ceremonial functions. Also note the sequence of square, pentagonal, and hexagonal forms that proceed from the outer circumference of the ancient tomb of Hadrian. Antonio had no reservations about experimenting with the idea of an external hexagonal perimeter, a relatively unusual form in military architecture, where the pentagon had been the preferred form for a citadel as far back as Francesco di Giorgio's anthropomorphic designs and Giuliano da Sangallo's fortress at Poggio Imperiale. The "strada" functions as a *pomerium,* controlled by transversal walls along the Tiber, and joins Via Alessandrina toward St. Peter's, as in U 939A. See also U 1012A r. and v., 1016A r. and v., 1020A v., 755A.

BIBLIOGRAPHY: Ferri (1885) 167; Rocchi (1902) I: 194; II pl. XXXVIII; Fiore (1986) 340.

F.P.F.

U 914A *recto*

ANTONIO DA SANGALLO THE YOUNGER
Rome, study for an arch with four facades in Piazza San Marco for the entry of Charles V, 1536.
Dimensions: 328 x 274 mm.
Technique: Pen and brown ink, traces of stylus, caliper marks.
Paper: Restoration at top right margin, left lower corner (with heaviest paper integrated), rubbed and restored at three points.

INSCRIPTION: (top center) *Per farsi di rieto(?) alla piaza di Santo Marco*

The plan of the octagonal arch "per farsi di rieto[?] alla piaza di Santo Marco" has a rigorous, radial symmetry, with four pilasters surrounding the central domed covering. The broken line of each facade is articulated by four columns, alternating with six semicolumns, which probably rest on a continuous stylobate.

The design is certainly part of a preliminary plan for the arch to be built in the Piazza San Marco (now Piazza Venezia), perhaps in the middle of the piazza corresponding to the main entrance to the Palazzo Venezia. (In March 1536 the idea was to have the emperor Charles V stay in the Palazzo Venezia during his visit. In this case the arch would have been the point of both arrival and departure between the two stages of the route. Following our reconstruction (Madonna, 1980, fig. 75), the arch might have been placed obliquely along the axis of the triumphal march between Via Macel dei Corvi and the corner of

the palazzo. The unusual configuration of the arch may be relevant to the debate on central-plan constructions (such as Santa Maria, Loreto, or the Oratory on the Isola Bisentina) or to plans for stage sets.

The four circular staircases in the pilasters must have been intended to give access to a choir in the attic for the concert ultimately held to honor the emperor.

BIBLIOGRAPHY: Podestà (1877) 308–15; Giovannoni (1959) I: 310–11; II: fig. 330; Madonna (1980) figs. 73, 75.

M.F./G.M.

U929A *recto*

ANTONIO DA SANGALLO THE YOUNGER
Study for a triumphal arch, 1536(?).
Dimensions: 173 x 102/109 mm.
Technique: Pen and brown ink, four stylus marks, three of them restored.

This sketch, much more detailed to the left, shows a Serlian arch framed by two pilasters, each composed of a quadrangular nucleus, flanked by at least two freestanding columns in order to embellish the barrel vault, one of them to the front, the other on the internal side, and both linked to the pilaster in portions complete with trabeations; the columns support a small pilaster with a large figure or caryatid in high relief on the exterior, and a complex arched lintel on the interior. The latter seems to be pierced by a sunburst with oculi and corbels or some sort of dividers, echoing Bramante's studies for the interior of St. Peter's or the screened arches at the Genazzano Ninfeo. (See also U 1109A.) At the top of the arch is a large coat of arms, crowned by two figures in full relief.

The arch probably showed a Serlian motif on both sides, with four exposed columns; in that case, the motif with columns paired in depth would be a precursor of Sansovino's Marciana Library in Venice and the Palladian basilica in Vicenza. If related to the celebratory monuments planned for Charles V's triumphal entry in Rome (1536), it should be compared not so much with the studies for Via Alessandrina in Borgo (see U 1155A, 1672A)—the width of the vaulted passage seems too narrow for that location—as with those for arches in unidentified sites shown in the middle of U 1269A.

BIBLIOGRAPHY: Giovannoni (1959) I: 310–11.

M.F./G.M.

U 931A *recto*

ANTONIO DA SANGALLO THE YOUNGER
Florence, Fortezza da Basso, section and plan of the barracks, late 1534.
Dimensions: 545 x 431 mm (maximal).
Technique: Pen and brown ink with extensive stylus marks, straightedge.
Paper: Folded in sixths.
Drawing Scale: braccia (10 *braccia* = 41 mm).

INSCRIPTION: (top center) *Tutto questo edifitio e in volta senza legniame / salvo che in li stantie si potria fare qualche palcho / alle inposte di ditte volte come saria nelle stanze / di soldati che sono pichole e in li magazini e in le / stalle per molto stantie in suditti palchi;* (top right) *Le misure pritirarsi in dentro sempre si debo pigliare / da questa stella elinia quale cade in sul di fuora / dello schalino da basso in pie della scarpa dove / el muro delle cortina si trova questo braccia 11;* (from top down, second floor) *stantie tertie / Bono per granari; stantie per soldati; porticho al / piano delle / stantie di / sopra; stantie siconde; stantie per li / soldati; porticho / al pari del te/raglio; Lo terraglio in questo locho p[almi] 38 b[raccia] 6 d[ita] 6;* (ground floor) *piazza; portico al pi/ano della pi/azza; stantie al piano / terreno; stantie per stia/mi e per legnie; Terrapieno;* (basement) *portico delle Cantine; fondamenti sub/teranei; piano delle Cantine; cantine; piano delle Cantine; Cantine fredde;* (bottom) *a me pareria cavare tutto lo terreno quale e dal piano / delle Cantine in su e perche se a murare presto in sulli fonda/menti e dar loro el carico a dosso si vorebono murare a mano / con calcie grosse e da ditti fondamenti in su ogni cosa / murare a mano;* (bottom, left top corner in reddish ink) *cosi in cantina; Queste stantie segn/iate di rosso farano / al piano delle loggie / di sopra e serannio / larghe p[almi] 11 d[ita] 6 & lo/nge p[almi] 16;* (in brown ink, left) *In cantina questo potrebbe esse / tutto uno Corpo fino al muro / che regie el terrapieno volendo / si po fare overo fare cantine apartate quale sarieno mo/lte fredde;* (central room, in reddish ink) *Queste segniate di / rosso saranno le st/antie de soldati al pia/no del terraglio & / serano longe p[almi] 11 d[ita] 6 / & largi p[almi] 7½;* (portico) *al piano del terrapieno questa a essere tutto / porticho in torno in torno acietto che dove / sara el maschio ello locho del castellano; Queste stantie sutera/nee possono ser/vire per chose che non / temino uno poco / de unidite o saria legnie e cose simile; questo si e el muro che regie el terrapieno*

This drawing represents the full development of the barracks that were to ring the *piazza d'armi* at the Fortezza da Basso, Florence (see U 316A). Designed initially to be a story and a half in height, or possibly two stories (U 768A, 1282A), the project grows to be a full basement, two full arcade stories, and an attic. In

addition, other changes have taken place to the arcades. The piers have been thickened and deepened and what appears to have been conceived of either as a barrel vault or possibly a sail vault, has been changed to a series of shallow domes marking the entries to the rooms. The piers have been beveled to make the arcades into a series of rotundas.

The change in the scale of the accommodations (for storage in the basement, for soldiers and horses above) seems a response to the abandonment of the series of buildings that had been planned to fill the center of the fortress (U 782A, 783A). This change—from an urban plan with distinct buildings arranged in a semicircular layout around a rectangular piazza, to modularized multifunctional arcaded structures on a scale approaching that of a major civic building (like the Uffizi)—reflects a rationalization and centralization of authority. Indeed, Antonio the Younger borrows elements from civil and religious architecture for the great structure shown here. The pair of Doric pilasters are analyzed elsewhere (U 1282A) but the domed arcade hall and beveled piers recall St. Peter's. Roughly similar designs were used for the Osteria at Castro (U 299A). The interior rooms at basement, ground, and first floor level are barrel-vaulted, and the wide stairs, running the depth of the building, provide access to the upper floors as well as to the terreplein, the terrace found at the earth-filled rampart. It is interesting to note how little wood was planned for the structure (as Antonio the Younger notes), probably as a way of fireproofing the building.

A date of late 1534 has been given since work on the ramparts could have been started when the inner structures were under design. The barracks ultimately were not built to a design of Antonio the Younger.

BIBLIOGRAPHY: Ferri (1885) 57; Giovannoni (1959) I: 348, 350; II: fig. 377.

N.A./S.P.

U 933A *recto*

ANTONIO DA SANGALLO THE YOUNGER
Civitavecchia, study for the fortifications, ca. 1538.
Dimensions: 252 x 405 mm.
Technique: Pen and brown ink superimposed in some parts over traces of gray chalk.
Paper: Partially yellowed fold marks.

INSCRIPTION: *Civita vechia; schizo di Civita vechia; Bastione del porticciolo; Ca[n]ne 51; Macha dello / Ulivo; Dallo ulivo pe[r]sino alla po[n]ta del bastione / di tera sie Canne 184 / 184; C[anne] 138; C[anne] 12; c[ontra] forte del monte sie piu Canne / 12 che fan la fro[n]te Canne 150; 138; porta antica; Ca[n]ne 96; Ca[n]ne 184*

This drawing uses various datum points to calculate the measurements for new fortifications to be built upriver from the ancient walls of Civitavecchia between the so-called Rocca Nuova (upper left) and the bastion at the small port (upper right).

BIBLIOGRAPHY: Vasari-Milanesi (1878–85) V: 505; Guglielmotti (1880) 249–50; Ferri (1885) 28; Giovannoni (1959) I: 74, 427; Fiore (1986) 333; Fagliari Zeni Buchicchio (1988) 318, 329–30.

F.Z.B.

U 934 A *recto and verso*

ANTONIO DA SANGALLO THE YOUNGER
Civitavecchia, survey sketches for the fortifications, ca. 1538.

Recto			Verso	
	b	d	b	
a				a
c				
	a			

Dimensions: 290 x 441/434 mm.
Technique: Pen and brown ink.
Paper: Partially yellowed, fold marks.
Drawing Scale: assumed to be in Roman *palmi* with the orientation indicated by the number of degree of the wind directions: T[ramontana], G[reco], A[urora], S[cirocco], O[stro], L[ibeccio], P[onente], M[aestro].

Inscription, Recto: (a) *Bisogna mettere / la busola apu[n]to alli / 4 ve[n]ti e no[n]e al falso / della tramo[n]tana; * contrasegnio / stella; corritoro; alla ponta della / Casaccia, *; i[n] quadro;* (b) *110; Casaccia dalla po[n]ta del baluardo / fino a tutta la Casaccia;* (c) *Bastione di terra; * Contra segno / stella; mare; alla torre a facce; forno; al pu[n]tone della rocha; alla Casaccia D; *;* (d) *forno; torre della / terra; po[n]tone; molo; alla Casaccia; al fariglione; **
Verso: *Civita vechia;* (a) *torre tonda diverso / lo monte nello alto / della terra; torre diverso lo monte / a faccie nello alto / della terra;* (b) *torrone della rocha / de mezo a faccie; qui son prese / le misure; torre della rocha / diverso terra; prato overo / piaza; alla ponta del baluardo; al molo; al fariglione; alla torre della terra; alla a; torre della terra / i[n] sul porto; punton de mezo / della rocha; molo; fariglione i[n] mare / i[n] sullisola scoglata; Casaccia in la / punta del / molo; al palazzo della / Rocha del porto / dove sono i fornj; alla torre della / terra i[n] ssul porto; alla torre della terra / dallalto*

168

Two distinct parts of these designs (*a* on the recto and *a* on the verso) give the measurements and compass readings of the main alignments needed to make a clean copy in scale of the plan of Civitavecchia from the harbor to the Rocca Nuova. The plan includes the perimeter of the existing city walls. In the other four sketches (*b, c, d, f* on the recto, and *b* on the verso), further compass readings have been taken corresponding to the four main datum points. The bastions around the inner harbor are indicated as already in place, thus the sheet seems to be an initial proposal for enlarging the first bastion of the inner harbor landward, linking it with a big, new bastion upriver that would be linked in turn, on the opposite side, with the Rocca Nuova. See also U 933A and 935A.

BIBLIOGRAPHY: Guglielmotti (1880) 219 n. 70, 251–55, 257–59; Vasari-Milanesi (1878–85) V: 505; Ferri (1885) 28; Giovannoni (1959) I: 74, 427; Fagliari Zeni Buchicchio (1988) 319, 328 n. 105, 330.

F.Z.B.

U 935A *recto*

ANTONIO DA SANGALLO THE YOUNGER
Civitavecchia, fortification studies, ca. 1538.
Dimensions: 268/273 x 415 mm.
Technique: Pen and brown ink.
Paper: Partially yellowed at edges, folded in four.

INSCRIPTION: *civita vechia; mare; mare; Al mare; mare; Al mare*

This sheet shows a rough plan of Civitavecchia: the Rocca Nuova to the left, the port in the middle, with the walls of the town below, and the inner harbor to the right with two bastions toward Tarquinia.

BIBLIOGRAPHY: Vasari (1846–70) X: 63; Guglielmotti (1880) 247–49; Vasari-Milanesi (1878–85) V: 505; Ferri (1885) 28; Giovannoni (1959) I: 74, 427; Fiore (1986) 333, 630; Fagliari Zeno Buchicchio (1988) 318, 330.

F.Z.B.

U 936A *recto*

ANTONIO DA SANGALLO THE YOUNGER
Rome, elevation of the Vatican fortifications from the Canneto bastion to the Santo Antonino *tenaglia*, 1542.
Dimensions: 160 x 215 mm.
Technique: Pen and brown ink.
Paper: Light, cut and yellowed at the edges, restored on the top corners.

INSCRIPTION: *per lafronte di Santo antonino; Baldustio; Cavaliere; Canto; Valle dinferno; Santo / antonino*

The top part of the sheet shows the double bastion or hornwork in relation to the Nicholas V tower, now known as the Radio Tower (see also U 937A plan); below are the outer walls, protected by a bastion with a withdrawn double flank, the second face extended, and the salient positioned to correspond with the emergence of the Nicholas III walls (elsewhere called "Canneto"). This last solution, also found in U 1361A with a single bastion, probably would allow advancing the defense to include the existing walls; in other solutions they would have to be demolished. Above all, it would have made it possible even here to build the new fortifications on the edge of the high ground, amply shown in the form of a *scarpone*, as Antonio called it in his designs for the Ardeatine bastion, in order to ensure complete control from above by the fortification. With this in mind, Antonio the Younger not only has utilized the towers in the existing walls as cavaliers, but has placed embrasures in the towers. These embrasures were meant for flanking from above, and they are crowned, in turn, by merlons for lighter firearms. The impressiveness of such construction should be noted, because it probably intensified the debate in subsequent discussions over whether to hold the heights or the valley. It also corresponds to Antonio's design for the Colonnella bastion, already realized in part, for the fortifications on the Aventine. See also U 1012A r. and v., 1016A r. and v., 939A, 1515A, 1017A, 937A, 1876A, 1519A, 1524A, 940A r. and v., 1361A, 1018A.

BIBLIOGRAPHY: Vasari-Milanesi (1878–85) V: 486; Ferri (1885) 167; Rocchi (1902) I: 199–200; II: pl. XLVII; Giovannoni (1959) I: 366; Pepper (1976) 164; Fiore (1986) 340.

F.P.F.

U 937A *recto*

ANTONIO DA SANGALLO THE YOUNGER
Rome, study for the double-bastion solution at the peak of the Santo Antonino Vatican defense circuit, 1542.
Dimensions: 63 + 29/55 x 289/293 mm (irregularly cut).
Technique: Pen and brown ink.
Paper: Lightweight, trimmed on the edges except for the right one, with the original inscription reinserted.
Drawing Scale: Roman *palmi*.

INSCRIPTION: *Baluardi di / Santo antonino*

In this sheet Antonio the Younger explores the solu-

tion of double bastions, either pincer shaped or with a kite tail, to use Castriotto's term, at the upper edge of the Vatican circuit. The study has been carried out with geometric precision and almost in scale, including the measurements of the faces, flanks, and intermediary curtain. Note that in order to contain the bastions on the crest of the hill and at the same time move forward with respect to the Radio Tower (as it is called today) on the existing Nicholas V circuit, Antonio has limited their width, giving them faces 250 *palmi* long and increasing the length of the intermediary curtain to 460 *palmi*, that is to say, slightly more than 110 meters. The tower is placed symmetrically between the two bastions, both of which are called "di Santo antonino," as it is shown in U 936A. See also U 1012A r. and v., 1016A r. and v., 939A, 1515A, 1017A, 936A, 1876A, 1519A, 1524A, 940A r. and v., 1361A, 1018A.

BIBLIOGRAPHY: Ferri (1885) 167; Rocchi (1902) I: 200; II: pl. XLVIII; Giovannoni (1959) I: 366.

F.P.F.

U 938A *recto*

ANTONIO DA SANGALLO THE YOUNGER
Rome, elevation of the fortifications on the Aventine hill and
the Colonnella bastion at the new Porta San Paolo, 1537.
Dimensions: 180 x 219 mm.
Paper: Yellowed on the edges, trimmed except on the right
side.
Technique: Pen and brown ink.
Drawing Scale: Roman *palmi*.

INSCRIPTION: *Lo piano di sopra delcordone del baluardo antoniano cioe el piano di sopra / alto palmi 50 sopra alpiano dello scarpone e batte in lavignia del S[igno]re noferi / Santa Croce alto palmi 4 in circha segniato una stella in uno cerchio grosso / e al baluardo in sulla muraglia cheva asanpagolo batte sopra alpiano del / terreno p[almi] 65 come apare una crocetta nelmuro di mattoni dalcanto di / dentro quale e piu basa cheldi sopra delcordone p[almi] 50 e da ditta croce atterra / di fuora sie p[almi] 15 / E piano de lo scarpone della Colonella sii e piu basso chelmuro di marcant[oni]o dove / aessere laporta p[almi] 8 elpiano di sopra delcordone della Colonnella mettendolo / alto p[almi] 50 verria alla porta alto 42; Colonnella*

This is the only elevation of the walls planned by Antonio the Younger for the left bank of the Tiber. The walls vary in height from 50 *palmi* for the curtain (slightly more than 11 meters) to 65–70 *palmi* (from 14.5 to 15.5 meters) for the bastions; these measure-

ments correspond precisely to those for the Colonnella bastion. Antonio's comments reveal how preoccupied he was with the vertical connection of the various parts, starting with the Colonnella up to the "antoniano," that is, the Ardeatine bastion (not shown). While both Rocchi (1902) and Giovannoni (1959) identified the drawing as preparation for the Ardeatine bastion, the design, in fact, shows the Colonnella bastion. The Colonnella bastion is readily identifiable by the blunt angle with a spur at its base, as is clearly shown in the design and still recognizable today on site. Such specific detail suggests that this sheet represents the definitive solution for the plan, which is characterized by the placement of a bastion corresponding to the small Aventine hill and just before the new recessed Porta San Paolo. The gate is characterized by an arch and indications of a double architectural order on one side. Beyond the gate the battered angle of another bastion may be glimpsed, probably similar to the variation of U 1431A. See also U 1019A, 1514A, 1015A, 1431A r. and v.

BIBLIOGRAPHY: Vasari-Milanesi (1878–85) V: 485–86; Ferri (1885) 167; Huelsen (1894) 329; Rocchi (1902) I: 185; II: pl. XXXIV; Giovannoni (1959) I: 362; Bellanca (1986) 384–85; Fiore (1986) 338.

F.P.F.

U 939A *recto*

ANTONIO DA SANGALLO THE YOUNGER
Rome, study for the fortification of Castel Sant'Angelo and the
southern flank of the Vatican hill and Borgo, 1541.
Dimensions: 132 x 299 mm.
Technique: Pen and brown ink.
Paper: Trimmed at three edges (not at left), restored on the
upper right corner, central insert with the original
caption, yellowed margins, stains.

INSCRIPTION: (central insert) *Fortificazioni [. . .] / Castello e borgo; Via alexandrina; Castello; Belvedere; Gallinaro; Canneto*

The defenses for the Castel Sant'Angelo correspond more or less entirely to those shown in U 910A, including the terrepleins and the internal, arcaded courtyard in pentagonal form. Here, however, the entrance gate—Via Alessandrina leading to the Porta Collina, shown as partially preserved—is designed differently; so too is the curtain facing the Borgo, which has been prolonged by means of double flanks that almost cut the hexagon of the castle in two symmetrical blocks of bastions. The new bastioned walls of the Vatican

Borgo and hill are connected directly and aligned with the face of the castle bastion facing the Borgo so that, as a result, they are similarly flanked by the castle bastion on the face toward Prati. They then continue toward the Belvedere as in U 1016A, outside the Swiss tower and equipped with an intermediary platform. The latter, much like the one at Incoronato that Antonio the Younger was also to design for the defense of the other side of the Vatican hill, was subsequently given orillons as were the other flanks up to the Belvedere bastion. From there, the walls up to the Gallinaro and Canneto bastions have been sketched in roughly and not at all to scale. See also U 1012A r. and v., 1016A r. and v., 1020A v., 910A, 755A.

BIBLIOGRAPHY: Vasari-Milanesi (1878–85) V: 486; Ferri (1885) 167; Rocchi (1902) I: 194–95; II: pl. XXXVIII.

F.P.F.

U 940A *recto and verso*

ANTONIO DA SANGALLO THE YOUNGER
Rome, study for the Vatican hill fortifications, 1542.
Dimensions: 220 x 294 mm.
Technique: Pen and brown ink with ruler and dividers used on the recto.
Drawing Scale: Roman *palmi* on recto; verso without measurements.

INSCRIPTION, Recto: *Corritore; Nicolo; Belvedere; gallinaro; p[almi] 5; 100 palmi; per 20 volte tanto sia palmi .5. / li cento palmi*
Verso: *argini; antifossa conaqua; bastione in sullo argine / del fosso in sulli anguli aperto di dentro; fosso secho; Baluardo; muro basso; uscita; parapetto delluscita / bassa che copre li omini; uscita; parapetto della uscita*

The recto contains a detailed study of the new walls from the Passetto with the Nicholas V tower up to the Gallinaro, which has been represented to scale and comes close to the general ideas expressed in U 1876A. Even here the faces of the Belvedere bastion are ample, 600 *palmi* (134 meters), and a similar correspondence exists between the measurements of the two sheets, however different in execution. Rocchi (1902) suggested that this study indicates progress made in the planning of the bastioned front in the first half of the sixteenth century. It may also be suggested that the design corresponds to the final stage of Antonio's planning, because it relates rather well to the overall picture of the bastioned circuit in U 1018A. Furthermore, on the verso he is concerned with the execution of details for the defense of the moat.

Antonio the Younger's plan on the verso is the only one we have by him for the moat as part of the Vatican defenses. The architect has envisioned a double moat, dry inside and wet on the exterior, defended by artillery positions in the counterscarp on the ground in front of the bastions, and probably with a parapet on the most exterior part of the moat as well. On the intermediary embankment large merlons and, above all, arched openings corresponding to the corners are indicated, the latter surely intended to contain artillery positions and functioning as caponiers, in further defense of the bastioned walls and exit gates. These gates open on to the moat not only on every flank of the bastions, as in the case of the completed Ardeatine bastion, but also in the middle of the curtain, and are protected in turn by low earthworks to shield the defenders. Here again we see a system that foreshadows the solutions adopted in the eighteenth century to maximize defenses: The wet external moat eliminates the dangers of the mines and, together with the dry internal moat, allows for easy defensive maneuvering, incorporating the virtues and avoiding the defects that fueled the ongoing debate between dry or wet moats. This solution was probably meant for the lower part of the Vatican circuit, on the rather level ground near the Tiber. A simplified version, without water, might well have been contemplated for the higher parts where the rugged terrain and the lack of space in depth, as well the greater safety from mines, would have made a wet ditch useless. See also U 1012A r. and v., 1016A r. and v., 939A, 1515A, 1017A, 937A, 936A, 1876A, 1519A, 1524A, 1361A, 1018A.

BIBLIOGRAPHY: Rocchi (1902) I: 197, 199; II: pls. XLII, XLVII; Giovannoni (1959) I: 81, 366.

F.P.F.

U 941A *recto*

ANTONIO DA SANGALLO THE YOUNGER
Rome, study for the Porta Santo Spirito gate, 1542.
Dimensions: 199 x 289 mm.
Technique: Pen and brown ink, prepared with ruler and stylus.
Paper: Cut on the margins except right, torn and restored on the top right corner, yellowed borders.
Drawing Scale: Roman *palmi*.

INSCRIPTION: *Lo scarpone si tenga / piu basso chelpiano / della porta p[almi] 10; argine delfosso; strada; argini delfosso; fosso; fiume; Muro per coprire la / porta; fosso; Camposanto di Santo / Spirito; chiesa*

Unlike the solution with the gate almost carved out of

the angle of the bastion, as in U 1012A and 1018A, in this detailed study Antonio has tried a new approach, adapting the bastion to the course of the river in order to obtain a gate and a postern. Accordingly, the Porta Santo Spirito has been placed inside one of the faces of the bastion, which Antonio has doubled, subsequently adding a second flank, as can be seen from the inscription ("fosso") that is crossed out by the second flank. The secondary entrance opens on to the other face, protected by a wall along the riverbank. While we know nothing about the eventual means of access that Antonio would have designed for the secondary entrance (perhaps for bringing in supplies from a passageway in the Pons Triumphalis ruins or, more simply, as an emergency exit), the Porta Santo Spirito clearly has been placed on the axis of what is now Via della Lungara, referred to as "strada" in the plan. Furthermore, the plan is already at an advanced stage and very close to the one shown in detail in U 1359A and 1360A r. and v., with the facade marked by the triumphal array of semicolumns, the internal chamber, and the two side areas with stairways and embrasures, which are intended to guard the space inside the bastion that is accessible by a ramp. The ramp compensates for the difference in height (10 *palmi* according to the inscription) between the gate and the base of the scarp, the "scarpone" on the level of the moat. Thus the gate, designed as an arch of triumph, would have dominated the approaches from the Via sub Janiculo (the present-day Via della Lungara) and become the perspectival backdrop at the end of the street. It should be noted that the front of the gate is not curved here, as in U 1359A and 1360A and as it was built until work was interrupted in 1545. The emergency exit toward the Tiber instead is of no particular architectural character and is guarded only by an artillery position to the left of the entrance, possibly at the Santo Spirito cemetery, which is indicated by a representative of the small chapel that probably was used in 1659 by the "Arciconfraternita ospitaliera di S. Spirito in Saxia" and demolished, together with the cemetery, in order to enlarge the hospital under Pope Benedict XIV. See also U 1359A, 1360A r. and v., 902A, 1096A r. and v., 1290A.

BIBLIOGRAPHY: Vasari-Milanesi (1878–85) V: 486; Ferri (1885) 167; Rocchi (1902) I: 198; II: pl. XLVI; De Angelis (1950) 89ff; Giovannoni (1959) I: 81, 365; Fancelli (1986) 232, 242 n. 6; Manfredini (1989).

<div align="right">F.P.F.</div>

U 942A *recto*

ANTONIO DA SANGALLO THE YOUNGER(?)
Fortification study, use of bastions, demi-bastions, and platform for unknown location, mid-1530's.
Dimensions: 117 x 414 mm.
Technique: Pen and brown ink, red chalk, stylus, pin, straightedge.
Paper: Darkened at edges.

The drawing shows a potential technique for providing flanking fire between bastions that are spread far apart along a long curtain. Antonio the Younger shows how demi-bastions (a curtain broken to form a single flank) may be incorporated with the more traditional bastion forms at the angles. This was the system used for the double-flanked Ardeatine bastion. At the center, possibly protecting a portal, stands a platform. Giovannoni associates this sheet with other drawings that show projecting bastions, such as U 805A, as well as studies for the Fortezza da Basso and the Rocca Paolina. The sheet may also be related to a similar sketch on U 1390A that is in the hand of Giovan Francesco da Sangallo. The date of U 942A recto is not known but the nature of Antonio the Younger's interest, as demonstrated here, suggests the period of the mid-1530's.

The attribution has been provided with a question mark because the hand cannot be identified with absolute certainty. This kind of drawing, for an unspecified location, is relatively unusual in the *oeuvre* of Antonio the Younger, and it lacks many of the characteristics of the hand of Antonio.

BIBLIOGRAPHY: Giovannoni (1959) I: 80, 366, 428.

<div align="right">N.A./S.P.</div>

U 943A *recto and verso*

ANTONIO THE YOUNGER AND CIRCLE
Tarquinia and Civitavecchia, fortification studies, ca. 1538.
Dimensions: 437 x 544 mm.
Technique: Pen and brown ink, parts on the recto superimposed on gray chalk.
Paper: Partially yellowed.
Drawing Scale: assumed to be in *piedi,* indicated in *canne.*

INSCRIPTION, Recto: *abitato; abitato; abitato ripe; ripe ripe ripe; ripe; foso deto / san francesco; ripieno; ripieno ripieno; ripieno; baluardo fuore; foso di fuore; porta ala madalena; p[orta]; pieno rivelino; p[orta]; to[r]re; torre; p[orta]; torre; bastione; bastione; p[orta]; la madonna di / chastello; chase; luogo dove si semina / grano; p[orta] an[ti]ca; chiesa a / parj della/ terra*

Verso: (later hand) *questo schizzo appartiene / a Civita Vecchia / (Non e Antonio però)*

The medieval walls of Tarquinia are recognizable on the recto where new defenses have also been proposed: two new bastions, one 70 *piedi* per side and the other 100 *piedi*, along with the creation of a bastion at 90 degrees with two sides of 50 *canne* in the part of town closest to the sea and within the reentrant of the ancient walls. The verso shows a partial copy of an original plan, representing the trapezoid of the ancient walls of Civitavecchia and the inner harbor with the small bastions. The page, itself, must originally have been larger so as to contain both the Rocca Nuova and the proposal for a new triangular system of fortifications of which only the traces of two corner bastions are visible: the one upriver from the town, and the other at the end of the inner harbor toward Tarquinia. Even without knowing who in Antonio's circle was responsible for this sheet, the design can be dated 1538, due to its close resemblance to the defenses proposed by Antonio for Le Murelle di Montalto di Castro in U 963A and for Civitavecchia itself in U 934A r. and v.

BIBLIOGRAPHY: Guglielmotti (1880) 260; Ferri (1885) 28; Giovannoni (1959) I: 82, 428.

F.Z.B.

U 944A *recto*

ANTONIO DA SANGALLO THE YOUNGER
Pratica, plan of the town, after 1539.
Dimensions: 293/290 x 426/423 mm.
Technique: Pen and brown ink.
Paper: Folded.
Drawing Scale: palmi romani with orientation of the winds indicated by degrees: T[ramontana], G[reco], Õ [Levante], S[cirocco], O[stro], L[ibeccio], P[onente], M[aestro].

INSCRIPTION: (to left) *270 / fino alla chiesa; fino alla torre / de leva[n]te canne 87½; muro; contraforte;* (to right) *ripe; jardino; alla gola della torre / diverso la porta; alla torretta alla fine / del muro traverso*

This sheet may be dated after 1539. It shows two schematic plans that reveal special interest in the remains of the ancient tower of the *rocca* and the church with its three aisles. The sheet was at one time related to the Roman fortifications. In fact, however, all the measurements can be verified on U 843A r., which shows the town of Pratica. See also U 725A r. and 838A r.

BIBLIOGRAPHY: Ferri (1885) 168.

F.Z.B.

U 945A *recto*

ANTONIO DA SANGALLO THE YOUNGER
Castro, sketches of a large fortification for the land bridge, 1537.

a (within it) b c
 d

Dimensions: 289 x 436 mm.
Technique: Pen, light and dark brown ink.
Paper: Slightly yellowed, folded twice.
Drawing Scale: Roman *canne* and *palmi.*

INSCRIPTION: (a) *canne 180 incircha p[almi]1800; S[an]to Francesco; S[an]ta maria; Sono 4 cami[ni?]; Colomba; Porta lamberta;* (c) *Tramontana; Basso*

Four notations indicate unmistakably that sketch *a* is one of the projects for the Castro fortifications: "San Francesco" is the name of the small mendicant church that was located at the city wall, a section of which, with two round towers, is also depicted elsewhere (see U 813A r. and 752A v.); "Porta Lamberta" refers to the lower city gate, with its characteristic curve of rocky ledge (see U 813A r. and v., 752A r. and v., 753A r., 294A r., and 750A r.); "Santa Maria" may refer to the small church of Santa Maria dei Servi, which is shown in perspective on U 813A r.; "Colomba" is a reference to the columbaria still seen today on the slopes above the Olpita, near the ruins of Castro. A comparison with Soldati's plan ("Castro and Nepi," fig. 1) shows that this area would have extended a considerable distance across the plateau opposite the city, which is connected with it by a land bridge. Its somewhat lower-lying section, whose steep cliffs fall away to the Olpita (see U 813A r., "prati"), is provided with bastions taking advantage of the projecting ledges, which are indicated by wavy lines. A five-cornered fortification with three large bastions and recessed flanks is adapted to the upper part, which rises steeply in places. This project is preceded by the sketch in the center of *a*, *b*, which shows a fortification with four bastions. Sketch *c* again takes up the theme of three bastions, adding a fourth; all are measured exactly. At *d* is a cursory sketch of a bastion. We have no information from the sixteenth century about further plans to provide the city of Castro with massive fortifications of this kind. Projects from the seventeenth cen-

tury survive, however (Biblioteca Apostolica Vaticana, Barb. lat. 9901, fol. 25); though in a different form, they include the land opposite the city in the network of defenses.

BIBLIOGRAPHY: Ferri (1885) 168.

H.G.

U 946A recto

ANTONIO DA SANGALLO THE YOUNGER
Civitavecchia, inner harbor, 1515–19.
Dimensions: 305/311 x 455/459 mm.
Technique: Pen and brown ink, stylus, straightedge, calipers, and pin. Interior of the small port and the walls in red wash.
Paper: Thick, partially yellowed, fold mark parallel to the short sides.

INSCRIPTION, Recto: *Porticello; Giardino; Linia del partimento*
Verso: *Porticello*

This sheet may be dated 1515–19 for the following reasons: Not only could a general plan for the inner harbor at Civitavecchia not have been done before 1515, but the soundings had to be taken and the water grid completed between 1517, when the last excavations for the small port were done, and 1519, when Antonio deepened the mouth toward the main port from 10 to 16 *palmi.*

BIBLIOGRAPHY: Guglielmotti (1880) 260–61; Vasari-Milanesi (1878–85) V: 453–54; Ferri (1885) 28; Giovannoni (1959) I: 74, 428; Bruschi (1974) 535–65; Fiore (1986) 333; Fagliari Zeni Buchicchio (1988) 315–19.

F.Z.B.

U 953A recto

ANTONIO DA SANGALLO THE YOUNGER
Nepi, Rocca, survey of measurements of the residential wing, 1537.
Dimensions: 428 x 290 mm.
Technique: Pen and brown ink, stylus, straightedge, pin.
Paper: Slightly yellowed and spotted, new support at two corners.
Drawing Scale: piedi and *dita* (50 *piedi* = 76 mm).

INSCRIPTION: (from bottom to top) *questo si e el partimento delle stantie della rocha di nepi quale e asai bella partimento torna / asai bene in opera e asai comodo; porta maestra della rocha; questo voria essere / uno porticho; Cortile scoperto longo / piedi 104 Dita 12; piedi 68; questo partimento qui / sta*

Cosi al piano / di sopra di sotto / sono le stanze tutte / libere senza que/sto andito; la terra viene / da questa banda; al piano terreno Cuc/ina Comune al piano / di sopra salotto; piedi 33 Dita 4; piedi 68; sotto terra Cantina al piano terreno / tinello Comune al piano di sopra sala; Scoperto; Cucina / ad alto; maschio

The Rocca at Nepi at this time was rectangular in form: a slightly banked protective wall with four round towers, dating from the fifteenth century, surrounding a palace and two older towers, one rectangular (next to "scoperto") and the other large and round ("maschio"). Antonio the Younger used Baronino's measurements in this ground plan (see "Castro and Nepi").

Besides the ground floor, the drawing shows the location and sizes of the residential rooms on the *piano nobile.* In the accompanying inscriptions, Antonio considers the use of the parterre and upper story for the duke's household. His first suggested reconstruction includes a "porticho," indicated by dots, and a stately staircase in the courtyard at the right. But neither these nor other significant structural changes are shown in a ground plan of the Rocca of 1855 (ASR, Mappe e Disegni, Coll. I, cart. 47, no. 25).

BIBLIOGRAPHY: Ferri (1885) 23; Giovannoni (1959) I: 346; Imperi (1977) 134, 135.

H.G.

U 954A recto

ANTONIO DA SANGALLO THE YOUNGER
Nepi, fortification studies and site survey, 1537–45.
Dimensions: 156 x 218 mm.
Technique: Pen and brown ink.
Paper: Partially yellowed.

INSCRIPTION: *Nepi; tufo alto; chiesetta; alto; chiesa ruinata; alto; fossone; vechio; questi sono / tre modi di / fortificare nepi / uno stretto / uno mezano / uno magiore / Al picolo vole 3 baluardi / el mezano tre baluardi / el magiore ne vole qua/ttro baluardioli / Lo gra[n]de e bono perfetto / perche toglie p[er] se dua Cava/lieri di na[n]ti che sono ca/lvalieri alla terra di/verso roma e guarda la / terra da questa ba[n]da fino / da pie alla terra e piglia dentro el mulino e sono / 4 baluardi*
Verso: *Nepi per lo ducha / Di castro*

Together with U 955A and 956A, this sheet shows the preliminary phase of on-site studies for three different solutions for the Nepi fortifications. For information on the construction, see U 1787A.

BIBLIOGRAPHY: Vasari (1846–70) X: 67; Vasari-Milanesi

(1878–85) V: 508; Ferri (1885) 101; Giovannoni (1959) I: 346–47, 428; Giess (1978) 71 n. 144, 72–79; Fiore (1986) 341–42.

<div align="right">F.Z.B.</div>

U 955A *recto*

ANTONIO DA SANGALLO THE YOUNGER
Nepi, study for the fortifications, 1537–45.
Dimensions: 212/217 x 289/293 mm.
Technique: Pen and brown ink.
Paper: Partially yellowed, fold marks, with an inscription pasted in the middle of the page.
Drawing Scale: passi.

INSCRIPTION: *Schizo di Nepi del S[igno]re / Optavio di farnese* (insert); *fossone; mulino; rimettere; A; A / monte dallevare; mulini; alto; alto; qui sbassa; mo[n]terozo / rialza / scoglio; fossone che viene / al ponte*

After on-site research, annotated in U 954A with three different solutions, this design, together with U 956A, shows Antonio's proposal for the fortifications at Nepi. For what was actually built, see U 1787A. The inscription regarding Ottavio Farnese was added later.

BIBLIOGRAPHY: Vasari (1854) X: 67; Vasari-Milanesi (1878–85) V: 508; Ferri (1885) 101; Giovannoni (1959) I: 251, 346, 428; Giess (1978) 71 n. 144; Fiore (1986) 341–42, 636.

<div align="right">F.Z.B.</div>

U 956A *recto*

ANTONIO DA SANGALLO THE YOUNGER
Nepi, fortifications, 1537–45.
Dimensions: 227/217 x 294 mm.
Technique: Pen and brown ink.
Paper: Partially yellowed, fold marks.

INSCRIPTION: *Nepi; fossone; bastione; Carreto; levare; porre; valle del fiume; Collina alta qua[n]to la terra; monte di tufo / dallevarsi; cava mo[n]te di tufo; vechio; novo; valle che / mo[n]ta[n]do / dolcem[en]te; fossone; punta / del sito alta; Cosi si piglia tutti li Cavallieri da questa ba[n]da; porta romana; sepolture; chiesa ruinata; Coliseo A; Coliseo tagliato nel tufo; nocje gra[n]de; fosone; fossone*

Together with U 955A, this design shows Antonio's definitive proposals for the fortifications of Nepi, based on his on-site research (see U 954A). For what was actually built, also see U 1787A.

BIBLIOGRAPHY: Vasari (1846–70) X: 67; Vasari-Milanesi

(1878–85) V: 508; Ferri (1885) 101; Giovannoni (1959) I: 251, 346–47, 429; Giess (1978) 71 n. 144, 72, 79; Fiore (1986) 341–42.

<div align="right">F.Z.B.</div>

U 958A *verso*

ANTONIO DA SANGALLO THE YOUNGER
Orvieto, sources of springwater under the cliff, 1525.
Dimensions: 203/197 x 255/256 mm.
Technique: Pen and brown ink.
Paper: Partially yellowed, folded.
Drawing Scale: Roman *piedi* (top), Florentine *braccia* (bottom).

INSCRIPTION: (center) *S[an]to Manno; S[an]to serio; Dellione;* (bottom right) *Dalaqua della fontana ala fine / della piagia sie b[raccia] 44 / Dalla fine della piagia fino al pia/no della cipta b[raccia] 45½ / La fontana di S[an]to serrio e piu / basa che S[an]to man[n]io br[accia] 28 / La scarpa del terreno alta br[accia] 41 / La ripa di tufo per fino al piano di sopra br[accia] 51 / Laltra fontana dellione e i[n] piano / Con san serio;* (top right) *monta; smonta; scarpa;* (top left) *morelle di mo[n]talto / del ducha di Castro*

On this sheet Antonio the Younger has calculated the gradients between the plateau of tufa on which Orvieto is built and the Sant'Ormanno (now called Concie), the San Zero, and the Leone springs in the scarp under the cliff; the first is to the west of the town and the others to the north and east, respectively.

The San Zero and Leone sources, as shown here, form a single jet of water at the conjunction of the two contour profiles to the left. The Sant'Ormanno spring is shown at the end of the profile to the right. The measurements probably were taken to determine the depth of the well to be drilled in order to tap the springwater. The visit of the architect may be dated 5 July 1525, when Stefano Tarugi, then papal *commissario* for the well near the fortress, proposed: "quod Magnifici Domini conservatores et Gubernatores una cum octo civibus Eligendis mittant pro magistro antonio de Sangallo architectorj et obstendatur hec civitas et quod omni conato provideatur si fontes existentes extra et propter menia possent Jnmitti Jn Civitate, ad hoc ut temporibus turbolentjbus non possit civitas Jpsa assediarj propter penjuram aquarum" (Archivio di Stato, Orvieto, *Bastardelli Riformanze* 555). See U 960A and 1242A for the well drilled near the Rocca. A clipping with a caption regarding Le Murelle near Montalto di Castro has been mounted on the page (see also U 963A).

BIBLIOGRAPHY: Vasari (1846–70) X: 54; Vasari-Milanesi (1878–85) V: 508; Ferri (1885) 104; Perali (1919) 30–31, 169–72, 175–76; Giovannoni (1959) I: 260, 338–40, 428.

<div align="right">F.Z.B.</div>

U 961A *recto*

ANTONIO DA SANGALLO THE YOUNGER
Orvieto, trusses of the Duomo, 1536.
Dimensions: 73/92 x 193 mm.
Technique: Pen and brown ink.
Paper: Thin, partially yellowed, on modern support.

INSCRIPTION: *per la fortificatio de Cavalli / di Orvieto; A travicelli; A; A; ascialone*

In these two sketches, Antonio the Younger shows in detail the technical solution he proposed for reinforcing the trusses of the cathedral at Orvieto. See also U 960A recto (Volume Two).

BIBLIOGRAPHY: Vasari-Milanesi (1878–85) V: 508; Ferri (1885) 104; Perali (1919) 176–77; Giovannoni (1959) I: 258, 428.

<div align="right">F.Z.B.</div>

U 963A *recto*

ANTONIO DA SANGALLO THE YOUNGER
Montalto di Castro, Le Murelle; Civitavecchia, Rocca Nuova, ca. 1538.

a b

c

Dimensions: 280 x 393 mm.
Technique: Pen and brown ink, with parts in gray chalk.
Paper: Piece cut out, partially yellowed.

INSCRIPTION: (a) *morelle / mare; C[ann]e 80; pali; C[ann]e 60; terra; cavo linare; al cavo; al mo[n]te arge[n]tario; al monte; ansedonia;* (b) *morelle / manufatti; mare; p[er] le murelle presso / a mo[n]talto; mare; terra;* (c) *Cornice / per lo Cavaliere / di Civita vechia*

The page was done by Antonio the Younger with the use of a compass and represents a rough survey copy of the ancient Etruscan seaward construction at Le Murelle, Montalto di Castro (*a*). The drawing also gives a first idea of his plan for new fortifications (*b*), similar to those for Civitavecchia in U 934A r. and v. The inscription "morelle di mo[n]talto / del ducha di Castro," inserted in U 958A v., refers to this page,

which also contains the design of the cornice, built between 1538 and 1544. This cornice was added to the top of the main tower of the Rocca Nuova at Civitavecchia; the tower took the form of a cavalier.

BIBLIOGRAPHY: Vasari-Milanesi (1878–85) V: 507; Ferri (1885) 28; Fagliari Zeni Buchicchio (1988) 323, 326–27 n. 105.

<div align="right">F.Z.B.</div>

U 970A *recto*

ANTONIO DA SANGALLO THE YOUNGER
Fabriano, elevation of Rocca, ca. 1526.
Dimensions: 136 x 140 mm.
Technique: Pen and brown ink, stylus.
Paper: Darkened at edges.

INSCRIPTION: *Faccia diverso la terra;* (later hand) *Rocca di fabriano*

The drawing probably shows part of a *rocca* near the Porta del Piano of Fabriano with the remains of the crenellation, machicolation, and the arms of a Medici pope, probably Clement VII. Two caponiers with single gun ports provide flanking fire at low level. This drawing is to be linked with U 971A r. and v., which show two elevations of the same section of the fortress.

The purpose of the drawing is not known. A *rocca* was built in Fabriano during the pontificate of Adrian VI. Clement VII ordered work to restore the *rocca* in 1528 and 1531. The fortress was demolished in the early nineteenth century and there seem to be no published records of its form. Giovannoni claims that Antonio the Younger was responsible for the caponiers as part of a program of lateral reinforcement. The caponiers shown here and in U 971A r. and v. are similar to the kind of low-level works used by Antonio at the angles of a fortified villa like Caprarola, although they differ in detail from caponiers for Florence and Castro (U 754A, 813A v.). It is not known, however, whether the drawing represents a proposal for new work or reflects work already on the ground, possibly by others.

Dating for U 970A, 971A r. and v. is troublesome. No dates for Antonio the Younger's visit to Fabriano have been published to our knowledge. Antonio was in the area during the Romagna trip of 1526. The presence of the Medicean arms only suggests that work had been undertaken by Clement VII (though it could have been Leo X); still, a post-1523 date is likely. The graphic style, however, does not seem much later; a dating ca. 1526 seems acceptable, though there

is no compelling reason to connect the drawings with the Romagna trip. If indeed by Antonio, they are rather weak examples of his skill.

BIBLIOGRAPHY: Ferri (1885) 38; Montani (1922); Benigni (1924); Giovannoni (1959) I: 82, 429; Molajoli (1968).

N.A./S.P.

U 971A *recto and verso*

ANTONIO DA SANGALLO THE YOUNGER
Fabriano, elevation of Rocca, ca. 1526.
Dimensions: 110 x 155 mm.
Technique: Pen and brown ink, stylus.
Paper: Darkened at edges.

INSCRIPTION, Recto: *Faccia laterale*
Verso: (cut from separate sheet and pasted in place) *Faccia laterale apresso / la porta della terra*

Drawing on the recto shows the lateral face (right-hand side) of U 970A. The crenellation at the far right has been removed. Drawing on the verso shows the lateral face (left-hand side) of U 970A stripped of almost all of its crenellation. Whether this drawing represents a proposal for removing the crenellation or a situation in which part of the crenellation has been taken away and not replaced is unclear.

For dating and issues related to the purpose of the drawing, see U 970A.

BIBLIOGRAPHY: See U 970A.

N.A./S.P.

U 972A *recto*

ANTONIO DA SANGALLO THE YOUNGER
Faenza, fortress, ca. 1526.
Dimensions: 331 x 200 mm.
Technique: Pen and brown ink, stylus used to grid paper, straightedge.
Paper: Darkened at edges.
Drawing Scale: 100 *piedi* = 72 mm.

INSCRIPTION: (at top) *Faenza*; (around plan) *fosso*; *questa e la porta che / va a pavola*; *terraglio*; *terraglio*; *terraglio*; *case*; *80 piedi*; *vacuo*; *vacuo*; *muro della / terra*; (text below plan) *Questa sia laforteza di faenza alla quale primamente bisongnia / farre nettare li fossi & rifare el sostengnio dellaqua di detti fossi / perche e rotto e sta pocha aqua ne fossi al presente*

Item bisognia rifoderare di muro le scarpe delle cortine delle due / faccie quali si mostrano alla Canpagnia quale piu tempo fa sono stati / scrostate Con pichoni per ruinare detta rocha

Item bisognieria ingrossare li torrioni dal ca[n]to di fuora perche sono picoli / e sottili di mura che li fianchi che vi sono presto si torrieno perche anno / pocha spalla

Item bisognia ingrossare o di muro e di terra le due faccie delle / Cortine diverso la terra per potere girare intorno Colla artiglieria

Item bisognia fare loro intorno li merli alla franzese e parapetti alle cortine / e torrioni e torre maestra

Item coprire le cinque torre a che Coprissi le Cortine anchora per a tempo di / pacie a tempo di guerra scuseria munitioni e si conserveria meglio / la muraglia e artiglierie e le guardie potrieno molto meglio guardare

Item levare cierto terreno quale e stato messo a presso li argini di fossi in la terra

Included by Beltrami among the drawings from the 1526 visit to the Romagna and so dated by all other sources, the sheet shows the medieval fortress of Faenza built 1372–73 and finally destroyed 27 March 1753 (see Medri). It was also seriously damaged in its resistance to Cesare Borgia (1500–1501).

The sheet is typical of the kind of consultancy work undertaken by Antonio the Younger during the 1526 visit to the Romagna and on other occasions (see the report for Pisa, U 809A). Dating of the Romagna series remains a problem (see U 727A). Antonio's *memoriale* is in the form of a series of recommendations: repointing the walls, thickening the towers, enlarging the walls so that artillery can be moved along them. Such proposals are typical of the renovations undertaken at many sites at this time (Siena, Florence, Pesaro, Urbino). One term used by Antonio may be of interest: He proposes to change the crenellation ("li merli") to French style ("alla franzese").

BIBLIOGRAPHY: Ferri (1885) 40; Beltrami (1902) 27; Medri (1908) 54–55; Giovannoni (1959) I: 78, 429; Mancini, Vichi (1959) 102; Archi, Piccinini (1973) 42–43.

N.A./S.P.

U973A *recto*

ANTONIO DA SANGALLO THE YOUNGER
Ferrara, bastion of San Rocco, 1526(?).
Dimensions: 189 x 272 mm.
Technique: Pen and brown ink.
Paper: Darkened edges.
Drawing Scale: Roman *palmi*.

INSCRIPTION: (at right) *di ferrara*; (bottom left) *palmi 60*; *fianchi delli torrioni di ferrara*

This schematic drawing may show Antonio the

Younger's sketch of the bastion of San Rocco, Ferrara (see also U 881A r. and v.), which is attributed to Biagio Rossetti and was built at the turn of the sixteenth century. The similarity is based on location as well as form (the angled salient). The drawing may have been done during the trip through the Romagna in 1526.

The sketch of a citadel, possibly for Ferrara, goes back to schemata developed by Filarete and seen through the experience of Cesariano, Fra Giocondo, and Leonardo da Vinci (Marconi). Antonio was to remain fascinated by the relation between rotated squares; we find similar sketches on sheets for the Castel Sant'Angelo and the Fortezza da Basso (U 758A).

BIBLIOGRAPHY: Ferri (1885) 41; Giovannoni (1959) I: 78, 429; Marconi et al. (1973) 87, fig. 125.

N.A./S.P.

U 975A *recto*

ANTONIO DA SANGALLO THE YOUNGER
Civitavecchia, Rocca Nuova, 1508–9.

```
     a        a
        c  c
  a    b  d    b
     a        a
  d           d
        e
```

Dimensions: 141 x 105 mm.
Technique: Pen and brown ink.

INSCRIPTION: (b) *chome lo papa vole partire / la rocha di civita / chosi*

The first part of the drawing (*a*), attributed erroneously to Civita Castellana, represents the Rocca Nuova at Civitavecchia as planned by Bramante. The second (*b*), to which the text refers, is a reduced variation; it doubles the main tower, eliminates the two corner towers, and was proposed by Julius II before April 1509. Antonio refers in particular to the range between the two main towers in the papal solution (*c*). A final variant (*d*), with details (*e*), may have been added several years later and does not refer to Civitavecchia. It could have been an idea for the Fortezza Santacroce, Veiano, instead.

BIBLIOGRAPHY: Vasari (1846–70) X: 62; Guglielmotti (1880) 193; Vasari-Milanesi (1878–85) V: 505; Ferri (1885) 28; Fiore (1986) 335, 632; Fagliari Zeni Buchicchio (1988) 280–83.

F.Z.B.

U 977A *recto*

ANTONIO DA SANGALLO THE YOUNGER
Civita Castellana, study of the fortress, 1512–13(?).
Dimensions: 430/435 x 287/295 mm.
Technique: Pen and brown ink.

INSCRIPTION: (from top) *fosso / insino alponte; insula di pierfrancesco da viterbo; vafino alla fine della terra opocho / mancho; fondo del fiume / evalle fonda / piu di 15 canne; C[anne] 10; Canne 5; ripe / ulliveto*

The drawing shows the Rocca encircled by a further defensive belt beginning from the cliffs that then follows the fortress trace. For a discussion of this plan, see Sanguinetti (1959). The plan is placed within a setting that includes topographic and hydrological information as well as references to roads.

Below and to the right (page was turned) are two sketches that refer to the structure of the walls near to the farthest angle of the perimeter; there an arcaded sequence of counterforts was located to hold back the scarp of the ditch. There is also a notation to suggest a pathway that begins at the point near a door facing the cliffs. This path is also visible in the drawing of the Rocca by Francisco de Hollanda, who was in Rome 1538–40. At the top and to the left, Antonio outlines the landscape with rapid strokes. Among these (to the left) can be recognized a small church.

The part of the Rocca that was most completely studied is the section alongside the cliffs where a corridor connects the fortress with the ground nearby. There is also another corridor, tangential to the cliffs, strengthened by a round tower, next to the curtain from which a door opens. This solution derives from the similar structure introduced by Alexander VI at the Castel Sant'Angelo, Rome. Further consideration of the plan of the Rocca is found at U 1145A.

We have accepted the dating of this sheet proposed by Bruschi (1985) for now, although a later date of 1535–43 may be possible. Consider that the entry of Charles V in 1535 with 10,000 men took place in an atmosphere of suspicion between pope and emperor. The fortresses of Civita Castellana and Civitavecchia were placed in a state of readiness, as is noted by Pastor as well as by notices in the *Mandati* in the Archivio di Stato, Rome (1535–37, 1539–42, 1540–43).

It should also be noted that Antonio the Younger refers to earlier work done by Pier Francesco da Viterbo. He is also cited by Antonio for his work at Verona (U 814A).

BIBLIOGRAPHY: Pastor (1959) V: 726 n. 3; Sanguinetti (1959) 84; Bruschi (1985) 67 n. 27.

E.B.

U 978A recto

ANTONIO DA SANGALLO THE YOUNGER
Ancona, bird's-eye view of the port, 1532–34.
Dimensions: 292 x 298 mm.
Technique: Reddish brown chalk, pen and brown ink.
Paper: Folded on right side, paper added far right, partial modern support.

INSCRIPTION: (at top left) *10 S. riaco*; *Canne 20 palmi 8*; (to right corner) *Canne 25 palmi 8 / passi / anconitani 32 / quali sono piedi 6 antichi luno / che sono palmi 8*; (in chalk at center) *20 passi*; (to right center) *Del porto de anchona*; *eldisotto dell archo e volto T[ramontana] 3 1/2 / larcho T[ramontana] 3 1/2*; *Capochiare*; *valle*; *M[onte] Santo incino*; *M[onte] Barcalone G[reco] 10*; *Montemariano G.F. 19*; *To[rre] fiumicino*; *gron de pesaro T[ramontana] 10*

Antonio the Younger visited Ancona in January 1532 and then again after September when Clement VII had decided to bring the city under direct papal control. Antonio's proposals (see U 1020A, 1502A) involved the enlargement of the citadel along the Astagno and the protection of the two main gates (Porta Calamo and Porta Capodimonte) with bastions. Among the structures leveled were the churches of San Giovanni in Pennocchiara, Sant'Agostino, and Santo Spirito as well as many private houses. The defenses along the northern front also were strengthened (U 1526A).

Unfortunately the drawings that survive show only Antonio the Younger's early thoughts for Ancona and it is hard to know how much was realized following his plans. Documents in the Archivio di Stato, Rome, place him in charge of the works through 1535, and a dedicatory inscription on the fortress is dated 1534. The Sienese architect Giovanni Battista Pelori assumed charge of the works after 1540 under orders from Paul III and worked, for the most part, along the northern defenses including overseeing work on the bastion of San Paolo al Cassero. This bastion is illustrated in a drawing attributed to Bartolomeo de' Rocchi (U 4225A); see also "The Fortification Drawings of Antonio da Sangallo the Younger," fig. 2.

The present drawing, a bird's-eye view, shows the port with the *molo* to the left and the main entry to the city at the top. To the right is the thinner groin that enclosed the port. Antonio has taken a series of compass bearings from the main *molo*. To the right of the sheet is the footprint plan of the Arch of Trajan.

BIBLIOGRAPHY: Ronchini (1864) 474; Ronchini (1868) 250; Alpheo (1870); Ferri (1885) 6; Pastor (1923) IV: 428; Giovannoni (1959) I: 75, 110, 394; Natalucci (1960) II: 21–45, fig. 5; Natalucci (1964); Fiore (1986) 336–37; Mezzetti, Pugnaloni (n.d.) 205–10.

N.A./S.P.

U 979A verso

GIOVANNI BATTISTA DA SANGALLO
Piacenza, tabular record of vertical dimensions of the fortifications, 1526.
Dimensions: 297 x 196 mm.
Technique: Pen and brown ink.

INSCRIPTION: *yhs 1526 die 19 Aprile*; *Livellatura del circuito de placentia facta fuora a la campagna / et derimpecto ali bastioni cemenzando a Santo Antonino / come loco piu alto, et andando verso Santo Benedecto*; *Trovo quello de Santo benedecto essere piu basso de quello de Santo Antonino / havendo sempre respecto ala campagna b[raccia] 3 c[anne] 5*; *Quello da la porta de stratta levata basso piu de quello / de Santo benedetto b[raccia] 2 C[anne] 3*; *Quello de campaina basso piu che quello de stralevata b[raccia] 14 c[anne] 1*; *Quello de Santo Sisto basso piu che quello de campagna braccia 0 canne 6*; *Quello de fusesta basso piu di quello de Sto Sisto braccia 0 canne 2 1/2*; *Quello de la Torisella alto piu de quello di fusesta b[raccia] 10*; *Quello dela corneliana alto piu de quello dela torisella b[raccia] 5 c[anne] 4*; *Quello de Santo Antonino alto piu de quello de la corneliana / b[raccia] 5 c[anne] 1 1/2*; *Ita che quello de fusesta e il piu basso et e piu basso / che quello de Santo Antonino (che e il piu alto) b[raccia] 20 c[anne] 5 1/2*; *Piacentia*; (later hand) *scrittura del Gobbo*

The Romagna inspection of 1526 finished in Piacenza where its participants completed their work. Giovanni Battista, Antonio the Younger, Giuliano Leno, and Michele Sanmicheli were met there by Pier Francesco da Viterbo. This verso, in the hand of Giovanni Battista, is an unusual survival preserved probably because of the recto. It records the vertical relation of the bastions one to another and to the surrounding countryside. A document such as this, in conjunction with a plan of the city's walls and an indication of the surrounding topography, would have enabled the architects to plan what kinds of proposals they might wish to make. Given the difficulty Renaissance architects had recording vertical dimension, it is interesting that Giovanni Battista should have presented the information in table form.

The sketches of Santo Todisio in Piacenza, on the recto (Volume Two), show the lantern with its many subsidiary turrets clustering around the cone of the dome. In plan this looks remarkably like the sketch in U 1344A of superimposed square traces and detached

outworks dated November 1526. Although the close dating and formal similarity may well be entirely fortuitous, the last-mentioned drawing would not have been the first Renaissance fortification proposal to have been generated by a geometrical pattern.

BIBLIOGRAPHY: Ferri (1885) 111.

N.A./S.P.

U 1012A *recto and verso*

ANTONIO DA SANGALLO THE YOUNGER
Rome, survey of the Vatican walls and Castel Sant'Angelo
 with studies of the Porta Santo Spirito and its bastion,
 1542.

Dimensions: 440 x 574 mm.
Technique: Pen and brown ink, compass.
Paper: Heavy, folded in four, with original but yellowed edges, patches and yellowed traces of insertions no longer present.
Drawing Scale: Roman *canne* and *palmi*.

INSCRIPTION, Recto: (a) *fino amezo / la strada; fuori*(?); *Boschetto; Santonofro / Cavaliere del pescia / pescia / p[orta] Santo L[. . .] / Gallero cimato*(?) */ muro alto / Muro basso*; (b) *che Castello rega / questa faccia de/l baluardo; Questo*; (c) **al maschio / *di Castello*; arco grande primo*
Verso: (a) *alla gola di belvedere G[reco] 12; alla pigna T[ramontana] 32; al maschio di Castello T[ramontana] 9; alla sponda del boschetto M[eridione] 22¹/₂; campanile di Santonofri M[eridione] 22; punta del Cavaliere delpescia M[eridione] 15; Casa del gallero M[eridione] 9; Casa del pescia M[eridione] 7¹/₂; tonino; alla gola de belvedere T[ramontana] 15¹/₂; al mezo elmaschio di Castello O[stro] 22; al mezo la porta atorione O[stro] 7; al principio del muro della guardia O[stro] 2¹/₂; alla porta del boschetto S[cirocco] 15; al campanile di Santonofrio S[cirocco] 38; alla punta del Cavaliere delpescia S[cirocco] 30; alla Casa del gallero S[cirocco] 26; alla Casa delpescia; Cavaliere / vafatto; Basso; fondato;* (b) *torretta; alto; Muro novo; Borbone;* (c) *Dallangolo / di belvedere / al mastio di Castello / S[cirocco] 38; D[al] belvedere alli laure / [. . .] canne 33*

The sheet, unpublished until now and erroneously

considered a plan for the new Via Paolina (Giovannoni, 1959), is in fact a survey drawing of the entire circumference of the Vatican walls and Castel Sant'Angelo, including three triangulations showing the angles and distances from the towers of Nicholas V and that on the Santo Spirito hill. On the recto the walls of the Torrione gate are shown: at bottom (*a*), up to Santo Spirito where a "Boschetto" is indicated, and from there to the "strada," later called the Via della Lungara, where the drawing is interrupted, only to start again in *c*, which again shows the road and continues up to the Ponte Neroniano. Such documentation gives valuable information about this little-known part of the medieval walls, built after Pope Leo IV (847–55) and destroyed, after Antonio's death, in order to construct the definitive sixteenth-century defenses. At *b* are the first four proposals for the bastion of the Porta Santo Spirito, opened on the angle in order to include the gate and with doubled flanks. This form of the Santo Spirito bastion was represented by Bufalini in the 1551 plan of Rome, but never carried out. The state of Castel Sant'Angelo is accurately and minutely delineated (*d*), with the gigantic drum of the antique Mole of Hadrian hemmed in by the walled square with internal measurements of 362 x 363 *palmi*, the small towers on the edges of the square built under Nicholas V, the keep guarding the bridge, and the octagonal platforms, shown in detail, dating from the time of Alexander VI. Also to be noted are the wall of the Bronzea gate that opened on to Via Alessandrina, the Passetto, and the emergency exit toward the Castello fields. The only detail that is inexact shows a small Nicholas V tower on the corner of Via Alessandrina, where one was never built, thereby dispensing with antique decoration at a point that was not strategic for defense.

On the verso, where the design most probably started, *d* shows a more summary sketch of the same Castello, from which, once again, use of compass and polar alignments and survey techniques can be deduced. In *c*, *a*, and *b*, respectively, are the southern segment of the walls, built under Nicholas III; the eastern limit of Nicholas V's walls, with the linkage to the more ancient walls; and the section around the Torrione gate, indicating the so-called "Borbone" point, where Charles of Bourbon, commander of Charles V's army, was mortally wounded on 6 May 1527 during the assault on the Porta Torrione with his Spaniards while the Landesknechts attacked the Santo Spirito hill, assaults that led ultimately to the Sack of Rome. See also U 1016A r. and v., 1020A v., 910A, 939A, 755A.

BIBLIOGRAPHY: ASR, Soldatesche e Galere, busta 15; Piale (1831); Vasari-Milanesi (1878–85) V: 485; Guglielmotti (1880) 93–136; 319–66; Quarenghi (1880) ; Ferri (1885) 167; Lanciani (1902–12) I: 34; Cagiano de Azevedo (1924); Borgatti (1926) 30–144; Grossi Gondi (1933); Gasbarri (1953); Magnuson (1954); Redig De Campos (1959); Prandi (1961); Marconi (1966), 124–25 n. 3; Prandi (1969); Cassanelli (1974) 61–112; Westfall (1974); Gasbarri (1978); Quercioli (1978); Quercioli (1982); Chastel (1983).

F.P.F.

U 1014A *recto*

ANTONIO DA SANGALLO THE YOUNGER
Studies for two triumphal displays for Charles V's entry in Rome, 1536.
Dimensions: 334 x 286 mm.
Technique: Pen and brown ink, various caliper marks.
Paper: Slight reinforcement along the top margin.

INSCRIPTION: (top) *Per la volta / [. . .]della / strada presso / a Sette Soli / di verdura;* (below) *Porta Santo Bastiano*

The lower part of the page contains a perspective sketch of the "Porta Santo Bastiano" arch. The ornamentation of the antique gate seems highly "ephemeral," probably consisting of a framework (of pilaster strips?) painted around the arch and along the corners of the projecting parts, linked by garlands or draperies as well as the canonical trabeation.

The arch with its Serlian motif suggests an ephemeral version of the Palazzo Farnese vestibule, with a central nave covered by a barrel vault, supported by two series of three columns.

The first temporary display consists of an ephemeral decoration of Porta San Sebastiano, with a large medallion in the attic over the barrel vault and two other medallions in each of the two towers (see the final correction to the variation on the right). The second arch, intended for the entrance to the major San Gregorio road near Settizonio ("Sette Soli"), crowned by four statues, might have been a homage paid to the emblem of the "Plus ultra" columns, depicted here as having spirals of greenery.

BIBLIOGRAPHY: Huelsen (1894); Lanciani (1902–12) II: 59; Giovannoni (1959) I: 310; Madonna (1980) fig. 61.

M.F./G.M.

U 1015A *recto*

ANTONIO DA SANGALLO THE YOUNGER
Rome, study for the fortification of the Aventine and San Saba hills, 1537.

Dimensions: 473 x 726 mm.
Technique: Pen and brown ink for the inscription, stylus, pin.
Paper: Thick, folded in four, cut on the edges, and restored on the vertical fold and lower left corner, some yellow stains and a red one.
Drawing Scale: Roman *canne* and *piedi*.

INSCRIPTION: *di Roma; Canne 215 romane quali sono piedi 1612½; Collina Cavaliere al basso dentro alle mura; Casetta; Valletta; Questa Cortina e battuta dentrovia / per fiancho quanto dura el piano non ci si / puo sta [. . .] e non ci si puo stare dentro in bataglia; fino amezo la porta Canne 125 / sono piedi 937½; piano a basso; Canne 89 / sono p[iedi] 667½; Monte di Santo Savo; Santo Savo; Mura; Dalle mura allinterno Canne 164 / sono p[iedi] 1230; Questa Cortina si e battuta dentrovia / dal Cavaliere della Collina quale e fuora / della terra enonsi puo stare alla difesa / in battaglia per essere batuta per fiancho; Canne 134 sono piedi 1005; Canne 30 p[iedi] 225 / Canne 38 p[iedi] 185 / Canne 120 p[iedi] 900 / p[iedi] 330 / valletta; Dalle mura alla Colonna sono canne / 174 quali sono piedi 1305; Colonna; Monte aventino di / scogli di tevertino; marmorata; piano di testacio; monte di Testaccio; muro Canto fiume*

The sheet shows only the traces of preparation for a fair copy, possibly the definitive plan on a grand scale, but it is measured and inscribed in pen and ink. The inscription excludes the desirability of carrying out the external defensive variation because it would be exposed to fire on the flanks outside the wall, just before the Ardeatine bastion. As for the internal defensive solution, the bastions under the main Aventine hill are still three in number, but they are more detailed than in U 1514A and now have the aspect of a tenaille trace, with a bastion added toward the Tiber in order to defend a gate that has been opened on a line with the so-called "marmorata" bank. The Colonnella bastion, referred to here simply as "Colonna," is quite close in dimension and form to the way it would be built. The solution for the reentrant and the gate between the lower Aventine hill and San Saba has been changed instead with respect to U 1019A and 1514A. In fact, we now have a bastion defending the gate linked to a bastion of similar dimensions that straddles the Aurelian walls where the new section of fortification ends. This latter bastion is not capable of flanking the ancient Porta San Paolo, but is linked to the line of fire of the next bastion on the outside of the Aurelian walls, in the direction of the Porta Ardeatina and in front of the "Collina Cavaliere." This area is indicated as dangerous because it might be exposed to bombardment during a siege. Thus the bastioned front

continues, utilizing the Aurelian walls as a curtain, even if for briefer segments than those proposed for the curtains planned *ex novo*. In the case of the external variation, there would be a length of 174 *canne*, or almost 390 meters, between the salients of the two bastions of the Colonna and Porta San Paolo: at the limit, presumably, of the range of the flanking artillery. According to Rocchi (1902), this is the most important drawing of the series, with solutions that precede Pagan and Vauban by more than a century, in particular for the construction of the bastioned front on the external side and for the flanks of the bastions at right angles to the lines of defense rather than the curtain, as was the common practice in the Italian school of fortification in the sixteenth century. See also U 1019A, 1514A, 1431A r. and v., 938A.

BIBLIOGRAPHY: Vasari-Milanesi (1878–85) V: 485; Ferri (1885) 168; Huelsen (1984) 329; Rocchi (1902) I: 181–83; II: pl. XXX; Rocchi (1908) 279; Giovannoni (1959) I: 360; Bellanca (1986) 384–85.

<div align="right">F.P.F.</div>

U 1016A *recto and verso*

ANTONIO DA SANGALLO THE YOUNGER
Rome, studies for the fortification of Castel Sant'Angelo and the Vatican hill, 1542.

Dimensions: 436 x 585 mm.
Technique: Pen and brown ink applied undiluted and thinned.
Paper: Heavy, uncut edges squared on the right and left with double lines, slight yellowing in the middle and on the edges, modern repair patches.

INSCRIPTION, Recto: (around inner circuit) *Sposata*; *Belvedere*; *orto*; *torre biancha*; *porta pertusa*; *Barcho*; *incoronati*; *Monte di Santo / Spirito*; *fiume*

On the left edge of the recto we find the only synthesized study we have of the entire circuit of Vatican defenses, including those of Castel Sant'Angelo. The design includes two proposals that belong together but are not superimposed on one another: an interior circuit in undiluted ink and an exterior circuit in diluted ink, in which Antonio has experimented with the idea of four instead of three bastions from the Belvedere to the Nicholas tower at the summit of the circuit, which then rejoins the interior circuit. In both cases Antonio envisons continuing the curtain inside the angle at the circular tower (the Radio Tower), thereby holding the valley. Although he quickly abandoned this early solution, it was later proposed once again by Montemelli-

no, opposed by Castriotto, and disputed in the meetings convened by Paul III. Another difference between the two circuits concerns advancing or withdrawing the front toward Trastevere and the Gianicolo; in both the solution of the long connection between Castel Sant'Angelo and the Belvedere (toward Prati) appears in embryonic form. All in all, the design contains anticipations of the final solutions that were adopted.

In the sketches at right, Antonio tries out various ways to deal with the defenses of Castel Sant'Angelo, from the simplest rhomboid form, of the sort recommended by Francesco di Giorgio and others, to the pentagonal form, more usual at his time (middle sketch), which implies an intention to follow the bend of the river, leaving intact the watchtower for the bridge built by Alexander VI. In the largest sketch (bottom right), the pentagon is articulated in order to connect more easily with the Vatican Borgo in a form not unlike the one planned later, but never constructed, for the Rocca Paolina, Perugia (see U 1354A). The decision to sacrifice the octagonal platform at the upper level of the castle is made clear here as is Antonio's intention to place the castle at the head (*caput*) of the pentagonal figure.

In an attempt to avoid this sacrifice, the verso shows a study for the transformation of the pentagon into a hexagon and its possible disposition along the river but the final result is shown in the small sketches and on the left half of the recto, where the desire to attain a perfect star and pentagonal form is united with the conservation of the tower ravelin on the bridge and the octagonal platform guarding the existing salients. This solution is confirmed not only by the insertion in the general study of the Vatican defenses on the same recto, but also by the large, detailed, final design of the Castel Sant'Angelo, U 755A.

The construction of the Vatican defenses in their bastioned form was decided in November 1542 (Pastor, 1959), probably the same year in which Paul III convoked the meeting presided over by Alessandro Vitelli and attended by De Marchi, Montemellino, Castriotto, Meleghino, Giovanni Mangone, and Galasso Alghisi (De Marchi, 1599, II: XXXIV). The first stone of the Belvedere bastion was laid, according to Luca Gaurico's horoscope (1552), on 18 April 1543. On 5 February 1545, during a meeting at which Michelangelo was also present, an argument broke out between Antonio the Younger and Montemellino over whether to hold the heights or the valley when planning the bastioned circuit. Michelangelo took part in the argument and that same year presented alterna-

tives that deepened the rift with Antonio. The bastion for the Porta Santo Spirito and the gate itself were not completed for reasons arising from this dispute. After Antonio's death (1546), his job was taken over by Meleghino, whose services had proven useful at the Perugia fortress where he had recently been employed, perhaps as head of the construction site. The definitive form of the circuit was decided on in 1548 and carried out, even if with parts still in earth, by Castriotto, who replaced Michelangelo as co-director with Meleghino after March 1548. The work was finally carried to completion by Francesco Laparelli, who after 1562 also completed the defenses of the Borgo and the bastioned pentagon for Castel Sant'Angelo for Pope Pius IV. In 1568 he also finished the work on the walls, and in all likelihood had a hand in the Belvedere bastion (Marconi, 1967). The attribution of the latter to Michelangelo (Guglielmotti, 1880; Rocchi, 1902) has correctly been questioned (Ackerman, 1961). See also U 1012A r. and v., 1020A v., 910A, 939A, 755A.

BIBLIOGRAPHY: Gaurico (1552) 7; De Marchi (1599); Guglielmotti (1880); Vasari-Milanesi (1878–85) V: 486; Ferri (1885) 167; Borgatti (1890a); Rocchi (1902) I: 195–96; II: pl. XXXIX; Rocchi (1908) 281; Cecchelli (1951); Giovannoni (1959) I: 365; II: fig. 386; Pastor (1959); Ackerman (1961) II: 113–14; Marconi (1966) 118, 122; D'Onofrio (1971); D'Onofrio (1978); Marconi et al. (1978) 392–96; Fancelli (1986) 232; Fiore (1986) 340.

F.P.F.

U 1017A *recto*

ANTONIO DA SANGALLO THE YOUNGER
Rome, study for the fortifications of the Vatican hill from the Swiss tower to the Church of the Incoronati, 1542.
Dimensions: 290 x 424 mm.
Technique: Pen and brown ink.
Paper: Lightweight, folded in eight, restored on the upper edge, trimmed on the lower edge, yellowed on the right.

INSCRIPTION: *Nicola; fondaria; Belvedere; Gallinaro; Canneto; Santo antonino; Cava; Inc; Incoronati*

This is the most complete of the group of Antonio's studies (see U 936A, 937A, 1876A) for a double-bastion solution corresponding to the salient of the existing Nicholas V walls, with the southernmost of the two bastions referred to here as "Santo antonino." In contrast to U 1016A, where a platform was advanced with respect to the tower inscribed "Nicola" (now the

Swiss tower), it emerges from the bastioned front with double embrasures in the gorge. The development of the line of fortifications appears well positioned on the perimeter of the Vatican hill and shows with what apparent ease Antonio was able to address and solve the problem. The largest bastion here would have been the Belvedere bastion, as was the case when construction was finished (see the plan of Rome by G.B. Nolli, 1748). Inside, all the existing walls would have been saved, with the exception of a brief section, built under Nicholas III, which was sacrificed to make room for the curtain between the "Gallinaro" and "Canneto" bastions. The solution proposed here reappears in Barb. lat. 4391, fol. 4 (Biblioteca Apostolica Vaticana) together with the alternatives to a single salient (Marconi, 1966, p. 116), or for defenses withdrawn and in the valley; the latter were insisted upon by Montemellino and vehemently opposed by Antonio, whose opinion would be seconded by his successor, Castriotto. See also U 936A, 1012A r. and v., 1016A r. and v., 939A, 1515A, 937A, 1876A, 1519A, 1524A, 940A r. and v., 1361A, 1018A.

BIBLIOGRAPHY: Maggi, Castriotto (1564) III, XII: 12, 86ff; Ferri (1885) 167; Rocchi (1902) I: 196; II: pl. XLI; Giovannoni (1959) I: 366, II: fig. 389; Ackerman (1961) II: 113–14; Marconi (1966) 112, 116, 118, 122; Marconi et al. (1978) 388–91; Fiore (1986) 340.

F.P.F.

U 1018A *recto*

ANTONIO DA SANGALLO THE YOUNGER
Rome, study for the fortifications of the Vatican hill, 1542.
Dimensions: 526 x 702 mm.
Technique: Pen and brown ink, stylus, ruler, dividers.
Paper: Heavy, folded in half, partially torn; restored along the fold, original edges, stains.

INSCRIPTION: (counterclockwise from lower middle) *Porta di Santo pietro; torrione di papa / nichola; Belvedere; Gallinaro; Canneto; Santo antoni/no; incoro/nati; monti di Santo / Spirito; porta di Santo Spirito; fiume*

The quality and size of the paper, and the careful rendering in scale, even without measurements, as well as the advanced stage of the solutions presented lead one to think of this as close to Antonio's final plan for the Vatican fortifications rather than just a simple study. This plan would be followed closely in the design, which is thought to be derivative of Antonio's plan (Biblioteca Apostolica Vaticana, Barb. lat. 4391, fol.

4; see Marconi, 1966). It contains all the most brilliant and practical solutions in the series for the Vatican hill: the large Belvedere bastion, followed by the smaller Gallinaro and Canneto bastions (see U 940A); the single summit bastion, Sant'Antonino, which is even larger here than the Belvedere and slightly bent in order to better protect the south slope (see U 1519A, 1876A); the Incoronati platform (see U 1524A); and the Porta Santo Spirito set in the salient of the bastion (see U 1012A, 1016A). In addition, the design indicates the thickness of the walls with the position of the double embrasures in the flanks, and even the firing chambers at Incoronati and Santo Spirito. Also indicated briefly are the existing structures that conditioned the proposed fortifications, such as the Villa Belvedere, the edge of the hill up to the farthest part of the Nicholas III walls, and the walls built at the edge of the hills under Nicholas V, who is mentioned specifically in the drawing because the tower (now called Swiss tower) guarding the Porta San Pietro was conserved. Despite the ensuing debate on the best way to deal with the bastioned walls on the Vatican hill (the well-known solution advocated by Antonio the Younger and Michelangelo in late 1545, as well as the definitive plan drawn up in 1548), Antonio's design here was the basis for all successive solutions, even those that finally led to greater strengthening of the hill. In these proposals the Sant'Antonino bastion was shortened in order to flank it with two other bastions that would make the coverage of the walls more articulate and efficient. The Porta Santo Spirito would be built by Antonio himself, much as indicated in the design—inside the salient of the bastion, as already contemplated in U 1012A. Work on the gate and the face of the bastion toward the river of the Porta Santo Spirito, for which a contract exists, dated 25 September 1545 (Bentivoglio, 1985), most certainly began earlier, after May 1543 (Ravioli, 1887), allowing Antonio ample time to supervise the construction. See also U 1012A r. and v., 1016A r. and v., 939A, 1515A, 1017A, 937A, 936A, 1876A, 1519A, 1524A, 940A r. and v., 1361A.

BIBLIOGRAPHY: Vasari-Milanesi (1878–85) V: 486; Ferri (1885) 167; Ravioli (1887–90); Rocchi (1902) I: 196; II: pl. XL; Rocchi (1908) 281; Giovannoni (1959) I: 365; Marconi (1966) 118, 122; Bentivoglio (1985); Fiore (1986) 340.

F.P.F.

U 1019A recto

ANTONIO DA SANGALLO THE YOUNGER
Rome, study for the fortification of the Aventine and San Saba hills, 1537.

Dimensions: 262 x 412 mm.
Technique: Pen and brown ink, red pencil.
Paper: Cut on three sides (not at top), yellowed and restored on the left side, folded vertically at center.
Drawing Scale: Roman *canne* and *palmi*.

INSCRIPTION: (from lower left) *Santo lazero; da marmorata alpontone / pasato Santo lazero passi 180 / C[anne]; ficuna; Colonella; Ca[nne] 174 dalla / Colonella fino / alla porta; valletta; monte mu/rato; Muro; [canne] 164 in tutto; torre ottava; p[almi] 600 la lungheza / a p[almi] trecento lalteza*

The design, freehand but measured and carefully set out, is one of the first of Antonio the Younger's studies for the fortification of the left bank of the Tiber, starting at the river and extending the new defenses along the heights of both Aventine hills and the Santa Saba hill up to the Aurelian walls. The walls would meet at the "torre ottava" (eighth tower), counting from the Porta San Paolo, formerly the porta Ostiensis, near the pyramid of Caius Cestus. This detail is drawn in reverse on the right and shows the same Aurelian walls from the Porta San Paolo up to the reentrant preceding the Porta Ardeatina, which was later replaced by a bastion designed by Antonio. The architect's planning method can easily be deduced from the design: In order to lay out the bastioned front, he traces a broken line corresponding to the slope of the topography where he intends to take up positions; there he obtains the first alignment of the face of the bastions, with internal, orthogonal flanks and curtain walls. The flanks, meant to protect the new gate between the lower Aventine hill and San Saba, are inclined differently. Overall, the new walls would have followed the ancient trace of the Servian walls, still existent here and there and marked as "monte mu/rato" and "Muro." The new gate, in turn, would have been placed where the ancient porta Rauduscu-lana once opened. By moving back the new line of defense from the Aurelian walls, Antonio also would have gained the highest and strongest position. The walls would have been kept as short as possible, overlooking the valley, the two banks of the Tiber, and the ancient Aurelian walls; the latter were left both as a first defense toward Monte Testaccio and as testimony to the city's ancient face to the world.

The Colonnella bastion was the only part of this plan to be constructed between October 1537 and September 1539, though it was built without its flank toward the Tiber. As for the San Saba bastion, work was interrupted in January 1539, and only the foun-

dations were built. Rocchi (1908) testifies to the remains of such walls, south of the Church of San Saba. Beyond the Porta San Paolo, the Ardeatine bastion would not be completed until April 1542.

The proposals for Roman defenses that Paul III wanted to renovate came less than three years after he became pope, and represent a response not only to the sack of the city in 1527 but also to the possible threat of pirate raids (Guglielmotti, 1880). (It is true, however, that the capture of Tunis [1535] eliminated any such motivation and thus leads us to question Paul's motives.) The commission was given to Antonio officially on 24 January 1538, when he was nominated "fabricae murorum almae Urbis nostrae" (Muentz, 1886). The interruption of work on the left bank, which had turned out to be costly as well as prolonged, cannot be justified so much by lack of funds as by changes in papal priorities and objectives, including the new danger to Rome posed by the defeat at Algiers (1541). In fact, after 1542, it was decided to fortify, first of all, the Vatican hill, on the right bank, with St. Peter's and the Vatican palaces—an undertaking not only more urgent but easier to build; on 18 April 1543, the foundation stone was laid for the Santo Spirito bastion. The danger to the papal government of extensive fortifications, built first on the left rather than the right bank, and requiring a large garrison that might be hard to control, while the Vatican hill itself was undefended, surely influenced the decision. According to De Marchi (1599, III: XXXIV), the entire city would have been fortified with at least eighteen bastions had the plan submitted by Antonio to the pope and his experts been accepted. See also U 1514A, 1015A, 1431A r. and v., 938A.

BIBLIOGRAPHY: ASR, Soldatesche e Galere, busta 15; Ravioli (1863); Guglielmotti (1880) 337; Vasari-Milanesi (1878–85) V: 486; Quarenghi (1880); Quarenghi (1882); Ravioli (1882); Ferri (1885) 168; Muentz (1886); Ravioli (1887); Huelsen (1894) 329; Rocchi (1902) I: 180; II: pl. XXXIX; Lanciani (1902–12); Rocchi (1908); Giovannoni (1959) I: 361; II: 58–63 II: fig. 387; Pastor (1959); Marconi (1966); Cozzi (1968); Cassanelli (1974); Pepper (1976); Marconi et al. (1978) 384–91; Bellanca (1986) 384; Fiore (1986) 338.

F.P.F.

U 1020A recto

ANTONIO DA SANGALLO THE YOUNGER
Ancona, plan of fortress, 1534–35(?).

Dimensions: 265 x 212 mm.
Technique: Pen and brown ink.
Paper: Folded in half, upper margin restored, lower margin trimmed.

INSCRIPTION: (from top to bottom) *porta di santo pietro; porta del calamo; Santo Francesco; Santo Spirito; per la rocha di anchona; Bastioni vechi; Cisterna*

Despite the later annotation on the verso, this recto is in fact a relatively early attempt by Antonio the Younger to provide an overall plan for the fortress at Ancona. It can probably can be dated to 1532–34, that is to say, after his first documented visit (January 1532) and the date of the dedicatory inscription on the citadel (see U 978A).

In this drawing Antonio is still feeling his way through the topography of the Astagno. Note that he is concerned to annotate the drawing with the location of the earlier walls ("bastioni vechi") and the drawing contains variant solutions. The preexisting churches of Santo Spirito and San Francesco, destroyed to make room for the fortress, are shown. The northern defense wall is marked in a simplified form before the addition of the new bastions.

U 1020A r. is a relatively early example of Antonio the Younger's adjustment of the polygonal fortress type to the local topography. The hand is firm and clear, yet the design is not rigid. Antonio is always ready to make adjustments and improvements. Similar examples can be seen at Castro (U 753A) and Perugia (U 1023A).

The view of the port (U 978A) may probably be dated before this sheet. The plan of the northern defense (U 1526A) may probably be dated after it. Fiore also associates U 1502A with Ancona. Note that the fortress at Ancona is much changed. In the 1570's a hornwork was added by Francesco Paciotto and his son Orazio.

BIBLIOGRAPHY: Ferri (1885) 6; Natalucci (1960) II: 21–45, fig. 6; Natalucci (1964); *Ancona e le Marche nel Cinquecento* (1982) 206; Fiore (1986) 336–37.

N.A./S.P.

U 1020A verso

ANTONIO DA SANGALLO THE YOUNGER
Rome, studies for the fortification of Castel Sant'Angelo, 1542.
Dimensions and Paper: See U 1020A recto.
Technique: Pen and brown ink.

INSCRIPTION: (later hand) *per Castello Santo agniolo; Disegni*

The study proposes a new defensive front for the Castel Sant'Angelo in Rome: two bastions and a cavalier in the form of an acute platform. A choice between three bastions or two is then presented, with a ravelin beyond the moat guarding a gate, toward Prati. Antonio finally opted for the pentagonal solution—as in other designs for the Vatican walls, possibly because it had more symbolic value and was easier to defend militarily—but not without first developing a last alternative with six salients as in U 910A and 939A. In any event, this sheet is a preparatory study, as can be seen by what appears on the right to be a canal with a lock for regulating the flow of water to the moat with a sluice upstream, an idea that would later be abandoned; furthermore, the design was done on a page that had been used before (see recto). Still, a dating of this study well before the recto cannot be excluded; in that case, the study would be a first hypothesis, jotted down well before more comprehensive plans for the defense of the Vatican hill, possibly as far back as 1534–35 and certainly even preceding other studies for the defense of the left bank in Rome. See also U 1012A r. and v., 1016A r. and v., 910A, 939A, 755A.

BIBLIOGRAPHY: Vasari-Milanesi (1878–85) V: 486; Rocchi (1902) I: 194; II: pl. XXXVIII; Fiore (1986) 340.

F.P.F.

U 1021A *recto*

ANTONIO DA SANGALLO THE YOUNGER
Perugia, Rocca Paolina, plan and facade elevation of the upper fortress, summer 1540.
Dimensions: 446 x 583 mm.
Technique: Pen and brown ink, light brown wash, stylus, pin, straightedge.
Paper: Folded into eight, darkened at edges.
Drawing Scale: braccia (100 *braccia* = 103 mm).

INSCRIPTION, Recto: (at top, unknown hand) *Facciata del palazzo di perugia*; (to left) *archo di mezo*; *palazzo di Signore gentile*; *strada che va al basso*; *strada*; *palazzo chera del Signore ridolfo / & del signore braccio*; *sapienza nuova*
Verso: *facciata del palazzo di perugia* (hand of Antonio the Younger)

Closely related to U 1510A, which shows the entire length of the proposed city facade for the Rocca Paolina, the drawing shows Antonio's original conception of the facade. The verso bears a note that the draw-ing shows "the facade of the palace." For further discussion of the relation between civilian and military symbolism in the facade of the Rocca Paolina, and the changes in design, see U 1510A. The drawing represents an interesting intermediate stage following the determination of the plan for the upper fortress (see U 271A), and at a time when the elevation is just being established. A likely terminus ante quem is 30 June 1540 when lines were laid and drawings sent to the pope in Rome.

The drawing is also interesting for the various uses of a dry stylus within the drawing process. Stylus lines are used to provide for the accuracy of the plan and to denote direction or potential direction of fire. Stylus marks are also used to connect the cornice lines of the fortress facade.

BIBLIOGRAPHY: Ferri (1885) 110; Giovannoni (1959) I: 353, 354, 432; II: fig. 366; Camerieri, Palombaro (1988) fig. 22.

N.A./S.P.

U 1022A *recto*

ANTONIO DA SANGALLO THE YOUNGER
Perugia, Rocca Paolina, studies of Colle Landone, summer 1540.
Dimensions: 222 x 302 mm (including modern support).
Technique: Pen and brown ink (at right) over reddish brown chalk.
Paper: Darkened at edges.

INSCRIPTION, Recto: (left) *mo*[. . .]; (at right, top to bottom) *Torre dove stare / lorloggio*; *Chiesa delli frati di / servi sta in alto / 4 canne piu che / la parte di sotto*; *piaza de servi / e di malatesta*; *muro anticho della citta di / quadri di Tevertino*; *questa parte e piu baso lo terreno / 4 canne che Servi*; *La ditta chiesa de servi e in alto / e se ne potria fare (la rohe* canceled) *la rocha perche / a buone mura*; (later hand) *cose di perugia*
Verso: (upper right) *Cose Di perugia*

Planning on the Rocca Paolina could have consumed little more than a month from the end of May to the end of June 1540 when lines were laid. U 1022A r. must be among the earlier studies of the site (see also U 1023A): The fortress is shown in a rough, generic military plan and the buildings on the Colle Landone, the site of the future fortress, are also noted.

The sheet was executed first in reddish brown chalk (on site?) and was then reinforced in pen and ink (in the studio?). In the sheet Antonio notes the preexistent church of Santa Maria dei Servi (later destroyed for the construction of the fortress) and the site of the

old walls of the city which he hoped to use as part of the fortress. Additional notes refer to topographic variations on site. The annotation "cose di perugia" on the recto is by someone other than Antonio the Younger, whom we cannot identify. But a similar note on the verso is by Antonio; it may be intended to aid the workshop archive of the drawings.

Though Giovannoni claimed to see the hand of Bartolomeo de' Rocchi in this sheet, it seems to us to be entirely in the hand of Antonio the Younger with the exception noted in the paragraph above.

BIBLIOGRAPHY: Ferri (1885) 110; Giovannoni (1959) I: 353; Camerieri, Palombaro (1988) 36, 39, fig. 2.

N.A./S.P.

U 1023A *recto*

ANTONIO DA SANGALLO THE YOUNGER
Perugia, panoramic view of the city, summer 1540.
Dimensions: 259 x 792 mm (approximate original maximum size); present modern support 327 x 820 mm.
Technique: Pen and brown ink, some reddish marks (ink? possibly applied accidentally).
Paper: Two sheets mounted on modern support, sheet to right overlaps smaller sheet to left, modern hinge at center.

INSCRIPTION: *porta a San / giuliano*; *G*; *sto pietro*

The drawing shows a panoramic view of the Colle Landone in Perugia prior to the construction of the Rocca Paolina (begun June 1540). The drawing may form part of Antonio the Younger's exploration of the city on an early visit at that time.

At the far right can be seen the church of San Pietro, and in the foreground center is Porta Eburnea and Porta San Prospero. At the top left and center are the Duomo and Palazzo Comunale; to the far left Antonio has marked a "porta a San giuliano," probably the Porta San Galigano, which stands at approximately this position.

Although the view seems to have been taken from a single viewing point, in fact it must have been constructed from at least two points, as it is not possible to see both San Pietro and Porta San Galigano from a single point. This would argue in favor of the drawing as an *aide mémoire,* as part of the preliminary studies for the Rocca Paolina.

BIBLIOGRAPHY: Ferri (1885) 110; Giovannoni (1959) I: 353, 432; Grohmann (1981a) 93, fig. 80; Camerieri, Palombaro (1988) fig. 1.

N.A./S.P.

U 1024A *recto*

ANTONIO DA SANGALLO THE YOUNGER
Perugia, Rocca Paolina, studies for embrasures, palace facing Santa Maria dei Servi, summer 1540.
Dimensions: 285 x 210 mm.
Technique: Pen and brown ink.
Paper: Darkened at edges.

INSCRIPTION, Recto: *tutto lo diametro sie; tutto lo diametro si 910; La circumferentia sie 2772; questa e bona; lo moduli in minuti 14; Lo diamitro sie 63 moduli minuti 85½ lo sette mosio 126 / in circumferentia sie 198 moduli minuti (882 canceled) 2772; A; A Buttafuocho; in le loggie del cortile de / la rocha le volte non abino / lunette alla muro / solo le abino alle pilastre;* (on added small insert in a new hand) *schizi della rocha / di perugia*
Verso: (in pencil) *Perugia*

The drawing shows the portal of a palace, destroyed in the construction of the Rocca Paolina, facing the church of Santa Maria dei Servi. Above are two studies of embrasures for the Rocca Paolina. The triple embrasure, to enable maximum traverse, is a defensive feature of particular interest to Antonio the Younger for it could be adapted economically to a preexisting wall. Here he studies how it can be employed within a recessed angle. (Comparable studies on a straight wall can be seen for Piacenza, U 807A.)

Although cited by Giovannoni (1959) as the work of Aristotile, in our opinion the drawing is entirely in the hand of Antonio the Younger and is to be dated to the early phase of work on the Rocca Paolina as the palace, later destroyed for the fortress, would indicate. The detail of the sketch of the portal and its annotations suggest that Antonio may have planned to salvage the portal for use in the more "civilian" palace-fortress envisioned initially, in much the same way as was done with the Etruscan gate (see U 1043A).

BIBLIOGRAPHY: Ferri (1885) 110; Giovannoni (1959) I: 354, 432; Camerieri, Palombaro (1988) fig. 29.

N.A./S.P.

U 1025A *recto*

ANTONIO DA SANGALLO THE YOUNGER
Perugia, plan of city walls, Etruscan inscription, summer 1540.
Dimensions: 212 x 277 mm.
Technique: Pen and brown ink.
Paper: Folded in quarters; darkened at edges.

INSCRIPTION, Recto: (top left) *JANMVS IPFIANI*; *questa e*

rotta; Lettere etrusche in el fiancho del portone / di San Servino del prima cerchio delle / mura de perugia fatte di quadri / di tevertino senza calcina; Servi; archo di Servito; torri; filo del [. . .]
Verso: (later hand, in pencil) *Sangallo Ant. il giov.*

As part of the construction of the Rocca Paolina in the summer of 1540 the team of Antonio the Younger and Jacopo Melighino had to undertake surveys of the pre-existent walls. Antonio uses the painstaking method of measuring section by section often used during the sixteenth century in these circumstances. This sheet may be dated prior to U 1029A, which makes use of these measurements for laying out the lower fortress of San Cataldo.

This study of the Etruscan-Roman walls ("del prima cerchio") near the church of Santa Maria dei Servi includes notations on the nature of the construction ("fatte di quadri di tevertino senza calcina") as well as a short Etruscan inscription. Even during the construction of the fortress Antonio uses the occasion to undertake studies of an archaeological nature. (The discovery of a cache of ancient sculpture and coins during January 1541 brought construction on the fortress to a brief halt while the architect inspected it.)

BIBLIOGRAPHY: Ferri (1885) 110; Camerieri, Palombaro (1988) 37, fig. 25

N.A./S.P.

U 1026A *recto and verso*

ANTONIO DA SANGALLO THE YOUNGER
Perugia, studies of the Baglione neighborhoods and the Colle Landone for the construction of the Rocca Paolina (*recto*). Plan of fortress; plan of the Church of Santa Maria dei Servi (*verso*). Summer 1540.
Dimensions: 286 x 434 mm.
Technique: Pen and brown ink, red chalk.
Paper: Paper folded into quarters, partial new support, surface abraded.

INSCRIPTION, Recto, Left half: (in red chalk) *strada; piaza; sapientia;* Right half: (in pen and brown ink) *torre; chiesa; torre di braccio;* (*M. 11 allangioli* canceled); *al monasterio p.1; puntone;* (*p. 15 allaguardiola* canceled); *Casa; Casa; torre del signio / gentile; alliangioli; ponente 15 alla guardiola*
Verso: *sapientia nova; Cortile*

Among the survey drawings that survive from the preliminary planning for the Rocca Paolina in the early summer of 1540, drawing U 1026A is one of the most important. Along with U 1029A and 1032A it shows

the extensive use of triangulation made by Antonio the Younger. It is also interesting for the mixture of media (red chalk, pen, and brown ink) suggesting that some topographical studies, at least, were undertaken in two phases: chalk first (on site?) and ink second (in the workshop?).

On the recto, to the right, Antonio the Younger uses the tower of Braccio Baglione as the point from which to undertake the beginnings of a plane-table survey (distances and compass bearings are marked); to the left is a plan of the streets, piazze, and buildings in the area of the Sapienza Nuova. On the verso is an early plan proposal for the Rocca Paolina and the Church of Santa Maria dei Servi.

BIBLIOGRAPHY: Ferri (1885) 110; Grohmann (1981) fig. 81; Giovannoni (1959) I: 353, 432; Camerieri, Palombaro (1988), figs. 25, 26.

N.A./S.P.

U 1027A *recto and verso*

ANTONIO DA SANGALLO THE YOUNGER
Perugia, Rocca Paolina, studies in plan and section for the lower fortress of San Cataldo, summer 1540.
Dimensions: 591 x 444 mm.
Technique: Pen and brown ink, straightedge.
Paper: Single sheet heavily folded in middle, darkened at edges, partial new support.
Drawing Scale: Roman *palmi.*

INSCRIPTION, Recto, Upper half: *questo serva per lo fiancho di santo Cataldo / e per quello della ponte; Alli due fianchi di baluardi da basso le Canno/niere saranno sopra al cordone perche anno / attirare allo in su; Le Cannoniere di fianchi diverso Santo Juliano / anno astare come questi;* (above bastion) *Questo abia la pendenza* (*del principio della scarpa* canceled) / *che ara el cordone;* (to right) *el maschio da qui in su;* (to left second floor) *Questo abbia la pendentia che ara /* (*lo principio dela scarpa* canceled) / *el cordone; archibusieri; questo abia di scarpa uno palmo e mezo per canne;* (lower level) *queste piaze pendino/* (*3 quarti di* canceled) *mezo palma per canna;* (to left first floor) *scoperta;* (to right) *queste piaze abbino di pendentia* (*li tre quarti di* canceled) *mezo palmo per canna; tutto palmi* (149 canceled) 150; (at far right embrasure) *Tutte le mura el cordone anno avere di scarpa uno palmo e mezo / per canna; per le Cannoniere della / rocha; Le bochette / sieno large / palmi 3 ala / palmi 5 el voto;* Lower half: (fortress plan) *strada; Cosi vole / stati; Santo Juliana;* (plan of bastion at curtain, right) *Casamatta;* (on ditch) *Dal pie della scarpa di questo baluar/do perfino al pie della scarpa del fian/cho quanto tira questa linia fara / palmi 124; fosso; scarpa; schiena da fino* [. . .]; *scarpa;* (bottom) *questo muro /*

sia grosso in / fondo palmi 25; In questo muro / bisognia lasare / una busa donde / possa uscire laqua / che piove nel fosso / e Cose dallaltra ba/nda
Verso, Bottom half: (plan of the lower work, along scarp at bottom left) in cima 12; in fondo 16; (bottom) in piano sia lo cielo / lo di sotto / in quanta / buono; (section through casemate) buttofuocho; piaza della casamatta; camino; palmi 6; (to right) porta; porta

U 1027A r. and v. contains studies of the *tenaglia* and casemates of the lower fortress of San Cataldo at the Rocca Paolina in Perugia. Both are probably preparatory studies resolved more fully on U 1029 and 271A and were probably executed at the same time as U 1030A.

Both recto and verso mix plan and perspective sections in order to clarify the nature of the interior spaces and are largely drawn freehand (see also U 1030A). The connection between the corridor and the lower fortress presented special problems, notably for the placement of the heavier artillery (see U 1027A v.). Extensive notes on the embrasures of this area can also be seen on U 1030A.

Drawings such as U 1029A, balancing formal exploration with definition, were critical for progress on so large a building. One of Antonio the Younger's abilities, something that obviously recommended him to Paul III at St. Peter's, was his extraordinary ability to plan, design, and build at the same time.

BIBLIOGRAPHY: Ferri (1885) 110; Bacile di Castiglione (1903) 360–61, fig. 12; Giovannoni (1959) I: 356, 432; Grohmann (1981a) fig. 82; Camerieri, Palombaro (1988) 94, figs. 20, 21.

N.A./S.P.

U 1028A *recto and verso*

ANTONIO DA SANGALLO THE YOUNGER
Perugia, topographical study plan, summer 1540.
Dimensions: 395 x 540 mm.
Technique: Pen and brown ink.
Paper: Darkened along one edge.

INSCRIPTION, Recto: (clockwise from lower left) *piaza; Santo lorenzo; piaza; monte di santo / severo altissi/mo dovera gia / la rocha; valle; Borgo di Santo Antonio piu basso / assai che Santo Severo; Coritoro & / mura Ca/stellani; porta Santo / antonio;* (next to dotted line) *Bisognia / aconciala / cosi;* (within bastion) *monte / Cavalie/re; nova; Collina; questa era gia una / rochetta da pigliare / el socorso & per lo Coritor/o andava alla rocha / chera gia in sul monte di / Santo Severo; valle profonda; chiesa; per questa valle / non puo venire /*

lartiglieria e giunta / presso alla muraglia / ne ricetto alto quanto la / muraglia dove si puo / piantare lartiglieria / e de Cavaliere al borgo di Santo antonio / e pero anno fatto dentro in el puntone / uno Cavalieretto dove puo stare due pezi de artiglieria; valle profonda; porta; alporta Santo Janni; (within dotted lines at top) *monte che sporgie / in fora bisognia / pigliarlo perche / guadagnia la vista / di tutte le / valle e toglie / questo locho / al nimicho; vechio;* (within the walls) *questo locho qui dinanzi / e necesario pigliarlo perche / e alto quanto la terra e grandezza dove / si potrebbe condurre lartiglieria / e battere in molti locchi della citta o fare molte / osevisioni olta alla batteria che puo / fare ordinaria monti in questa fronte / dove non i fianchi; santo / pietro; valle;* (at right within dotted lines) *novo; porta Santo / Pietro; porta Santo pietro; collina; ritirata / overo / riparo fatto / per le Signore Malate/sta;* (bottom right) *per questa Collina si / puo Condurre larteglia/ria facilmente perche / viene montando in verso / la terra faciole e dolce/mente e va sempre montando / fino alla porta e percio / questa porta bisognia aco/nciarla e dove le mura sono / inpochate e non ci si puo stare su / acombattere bisognia sbassarle / e ridurle a terrapiena perche si stia / in sul terreno a difendere perchel terre/no di dentro e piu alto cheldiforo / piu di tre Canne terreno fermo e sodo / cioe giardini in creta; da questa banda se deba mantiene dentro Santo Juliana secondo el parero di molti ma si potria fare senza*
Verso: *si potria anchora fare la rocha in sulle mura / diverso Santa giuliana allaltro muro piu in / dentro a meza via del muro anticho de/lla terra perche quanto piu fussi discosto dal / muro anticho saria mancho cavalierata / dallalto della terra siche bisognia fare / de due partiti luno o pigliare uno pocho / dellalto sopra el muro anticho insieme / Colbasso overamente discostari dallalto / piu che si puo e fare uno Coritoro che va da / di Casa lo legato fino alla rocha e buttare / in terra santa giuliana e se a da notare / che da questa banda la campagnia e piu larga / che da banda nisuna e piu piano e piu / abile alvenire el sochorso che banda vi saria*

Dalla muraglia anticha perfino alla mo/derna sono piu di 100 canne; (drawing at right from top to bottom) *piaza; Isola; osteria di Santo marcho; A; Sellari; Casa di mala/testa; Casa di me/sser gentile; servi; piaza; portoni; Case; muro anticho; Si potria fare cosi fortifichare la casa / di malatesta nellalto e di poi nel basso / fussi lo restante della rocha e Col tempo / si potria levare linsola segniata A e ditta rocha ne veneria in piaza; Canne 100; muro moderno; Canne 100 in circha; porta di / Santa Juliano; Santa Juliana / loco elevato ma / piu basso chella citta / per meza costa*

This fascinating sheet represents an early topographical and strategic study of the site of Perugia in the hand of Antonio the Younger. The drawing is entirely freehand in pen and ink and was probably executed on site.

One can imagine the architect on foot or on horse, drawing board in hand and inkwell looped over his free hand while he worked on the sheet. The preexisting walls are sketched in a continuous line and proposals are shown with a dotted line. The hills around Perugia are shown in a crumbly continuous line representing the contours. Undertaken during the early phases of planning for the Rocca Paolina, it recalls a similar study by Antonio the Younger for the Pincio ridge in Rome (U 301A) and is probably to be dated at approximately the same time as U 1023A. Giovannoni (1959, I: pp. 353–54) calls the sheet an intermediate solution; he notes that Antonio the Younger seems to refer to two solutions for the fortress, either palazzo-castello or *rocca*, and he refers to the note that "si potria fare la rocha" near Santa Giuliana (Giovannoni 1959, I: p. 355) as if an alternative were possible. Camerieri and Palombaro date the drawing to the early phases of planning and seem to imply that Antonio the Younger's first assignment was to evaluate alternative sites. (This would accord with their contention that the Rocca Paolina as built was not really the work of Antonio the Younger.) They cite the inscription on the verso that refers to building across the Santa Giuliana area and toward the east.

It is clear from this drawing that Antonio the Younger did undertake a study of the defense of the entire city of Perugia. On this sheet are measurements from the area of Colle Sole as well as the areas later occupied by the Rocca Paolina. In all likelihood the drawing was made as planning was beginning on the Rocca Paolina, though the site for the Rocca seems never to have been in doubt—after all, proposals probably already existed by Pier Francesco da Viterbo, which Antonio the Younger was reminded to respect in an undated letter published by Ronchini. Various people were involved at the beginning of Antonio the Younger's work, and it is even possible that the examination of the entire site was undertaken to calm the population that feared a fortress. For example, a note on the sheet refers to the opinion "di molti" regarding Santa Giuliana, suggesting that in this drawing Antonio the Younger was working closely with a group of advisers.

On the verso is a plan of the houses of the Baglione family in the area of San Cataldo and Santa Giuliana that were cleared when the Rocca Paolina was built.

BIBLIOGRAPHY: Ferri (1885) 110; Giovannoni (1959) I: 353, 354, 355, 432; Camerieri, Palombaro (1988) 29–32, figs. 4, 5.

N.A./S.P.

U 1029A *recto and verso*

ANTONIO DA SANGALLO THE YOUNGER
Perugia, plans for Rocca Paolina, summer 1540.
Dimensions: 439 x 299 mm.
Technique: Pen and brown ink.
Paper: Heavy, folded in four, darkened at edge.
Drawing Scale: Roman *palmi*.

INSCRIPTION, Recto: (in middle) *A 29 alla torre / del Signore gentile*; (top right) *M[aestro] 36 al canpanile / di Santo pietro*; *M[aestro] 20 allangolo*; *M[aestro] lo allangolo della / terra*; *M[aestro] 24 al cantarile*; *S[cirocco] 44 alla fine della mura [. . .]*; *L[evante] 8 alla torre del Signore gentile* Verso: (clockwise from top left) *tus & semis; tussemis & exei de Semis & exeis / due partis altitudine lumine co/nstituantur*; (to right) *orto delle monache*; (below left) *muro anticho*

Among the early drawings for the plan and layout of the Rocca Paolina in Perugia U 1029A is the critical sheet (see also U 1026A). The sheet is extensively discussed by Camerieri and Palombaro, to whom we are indebted for the identification of a number of features on the drawing.

The recto shows a provisional plan for the upper fortress on the Colle Landone, and a mixture of tentative layout sketches and survey or setting-out dimensions for the lower fortress of San Cataldo. The form of the lower fortress is shown with the triangulation lines that are being used to fix its place on the preexistent urban topography. Note that the Etruscan-Roman wall is shown more precisely mapped on U 1025A. The inscriptions make it clear that at this early stage compass bearings are used (see Camerieri and Palombaro). On the verso are topographic notes concerning the so-called *orto delle monache* of the San Cataldo and Monastery delle Vergini complex.

The placement of the enormous fortress of the Rocca Paolina within the dense urban fabric of Perugia must have consumed a great deal of time in the early phases of planning, as this drawing shows. This drawing must be dated just prior to U 271A and 272A, which largely fix the form of the fortress.

BIBLIOGRAPHY: Ferri (1885) 110; Camerieri, Palombaro (1988) 40–43, 90, figs. 13, 14.

N.A./S.P.

U 1030A *recto*

ANTONIO DA SANGALLO THE YOUNGER
Perugia, Rocca Paolina, study of the west flank of the fortress of San Cataldo, summer 1540 .

Dimensions: 435 x 292 mm.
Technique: Pen and brown ink.
Paper: Very thin, folded in half.

INSCRIPTION: (above) *per lo maschio vorria stare cosi*

In this study of the west flank of the fortress of San Cataldo at the Rocca Paolina, Antonio the Younger has examined the proposed *mastio* (effectively a cavalier because of its proximity to the wall) and its relation to the flank. The wall shows vestigal merlons, a rather old-fashioned form, coupled with protective parapets and covers not unlike those used by Baldassarre Peruzzi at the San Viene bastion, Siena (1528–32). In addition, there are shown the two tiers of flank batteries as at the Ardeatine Bastion, Rome. Below are studies of a *puntone* placed in the angle of a polygonal salient to remove the blind spot.

BIBLIOGRAPHY: Ferri (1885) 110; Giovannoni (1959) I: 354, 356; II: figs. 363, 365; Marconi et al. (1978) 427; Camerieri, Palombaro (1988) 77, 100, fig. 16.

N.A./S.P.

U 1030A *verso*

ANTONIO DA SANGALLO THE YOUNGER
Perugia, Rocca Paolina, (top) details of parapets, fire steps, and embrasures giving potential elevation or depression of fire; (below) section through casemate to wall showing potential elevation or depression of fire; 1540.
Dimensions and Paper: See U 1030 recto.
Technique: Pen and brown ink.
Drawing Scale: palmi.

INSCRIPTION: (from left) *Casa lo Signiore braccio perche piu alto / dal suo piano dal mattonato del Signiore gentile / palmi due e mezo si fara Con queste mi/sure qui dappie*; (below) *piano del mattonato / del Signore brachio piu alto che quello / del Signore gentile palmi 2¹/₂*; (to right) *palmi .ii. grossi qui / filo di muro; piano del matonato (di braccio* canceled*) / del Signore gentile si possono fare come / questo disegnio e cosi in le torri / si puo in tutta due dette torre tenensi / Colli loro piani al piano di quella del Signore / gentile e servira a questo disegnio*; (below, two sections showing alternative embrasure positions) *Queste misure di questa faccia / non sono bone bisognia governir/si Colle simile che sono in laltra / carta di la*; (at right) *questo parapetto si e piu alto / chel piano de mattonati del Signore / Braccio p[almi] 15*; (below) (*in la casa di braccio / per lo palazo viene cosi* canceled)

All military architecture required the effective placement of cannon. Even so, we rarely see this aspect of the military architect's work. In this drawing, however, we can see how Antonio the Younger planned the placement of the cannon within the embrasures and the design of the fire steps at the edge of the rampart of the upper fortress at the Rocca Paolina. Note that the cannon is shown mounted on a carriage with approximately a 20-degree angle of depression.

BIBLIOGRAPHY: Ferri (1885) 110; Giovannoni (1959) I: 354, 356, Marconi et al. (1978) 427; Camerieri, Palombaro (1988) 47, fig. 17.

N.A./S.P.

U 1031A *recto*

BERNARDINO NAVARRO(?) WITH ANNOTATIONS BY ANTONIO DA SANGALLO THE YOUNGER
Perugia, entry portal on Via del Bucaccio, summer 1534.

a e
b c d

Dimensions: 292 x 425 mm.
Technique: Pen and brown ink.
Paper: Folded in four, extensively repaired.

INSCRIPTION, Recto: (a, not by Antonio the Younger) *Scianfrancesco*; *San Savini*; (hand of Antonio the Younger) *S. Savini*; *Dal monte alla terra uno tiro / di balestro e in questo locho circha / allalteza sono pari e singuli*; *Strada va allo lago e a fiorentia*; (b) *monte martino dove uno Convento / di frati Cavaliere asai a ditto giardino / lontano a due tiri di balestro*; (c, not in hand of Antonio the Younger) *porta murata*; *bormia*; (hand of Antonio the Younger) *porta bormia*; *portone / vechio*; *strada che va a orvieto*; *fontanta*; (d) *Le mura sono grosse in fondo palmi 7 / in fondo in cima grosse palmi 4 / Lo giardino e rilevato circha palmi 30 / dallaltra Canpagnia e pende in verso / la campagnia / Le mura della terra saranno Cavaliere / al di sopra del giardino dal cordone in su*; (e, not in hand of Antonio the Younger) *funari*; (hand of Antonio the Younger) *porta de funari*; *bastioni*; *saniuliana*; *Santa Juliana / bastionato*; (later hand) *di Perugia*
Verso: *Di perugia di mano / di bernardino navarra*

This rather rugged sketch shows the Porta del Castellaro on the Via del Bucaccio in Perugia (the "strada che va a Orvieto") as drawn by the soldier Bernardino Navarro. Significant annotations are in the hand of Antonio the Younger and the entire sheet can probably be dated to the period of the construction of the Rocca Paolina when a great deal of thought was given to the defensive position of Perugia.

The drawing shows a forward *fortino* in front of

the walls possibly built by Fortebraccio da Montone, who was briefly in charge of the *Signoria* in Perugia in the fifteenth century. Antonio the Younger's written suggestion was to strengthen the angles of the wall but the need (for the *fortino* itself?) as he notes, is not great given that a defense of the area can be mounted from a nearby hill.

A number of drawings from the period of the construction of the Rocca Paolina relate to the defense of areas other than those occupied by the fortress (see U 1028A r., 1207A v.), but how seriously these drawings are to be taken is not clear. In our opinion, these proposals had a different status from those for the Rocca Paolina itself. Possibly they were undertaken to cool a citizenry that feared the worst from Antonio the Younger's presence and Pope Paul III's interest. Drawings such as U 1031A may well have been prepared to show the population that the defense of the entire city was on the pope's mind.

BIBLIOGRAPHY: Camerieri, Palombaro (1988) 58, pl. 2, fig. 6.

N.A./S.P.

U 1032A *recto and verso*

ANTONIO DA SANGALLO THE YOUNGER
Perugia, Rocca Paolina, studies for the upper-level fortress, summer 1540.

Recto					Verso			
a	b	c	d		x	x	a	x
e	f	g	h		x	x	b	c

Dimensions: 441 x 578 mm.
Technique: Pen and brown ink with notations in red chalk, straightedge.
Paper: Heavily creased and folded into eighths.

INSCRIPTION, Recto: (in brown ink unless noted)
a) Continuous scale from 1 to 35 in ink; red chalk linking lines
b) Blank
c) Plan of short section of wall: *qui—in sotto*
d) Plan of casemate, through wall
e) Plan of wall; red chalk over brown ink
f) Plan of wall; chalk over brown ink: *quanto sono grossi li tramezi & li stantie*
g) Plan of the upper fortress: *faccia del baluardo di Santo Cataldo / Balte aldi fuora della torre; Torre [. . .] alla goletta 3 dita*
h) *in cima alla punta del bastione della / punta del Dalvarole del palazzo sopra / alla goletta*

Verso:
x) Blank
a) Red chalk outline of section of wall
b) Partial elevation(?) in red chalk
c) Gray chalk; plan detail of Rocca Paolina: *alla langoli*

Folded successively, with each rectangle fold framing a separate sketch, this sheet shows a sequence of intensive studies of the upper-level works for the Rocca Paolina. The full purpose of the drawing is unclear. Much of it seems to have been done on site; other sections were done in the workshop. Camerieri and Palombaro argue that the sheet shows a series of different angles of various wall lines taken from a base line at the face of the fortress toward the city. The angled lines at *h* are keyed to the sketch at *g*. The drawing thus would serve as an important miniaturized record of the plan of the fortress; angles (and possibly dimensions at *a* could easily be read by an on-site draftsman from such a sheet.

There are some problems with this interpretation. In the first place, it is unclear why such an elaborate method was needed to record the dimensions and angles. Secondly, the purpose of the scale at *a* is not evident since it is not marked. For us the purpose of the sheet remains unclear though it is certainly related to the early phases of site planning in Perugia.

Giovannoni (1959) incorrectly identified this sheet as a study for Loreto.

BIBLIOGRAPHY: Ferri (1885) 110; Giovannoni (1959) I: 196, 452; Camerieri, Palombaro (1988): 37–38, fig. 15.

N.A./S.P.

U 1041A *verso*

ANTONIO DA SANGALLO THE YOUNGER
Study of staircases, section of a stair and riser, 1540–43(?).
Dimensions: 284/287 x 321 mm.
Technique: Pen and brown ink, straightedge, square.
Paper: Darkened at edges; repairs.

INSCRIPTION: *ipotenusa; palmi 2 1/10 alvivo e palmi 2 3/10 chologiunto del bastone; quincupla*

This puzzling drawing show a staircase placed next to a portal on which have been outlined the lines of the supports. There are several studies of stairs and their risers.

It seems possible that this sheet forms part of the group of studies for the Rocca Paolina, Perugia. Compare this sheet with U 1317A where there appear to be a number of angled lines drawn in that seem to refer

to stairs. Below and to the left is a scaled staircase some 33 mm long.

BIBLIOGRAPHY: Ferri (1885) 110.

E.B.

U 1049A *recto*

ANTONIO DA SANGALLO THE YOUNGER
Fabro, plan for the castle, ca. 1533.
Dimensions: 185 x 254 mm.
Technique: Pen and brown ink.
Paper: Yellowed, fold marks.
Drawing Scale: probably Roman *piedi*.

INSCRIPTION: *Fabro / del s[igno]re bandino / da Castel della Pieve*; *Torre*; *Casa del frate*; *Diritto della facia / della porta o fondo / di scarpa*; *alla porta*; *brecioluo*; *misure di fuora / sono i[n] fondo della scarpa*; *scarpa*; *scarpetta*; *scarpetta*; *a piombo*; *a pio[m]bo*; *Diritto*; *scarpetta*; *filo*; *filo*

This sheet may be dated around 1533 when Antonio was involved in projects to drain the Val di Chiana near Fabro. The circular tower already existed on the perimeter of the walls, but he planned the four bastions. The design was thought erroneously to be for Città della Pieve until it was discovered by comparison with site evidence to be for Fabro, which, according to the first book of Council records, still belonged in 1568 to the Neapolitan nobleman Matteo Stindardi, husband of Lucrezia Bandina.

BIBLIOGRAPHY: Ferri (1885) 23; Perali (1919) 170; Giovannoni (1959) I: 55, 76, 433.

F.Z.B.

U 1051A *recto*

ANTONIO DA SANGALLO THE YOUNGER AND OTHER HANDS
Fortification study for unknown location, probably ca. 1525 or 1530–33.
Dimensions: 297 x 186 mm.
Technique: Pen and brown ink.
Paper: Irregular, repairs top right corner, brown stains, crease marks.

INSCRIPTION, Recto: *Fortezza opinione / del Duca dalbania*
Verso: *Forteze*; *openione delducha / dalbania*

The drawing shows a rough sketch of a square fort with four round towers connected by means of a caponier to a blunt spear-shaped outwork in the form of a ravelin. The ravelin recalls the work of Francesco

di Giorgio; similar forms are proposed by him for Fossombrone. (Giovannoni describes this sheet as demonstrating the switch from medieval fortification to the transitional type, and relates it to designs by Francesco di Giorgio or Giuliano da Sangallo.)

The drawing is extremely rough but certain elements remind us of Antonio the Younger's hand: The embrasures, the sketchy construction of the round towers are quite close, though perhaps a little rougher than we are used to seeing. The only certain evidence of Antonio the Younger's hand is the inscription on the verso. Possibly the sheet shows a proposal for the modernization of a typical late-fifteenth-century fortress by addition of ravelins and caponiers in a manner favored by the Duke of Albany. The Spanish-built fortress of Salses, in Roussillon, provides the closest model for this kind of transitional solution. The manner of fortification does not seem to reflect the Antonio the Younger we know elsewhere. The verso is blank except for the notation in his hand.

The circumstances under which this sheet was created are not known. The "duca dalbania" referred to in the text is probably John Stewart, Duke of Albany (1481–1536), who was in Rome around 1525 and then again as French ambassador 1530–33. Albany accompanied Francis I in the Italian campaign against Charles V which ended in the disaster of Pavia (24 February 1525). Of Scots-French extraction, he had an active and relatively successful military career. Thus we would seem to have a sheet (with at least the handwriting of Antonio the Younger) that records Albany's opinion on some aspect of military architecture. It is possible that the drawing grew out of proposals for the modernization of the Castel Sant'Angelo with the tower of Alexander VI transformed into a ravelin.

What makes the drawing especially interesting is that it seems to reflect the kind of collaboration between a soldier and an architect that is spoken about in numerous treatises. Given the rough nature of the sheet, a relatively early date seems likely; Albany's departure from Rome in 1525 gives us a terminus ante quem.

BIBLIOGRAPHY: Giovannoni (1959) I: 73 n. 1; Fiore (1978) 49 n. 46.

N.A./S.P.

U 1052A *recto*

ANTONIO DA SANGALLO THE YOUNGER AND OTHER HANDS
Fortification studies: (top) traditional trace with square towers and a modern arrow-headed bastion; (middle) more

advanced trace with recessed casemates; (bottom) protostellar trace, ca. 1530.

Dimensions: 298 x 273 mm (including modern support); 292 x 273 mm (original sheet).

Technique: Pen and brown ink, red chalk.

Paper: Darkened at edges, repairs.

INSCRIPTION: (at top in pen and light brown ink) *cavaliere; cavaliere; Terra del Signiore / federigo da bozoli sta / cosi ogni faccia;* (in darker ink and new hand) *di suo mano;* (at bottom in red chalk) *Una citta staria bene cosi*

The upper drawing shows a trace comprising a central triangular work, and two square towers standing slightly forward of the curtain. The drawing seems too crude to represent a design from the Sangallo circle; and the annotation suggests that this is a record of the fortifications owned by Federigo da Bozzoli. The triangular central work sweeps the fronts of the two rectangular gun platforms, or towers, and is itself flanked by embrasures in the curtain. Possibly it represents additions to a much older medieval fortification. It seems to have prompted a series of more modern studies (below).

The two lower plans illustrate the use of a cranked trace to defend what is, in fact, a straight enceinte. A third solution, below them, shows bastions with triangular shoulders and a round-fronted intermediate gun platform. It has been cut off by the trimming of the sheet.

The problem of the reentrant flanking batteries is addressed by Antonio elsewhere (U 759A, 1389A, 1461A).

The purpose of this sheet is not known. It may have been intended to demonstrate a variety of modern defensive techniques. The sheet also seems to have been used to identify the hand of Antonio the Younger, and a later sixteenth-century hand (possibly Battista's?) seems to have noted across the writing that it is autograph. One is reminded that the Sangallo workshop's drawings became the subject of collectors' interest very early on.

BIBLIOGRAPHY: Fiore (1986) 334.

N.A./S.P.

U 1053A *recto*

ANTONIO DA SANGALLO THE YOUNGER
Mantua, detail of the walls, 1526(?).
Dimensions: 86 x 135 mm.
Technique: Pen and brown ink.
Paper: Heavy, darkened.

INSCRIPTION: *Mantova; porta*

This quick sketch of a short section of the Mantua walls is the only record we have of a possible visit by Antonio the Younger to that city. The fragmentary nature of the drawing is not unlike his sketches for Ferrara (U 881A). Any dating is clearly conjectural; a visit during the 1526 trip through the Romagna is possible, and Antonio the Younger would have had every reason to be interested in the fortifications at that time as a number of new bastions had been built starting in 1524. (It is also possible, however, that the drawing dates from the 1530's or 1540's when he was working on Parma and Piacenza.)

BIBLIOGRAPHY: Davari (1875); Ferri (1885) 87; Amadei (1954–57) V: 505.

N.A./S.P.

U 1076A *verso*

ANTONIO DA SANGALLO THE YOUNGER
Study of counterweighted grindstones.
Dimensions: 150 x 115 mm.
Technique: Pen and dark brown ink.

INSCRIPTION: *macina per contrapeso*

The drawing shows a counterweighted grindstone operated with a rope-pulley system and using handspikes. The mechanism as a whole seems to have more ingenuity than operability. Perhaps the sheet was intended to demonstrate the usefulness of pulleys?

BIBLIOGRAPHY: Ferri (1885) 88.

G.S.

U 1087A *recto*

ANTONIO DA SANGALLO THE YOUNGER
Study for a city gate (Porta Santo Spirito?); a triumphal device.
Dimensions: 231 x 213/217 mm.
Technique: Pen and brown ink, gaps by the pilasters of the two arches.
Paper: On modern support.

INSCRIPTION: (in pencil) *per la porta di S. Spirito*

The page shows sketches with plans and elevations of the two facades of the gate: to the left, a general plan; at top, a study for a pontifical coat of arms (Farnese?) between obelisks; bottom center, half of the exterior (or interior?), with two pairs of semicolumns framing

the arch and a single column corresponding to each of them in the elevation. Some measurements are noted.

One of the elevations shows a barrel vault, framed by four columns (Tuscan?), divided by niches and a superimposed oculus. The entablature, with greater projection over the columns and the barrel arch, supports an attic of similar contour, inscribed in the middle and crowned in turn by a large central coat of arms. On the right of the plan/elevation for the interior (exterior?) of the gate, other measurements refer to the width of the arch ("20" *braccia*) the height ("35" *braccia*), the dimensions of the pilasters, and so on.

The order is not apparent, but the robust rustication extending over the arch has been drawn, and over the cornice the high attic with its large inscription sustains a coat of arms framed on the sides by two smaller coats of arms, forming an acroterion.

BIBLIOGRAPHY: Giovannoni (1959) I: 310, 366; II: fig. 327.

M.F./G.M.

U 1092A *verso*

ANTONIO DA SANGALLO THE YOUNGER
Study of a pump, detail of three tubes with valves and a
 hammer.
Dimensions: 284 x 209 mm.
Technique: Pen and brown ink.
Paper: Extensive repairs; reinforced by new paper.

INSCRIPTION: *Questi magli son tre / abatono laqua ascontro / alla bocha della tromba / Lanimelle sapre e latro pigli / laqua. E come el maglio perde / la forza lanimella si chi[u]di / E queste magli li alza una / rota quale la volta lo fiume / E nel fuso a denti quali alzano / questi magli come fa a quelli / delle gualchiere o fabriche ad / aqua o di ferro o di rame E laqua / monta in grande alteza come / vede in Tolledo di Spaglia In / trombe e condotto bisognia / sia di metallo altrimenti / si rompa*

Antonio the Younger's note describes how cams strike the water near the mouth of the tubes, the valves open, and other valves take in water. As the cams lose power, the valve closes. The cams are raised by a wheel turned by river water. Cogs in the shaft raise the cams, as is done at fulling mills, or waterworks, or mills for iron or copper. The water may rise to a great height, as seen at Toledo in Spain. Pipes and tubes must be made of metal to sustain the pressure.

Antonio's mention of Toledo recalls the famous hydraulic constructions built there in Roman times.

They were cited by Taccola, then by Francesco di Giorgio, each of whom illustrated them in his own way, since they had not visited Toledo. Copies of Francesco's drawing sometimes omit the name "Toledo" for the citadel, as can be seen in a drawing by the Anonimo Ingegnere Senese and as recorded by one of the Anonymi (U 4080A r.; Ms Additional 34113, fol. 63 v.). Antonio's sketch of three tubes is unusual, and may be compared with his two-tube pump (U 1409A v.), but a Florentine copybook dating in 1548–52 (Codex Palat. 1417, fol. 57 r., Biblioteca Nazionale, Florence) illustrated a three-tube pump that the author said was like a pump operating in Hungary on the Danube. Its complete form includes the cams mentioned by Antonio and other levers that open and close valves.

BIBLIOGRAPHY: Francesco di Giorgio (*Opusculum*) fol. 60 v.; Ferri (1885) 91; Prager, Scaglia (1972) 137; Taccola (1984) 168–69, pls. 62, 216.

G.S.

U 1096A *recto and verso*

ANTONIO DA SANGALLO THE YOUNGER
Rome, study for the Porta Santo Spirito, 1542–43.
Dimensions: 203 x 271 mm.
Technique: Pen and brown ink.
Paper: Trimmed at the edges and restored at the top and left.
Drawing Scale: Roman *palmi*.

INSCRIPTION, Recto: *A piombatora; A; piombatora; in trastevere in un pezo di marm/oro chatello(?) / CMLII / Dice 952*

On the recto of the sheet are two studies for the external facade of the gate: an elevation to the right and a ground plan to the left. Even though it surely belongs to a preliminary stage of planning, any previous doubts about the sheet being for the gate may be banished for various reasons. The elevation, in fact, shows the Doric order, following Antonio's intentions and as seen in U 1359A and 1360A, with triglyphs and metopes; here there is also an interior patera. The narrow lateral bay clearly indicates a triumphal rhythm to be completed by a second column to the left; the niche does not have the same impost for the springing of the central arch only because the architect wanted to insert a plaque here in bas-relief above the niche in which a statue would be placed. The sloping base under the pedestal seems to allude to the foot of the gate, which, according to Prospero Mochi (1545–46),

was meant to contain a lower gate on the same axis over the moat. The elevation has been superimposed on the plan, as can be seen by the inscription "piombatora," covered by the figure of the statue and noted by Mochi as part of Antonio's intention. But the plan clearly shows the drawbridge; the two different fronts—the one on the exterior with semicolumns and niches, and the other, rectilinear with an embrasure; the chutes for pouring boiling oil (*piombatoia*); and the back passageway for the defenders. All this fortification equipment prevents one from considering the design as preparation for a triumphal arch rather than for the gate. And this holds true even though the solution is obviously so close to studies made for triumphal arches for Charles V (1536); see, in particular, the variation on the right side of U 1269A r. for San Marco, but also the Porta Lamberta for Castro (1537), as in U 750A v.

In the middle of the verso a fastigium, enclosing in its center Paul III's (Farnese) coat of arms, is clearly presented in two variations, one with a simple ribbon around the oval, and the other with a nude seated figure carrying an inscribed shield. To the right, still another variation shows the oval held by two standing figures of angels. Below the oval are other figures, of putti or angel children, and a plaque between grotesque masks. The fastigium also could have been meant for the top of the Porta Santo Spirito (Fancelli, 1986), but it would have hindered the maneuverability of the cannon on cavaliers. For this reason, and taking into account, above all, the torus and the inclined lines below, we propose interpreting the design as a study for an ornamental papal emblem to be placed on the beveled salient of the bastion, just above the line of the scarp. Possibly it was intended for the Santo Spirito bastion for which the first stone was laid 18 April 1543. In support of this view, note that the three armorial bearings represented are found also on the salients of the Ardeatine and Colonnella bastions, as well as on the later Belvedere bastion. The small sketches of rustication on the right corner probably are part of a study for the internal facade of the Porta Santo Spirito as in U 902A. See also U 941A, 1359A, 1360A r. and v., 902A, 1290A.

BIBLIOGRAPHY: Ferri (1885) 167; Degenhart (1955) 264 fig. 352, 266 n. 360; Giovannoni (1959) I: 366–67; II: fig. 52; Bentivoglio (1985); Clementi (1986); Fancelli (1986) 233–35, 240, 242 n. 8.

F.P.F.

U 1102A *recto*

ANTONIO DA SANGALLO THE YOUNGER
Geometrical studies.
Dimensions: 160 x 210 mm.
Technique: Pen and brown ink.
Paper: Center fold, repairs.

Left half: (a) Compasses for an ellipse (*sesto per fare avovati*). (b) Elliptical diagram (marked "A"). (c) Diagram of an ellipse. Right half: (d) Compasses (*sesti al ovati*). (e) Conical form.

INSCRIPTION: (c) *Lovate fatto chol filo / e chon dua punti / E a voler trovare una linia / che tochi a punto in sullo ovato / chontingiente;* (e) *A tagliare / una pira/mide squin/cia fa ova/to*

The drawing shows two compasses that produce ellipses and two diagrams of ellipses. One of them (*c*) is made by using a string and two points; the method finds a line that touches directly on the contiguous ellipse. The other ellipse (*b*) is formed by cutting a pyramid obliquely (see also U 830A). Compasses for ellipses are also illustrated by Benvenuto Della Volpaia (Codex Ital. Cl. IV, 41, 5363, fol. 18 r., Biblioteca Marciana, Venice). Antonio the Younger's affiliation with the members of the Della Volpaia family makes it likely that his drawings of instruments reflect those made or owned by Benvenuto Della Volpaia, as can be seen in drawings of compasses (U 4043A r.), an astrolabe (U 1454A r. and v.), and a quadrant (U 1455A r.).

BIBLIOGRAPHY: Ferri (1885) 81; Maccagni (1967) 3–13; Maccagni (1971) 65–73.

G.S.

U 1106A *recto*

ANTONIO DA SANGALLO THE YOUNGER
Studies of crossbows.
Dimensions: 295 x 235 mm.
Technique: Pen and brown ink.
Paper: Center fold.

(a) Note: *Decimo.* (b) Diagram outline of a crossbow. (c) Diagram outline of a crossbow with a screw. (d) Two outlines of crossbows.

INSCRIPTION: (c) *Una balestra quale si caricha / al contrario che llaltra e trae al con/trario che laltra e si caricha con / una vite; Veduta in Venetia / per maestro Jacomo Bonacostia / da Ferrare medicho mio fisicho*

Antonio the Younger's reference to the screw of a crossbow belongs to diagram *c.* He notes that the

crossbow is loaded in the opposite way from the other one on the sheet and discharges in the opposite way. A screw is used to load it. The bow was seen in Venice by his physician, Jacomo Bonacostia da Ferrara. The word "Decimo," at the upper edge of the folio, could refer to Book X of Vitruvius who wrote a chapter (xi) on ballistae. Antonio quoted from the preceding chapter, on catapults or *scorpioni*, when he referred to Plautus, *De catapulta*, on another drawing (U 1447A r.).

BIBLIOGRAPHY: Ferri (1885) 92; Hall (1956) 695–730.

<div align="right">G.S.</div>

U 1113A *recto*

ANTONIO DA SANGALLO THE YOUNGER
Study of a gristmill.
Dimensions: 160 x 205 mm.
Technique: Pen and brown ink.
Paper: Trimmed at edges.

INSCRIPTION: *semole*; *tritello*; *farina*; *farina fine*; *denti 10*

The gristmill produces semolina, bran, and two grades of flour. Its design is different from other gristmills illustrated in copybooks of the period.

BIBLIOGRAPHY: Ferri (1885) 89; Forbes (1956) 103–46.

<div align="right">G.S.</div>

U 1114A *recto*

ANTONIO DA SANGALLO THE YOUNGER
Study of a quinquereme galley.
Dimensions: 270 x 210 mm.
Technique: Pen and brown ink.
Paper: Center fold.

INSCRIPTION: *quinque reme*

Antonio the Younger's reading in Latin books introduced him to the word *quinquereme*, the oared ship of the Romans. Here he interpreted the word as he understood it, showing each oar positioned so that the oarsmen would stand upright, and an oarlock of unusual curvilinear shape on both sides of the hull. The Venetian gondola moved by the gondolier using only one oar might have been his model (although the lock is rather different), but the Venetian galleys bear no resemblance to Antonio's drawing.

The classical term "trireme" was also used for galleys built in the Venetian Arsenale in 1529. In 1525, Vettor Fausto presented his model of a quinquereme that proved itself at sea in 1529. The precise form of the boat is not known. Later scholars wishing to know the form of the Greek and Roman quinquereme have studied descriptive words of ancient historians and images found in paintings and reliefs, leading to a trireme galley reconstructed in Greece in 1987. Quite simply, the main question of the quinquereme concerns whether there were five men to the oar or five men each with his own oar. The debate was quite heated when J. Furtenbach, *Architectura navalis* (Ulm, 1629), illustrated a quinquereme galley with five men for each oar; M. Meibomius, *De fabrica triremium* (Amsterdam, 1671), reconstructed the "quinquereme antica," showing five oars moved by five oarsmen seated before and behind each other at three different levels. In summary, Antonio's drawing of the quinquereme is probably datable in the 1520's when at least one such galley was built in Venice; Antonio sketched a purely imaginary one.

BIBLIOGRAPHY: Ferri (1885) 92; Lethbridge (1956) 563–88; Concina (1984) 108–34; Morrison, Coates (1987).

<div align="right">G.S.</div>

U 1118A *recto and verso*

ANTONIO DA SANGALLO THE YOUNGER
Unknown location, fortification studies, ca. 1535.

a c
b d
 e

Dimensions: 234 x 202 mm.
Technique: Pen and brown ink.
Paper: Heavy, cut and repaired, trimmed along all edges.

Recto: (a, upside down) Fields of fire from caponiers (*otto 4*). (b) Fortified rotunda with outer ring of bastions. (c) Design of two bastions with flanking fire to their faces from mid-curtain embrasures. (d) Studies of bastions with curved flanks. (e) Timber catena for fortification foundation (*decimo*).
Verso: Silk-throwing spools over a cauldron of water (*fillatoro delli / Spinelli / nono*).

The recto of this sheet shows a series of problems associated with military architecture. The lower drawing is a conventional plan representation of the network of timbers, known as the *catena* (chain), which provided reinforcement for an earthwork. The sketches on the upper half of the sheet explore different aspects of a citadel comprising a central rotunda surrounded by an octagonal trace of bastions and ram-

parts. Bastions with curved flanks, intervening mini-bastions or perhaps caponiers, and flankers placed in mid-curtain are depicted, together with a study of the embrasures in the caponiers around the base of the citadel rotunda. Similar ideas appear in study sheets for the Fortezza da Basso, which may suggest a dating in the mid-1530's. (Examples of intermediate bastions: U 778A, 1467A. Examples of stellar works: U 1520A, 1344A. Examples of the curved reentrant: U 759A, 779A.)

The sheet has been rotated at least once.

On the verso, Antonio's sketch of four silk-throwing spools (*fillatoro*) on an inverted U-shaped band is divided into ninths (*nono*). It stands over a boiling pot whose purpose is not intelligible without the word for a silk-spinning wheel. Evidently the wheel belonged to the Spinelli. Their palace was built in the late fifteenth century and stands on Via Borgo Santa Croce 10, Florence. Leonardo da Vinci made many sketches of parts of textile machines, some of them similar to this sketch.

BIBLIOGRAPHY: Ferri (1885) 89; Strobino (1953); Patterson (1956) 190–220; Ponting (1979).

N.A./S.P., G.S.

U 1145A *recto and verso*

ANTONIO DA SANGALLO THE YOUNGER
Civita Castellana, plan of north wing of first floor of fortress; partial plan of the walls; door and capital from Falleri (*recto*). Civita Castellana, partial plan of western side of fortress (*verso*). 1512–13
Dimensions: 204 x 275 mm.
Technique: Pen and brown ink.
Paper: Thin, folded at one time off-center to right, repairs.

INSCRIPTION, Recto: (under capital) *infalleri in terra*; (with the crenellation) *merli de uno pezo A / un altro pezo e B; mura di falleri / porta in mezo / a dua torrioni*

The main part of the recto shows the distribution of the spaces in the zone of the papal apartments in the Rocca at Civita Castellana, which are indicated with measurements of the internal dimensions. The connection between these rooms and the entry staircase is indicated also. The measurements are virtually identical with those of the plan (Rome, Accademia di San Luca) by Ottaviano Mascherino, probably dated 1577–79 and made for the restorations of that period. Note however that the form of the stairs in the eastern bastion and the absence of the spiral stairs from the western bastion (see the verso) is a significant departure.

In discussing this sheet, Giovannoni refers only to the remains from Falleri (Falerii Novi). Ferri associates Falleri with Monte Massico (in the Terra di Lavoro); he refers to the plan by its annotation as an "ancient building." The sketch of the door refers to the so-called Porta Giove.

The mathematical calculation above refers to the entire face of the internal wall of the bastions.

On the verso is a partial plan of the western side of the Rocca of Civita Castellana. This measured sketch refers in a more detailed fashion to the recto plan. The zone covered is from the northwest bastion to the semicircular bastion. A rectangular room with its measurements is shown to the side.

For the overall plan of Civita Castellana and a discussion of issues related to the dating of the sheet, see U 977A.

BIBLIOGRAPHY: Ferri (1885) 96; Giovannoni (1959) I: 21.

E.B.

U 1155A *recto*

ANTONIO DA SANGALLO THE YOUNGER
Study for the triumphal arch on Via Alessandrina for Charles V's entry in Rome, 1536.
Dimensions: 243 x 294 mm.
Technique: Pen and brown ink, stylus marks.
Paper: Well preserved, with a small restoration on the lower left margin.

INSCRIPTION: (right margin) *Lo palmo e dita 12 / Da trave a trave / per larmatura sia / Dita 541 quali sono / palmi 45 D[ita] 1; 541 quali sono / palmi 45 D[ita] 1;* (top) *S[. . .] notare che [. . .] e dita 12 / el piedi anticho sie Dita 16;* (center) *oniuno dita 285 / palmj 23 D[ita] 9; palmj;* (bottom) *per l'entrata di borgo quale e larga / palmi 50;* (center left) *E necessario che questo archo / sie piu corto la dimesione delle colonne*

The plan illustrates a monumental access "per l'entrata di borgo," clearly structured as a vestibule with a nave and two aisles, which presumably was patterned on the atrium of the Farnese Palace (therefore, with two narrow side aisles with a flat ceiling and a barrel-vaulted central nave).

The four freestanding columns, two on each side, correspond to the same number of pilaster strips on the wall, which extends toward the two external and internal facades, creating a sort of mirror effect, countersigned by other corner pilaster strips. Niches with flat surfaces to the back probably were carved between the outer pilaster strips, while inside each

pilaster strip (those on the left side, in particular) a rectangular space has been indicated, alluding most likely to the wooden structure of the temporary display. Another version of this project can be found in U 1672A. The study should be compared with the plans attributed by De Angelis D'Ossat to Peruzzi for Via Alessandrina.

BIBLIOGRAPHY: Egger (1902) 144; Giovannoni (1959) I: 310–11; De Angelis D'Ossat (1982) 984–86; Madonna (1980) fig. 83.

M.F./G.M.

U 1179A *recto*

ANTONIO DA SANGALLO THE YOUNGER
Rome, study of a Corinthian order and note about the gates between the Tiber and the Porta Latina.
Dimensions: 358/360 x 283/285 mm.
Technique: Pen and brown ink.
Paper: Partially restored, bottom right, top left.

INSCRIPTION: (bottom left) *Le porte di roma i[n]comi[n]ciando / alfiume ciera una porta ca[n]to / alfiume ditta / seco[n]da porta quella che ogi s.to pagolo / canto lameta quadra di caio Cestio / chelvulga dice lameta romulo / Tertia porta sie i[n] crusa nelbastione / della[n]toniana alfianco di verso laporta di / s.to pagolo quale veniva dalla apia / e metteva a sa[n]to san / la (seco[n] and tertia canceled) quarta porta ditta apia sie i[n] crusa nel / laltro baluardo quale metteva a santa / balbina e di poi asanta prisca in ave[n]tino;* (four-line insertion follows) *e se afro[n]tava i[n]sieme / collaltra cioe colla / tertia nel circha a sa[n]ta balbina* (end insertion) */ quale viene i[n] mezo daditto baluardo / e viene alinia adirittura colla via apia / apia di Capo di bove a ditta porta apia / La (quarta canceled) qui[n]ta (porta canceled) porta sie la laporta sa[n]to se/bastiano ditta Capena quale no[n] viene diritta colla via apia p[er]che al fumicello(?) / dellatravicella piglia una storta i[n]verso / porta latina;* (top right) *qua[n]to sia largo le / me[n]sole / Qua [n]to sia dalluna / allaltra me[n]sola / Qua[n]to sieno largi / li di[n]telli / qua[n]to sia da luno / dentello allaltro / sel basto[n]cino rigira / sopra alle me[n]sole;* (top left, upside down) *palmi 10 nelo regolo di tevertino; tevertino; Tevertino; Tevertino; lega;* (bottom right, addition) *sono dita 2287/10*

This page is complex with regard to its subject matter in that the bottom part is devoted entirely to a long written note about Roman gates plus measurements and calculations. The upper part, instead, is divided into two symmetrical halves. The left half should be inverted in order to read it correctly; it concerns probable cuts of travertine for the lower part of the pedestal of the base, with detailed analysis and calculations of the various moldings. In addition, the right of the upper half has been subdivided in two equal sections: below a Corinthian cornice, seen in section and perspective (where among other things, modillions over dentils have been noted), is a "suite" of moldings constituting the base of a pedestal that seems to be the dimensional development of the sketch on the upper left part of the page. Such development also allows for annotating sculptural ornament.

BIBLIOGRAPHY: Ferri (1885) 157; Giovannoni (1959) I: 23.

M.F./G.M.

U 1185A *recto*

ANTONIO DA SANGALLO THE YOUNGER
Studies of the Macedonian phalanx, after 1530.
Dimensions: 285 x 415 mm.
Technique: Pen and brown ink.
Paper: Center fold, repairs, partially yellowed.

INSCRIPTION, Right half: (below soldiers) *saressa maciedoni che cioe / piche tre longa cubita 14 / quali sono velcircha b[raccia] 10½ / fiorentine; La minore sie longa Cupiti otto; Cubiti 8 sono bragia / sei in circha;* (page turned) *falange—4 / in la meta Cohorti Mili—8 / Cohorti D—16 / Manipuli .xxxii. / Centurij 64 / Decurie quadruplaci 128 / Decurie duplaci 256 / Decurie 512;* Left half: *Cornola / & pes / & ali; Corno destra / e caputo / e ala; ordinatio / densato / Constipato*

This is one of the sheets in which Antonio the Younger, possibly in concert with an adviser, interpreted ancient battle practice. (See also U 1245A.) The precise source of this sheet is not known. It seems to incorporate elements from Polybius (*The Histories,* Book 18: 29) concerning the nature of Greek warfare and in particular the form of the Macedonian phalanx of which the consul Lucius Aemilius is reported to have said that "he had never beheld anything more alarming and terrible" (Polybius, *The Histories,* Book 29: 17). The length of the Macedonian pike was generally given as 14 cubits (as here) with 2 cubits at the butt for counterbalance (thus making a total of 16 cubits). As discussed in Polybius and other sources (Aelian, *Tactics;* Asclepiodotus, *Tactics*), this meant that the hoplites in the rear of the phalanx would have their pikes project 2 cubits less as one moves in depth. This appears to be shown on the lower right. The figures used by Antonio for the disposition of the hoplites corresponds to those employed by Aelian (*Tactics,* chapter 14).

Elsewhere on the sheet we see Antonio the

Younger's interpretation of the disposition of the soldiers in various forms of closed and open orders in triangular and rectangular patterns. Such matters are not discussed by Polybius but are found elsewhere. Asclepiodotus, for example, discusses various wedge formations (*Tactics*, 11: 6–8) as does Aelian (*Tactics*, chapter 36). (I am grateful to Robert Brown of the Classics Department at Vassar College for this reference.)

That Antonio the Younger worked on a series of representations of ancient battle practice in conjunction with an adviser is likely. Editions of the various ancient treatises called out for illustrations. U 1245A may be another sheet from this effort. (See also U 1051A.) No certain date can be offered for this sheet.

BIBLIOGRAPHY: (not published).

N.A.

U 1207A *recto and verso*

ANTONIO DA SANGALLO THE YOUNGER
Perugia, studies for the fortification of the city, summer 1540.
Dimensions: 294 x 407 mm.
Technique: Pen and brown ink, with red chalk on recto.
Paper: Folded in four.

INSCRIPTION, Verso, Left half: *agionta*; *Cavalie/ro*; *porta Santo Ant[oni]o*

The left half of the recto shows an elevation of the Porta Marzia, Perugia, and the right half of the verso shows a further detail of the portal and a plan and section of the Church of San Michele Arcangelo, Perugia. These drawings will be discussed in Volume Three. The right half of the recto and the left half of the verso show important drawings related to military architecture and thus will be considered here.

This sheet is one of the only pieces of evidence to show Antonio the Younger's (and thus Paul III's) early interest in the defenses of the city of Perugia prior to construction of the Rocca Paolina. The recto also shows (lower right) a hypothetical solution for a star-shaped fortress in red chalk to be centered on the Church of San Michele Arcangelo in the north. Above is a series of variations on the outline traces for the defense of the city. The verso show the flank of the city along the Porta Sant'Antonio to the northeast with two solutions: a withdrawn flank with fire maintained by withdrawn embrasures; an advanced solution with a cavalier and bastion.

It is not known whether these proposals were ever seriously considered by Paul III. The recto side (in red chalk) seems purely hypothetical, the kind of thing Antonio himself thought about but which was not taken further. The notion of a stellar fortress on this site seems an extreme solution. The verso is more typical of the kinds of renovation to preexisting walls undertaken at this time.

BIBLIOGRAPHY: Ferri (1885) 110; Bacile di Castiglione (1903) 360; Camerieri, Palombaro (1988) 29, 79, figs. 7, 8.

N.A./S.P.

U 1212A *recto*

ANTONIO DA SANGALLO THE YOUNGER
Device to split water lines for ancient aqueduct; lid, 1531.
Dimensions: 215 x 160 mm.
Technique: Pen and brown ink.

INSCRIPTION: *Nel 1531 di primo de aprile incircha / questo sie cierte sepulture quale furo trovate / infra Santo Adriano el tenpio di Antonino e Faustina / e la via sacra el foro transitorio ed era di metallo / segniato in due faccie come vedi Liber 896 / e quello / de quale e fatto per 500 a quella linia in mezo / come vede in le tre buse era cienare e in cima / alle buse era serato con pionbo colato e fine Amo / ne trovate 3 posavate in su uno quadro di ma/rmo grande e laltezza loro era cinta da due qua/dri di trevertino e sopra era la basa de una colo/na dello edifitio;* (at the lid) *coperchio;* (the object inscribed) *P.DCCCXCVI;* al *peso moderno / pesa liber; pondo 896 cioe liber*

This sheet is a fascinating clue to the archaeological interests of the artists and architects in Rome during the early sixteenth century. It testifies to the reuse of ancient objects in various periods. Antonio the Younger's note reads like an archaeological report. He states that the "vessel," which he considered a cinerary urn for the ashes found in it, was discovered 1 April 1531, between the Church of Sant'Adriano and the Temple of Antoninus and Faustina, and between the Via Sacra and the Forum Transitorium. The vessel was sealed with fine lead. Three such vessels were found resting on a marble slab, two travertine slabs at the sides, and a column base of a building over them. Antonio translated the "P" of the inscription as "pondus," and he read the Roman numerals as "896."

The pen technique used by Antonio is the kind of penstroke shading that I have characterized as "early" (see U 818A r.) and used before 1526 (U 819A r.) when he sketched mills in Cesena with his penline technique. The identification of the vessel as a channel-splitting device was provided by T. Russell Scott of the Classics Department at Bryn Mawr College.

BIBLIOGRAPHY: (not published).

G.S.

U 1215A *verso*

ANTONIO DA SANGALLO THE YOUNGER
Studies of gears.
Dimensions: 215 x 430 mm.
Technique: Pen and brown ink.
Paper: Heavy.

Left half: (a) List of persons and payments. (b) Note: *10 dottobre 1543 / 4 [ottobre] 1544 / 16 [ottobre] 1545.* (c) Calculations. Right half: (d) Gears with ropes in parallel, detail. (e) Gears with ropes in parallel, detail. (f) Gear with screw winch (*vite / voltando ausando / argana in piano*) and cogwheel lantern (*rota a gre/tole esie / no dua ro/te cioe uno / per banda alla / rota grande*). (g) Gear rack (*martinetto*) or lifting jack. (h) Gear rack or lifting jack.

INSCRIPTION: (a) *A Batista Pichoriere a de di fe/braio s[cudi] 2 doro / a Mesemicholo Casola a di 4 / s[cudi] 2 doro / all Alberto s[cudo] uno doro / a Cristofano a di 7 s[cudi] 3 s[oldi] 30 / a Grestofano per dare a pre/te Bernardino s[cudo] u/no doro / a Merchantonio del Po / 8 s[cudi] 6 doro 34 Paulini s[cudi] 11 s[oldi] 40*

The rope hoists on this sheet are discussed with others like them on U 1449A r. and v. Two gear-rack details or lifting jacks named *martinetto* are identical with one on folio U 1564A. A structure named "martini" and "martinetto" with cranks and triple gears supported on a frame was finely illustrated, measured, and described at length in a chapter by a Florentine engineer (Codex Palat. 1477, fols. 81 r., 81 v., 82 r., 83 r., 84 r., 85 r., Biblioteca Nazionale, Florence) and a Florentine copyist of that manuscript (Codex Palat. 1077, fols. 34 r., 35 r., Biblioteca Nazionale, Florence). Both manuscripts date ca. 1548–53. Antonio the Younger's gear racks differ from these components in that mechanism. Francesco di Giorgio illustrated gear racks for several pumps, column lifts, and pile driver, although he named the components differently *(Trattato I,* fols. 45 v., 46 r., 48 v., 51 v., in Martini-Maltese, I: pls. 82, 83, 88, 93, 94). An anonymous artist also sketched a lifting jack in Codex Atlanticus, fol. 359 r., Biblioteca Ambrosiana, Milan.

Unfortunately the years 1543, 1544, and 1545 that Antonio wrote beside the numbered days of October are not useful for dating the mechanism he sketched on the sheet; the left half remained blank until he added these dates and the list of payments to workmen (canceled and annotated by someone else who also wrote the same word six times in the lower right corner); these payments are dated 3 February in an unspecified year.

BIBLIOGRAPHY: Ferri (1885) 88; Martini-Maltese (1967) I: pls. 82–94.

G.S.

U 1217A *recto and verso*

ANTONIO DA SANGALLO THE YOUNGER
Ravenna, plans for improvement of the drainage canals; Latin inscription in Cesena, ca. 1545(?).
Dimensions: 295 x 425 mm.
Technique: Pen and brown ink.
Paper: Two sheets glued together; darkened at edges.

INSCRIPTION, Recto: *Bisogniano fare inbonotoro novo si puo pigliare / alla rotta di Santa Caterina overo aque resta de / fabri e andare con un diritto fino al chantone della / posessione di messer pietro pagolo da fuligni alle fa/re uno pocho de volta e andare acanto alle sasci grossi / di ditta posessione va diritta fino al ponte del possa dell veschovo quale e in sulla strada di Santo benedetto;* (top, upside down) *rotta; rotta del monte; Fiume del monte; Dalla rotta alla terra Circha de miglia; Ponte di Bri; Rotto di / Santa Caterina; Ravenna;* (center, above) *Chiusa del / cardinale; via Cuna vota; Cuna ripiena; Canale da farsi; di popolo / da fulignio; questa va tutto per disciato;* (below) *Valle torta; naturalmente / tutte laque / cascha qui; sanmichele; via da Sanmichele;* (to left) *Canale / via del vescovo;* (to right) *bottuccio / con aqua; bottuccio / asciutto; via del berto; Basso; via del zoldo; selva / della Caldarana*
Verso: *paduli Di ravenna; nel veschovado di ravenna / in una salotta; C AEMILIO SEVER / I.N. PAN. VIX. AN. XLII / MIL AN. XXII IN FER / VALERIA FLAVINA / CONI P.O. / ET PINNIVS PROBVS .H.*

Not only is the precise purpose of this sheet unknown, but so too is the date. Written in the rough, swift, assured writing style that Antonio was to use to great effect during the height of his career, this sheet can possibly be dated to the time of the later work at Parma and Piacenza when he was in northern Italy. The sheet shows a rough plan of the roads and drainage ditches near Ravenna and seems to have been part of a plan to improve drainage in the region, as the note (lower left) makes plain. Precisely what was to be done (or why) is not stated. Note the annotations referring to the drainage canals that need to be built ("da farsi") and those that are filled ("cuna ripiena").

Antonio was active on a variety of drainage and improvement projects, see U 797A, 880A. For his earlier visits to Ravenna, see U 884A, 887A.

BIBLIOGRAPHY: Ferri (1885) 120; Giovannoni (1959) I: 70.

N.A.

U 1222A *recto*

ANTONIO DA SANGALLO THE YOUNGER
Tarquinia, cistern and plan of the old part of the town, before 1540.
Dimensions: 156/153 x 211/206 mm.
Technique: Pen and brown ink.
Paper: Partially yellowed.
Drawing Scale: Roman *piedi.*

INSCRIPTION: (top left) *Conserva daqua / i[n] tarquinia; P[ie]di 16;* (to right) *Castello di tarquino; muro; i[n] questo mo[n]te si / passava p[er] uno muro / come u[n] ponte; La citta; Rip[e]; La citta di tarquinia sie presso a corneto / uno miglio e mezo e apresso alla marta / fiume miglio e mezo di verso roma / e de i[n] sun uno monte che ale ripe piu che li ¾ / e uno Castello i[n] sun uno mo[n]ticello spichato / dalla citta quale al prexe[n]te si chiama el caste/llo di tarquinio e la citta la civita*

In this sheet, datable before 1540, Antonio the Younger provides the basic measurements of an antique cistern that he had noticed near present-day Tarquinia. (Tarquinia was called Corneto until the last century.) He also examined and commented on the site of the ancient Etruscan and Roman city of Tarquinia which is not the same as the present one.

For further evidence of Antonio the Younger's interest in the ancient techniques of water management, see U 1212A.

BIBLIOGRAPHY: Ferri (1885) 216; Pallottino (1937) 94; Giovannoni (1959) I: 21, 438; Vasori (1980) 143–44.

F.Z.B.

U 1242A *recto*

ANTONIO DA SANGALLO THE YOUNGER
Orvieto, well near the fortress, 1525–28.
Dimensions: 95/96 x 177/174.5 mm.
Technique: Pen and brown ink.
Paper: Partially yellowed, folded parallel to short side.
Drawing Scale: Roman *piedi* and *dita.*

INSCRIPTION: (mathematical calculations) *a piedi 21 di longeza / sara in diametro dita 21 / in circincu[n]perentia Dita 66 / lottava parte sie 8¼ / Lo tutto di canali*

This sheet, datable 1525–28, contains two sketches for a double spiraled ramp that has been identified as the one built for the well near the fortress in Orvieto. Notes to the effect that the length of 21 *piedi* would be reproduced with a diameter of 21 *dita* and a circumference of 66 *dita* lead one to believe that Antonio intended to make a small model, possibly in wood, in order to demonstrate the function of the two distinct but contiguous walkways, one leading up and the other down. See also U 958A v., 960A.

BIBLIOGRAPHY: Perali (1919) 31, 169–72, 175–76; Giovannoni (1959) I: 338–40, 439.

F.Z.B.

U 1245A *recto*

ANTONIO DA SANGALLO THE YOUNGER
Study of castramentation, after 1530.
Dimensions: 211 x 286 mm.
Technique: Pen and brown ink.
Paper: Darkened at edges, trimmed.
Drawing Scale: total dimension of circumference equals 3600 *braccia* as computed in the text (top, center); reentrant to reentrant is 150 *braccia;* the face of each salient is 104⅙ *braccia* = 25 mm.

INSCRIPTION: (on drawing) *Fanterie; Maestranze; Kavalli; circunferentia br[acchia] 3600;* (top right) *Legioni 4 / Ragioni 24 / et ogni ragioni uno autt / sieno stantie / 64 per ragione accio / che ogni decario ne / abia lo suo allogiamento / e per straordinari una / per lo millinario / una per li ognuno mariscolo 4 / una per le signifero e suoni / in tutto allogiamenti 70;* (bottom) *Lo diametro sie br[accia] 1145¹⁰/₂₂ / Lo mezo diametro sie br[accia] 572¹⁶/₂₂ di braccio / se dove sono braccio se mi fa piedi / gira labito del bastione uno miglio / se stanno albrachia gira due*

Although the radial plan seems to be based on Filarete's design for a fortress, it is in fact a study for a military encampment or barracks. It is planned radially, inside a stellar trace, with central *piazza d'armi,* and with barracks in the wedges between the radial "streets." Cavalry ("Kavalli") are housed on the inside, infantry ("Fanterie") in the outer accommodation. The text, although very difficult to read, seems to comprise a breakdown of accommodations for each of four "legions" (companies?), culminating in the summary of seventy barracks ("in tutto allogiamenti 70"). The sheet is related to the kinds of plans undertaken to complement the written description of the Roman camp by the historian Polybius and later elaborated by Sebastiano Serlio and others.

The similarity to Palmanova (trace and radial streets), noted by Giovannoni, seems not to be decisive but rather, as suggested by De la Croix, part of the tradition of radial plans executed throughout the sixteenth century.

Attempts to adapt ancient military experience to sixteenth-century needs were common enough. The text of Polybius on the ancient encampment was, for example, adapted by Sebastiano Serlio in his unpublished Ninth Book. On another sheet, U 1185A, Antonio the Younger outlines the disposition of soldiers and their use of the spear in Antiquity.

The dating for this sheet is problematic. The script and drawing are relatively assured; hence a date after 1530 has been proposed. Antonio the Younger probably had a humanist military adviser (see U 1051A).

BIBLIOGRAPHY: Giovannoni (1959) I: 55 n. 1, 83, 439; De la Croix (1960) 272.

N.A./S.P.

U 1256A *recto*

ANTONIO DA SANGALLO THE YOUNGER (OR GIOVANNI BATTISTA DA SANGALLO)
Plan for a triumphal arch.
Dimensions: 170/188 x 277/270 mm.
Technique: Pen and brown ink, traces of stylus and ruler, caliper mark in the middle of the arch and the engaged columns.

INSCRIPTION: (in pencil, later hand) *cfr La Porta S. Spirito*

The rigorously symmetrical plan shows a triumphal arch with an anterior facade composed of two pairs of semicolumns—probably mounted on a single stylobate—next to the main pilasters supporting the vault, and a posterior facade in which the arch is framed by a single semicolumn on each side, again on a stylobate. On the two sides are walls which, rotated 90 degrees, form a sort of shelter with interior surfaces articulated by pilaster strips.

This may be an initial plan for the triumphal arch in "S.to Marcho" (aligned with the facade of Palazzo Venezia, at the present end of Via del Plebiscito), which was to be built for Charles V's entry in Rome (1536). The study should be compared with the plan to the center right of U 1269A r.

BIBLIOGRAPHY: Giovannoni (1959) I: 310–11; Madonna (1980) figs. 73, 76.

M.F./G.M.

U 1268A *recto*

ANTONIO DA SANGALLO THE YOUNGER
Plan of mill; handlebar.
Dimensions: 410 x 280 mm.
Technique: Pen and brown ink.
Paper: Center fold, trimmed.

INSCRIPTION: *Piedi XV*; *Lo diamitro dove a voltare la stanga sie piedi XXXX / La rota grande sia di diametro da mezo luno dente / all altro piedi XV & ara denti CXX / La gabbia del rotone sia diamitro piedi iii in sul mezo delle gretole / & ara gretole XXIII / La rota della gabbia ara di diametro di mezo luno dente / all altro mezo dente piedi V & ara denti XL / Lo rochetto ara di diamitro piedi uno da mezo luna gretola all altra / & ara gretole viii / Lo dente viene grosso* $^{11}/_{56}$ *di pie & cosi lo voto* $^{11}/_{56}$ *di pie / * Dente /* $^{11}/_{56}$ *di pie * / La macina larga piedi iii / Quando Lo cavallo va intorno una volta la macina da volte XXV;* (handlebar) *stanga longa / dal cientro piedi / XX*

Antonio's text specifies the measurements for each component of this large, horse-driven mill (diameter of 40 feet). It is a quadruple mill with cogwheel (*rota grande*) and lantern (*gretole*), millstone (*macina*) and wheel (*rochetto*). His unit of measure of thickness of the teeth is set off between two asterisks. Antonio calculated that the horse's single course turned the millstones twenty-five times. He did not cite the mill's location, and there is no evidence to indicate that it was built in Ancona as a later note on the verso suggests. This design was made in his studio, using compass and straightedge, and nothing like it is known to me among the illustrated manuscripts and printed books. Another idea of Antonio's is the arrangement of four mills on a horizontal shaft (U 1436A r.), equally fanciful and of doubtful construction.

BIBLIOGRAPHY: Ferri (1885) 6.

G.S.

U 1269A *recto and verso*

ANTONIO DA SANGALLO THE YOUNGER
Studies for triumphal arches for the entry of Charles V in Rome, 1536.
Dimensions: 287 x 438 mm.
Technique: Pen and brown ink, black pencil marks.
Paper: Restored on left margin and upper right corner.

INSCRIPTION, Recto: *Santo Marcho; Santo bartolomeo (me* canceled) / *ma challe facie e lcontra/tto della rinuntia che fece / laiacopina(?) quando si marito / che dalla sia dota in su rinun/tia aogni altra cosa;* (middle) *dietro soli marcello; S.*

marcho; di Capodifiore; (right) *di ripa; zocholo; dado*
Verso: *Marforio*

The left half of the recto contains four sketches with partial elevations of a triumphal arch, composed of pilasters with two trabeated columns surmounted by a three-part crown. The first variation (bottom left) shows two figures in full relief on top of two Doric columns. The figures frame an oval and buttress the highest part of the crown, which is capped with a triangular pediment with acroterial statues. The second variation (top left) presents two possibly Ionic columns surmounted by an aedicule. The third (bottom right) has two Ionic columns supporting a circular-arched pediment and resting on a single stylobate festooned with garlands. The two columns of the probable fourth variation (upper right) are surmounted by a recumbent statue that appears to buttress the attic in the middle of the arch.

The right side of the page includes various plans relating to the arch on the corner of the Palazzo Venezia. In the upper sketch, the most complex of the series, are shown at least three possible articulations superimposed one on the other between the piazza and what is now Via del Plebiscito. Close to the margin of the page an elevation of the arch has been indicated in a version with two semicolumns on each side and a pedimented attic buttressed by volutes and acroterial statues.

The studies on the left side of the page, in our opinion, are closely related to plans for the celebratory arch in Piazza San Marco (see elevation far right). As for the superimposed design for an arch on a curved street, it could either be for Via Macel dei Corvi toward Palazzetto Venezia, or for Via del Pellegrino toward the Palazzo della Cancelleria. (This last hypothesis would explain the reference to the "capo di fiori.") On the bottom right of the page is another study for this second celebratory arch, analogous to the one for the Via Alessandrina in the Borgo.

The right side clearly is devoted to studies for the "Santo Marcho" arch, a complicated project. These studies have been analyzed by Madonna (1980).

The elevation on the upper left of the verso is a study for a display with two columns on each side framing a large arch opening on an exedra and surmounted by a shell-shaped bowl vault. Another elevation (to right) shows an analogous facade with a barrel vault, with another narrower vault below, framed by columns. A third sketch (on the lower right) proposes a barrel vault with two freestanding columns on each side, linked to the walls of the street

by way of a ceiling supported by pilaster strips. The arch here appears to be crowned by a pedimented attic over the central vault, buttressed by volutes. On the lower left, there is also a sketch regarding the placement of the "Marforio" statue.

The first two monumental displays seem to refer to the triumphal arch in Piazza "Santo Marcho" (see U 1269A r.). In this case we have solutions for the oblique facade: the first an exedra, and the second with a passageway under the barrel vault (the right side of the sketch should be interpreted as a partial variation based on antique arches, or possibly as the recessed front toward Via del Plebiscito).

The third refers to the arch for Via Alessandrina (also see U 1155A, 1672A, and even 1671A). The fourth shows the installation of Marforio in the Roman Forum inside a monumental aedicule, almost a fountain display.

BIBLIOGRAPHY: Podestà (1877) 308–15, 328–29; Lanciani (1902–12) II: 58–63; Giovannoni (1959) I: 310–11; II: fig. 329; Madonna (1980) figs. 67, 72, 76–78.

M.F./G.M.

U 1282A *recto*

ANTONIO DA SANGALLO THE YOUNGER
Florence, Fortezza da Basso, studies of barracks and stables, 1535.
Dimensions: 405 x 268 mm.
Paper: Darkened at edges.
Technique: Pen and brown ink, pin.

INSCRIPTION: (center left) *La colonna moduli 15 / Larchitrave moduli 6 / Lo fregio moduli 1¹/₂ / La cornietie moduli 1¹/₂ / In tutto moduli 19 / Lo modulo sie ¹⁴/₁₉ di braccio*

Along with U 768A this sheet is a study of the stables and barracks for the Fortezza da Basso, Florence. See also U 931A, 1659A. It shows the remarkable degree of architectural detail reached in the design of these accommodation wings. Among the most interesting sections of this sheet are the division of the stables into stalls (top and middle). The horses are even shown at either side of the elegant central barrel vault. A cavity in the wall pier allows feed to be passed down to them quite easily from the upper story. In this drawing the second story is barely indicated. It is developed further in U 931A. The exterior of the stables would have had doubled Doric half-columns developed, possibly, from the Palazzo Baldassini, Rome.

An interesting aspect of the drawing is the sectional

study (middle) that shows the stables in relation to the terreplein, the outer ramparts, and the lower-level countermine galleries. To the right (below) appears to be a sketch of a quill pen.

BIBLIOGRAPHY: Ferri (1885) 57; Giovannoni (1959) I: 349–50; II: fig. 378.

N.A./S.P.

U 1289A *recto and verso*

ANTONIO DA SANGALLO THE YOUNGER
Rome, Ardeatine bastion; studies in plan and section sketches
 of antique cornices, 1537.

Recto				Verso	
a				a	d
b	c	d		b	c

Dimensions: 328 x 284 mm.
Technique: Pen and brown ink.
Drawing Scale: Roman *palmi* and *dita.*

INSCRIPTION, Recto: (a) *Li volti delle faccie dinanzi / La pianta di tutti li Corritori / Lo porticello / Li volti delle Cannoniere dinanzi / e loro piante e misure / pigliare la risegalasata / sotto le Cannoniere / Lo ponto che sponta per fuora / lo muro fuora dello angolo(?) / delle Contramine / Li principij delle Casamatte / quanto stava attachato li / fili di pozi / quanto sono sopra(?) li bochi / de pozi;* (c) *a bottega delsiena;* (d) *asanta prischa*
Verso: (a) *ragua/gliata; vivo Coritore;* (b) *laf[. . .]tta / raguagliata;* (c) *di sotto dello / [an]golo; limo; cima dello scarpone; piano maestro;* (d) *in la cannoniera / lo muro di mezzo / al detto piano;* (in a later hand [Ferri?]) *in la cannoniera / lo muro di mezo / al detto piano*

The recto is noteworthy above all for the three profiles (*b, c, d*) of cornices at the bottom of the page with corbels in the frieze. In *b* and *c* the corbel is also shown in perspective. They are antique examples to which Antonio would have paid special attention, in imitation of both his uncle Giuliano, who had used a similar solution in the Palazzo Gondi, Florence, and the Palazzo Della Valle, Rome, and of Raphael, in the Alberini Palace, Rome. The annotation "siena" might refer to Baldassarre Peruzzi, who returned to Rome after 1533. In the section of an embrasure of the Ardeatine bastion *a* is clear and is shown without merlons above the cornice that tops the battered salient. On the side there is also a list of particulars to be kept in mind for use in planning.

The verso contains notes concerning measurements that reflect solutions also found on U 892A r. and v. and 1517A r. and v. regarding the plans for the Ardeatine bastion, and section studies of the scarp (*d*) and the scarp corridor from the "piano maestro" (the so-called foundation level) to the scarp cornice (*c*). See also U 892A r. and v., 1179A, 1517A r. and v., 1362A, 1505A.

BIBLIOGRAPHY: Ferri (1885) 153, 159; Huelsen (1894) 329; Rocchi (1902) I: 185; II: pl. XXXIV; Bartoli (1914–22) III: tav. CCLVIII, fig. 439; VI: 81; Pagliara (1990–92).

F.P.F.

U 1290A *recto*

ANTONIO DA SANGALLO THE YOUNGER
Rome, detail of the Santo Spirito gate, 1542–43.
Dimensions: 478 x 389 mm.
Technique: Pen and brown ink, stylus, ruler, dividers.
Paper: Heavy, trimmed at left edge, restored along bottom,
 yellowed along median axes and edges.
Drawing Scale: Roman *palmi* (4 *palmi* = 49.5 mm).

INSCRIPTION: *Li stipiti longhi palmj / 5 sono dita 60; Lo vano della porta p[almi] 18 / li stipiti palmi 5 luno / larcho nel vivo p[almi] 3 / cioe D[ita] 36 cioe / lomenbretto dellarco; sono dita 162; palmi 5; Questo regolone sia largo p[almi] 2 ovvero alto / cioe D[ita] 24; Misurato adita di / 12 per palmo & 16 / per piede; scarpa del fosso disotto palmj 20*

The design, recognized first by Bentivoglio (1985) for the Santo Spirito gate, also confirms Fancelli's interpretation (1986). This is a working drawing, as revealed by the dimensions, execution, and details, notably the relations among the lower levels—the plinth, base, and shaft—of the semicolumns; all these were built as drawn. Only the dado of the pedestal appears to be lower than it is in reality, with the projection of the cyma even more marked. Note however that Antonio the Younger has clearly chosen an Ionic base for the Doric order of the gate in the working drawing, following the example of Bramante and discarding the equivocal Tuscan base shown in U 1096A. As in U 1096A, however, we find a smooth fascia under the plinth, more typical of an Italic temple than a triumphal arch. This gives more elevation to the overall proportions of the Doric order. Thus the solution is a synthesis of various antique and original motifs when compared with Vitruvius's proposals and as such it is characteristic of Antonio's mature style. For comparison, see also U 941A, 1359A, 1360A r. and v., 902A, 1096A r. and v.

BIBLIOGRAPHY: Bruschi (1983) 14; Bentivoglio (1985); Fancelli (1986) 233, 238.

<div align="right">F.P.F.</div>

U 1294A *recto*

ANTONIO DA SANGALLO THE YOUNGER
Notes on comparative agrarian and architectural
 measurements, 1535(?).
Dimensions: 61 x 164 mm.
Technique: Pen and brown ink.
Paper: Darkened at edges, cut, repaired.

INSCRIPTION: *Lo staiolo sie una misura colquale si misura / le terreni a Roma quale elongo palmi 5¾ / de palmi de muro de sorte che una peza de / vignia se e 40 de detto staiola per ogni verso / quale sono Canne 23 p[er] ogni verso in tutto qua/drato canne 529*

The problem of metrical equivalents bedeviled the Sangallo workshop (see also U 829A, 1043A). One can imagine that sheets such as these would have been posted around the workshop, pinned to tables and desks to impress the assistants with certain basic facts of architectural life.

BIBLIOGRAPHY: (not published).

<div align="right">E.B., N.A.</div>

U 1302A *recto and verso*

ANTONIO DA SANGALLO THE YOUNGER
View of an ideal city and harbor, 1508–13(?).
Dimensions: 437 x 292 mm.
Technique: Pen and brown ink.
Paper: Repaired at center, along edges.

INSCRIPTION, Recto: *foro; Porto; seratore; seratore*

The bird's-eye view on the recto represents a Vitruvian city with a harbor, as is made clear by the arcaded forum near the sea with a main arch axis. The harbor, also arcaded toward the city and on an axis with the forum, is in the form of an amphitheater, separated from the open sea by two symmetrical concave jetties, their mouth closed to ships by a chain. An isolated tower looms over houses surrounded by walls with circular towers. The design, which fills only the upper part of the page, was doubtless inspired by a version of Francesco di Giorgio's city with harbor in his *Trattati* in the Codex Magliabechiano II.I.141, fol. 86 r., in the Biblioteca Nazionale, Florence. This is confirmed by details such as the double sluice gates (*saracinesche*)

in both designs, meant to prevent the harbor from silting, according to the *Trattati;* also by the form and position of the arcade, the stairway between the arcade and the jetty, and the tower among the houses. If Antonio's design is more complete, this may be due not only to his additions but also to the fact that he had a more complete original to work from.

Though the point of view is different, the second view of a seaport, drawn by Antonio on the lower half of the verso, is almost identical with Francesco di Giorgio's model in the *Trattati* (fol. 86 v.), and therefore the curved arms of the harbor end in cylindrical towers and the forum, open to the port, is flanked on three sides by arcades, with a central-plan building, probably octagonal, standing alone on the axis of the forum. In both designs we also find a single sluice (*saracinesca*), walls with circular towers, a domed circular building, and a two-story parallelepiped structure near the walls. Antonio must have had access to some version or other of Francesco di Giorgio's *Trattati* and used it to copy the two models of an ideal city, models that were conceived in the cultural and figurative climate that produced the Urbino perspective panels dedicated to the theme of a new urban utopia. Therefore, these exercises in style done in Antonio's youth may or may not be linked to his participation in Bramante's plans for Civitavecchia.

BIBLIOGRAPHY: Ferri (1885) 117; Giovannoni (1959) II: fig. 37; Martini-Malterse (1967) II: pls. 309, 310.

<div align="right">F.P.F.</div>

U 1317A *recto*

ANTONIO DA SANGALLO THE YOUNGER
Study of stairs and their slope.
Dimensions: 594 x 434 mm.
Technique: Pen and brown ink, stylus, dividers.
Paper: Folded in half, repairs at right edge and along center
 line.

INSCRIPTION: (bottom) *pendentia di scale;* (below, in later hand) *pendentia di scale;* (from left) *monte cavallo sextupla palmi 1⅔* (numbers illegible beneath erasure) *per canna / Quintupla palmi 2 per canna / Quadrupla palmi 2½ per canna / Tripla palmi 3⅓ per canna / Dupla palmi 5 per canna / Victruvio;* (below the drawing) *tripla; dupla*

The image is based on the passage from Book 9, preface 8, of Vitruvius's *De Architectura* in which he describes the proportional relation (3:4) of a staircase. Antonio the Younger compares this passage with the proportions of the stairs of the Temple of Serapis on

the Quirinal hill (left) and computes all the possible intermediate solutions. The drawing is based on Vitruvius in order to provide a reckoner that will help with the task of design. The slope is expressed in terms of the relation between height and length.

BIBLIOGRAPHY: Ferri (1885) 210; Frommel (1973) I: 63; III: 188d.

<div align="right">P.N.P.</div>

U 1344A *recto and verso*

ANTONIO DA SANGALLO THE YOUNGER
Property list; plumed helmet (*recto*). Theoretical study of
 fortifications (*verso*). Dated 6 November 1526.
Dimensions: 162 x 220 mm.
Technique: Pen and black ink.
Paper: Ragged edges, repaired tear across center.

INSCRIPTION, Recto: (list that begins in bill for work on a wall and becomes list of ceremonial garments) *A di 6 di novembre 1526 / Misura dello lavoro di muro / A mamassimo mio quarto fratello francisco da fulingni / Ive prego dame damore de gratia [. . .] / Aurem disse; palle quatro dalluma; una caocia dalluma; cinque falchole benedette dal papa; fura bianche e gialle; dua falchole lavorate di ciera / biancha; uno piatto di porcellano; uno gonifietto da sostana; nel fuocho; 14 nape doro di seta verde / biancha e rossa da toilette; otto nape bianche di napa / sono in due sachette*
Verso: *fosso* (five times); *Rocha*

While the recto carries a date for the drawing (6 November 1526), the real interest in the sheet is found on the verso. There Antonio has drawn two studies of fortresses. The lower sketch has two superimposed star-shaped fortress traces with circular central features, knob-shaped bastions at each salient, surrounded in the lower segments by triangular detached ravelins in geometrical ditches. The upper sketch on the verso develops this theme to show in more detail the relationship of the angled ditch and its outworks.

The two sketches mix traditions. We see both concentric planning around a circular central keep with a stellar trace comprising round towers on stem-like flanks and considerable defense in depth from triangular outworks of the ravelin type. The concentric planning, the round towers, and the circular central feature all recall the fifteenth-century tradition of Francesco di Giorgio, while the detached outworks look forward to the mid-sixteenth-century designs of Francesco De Marchi.

In U 979A v. similar formal ideas seem to be explored in connection with the work at Sant'Antoni-

no, Piacenza (probably also dated to 1526), and Giovannoni notes similar forms in U 727A v., 777A, 778A, 1051A v., and 1389A. See also the design for a central keep such as U 759A.

BIBLIOGRAPHY: Ferri (1885) 78; Giovannoni (1959) I: 81, 83, 443.

<div align="right">N.A./S.P.</div>

U 1353A *recto*

GIOVAN FRANCESCO DA SANGALLO
Fortification study, unknown location, ca. 1530.
Dimensions: 237 x 357 mm.
Technique: Pen and brown ink, stylus, pin, straightedge.

INSCRIPTION: *Questo*

This is a study for an entry system, sheltered in the flank of a three-sided defensive work, that leads to a distinctive octagonal interior chamber. Stairs lead into the chamber. There is a deep pit indicated outside the gate, either at ground level, or at the bottom of a dry ditch.

There is no indication of date or location. The scale seems to suggest a relatively small work, possibly for the fortress at Civita Castellana or for a corner of the Fortezza da Basso, Florence (see U 757A). The general assurance of the lines seems to suggest a work close to the Sangallo workshop's most active period. The parallel-line shading suggests the hand of Giovan Francesco.

BIBLIOGRAPHY: Ferri (1885) 78.

<div align="right">N.A./S.P.</div>

U 1354A *recto*

ARISTOTILE DA SANGALLO
Perugia, Rocca Paolina, ground floor plan of upper fortress,
 1542(?).
Dimensions: 970 x 835 mm.
Technique: Pen and brown ink, light brown wash, light red
 wash, blue wax crayon, blue and red chalk, straightedge,
 pin.
Paper: Thick, made from two big sheets and two small
 additions pasted together (as in diagram) with 8-mm
 overlap.
Drawing Scale: 100 *palmi* = 163 mm.

INSCRIPTION: (see key) (1) *latrine*; (2) *cucina*; (3) *conserva*; (4) *intrata cucina*; (5) *conserva di legno*; (6) *scoperto*; (7) *anito che va in cucina et latrine*; (8) *monitiun d'arme*; (9) *stalle sette ala[. . .]* (symbol); (10) *cavalleria*; (11) *officina*; (12) *sala*

sotto et sopra; (13) scoperto; (14) sala di sopra et soto; (15) scala de/lla scala; (16) sala sotto et sopra; (17) sala sotto et sopra; (18) [. . .]; (19) strada [. . .] la porta della volta; (20) [. . .]

1354 R.

Universally attributed to Bastiano da Sangallo, called Aristotile, U 1354A is the kind of relatively finished record drawing that probably reflects the Rocca Paolina as it was built. The drawing shows a plan of the upper fortress. All major decisions on space distribution have been taken; it fills in the areas left blank on U 271A. (Giovannoni, 1959, I: p. 76, considers that the sheet has annotations by Bartolomeo de' Rocchi. We cannot identify these notes.) Even so, dating is difficult. There is no fundamental difference from the plans dated to the summer of 1540 and yet we do not know when Aristotile came on site; possibly, this sheet was executed to record the state of the Rocca for the workshop. It is also unclear what is the purpose of the hard-lined cranked plan that has been added in blue wax crayon over the Rocca. (Could it be a section, upside down, showing the heights of different corridors, or the direction and inclination of drains or ventilation ducts?) We have dated the drawing, with some hesitation, to 1542.

BIBLIOGRAPHY: Ferri (1885) 111; Bacile di Castiglione (1903) 359, fig. 9; Giovannoni (1959) I: 76, 443; II: fig. 368; Marconi et al. (1978) 428; Grohmann (1981a) fig. 83; Camerieri, Palombaro (1988) 47, 95, 99, 100, fig. 33.

N.A./S.P.

U 1359A recto

ANTONIO DA SANGALLO THE YOUNGER
Rome, plan for the Santo Spirito gate, 1542–43.
Dimensions: 442 x 281 mm.
Technique: Pen and brown ink, stylus, ruler, dividers.
Paper: Edges uncut except for the right one, patches and stains.
Drawing Scale: Roman *palmi* (20 *palmi* = 64 mm).

INSCRIPTION: *Disegno fatto; piombatora; fosso per la coda / del ponte; fosso sotto lo / ponte levatu/ro*

This scale drawing, almost a working study, shows a plan for the Porta Santo Spirito: The external front is curved and with orders, the interior facing the Borgo is more simple and rectilinear. The guardroom is placed in the center of the Latin cross with beveled corner pilasters of Bramantesque origin. In all probability it was covered with a domical vault (Fancelli, 1986) similar to the one in herringbone work built by Giuliano da Sangallo and Antonio the Elder for the guardroom in the entrance to the fortress of Poggio Imperiale. Access to the guardroom was limited by a double moat, spanned at the second moat by a drawbridge that could be cut down easily, because it was hinged on the wall separating the two parts. The internal moat thus would have backed up the external one. We know about both from early representations and from the letters of Prospero Mochi (1545–46) to Pier Luigi Farnese that also speak of a doorway under the main door, on the level of the moat. It is from there, one must assume, that the diagonal lines in the sketch branch off to an underground passage leading toward a flank of the gate. Its real function, nonetheless, becomes clear only by realizing that U 1360A v. represents the continuation of the design on this recto, which became detached. The passageway surely would have led upward to the curved ramp visible in U 1360A v. until it reached the covering of the guardroom, where the cannon could have been transported and stationed on the roof of the gate. (This arrangement would have produced an incline of 30 percent.) A stairway for the guards would have been placed on the other side, toward the Borgo, leaving space under the ramps for the firing chamber of the arquebusiers, who would have stood back to back with those facing the Borgo. In order to intensify defensive fire, the four main arquebus positions are open on the external facade as well, between the bases of the paired semicolumns to be exact, a solution that would have been carried out during construction, contrary to indications in U

1360A, with its similar plan for the gate. Such would also have been the case for the entranceway and the side rooms, as pointed out by Fancelli (1986), who compared the drawings with his survey of the present-day monument.

Furthermore, the concave front displays the paired semicolumns, or, more precisely, the columns projecting from the wall for more than half their circumference, with interposed semicircular niches, as can be seen better in the case of U 1360A r., a drawing that pertains more to actual construction. Until now it seems not to have been noticed that the design calls for fifteen metopes and sixteen triglyphs, which immediately makes clear that Antonio had a Doric order in mind, although he was unable to complete his buildings. In view of the slender proportions of the order (1:8.5), the gate was construed as Ionic or Corinthian by Giovannoni (1959), ignoring Mochi, who spoke of a "porton dorico e militar" (Quarenghi, 1880; Rocchi, 1902; Bentivoglio, 1985), and Letarouilly's Doric reconstruction. This design with metopes and triglyphs is much more critical for a reconstruction of the uncompleted Porta Santo Spirito. Here, for example, the measurements of 4 *palmi* for the metopes and 3 *palmi* for the triglyphs are not far in proportional terms from those in U 301A v. of ten-fourths of a *palmo* for the triglyphs and fifteen-fourths of a *palmo* for the metopes, which we have identified with plans for the Flaminia and Ripetta gates in U 301A v. Yet unlike those gates, the triglyph here is folded into the corner without variation between the two parts corresponding to the projection of the entablature and the entablature itself, which proceeds continuously and does not reenter, beyond the semicolumns, along the central part of the rhythmic framework. The Porta Santo Spirito also shows a concave front, like the facade of the Roman Zecca (the papal mint), an imitation of antique *clavicula* portals, which were reproduced in Hygino Gromatico's *De munitionibus castrorum*. This model was used for the Molo gate in Genoa by one of Antonio's students, Galeazzo Alessi (Marconi, 1975); the intent of this layout was to make formally explicit the concentration of optical and defensive foci on the axis, as in the interior of the gate delineated in U 1431A v. for the access under San Saba. Mochi describes "Piramidoni," that is, obelisks, on the attic of the gate. See also U 941A, 1360A r. and v., 1096A r. and v., 1290A.

BIBLIOGRAPHY: Letarouilly (1849) I: 184; Letarouilly (1868) I: figs. 1, 184; Ronchini (1872) 166–67; Gotti (1875) I: 296–99; Quarenghi (1880) 167; Ferri (1885) 167; Rocchi (1902) I: 177; Giovannoni (1959) I: 366; II: fig. 381; Marconi (1975); Bentivoglio (1985) 79; Fancelli (1986) 232–33, 242 n. 7.

F.P.F.

U 1360A *recto and verso*

ANTONIO DA SANGALLO THE YOUNGER
Rome, plan for the Porta Santo Spirito, 1542–43.
Dimensions: 442 x 287 mm.
Technique: Pen and brown ink, brush and diluted brown ink, stylus, ruler, and dividers.
Paper: Uncut edges except on the right side, a few patches and yellow stains.
Drawing Scale: (recto and verso) Roman *palmi* (20 *palmi* = 64 mm).

INSCRIPTION, Recto: *fosso per la coda del ponte*; *fosso sotto lo ponte / levatoro*; *a piombo*

The plan on the recto may be considered an elaboration of one for the same gate in U 1359A. Antonio has tried here to make the four arms that meet under the domical vault of the guardroom more alike and has modified the firing chambers, the front ones in particular, placing the arquebuses on the level of the niches, which would have prevented putting statues in them; the statues, or "figuroni," as they were called by Mochi (1545–46) have been identified uncertainly as St. Peter and St. Paul (Giovannoni, 1959) and are already visible on U 1096A. The concave facade, with its paired triumphal three-quarter columns projecting from the wall—the way they would be built—has measurements of 4 *palmi* for the columns, 8 for the niches, 18 for the interaxis between the columns, and 34 from column to column facing the central arch. It should be noted, however, that although U 1360A r. shows a facade that is closer overall to the one actually constructed, it is superseded by U 1359A for the columns, shown there as built, 5 *palmi* in diameter. On the other hand, the curve of the facade here corresponds better to a circular segment with a radius of just over 20 meters. These measurements are taken from the actual gate and were noted by Fancelli (1986). Finally, the breadth of the design, slightly wider than that of U 1359A, enables us to see the conclusion—above and beyond the entire symmetrical development—of the Doric frieze: a reentrant triglyph concluded by a portion of metope, unlike U 301A v. for the Flaminia and Ripetta gates. This detail is ignored or erroneously reconstructed by Letarouilly (1868), even if he correctly designates the gate as Doric.

The sheet attached to the verso, as noted here for the first time, was originally the right part of U 1359A recto. Also done in scale, the design shows alternative ways, given the available space, to insert a ramp for the movement of cannon and men through the gate on the level of the moat in order to defend it from above. The choice, in darker ink, comprises a second ramp and the two preceding chambers from the level of the main gate. By means of two arquebuses, the most exposed room could be controlled from the ramp. Subsequent changes in plan probably prompted Antonio to divide this part of the design from the other, almost a fair copy, and reuse the page on the verso, which has now become the recto of 1360A. See also U 941A, 1359A, 902A, 1096A r. and v., 1290A.

BIBLIOGRAPHY: Ferri (1885) 167; Lanciani (1902–12) II: 58–63; Rocchi (1902) I: 177; Giovannoni (1959) I: 366; Cozzi (1968); Fancelli (1986) 232–33, 242 n. 7.

<div align="right">F.P.F.</div>

U 1361A *recto*

ANTONIO DA SANGALLO THE YOUNGER
Rome, study for the fortification of the Vatican hill, 1542.
Dimensions: 213 (average height) x 73 x 283 mm (bases).
Technique: Pen and brown ink.
Paper: Light, folded in half.

INSCRIPTION: (clockwise from top left) *Santo / Antonino*; *torrione / grande*; *Canneto*; *gallinaro*; *Torrione / in belvedere*; *incoronati*

In this study, the hypothetical new Vatican defenses are drawn in an unbroken line, along with dotted lines to indicate the existing walls. The drawing replicates U 1519A and 1524A with a single bastion, Sant'Antonino, along the high edge; but it moves the bastion back in order to make it comply with the new proposal to unify the Gallinaro and Canneto bastions located elsewhere into a single large bastion with a doubled flank. Presumably, the design provided for the Incoronati bastion platform on the other slope, thus synthesizing all of Antonio's main ideas for adapting the bastioned front to the hilly site. The lines of fire, drawn in pen, clarify the basic criteria used by Antonio in his geometric planning for the bastioned front. See also U 1012A r. and v., 1016A r. and v., 939A, 1515A, 1017A, 937A, 936A, 1876A, 1519A, 1524A, 940A r. and v., 1018A.

BIBLIOGRAPHY: Ferri (1885) 167; Rocchi (1902) I: 197; II: pl. XLII; Giovannoni (1959) I: 81, 366.

<div align="right">F.P.F.</div>

U 1362A *recto*

ANTONIO DA SANGALLO THE YOUNGER
Rome, plan for the double flank of the Ardeatine bastion, 1537.
Dimensions: 446 x 589 mm.
Technique: Pen and brown ink, stylus, ruler, and dividers, a few erasures and corrections, compass.
Paper: Folded in half, original edges, mounted corners, central patch, with yellowed borders and other stains.
Drawing Scale: Roman *palmi* (100 Roman *palmi* = 108 mm).

INSCRIPTION: *A*; *B*; *C*; *linia*; *D*; *A*; *scarpa*; *scarpetta*; *scarpone*; *B*; *p[almi] 106 fino allangolo / della scarpa della / torre*; *C*; *D*; *Muraglia / vechia*; *Palmi*; (in a later hand [Ferri?], upside down) *Bastione di Roma importantissimo*

The plan, with section points "A" through "D," represents half of the Ardeatine bastion on the level of the countermine tunnel constructed on the side that guards the Porta San Sebastiano and the adjoining ancient walls. The erasure on the second face was made to correct the inclination; the erasure on the first flank, to eliminate the existing embrasures on the upper level. The lines drawn with stylus and pen with light-colored ink also give a glimpse of the countermine chambers and corridors, as well as of the emergency exit, on the lower level of the scarp corridor. The overall measurements of the faces (250 *palmi* and 280 *palmi*) equal those indicated in U 1517A r.; those on the section correspond to U 1289A v. (see section "C" particularly); those of the countermine chambers and their reciprocal distances correspond to U 1505A. Although it is not a definitive plan, the study seems to recapitulate the results of preparatory studies and put them in scale. In fact, when constructed, the proportion between the first and second faces was changed, the first being shorter and thus realized according to a design that was rectified, however slightly. Also, the ventilation shafts in the oval rooms along the countermine tunnel were placed on an axis rather than on one side.

The other half of the bastion is developed only partially, with a face of equal inclination with respect to the main axis: A survey of the present-day monument indicates the nonsymmetrical inclination of this simple flank with the embrasures, doubtless due to a slight variation introduced to take into account the different layout of the ancient defensive curtain on the side of the Porta San Paolo. See also U 892A r. and v., 1517A r. and v., 1289A r. and v., 1505A.

BIBLIOGRAPHY: Ferri (1885) 167; Huelsen (1894) 323; Rocchi (1902) I: 184; II: pl. XXXIII; Giovannoni (1959) I:

81, 362; Pepper (1976) 164; Marconi et al. (1978) 386–87; Fiore (1986) 339.

<div align="right">F.P.F.</div>

U 1389A *recto*

GIOVAN FRANCESCO DA SANGALLO WITH ANTONIO DA SANGALLO THE YOUNGER
Theoretical studies, with stellar and bastioned trace; caponiers in ditches, before 1530.

Dimensions: 193 x 296 mm.
Technique: Pen and brown ink.
Paper: Darkened at edges.

(a) Field of fire from embrasures at different heights: *queste sono quelle danderare / quello fantocio.* (b) Cutaway section/perspective of rampart and ditch showing firing levels of cannon on parapet and in chamber below. It is keyed into *a*, showing how the infantry embrasures (angled steeply down) are fitted in between the spaces used by cannon at upper and lower levels. (c) Rough sketch of trefoil bastions, linked by wall/corridor to a ravelin/caponier. (d) Stellar trace study with *capannati* or bastions at each salient and casemates in the ditch: *puntoni* (at salient), *chasemate* (in ditch), *puntoni chasemate.* (e) Sketch of stellar work. (f) Enlarged study of reentrant and its two flanking salients, developed from the stellar diagram. The salient has a small defensive work within an outer part of a *puntone*. A freestanding caponier with five embrasures and open rear in ditch in the hand of Antonio (upside down): *chueste mura sono piu alte / che puntoni braccia 20.* (g) Cruder study of similar reentrant, without caponier, in hand of Antonio: *Per due cinte* (to indicate connection between inner and outer enceintes).

This sheet represents the kind of study that the Sangallo workshop might have used to develop ideas. The main hand is that of Giovan Francesco (at *a, b, d, e, f*). Antonio's hand and script are recognizable elsewhere (*c, g*). It is not far, in character, from U 1344A v. where there are similar experiments with the stellar trace. See also the experiments with the Fortezza da Basso trace (U 758A, 759A r. and v., 781A, 1118A). The reentrant trace used at *f* is one that Antonio experiments with extensively. See, for example, the reentrant

sally port (U 1509A). At *d* and *e* there is a series of exploratory studies for the delivery of defensive fire to a fort with a stellar trace. The starting point is a diagram *e*, formed from the overlay of four equilateral triangles. The advantage of such an enceinte is that defensive fire can be directed outward in all directions. In the absence of bastions with flanks, however, it is difficult to depress guns sufficiently to cover the foot of the works as is shown in the sketch *d*; muzzle-loading weapons cannot be so steeply angled. In the other sketches the architects explore the use of freestanding casemates (pillboxes) in the ditch between each point of the star, *puntoni* (similar in form and size to the casemates) built on each point, and the complex junctions created by this type of geometry.

Any date for the sheet is tentative. The work here seems to reflect the kind of studies undertaken in Florence, or problems posed by the fortress in Bologna; hence a date ca. 1530 seems appropriate.

BIBLIOGRAPHY: Ferri (1885) 78; Giovannoni (1959) I: 73, 77, 83, 444.

<div align="right">N.A/S.P.</div>

U 1390A *recto*

GIOVAN FRANCESCO DA SANGALLO
Fortification studies, location unknown; ca. 1530.

Dimensions: 172 x 273 mm.
Technique: Pen and brown ink.
Paper: Darkened at edges.

(a) Section of ditch, rampart, and counterscarp with a covered way coming about one-third of the way to ditch floor. The angle of depression of the gun embrasure is dimensioned: *20 pasi; profilo.* (b) Rough sketch of square trace with round towers at each corner and on one side. (c) Sketch of zigzag trace exploring possibility of diamond-shaped caponiers or ravelins in the reentrants: *fuora; drento / fortifiare.* (d) Rough sketch plan of embrasures with square chambers: *piano di sopra.* (e) Plan of bastion with orillons and curved flanks: *fiancho prefetto.* (f) Study of how to increase field of fire between two widely separated bastions by adding small bastions at equal distances along a straight curtain: *fosso.*

This sheet of multiple studies takes up problems char-

acteristic of the Sangallo workshop. Concerning some of these matters, we have drawings in the hand of Antonio himself: plan of the rounded bastion, see U 778A, 1467A; angling of the gun embrasure, see U 885A, 1030A; square trace with circular towers, see U 887A v.; two reentrants joined by a caponier or tunnel, see U 1052A; bastions added to a straight wall, see U 942A; a cranked wall, see U 1389A; the fortress at *a* recalls U 1051A as well as the Castel Sant'Angelo (see U 1020A v.). The sureness of the hand and the placement on the page suggest that this may have been a demonstration drawing rather than a study sheet.

All matters on the sheet seem to reflect a proposal for a relatively large-scale fortress in a plain, possibly Ravenna or Bologna. The sketch at *f* recalls the double-flanked bastion for Rome (see U 942A). In the absence of further information, a dating ca. 1530, therefore, seems appropriate.

BIBLIOGRAPHY: Ferri (1885) 78; Giovannoni (1959) I: 77, 444.

N.A/S.P.

U 1392A *recto and verso*

GIOVAN FRANCESCO DA SANGALLO
Piacenza, studies of bastion showing flanks, countermines, cavaliers, and their ramps, 1529(?).

```
a                    b
c
      d
             e
```

Dimensions: 290 x 431 mm.
Technique: Pen and brown ink.
Paper: Folded in half vertically; darkened partially at edges.
Drawing Scale: piedi (18 *piedi* = 27 mm).

INSCRIPTION, Recto: (a) *fiancho*; *murato*; *foso*; *pie*; (around sketch) *muro*; *La bocha della bonbardiera di fuora alta al piano / della chanpagna piu alta uno pie dal chanto / di drento* (*dalchanto* canceled) *alta piedi 15 che mene / a pendere piedi 4 lo piano dove si sta arrivare / piu alto che ditta chanpagnia piedi 2½ La scharpa / va sotto al ditto piano della chanpagnia piedi 14 / sopra a ditto piano piedi 101;* (b) *chane .x. di piedi in tutto piedi 60;* (c) *argine; lo piano della chanpagnia; scharpone; La chanoniera pende innanzi / br[accia] 2 lo parapetto dimezo le dua / chanoniere alte br[accia] 3 e tanto piu / quanto elo parapetto della chanoniera;* (d) *fiancho; Basa; Schoperto; choperto; andito in fino / a la tera; piaza alta / terzo piano; choperto e sopra / parapetti dal terzo piano; andito / in fino / ala tera; al calatoro della*

chasamatta; entrata; (e) *Baluardo*
Verso: *Lo murato a in groseza / piedi 18 in torno in torno; pie 5 alto lo parapetto; piedi 2 alto / questo bancho; piedi 120; parapetto dello chavaliere; tiri in chanpagnia; parapetto; piaza della arti/glieria; parapetto; tiri in chanpagnia*

This sheet of linked studies of a bastion and its component parts forms part of a series that includes U 1395A, 1396A, 1397A, 1424A, and 1425A (all except the last with the same watermark). Technically the most interesting aspects of the design are the countermines (see U 1396A and 1424A) and the cavalier, illustrated here with a massive protective traverse to the front shielding sideways-oriented parapets with guns firing *en barbette* into the country along lines marked and annotated.

The sheet contains a remarkably complete set of analyses of the bastion and its parts. On the recto side (see sketch) are six studies. (*a*) A plan section of the bastion flank showing merlons that split to form two embrasures. To the right and slightly below, the same bastion is redrawn in schematic fashion to show it with straight flanks and flanking batteries (hatched). (*b*) Drawn upside down, Giovan Francesco shows a section through a glacis, covered way, counterscarp, ditch, and rampart, with two tiers of countermines and their ventilation and lighting flues. (*c*) A section through a rampart showing the curved parapet, fire step (banquette), and internal galleries and flues. (*d*) A diagrammatic plan of a low-level open-flank battery, its covered bomb shelters, and the access tunnel linking it to the fortress interior. (*e*) Detailed plan section of a recessed ("traitor") flank battery, protected by a curved orillon, with upper-level triple embrasures and a lower-level countermine.

On the verso, all of these sketches are pulled together into a single plan of the bastion, its internal defenses, and its cavalier. The relationship between U 1392A v. and Antonio's drawing U 805A is of special interest. Both show a bastion and cavalier for Piacenza and the measurements between the two drawings largely correspond. It is possible that the entire sequence of Antonio's drawings for Piacenza date from 1529. It is likely that Giovan Francesco's drawings, dating from ca. 1529, represent an early phase of the shop's operation at Piacenza and that Antonio may have reused the drawings (see U 808A) in the 1540's when he returned to Piacenza.

BIBLIOGRAPHY: Giovannoni (1959) I: 77.

N.A./S.P.

U 1395A recto

GIOVAN FRANCESCO DA SANGALLO
Piacenza, ditch section and countermine detail plan, 1529(?).
Dimensions: 436 x 297 mm.
Technique: Pen and brown ink.
Paper: Modern support.
Drawing Scale: (upper drawing) *piedi veronesi* (60 = 164 mm);
 (lower drawing) *braccio piacentino* (*quarto di braccio di
 piacenza* = 115 mm); (bottom of drawing) *piedi* (36 *piedi*
 = 163 mm).

INSCRIPTION: (upper drawing) *fondo del fosso; Arincontro
alli baluardi largo lo fosso piedi 69 / aschontro alle chortine
largo piedi 90 cioe chane / 15 veronese di piedi 6 luna dalle
channe;* (lower drawing) *exalatoro;* (top left, center)
exalatoro; (middle right) *contramina longa / e sotto tramezato
ch*[. . .hole in paper] *puntegiato;* (below right) *sfiatatoro
nella chontramyna / lunga;* (later hand) *Di Verona*

The upper drawing shows a section of a ditch and
counterscarp, showing a covered way and its dimen-
sions. The lower drawing shows details of a plan of a
countermine and its ventilation flues. The whole sheet
is marked (top left) "Di Verona" in darker (that is,
more modern) ink. This misattribution presumably
comes from the first scale in Veronese feet ("piedi
veronesi"). The drawing clearly forms part of the Pia-
cenza series and relates to sheets such as U 1392A,
1396A, 1397A, 1424A, and 1425A. This identification
is also confirmed by the watermark.

Although attributed by Giovannoni (1959) to Gio-
vanni Battista, a comparison with the material assem-
bled by Buddensieg (1975) suggests a proper
attribution of the entire series to Giovan Francesco.
On some of the dating problems associated with the
Piacenza series, see U 808A and 1392A.

BIBLIOGRAPHY: Giovannoni (1959) I: 77, 444.

<div align="right">N.A./S.P.</div>

U 1396A recto

GIOVAN FRANCESCO DA SANGALLO
Piacenza, section through ditch, scarp, and rampart showing
 internal arrangements of countermines and ventilation
 flues (above), with detailed plan of countermine level
 (below), 1529(?).
Dimensions: 416 x 293 mm.
Technique: Pen and brown ink.
Paper: Darkened at edges.

INSCRIPTION, Recto: (above) *piano delacqua; pie 6;* (in
ditch) *fondamento; piedi 15; chamino della dentro mura;*

*contramina; contramina sotto / lacqua; piedi 13; piedi 14;
parapetto; pie 5; schalone; pie 2; Terra; piedi 16; piedi 14;
piano dello schapone e fondo della / chanoniera;* (in base of
rampart) *fondo del fosso;* (below) *e sopra dove sta questo*
(page cut); *Queste sone archibusiere sono nelle / chontramyne
longa 3 canni posono / tirare aytempo che non si dianora luno
laltro / cosi fuora non apare se non e una bucha;* (right)
exalatoro
Verso: *Baluardo sichondo lomo* (page cut)

This sheet contains a detailed section (above) and plan
(below) of the rampart and its countermine system at
Piacenza. The drawing is closely related to other
drawings for Piacenza (see U 802A, 1392A, 1395A,
1397A). In the section a wet ditch is indicated. In the
plan, mushroom-shaped countermine chambers, coun-
terforts, access gallery, and the gallery's small-arms
embrasures are all shown. Giovannoni attributed the
drawing to Giovanni Battista but comparison with the
other Piacenza drawings proves this to be the work of
Giovan Francesco. For issues of dating, see U 808A
and 1392A.

BIBLIOGRAPHY: Giovannoni (1959) I: 77, 444; Marconi
et al. (1978) 152.

<div align="right">N.A./S.P.</div>

U 1397A recto

GIOVAN FRANCESCO DA SANGALLO
Piacenza, plan section through the flank and orillon of a
 bastion at countermine level, 1529(?).
Dimensions: 432 x 290 mm.
Technique: Pen and brown ink.
Paper: Folded in half, darkened at edges, modern
 reinforcements.

INSCRIPTION, Recto: *Baluardo sichondo lo mo/dello; piano
della citta / di drento; mura della chortina vechia;* (*mura della
chortina vechia* canceled); *dalla stella alloangolo della /
chortina piedi 84 cioe channe 14 veronese; A piedi 90 B*
Verso: *dello*

This sheet illustrates a detailed study of the counter-
mine chambers and communication gallery in the
shoulder of a bastion. These details relate to the
sequence of drawings by Giovan Francesco da Sangal-
lo for the fortress at Piacenza. See also U 1392A,
1395A, 1396A, 1424A, and 1425A. U 1397A is also
extremely close to the drawing of the San Benedetto
bastion in Piacenza made by Antonio the Younger (U
802A), for which it may be a preparatory study possi-
bly executed on an earlier visit.

BIBLIOGRAPHY: Giovannoni (1959) I: 77, 444; Buddensieg (1975) 108.

N.A/S.P.

U 1409A *verso*

ANTONIO DA SANGALLO THE YOUNGER
Studies of a pump, gears, valves, and chorobates.

Dimensions: 410 x 270 mm.
Technique: Pen and brown ink.
Paper: Center fold.

Left half: (a) Pump with double tubes and valves (*Tesibica machina*). (b) L[*ibro*] X [Book X, Vitruvius]. (c) Valves, in plan view (*B; cosi*). (d) Gear rack in ellipse (*A*). (e) Gear rack in plan view (*A*). (f) Crankshaft with cams (*B*). (g) Gear rack in larger plan view. Right half: (h) L[*ibro*] VIII [Book VIII, Vitruvius]. (i) Elevation and plan of building with nave and side aisles. (j) Leveling instrument, or chorobates (*corobata /A, cardine*), its base and pinion annotated: *pteromatos; pronao; libro 5; capitolo iiii; e interiore del labrum; A*). (k) Slider of the chorobates, detail. (l) Vessel on octagonal base (*otto / facci*). (m) Vase in left-half profile; vase in right-half profile.

The exterior of the pump of Ctesibius, a force pump with a side tube, is illustrated (*a*). It is not clear whether any of the details (*c* to *g*) belong to this version. Antonio's note for Book X possibly derives from Vitruvius's description (X.vii.1–4) of machines published in Cesare Cesariano's edition of 1521 ("De la Ctesibica machina quale altissimamente extolle laqua capo XII," pp. CLXXI v., CLXXII r.). Antonio and Cesariano had used the name "Ctesibica machina," as did other Vitruvianists for a long time. While Cesariano commented on this pump extensively, he did not illustrate it. Although Antonio's pump is based on hydraulic engines that others developed before him, there is nothing quite like it in Francesco di Giorgio's *Trattato I*, fols. 45 v.–48 r. (Martini-Maltese, I: pls. 81–87). Is it a coincidence that Antonio's chorobates drawings (*j*) and (*k*), also derived from Vitruvius (VIII.v.1–2), resemble Cesariano's illustrations ("Instrumentorum quibus utuntur ad aquarum productiones agrimensorum quae ad librationes et termi-

nationes figura," p. CXXXVIII r. in the chapter "De le perductione et libramenti de le aque et instrumenti ad tale uso cap VI")? Antonio made other drawings of chorobates (U 1460A r.) but his wording is too generalized to allow us to conclude that it was drawn from Cesariano's commentary on the chorobates (pp. CXXXVII r. and v.).

BIBLIOGRAPHY: Cesariano (1521); Ferri (1885) 91.

G.S.

U 1419A *recto*

ANTONIO DA SANGALLO THE YOUNGER(?)
Unknown location, view and partial plan of fortifications, 1530(?).
Dimensions: 147 x 214 mm.
Technique: Pen and dark gray ink.
Paper: Darkened at edges.

No location has been discovered for this unusual partial plan and view of a series of fortification works. Ferri even doubts the attribution to Antonio the Younger, giving it to the architect with a question mark, as we do. Giovannoni (1959) does not mention the drawing.

The work seems to consist of a town wall attached to a fortress, but it is impossible to tell whether it is a fantasy or an actual site. The notation of the dimensions might suggest a specific site. One possible location is Ancona, where Antonio the Younger provided proposals for the western front of the city (see U 1526A v.). The bastion, to the left on our sheet, is thus seen in an early phase of development; it is more fully developed in U 1526A verso. There are difficulties with this identification with Ancona (differences in the curtain, the upper levels of the towers, etc.); other sites seem even less convincing for now.

Unfortunately the watermark is one of a kind in our experience of Antonio the Younger and is, therefore, of little help in dating or locating the drawing. Even the date must be conjectural: later, rather than earlier, in Antonio the Younger's career due to the vigor of the line.

BIBLIOGRAPHY: Ferri (1885) 78.

N.A./S.P.

U 1424A *recto*

GIOVANNI BATTISTA DA SANGALLO
Piacenza, detailed plan of countermine, 1545.
Dimensions: 139 x 186 mm.

Technique: Pen and brown ink.

Paper: Section removed bottom right. Fraction of watermark, design not identifiable.

Drawing Scale: braccia.

INSCRIPTION: *Lunetta; lunetta; Lume / alto braccia 5¼*

This sheet and its companion, U 1425A recto, are working drawings in the modern sense; they show precise dimensions for laying out the countermine, its access gallery, and the openings off the side. Particularly interesting are the annotations of the "lunette" (fanlights) and "lume alto" (high light), which make it clear that the internal flues, which certainly served as ventilation flues as well, were in fact designed to light the lower levels. In other drawings for Piacenza by Antonio the Younger and Giovan Francesco (U 802A, 808A, 1392A, 1395A, 1397A) the location of these ventilation/light shafts can be identified.

This sheet and its companion (U 1425A r.) were at one time identified (Bartoli) as small bath structures. This identification can no longer be sustained. (Thanks are due Annarosa Cerutti-Fusco who kindly supplied information on this earlier identification.)

BIBLIOGRAPHY: Ferri (1885) 205; Bartoli (1914–22) II: fig. 512, pl. 251; VI: 95.

N.A./S.P.

U 1425A *recto*

GIOVANNI BATTISTA DA SANGALLO
Piacenza, detailed plan of countermine, 1545.
Dimensions: 170 x 220 mm.
Drawing Scale: braccia.

INSCRIPTION: *Lunetta; Lume; Lunetta per lume*

Almost identical to U 1424A recto, this sheet is more roughly drafted and probably served as a preliminary working drawing. For a discussion of the function and location of the countermine, see the entry for U 1424A r. All of the dimensions are the same as on U 1424A r., with one addition of *braccia 5* (lower left). Slight variations in the wording of annotations merely serve to amplify the function of the lighting arrangements.

BIBLIOGRAPHY: Ferri (1885) 205; Bartoli (1914–22) IV: fig. 513, pl. 39; VI: 95.

N.A./S.P.

U 1431A *recto and verso*

ANTONIO DA SANGALLO THE YOUNGER
Rome, study for the fortifications of the San Saba hill and the new Porta Ostiense, 1537.
Dimensions: 443 x 586 mm.
Technique: Pen and brown ink, stylus, ruler (recto); pen and brown ink, traces of red pencil (verso).
Paper: Folded in four, original edges yellowed, patches and traces of patches due to restoration.
Drawing Scale: 50 Roman *canne* = 490 mm (recto).

INSCRIPTION, Recto: *monte; porta; muro; monte; muro; muro; monte; finalle mura Ca[n]ne 89; Ca[nne] 164 in tutto fino alle mura; meta; Canne 125 fino amezo la porta; Canne 215; Ca[n]ne 50; passi 15; p[ie]di 75; p[ie]di 375*
Verso: *Baluardo; angiporto / e antiporto; Baluardo; porta / S[an]to pa[o]lo; meta*

The design on the recto, done in scale, is a more complete version of the defensive strategy proposed in U 1015A, including the external variation for the eastern sector between the lower Aventine and the Ardeatine bastions. This last detail demonstrates how unified Antonio's planning was for the defensive sector to the left of the Tiber, at least up to the Ardeatine bastion, as is also apparent in U 938A. It also shows that the planning, though less detailed, continued as far as the Lateran (see U 301A v.). Note the detail of the new gate inserted between the Servian *monte* and *muro*, which is connected in a straight line with the Porta San Paolo and furnished like the latter with a main gate and a forward gate. The guardroom between the two gates has a "nave" and two aisles, in keeping with Antonio's interpretation (after Fra Giocondo) of the Vitruvian atrium.

The design of the gate drawn on the verso repeats the same solution but enriches it with an internal anteportal of triangular shape with a curved base meant for the emplacement of defensive artillery. The resulting lateral access to the interior is all to the advantage of the defenders. The design on the verso, not in scale, suggests a further solution for the bastioned front because it shows the gate enclosed between two bastions and corresponds perhaps to the intermediary solution in U 1514A, which indicates the addition of a gate. On the verso are traces in red pencil of calipers in open and closed position very similar in form to the ones in ink on U 1526A r. See also U 1019A, 1514A, 1015A, 938A.

BIBLIOGRAPHY: Ferri (1885) 167; Huelsen (1894) 329; Rocchi (1902) I: 180–81; II: pl. XXIX; Giovannoni (1959) I: 81, 361; Fiore (1986) 338.

F.P.F.

U 1432A *recto*

ANTONIO DA SANGALLO THE YOUNGER
Study of strategy for sinking a ship.
Dimensions: 168 x 220 mm.
Technique: Pen and brown ink.
Paper: Repaired upper right.

The origins of this image of ship-sinking and others like it in the Notebook of Taccola have been discussed elsewhere (see U 818A r.). It is likely that Antonio's model was Ms Additional 34113, British Library, London. For the ship-sinking device, see folio 105 r.

BIBLIOGRAPHY: Ferri (1885) 91; Taccola (1984).

G.S.

U 1435A *recto*

ANTONIO DA SANGALLO THE YOUNGER
Studies of a car with a treadwheel moved by two men.
Dimensions: 115 x 85 mm.
Technique: Pen and brown ink.
Paper: Edges reinforced.

INSCRIPTION: *segnio*

This imaginative design is one more illustration of Antonio's interest in the treadwheel (see U 852A r.). It is different from the car with cogwheel-lantern gears illustrated in Robertus Valturius's *De re militari* (Latin edition, 1472; Italian edition, 1483). It is unrelated to any of the cars in the series by Francesco di Giorgio (*Opusculum de architectura*, Ms. 197 b 21, British Museum, London; *Trattato I*, fols. 52 r. and 52 v., illustrated by Maltese, I: pls. 95, 96). Another fantasy car (U 1450A r.) was copied by Antonio from one in the copybook of the Anonimo Ingegnere Senese.

It is possible that the inscription may be read as *sognio* ("dream"), thus explaining the fantastic nature of the vehicle.

BIBLIOGRAPHY: Ferri (1885) 88; Martini-Maltese (1967) I: pls. 95, 96.

G.S.

U 1436A *recto*

ANTONIO DA SANGALLO THE YOUNGER
Four mills operated by two men treading a great wheel.
Dimensions: 100 x 193 mm.
Technique: Pen and brown ink.
Paper: Darkened at edges.

Antonio the Younger expressed his opinion about the superior power of the treadwheel (U 852A r.) when he criticized the hand-cranked pulverizer he saw in Pitigliano. This quadruple set of mills on a horizontal shaft is a hypothetical arrangement like his design of a horse-driven quadruple mill in a circle (U 1268A r.).

BIBLIOGRAPHY: Ferri (1885) 88.

G.S.

U 1437A *recto*

ANTONIO DA SANGALLO THE YOUNGER
Studies of rope-and-pulleys system with human-powered
 treadwheel.
Dimensions: 200 x 280 mm.
Technique: Pen and brown ink.
Paper: Darkened at edges.

This is another example of Antonio's interest in the treadwheel; see also U 852A r. This one is moved by men standing on its outside. It probably reflects some discussions about the pulley-rope system with nine pulleys, like another one he illustrated with ten pulleys (U 4058A r.); there it was to function as a grain thresher.

BIBLIOGRAPHY: Ferri (1885) 88.

G.S.

U 1438A *recto*

ANTONIO DA SANGALLO THE YOUNGER
Study of a boat with paddlewheels; treadwheel operated by
 men.
Dimensions: 140 x 210 mm.
Technique: Pen and brown ink.
Paper: Darkened at edges.

INSCRIPTION: *Difitii overo machine che caminono / stando nella machina si fanno cami/nare in varii modi; Questa va in le machine / de li ingenii ordinari*

As stated previously (U 818A r.), this drawing is one of a series that began in Taccola's Notebook. Others like it in Antonio's manuscript source (Ms Additional 34113, fol. 116 r., British Library, London) prove that he himself copied this one and added details at the top. Again his interest is in the treadwheel (see U 852A r.). His first sentence may be translated as "machines that move while riders are in them are made to move in various ways." The word "machines" would have included the treadwheel-powered car (U 1435A r.), the

treadwheel-powered mills (U 1436A r.), the lift (U 1437 r.), and any other machines with treadwheels. In his last sentence he says the machine should be classed as an "ordinary device," which he defines as a category of engine. Other categories are "various types of engines" (U 1496A v.), "hoists" (U 1449A r.), and "astrolabes and quadrants" (U 1454A v.).

BIBLIOGRAPHY: Ferri (1885) 92.

G.S.

U 1439A *recto and verso*

ANTONIO DA SANGALLO THE YOUNGER
Studies of hoists and crane.

```
    a        b
 c     d
          e
       f  g
 h
```

Dimensions: 433 x 300 mm.
Technique: Pen and gray-black ink.
Paper: Worn, stained.

Recto. (a) Hoist with rope winder, gear, and reversible screw. (b) Hoist with rope winder, gear on a mast, ox-driven. (c) Cryptic notes (undecipherable). (d) Note: *D[enari] 2 S[old]i 51 / di chonto vechio / avere Vettorio.* (e) Treadwheel with human operator, detail. (f) Rope pulleys in three details. (g) Note (upside down): *d / di / domeni / Sono amato pianto.* (h) Fireplace with stemma.
Verso. Rotating wooden lever crane.

The cogwheel lantern hoists (*a* and *b*) are two variants of Brunelleschi's hoist with animal drive and reversible screw, which will be discussed more fully later (U 1504A r.). The crane on the verso is discussed in conjunction with another (U 1479A r.).

BIBLIOGRAPHY: Ferri (1885) 15, 88.

G.S.

U 1440A *recto*

ANTONIO DA SANGALLO THE YOUNGER
Studies of rope hoists.
Dimensions: 290 x 430 mm.
Technique: Pen and brown ink.
Paper: Center fold.

Left half: (a) Bucket hoist with rope pulleys (*puleggia*) and capstan. (b) Bucket hoist with rope pulleys and turned by

a horse. Right half: (c) Treadwheel hoist with pulleys.

INSCRIPTION: (a) *Questa machina sie per tirare roba a una fabricha di muro / overo per cavare aqua de uno pozo; Ma queste pulegie da basso / vogliono stare piu lontane luna dalla llatra almeno tanto quanto / sono longe le stanghe dell argano acio ditte stange possino / girare intorno quando li omeni le pontano;* (b) *Si puo fare el medesimo / con uno cavallo come / vedi questo schizo e fa / opera asai El cavallo va / una volta in qua e una / in la; Bisognia che uno holmo lo guidi quando per in / verso e quando per laltro & / lo facci fermare tanto / si carichi e scarichi / La botta sia grossa piedi sei / La stanga sia longa piedi / .xviii. dal mezo dello stile / al mezo del cavallo;* (c) *In questa rota possano stare / li omeni a calcare overo / di dentro in la rota overo di / fuora come meglio ti palrera; E per tirare uno de pesi / si camina per inlverso tanto / chel peso sia arivato in alto / e poi si camina per laltro / verso e ssi leva laltro / peso e laltra corda torna / a basso Bisogni ci sia uno con/trapeso acio la corda torni / a baso tirando su pietra o / legni / Ma tirando saxi o calcina / o aqua basta li bigonci e / le casse dove si mette li saxi / quale fanno contrapeso / loro medesimi*

These rope hoists are related to others on U 1504A r., where they are discussed.

BIBLIOGRAPHY: Ferri (1885) 89.

G.S.

U 1440A *verso*

ANTONIO DA SANGALLO THE YOUNGER
Studies of lifting devices.
Dimensions and Paper: See U 1440A recto.
Technique: Pen and brown ink.

Left half: (a) Bucket hoist with treadwheel, gear, and rope pulleys. Right half: (b) Bale-lifting lever on a flatcar. (c) Water scoop.

INSCRIPTION: (a) *Questa machina la movano li omeni quali ci vanno dentro caminado tanto per un verso che luno delli / pesi sia in cima E come quello si vota o scaricha lui / sta fermo e come scaricho si volta caminado per laltra / banda e conducie laltro peso in cima; E laltro bigonzo / voto torna a basso per enpirsi ma va tardo Ma leva / gran peso con pocha faticha che uno omo solo leva un gran / peso*

A bucket hoist almost identical to this one first appeared in Francesco di Giorgio's *Trattato I,* fol. 50 v. (Martini-Maltese, I: pl. 92), and again in *Trattato II,* fol. 91 v. (Martini-Maltese, II: pl. 318), but Antonio modified its frame and wrote his own text, which repeats his wording about rope movement and the

loading and unloading of weights (for further discussion, see U 1504A r.). Here, suffice to say that Antonio utilized Francesco di Giorgio's *Trattato II* in Codex Magliabechiano II.1.141, Biblioteca Nazionale, Florence, as explained at U 1443A r. In "Drawings of Machines" it is pointed out that Antonio's drawings of the bale-lifter and water scoop were derived from copies of Taccola's Notebook drawings (Ms CLM 197, part II, Bayerisches Staatsbibliothek, Munich) executed by the Anonimo Ingegnere Senese in his copybook (Ms Additional 34113, fol. 93 v., British Library, London).

BIBLIOGRAPHY: Ferri (1885) 89; Martini-Maltese (1967) II: pl. 318; Taccola (1984).

G.S.

U 1441A *recto*

ANTONIO DA SANGALLO THE YOUNGER
Studies of machines.
Dimensions: 328 x 215 mm.
Technique: Pen and gray-black ink.
Paper: Darkened on three sides; discoloration at left.

(left) Press of iron for medal-making (*per choniare medaglie / tuto di ferro la vite / e ogni chosa*). (right) Lathe of iron for screws (*per fare vite a tornio / di ferro e bisognia sia tutto / di ferro ed aciaio*).

The sheet was once half a folio from Antonio the Younger's sketchbook. His drawing of a minting machine differs only in its frame from one designed by Baldassarre Peruzzi (U 504A v.); both of them probably are based on existing presses. The press of Benvenuto Della Volpaia's cogwheel mechanism, which served for pulling a saw and minting coins ("disegno d'uno strumento che e per tirar seghe e per batter moneta": Codex Ital. Cl. IV, 41, 5363, fol. 19 r., Biblioteca Marciana, Venice), is completely different. The operation of Antonio's lathe for screws is difficult to understand, but it is clearly different from his representation of a traditional lathe (U 1445A r., 1564A r.) and from a similar lathe by one of the Anonymi (U 4086A r.), as well as from many illustrated by Leonardo in the Codex Atlanticus and other sketchbooks. Concerning a possible date for this sheet, see the essay by C.L. Frommel in this volume.

BIBLIOGRAPHY: Ferri (1885) 88; Gille (1956) 629–59; Adams (1978) 201–6.

G.S.

U 1441A *verso*

ANTONIO DA SANGALLO THE YOUNGER
Flintlock (arquebus) trigger with a figurine of a male nude.
Dimensions and Paper: See 1441A recto.
Technique: Pen and brown ink.

INSCRIPTION: *molla per dare fuocho a uno archibuso*

This sheet shows the simpler of two triggers, the more complex one being U 4041A r. Leonardo shows at least four like this one (Codex Madrid I, fols. 18 v., 94 r., 98 v., 99 v., Ms 8936, Biblioteca Nacional, Madrid).

I considered some parts of the drawings to be artistic fantasies until Simon Pepper explained how the simpler one functioned: The long trigger arm (lower right) is raised to open the cover of the flash pan (which holds the priming powder) and tilt into the pan the miniature human figure that holds the glowing match cord. It is a sophisticated solution, for the matchlocks of the period normally had their flashpan protected by a cover that was pulled aside prior to use. This "automatic" matchlock did not expose the priming powder to rain and wind in the time it took to aim and fire the weapon.

BIBLIOGRAPHY: Ferri (1885) 92; Hall (1956) 695–730; Leonardo da Vinci (1974).

G.S.

U 1442A *recto and verso*

ANTONIO DA SANGALLO THE YOUNGER
Mill wheels in Cesena, Pitigliano, and San Leo.
Dimensions: 278 x 218 mm.
Technique: Pen and ink.
Paper: Darkened at edges; center fold.

Recto: (top) Mill wheel in Cesena turned by a horse moves a pulverizer at left and mill wheel at right. (bottom) Mill wheel hand-cranked with four iron cannonballs as flyweights at Pitigliano and San Leo.
Verso: Mill similar in outline to that in Cesena.

INSCRIPTION: (left) *In una volta della / rota grande de le due / rote voltano 7 / e lo rochetto de pestoni / volterano volte 14*; (center) *Questo sie nella rocha di Ciesena / per uno mulino Lo volta uno cavallo / e quando la volti lo mulino e la polvera / si pesta Lo volta dua cavalli / misurata a piedi antichi*; (right) *In una volta della / rota grande le due / rote voltano 7 / Lo rochetto e la macina voltano 42*; (below) *In Santo Leo e in Piti/gliano/ Lo rochetto / mezo pie la rota dentata uno pie / La volta dello stile 3 palmi / cioe dita 12 / le palle sono palle di cannone di ferro colate*

As usual, Antonio's notes stress dimensions of components and number of revolutions made by the components in relation to one another. Suspension rods for the great wheel recur also in the mill in Arezzo (U 1467A r.) where the turning bar for the horse is at ground level. Antonio showed two other versions of the mill pulverizer in Cesena (U 819A r., 1461A v.), all possibly sketched in 1526 when he and Michele Sanmicheli visited the forts in Romagna. The hand-cranked mill with weight-wheel of iron balls on chains is like another in Pitigliano (U 852A r.), but in this case Antonio named the site of San Leo near Arezzo and some distance from Pitigliano. He sketched two other similar mills, one in Pisa (U 1445A r.) and another with flyweights in Ancona (U 1446A r.). Concerning a possible date for this sheet, see the essay by C.L. Frommel in this volume.

BIBLIOGRAPHY: Ferri (1885) 24, 84, 114; Curti (1985) 44, fig. 4.

G.S.

U 1443A *recto*

ANTONIO DA SANGALLO THE YOUNGER
Column lifts and pump.
Dimensions: 288 x 427 mm.
Technique: Pen and brown ink.
Paper: Center fold.

"12" Column lift with vertical racks and central screw. "13" Column lift with roller-ladders and central screw. "14" Pump with valves in a tube.

INSCRIPTION: *Questo e debole / pigliando la vite / li rulletti perche / ditti rulletti non / poso freta quanto / li denti pureche / llo vedera la / varieta e quello / si puo fare ma / che ne discriva/re li buoni*

Antonio the Younger's note criticizes the choice of a screw (*vite*) on the rollers (*rulletti*) for its slow movement; rollers do not move as quickly as teeth on the screw. If I understand the rest of his sentence, he notes that the variety of mechanisms with their screws can be seen and made, but only the good ones may be shown. What Antonio does not state is that he copied these column lifts and pump, as well as the two other column lifts and the obelisk hauler on the verso side, from Francesco di Giorgio's *Trattato II* Supplement when he had Codex Magliabechiano II.1.41 (now Biblioteca Nazionale, Florence) in hand at Monte Oliveto Maggiore where it was transcribed and illustrated in the scriptorium, as explained in "Drawings of

Machines." Antonio the Younger's drawings on both sides of this sheet may be compared with Francesco's drawings of them as follows: U 1443A r., copied from *Trattato II*, 93 v., 94 r., 94 r. (Martini-Maltese, II: pls. 322, 323); U 1443A v., right half, copied from *Trattato II*, 93 r., 93 r., 93 v. (Martini-Maltese, II: pls. 321, 322).

Antonio numbered the mechanisms from *9* to *14*. Numerals *1* through *7* began on folio U 4078A r., and numerals *15* through *28* are on U 1471A r. and v. Considering Antonio's numerals in relation to his commentary about variety and the good mechanisms, he seems to have decided to use them for some illustrated book of his own. Only the hoists on U 1482A r. and v. and on U 1483A r. and v., which show Antonio's early style of drawing with penstroke shading, were copied from Francesco's *Trattato II* with texts, as if intended for use in a treatise. The present sheet has the same watermark as that found on U 1471A. Both sheets show mechanisms in Antonio's penline technique characteristic of his second and later sketchbook (U 848A r.), which may have a different watermark. Like Antonio the Younger's copies (U 1482A r. and v., 1483A r. and v.), the column lifts and pump obelisk hauler on this sheet (U 1443A r. and v.) and eleven of the fourteen mills (U 1471A r. and v.) were all copied from Francesco di Giorgio's *Trattato II* Supplement. Concerning a possible date for this sheet, see the essay by C.L. Frommel in this volume. See also "Drawings of Machines."

BIBLIOGRAPHY: Ferri (1885) 91; Martini-Maltese (1967) II: pls. 317–322.

G.S.

U 1443A *verso*

ANTONIO DA SANGALLO THE YOUNGER
Studies for lifting devices.
Dimensions, Technique, and Paper: See U 1443A r.

Left half: (a) Archimedean screw. (b) Archimedean screw(?) with wheel at top. (c) Rope-pulleys system(?) (see U 1444A r.). Right half: (d) "9" Obelisk hauler with gear, rack, and screw. (e) "10" Column lift with central rack and two screws. (f) "11" Column lift with two racks and two screws.

Antonio the Younger's drawings (9–11) are discussed with others he illustrated from Francesco di Giorgio's *Trattato II* on U 1443A r.

BIBLIOGRAPHY: Ferri (1885) 91.

G.S.

U 1444A *recto*

Antonio da Sangallo the Younger
Studies of pulleys.
Dimensions: 290 x 415 mm.
Technique: Pen and brown ink.
Paper: Center fold.

Left half: (a) Tripod hoist of wood beams, rope pulleys at oblique angle. (b) Pulley rope, wheel, and capstan. (c) Pulley rope (*esteriore*), detail. Right half (upside down): (d) Pulley rope (*orbicholo sechondo / trochea summo / orbicholo inmus / interiore / exteriore / orbicho sumo / trochlea temone / inma radicie machina*). (e) Pulleys, detail.

Inscription: (a) *Libro 10 capitolo iii / ve le serve a rizare la machina / poi per tirare li pesi in alto sordi/scha le traglie ordinariamente;* (b) *Capitolo .iiii. / Vole sia tutta / una fune lo mezata / quando se mette nel / buso delli tagla / di sotto e qui vi legata / che non posa schorrere;* (d) *Li[bro] X capitello V. / Polyspaston chiamato cioe molti / orbicholi overo rotelle / le quale in alteza le puoi / fare quante a vuoi Pare chel / primo capo sia attachato / ala cima della machina / e poi trapassato per le rotelle / da llo alto Lultimo capo ven/ga al basso alla pulegia / e sia in ogni trochlea in latitudine / tre ordini di rote perche quando / saranno tre rote in alteza e due / in largeza facerano nove rote / per ciaschuna traglia e chosi / conseguente*

Antonio the Younger's book and chapter reference and the discussion of the polyspast is a clue to his source in Vitruvius (X.ii). He utilized the translation of 1521 by Cesare Cesariano, as indicated by the chapter citation. For the first note (*a*), Cesariano's chapter heading ("De diverse appellatione de machine et cum qual ratione se errigeno capo tertio," p. CLXIIII r.) corresponds to "capitolo iii," taken perhaps from the commentary rather than from the translation. For the second note (*b*), Cesariano's chapter heading on p. CLXIIII v. is "De una machina simile a la superiore cum la quale li colossicoteri piu securamente se pono trahere immutata solamente la sucula in tympano, capo IIII." Antonio paraphrased the translation. For the note *d*, Cesariano's chapter heading on p. CLXV r. is "De una altra generatione de tractoria machina, capo V," and Antonio's note is a paraphrase of the translation or of Cesariano's commentary. Antonio's drawings of a tripod hoist and pulley-rope system are copies of Cesariano's illustrations on pages CLXV r. and CLXVI r. of his chapter V. Antonio's borrowings from Cesariano are all mentioned in "Drawings of Machines." Concerning a possible date for this sheet, see the essay by C.L. Frommel in this volume.

Bibliography: Cesariano (1521); Ferri (1885) 88.

G.S.

U 1445A *recto*

Antonio da Sangallo the Younger
Studies of mill, lathe, screw drill, possibly 1524.

Dimensions: 217 x 285 mm.
Technique: Pen and brown ink.
Paper: Upper left corner missing.

Left half: (a) Horse-driven mill pulverizer (*macino*) in Pisa. Right half: (b) Lathe for screws, and details (*A, B, C, D; A. Lama di ferro / B. Matre della vite di / metallo; Cosi sta lo fero / come segniata / C / potra stare / come e segniato / D*). (c) Screw drill (*E, F*) and its plan, in detail. (d) Screw drill (*G, H*) and two plans in detail (*ferro / vite*). (e) Screw drill and circular plan with six teeth.

Inscription: (a) *In cittadella di Pisa; La rota dentata a in taglio denti / 96 La rochetto del mulino sie / otto denti che una volta che / da el cavallo la macina ne / da 12 E macina farina / zolfo sanitro carbone; La rota dentata di sotto sia denti / 70 La rochetta a denti.7. che ogni / volta che da el cavallo lo rochetto / ne da 10 e ogni pestone da 20 / colpi Li pestoni sono di 100 libre luno;* (c) *Queste sie uno scuchio / da fare le matre delle vite / ed e in cinque faccie / dove e segniato E / e dove e segniato F / sie tondo e falle molto / bene de acciaro temperato;* (d) *Questo sie uno altro / suchio quadro dentato / quale in sulli cantoni / e dove segniato G / e equale e dove / segniato H e piramidato;* (e) *Questo faria / meglio di tutti*

Antonio the Younger's note about the mill pulverizer in Pisa, like most of his other notes about mills, is concerned with motor motion. A mill pulverizer in exactly the same form, but differently scaled, was sketched by Benvenuto Della Volpaia (Codex Ital. Cl. IV, 41, 5363, fol. 51 r., Biblioteca Marciana, Venice), who wrote that it was "nella cittadella di Pisa che macina carbone e salnitro. . . ," and on folio 50 v. he dated his mill illustration, "nella fortezza cittadella di Pisa per macinare 1524."

Antonio the Younger's lathe for screws has the same form as that on U 1564A r., but in the present example he illustrated some parts separately. He illustrated a more unusual lathe on U 1441A r.

Bibliography: Ferri (1885) 88, 112; Maccagni (1967) 3–13; Maccagni (1971) 65–73.

G.S.

U 1445A *verso*

<small>ANTONIO DA SANGALLO THE YOUNGER</small>
Study of a wheel by Pasquino and a pump.
Dimensions and Paper: See U 1445A recto.
Technique: Pen and brown ink.

(a) Wheel: five balls on chains as weight-wheel in plan view
(*questa faria / colle palle sciolte; questo e di Pa/squino*).
 (b) Pump with four tubes and treadwheel.

INSCRIPTION: (b) *Rota che volta da sse e fa lavorare / le quattro tronbe la fa voltare cinque / palle di pionbo di mezo canno arata/chate in ditta rota intrinseche con cierte / catene come di sopra*

This mill, made by a certain Pasquino, has a weight-wheel with five lead balls on chains attached to a horizontal wheel. Antonio the Younger noted that the weight-wheel operated four tubes and that each ball measured one-half *canna* and was attached in the main wheel by chains, as shown above. Others of this type are illustrated on U 852A r., 1442A r., and 1446A r., and I discuss what is known about it in "Drawings of Machines."

BIBLIOGRAPHY: Ferri (1885) 88, 112.

<div align="right">G.S.</div>

U 1446A *recto*

<small>ANTONIO DA SANGALLO THE YOUNGER</small>
Gristmill with iron ball weights on a wheel turned by a horse.
Dimensions: 285 x 210 mm.
Technique: Pen and brown ink.

INSCRIPTION: *Dal mezo dello stile al mezo del cavallo sie piedi 14 / La rota dello stile sie di diamitro piedi 14 di circumferentia / sia piedi 44 ara denti 88 ——— cioe 88 / La rocha ove dara detta rota ara di diamitro piedi 7 / di circumferentia piedi 22 ara denti 44 ——— cioe 44 / La rota conessa a detta rocha ara di diamitro piedi / 14 di circumferentia piedi 44 ara denti 88 cioe 88 / Lo rochetto ara di diametro piedi 1° dita 4¼ / e ara denti 8. E quando el cavallo dara una volta / la macina ne dara volte 22 / La sstantia volesse larga piedi 32*

This note represents a builder's specification giving precise dimensions of all components of a gristmill, preexisting or to be built, in a mill house 32 feet wide. Antonio the Younger does not state the mill's location, but the dimensions frequently correspond to those he cited for a mill in Ancona on the verso. There he illustrated its overshot waterwheel and listed five items,

beginning with the length of the mill channel in the garden up to the sea level. He notes locks in the channel, distances to the moat, and the water well in the garden where the mill channel begins. He notes that two mills can be built, and the dimensions cited thereafter correspond to the gristmill on this, the recto side of the sheet. Some discussion of the mill with weight-wheel, said to have originated in Germany, will be found in "Drawings of Machines."

BIBLIOGRAPHY: Ferri (1885) 89; Forbes (1956) 663–94.

<div align="right">G.S.</div>

U 1446A *verso*

<small>ANTONIO DA SANGALLO THE YOUNGER</small>
Ancona, study of an overshot waterwheel.
Dimensions: See U 1446A recto.
Technique: Pen and brown ink.

INSCRIPTION: *Anchona / Dal piano del canale del mulino in lorto sino alla superfitie / del mare sono palmi 38 / Dal piano del ditto canale al piano del aqua dove scie alle vasche / del tiratoio dove va in la chiavicha sie palmi 9 / Dal ditto piano al piano del fosso lo fosso e piu basso palmi uno / Dal fondo del fosso al pozo del orto dove comincia lo canale de/lo mullino e pendentia palmi otto si po alzare detto palmi otto Si puo fare dua mulini di palmi 18 di rote / Lo tutto della rota sia piedi 14 di diamitro sara di cir/cumferentia piedi 44 / La rota dentata in testa sara piedi 3½ ara di circumferentia / piedi 11 ara denti 33 Lo rochetto ara denti otto e quando / la rota dara una volta lo rochetto overo macina dara / volte 4⅛*

This is a builder's specification (canal, locks, basin, garden well, and mill) setting forth the essential components and their connections with each other and with the sea. Antonio shows special interest in the potential productivity of the mechanism. He may have been working on the fortress at Ancona as early as 1514–16. He was named director of the works in 1526; he was still working there in 1533. As part of his work, he designed canals, waterwheels, and a gristmill. See also his drawing of the port (U 978A r.) and other drawings for Ancona (U 1020A, 1502A, 1526A).

BIBLIOGRAPHY: Ferri (1885) 6.

<div align="right">G.S.</div>

U 1447A *recto*

<small>ANTONIO DA SANGALLO THE YOUNGER</small>
Studies of a snapper or catapult; studies of a gear rack.

Dimensions: 230 x 290 mm.
Technique: Pen and brown ink.
Paper: Center fold

Left half: (a) Snapper (*Dimancla / tabule / A cardine*). (b) Note: *¹/₉ della soma principale / 43—V / 54—VI / 63—VII / 72—VIII / 81—VIIII / 90—X.* (c) Note: *Diamitro 56 / circumferentia 176.* (d) Snapper. (e) Snapper, detail. (f) Note (at top). (g) Note (at bottom). Right half: (h) Note (upper left). (i) Note (center). (j) Gear rack within curved edges. (k) Gear rack within curved edges. (l) Calculations by ninths continuing the note (b).

INSCRIPTION: (f) *Capituli tabule parallele / in summo e decumo grose / uno foramino / Large uno foramine e tre / quadri cioe dodrante;* (g) *Vide Plauto de catapulta / atque te ita nervo torquento uti / catapultae solent;* (h) *Cinque vie 9—45 / Sei vie nove—54 / Sette vie 9—63 / Otto vie 9—72 / Nove vie 9—81 / Diece vie 9—90 / Da dieci in su chrescie ogni / X libbra 7 dita e poi se ne piglia / la nona parte per lo forame;* (i) *Tanto quante libbre sono / la nona parte sono le dita / del foramene*

A full discussion of this snapper appears with others of identical form (U 1458A r. and v.). Note *f* was derived from Cesariano's 1521 edition of Vitruvius in his commentary, "De le ratione de le catapulte et scorpione, capo XV," p. CLXXV r. Note *g* with reference to Plautus, *De catapulta,* is a treatise never listed in the classical literature. Of the authors who wrote on catapults, Cesariano mentioned Valturius, Fra Giocondo, Giorgio della Valle, Festo Pompeio, Priscian, Varro, and Josephus, *De bello Judaico,* III, chap. 14, where a distinction is made between the ballista and the catapult. Cesariano commented at length about the *manicula,* which he found in Vitruvius (X.x.4) who wrote, "Chelae sive manucla dicitur," translated as "socket-piece" or "trigger or handle." See "Drawings of Machines" for Antonio the Younger's borrowings from Cesariano. Pagliara has found the source for Fra Giocondo's illustration (Vitruvius edition, 1511) of a catapult as a Byzantine ballista drafted in a medieval manuscript.

BIBLIOGRAPHY: Cesariano (1521); Ferri (1885) 89; Pagliara (1986) III: 5–85.

G.S.

U 1447A *verso*

ANTONIO DA SANGALLO THE YOUNGER
Studies of gristmills; studies of snappers.
Dimensions and Paper: See U 1447A recto.
Technique: Pen and brown ink.

Counterclockwise from top: (a) Gristmill with paddlewheel. (b) Gristmill with paddlewheel in river (*fiume*), its parts identified: *A; B; C; D; 102 denti; E; 204 denti; F; 6 denti; G; infundibulum / cioe la tramogia / cultro idest bilico.* (c) Note at bottom left about gristmill at *b: A rota / B pine / C axe / D timpano dentato a perpendiculo / E timpano magiore pure dentata / in piano colocato / F molarum / G infundibulum.* (d) Snapper. (e) Note written by Giovan Francesco da Sangallo about the snapper: *questa se apresta piu.* (f) Geometric sketch.

Inscription (a) *Quelli che anno stanpato fino a ogi / lanno disegniato cosi; A me pare che lli / abia avere un altro timpano in piano / come questo di sotto disegniato*

The snapper (*d*), like another on the recto side of this sheet, is discussed with others on U 1458A recto. Antonio the Younger's note concerning the two gristmills has led to the source of his first illustration (*a*) where he cites "those who have published up until now have designed it like this, and it seems to me that it ought to have another wheel, a horizontal one, as illustrated here below." Antonio's oblique reference to books in print can be identified, once again, as Cesariano's 1521 edition of Vitruvius where a waterwheel like Antonio's first one is illustrated on p. CLXX verso in chapter X ("De le rote et timpani per masinare la farina"). Antonio then illustrates in gristmill *b* what he considered an improved design. He surely based it on his working experience as a millwright. He illustrated one he had seen in Pisa (U 1445A r.) and others he probably built in Cesena (U 819A r., 1442A r.), Pitigliano (U 852A r., 1442A r.), and Ancona (U 1446A r. and v.). This mill differs from those due to its undershot waterwheel in a river. His note is one of many he wrote about the strength, weakness, and efficiency of various types of mechanisms. He may have had in mind to collect this sheet with others for the category "Waterworks" ("Difitii daqua"), a title (of a treatise or of a chapter?) he cited on U 4052A verso. His numerous borrowings from Cesariano are discussed in "Drawings of Machines."

BIBLIOGRAPHY: Cesariano (1521); Ferri (1885) 89.

G.S.

U 1448A recto

ANTONIO DA SANGALLO THE YOUNGER
Studies of a windmill, possibly in Orbetello.
Dimensions: 260 x 172 mm.
Technique: Pen and brown ink.
Paper: Darkened at edges; corner lost bottom left.

(a) Windmill on circular platform, at Orbetello. (b) Winch, detail. (c) Windmill on round tower with twelve columns (*12 colonne; la chasa sta ferma / e lo chapello gira*). (d) Windmill in plan view.

INSCRIPTION: (a) *La farfalla li sta[n]gi / longi b[raccia] 16 1/3 / Le vele longe b[raccia] 8 / large b[raccia] 4 / La rota denti 40 dentata in su de/nti diamit[r]o b[raccio] 2 1/3 / La rocha 2/3 di bracio / a gretole dieci / La macino a di diamitro quanto la rota dentata / b[raccia] 2 1/3 a Orbatello / La chasa longo b[raccia] 10 / larga b[raccia] 6 / La ro/ta in su che gira lo / mulino quale sta in / terra diamitro b[raccia] 10*

I may be mistaken in reading the inscription "orbatello" as the west-coast seaport of Orbetello, since *orbitale* also means "orbit." In this note, like many others, Antonio lists dimensions of each component, including the arms (*farafalla*) of the vanes (*vele*), cogwheel lantern (*gretole*), grindstone (*macina*), framework (*chasa*), and the wheel that turns the mill at the ground. Concerning the second windmill (*c*), he observes that the structure is fixed and the roof (*chapello*) turns. This is a variant of a mill he copied from Francesco di Giorgio's *Trattato II* Supplement (U 1471A v.), but for which Francesco provided no text. A windmill that Francesco illustrated in *Trattato I*, fol. 38 r. (Martini-Maltese, I: pl. 71), revolves on rollers under its platform, while its roof is stationary. This is true also for two other windmills with conical roofs by the Anonimo Ingegnere Senese (Ms Additional 34113, fols. 79 r., 79 v., British Library, London), a manuscript copybook that Antonio utilized for his copies of Taccola's material (U 818A r., 848A r., and others). Antonio's windmill (*a*), perhaps at Orbetello, resembles two that Leonardo da Vinci described in his Codex Madrid II, fol. 43 r., Ms 8937, Biblioteca Nacional, Madrid, when he worked at Civitavecchia or Piombino in 1504. C. Gibbs-Smith, writing about Leonardo, has noted that windmills were a relatively unimportant part of technology in Italy due to unfavorable weather conditions, but this might have to be reconsidered for coastal cities such as Orbetello, Piombino, and Civitavecchia. Francesco di Giorgio's examples, like the rotating ones of Antonio the Younger, were recommended for coastal places and other windy regions.

BIBLIOGRAPHY: Ferri (1885) 100; Forbes (1956) 614–22; Leonardo da Vinci (1974); Gibbs-Smith (1978).

G.S.

U 1448A verso

ANTONIO DA SANGALLO THE YOUNGER
Unknown location, fortification study, triangular bastion or caponier, date unknown.
Dimensions and Paper: See U 1448A recto.
Technique: Pen and brown ink.

Outline plan of defensework projecting from a curtain wall. If the measurements are in *braccia*, as is common in Antonio's drawings, the work is likely to be the plan of a caponier or a square tower to which may have been added the pointed salient. There is no indication of location, and dating, on such slim evidence, is not possible.

BIBLIOGRAPHY: Giovannoni (1959) I: 71, 445.

N.A./S.P.

U 1449A recto

ANTONIO DA SANGALLO THE YOUNGER
Studies of lifting devices.
Dimensions: 290 x 427 mm.
Technique: Pen and brown ink.
Paper: Center fold.

Left half: (following Antonio's numbers) (a) "7" Traveling crane with antennae (*ventelo*), gear, and handle. (b) "8" Traveling crane with antennae, gear, and handle. Right half: Title: *Tirari.* (c) "1°" Hoist with gear, capstan, rope pulleys. (d) "2" Hoist with treadwheel moved by men. (e) "3" Hoist with gear (*tardo*). (f) "4" Hoist with gears, capstan, and rope. (g) "5" Hoist with gears, capstan, and rope (*curba; tardo*). (h) Hoist, detail of post with pulley rope (*veloce*).

INSCRIPTION: (a, bottom left) *Questa machina sia / la moto da uno rochetto longo che piglia / le due rote dentate / dentato che a le stanpe co/me largano da tutta due / le bande come largano / e si volta con le stange / E detto rochetto volta due / rote dentate che in su llasse / se volge la corda che viene / giu dalle rotelle quali so/no nove rotelle & cosi / passando per tante rotelle / a forza acapo solo quanto / passassi per le taglie infu/nate; (b, upper right) Questa sie una antenna / quale al moto dall asse delle / rote che anno li manegi / e tirano la corda infunata / in le tragle; (center) La sucola che a le stanpe da due capi / come largano tira / la traglia di sopra / piu a costo all aintenne / o piu discosto alor modo / del nastro e*

223

passa per tre / rotelle; (d) *Questo puo tirare / come sta che uno / capo della corda / vadia & laltro to/rni;* (e) *Anchora puo tirare / tutti a due a uno / tratto;* (f) *Questo puo st/are con una cur/ba come sta / e anchora ne po / avere due. Questa vole stare di sopra / e le stanpe di soto;* (h, bottom left) *Per tirare colle casse grande / roba ad alto che una cosa / vadia e laltra venga ma / bisognia* (che luna calla va canceled) / *chel cavallo storni indietro co/me luna delle casse sia / in alto*

For discussion of the drawings, see entry below for U 1449 verso.

BIBLIOGRAPHY: Ferri (1885) 88.

G.S.

U 1449A *verso*

ANTONIO DA SANGALLO THE YOUNGER
Studies of cranes and hoists.

Dimensions and Paper: See U 1449A recto.
Technique: Pen and brown ink.

Left half: (a) "6" Crane (variant) of Brunelleschi's invention, its horizontal screw (*B / vezosa cioe vite*) and nut (*A / femina*), mast with pinion (*busola o perno*), details of turnbuckles on hooks (*cosi vole stare*) and a counterweight (*contrapeso*). Right half: (b) Crane of Brunelleschi, detail of post and rope (*curba*), modified with gear and handles. (c) Hoist with treadwheel, gear, and rope. (d) Hoist with gear, ropes, and handles. (e) Hoist with capstan, ropes, and a man pulling a rope.

INSCRIPTION: (a) *Questa vite a stare ferma nel canetto e bisognia abia / due vezose una dentro al tramezo segnate A. Laltra / fuora del tramezo quale tire in dentro segniata B / e quella segniata A spinga lo peso in fuora / vezosa cioe vite / femina;* (at left) *Questo contrapeso / ce necesario quando le / cariche quale tenga / lo telaio contrapesato / col peso che ssi tira altri/menti la machina si ro/mporea nella busola;* (right) *Bisogna sia una / corda su le quale passa / per sette rote e va de capi / a due argani;* (b) *La corda sia una sola passi / per 7 rote e vada allo asse de/lla rota dentata che ditta* (a in su di *sopra* written above the line) / *curba ditto asse cioe tutti / a due li capi; La rota dentata la volti una / vite grossa che abbia le stanpi / come li argani per movare le stanpe / e levera ogni gran peso ma tardo; / Anchora si puo tirare / cosi colla vite;* (c) *Anchora si puo tirare / cosi colla rota dentro omeni / col*

rocheto e rota dentata / Lo rochetto / vole stare / de sopra; (d) *Ancora si puo fa/re cosi col rochetto / voltato da cavallo overo / omeni che volti la rota / dentata nello lato e lla/sse de detta rota sia la / curba dove se avolti / la corda che tira lo pe/so in alto / Sta meglio / questo de sotto / che di sopra;* (e) *Ancora si puo tirare cosi con questo che da / quello che si tira in nave lintenne della vela quadra*

The traveling cranes, modified Brunelleschian crane and its detail, and nine rope hoists with gears on U 1449A r. and v. were illustrated by Antonio the Younger using straightforward outline technique in pen without shading as is characteristic of his second sketchbook. (For a further discussion of this type of representation, see U 848A r., 1443A r. and v.). Winches and screws with four-sided tops are typical of Antonio's designs here and in U 1215A v. Six of these rope hoists have ropes balanced on both sides of the rope winder, like others he illustrated earlier and with his technique of penstroke shading (U 1440A r.). There his texts about rope movement for gear mechanisms and treadwheels are his own considerations of the problem, which he continued to study in the present engine drawings executed in his developed penline technique. Francesco di Giorgio's two examples of ropes moved on two sides of the rope winder in *Trattato I,* fol. 51 r. (Martini-Maltese, I: pl. 93), are different from Antonio's.

Antonio entitled the present sheet "Tirari" (hoist, hauler, lift, and crane), numbering his examples from 1 to 8. He intended them for a chapter of a treatise or book, as discussed on U 1438A r.; there he gives other titles for categories of machines. He obtained engine drawings from copybooks and treatises by other architects; he derived sketches numbered *1, 2, 3, 5,* and *6* from Francesco di Giorgio's *Trattato II* Supplement, as he did for drawings and texts on U 1482A r. and v., 1483A r. and v. For the present set, however, Antonio's analytical notes are his own, entirely independent of Francesco's wording. Antonio's drawings numbered from *1* to *5* may be compared for their similarities and differences with those of Francesco as follows: *Trattato II,* 91 r. (Martini-Maltese, II: pl. 317); 91 v. (pl. 318); 91 v. (pl. 318); 92 r. (pl. 319); 92 v. (pl. 320). Antonio's traveling cranes numbered *7* and *8* are not among Francesco's examples, and are probably based on examples by Buonaccorso Ghiberti (*Zibaldone,* fol. 95 v., Banco rari 228, Biblioteca Nazionale, Florence) and by Leonardo (Codex Atlanticus, fol. 49 v., Biblioteca Ambrosiana, Milan), but there is a close similarity to one by Giovan Francesco da Sangallo (U 3951A r.).

All other mechanisms on this sheet and on U 1215A v. are drafts for structures with ropes balanced on the rope winder. Antonio's analytical notes for many of them seem preparatory for a treatise describing how the components work, much in the manner of Francesco di Giorgio. It is surprising to find that a Florentine architect chose a variant of the Brunelleschian crane from a Sienese treatise. Antonio's notes do not include anything to suggest he knew of its Florentine origin, and this fact is not noted by Francesco di Giorgio either. The only note in the cycle of machine drawings that refers to the cathedral in Florence is Giovanni Battista da Sangallo's note for the Brunelleschian crane of the lantern (U 1165 r.), copied from the *Taccuino* of the Florentine architect Giuliano da Sangallo.

BIBLIOGRAPHY: Ferri (1885) 88; Martini-Maltese (1967) II: pls. 317–331; Prager, Scaglia (1970) 65–109.

G.S.

U 1450A *recto*

ANTONIO DA SANGALLO THE YOUNGER
Mechanical and military stratagems.
Dimensions: 290 x 435 mm.
Technique: Pen and brown ink.
Paper: Heavy, center fold, corners broken, ink blotch at lower left.

Left half: (a) Four-wheel car with pairs of gears and handspikes. Right half: (b) Bale-lifting lever in wooden structure (*questa machina sie per scarichare / nave e cose simile*). (c) Boat with drill piercing another boat. (d) Drill, detail of *c*.

INSCRIPTION: (a) *Questo e una machina de uno carro quali / si fa caminare stando in sul carro come erano / quelli delle torre antiche di legniame e a vite / e testudine a simile cose quale era necesario sta/re in la machina quelli che lla facevano andare / [. . .] della osensione de nimici voltanto pure / [. . .] cose pure che vadia basta;* (d) *Questa machina sie per busare una nave sotto / aqua con un trivello grosso; El manicho sie / a vite perche quello che a questa non possa tornare / indietro*

Francesco di Giorgio illustrated cars propelled by gears first in his *Opusculum de architectura* (Ms 197 b 21, British Museum, London), and later in a selection in his *Trattato I*, fols. 51 r., 51 v. (Martini-Maltese, I: pls. 95, 96). Antonio the Younger's drawing of a car was in fact derived from a sketch by the Anonimo Ingegnere Senese (Ms Additional 34113, fol. 154 v.,

British Library, London), and it is not illustrated elsewhere. Antonio speculated that the car was used like the mobile wooden towers of Antiquity with battering rams and the like. He learned about "turris ambulatorias" in Flavius Vegetius Renatus, *Epitoma rei militaris,* whose terms he adopted on folio U 1470A r. On U 1461A r. he cited "Vegetio de larte militare." His wording about a car made to run by its riders recalls his notes for other mechanisms (U 1435A r., 1438A r.). His three drawings on the facing folio originated in Taccola's Notebook (Ms CLM 197, part II, Bayerisches Staatsbibliothek, Munich), but Antonio copied them from the Anonimo's copybook (Ms Additional 34113, fols. 58 v., 107 r., 205 v.). From the same source, Antonio also copied drawings for his first and second sketchbooks (U 818A r., 848A r., 1432A r., 1438A r., 1440A v., 1450A r. and v., 1451A r. and v., 1452A r. and v., 1476A r., 1481A r. and v., 3976A r. and v., 4059A r. and v., 4060A r. and v., 4064A r. and v., 4065A r. and v.).

BIBLIOGRAPHY: Ferri (1885) 91; Vegetius Renatus (1885); Taccola (1984).

G.S.

U 1450A *verso*

ANTONIO DA SANGALLO THE YOUNGER
Mechanical studies.
Dimensions and Paper: See U 1450A recto.
Technique: Pen and brown ink.

Left half: (a) Ferry roped to a post on the riverbank. (b) Pile driver on two boats. (c) Pile driver as a lever on a four-wheel car. Right half: Circular and rotary crane, variant of a Brunelleschian crane for the cathedral's lantern.

Antonio's source for three of these engines lies in the copybook of the Anonimo Ingegnere Senese, as is explained for the engines on the recto side of the sheet: the ferry, from Ms Additional 34113, fol. 50 v., British Library, London; the pile driver on wheels from fol. 91 v., the crane from fol. 81 v. The pile driver on boats was lost from the British Library copybook; it is reproduced in another book with an identical selection (Codex S.IV.5, fol. 65 v., Biblioteca Comunale, Siena), which that copyist based on the Anonimo's copybook.

BIBLIOGRAPHY: Ferri (1885) 89; Anonimo (1986).

G.S.

U 1451A *recto*

ANTONIO DA SANGALLO THE YOUNGER
Studies of various military devices.

```
a       | e    f
b       |    i  h g
c       |
d       | j  k  l  m
```

Dimensions: 293 x 430 mm.
Technique: Pen and brown ink.
Paper: Center fold.

Left half: (a) Bridge on four boats roped to the ground. (b) Bridge of ladders on three boats (*possono esse[re] botte o casse ma vogleno essere longe / altrimenti anderieno sotto sopra*). (c) Bridge of seven barrels. (d) Floating trap (*per mettere in uno porto per impedire le nave*). Right half: (e) Walled city; cats with incendiaries entering underground holes. (f) Pigeon and sun (*sole*). (g) Fireball and mortar. (h) Soldier with bow and arrow. (i) Water wings for swimming (*per mettere al petto*). (j) Drill with crown wheel. (k) Drill (*trapano a petto*). (l) Drill, gear-driven with crown wheel. (m) Drill with hand crank and crown wheel.

All engine drawings (*a* to *i*) were first illustrated in Taccola's Notebook (Ms CLM 197, part II, Bayerisches Staatsbibliothek, Munich), but Antonio the Younger's direct source for them and for the four drills (*j* to *m*) was the Anonimo Ingegnere Senese's copybook (Ms Additional 34113, British Library, London), where the drills from Francesco di Giorgio's *Trattato I* (Codex 148, Biblioteca Reale, Turin) had been copied. A comparison of Antonio the Younger's copies (*a* to *m*) with examples in the Anonimo's copybook is as follows (ellipses show a loss of archetype): (. . .), 115 r., 61 v., 117 v., (. . .), (. . .), (. . .), 157 v., 157 v., 157v., 157 v. I have explained earlier (see U 848A r.) that Antonio's drawings in a second sketchbook, of which the present sheet was a part, are characterized by a free penline without shading.

BIBLIOGRAPHY: Martini-Maltese (1967) I: pl. 125; Taccola (1984).

G.S.

U 1451A *verso*

ANTONIO DA SANGALLO THE YOUNGER
Studies of various military devices.
Dimensions and Paper: See U 1451A recto.
Technique: Pen and brown ink.

Left half: (a) Shield on six-wheel car, its drawbridge protecting a soldier-demolisher. (b) Bridge of interconnected beams (*per fare ponti*). (c) Shelter on three wheels and roofed. (d) Horse, yoked, with a battering rod. (e) Shelter on three wheels and roofed. Right half: (f) Oxen transferring a tower and a man pushing against it. (g) Mobile tower and battering ram.

Antonio's source is the copybook of the Anonimo Ingegnere Senese for the engines illustrated on this side of the sheet as explained for U 1451A recto. The engines have counterparts in the Anonimo's copybook as follows (ellipses show a loss of archetype): 140 r., 114 v., 128 r., (. . .), (. . .), 136 v.

BIBLIOGRAPHY: See U 1451 recto.

G.S.

U 1452A *recto*

ANTONIO DA SANGALLO THE YOUNGER
Studies of wheeled vehicles.

Dimensions: 280 x 435 mm.
Technique: Pen and brown ink.
Paper: Center fold.

Left half: (a) Flatcar shield, climbing pole, and fire bucket. (b) Two-wheel cart with shield and fire barrel. (c) Tricycle with fire basket on a pole. (d) Flatcar shield with fire-launching pole. Right half: (e) Oven (*forno*) on a flatcar. (f) Flatcar shield and fire-launching pole. (g) Five-wheel flatcar with fire-hurling pole. (h) Eight-wheel shelter with drawbridge and fire-launching pole. (i) Six-wheel shelter with sickles in its sides and fire pots. (j) Three-wheel shelter and fire-launching pole.

This sheet is part of Antonio the Younger's second sketchbook, as explained on U 848A r.; the paper has an identical watermark. Again his source was probably the Anonimo's copybook, which provided him with all the figures and military devices copied on the verso of this sheet. In the case of the recto side, the Anonimo's copybook illustrated only the shelter with sickles (*i*); the shields with fire launchers originated in Taccola's Notebook. In all likelihood, therefore, these have been lost from the copybook, which even now

is the most complete set of copies after Taccola's manuscripts if we exclude the material in *De machinis* (Ms CLM 28800, Bayerisches Staatsbibliothek, Munich).

BIBLIOGRAPHY: Ferri (1885) 92; Taccola (1971); Taccola (1984).

G.S.

U 1452A *verso*

ANTONIO DA SANGALLO THE YOUNGER
Studies of military weaponry.
Dimensions and Paper: See U 1452A recto.
Technique: Pen and brown ink.

Left half: (a) Soldier with helmet, shield, and sword. (b) Horse with saddlebags. (c) Soldier hurling a grenade. (d) Hillside with fireballs descending, carts, and tent. Right half: (e) Equestrian gunner, a horn protruding from the horse's head. (f) Mortar in horizontal position. (g) Rocket with a blade. (h) Two-part mortar.

These subjects originated in Taccola's Notebook and Antonio copied them from the Anonimo's copybook (*a* to *h*): 145 v., 124 v., 124 v., 144 r., 148 v., 109 v., 109 v., 148 v. The next sheet preserved from Antonio's second sketchbook is U 3976A, followed by U 4059A; most have the same watermark.

BIBLIOGRAPHY: Ferri (1885) 92.

G.S.

U 1454A *recto and verso*

ANTONIO DA SANGALLO THE YOUNGER
Study of an astrolabe, possibly pre-1520.
Dimensions: 230 x 335 mm.
Technique: Pen and brown ink, straightedge, compass.
Paper: Center fold.

Recto. (a, left) Moorish astrolabe, back side (*Da questa banda sta lo alidada / Strolabio / Egyptizio daritto e / dariverso*). (b, right) Moorish astrolabe, front central area (*Da questa banda si incapassa le tavole / luna sopra a llaltra cioe tre tavole e di poi la ragna / qui retro desegniate*). (c, middle at top) Moorish astrolabe, detail of alidade (*Alidada / Li busi dello alidada colli / quali sintraguarda sono / tutti dal mezo in la come / sta segniata*). (d) Moorish astrolabe, detail, screw and nut as replacement of an original pin and ringlet (*vite femina / asse a vite quale / se cingie le tavole / et la ragna et / lo alidado*).
Verso. Moorish astrolabe, rete or the third plate named *ragna* at *b* and *d*, which is set on the front plate.

Antonio the Younger separated an astrolabe into three parts and a pin, then executed drawings of each part: the plate's front central area and back plate, rete, alidade, and screw and nut. The latter element was a replacement for the astrolabe's original pin and ringlet (Thomas B. Settle, oral communication). Examples of medieval armor preserved today include screws and nuts through thin metal plates. However, sometime before Brunelleschi invented his new hoist in 1418, craftsmen had perfected the precise threading of a screw and its nut so that these engage each other exactly, and had perfected the method of casting them in metal. For Brunelleschi's hoist, Donatello executed (sometime before 1425) a 29-pound bronze *mozetto* (nut block or screw vise), and Lorenzo Ghiberti made five replacements. If Antonio the Younger did not make the screw and nut for this astrolabe before he illustrated it, an artisan before him had made the substitute. Antonio was informed by its owner that the instrument was Egyptian. Moorish astrolabes like this one, made in the western Muslim world, passed to Egypt and thence to Venice or Ancona. Had it come from Spain to Livorno, Pisa, or Naples, it would probably not have been called Egyptian.

Antonio the Younger transcribed in facsimile all Kufic letters engraved on the face. We marvel at his determination to make a facsimile of the letters. Kufic letters of this type were used mainly in Morocco. The instrument maker's signature may be transliterated as "made by Andallah[?] 'Ali 'Isā" (George Saliba, oral communication). Further study may make it possible to identify the specific astrolabe. Antonio's calligraphy being rather controlled, its characteristics resemble his writing ca. 1500–1520.

Antonio the Younger's astrolabe drawings (U 1454A r. and v.) resemble four instruments dating from the tenth and eleventh centuries (confirmed by Saliba, oral communication). The retia of these four all show the same form of dagger-shaped star pointers, designed in that period. The retia of three of the four astrolabes have more star pointers than appear on Antonio's drawing (U 1454A v.). One is a Byzantine astrolabe traditionally said to have been owned by Pope Sylvester II (Istituto e Museo delle Scienze, Florence); another is an astrolabe made in Córdoba in 1026–27 by Muhammad b. as-Saffār (no. 1959-64, Royal Scottish Museum, Edinburgh). The third, by al-Mūṣil b. Muhammad (no. 1, The Time Museum, Rockford, Illinois), is believed to have been made in the Muslim East. The fourth, a tenth-century astrolabe signed in western Kufic by Ahmed Ben Khalaf and made for Dafar (Bibliothèque Nationale, Paris) has the same

number of star pointers, all of them in the same places as Antonio's, but its alidade must be a replacement. Its Kufic letters on the front central area, back, and rete show great similarity with those markings on Antonio's drawing.

On the front rim (right side on U 1454A r.) are numerical scales of degrees, which, when used with the rete, help determine the right ascension of the celestial equator, and when used with the alidade they measure the zenith distances. Zodiac signs on the smaller off-center circle on the rete (U 1454A v.) refer to the actual projection of the ecliptic circle or sun's path on the equator plane. On the central perpendicular lines and around the rim of the upper semicircle are numerals for horizontal and altitude circles called "mugatarāt" (almucantars), all projected for every six degrees of altitude, and for a locality marked "for latitude 30, hour 14." The curves marked on the lower semicircle are for the usual seasonal hours. On the back (at left, on U 1454A r.), where the instrument maker's signature is written on the upper right rim, the outer margin would show cotangent scales, but here the zone is blank. On the next inner circle, markings for the days of the solar year are arranged so that the vernal equinox falls around March 15. Zodiac divisions are used to determine the position of the sun for any day. On the inset square, the markings may be translated as "reversed tangent on the vertical," that is, the cotangent and direct tangent on the horizontal. The rete (U 1454A v.) includes star indicators with their regular names on the dagger-shaped pointers, of which the lowermost one correctly marked the southern star of Sirius ("Big Dog"). Twelve zodiac signs are named on the full ring. By rotating the rete, the zodiac signs trace the apparent path of the sun. (I am indebted again to George Saliba for the interpretation of the inscription.)

Despite Antonio's ignorance of Arabic, I venture to guess that because there were precise positions for the data engraved on astrolabes, a European instrument maker could reasonably understand and interpret them. Antonio's notes indicate his knowledge of the names for the parts, the function of the sightholes in the alidade, and how the parts fitted together and functioned. In fact, his Arabic numerals written on the upper left of the back view and on the upper right of the front indicate that someone had calculated the equivalences for the scales engraved in Kufic. A clear case can be seen on the upper left edge of the back where the numeral "60" is correctly placed next to the letter "sīn," "70" next to " 'ain" (Saliba, oral communication). Antonio the Younger learned tech-

nical terms such as *ragna* and alidade from craftsmen who made astrolabes, quadrants, compasses, dividers, cranequins for flintlocks, clocks, marine astrolabes and quadrants, armillary spheres, and optical lenses. (Fra Giocondo, for example, illustrated [1511] an instrument that he called "polymetrus est mesolabius" and an "orologio solare" held in the hand of Archytas of Tarentum [Vitruvius, IX., pref. 14]).

Antonio the Younger also illustrated a mid-Trecento European quadrant engraved in Latin (U 1455A r.). Its parts include (oral communication, Thomas Settle) a sliding scale shown between the black wedges, zodiac tables, Roman numerals on its rim, and a column list for the years 1339–54 written in Arabic numerals. That quadrant had been made in those years, perhaps in Italy where mathematicians used Arabic numerals in the early Trecento. It was an "antique" when Antonio illustrated it.

Antonio's facsimiles of quadrant and astrolabe are evidence of his special interest in the instruments utilized by land surveyors, civil engineers, and military captains when they set a cannon's trajectory or designed fortifications. Antonio may have used an Italian quadrant when he built the first complete angle-bastioned enceinte (1515) at Civitavecchia. Indeed, he called his file of drawings "astrolabes and quadrants" (U 1455A v.). Mariano Taccola (ca. 1420) used these terms alternately for an Italian astrolabe, writing "quadrantis vel stralabii." His quadrant hangs by a ring on a pole driven into the ground. Another form of Italian quadrant was illustrated by Francesco di Giorgio in his *Trattato I*.

A quadrant of Moorish origin incompletely illustrated (U 3945A r. and v.) with Kufic letters on its rim has been misattributed to Giovanni Battista da Sangallo. His writing differs from numerals and a note ("mobile distate") on this drawing, which I have placed with works by anonymous artists (see "Drawings of Machines," Appendix). Another quadrant drawing by an Anonymus, which has been misattributed to Giovanni Battista (U 3945A r.), represents the west side of Egnatio Danti's astronomical quadrant installed (1572) on the face of Santa Maria Novella in Florence. M.L. Righini Bonelli and Thomas B. Settle note that the drawing was made probably while the installation was being planned, since they found discrepancies between the drawing and the instrument *in situ*. The Moorish astrolabe and the Italian quadrant of 1339–54 illustrated by Antonio the Younger (U 1455A r., 1454A r. and v.) may have been owned by Antonio's friend the instrument maker Benvenuto

Della Volpaia, whose father Lorenzo made the famous clock for Lorenzo de' Medici sometime before 1484. His descendants made nocturnal clocks in new Italian forms some of which Benvenuto illustrated (Codex Ital. Cl. IV, 41, 5363, Biblioteca Marciana, Venice).

Antonio the Younger also knew Fra Giovanni Giocondo of Verona, the widely traveled and learned architect-engineer, antiquarian, epigrapher, mathematician, and author of the 1511 edition of Vitruvius. He was appointed (1514) to the Fabbrica of St. Peter's in Rome, with Giuliano da Sangallo and Raphael. Antonio the Younger had worked in Rome since 1507. On U 1463A r. he wrote the words "Gieometria de fra Jochundo," a note that will be discussed in the entry for that sheet.

Recently, Lucio Ciapponi found Fra Giocondo's authentic writing on geometry and his drawings of instruments, including one that measures a height by a gnomon or astrolabe called "quadrantis perpendiculum vel astrolabi dioptra." He described but did not illustrate how to construct a theodolite. Fra Giocondo said he invented these instruments, but in fact he probably merely refined existing instruments, for example, two types of chorobates, one of which he illustrated and named "libra aquaria" or "libra pensilis ut astrolabi." He illustrated an instrument ("polymetrus est mesolabiis") to measure the center of proportioning lines: a cylinder marked with numerals, months of the year, and zodiac signs. Describing its construction, he called it an "horologium viatorum." Thus we may add to Fra Giocondo's wide accomplishments his expertise as an instrument maker. Evidently, Antonio the Younger moved in circles of learned men and instrument makers. Further study of Fra Giocondo's manuscripts might clarify Antonio the Younger's relation to him. Did he, for example, show Antonio the Moorish astrolabe and the Italian quadrant of 1339–54 when they were working together in Rome?

BIBLIOGRAPHY: Ferri (1885) 34; Gunther (1932); Righini Bonelli (1968); Maccagni (1971); Righini Bonelli, Settle (1979) 3–13; Galluzzi (1980) 185–94; Ciapponi (1984) 181–96; Gibbs, Saliba (1984); Turner (1985) figs. 14, 22, 23, 41, pl. 1; Miniati (1987) no. 12; Pepper, Adams (1986); Saliba (1991).

G.S.

U 1455A *recto*

ANTONIO DA SANGALLO THE YOUNGER
Study of a quadrant.

Dimensions: 220 x 430 mm.
Technique: Pen and black ink.

(left) Quadrant, front side, with sliding scale between black wedges, names of astrological symbols in Latin, and Roman numerals. (right) Quadrant, back side, with months named in Italian, astrological names written in Latin as the sides of squares, and a column with the years 1339–54.

INSCRIPTION, Recto: *Quello dove se li dodici segni e lli 12 mesi / si chamina inanzi e [i]ndiet[r]o*
Verso: *Strolabii et quadranti*

This drawing of an Italian quadrant of the first half of the fourteenth century is discussed with Antonio the Younger's other astrolabe and quadrant drawings at U 1454A r. and v. There I discuss a quadrant with sliding scale and Arabic signs (see U 3945A r. and v.), attributed in the past to Giovanni Battista da Sangallo, but which I have put with the Anonymi ("Drawings of Machines, "Appendix) since Giovanni Battista did not write the numerals or the note ("mobile distate"); the strongly formed head of a man in the corner of the quadrant is a key stylistic factor for the correct attribution of the drawing. Note that the quadrant back is inverted, thus the months appear inverted, with the "top" at the bottom of the sheet. Concerning the dating of this sheet, see the essay by C.L. Frommel in this volume.

BIBLIOGRAPHY: Ferri (1885) 34.

G.S.

U 1456A *recto*

ANTONIO DA SANGALLO THE YOUNGER
Diagram and notes concerning geometry and cube roots, ca. 1530.
Dimensions: 205 x 285 mm.
Technique: Pen and gray-black ink.
Paper: Heavy.

INSCRIPTION: *Questa stara bene come / sara raconga bisognia / aconciare questa cosi o per / fare si dica colla cuba / che sie tanto luna quanto / laltra pigliare lo tutto / di questa e tanto fare grande / la cuba e quella poi pa/rtire in tre per ogni verso / e lo restante fare come sta / quella e cosi si diranno / luna col laltra de una / medesima grandeza la / superfitiale e la cubicha / e si vede che diferentia si e / dalle misure superfitiale / alle cubiche; Superfitie; cientro; cientro*

For a discussion of Antonio the Younger's interests in the calculation of the cube and the cube root, see U

1466A r. The present sheet seems to be a preparatory study for the kind of calculation device shown there.

These kinds of operations were of great interest in architectural circles in the early part of the sixteenth century. One of the sources for this interest may have been Fra Giovanni Giocondo, who requested permission in 1512 to publish a study of ancient mathematics. Antonio the Younger probably knew that work since it was owned by Monsignor Angelo Colocci who owned the codex, now in the Vatican (Biblioteca Apostolica Vaticana, Vat. lat. 4539). As an indication of its importance, see U 1454A r. and v., where Antonio comments on Fra Giocondo's drawings of instruments.

BIBLIOGRAPHY: Ferri (1885) 81; Fiocco (1915); Brenzoni (1960); Ciapponi (1984) 181–96; Fontana (1987).

<div align="right">N.A., P.N.P., G.S.</div>

U 1457A *recto*

ANTONIO DA SANGALLO THE YOUNGER
Studies of cube roots and geometrical problems, possibly after 1530.
Dimensions: 145 x 180 mm.
Technique: Pen and brown ink.

INSCRIPTION, Recto: *Sextuplo / Quintuplo / Quadruplo / Triplo / Duplo / Cubo simple / (Cubo canceled) / Cubiche / Cientro*
Verso: *Gieometria*

For discussion of the problems related to cube roots and Antonio the Younger's interest in these matters, see U 1456A r., 1463A r. and v., and 1466 r.

BIBLIOGRAPHY: Ferri (1885) 81.

<div align="right">G.S.</div>

U 1458A *recto and verso*

ANTONIO DA SANGALLO THE YOUNGER
Studies of snappers.
Dimensions: 140 x 183 mm.
Technique: Pen and brown ink.
Paper: Center fold.

Recto. Left half: Text for a snapper, sometimes called a catapult. Right half: Text continued. (above left) Stanchion for the snapper (*braccia*) and its socket (*A, capitello*). (above right) Snapper, detail (*cordele / capitella / anserudenti*).
Verso. Text continued, see inscription.

INSCRIPTION, Recto: *Piglia dui legni longi asai / (a date* canceled) *cingiungili insieme / (canceled: tanta distante luno*

dall altro quanto / e la longeza de capitelli) E da / uno capo farai li ascialono do/ve meterai uno verriciello / colli manichi e in mezo di detto / legno da uno capo cioe fra lu/no legni e laltro inscrevi ove/ro incasterai tanta busa / dove possa intrari li capitelli / E colli conii le serierii in de/tta busa acioche inello tendero / ditto capitelli no si movino / Di poi mettere li / modioli di rame / ne capitello e mette / la corda a torta co / braccio che la tie/ne E fermare detta corda con u/no conio di ferro dall uno capo / el altro capo si legi a una corda che / vada al verrochio E di poi col
Verso: *ditto verochi si tiri tanto che / dall altro capo della corda del / cappio si possa mettere laltro / conio; E cosi fare all altra cor/da dall altro canto; E bisognia / avertire che nel tirare ditte / corde si tiri tanto luno quanto / laltra equalmente e chi ttocando / le co mano rendino el mede/simo sino luno che llaltra / E cosi poi se stringha un altra vo/lta colli conii che ancora / parimente rendino ditte corde / parimente E sono accio parimen/te le due braccio traggino*

On three sheets (U 1447A r. and v., 1458A r. and v., and 1485A r.), Antonio the Younger illustrated the same structure three times. There is a slight variant (U 1447A r.) which features a large framework. Although Vitruvius's word "catapult" is more common, see Antonio's note (U 1447A r.), "Vide Plauto, De catapulta," I prefer the generic term "snapper." The treatise (Plautus, *De catapulta*) cannot be identified among the scientific material from Antiquity; Plautus's name has been associated with the literature of the theater. Antonio's analytical texts beside two drawings of a rope twisted around a rod by a tool (U 1447A r., 1458A r., 1485A r.) were derived from Cesariano's 1521 edition of Vitruvius in translation. Antonio's texts are paraphrases and extrapolations of Vitruvius (X.xii.1–2; Cesariano, X. xv. and xviii, pp. CLXXVII r. and v.). However, Cesariano did not illustrate a catapult in his two chapters, "De la ratione de la catapulte et scorpioni, capo XV," and "De modo de accordare et temperare le catapulte e baliste, capo XVIII." Antonio did so in his own way, on three folios. Where his notes for the snapper on this sheet and on U 1485A r. were borrowed from Cesariano, his drawings of the snapper reconstruct what he thought of as the ancient catapult described by Vitruvius. It relates no doubt to a tool he used in the workshop. His text describes how the structure is made, progressing from one point to another with the clarity of a textbook or technician's manual. He had "taken notes" from Cesariano's book, but wrote his own ideas about the Vitruvian catapult. His predecessors for this type of descriptive writing were Taccola and Francesco di Giorgio. See Antonio's other selections

from Cesariano, all cited in "Drawings of Machines."

BIBLIOGRAPHY: Cesariano (1521); Ferri (1885) 89.

G.S.

U 1459A *recto and verso*

ANTONIO DA SANGALLO THE YOUNGER
Study of the constellations in the northern hemisphere;
determination of location of north pole, after 1540.

b

a

c d

Dimensions: 287 x 200 mm.
Technique: Pen and brown ink, stylus.
Paper: Medium weight, reinforcements on all four sides.

INSCRIPTION, Recto: *Lo polo e dentro / alla tuoi montagna / tanto quanto sono queste / due stelle lontane luna / dalaltra per quella linia / che va dalla tramonta alle / dua stella di fuora deli/chano(?); Cosi sta a mezo / diciembre; polo; Cosi; (per pendicholo canceled); per pendicholo; polo*
Verso: *per pendicholo; [. . .]; [. . .]*

U 1459A recto contains four astronomical studies prepared by Antonio da Sangallo the Younger for his commentary on the sixth chapter of Book 9 of Vitruvius's *De Architectura*. Following the ideas formulated by sailors and by the astronomer Pedro da Medina, who confirmed the antique doctrines of Eudoxus and Hipparchus in *Arte del Navegar* (published in Vallodolid, 1522; in Venice, 1528, 1540), Antonio da Sangallo succeeds in determining the actual position of the northern hemisphere's pole by means of nocturnal observations.

As a matter of scientific fact, the north pole is the center of two concentric circles created by the rotation completed within twenty-four hours by the line between the North Star (the last star of the Little Bear constellation) and the horologium (one of the two "guards" of the Great Bear). These two stars and the north pole together form a triangle. In this sketch (*a*) Antonio follows the discussion provided by Pedro da Medina in recognizing Hipparchus's concept that the stars and the sky rotate around the pole from east to west. The pole, however, contrary to appearances, is not a fixed and unchangeable point by virtue of the procession of the equinoxes. We know today that the celestial pole describes in the sky a small circle around the elliptical pole.

Antonio the Younger's method is explained in a passage from a manuscript in the Biblioteca Marciana, Venice (Codex Ital. Cl. IV, cod. it. 152 = 5106), a work by Daniele Barbaro, preparatory to his 1556 edition of Vitruvius's *De Architectura*. In this passage Barbaro is commenting on a section from *Arte del Navegar* (ed. 1540, fols. 96–101). He writes: "La tramontana della quale si servono i nostri marinari, è quella stella, che è l'ultima nella coda dell'Orsa Minore, imaginiao una linea dritta dalle ultime due stelle dell'Orsa Maggiore. . .che vadi fino alla prossima stella, che se le fa incontra, ivi è la stella vicina al Polo del Mondo, che si chiama. . .la tramontana adunque è la prima delle sette stelle, che fanno l'Orsa Minore . . .queste sono sette stelle assai chiare [note that Antonio points out the three most luminous stars]. . .si muovono d'intorno al polo con egual distanza in hore 24 da Levante a Ponente, & la tramontana, per esser piu vicina al Polo fa minor giro, & per essa essendo il Polo invisibile, si conosce l'alatezza del Polo sopra l'orizonte, et il luogo del Polo si conosce per un'altra stella dell'Orsa Maggiore. . .che è la piu lucente delle due guardie. . .& quella Stella, è detta horologiale, perche gira come ruota di horologio, dando a conoscere in ogni tempo dell'anno, che hora è della notte. . .et sempre tra le guardie, e la tramontana sta il Polo, in modo che quando le guardie stan di sopra il Polo la tramontana sta di sotto. Da poi sapendosi dove stanno le guardie, si sa in che parte del Polo, & in che distanza di esso sia la Tramontana."

Studies *b* and *c* are preparatory for the sketch at *d* in which Antonio the Younger determines the distances among the three brightest stars of the Little Bear, as well as the seven brightest stars of the Great Bear, using as a rule the distance between the North Star and the pole.

It is probable that Antonio knew the earlier studies of the constellations, carried out by Conradus Heinfogel, co-author of a sky map of the northern hemisphere that was published in 1515 in Nuremberg, designed by Albrecht Dürer, and printed by Stabius. In that map the two constellations of the Bears are rendered with the same arrangement as the ones in the Antonio's designs *b–d*.

In addition, Antonio knew the treatise *In Spheram Materialem: Vorred Seytmal das man zu dieser zeyt vil theutscher Kunst zu trucken geyt* by Conradus Heinfogel (1519). Study *a* derives directly from Heinfogel's text (chap. 7, fol 7 r.), in which this portion of the vault of heaven is described from the point of view that Antonio's map represented.

Dating of the sheet is further confirmed by the form

of the "h," as discussed by Frommel.

BIBLIOGRAPHY: Ferri (1885) 34; Losito (1989).

M.L.

U 1460A *recto*

ANTONIO DA SANGALLO THE YOUNGER
Studies of chorobates (leveling instrument).
Dimensions: 215 x 210 mm.
Technique: Pen and brown ink.

(top) Rod with square bolt and a socket (*lignio / palmi 2 pietra*). (bottom) Slider of the chorobates, side view and (bottom right) end view.

INSCRIPTION: *Legnio tondo fora/to longi p[almi] 8 lo piu / longo lo piu chorto / palmi 5 sono corti / e va in piano e poi / monta per channe 10 dalteza / e ferme bene ed e tuto dischoperto / come vedi*

The sketches and the note seem to describe the Vitruvian chorobates illustrated by Cesariano (VIII.v.1–2); they are thus discussed with the others (U 1409A v.).

BIBLIOGRAPHY: Ferri (1885) 89.

G.S.

U 1461A *recto*

ANTONIO DA SANGALLO THE YOUNGER
Studies of hodometer and sounding vases, after Vitruvius; proportions of the atrium, after Vitruvius.

Dimensions: 290 x 428 mm.
Technique: Pen and brown ink.
Paper: Center fold.

Left half (sheet rotated): (a) Antonio's five examples of Vitruvian sounding vases reclining in their niches under the steps of a theater. (b) Notes on the proportions of the Vitruvian atrium and alae from 30 to 100 (*longitudine atrii*; *latitudine alee*). (c) Antonio's elevation of the atrium (*atrio*) and tablinum (*tabulino*). Right half: (d) Note, reference to the book of Vegtius Renatus: *VE/GETIO / DE LARTE / MILITARE / NELLA* (canceled words) *COMUNE / LINGUA*. (e) Hodometer. (f) Note concerning the hodometer.

INSCRIPTION: (c) *Lalteza dell atrio sara li ¾ della longeza dell* (*cosi* canceled) *atrio / Le ale si piglieranno sotto al trave* (*dele* canceled) *e lo resto li lacunarii / Et larca sopra allo trave aveva la sua ragione / Le ale della destra e dalla sinistra la latitudine quando / latrio sara longo a XXX piedi; (f) P[iedi] 30 15–¹⁴/₂₂ Diamitro / de la rota se di circunferentia / piedi 12¹/₂*

Antonio the Younger's sketches of sounding vases (a) are interpretations of descriptions by Vitruvius (V.v.1–5), which state: "vessels are arranged in niches constructed in between the seats of the theater. . .set upside down. . .and supported by wedges. . ." Antonio's note "L[ibro] V" is written between two vases. Niches have not been found in the small theater in Pompeii or in the large Teatro Marcello in Rome. Francesco di Giorgio illustrated the Vitruvian passage about sounding vases in his own way (*Trattato I*, fol. 14 r., Biblioteca Reale, Turin). Antonio the Younger also illustrated four versions of the theater steps with a seated person (U 1472A r. and v.). A circular cavity is on the stone step of the "Magnatore," a man sits on a step, placing first one foot then another in the cavity on the step below him, and in one example he sits in the cavity. Antonio noted, "he sat like this or like that" ("se stava chosi o chome stavano; se stava cosi; o chosi"). The plan (U 1472A r.) of a small hemicycle with eight columns is the size of an odeum. Antonio said it was decorated with stucco and mosaic, and a marble piece was in its assembly room (*chonventi*). No trace has been found of the Odeum of Domitian. The Auditorium Maecenatis on the Esquiline does not include columns. The Turris Maecenatiana stood in the gardens, but there is no evidence for the name "Magnatore."

Antonio's calculations of proportions from 30 to 100 (b) are his way of interpreting Vitruvius's dimensions of the alae of the atrium (VI.iii.4). For the proportions, he probably used Cesariano's edition (VI. iv, p. LXXXXVIII v.): "De la longitudine et latitudine e symmetria. De li atrii: et de le loro ale: et tablini. Capo quarto." Although the elevation drawing (c) is Antonio's own interpretation, like another he shows on the verso side, and Cesariano did not illustrate the elevation, merely diagrams, Cesariano's words under the drawing (c) may be compared with Antonio's: "La altitudine de quilli quanta sera stata la longitudine dempta la quarta parte soto li trabi sia elevata il resto de li lacunarii: & de la area sopra li trabi la ratione cosi si habia. Per le ale da la dextra & sinistra parte la latitudine. Quando la longitudine del atrio da pedi XXX ad pedi XL de la tertia parte di epso sia constituita."

Antonio's reference to the book on the military arts

by Vegetius (d) refers to one of three editions in 1524, 1525, and 1540, each with a uniform title (*Vegetio de larte militare ne la commune lingua novamente tradotto*) and published by various printers in Venice. The word "novamente" in each title since 1524 seems to mean "newly printed as a translation," although no translation is known before that one. In any case, Antonio the Younger had an edition in hand. He also had a Latin edition of Vegetius, according to technical words he quoted on U 1470A r., where his images reflect his understanding of the Latin words, hardly different in Italian. Incidentally, preceding Antonio the Younger for the Latin edition (1484), Francesco di Giorgio, in his *Trattato II* on fortifications, cited: "Vegezio nel suo libro De re militari."

Antonio's sketch of the hodometer (e) is a detail he derived from Cesariano's illustration of a horse-drawn wagon with hodometer (X. xiii, p. CLXXIIII r.). Only the words in the note (f) about the circumference of the hodometer's wheel are derived from Cesariano's translation (p. CLXXIII v.): "Le rote quale serano ne la carreta siano large per il medio diametro de pedi quatro & uno sextante :. . .habia compito uno certo modo del spatio de pedi XII e mezo. . ." Since Antonio's numerals in the first place do not correspond to any by Cesariano or Vitruvius, they are surely his own calculations.

BIBLIOGRAPHY: Cesariano (1521); Vegetius Renatus (1540): Book II, chaps. 26, 31; Book III, chap. 24, 75 v.–76 r.; Jordan (1907) 346–47; Platner (1911) 465, fig. 88; Martini-Maltese (1967) I: pl. 23; II: 417.

G.S.

U 1461A *verso*

ANTONIO DA SANGALLO THE YOUNGER
Studies of an atrium; proportions; grist mill in Cesena.

```
  a c
    e d
b      g    f
  a
```

Dimensions and Paper: See U 1461A recto.
Technique: Pen and brown ink.

Left half: (a) Antonio's numerical proportioning of the atrium and tablinum from 20 to 100 *piedi* at right side of list (*Vitruvio* repeated three times) and references at right to Vitruvius's Book VI (*L[ibro] VI*). (b) Notes of proportions (at left of the list). (c) Notes of proportions (at top). (d) Notes of proportions (at right). Right half, inverted: (e) Antonio's elevation of the atrium and

tablinum (vertically on page) (*Longeza atrio / Atrio / Alteza tabulini / Tabulini*). (f) Note on Vitruvius's Book VI (*L[ibro] VI*). (g, along center fold) Gristmill and pulverizer in Cesena.

INSCRIPTION: (b) *Longitudini / atrii / piede 20 / Latitudine delle allee*; (c) *Longitudine atrii modulo della alia / in minute 40 / (Latitudine delle alve* canceled) *e una parte in minuti overo moduli*; (d) *In ciascuno loco senpre / ciascuna ala a esere / larga moduli 42 / di quelli moduli dove / si trova / Tutte a due le alie / insieme sono 8; Da capo li moduli / saranno picoli / Da pie saranno / grandi.* Right half: (e) *La proportione chel da del atrio sie del corpo di mezo / e le alie sono agiunte come qui / Questo mezo sta / bene*; (g) *Per pestare la polvere / Nell arga di Ciesena / Farina / B[raccia] 8*

Although Antonio cites Vitruvius and his Book VI (a), his numerical proportioning of the atrium, alae, and tablinum (Vitruvius, VI.iii.4–6) is his own. For these parts of the house, Antonio disregarded Cesariano's translation of Vitruvius. This is clear also in Antonio's notes c, d, and e where he uses his architectural terms for measurements ("moduli" and "minuti"). Antonio's elevation drawing (e) of the atrium and tablinum is his personal interpretation of Vitruvius, and its form differs only slightly from his drawing on the recto side.

Antonio's note g for the combined gristmill and pulverizer turned by a horse indicates that such an engine was operating in Cesena. The pulverizer for gunpowder with five mortars and pestles is a variant of two in the Rocca di Cesena (U 819A r., 1442A r. and v.). Antonio may have made this drawing during his trip through the Romagna to inspect fortifications in 1526. (Although, see the dating issues raised by C.L. Frommel in his essay in this volume.)

BIBLIOGRAPHY: Cesariano (1521); Ferri (1885) 24.

G.S.

U 1463A *recto and verso*

ANTONIO DA SANGALLO THE YOUNGER
Geometrical studies, 1507.
Dimensions: 365 x 260 mm.
Technique: Pen and brown ink.
Paper: Torn at left and right sides.

Recto. Geometrical diagram(?).
Verso. Diagram of a triangle; circle inscribed with three squares.

INSCRIPTION, Recto: *Gieometria; Gieometria di Fra Jochundo*

Antonio the Younger's geometric diagrams are illustrated on sheets U 1456A r. (diagram and notes on cube root); 1457A r. and v. (diagram notes on geometry, and the title "Gieometria"); 1488A v. (diagram notes on how to divide a perpendicular line). Fra Giocondo is named as author. The same inscription title "Geometria di Fra Jochundo" is cited in the monographs on Fra Giovanni Giocondo by Fiocco and Brenzoni, as if it existed on a series of Uffizi sheets (U 3936A r., 3937A r. and v., 3938A r., 3743A r.). But Lucia Ciapponi (1984) cited the *frate*'s authentic geometrical studies as U 3936A–3943A. She also published evidence that he had drafted a treatise on mathematics and geometry, and she discovered that in 1512 Fra Giocondo formally requested a patent to publish his studies on ancient mathematics. For Fra Giocondo on geometry, see Codex Plut. 29, 43, Biblioteca Medicea Laurenziana, Florence; and Codex Vat. lat. 4539, Biblioteca Apostolica Vaticana.

In light of these findings, Antonio the Younger's reference to Fra Giocondo on geometry is likely to be the earliest reflection of his works, if not actually contemporary with the *frate*'s studies. Antonio's diagrams (U 1456A r., 1457A r., 1463A r., 1488A v.) may have been copied from Fra Giocondo's codices or from the Uffizi sheets cited above or from his treatise drafted before 1512. In all probability, Antonio executed the diagrams in Rome where he was working in 1507. Fra Giocondo (d. 1515) was employed along with Giuliano da Sangallo and Raphael as papal architects in the Fabbrica di San Pietro, and Antonio ultimately assumed Giuliano's position in 1520. In those years, Antonio the Younger probably was acquainted with the humanist-Vitruvianist Monsignor Angelo Colocci, who owned Fra Giocondo's codex now in the Vatican, and he was the colleague of Fabio Calvo who translated Vitruvius ca. 1514 (Codex Ital. 37, Bayerisches Staatsbibliothek, Munich). Fra Giocondo's drawings of instruments (astrolabe, quadrant, chorobates, theodolite, and polymetrus) are commented on in connection with Antonio's drawings of astrolabe or quadrant at U 1454A r. and v.

BIBLIOGRAPHY: Ferri (1885) 81; Fiocco (1915); Brenzoni (1960) 100; Fanelli (1979); Ciapponi (1984) 181–96; Fontana (1987).

G.S.

U 1464A *recto and verso*

ANTONIO DA SANGALLO THE YOUNGER
Florence, Laurentian Library stairs, wall elevation, a

mazzocchio (*recto*). Florence, Porta Faenza, 1526–27 or 1531 (*verso*).

Dimensions: Original sheet irregularly cut, modern support 291 x 215 mm.
Technique: Pen and brown ink.
Paper: Extremely thin.

INSCRIPTION, Recto: *Scala Porida*; *Scala a faccie*
Verso: *scala*; *porta a faenza*

The recto shows a collection of studies related to the Laurentian Library, Florence. Above are two variations on stair construction: one rounded, the other interlocking at the corner. In the center of the sheet is a *mazzocchio*. This is one of four representations of *mazzocchi* among the drawings of Antonio the Younger. The other examples are U 831A, 832A, 4120A. (For a fuller discussion of the *mazzocchio*, see U 831A.) Below is a section through the *ricetto* of the Laurentian Library and studies of forms of the stairs. These studies will be discussed in Volume Three. For now it is sufficient to note that these studies have a terminus ante quem of 1533.

The verso has been dated by Manetti to the period around 1527 when the Sangallo shop was engaged to help with the updating of the Florentine fortifications. Marani suggests that the drawing may date from 1525–27, prior to the nomination of Michelangelo as "generale governatore et procuratore" of the fortifications in January 1529. Both Marani and Manetti agree that it may form the basis for a drawing by Michelangelo (Casa Buonarotti 18A). Certainly the scale of the proposal associates it with the earlier period of Antonio the Younger's activity in Florence, rather than the period of the Fortezza da Basso.

In our opinion, the connection with the Michelangelo is not sufficiently convincing to claim precedence for the Antonio the Younger sheet. Indeed, everything we know about the relations between the two architects would suggest an influence in the other direction. It may even be that this sheet dates to the period just after the siege of Florence when the Sangallo shop seems to have taken special interest in Michelangelo's designs and some of the problems faced in the refortification of the entire enceinte (see U 757A, 761A).

Making allowance for what is a relatively crude drawing, the dimensions of the barbican compared with those of the wall are roughly consistent with those cited by Friedman. The proposal, such as it is, centers on the blocking of the outer barbican gate to form a solid triangular salient that can be swept by defensive gunfire from neighboring towers. The barbi-

can itself thus forms a simple form of bastion, with a very restricted internal space. In short, all the signs are of a makeshift solution.

Although there is no firm date for this sheet, we have at least a rough time frame (1526–31) for Antonio's interest in *mazzocchi*. Though the relation is not compelling we have used this to date the other sheets with a similar subject (U 831A, 832A, 4120A).

BIBLIOGRAPHY: Ferri (1885) 57; Friedman (1978) 179–81; Manetti (1980) 32, 108, 113, fig. 5; Marani (1984) 111: fig. 68.

N.A./S.P.

U 1466A *recto*

ANTONIO DA SANGALLO THE YOUNGER
Calculator for cubes and cube roots.
Dimensions: 241 x 382 mm.
Technique: Pen and brown ink, stylus, straightedge.
Paper: Reinforced at corners and along the middle lines, stylus.

INSCRIPTION: *Quadrato fa 100 / Cubo fa 1000*

The sheet seems to represent a kind of graphic table for the approximate calculation of the cube of numbers between 10 and 30, and cube roots between 1000 and 27,000. (It is also possible that the sheet might represent a comparative table of dimensions of an expanding cube.)

From an analysis of the curves traced with a dry stylus on the sheet it is possible to establish that the arc would form part of a circle with its center at the lower left hand of the sheet.

The sheet is similar to U 3949A though slightly less clear in presentation and with fewer details.

Using the scale on the left-hand square one can read the number to be cubed; this is done by identifying the vertical lines that define the number. Following these lines, up and then to the right, one meets the scale on the lower right margin of the sheet; thus it is possible to define the interval of the cube of a given number and to determine the approximate value of the cubed number.

For a cube root one reads from the lower right margin and follows the same path in the opposite direction. Thus one arrives at an approximate value of a cube root for a number between 1000 and 27,000.

BIBLIOGRAPHY: (not published).

P.N.P./G.L.V.

U 1467A *recto and verso*

ANTONIO DA SANGALLO THE YOUNGER
Studies of mills, capital, coat of arms, 1527–35.
Dimensions: 283 x 416 mm.
Technique: Pen and brown ink.
Paper: Center fold.

Recto. Left half: (a) Mill wheel (*catene di fero*) in Arezzo (*in Arezo / in cittadella / ed e bono*). (b) Corinthian capital (*davanzale corintio / in Arezo*). (c) Fort plan in outline, partially rendered. Right half: (d) Stemma with helmet, bird, and shield.
Verso. Note about a mill in Orvieto.

INSCRIPTION, Verso: *Uno mulino in Orvieto quale e una / stanga longa dallo stile braccia 6 E in lo / stile e una rota dentata in taglio larga / braccia 6 quale a denti 96 Ed a in tre roche/tti di sei denti overo gretole luno / E volte tre macine large braccia 1 ¹/₁ luna*

The mill structure in Arezzo resembles one in Cesena (U 1442A r.); the wheel is suspended on iron chains in a similar manner. Antonio the Younger's note for the mill in Orvieto states the dimensions of each component, a method he practiced wherever he went. In Orvieto he built the Well of San Patrizio in 1527–35 and this provides a likely date for the sheet.

BIBLIOGRAPHY: Ferri (1885) 9.

G.S.

U 1468A *recto*

ANTONIO DA SANGALLO THE YOUNGER
Studies of a pump with an Archimedean screw.
Dimensions: 425 x 285 mm.
Technique: Pen and brown ink.

Pump with Archimedean screw, pipe (A, *tromba*), another pipe (*questa e quanto giocha lo standuffo*) and gear rack.

INSCRIPTION: (upper left) *Nel foro segniato A / mettono tutte le fistole / e tutte fanno una tromba / che porta lacqua in alto*; (at right) *Poria ancora entra/re laqua per questo for[o] / ed essere turato in fon/do e basteria una / palla sola*; (bottom left) *Vogliano esere p[almi] 4 standuffi (denti 18 p[almi] 3 denti 12 p[almi] 2 canceled) tanti denti che abino partimento / in tre perche senpre el terzo la/vora e due tertii restono vachui / come faria 3. 6. 9. 12. 15. 18 / 21. 24. 27. 30. 33. 36. 39. / 42. 45. 48. 51. 54. 57 / 60*

This unusual form of technical drawing on a very large single sheet provides a plan of assembled components, rather than the usual external view or the

plan of the quadruple mill (U 1268A r.). It is not clear how the components are attached to one another or how they stand in relation to one another in space. A Florentine copyist working ca. 1548–52 (see Codex Palat. 1417, fol. 32 v., Biblioteca Nazionale, Florence) illustrated an external view of a pump that seems to resemble the present one, showing an Archimedean screw passing through a wellhead; at midpoint it is geared to a cogwheel lantern on a post that turns when men use the handspikes. Antonio's notes state that in hole "A" all the tubes are placed for a pipe that raises water. The water can also enter from this hole and, being plugged at the bottom, one ball will suffice. The *stantuffi* should be 4 feet; teeth, as many as are divisible by 3, because one-third of them always engage and two-thirds are empty, as for example three times 1 through 20. Antonio also mentioned the *stantuffo* and ball (*palla*) in another mechanism with a hand-cranked pump (U 294A v.), with a wheel (U 847A v.), and a four-tooth gear in elliptical racks (U 847A r., 1409A v., 1493A r.). His note about teeth engaged and others at rest recalls one on the last-named sheet, this drawing being a version of that one. Concerning a possible dating for this sheet, see the essay of C.L. Frommel in this volume.

BIBLIOGRAPHY: Ferri (1885) 91.

<div align="right">G.S.</div>

U 1469A *recto*

ANTONIO DA SANGALLO THE YOUNGER
Studies of mills.

Dimensions: 295 x 420 mm.
Technique: Pen and brown ink.
Paper: Original center fold, now repaired; darkened at edges.

Left half: (a) Post of jointed wood (*capitulum*) for a beam press(?), in two details. (b) Millhouse(?): four posts and two crossed beams in plan view (*trabo* 37½; *trabeculi* 23½; *area rotonda*; *area piedi* 6). (c) Posts with sockets, in four details. Right half: (d) Note about two feastdays (written crosswise). (e) Lid or millstone, jointed (*orbeni*). (f) Lid or millstone, jointed (*catene / orbene / piedi* 4). (g) Lid or millstone, in plan view. (h) Note for these lids or millstones, in Latin, selected at random from chapters in

Cato, *De re rustica*, I.xviii (edition of 1496), Italian glosses by Antonio the Younger. (i) Table. (j) Notes (written crosswise) from chapters in Palladius, *De re rustica*, I.xx; from chapters in Columella, *Rei rusticae*, I.viii; V.viii; etc. (both authors in 1496 edition). (k) Beam press(?) for crushing olives: measured sketches (upside-down on sheet) with Latin notes from Cato, I.xviii, and Antonio's Italian glosses on Cato's words or written independently.

INSCRIPTION: (d) *Domenica a ore 18¼ / lo di di S. G. Dicolatto a di / 29 dagosto / a di primo di settembre a ore / 3 la sera di S[anto] Gilio*; (h) *Orbeni olearium latum piedi 4 / grossa dita sei. Punicariis coagmentis cioe sia inconblata / con lla colla de ruona cioe di vernici / subfondis in ligniea adindito / Eas ubi confixeris clavis corneis / cio confitto colli chiovi di osso / E abbia tre catene cioe tre sprange / attraverso confitte colli chiodi di ferro*; (j) *Olei fattorino / Palladio libro I c. xx / Columella / Libro I ca. viii / libro V ca. viii / Libro XII ca. ii / liii / liiii / lv*; (k) *La stantia longa / piedi 66* (on post) *capitulo 16* / (on beam) *prelo 25* / (on round form) *cuniarium / stipito; sustula preter cardini / piedi 19*; / (on measured post) *capitulo* / (on socket) *buso piedi .x.* / (on socket in plan view) *excalpta dita sei / cioe excavata / overo intacata* / (note) *inter binos stipites / vettibus locum / pendum 22* / (notes) *arbore / oncie 6 / pedicino / Robore*

See entry for U 1469A v.

BIBLIOGRAPHY: Ferri (1885) 89.

<div align="right">G.S.</div>

U 1469A *verso*

ANTONIO DA SANGALLO THE YOUNGER
Studies of presses, mills, and pulleys.

Dimensions and Paper: See U 1469A recto.
Technique: Pen and brown ink.

Left half: (a) Beam press for crushing olives or grapes (*La sucula e in piano con di so/tto del buso / prelo / sucula; macina; caviglia / di ferro / macina / ove lingnia ove bilica*). (b) Roller mill (*trapetum*) for crushing olives (*A / B / A ferro / B legnio / modiolo*). Right half: (c) Pulley-rope system, lettered *A–G; A–F*. (d) Pulleys, two examples. (e) Roller mill (*trapetum*), three measured millstones on concave stones (*modeani / Cato / modeani / Cato / modeani / Cato*).

INSCRIPTION: (e) *Trapetos latos maximos pedes .iiii. .s. / orbis altos pedes .iii. .s. orbes modios Nota orbes medio .s. cioe lo tondo di mezo / Ex lapidicinis cum eximet crassos / pedem & palmum intermiliarium et labrum pede .ii. digitos .ii. / labra crassa digita; Secundarium trapetum latum pedos .iiii. & palmum / intermiliarium et labrum .i. digit .i. labra crassa / digitos .ii. orbes altos pedes .iii. et digitos .v. / crassos pie .i. .2. digitos .iii. foramen in orbeis semi/pedum quoquo versum facito; Tertium trapetum latum pedi .iiii. in termiliarium et / labrum pedem .i. digitos .v. orbis altus pe .iii. digitos .ii. / crassos pe .i. digitos .ii. Trapetum ubi aventum erit / ubi statium ibi et commodato concinnateque*

Antonio the Younger's notes provide some clues to the authors he transcribed from the Latin and then interpolated with glosses in Italian. He named Palladius's book and Columella's books and chapters on the presses and millstone for crushing olives. It is not clear whether his sketches on the recto of beam-press lids (*e, f, g*) and a millhouse in plan view (*b*) are based on structures he saw around him or whether they comprise a reconstruction made following descriptions by Palladius and Columella. Possibly the sketches include both elements. On the verso side of the sheet, he illustrated two types of presses for crushing olives. The identity of the author he quoted in Latin for three versions of the roller mill called *trapetum* is unknown. Antonio sketched another press (U 7975A r.). Concerning a possible date for this sheets, see the essay of C.L. Frommel in this volume.

BIBLIOGRAPHY: Columella (1496); Palladius (1496); Ferri (1885) 89; Cato (1954); Columella (1968).

G.S.

U 1470A *recto*

ANTONIO DA SANGALLO THE YOUNGER
Studies of weapons.
Dimensions: 415 x 264 mm.
Technique: Pen and brown ink.
Paper: Center fold, repairs at corners.

(a) Hand positions for releasing arrows, four examples. (b) Release hooks of crossbows in six examples, two of which are annotated: *questa / scaricha.* (c) Trebuchet on a shelter wagon (*bilico vole / stare qui piu / alto che none / accio che lo contra/peso non toche in sul / piano del carro*). (d) Crossbow (*Balista*) with a slingshot (*carcha*). (e) Horse-drawn car with trebuchet (*carro balista sive onagro / 1*). (f) Soldier with slingshot (*fundibalatores / 3*). (g) Soldier with grenade (*manobalistraro / 2*). (h) Soldier hurling slingstone (*funditore / 4*). (i) Note: *1. Carro*

balistae onagro / 2. Manubalistarij co mano / 3. Fundibulatores; fundibulatorij / 4. Funditores funditores. (j) Cannonball calculations: *La pietra monta [. . .] la meatti / [. . .] resta avere [. . .]*.

As a precedent for Antonio the Younger's sketches of the hand positions, see Taccola's Notebook sketches of a hand balancing a pot on a stick and hand holding a bow to release an arrow (Ms CLM 197, part II, fols. 67 v., 84 v., Bayerisches Staatsbibliothek, Munich). As usual, Antonio had some critical observations about the way the bearing of the trebuchet should be higher so that the counterweight does not strike the wagon floor.

Although Antonio quoted the title of Vegetius in translation on U 1461A r., on the present sheet he transcribed and illustrated several words from the Latin edition of Vegetius (*Epitoma rei militaris*, first published in 1484), specifically the words *ballista, carrus, funda,* and *manus.* He cross-referenced the words and images with the numbers 1 to 4. Antonio's notes and the related references in Vegetius (Book II, chap. 26; Book IV, chap. 24) are as follows:
(List) *1 Carro balistae—onagro;* sketch of horse-drawn or ox-drawn flatcar with trebuchet and slingshot: *carro balista sive onagro.*
(List) *2 Manubalistarij—co mano;* sketch of man hurling grenade: *manobalistraro.*
(List) *3 Fundibulatores—fundibulatorij;* sketch of man hurling stone in a sling attached to a pole: *fundibalatores.*
(List) *4 Funditores—funditores;* sketch of man hurling stone in a sling: *funditore.*

Vegetius states (II, 26): "In a legion there were fifty-five ballista wagons [*carrobalistae*] discharging stones or other missiles; in each cohort there was a slingshot or stone-hurler [*onagro*] carried on a wagon pulled by two oxen." Thus Antonio the Younger's illustration of a flatcar bearing a trebuchet and a slingshot reflects his note of identification, since Vegetius did not write that a *carrobalista* was an *onagro*. Concerning a date for this sheet, see the essay of C.L. Frommel in this volume.

BIBLIOGRAPHY: Vegetius Renatus (1540) Books II, IV; Ferri (1885) 92; Vegetius Renatus (1885) 126–44.

G.S.

U 1471A *recto*

ANTONIO DA SANGALLO THE YOUNGER
Studies of gristmills.

Dimensions: 285 x 420 mm.
Technique: Pen and brown ink.
Paper: Center fold; darkened at edges.

Left half: (a) "19" Gristmill with weight-wheel and crank. (b) "20" Gristmill with weight-wheel and crank. (c) "21" Gristmill. (d) "22" Gristmill. Right half: (e) "23" Gristmill. (f) "24" Gristmill with horse-powered treadwheel. (g) "25" Gristmill with horse-powered treadwheel. (h) "26" Gristmill with two men on treadwheel. (i) Gristmill.

INSCRIPTION: (h) *Questo e simplice / ed e bono ma / uno poco lento / Le rote grande piedi 32 / La rota dentata palmi 8 / Lo rochetto palmo uno / Lo asse della rota p[almi] 2 / fa due mulini;* (i) *Questo lo potra voltare / un cavallo con questa rote dentata / in piano*

The numbered gristmills begin on the verso side of the sheet. See U 1471A v. for the discussion of the entire sheet.

BIBLIOGRAPHY: Ferri (1885) 100.

<div align="right">G.S.</div>

U 1471A *verso*

ANTONIO DA SANGALLO THE YOUNGER
Studies of gristmills.
Dimensions and Paper: See U 1471A recto.
Technique: Pen and brown ink.

Left half: (a) "27" Gristmill with three hoppers, horse-driven. (b) Grindstones in three details (*vole stare cosi*). (c) Gristmill with three gears. Right half: (d) "15" Pump. (e) "16" Gristmill. (f) "17" Gristmill. (g) "18" Rotatable tower windmill with a holding device (*vizosa*). (h) Vanes of a windmill (*le farfalle vene stanno / cosi uno no pocho svoltate*).

INSCRIPTION: (a) *Questo puo ma/cinare tre ma/cine o[vero] 4;* (c) *Questo puo voltare 3 macine o[vero] 4 / La rota grande la volti uno cavallo / e ditte rota volti 3 rochettoni che / abino ciascuno rochettoni anessa / una rota dentata quali dieno nel / rochetto della macina E uno ca/vallo volta 3 macine;* (d) *Lo guscio del manta/co sta fermo e lo tramezo / di mezo va su e giu / cosa dificile a tenere / lo fiuto che non sfiuti;* (g) *La vite fa voltare lo mulino / al vento a quella parte dove / egli speta / Queste vele non possono / girare se non sono di tavo/le*

As explained elsewhere (U 1443A r., 1482A r. and v.), eleven of fourteen mills on this sheet's recto and verso sides were copied by Antonio the Younger from Francesco di Giorgio's *Trattato II* Supplement, their concordance being as follows: (recto) 96 r., 96 r. and v., 97 r., 97 r., 98 r., 97 v.; (verso) 94 v., 95 r., 95 v., 95 v. (Martini-Maltese, II: pls. 327–331). Though he transcribed elements from previous pages of *Trattato II* (U 1482A r. and v., 1483A r. and v.), Antonio did not transcribe any of Francesco's descriptions of mills on U 1471A r. and v. or of column lifts and pumps on U 1443A r. and v. He numbered each mill drawing beginning on the sheet now known as the verso, with mills *15* to *18*; the series continued on the left half of the recto side with mills *19–22*, on the right half with mills *23–26*, and on the left half of the verso side with mills *27* and *28*. Strangely, mills *26, 27,* and *28* were not derived from the *Trattato II* Supplement. He measured mill *26* and commented on its slow motion, a criticism he often made about gear mechanisms. His understanding of machine functions is expressed for pump *15*, saying the bellows case stays in fixed position while the piece in the middle moves up and down, making it difficult for the bellows to hold air so that it does not exhale. He noted that the screw clamp (*vizosa*) for windmill *18* permits the operator of the windmill to shift it in the wind's direction; the vanes must be made of wood, and arranged as shown in a separate detail. Antonio illustrated and commented on other windmills (U 1448A r.). He also used numbering sequences elsewhere. A sheet with hoists, obelisk hauler, and crane (U 4078A r.), derived from Francesco's *Trattato II* Supplement, begins with numerals *1* through *7*; another sheet (U 1443A r. and v.) has numerals *9* through *14* for column lifts, pump, and obelisk hauler. U 1443A, 1448A, and the present sheet show the same watermark. (U 4078A is without a watermark.) All three surely belonged to Antonio's second sketchbook; the drawings are marked by a free penline technique without shading strokes. The present sheet retains its original foliation "9." The sheets preserved from his second sketchbook begin with U 848A r., where all others are listed. The question of when Antonio the Younger visited Siena is discussed in "Drawings of Machines."

Concerning a possible date for this sheet, see the essay of C.L. Frommel in this volume.

BIBLIOGRAPHY: Ferri (1885) 100; Martini-Maltese (1967) II: pls.327–331.

<div align="right">G.S.</div>

U 1472A *recto*

ANTONIO DA SANGALLO THE YOUNGER
Studies of theater steps and machines, before 1515.

Dimensions: 240 x 335 mm.
Technique: Pen and ink.
Paper: Center fold, heavy.

Left half: (a) Four column bases, a step under each (*qui repeated four times*), a man seated on one step (*se stava / cosi*), another man on the second (*o chosi*). (b) Hemicycle of an odeum(?) with eight columns (*tonda la colonna*) in plan view. Right half, vertically on page: (c) Pulverizer, hand-cranked and with cams (*palmi 12 / per pestare polvere*). (d) Bar-breaking tool (*sega; ferro; per segare uno fero*).

INSCRIPTION: (a) *Quanto larga la magna tora / la basa sopra la mangia tora / La basa arischontro come stava*

For drawings *a* and *b*, see U 1461A r., where there are related objects. The hand-cranked pulverizer has no parallel among Antonio the Younger's drawings, though the object itself was probably common enough; instead he illustrated several horse-powered pulverizers (U 819A r., 1442A r., 1445A r., 1461A v.). The bar-breaking tool is Antonio's exact copy of one of several by Leonardo da Vinci (Codex Atlanticus, fols. 6 r., *a*; 6 v., *a*; 16 r., *c*; 16 v., *b*; Biblioteca Ambrosiana, Milan), executed sometime before 1515 when he went to France, taking his drawings with him. This would seem to confirm an early date for Antonio's drawing and indicates that he met Leonardo in Rome or Florence. It would seem to be at this time, too, that Giovan Francesco da Sangallo added sketches of Leonardo's ornithopter on the space remaining on the sheet where he sketched the Mausoleum of Augustus (U 3956A r.), and Antonio the Younger redesigned the roasting spit (U 1564A v.) over one illustrated by Leonardo, which had been copied by Giuliano da Sangallo before 1504 in his *Taccuino*.

For confirmation of the dating, see the essay by C.L. Frommel in this volume.

BIBLIOGRAPHY: Ferri (1885) 89.

G.S.

U 1472A *verso*

ANTONIO DA SANGALLO THE YOUNGER
Studies of theaters.
Dimensions and Paper: See 1472A recto.
Technique: Pen and brown ink.

Left half: (a) Column base, measured; shown crosswise at top. (b) Corinthian capital, measured. (c) Architrave profile, measured. (d) Elliptical form, measured. (e) Hemicycle of a theater. Right half: (f) Man seated in a cavity on a step

near a column base (*se stava cosi o chome stavano*). (g) Hemicycle, measured, in partial plan (*un mexo quadro / da chapo / sono sette nichi / qui era inchrostato di stucho / e di mosaicho*). (h) Man seated on a step beneath column bases, and a cavity shown in bottom step near his foot. (i) Marble block (*perni lasati di marmo / ne chonventi*), detail. (j) Column, measured. (k) Column base and a deep step, its profile like one on the upper left of U 1472A r.

Comments about the cavity shown at *f, g, h,* and *k* will be found at U 1461A r.

BIBLIOGRAPHY: Ferri (1885) 89.

G.S.

U 1473A *recto*

ANTONIO DA SANGALLO THE YOUNGER
Studies of fortress gates.
Dimensions: 295 x 415 mm.
Technique: Pen and brown ink.
Paper: Original center fold; lower edge ragged.

Left half: (a) Revolving gate (*A; Botta; / A; B; C*) with treadwheel operated by men turning gears (*B; D*) and shaft (*saracinesca*). (b) Note about the parts and measurements. (c) Revolving gate mechanism in plan view and measured. Right half: (d) Revolving gate with two entries. (e) Revolving gate in plan view, two entries (*serrato / aperto*), and gate lifted on rope pulleys, detail.

INSCRIPTION: (a) *Questa rota si e necesario sia / grande quanto e grossa la botte / per vicatare a trovare la saracinescha / quele e sul diritto del ponte Quando la caditore overo / saracinescha sie calata la po/rta viene dove e segniato A / e lomo entra in la botte per la po/rta di poi si volta la rota e lla / porta si parte el ponte va inanzi / e la saracinescha se alza e la / porta viene dove e segniato / B. E lomo sta fora e trova / laltra saracinesca alzata / el ponte pasato le rota / cha essere una porta sola /. piedi 20;* (b) *A. La botte grossa piedi 14 B. La rocha palmi 6 / perche non da dua volte intere C. La rota dentata sia piedi 7 D. La rota sia grossa overo larga p[almi] 2 / perche da due volte al [. . .] palmi 12;* (e) *Le caditore se alzino con catena o corda / che se avoltino in sul fuso al contra/rio luna dell altra che vadino / a una pulegia che sia in alto / Faciendo cosi sara aperto da uno / canto la porta La saracinesca / alzate el ponte spinto inanzi da / uno di lati alla volta e come / sentra in la botte da uno canto si serra / e dall altro se apre voltando [. . .];* (at left side) *Si puo fare anchora uno / altro condita ponto / e due porte in le botte / che anno / medesimo tempo o sara serato / o sara aperto*

Antonio the Younger's inscription explains how the gate of a fortress works to check the entry and exit of soldiers and what happens when the closing gate is open or shut. He developed these designs of revolving gate mechanisms after a simpler one by Francesco di Giorgio to be found in his chapter on forts in *Trattato II*, Codex Magliabechiano II.1.141, fol. 83 r., Biblioteca Nazionale, Florence (Martini-Maltese, II: pl. 303, and pp. 478–79). As I have explained in "Drawings of Machines," many of the drawings and texts from Francesco's treatise were seen by Antonio at Monte Oliveto Maggiore near Siena (U 1443A r. and v., 1471A r. and v., 1482A r. and v., 1483A r. and v.). Francesco said he devised the instrument he illustrated so that the gatekeeper would not be deceived when soldiers exited the fort. Antonio's description owes to Francesco only a phrase or two about the raising and lowering of the gate. Concerning a possible dating for this sheet, see the essay of C.L. Frommel in this volume and "Drawings of Machines."

BIBLIOGRAPHY: Ferri (1885) 78; Martini-Maltese (1967) II: pl. 303.

G.S.

U 1476A *recto*

ANTONIO DA SANGALLO THE YOUNGER
Levered bridges on interconnected boats.
Dimensions: 130 x 217 mm.
Technique: Pen and brown ink.
Paper: Trimmed at edges.

INSCRIPTION: *Modi di fare ponti in su fiumi*

Taccola's Notebook (Ms CLM 197, part II, fol. 38 v., Bayerisches Staatsbibliothek, Munich) introduced this design "ponti super aquam," but Antonio copied it probably from the Anonimo Ingegnere Senese's copybook (Ms Additional 34113, British Library, London), although it is now lost from that copybook. He used it for other drawings in the same style as this one (U 818A r., 848A r., 1432A r., 1438A r., 1440A r., 1450A r. and v., 1451A r. and v., 1452A r. and v., 1481A r. and v., 3976A r. and v., 4059A r. and v., 4060A r. and v., 4064A r. and v., 4065A r. and v.) as part of his first or second sketchbook.

BIBLIOGRAPHY: Ferri (1885) 92; Taccola (1984).

G.S.

U 1477A *recto*

ANTONIO DA SANGALLO THE YOUNGER
Study of a waterwheel; salutation of letter.
Dimensions: 210 x 200 mm.
Technique: Pen and brown ink.

(top) Note of salutation for a letter: *Messer Filippo salute Questa per avisarvi / Animi / Anistani.* (middle) Waterwheel with Archimedean screw, gear drive, and overshot wheel.

INSCRIPTION: *Uno mulino in aqua morta quale la rota grande a in essa una / rota dentata da ogni banda quale una rota volta la vite che porta / su laqua e laqua cascha in le casse della rota grande E voltanto la rota / grande fa colla rota dentata dall altra banda voltare el rochetto e lla ma/cina E la vite vole avere otto pani come quella di viotu [. . .] e sara el moto perpetuo che fara uno mulino / La vite a intorno a se una rocha di gretole*

The identity of "Messer" Filippo is not known. (This form of address does not suit Filippo da Sangallo.) Some parts of Antonio's descriptive note for the waterwheel are no clearer than the sketch. He says a mill with a great wheel in a pond has a cogwheel on each side; the wheel turns the screw that raises the water; the water falls in the great wheel's cases. As the great wheel turns, it turns the lantern (*rochetto*) on the cogwheel on the other side and turns the grindstone. The screw must have eight turns; the text is incomplete at this point. Perpetual motion turns a mill. The screw has a lantern (*roche di gretole*) beside it. Leonardo illustrated a similar combination (Codex Atlanticus, fols. 7 v., *a*; 386 r., *b*, Biblioteca Ambrosiana, Milan).

Concerning a possible dating for this sheet, see the essay of C.L. Frommel in this volume.

BIBLIOGRAPHY: Ferri (1885) 100.

G.S.

U 1478A *recto*

ANTONIO DA SANGALLO THE YOUNGER
Geometrical studies.
Dimensions: 266 x 217 mm.
Technique: Pen and brown ink.
Paper: Thin, darkened at edges, modern reinforcements at corner and on the right margin.
Drawing Scale: braccia.

INSCRIPTION: *Riprova che de ogni pirimi sia la piramida / la tertia parte della sua colonna faciendo uno / quadro longo per*

ogni verso b[raccia] 8 alto bracia quatro / in ditto quadro chavando una piramida in basa b[raccia] 8 / alta b[raccia] 4 le sua spoglie sono quattro meze piramide / che montene insieme dua fanno dua piramide / oltre alla prima che fa la somma di tre piramide / cosi conseguentemente e di neciesseta facino tutte / le altre

The drawing shows the proof for the theorem: Every prism is divisible into three equal pyramids.

On the sheet are two series of figures. The first series, on the upper part of the sheet, does not seem to lead to a convincing division and thus may be considered a first trial. The prism ABCDEFGH is divided into five pyramids: VEFGH, AVDEF, AVBGH, BVCGH, and CVDEH. The first has a square base and is reproduced next to the prism; there is another attempt at subdivision into four pyramids with triangular faces as the pyramid HGK'V' demonstrates. The other four pyramids, AVDEF, AVBGH, BVCGH, and CVDEH, by the junction of the faces BVC and ADV and the faces ABV and DVC, as can be seen in the drawing top right, generate two pyramids with rectangular bases, which, if the original prism had a square base, would result as equivalent one to another, but unlike the pyramid VEFGH. The final drawing could be a study for a different composition of pyramids.

The second series (in the central part of the sheet) is referred to by the inscription. The text describes the right-angled prism ABCDEFGH with its square base, AB = BC = CD = DA = 8 (braccia) and 4 (braccia) high: AF = BG = CH = DE = 4. If the pyramid ABCDV is removed from the prism (the base is 64 and the height VZ = 4), the remaining part is divisible into four half- ("mezze") pyramids BCHGV, ADEFV, ABGFV, and CDEHV, whose bases ADEF, ABGF, BCHG, and CDEH have a surface equal to 32 and relative heights VK, VL, VM, and VN with length equal to 4. Since the faces VEF, VFG, VGH, and VHE of the four pyramids are perpendicular in relation to the bases ADEF, ABGF, BCHG, and CDEH, by uniting these pyramids two by two—for example along the faces VEF and VFG, VGH and VHE—one obtains two pyramids of a height equal to 4 and of a base area equal to 32 + 32 = 64 and thus equivalent to the pyramid ABCDV.

It is interesting to note how the subdivison of the prism is represented through an opening into five pieces: the pyramid ABCDV and the four half-pyramids. The representation includes the division of the parts and equivalents of the pyramid through the direct comparison of their dimensions.

Note further that at the top right of the sheet is a number that may be 156 or 256; if 256 it might refer to the volume of the prism from the second series of figures inasmuch as it would be equal to 8 x 8 x 4 = 256.

BIBLIOGRAPHY: (not published).

G.L.V.

U 1479A *recto and verso*

ANTONIO DA SANGALLO THE YOUNGER
Studies of tilting cranes.
Dimensions: 290 x 215 mm.
Technique: Pen and brown ink.

Recto. (a) Pivoting crane with tilting lever for lifting blocks from a boat, its crossbeam with five slots inscribed five times *anime*. (b) Pinion (*axe*), detail. (c) Beam with sockets in three slot sizes (*le picole / mezani / grandi*). (d) Three hooks. (e) Boat holding the blocks. (f) Stanchion of the crane, detail.
Verso. (a) Beam with a round opening (*cosi se fatto opera mirabilamente*). (b) Stanchion of the crane's mast.

INSCRIPTION, Recto: (a) *Lo asso vole stare in el bilancio / el tutto delle trave [. . .] per e/ssere piu sottile el ma/nicho dereto overo coda / Fare molto piu longo al bi/licho in dietro che dal bilicho / inanzi I cosi sara gagliar/da la leva e ara fori 5 / di levarole pesi prende sen/za faticha;* (bottom) *Ci vole uno trave longo p[almi] 70 / tre travi di quelli largi longi p[almi] 35 / uno trave di palmi 40 largo p[almi] 2 / uno legnio tondo o uno trave per la coda / sara bono dolmo castagnio o di que/rcia longo e sottile vorria p[almi] 70*

Antonio the Younger is likely to have been the inventor of this pivoting and tilting crane for lifting stone blocks from a boat. He recorded the crossbeam and jointed post again on the verso side, and illustrated it with different measurements a second time (U 4042A r.). He studied its parts in order to build a workable structure just as a good carpenter or millwright might do. His note refers to the way "the work was done marvelously." He wrote that "the axis must hold in balance all the beams, more slender at the rear beam or tail. Make the rear bearing longer than the front one. In that way lifting will be done smoothly. The lever will have five sockets, so it takes weights easily. One needs a beam 70 *palmi* long, three beams of the large kind 35 *palmi* in length, a beam 40 *palmi* long, 2 *palmi* wide, a round piece of wood or a beam for the tail. It will be good if the wood is elm, chestnut, or oak, long and slender in the range of 70 *palmi*." This

crane is developed over another that was probably in use for a long time (U 1439A v., an identical one by an anonymous artist on U 1385A v.), which pivots in a four-legged framework, its lever set at angle. It cannot tilt up and down like the cranes (U 1449A r., 3951A r.). The same form of pivotable mast may be seen on Antonio's drawing of a bale-lifter on a boat (U 1501A r.), its upper crossbeam with holding pegs tilted at an angle as it passes through a slot in the mast, and a pegged weight-lifting beam through a slot lower down the mast. The present sheet is one-half of a once-folded sheet, but the details are more developed than on U 4042A r. where Antonio illustrated another version.

Concerning a possible dating for this sheet, see the essay of C.L. Frommel in this volume.

BIBLIOGRAPHY: Ferri (1885) 81, 89.

<div align="right">G.S.</div>

U 1480A *recto and verso*

ANTONIO DA SANGALLO THE YOUNGER
Studies of gristmill and gears.
Dimensions: 112 x 212 mm.
Technique: Pen and brown ink.
Paper: Darkened at edges and partially reinforced.

Recto. (a) Gristmill with gears and treadwheel moved by a horse, its parts lettered *A–F*; then *otto denti*. (b) Note: *A 40 — 120 / B 20 — 60 / C 10 — 30 / D 20 — 60 / E 2 — 6*. (c) Gears, in plan view, detail.
Verso. Mill wheels with handle and yoke for a horse.

INSCRIPTION, Recto: (a) *Cosi lo rochetto da 20 volte / quando la rota grande una*

As usual, Antonio the Younger's notes record the mill's capacity or motor motion; the lantern (*rochetto, B*) turns twenty times to the great wheel's one. He keyed the mill's components by letter; the numerals in two columns calculate the number of rotations. Horse-driven treadwheels were commonly built, and Antonio repeatedly expressed his preference for the treadwheel (U 852A r., 1436A r., 1437A r., 1440A r. and v., 1473A r., 1504A r.). Francesco di Giorgio illustrated a gristmill like this one in *Trattato II* Supplement, which Antonio copied (U 1471A r.). Concerning a possible dating for this sheet, see the essay of C.L. Frommel in this volume; see also "Drawings of Machines."

BIBLIOGRAPHY: Ferri (1885) 100; Forbes (1956) 103–46; Keller (1969) 225–31.

<div align="right">G.S.</div>

U 1481A *recto and verso*

ANTONIO DA SANGALLO THE YOUNGER
Studies of cannons and trebuchets.
Dimensions: 285 x 220 mm.
Technique: Pen and brown ink.
Paper: Heavy.

Recto. (a) Cannonball fired from a boat. (b) Cannonball fired from a boat with a shield (*mantelletto / coperto*).
Verso. (a) Trebuchet on a boat. (b) Trebuchet on a platform.

INSCRIPTION, Recto: (a) *Defensione contra allo inimico in varie sorte / e prima per cose marittime per via de artiglierie / overo bonbarde o simile E prima questa / bombarda tira una palla della largeza della / sua canne tanta grossa E inanzi a ditta palla / sie una fuza grandissima quanto la forza della / artiglierie puo conportare;* (b) *Machina per fare el medesimo efetto ma e piu / sicura per avere sopra di se lo coprato e dinanzi el suo / mantelletto da alzare e basare*

This sheet was part of Antonio's first sketchbook, executed with penstroke shading, as explained in U 818A r. While the engine drawings in Taccola's Notebook originated the series, Antonio derived his drawings from the Anonimo Ingegnere Senese's copybook (Ms Additional 34113, British Library, London). A concordance with that copybook is the following for three armed boats and a trebuchet: fols. 108 v., 108 v., 107 v., 132 v. Antonio's opening sentence definitely is based on Taccola's language about the enemy and the bombard, which the Anonimo translated for other machines, although he wrote nothing about these four. Concerning a possible dating for this sheet, see the essay of C.L. Frommel in this volume; see also "Drawings of Machines."

BIBLIOGRAPHY: Ferri (1885) 92; Taccola (1984).

<div align="right">G.S.</div>

U 1482A *recto*

ANTONIO DA SANGALLO THE YOUNGER
Hoist with rope, gears, and roller operated by a seated man.
Dimensions: 340 x 230 mm.
Technique: Pen and gray-black ink.
Paper: Upper left corner lost.

INSCRIPTION: *Primo / [Pigli]ando principio dalli argani e da dichiarare alcuni modi / [. . .] quali chon ragione maggiore peso e piu facile se possa muovere / In prima facisi uno rochetto nello stile in el quale stile abbia / sua buse da mettere le stange per voltare el quale stile sia / de diamitro tre quarti de uno piede El rubechio appresso / a questo sia per fiancho*

operiato dentato de diamitro de piedi / due E el rochetto un pie chonnesso allo stile del rubechio cholli / vergoli rullati li quali percotino li denti della rota dove e / chomessa la churba del chanape Sia per piano dentata / de diamitro de piede tre la churba sia in diamitro piedi uno / e mezo El chanape dell aqua puo essere sinplicie e doppio / referendosi alli chalciesi per piano ett alle charriole dadalto / chome apare per la figura 12 La churba puo essere sotta / e sopra e sopra all ultima rota ma piu forte tirare / E quando sia di sotto lochata

See U 1482A v.

BIBLIOGRAPHY: Ferri (1885) 88.

G.S.

U 1482A *verso*

ANTONIO DA SANGALLO THE YOUNGER
Hoist with rope, gear, and treadwheel operated by a man.
Dimensions and Paper: See U 1482A recto.
Technique: Pen and gray-black ink.

INSCRIPTION: *Secundo / Puossi el medesimo effetto per altra via conseguire so [. . .] / Una rota de[n]tro alla quale vada uno uomo voltando quella / La ruota sia piedi XV e lo stile suo piedi uno e uno terzo infino / ad due E sopra del quale sia una vite in diamitro piedi due / la quale perchota sopra de uno rotello siche li denti suoi inchastrino / nella vite Et el rotello sia piede tre in deamitro / Lo stile di questo sieno due churbe luna a destra e laltra a ssinistra / de diametro piede due chome appare per lo disegnio*

Antonio copied the drawings of hoists on the recto and verso sides of this sheet and transcribed the texts from Francesco di Giorgio's *Trattato II* Supplement, Codex Magliabechiano II.1.141, fols. 91 r., 91 v., Biblioteca Nazionale, Florence (Martini-Maltese, II: pp. 495–96, pls. 317, 318), which he studied when the codex was at Monte Oliveto Maggiore near Siena. (For further information, see essay "Drawings of Machines.") He transcribed the Sienese technical words without changing them into comparable Florentine terms, and copied some unintelligible words such as "dadalto." He mistook the reference "segno IZ" for "figura 12," and added the last sentence. He copied these two hoists again (U 1449A r., 1440A v.), the latter with a slight change of frame and his own new text about rope movement. Antonio's technique of penstroke shading on drawings (U 1482A r. and v., 1483A r. and v., 1450A r.) indicates that these belonged in his first sketchbook. His change to a penline technique for drawings in the second sketchbook (U 848A r. and others) is datable ca. 1526 by his work in Cese-

na where he also executed drawings (U 819A r.).

Concerning a possible dating for this sheet, see the essay of C.L. Frommel in this volume; see also "Drawings of Machines."

BIBLIOGRAPHY: Ferri (1885) 88; Martini-Maltese (1967) II: pls. 317–331.

G.S.

U 1483A *recto and verso*

ANTONIO DA SANGALLO THE YOUNGER
Studies of hoists, gears, and rope winders.
Dimensions: 240 x 215 mm.
Technique: Pen and gray-black ink.
Paper: Cropped at top and bottom.

INSCRIPTION, Recto: *[. . .] piede uno e uno tr[. . .] Al sommo di questo fra uno rocheto / rullato in diamitro piedi dua e uno quarto E per questo / perchuote sopra li denti della ruota de diamitro piede / cinque La churba desta due e mezo / chome appare per la figura*
Verso: *[. . .] e mezo chome meglio / per la fi[g]ura si chonprende appunto*

Like the U 1482A r. and v., this sheet is transcribed and copied from Francesco di Giorgio's *Trattato II* Supplement. Corresponding images include those on fols. 92 r., 91 v. (Martini-Maltese, II: pp. 497, 496, pls. 319, 318). Antonio's notes "primo" and "secundo" at the head of the sheet, which seem to suggest a first or second chapter, are instead taken from *Trattato II*'s marginal notes. Drawings carefully executed with penstroke shading recall his drawings on U 1440A r. and v., which belong to his earliest style. As I have stated in "Drawings of Machines," Francesco's treatise, the only illustrated version, was probably in the scriptorium of Monte Oliveto Maggiore. Its whereabouts afterward are unknown until 1803, when Vincenzo Follini and Giuseppe Del Rosso rediscovered it in the Biblioteca Magliabechiana, Florence. It came there from the collection of Carlo di Tommaso Strozzi who died in 1670.

Concerning a possible dating for this sheet, see the essay of C.L. Frommel in this volume; see also "Drawings of Machines."

BIBLIOGRAPHY: Ferri (1885) 88; Martini-Maltese (1967) II: pls. 317–331.

G.S.

U 1484A recto

Antonio da Sangallo the Younger
Studies of hoists and rope pulleys.
Dimensions: 235 x 260 mm.
Technique: Pen and dark brown ink.
Paper: Center fold.

Left half: (a) Hoist with rope pulleys. (b) Hoist with rope pulleys and cranks. Right half: (c) Hoist with rope pulleys and counterweight. (d) Hoist with rope pulleys and cogwheel lantern.

These four sketches of different arrangements of ropes on pulleys seem related to problems of rope movement, problems that Antonio investigated elsewhere (U 1215A v., 1440A r. and v., 1449A r. and v., 1504A r.). For a discussion of these issues, see U 1504A.

Hoists *a* and *d* first appear in Francesco di Giorgio's *Trattato I* (Martini-Maltese, I: pls. 124, 90, 91) but the double-crank hoist with ropes and pulleys (*b*) was illustrated by Benvenuto Della Volpaia (Codex Ital. Cl. IV. 41, 5363, Biblioteca Marciana, Venice, fol. 90 r.), facing fol. 89 v., with a note entitled "La mola di Maestro Cristofano fornaio di papa Lione in Roma presso alla Compagnia de Fiorentini." His reference to Leo X is useful evidence for the date of 1514 proposed by Frommel for the notes by Antonio the Younger on the verso.

BIBLIOGRAPHY: Ferri (1885) 88.

G.S.

U 1484A verso

Antonio da Sangallo the Younger
Entablature profile; names of workers, payments, prices of vegetables, 1514.
Dimensions and Paper: See U 1484A recto.
Technique: Pen and brown ink.

INSCRIPTION: *Per fare salsa e chacio lire 1 / Guatiglla in chiodi per le ghientine giulii 6 / Guatigualle in chiodi per le cientine giulii 8 / Venerdi sera a di 26 a ciena (giulii canceled) baiocchi 10 / In chiodi Pallino giulii 4 / A Giovanni di chonto fatto in dua volte baiocchi 27 / A Rosso baiocchi 15 / A Rosso per pichioni baiocchi 12 / A Giovanni per le scharpe baiocchi 15 / A Gollini porto lle sprange di fero baiocchi 4 / In chiodi per Belvedere baiocchi 6 / A Pallino per giodi per cientine baiocchi 30 / Altri bissi per trivelli baiocchi 4 / In chacio per cholla baiocchi 2; Giovedi in uova prosutto chacio / Schafri insallata baiocchi 22 / Venerdi baiocchi 6 / Venerdi insalata schafrigatto uova baiocchi 1 / Sabato in chacio in schafri insalata e olio baiocchi 24;* (to right of column) *Altiri bissi giulio 1 / Alesso giulio 1*

In the opinion of C.L. Frommel, this sheet can be connected with the St. Peter's workshop. Frommel has proposed a date before 1514. One payment was made in nails for the Belvedere. Frommel kindly deciphered the symbols for coins used on the sheet. The *baiocco* was a copper coin in use in the Papal States until 1866. The names of some of the workers are clear: Rosso, Giovani, Pallino. "Guatigalla" seems unusual but Guatto or Quatto refers in the Tuscan dialect to one who is short and bent over, silent and mysterious. Among the foods are sauces (*salsa*), cheese (*cacio*), eggs (*uova*), salad (*insalata*), fowl (*picchio, piccione*). Building materials include nails (*chiodi*), hoe spikes (*piccamarra*), iron latch (*spranga di ferro*), linen fabrics (*bissi*), drills (*trivelli*), shoes (*scarpe*), glue (*colla*).

BIBLIOGRAPHY: Ferri (1885) 88.

G.S.

U 1485A recto

Antonio da Sangallo the Younger
Studies of a pump; studies of a snapper.
Dimensions: 140 x 200 mm.
Technique: Pen and light brown ink (at left); dark brown ink (at right).
Paper: Center fold; darkened at edges.

Left half: (a) Pump with double tubes and valves moved on levers twice inscribed *ferro* and ropes operated by a man. Right half: (b) Rope twisted around a pin (*cunei ferrei*), socket (*modioli*), handle (*bracia*), cord holder (*enserudenti cioe cappii di corde*), and winder (*sucula*). (c) Socket, detail.

INSCRIPTION: (a) *Bartolino / Bisognia ocupiero / per di sopra le trombe / dall animelle / in sue poi lavorare / edifitice a tirare*

As stated previously (U 1458A r. and v.), the rope twisted around a rod (*b*) is Antonio's conception of the description of the catapult in Cesariano's translation and commentary on Vitruvius (X.xvii). The name "Bartolino" beside the pump probably refers to Giovanni Bartolini whom Benvenuto Della Volpaia named in his chapter heading (Codex Ital. Cl. IV, 41, 5363, fol. 41 v., Biblioteca Marciana, Venice) for a mechanism's capacity: "1521. Giovanni Bartolini perchora a questo e non mi piace." The two-tube pump with pairs of valves in each tube (*a*) may be called a variant of one with three tubes (U 1092A v.); it differs from the two-tube pressure pump called the Ctesibian pump (U 1409A v.). It is difficult to say what rela-

tionship it has with another pressure pump (U 1486A r.). These are distinguished from another mechanical principle illustrated by Antonio the Younger with a gear rack in an elliptical opening (U 847A r.). In the year 1535 (see U 854A r.), Camillo Agrippa, the Milanese hydraulic engineer and inventor, came to Rome and was in contact with Antonio the Younger. He designed a pump for the fountain of the Villa Medici in Rome of which Oreste Biringuccio made a sketch (Codex S.IV.1, fols. 137 v.–138 r., and 135 v.–136 r., Biblioteca Comunale, Siena), naming the inventor "Agrippa" and the pump's location "Medici." Its form was quite different from that of Bartolini and the others sketched by Antonio the Younger. For levered pumps, Antonio's examples compare best with those of Francesco di Giorgio's *Trattato I*, fols. 45 v.–47 v. (Martini-Maltese, I: pls. 82–86).

BIBLIOGRAPHY: Ferri (1885) 91; Martini-Maltese (1967) I: pls. 82–86.

G.S.

U 1486A *recto*

ANTONIO DA SANGALLO THE YOUNGER
Studies of pumps; techniques of surface measure.
Dimensions: 222 x 205 mm.
Technique: Pen and light gray-brown ink.
Paper: Darkened at edge; torn from album.

(a) Pump. (b) Self-releasing hooks(?) for the pump. (c) Pump, detail. (d) Note about grain measure and surface measure.

INSCRIPTION: (a) *Lanimelle sono come due taglieri / da uno lato di sotto piano e di sopra colme / Lo paletto di mezo sta fermo e lanimelle / vanno in su e in giu lalza la forza dell / aqua;* (d) *A Fiorentia si misura a stioro e a staioro / cioe a stioro a chorda E staioro a Sena / Ogni staioro a Sena e 5184 b[raccia] quadre E tre / staiore a chorda sono uno staioro a Senna*

The sheet is preserved in its original full-length form. Antonio sketched the pump schematically; only his note beside it refers to valves, which he described as being like two tablets, one side flat and the other convex. The disk between them keeps its position and the valves go up and down, moved by water. Even in its schematic form the pump resembles Francesco di Giorgio's levered pumps (*Trattato I*, fols. 46 r., 47 v.; *Trattato II*, fol. 94 r.). It is certain that Antonio copied the latter (U 1443A r.), for he restated Francesco's words related to the valve: "dove in mezzo sia uno

stile di ferro el quale gionghi insino al fondo, in mezzo dello stile sia uno tondo fisso in quello, a guisa di tagliere, con due animelle. . . ."

Concerning a possible dating for this sheet, see the essay of C.L. Frommel in this volume.

BIBLIOGRAPHY: Ferri (1885) 91; Martini-Maltese (1967) I: pls. 83, 86; II: 500, pl. 323.

G.S.

U 1487A *recto*

ANTONIO DA SANGALLO THE YOUNGER
Studies of mill gears.
Dimensions: 198 x 206 mm.
Technique: Pen and brown ink.
Paper: Darkened at edges.

(a, above left) Mill gears with rod and yoke for a horse. (b, below left) Mill gears with rod and yoke for a horse. (c, right) Mill gears with rod and yoke for a horse. (d, top) Note about the size of parts. (e) Note for the mills.

INSCRIPTION: (d) *Lo rochetto denti 8 / La rota dentata in costa 36 / La rocha gretolo 18 / La rota grande 136;* (e) *Questi tre sono una medesima forza*

As in many of Antonio's notes, his interest here is in the capacity of the mechanism. He recorded information concerning each component such as the number of teeth on the lantern (*rochetto*), the number of cogwheel pegs (*costa*), the number of rods (*gretole*), and the number of pegs on the great wheel (*rota grande*). He sketched another version of *c* on U 1495A r. His pen technique for the mills on the present sheet compares most favorably with that of his second sketchbook (ca. 1526), as explained elsewhere (see U 848A and others). Concerning a possible dating for this sheet, see the essay of C.L. Frommel in this volume.

BIBLIOGRAPHY: Ferri (1885) 89.

G.S.

U 1488A *recto*

ANTONIO DA SANGALLO THE YOUNGER
Study of a waterwheel; study of a bucket chain at the Ospedale degli Innocenti, Florence.
Dimensions: 120 x 120 mm.
Technique: Pen and light brown ink.
Paper: Trimmed on all sides.

(above) Waterwheel with bucket chain and gears (*pie 4; piedi*

6) in the Ospedale degli Innocenti, Florence (*all Inocienti*). (below) Chain, detail.

INSCRIPTION: *Sechie / large piedi 1° / alte piedi 2½ / lo totto / grosse mezo pie; La catena dove / e uno ferro solo / e grosso uno dito / e dove / sono dua sono / grossi mezo dito luno*

The same pump was sketched and identified "el tirare dello Spedale dell Inocienti" by Benvenuto Della Volpaia (Codex Ital. Cl. IV, 41, 5363, fol. 42 r., Biblioteca Marciana, Venice). Benvenuto measured every part and calculated the operational factors. Concerning a possible dating of this sheet, see the essay of C.L. Frommel in this volume.

BIBLIOGRAPHY: Ferri (1885) 89; Maccagni (1967) 3–13.

G.S.

U 1488A *verso*

ANTONIO DA SANGALLO THE YOUNGER
Geometrical studies.
Dimensions and Paper: See U 1488A recto.
Technique: Pen and light brown ink.

INSCRIPTION: (upper right) *Per dividare una linia / aprendo le seste a uno tratto / andare 5 parte in qua quanto / se apre le seste 5 volte;* (lower left) *E cinque volte qui e poi / tirare le linie diagonie / dall uno all altro e cosi la linia / perpendiculare viene partita / in cinque parti equali*

A discussion of this drawing, which shows how to divide a perpendicular line, and others on geometry will be found at U 1456A.

BIBLIOGRAPHY: Ferri (1885) 81.

G.S.

U 1490A *recto and verso*

ANTONIO DA SANGALLO THE YOUNGER
Fortification studies, outworks, after 1530.
Dimensions: (original sheet) 181 x 101 mm; (new support) 181 x 119 mm.
Technique: Pen and brown ink.

INSCRIPTION, Recto: (upper figure) *questo vole / piu agionte;* (lower figure) *quelle che anno / poche gionte faci/no questo*
Verso: *passi mille sono piedi 5000 si mette fanti 666; piedi 5000*

A variety of outworks were developed to strengthen the ramparts and bastions of sixteenth-century fortifications. Works of the kind illustrated on the recto

could also serve as temporary field fortifications, either in isolation or in combination. The strategic context for these particular designs is not known, however.

The arrowhead work (recto, below) was the most common plan form and, when used in conjunction with permanent fortifications, was placed in front of the curtain between bastions so that its outer faces could be swept by gunfire from the bastion face batteries. Antonio the Younger's annotation to the larger work (recto, above) points out its need for a larger garrison. By reason of its cranked plan, this outwork is capable of providing its own flanking fire. Both works are open to the rear, as advised by treatise writers from Vitruvius onward, so as to prevent their use against the main works, if captured.

The verso seems to show the computation of infantry strength along a defensework. This sheet may, possibly, be linked to other drawings dealing with the theoretical aspects of warfare, such as U 1245A recto or 1344A recto.

BIBLIOGRAPHY: Ferri (1885) 78.

N.A./S.P.

U 1491A *recto and verso*

ANTONIO DA SANGALLO THE YOUNGER
Proportion studies and compass.
Dimensions: 207 x 273 mm.
Technique: Pen and brown ink; verso, pen and brown ink, stylus, pin, straightedge.
Paper: Heavily restored at top left edge, darkened at side.

INSCRIPTION, Verso: (the text begins on the present-day verso and continues to the recto) *per fare una regola da trovare ogni proportione di qualunque sorte si sia / in prima bisognia tirare una linea in piano longa e in mezo di / questa segniare una linea perpendiculare in su la quale si segni 4 / ponti equidistanti quali farano 3 spatii e in cima segniare A / di poi B di poi C di poi in sulla intersegatione della linea da basso segnia/rai D di poi a mano ritta per la linea in piano segnierai quattro simile / distantie e in capo segnierai E di poi tira una linea ipotemusa da E / al B e formerai uno triangolo di proportione di due tanto longo quanto / sie alto di poi parti la linia ipotemusa dal B allo E in spatii 26 / quali faranno ponti 27 incominciando al ponto B a dire uno di ma/no in mano fino al ponto E dove e lultimo sara 27 di poi tiri(?) / una linia dal punto 8 al ponto C di poi tanto abasso(?) / che li entersegi in sulla linia / quale sta in piano elli se/gniare F e sul ditto ponto / F fare cientro e dal dito / centro dello F a ciascuno / numero o punto qua/li sono in sulla linia / ipote musa [sic] tirare / a ciascuno una linia / (to the right) e dove lase intersegano sulla linia perpendiculare / li descriveranno li punti della*

proportione / quali saranno misure di corpi cubici lo piano /
sinplice da A a B sie(?) uno cubo quale ara li sua lati per
cia/scuno verso quanto sie longo dallo A al B e sara segniato /
uno e quello che supra la linia perpendiculare saranno segn/iati
2 sara duplo al primo e quello sara segni/ato 3 sara triplo al
primo e quello che sara se/gniato 4 sara quattro volte quanto
el primo / e cosi di mano in mano fino alli 27 / sempre
pigliando dal ponto 4 fino alli / ponti dal numero che vuoi; (on
left margin in a sixteenth-century hand) *Conpare carissimo in*
questo punto conto la risposta di V. S[ignoria] / Carigeni
ampua(?) quotip(?) in momu spechino carri farplla dinterni
Recto: (in the hand of Antonio the Younger) *Di poi a queste*
visitrova infinite proportione per come come quello che
segniato due e duplo al primo / cosi el 3 e triplo al primo
ancora e 1½ quanto ello 2 e cosi el 4 e quadruplo al primo
ancora e uno / quarto piu chel tre e dopio al 2 ancora el quinto
e cinque volte quanto el primo e un quinto piu che il / 4 e ²/₅
piu chel 3 e ³/₅ piu chel 2 che cosi va infino in 27 faciendo
queste diminutione di / proportione / Ma per potere fare
queste proportion di piu sorte grande e pichole si fa uno
compasso di ferro o di legnio / che tenga lo diritto e se vi se
segnia suso le medesimo misure e proportione (quale sono in
sula canceled) */ linia perpendiculare alo punto A sia lo perno*
di ditte seste e di poi li altri punti di mano in mano / e quando
voi proportione picole apri poco le seste e quando le voi
grandi apre le sexte asai e / e cosi arai proportione di tute le
sorte che ttu vorai e nota che conquesto conpaso ai asse(?) /
gliare daluno punto tanto (sotto canceled) *allaltro quali sono*
segniati insulli e gambe delle seste al primo al / secondo e al
tertio e cosi infino in 27 e apri le seste e stringi quanto vuoi
che senpre / ditte distantie quale saranno da luno punto
allaltro quali sono segniati in sulle gambe / delle seste sempre
saranno in le medesime proportione come le sopra schritte

A more accurate and precise hand has started work on this sheet, but Antonio, using a compass, has traced out (recto and verso) a series of geometric contructions similar to those on U 1500A r. (below). The lengthy text clarifies the drawings on both sheets. Antonio attempts to fix a graphic procedure that will allow him to search among different sizes and proportional relationships. The text continues on U 1500A, partly on 856A v., possibly on 1466A r. and 3949A r. The practical value of the result is the same as the "regola circulare" that is applied to proportion various architectural elements on U 826A r.

BIBLIOGRAPHY: Ferri (1885) 81.

N.A., P.N.P./G.L.V.

U 1492A *recto*

ANTONIO DA SANGALLO THE YOUNGER
Study of a waterpipe.
Dimensions: 135 x 174 mm.
Technique: Pen and brown ink.
Paper: Heavy.

Tube, in plan view of hexagonal, pentagonal, and round units.

INSCRIPTION: *sesquaria / quinaria / dito* (five times) */ uncia / dito; Perche pigliando la piastra piana di / tante dita quanto volevi la fistola / e faciendola tondo di dentro se stringe/ra e di fuora se allogane / Vitruvio trove che lle si facie/ssino a faccie fino a venti dita / e di poi tonde dalli in su / e cosi venivano iuste / Cosi vanno fino a venti / faccie ciascuna facia / de uno dito; E da tante / quante faccie la da quello / si pigli lo nome*

Antonio's mention of Vitruvius is a clue to the origin of his last sentence. Vitruvius (VIII.vi.4) writes: "The [lead] pipes get their names of their sizes from the width of the plates, taken in digits, before they are rolled into tubes. Thus, when a pipe is made from a plate fifty digits in width, it will be called a 'fifty,' and so on with the rest." Antonio derived his information from Cesariano's edition of 1521 in the chapter "In quanti modi si conduceno le aque, c. VIII" on p. CXXXIX v. Antonio's first sentence, however, owes nothing to Vitruvius or to Cesariano's commentary, where he digressed at length on other matters (it may, of course, be a paraphrase of Cesariano's translation where he says, "Ma da la latitudine de le lamine: quanti digiti haverano hauto: avante che se flectano in la rotunditate: cosi le fistule concipeno li nomi de le magnitudine"). That Antonio the Younger had his own ideas about the construction of lead pipes is clear in his diagram, which differs from Cesariano's illustrated on page CXXXX v. It should also be noted that Antonio's drawing of the chorobates (U 1409A v.) is partly related to one by Cesariano in the preceding chapter, "Per le perductione et libramenti de le aque: et instrumenti ad tale uso, c. VI" on page CXXXVIII r. Other drawings and notes borrowed from Cesariano are at U 1444A r., 1460A r., 1461A r. Concerning a possible dating for this sheet, see the essay of C.L. Frommel in this volume.

BIBLIOGRAPHY: Cesariano (1521); Ferri (1885) 81.

G.S.

U 1493A *recto*

ANTONIO DA SANGALLO THE YOUNGER
Study of pumps and gear rack.

Dimensions: 203 x 190 mm.
Technique: Pen and brown ink.

(left) Pump with valves and gear racks in ellipse. (right) Gear rack on tube with screws (*a vite / a vite*) and a flyweight of balls on chains.

This is another version of a pump with gear racks in an ellipse. There exist three other experimental drafts (U 847A r., 1409A r., 1468A r.). In the first example, Antonio explained briefly how the teeth of the gear are divided: four teeth while the racks have twelve. On the evidence of some later developments historians of technology have named it the "interrupted spur gear and racks" for the type in rectangular racks, but I find no illustration of it in manuscripts of Francesco di Giorgio or even in works written during Antonio the Younger's lifetime. Francesco did illustrate a mechanism for a pump in his *Opusculum de architectura,* fol. 52 v. (Ms 197 b 21, British Museum, London) that has been called an "interrupted lanterns and spur gear sectors," comprising a pair of curved racks turning on a lantern. For such terms, some of which are different from those I have used, see Ferguson's picture glossary of prime movers, water pumps, gearing, gears and cams, chains and linkages, and miscellaneous devices in his edition of Ramelli's *Various and Ingenious Engines* (1976).

BIBLIOGRAPHY: Ferri (1885) 91; Ramelli-Gnudi, Ferguson (1976) 561–68.

G.S.

U 1494A *recto and verso*

ANTONIO DA SANGALLO THE YOUNGER
Waterwheel with bucket chain, gear, and horizontal
 waterwheel (*recto*). Corinthian half-column in elevation
 and a plan view (*verso*).
Dimensions: 206 x 185 mm.
Technique: Pen and brown ink.
Paper: Darkened at edges; fragmented right side.

There are no notes on these drawings and the style is very free, more so than is usual in Antonio the Younger's work. Still, the sheet's similarity to an annotated drawing (U 1496A r.) suggests it is his work. His other examples of bucket-chain waterwheels (U 4052A r. and v.) are distinguished from this one not only by pen technique but also by the form of the horizontal waterwheel, which provides power for many of Francesco di Giorgio's gristmills in chapter 10 of his *Trattato I* (Martini-Maltese, I: pls. 63–65); none of

those uses a bucket-chain. Medieval mills in Tuscany have preserved parts of the horizontal waterwheel known as the *ritrecine* (see Muendel).

BIBLIOGRAPHY: Ferri (1885) 91; Forbes (1956) 589–622; Muendel (1974) 194–225; Romby, Capaccioli (1981); Foresti (1984); Muendel (1984) 215–47; Muendel (1991) 498–520; Muendel (1992) 71–113.

G.S.

U 1495A *recto*

ANTONIO DA SANGALLO THE YOUNGER
Gristmill turned by a horse, measured for components and
 revolutions.
Dimensions: 119 x 157 mm.
Technique: Pen and brown ink.

INSCRIPTION: *passi 9 / pasi 4 / Quando le cani / da una volta / la macina ne da / 30*

For another version of this mill see U 1487A r. The measurements for this mill are almost the same as those for another (U 1480A r.), which differs from this one by including a horse-driven treadwheel. Antonio the Younger always prefers the cogwheel-lantern gear; he also refers to the mill's capacity and the ratio of revolutions of the grindstone to another component.

BIBLIOGRAPHY: Ferri (1885) 100.

G.S.

U 1496A *recto*

ANTONIO DA SANGALLO THE YOUNGER
Machine studies.
Dimensions: 180 x 150 mm.
Technique: Pen and brown ink.
Paper: Darkened at edges; reinforced.

Recto. Marble-cutting mill (*sega per marmi*).
Verso. *Ingegni di piu sorte.*

This arrangement of a marble-cutting saw and its undershot wheel in water is not found among the drawings and descriptions by Benvenuto Della Volpaia (Codex Ital. Cl. IV, 41, 5363, fols. 49 v., 50 r., 79 r., 79 v., 82 r., 82 v., 84 v., 85 r., 87 r., Biblioteca Marciana, Venice). However, Alberto Alberti copied Benvenuto's porphyry cutting saw (Vol. 2503, Inv. FN 2687, fols. 181 r., 181 v., Gabinetto Nazionale delle Stampe, Rome). Components combined like the present example appear in Leonardo da Vinci's drawings (Codex Atlanticus, 381 r., *b*), but the upright shaft is

connected directly to the hub of the wheel. Antonio's note on the verso, which may be translated as "Various Kinds of Engines," is one of his classifications of engines. Other classifications are "Ordinary Devices" (U 1438A r.), "Hoists" (U 1439A r. and v., 1449A r. and v.), "Waterworks" (U 4052A v.), and "Astrolabes" (U 1454A r. and v., 1455A r.).

BIBLIOGRAPHY: Ferri (1885) 89.

G.S.

U 1497A *recto*

ANTONIO DA SANGALLO THE YOUNGER
Studies of mills.
Dimensions: 162 x 120 mm.
Technique: Pen and light brown ink.
Paper: Darkened at edges; reinforced.

(top) Mill gears, measured. (bottom) Roundel divided in six parts, a small roundel in center, and oblique lines.

Antonio's numerals are the basis for the attribution of the drawings to him. Similar components may be seen on other mills (U 819A r., 1480A r.). The plan at bottom may possibly refer to the casing of the gear.

BIBLIOGRAPHY: Ferri (1885) 100.

G.S.

U 1498A *recto and verso*

ANTONIO DA SANGALLO THE YOUNGER
Study of obelisk lift and hauler (*recto*). Two rectangular blocks separated from each other (*verso*).
Dimensions: 182 x 132 mm.
Technique: Pen and dark brown ink.
Paper: Darkened at edges; reinforced.

This sheet shows one of a series of obelisk lifts and haulers that originated in Francesco di Giorgio's *Opusculum de architectura* (Ms 197 b 21, British Museum, London), although it is illustrated neither there nor in his *Trattato I,* nor in the copybook of the Anonimo Ingegnere Senese that provided Antonio with so many engine drawings (Ms Additional 34113, British Library, London). It is illustrated, however, in Buonaccorso Ghiberti's *Zibaldone,* fol. 125 v. (Ms Banco rari 228, Biblioteca Nazionale, Florence), and Antonio may have copied it from that codex. The numeral "4" on the obelisk may have been intended as a cross-reference, possibly to a text, but it may have another meaning. Note that the numeral is repeated

on each of four pumps by one of the Anonymi (U 4055A r., 4073A r.).

BIBLIOGRAPHY: Ferri (1885) 88.

G.S.

U 1499A *recto*

ANTONIO DA SANGALLO THE YOUNGER(?)
Studies for a globe or an armillary sphere.
Dimensions: 192 x 219 mm.
Technique: Pen and brown ink, stylus.
Paper: Original sheet fragmented, new support.

This sheet, possibly in the hand of Antonio the Younger, testifies to his further interest in problems of cartography. (For a discussion of these matters, see U 850A.) The short lines below may be an effort to represent the latitudes. Ferri identifies the drawing as representing an armillary sphere.

BIBLIOGRAPHY: Ferri (1885) 35.

N.A.

U 1500A *recto*

ANTONIO DA SANGALLO THE YOUNGER
Geometrical studies.
Dimensions: 149 x 268 mm.
Technique: Pen and brown ink, stylus, compass, pin used to construct upper drawing.

INSCRIPTION: *provare questa*

This sheet contains three drawings: The first (at top) is formed from a square whose lower side is continued to the right is a series of nine pieces; from the upper left corner a series of segments join the corner with the ends of horizontal segments in order to expand the length so as to multiply the square up to ten times. In this way the drawing provides for a series of ten right-angled triangles in which the hypotenuse is the equivalent of $\sqrt{2}$, $\sqrt{3}$, and so on to $\sqrt{10}$.

In order to construct this drawing Antonio placed the compass in the upper left corner of the small square and opened the compass progressively on each strike by 17.5 mm (about an *oncia*), thus intersecting with the lines of the circle drawn by the stylus.

Somewhat similar is the beginning of the construction of the two lower figures. The left triangle has a base (90 mm) double the height of the triangle, 200 and 100 units, respectively, as shown on the drawing. The triangle on the right has a base (135 mm) three

times greater than the height (45 mm). The text of U 1491A makes it clear that Antonio was attempting to define proportional relations through graphic means that he would then fix more clearly in U 1491A.

BIBLIOGRAPHY: Ferri (1885) 91.

<div align="right">P.N.P./G.L.V.</div>

U 1501A *recto*

ANTONIO DA SANGALLO THE YOUNGER
Boat with pivoting mast and tilting lever as bale-lifter.
Dimensions: 147 x 220 mm.
Technique: Pen and brown ink.
Paper: Reinforced with modern support.

INSCRIPTION: *Diesegni*

The sheet is one-half of an original employed crosswise. See U 1479A recto for a discussion of its relation to Antonio's other proposed devices for pivoting and tilting.

BIBLIOGRAPHY: Ferri (1885) 91.

<div align="right">G.S.</div>

U 1502A *recto and verso*

ANTONIO DA SANGALLO THE YOUNGER
Study of bastion flank showing merlons and embrasures over parapet, possibly Ancona, after 1530.
Dimensions: 167 x 203 mm (irregular) on partially new support.
Technique: Pen and brown ink.
Paper: Reinforced; fragmented at right.

INSCRIPTION, Verso: *La testa di sotto delli stipiti sia fatta / con questa apunto e quella di sopra / abia piu porta qui ariscontra de A & B / quanto e da A a B e sara biecha tutto / questo la faccia che vieni in la bombardiera A —— B*

The recto shows part of the square (or possibly polygonal) shoulder of a bastion (right), and the recessed flank battery (left). A single embrasure opens from an internal casemate, and is spanned by a shallow brick arch. Above it a single merlon divides two embrasures from an open platform. This merlon is elaborately curved to deflect incoming cannon fire. The viewpoint has been raised to expose the curves of the merlon, thus distorting the perspective of the sketch. The merlon is unusually elaborate. The upper facets of the shoulder are beveled to deflect shot.

Overall the sketch is similar to embrasures for Castro (U 294A) and recalls, notably, the fortress at Ancona where there is a similar arched embrasure and beveled shoulder.

This sheet has been dated after 1530 on the basis of the distinctive "ch" (see "biecha") found on the verso. See essay of C.L. Frommel in this volume.

BIBLIOGRAPHY: (not published).

<div align="right">N.A./S.P.</div>

U 1503A *recto*

ANTONIO DA SANGALLO THE YOUNGER
Studies of sluice gates.
Dimensions: 287 x 215 mm.
Technique: Pen and brown ink.
Paper: Darkened at edges; reinforced.

(a) Sluice gate, detail of woodwork and bearing (*bilicho*) at the waterfall (*cateratta*). (b) Gate-lifting wheel, detail. (c) Sluice-gate structure (*piedi 36 / piedi 9 una / bilicho; bisognia sia*). (d) Sluice-gate brake, detail (*freno chome nottole*).

INSCRIPTION: *Si puo fare uno legnio overo dua / didietro bilicato cosi che entrino / in el muro dalle bande*

There is no record that Antonio actually built sluice gates, but he studied canals near Modena (U 797A r.), built a canal at Ancona, and illustrated sluice gates in Genoa (U 901A r.). He seems to have had an idea about improvement or change, saying a brake or bar (*nottola*) could be made of one piece of wood or two with the bearing (*bilico*) at the back so it enters in the masonry from the side. Concerning a possible dating for this sheet, see the essay of C.L. Frommel in this volume.

BIBLIOGRAPHY: Ferri (1885) 91; Forbes (1956) 663–94.

<div align="right">G.S.</div>

U 1504A *recto*

ANTONIO DA SANGALLO THE YOUNGER
Studies of treadwheel and hoists.
Dimensions: 280 x 215 mm.
Technique: Pen and brown ink.
Paper: Torn edge at right.

(a) Hoist with a treadwheel (*veloce*) and a man as operator. (b) Hoist with reversible screw (variant of Brunelleschi's invention), operated by an ox. (c) Rollers (variants) of Brunelleschi's hoist, details, in plan view, in upright position, and in side view.

INSCRIPTION: (a) *Rota larga / palmi 9 lo / votorano tre*

omeni / aparo / Alta palmi 40 / La curba overo / botte alto palmi 8; Le case sono alte palmi 2 / longe per ogni verso palmi 6 / et luna va e laltra viene; / Per tirare roba in alto che luna / cassa vadia et laltra venga; Questa sono tenere dua / casse da ogni banda; (b) Questo bue camina sempre / per uno verso e una cassa / del peso va in su e laltra torna / in giu Ma quando uno de pesi / e salito in alto bisognia / abasare la vite perche la rocha / pigli gli denti della rota da / basso e cosi quelli dal alto; (c) Li denti della rota dentata / sono rullitti

This single sheet, once half of a folded one, retains its original foliation ("7"). Antonio's pen technique and composition for these engine drawings are looser than his carefully organized drawings and methodical pen-stroke shading for another series of hoists (U 1440A r. and v.), though both sheets have almost the same measurements. He illustrated the hoist with treadwheel twice, showing rope-winding on both sides of the rope drum or winder, and alternating the ascent and descent of the load, as described in detail (U 1440A r.). On this sheet, however, he borrowed elements from U 1440A and limited his comments to rope movement and the dimension of the components.

Balancing ropes on two sides of the rope winder is probably an innovation of Antonio the Younger's, considering his preference for treadwheels and the fact that there is no parallel for two other hoists with balanced rope-winding (U 1440A r.), one operated by men, another by a horse guided by a man. The wording recalls how Brunelleschi's reversible hoist was utilized on the workplace. (Note the hoist moves back and forth and must stop when the load is to be filled or emptied.) Nevertheless, Antonio's horse-driven hoist does not resemble Brunelleschi's invention nor does the ox-driven one shown here.

Antonio's ox-driven reversible hoist moves ropes on one side of the rope winder. His text states that the ox always walks in one direction. When the weight has reached the top the screw must be lowered, to cause the lantern to operate on the lower cogwheel; the screw must be raised to shift the function to the upper wheel. Clearly Antonio had learned the function of the screw on Brunelleschi's reversible hoist, where the upper and lower gears were engaged alternately. Antonio's drawing does not include the lower gear, however, and his note about the single direction of the ox does not apply for the reversible screw.

Upper and lower gears appear in Taccola's versions of Brunelleschi's reversible hoist, illustrated with and without the screw, which he composed from a verbal description (*De ingeneis, Book III*, 36 r., 36 v., 37 r., 37 v., 38 r., 38 v., Biblioteca Nazionale, Florence), and

Taccola's texts describe the rope movement and loads carried up and down. Antonio's one-sided rope winder looks like Taccola's designs, and, most importantly, the resemblance extends to his wording about rope movement, animal movement, and stopping to load and unload the weight. Taccola's three hoist drawings, with and without the screw, were copied and his texts translated by the Anonimo Ingegnere Senese (Ms Additional 34113, 25 v., 26 r., 26 v., 83 v., 85 r., 87 r., 184 v., British Library, London). Antonio's ox-driven reversible hoist is not among the examples drawn from the Anonimo's copybook. The Anonimo's two versions of reversible hoists (fols. 87 r., 184 v.) are furnished with additional gears besides the rope winder, and one identical to Antonio's hoist does not include a screw (fol. 83 r.). Evidently Antonio developed his own version from his study of the Anonimo's. Taccola's hoists and other examples were selected for illustration in Francesco di Giorgio's *Trattato I*, 49 v., 50 r., 51 r. (Martini-Maltese, I: pls. 90, 91, 93), but none of these recurs in Antonio's series. Antonio's two other hoists with one-sided rope winders (U 1439A r.)—one turned by an ox, another with reversible screw, and neither with a lower gear—are likely to be his designs, as is the present sheet which has, moreover, two counterparts by one of the Anonimi (U 4077A r., 4079A r.).

The rollers fitted on angle hooks (*c*) were not derived from the Anonimo's copybook (Ms Additional 34113). These were critical components of Brunelleschi's reversible hoist and his "secret hoist" (also called the "light hoist" because it could not lift great weights), and were illustrated in detail only in Buonaccorso Ghiberti's *Zibaldone*, fols. 95 r., 98 v. (Ms Banco rari 228, Biblioteca Nazionale, Florence) and by Leonardo (Codex Atlanticus, fol. 391 v., *b*, Biblioteca Ambrosiana, Milan). Neither of these sketches is identical to Antonio's rollers in shape and in the representation of the angle hook. Therefore, Antonio might have sketched them from the reversible hoist or its components preserved somewhere near the cathedral in Florence. In that case, there is no good explanation for his poor illustration of Brunelleschi's reversible hoist. Rollers and angle hooks similar to Antonio's were illustrated for gristmills by the Anonimo (fols. 236 v., 237 r., 244 v.), indicating that he and millwrights realized the usefulness of such rollers. Antonio's engine drawings show that he favored hoists with rope pulleys and the treadwheel moved by men or horses.

Concerning a possible dating for this sheet, see the essay of C.L. Frommel in this volume.

BIBLIOGRAPHY: Ferri (1885) 100; Martini-Maltese (1967) I: pls. 90, 91, 93; Keller (1969) 225–31; Prager, Scaglia (1970) 65–109; Prager, Scaglia (1972) 88–93, 199–201.

<div align="right">G.S.</div>

U 1505A *recto*

ANTONIO DA SANGALLO THE YOUNGER
Rome, study of the countermine chambers in the southeast face of the Ardeatine bastion, 1537.
Dimensions: 186 x 276 mm.
Technique: Pen and brush with brown ink.
Paper: Folded in half, with cut and yellowed edges, reinforced by patches and restoration on the corners.
Drawing Scale: Roman *canne* and *palmi*.

INSCRIPTION: *Canne 25*; *pozolana*; *piano della creta*; *in palmi 12*; *pende p[almi] 3*; *Creta*

The study describes in great detail the countermine chambers or shafts below the level of the scarp corridor, corresponding to the oval spaces designed to enlarge the corridor along its length. The reciprocal and internal distances correspond to those in U 1362A, which recapitulates the elements of the plan. The chambers are octagonal and show the angled insertion of the countermine, that is, of the excavation that, starting with the line underlying the *scarpone,* would continue first into the *pozolana,* and then to the surrounding terrain until it intercepted the tunnels dug by the besiegers in order to mine the bastion. The section gives specific details for a countermine chamber, with a domed vault, that would be accessible by way of a central trapdoor from the scarp corridor above. At that level an arquebus, shown below, could control the entrance to the countermine, which would also receive some ventilation from the opening. The angled passageway between the countermine chamber and the countermine appears to be closed, at least by a door to reinforce it in case of explosions in the tunnel, and it slopes toward the exterior to avoid flooding. See also U 892A r. and v., 1517A r. and v., 1289A r. and v., 1362A r. and v.

BIBLIOGRAPHY: Ferri (1885) 168; Huelsen (1894) 329; Rocchi (1902) I: 184; II: pl. XXXIV; Pepper (1976) 164; Fiore (1986) 339.

<div align="right">F.P.F.</div>

U 1506A *recto*

ANTONIO DA SANGALLO THE YOUNGER
Perugia, Rocca Paolina, studies for embrasures, summer 1540.

Dimensions: 85 x 264 mm.
Technique: Pen and brown ink.
Paper: Thin, on modern support, darkened at edges.
Drawing Scale: canne(?).

INSCRIPTION: *questa sta / bene*

This is the second elevation study of the southwestern flank of the upper fortress at the Rocca Paolina, Perugia. Like U 1502A recto, it is roughly executed in strip fashion almost as if Antonio the Younger wanted to obtain a rapid sense of the fortress's elevation from a ground plan. This drawing is not cited by Giovannoni (1959) or Camerieri and Palombaro (1988). For further discussion of this kind of drawing, see the entry at U 1502A recto.

BIBLIOGRAPHY: (not published).

<div align="right">N.A./S.P.</div>

U 1507A *recto and verso*

ANTONIO DA SANGALLO THE YOUNGER
Fortification studies. Triangular fortress with outworks in the ditch (*recto*). Fortress with ravelins and casemate in the ditch (*verso*). Ca. 1535.
Dimensions: 264 x 202 mm.
Technique: Pen and brown ink.
Paper: Thin, partially opened by ink.

INSCRIPTION, Recto: *rivellino*; *Casamatta Bassa*

Though this sheet was identified by Giovannoni as an early sketch for the Fortezza da Basso, we see no reason to associate any of the drawings with any specific stage of the construction of the fortress. It is one of many sketches, probably dating from the mid-1530's and possibly associated with problems that arose at the Fortezza da Basso, in which Antonio the Younger explores the use of outworks. (The character of the drawing is also close to some of the studies done for Ancona such as U 1502A verso.) The diamond-shaped ravelins (recto and verso) can be swept by fire on all four faces, and as such they represent an improvement on the more common triangular plan. The caponier (casemate) on the ditch floor in front of the bastion salient is well placed to provide fire to the rear of the ravelin, as well as to the face of the bastion. (A similar solution is illustrated in U 893A recto.) This example looks as if it may have been designed to sit in the counterscarp (outer wall) of the ditch.

The fortress on the recto is triangular, with three bastions (the smallest number for an all-round flank-

ing fire system) and three intermediate ravelins. That on the verso is four-sided. The ravelins are drawn with what appear to be shaped roofs and, in one case, an arched opening. All of these features suggest that these sketches are of small works which, although unscaled, are likely to have been much smaller than anything envisaged for the Fortezza da Basso.

BIBLIOGRAPHY: Ferri (1885) 78; Giovannoni (1959) I: 80, 446.

N.A./S.P.

U 1508A *recto and verso*

ANTONIO DA SANGALLO THE YOUNGER
Perugia, studies for the Rocca Paolina, summer 1540.
Dimensions: 215 x 266 mm.
Technique: Pen and brown ink.
Paper: Cut, darkened at edges, partial new support.

INSCRIPTION, Recto: *servi; adioporto; frapezi e adio / porto; corito; per alpozo e larco; archo; martio*
Verso: *per la fortezza*(?) *sottolegunbere*(?)

The recto contains a series of preliminary studies of flanking gun positions at two levels in the reentrant corners of the upper fortress at the Rocca Paolina, Perugia. The highly articulated architectural quality of the series derives from the designer's preoccupation with the lines of fire to the foot of the walls, from the lower tier of embrasures placed halfway between ground level and cordon. Hence the very shallow-angled scarping immediately in front of the embrasures, which gives these details their plastic quality. These were studies for the southwest face of the upper fortress. They do not appear to have been executed as designed. Antonio the Younger's approach, however, is both highly systematic and conscious of the three-dimensional qualities of the design. The studies are laid out as a series of four strips, each represented as a projection that is more like an axonometric than an elevation.

The verso seems to show an early study of the tenaille at the lower end of the lower fortress of San Cataldo at the Rocca Paolina prior to the more completed plans (U 272A). This sheet may be dated just prior to U 1027A verso.

Both recto and verso are in the hand of Antonio the Younger.

BIBLIOGRAPHY: Ferri (1885) 168.

N.A./S.P.

U 1509A *recto*

ANTONIO DA SANGALLO THE YOUNGER
Plan of a sally port within a hornwork; section through rampart and ditch, unknown location, after 1530.
Dimensions: 291 x 444 mm (with new support); 291 x 430 mm (original sheet).
Technique: Pen and brown ink.
Paper: Center fold.

INSCRIPTION: (at right) *Le merli sieno di saxo / e cosi el coperchio*; (below) *fossetto*

The plan (left) shows a sally port recessed into a rampart between two orillons, possibly at the end of a hornwork. The sally port has two doorways opening on to a ramp of stairs. It is protected by an embrasure firing out of the recess to the front, and by the cross-fire from the guns behind the orillons. The section evidently belongs to the same scheme; it shows two underground galleries and an unusual design for the parapet and upper works. These seem to be treated as a fortified roof with stone merlons and a cover (*coperchio*). All of this suggests that the site, unknown, was overlooked and needed to be protected from fire above.

Dating and specific location present a problem. (The drawing is not cited by Giovannoni.) The plan is quite close to proposals for Castro (see in particular U 295A; also U 778A, 1389A), and the sure handling of the lines suggests a date after 1530.

BIBLIOGRAPHY: Ferri (1885) 78.

N.A./S.P.

U 1510A *recto*

ANTONIO DA SANGALLO THE YOUNGER(?)
Perugia, Rocca Paolina, town facade, summer 1540.
Dimensions: 214 x 811 mm.
Technique: Pen and brown ink, pink and brown wash, stylus, straightedge, pin.
Paper: Four sheets, partial new support; tear at center.
Drawing Scale: Roman *palmi* (156 mm = 100 *palmi*).

INSCRIPTION: (at right by window) *Le finestrona / sono di questa / sorta ferrate / a gabbia*; (at extreme right) *Le Cose bianche sono / travertine & le rosse / sono di mattoni*; (below) *piano della piazza*

U 1510A recto is one of the few drawings for the Rocca Paolina project that seem almost to be in a finished state; there is a carefully laid-down underdrawing and wash. Even so, the facade is not complete and

the upper part of the facade is only barely outlined. See also U 1021A, which shows half the facade and lacks the upper termination, but which pairs the facade with the plan of the upper fortress.

This drawing has been used by most writers to show that Antonio the Younger's first project for the Rocca Paolina was of a fortress-palace type (such as Caprarola). There is little to distinguish the facade shown here from, say, the facade of the Palazzo Farnese in Rome. The notations on this sheet and others, such as U 1021A, refer to the "facade of the palace." Paul III seems ultimately to have decided in favor of a more overtly military structure; the lower scarp was covered with brick thus covering the windows, a ditch was dug, and the overall aspect of the fortress to the city was changed.

The sheet may be dated relatively early in the design process along with most of the other Perugia drawings. A completed drawing of this facade may have been sent to Paul III late in June 1540. There has been no discussion of the authorship of this sheet. Although the handwriting is certainly that of Antonio the Younger it is possible that the drawing itself is by someone else, either Jacopo Melighino or Aristotile da Sangallo; the use of ruled lines makes identification difficult, but knowing how busy Antonio was, it seems unlikely that he had time to work up drawings such as this one.

It has been argued by Camerieri and Palombaro (1988, p. 25) that this change in plan violated Antonio the Younger's intentions. Certainly the change is not visible in any of Antonio's drawings; but he still may have been responsible for the new plan. The absence of drawings to confirm his participation may only be the result of their importance for the construction process.

BIBLIOGRAPHY: Ferri (1885) 110; Giovannoni (1959) I: 41, 66, 354; II: fig. 361; Camerieri, Palombaro (1988) 25, 47, fig. 24.

N.A./S.P.

U 1511A *recto and verso*

ANTONIO DA SANGALLO THE YOUNGER
Ascoli Piceno, view of the city (*recto*). Ascoli from within
 walls (*verso*). 1540.
Dimensions: 198 x 435 mm.
Technique: Pen and brown ink.
Paper: Folded; damaged top and right side; darkened at top.

INSCRIPTION, Recto: (left) *Castellani; Congiuntione delli due fiumi; Santa maria delle vergine;* (center) *Santo pi[etr]o in*

castello; tronto; tiratori e tinte e purgo; (right, from top) *casero; porta murata; porta romana*

This view of the town probably was undertaken to study the question of the placement of a fortress in November 1540. Papal forces had been humiliated by the local *montagnuoli* in July 1539, and in December 1539 Paul III decided to remove eleven feudatory castles from control of the city. At the same time it was decided to rebuild the Fortezza Malatesta at the eastern edge of the town. Antonio the Younger was invited to Ascoli, and payments of November 1540 record his presence there.

This drawing and the verso are executed in the abbreviated style that Antonio the Younger used at Perugia for topographic investigation (U 1023A). The drawing is quite different from U 729A recto, which is a plan. While both kinds of views are used at Perugia, the absence of any mention of issues related to fortification on the more analytical bird's-eye view (U 729A) suggests that it belongs to the earlier visit to Ascoli.

BIBLIOGRAPHY: Ferri (1885) 10; Giovannoni (1959) I: 76, 446; Fabiani (1957–59) I: 241–44.

N.A./S.P.

U 1512A *recto*

ANTONIO DA SANGALLO THE YOUNGER
Fortification study, unknown location, ca. 1530.
Dimensions: 374 x 221 mm.
Technique: Pen and brown ink.
Paper: Stained lower right, darkened at left.
Drawing Scale: canne and *palmi.*

INSCRIPTION: (from top, clockwise) (*Vlivo mezo* canceled); *passone; vlivo mozzo; arboro; via butarlo; corno quarto; sono corni 4 ma / si possono ridurr* (page cut) *altri; Toretta; Santa mari*

The location of this sketch is not known. It appears to be for a hill town and recalls, in outline, the town of Castro. The hand is certainly that of Antonio the Younger. We see the same shorthand annotations of the topography that we see in the drawings for Perugia (U 1028A). In the lower right we see Antonio choosing between a large single bastion and a hornwork; a similar problem was faced by him at Castro (U 752A). The measurements suggest that we are dealing with an actual site.

BIBLIOGRAPHY: Ferri (1885) 78.

N.A./S.P.

U 1513A *recto and verso*

ANTONIO DA SANGALLO THE YOUNGER WITH GIOVAN
FRANCESCO DA SANGALLO(?)
Unknown location, study of three bastions linked by a cranked
 curtain, defending gate, security lobby, and ramp (*recto*).
 Preliminary study for similar defensive system, with cut-
 and-fill diagram (*verso*). Ca. 1530.
Dimensions: 291 x 422 mm.
Technique: Pen and brown ink, stylus, straightedge.
Paper: Thin, worn, lacking top right section, edges darkened
 and reinforced.
Drawing Scale: braccia, piedi, and *pertichi* are mentioned.

INSCRIPTION, Recto: (top left) *Lalteza delle mura sie allo
punto / delli tre anguli piedi 60 / in mezo sono alte piedi 40;*
(along ramp) *braccia 24 ne viene 13 1/3;* (center right) *pertiche
32 / al tucto*
Verso: *Lo fondamento del puntone dinanzi volesser / cavato
sotto fino che trova el sasso se a [. . .] / Largo piedi 20 cioe
15 fuora del filo / e cinque dentro al filo; E le faccie achanto e
mura vechie quali / fanno le faccie delli 2 puntoni delli / angoli
bisogna cavare li fondamenti / piu fuoro chel filo piedi 10;* (at
salient) *interne messo;* (left and right of triangle) *filo messo;
qui sono messo lo filo; filo messo; filo messo;* (below triangle)
Le [. . .] sie piedi 330 / cioe pertiche 33 di piedi 10 luna; (at
bottom) *Si ritira in dentro del diritto delli punti / dello
puntone da canto piedi lo; interne messo*

This drawing was identified by Giovannoni as one of
the series that define the layout of the Fortezza da
Basso, Florence. Many such drawings were made,
often using the stellar trace. Experiments can be seen
from the earliest stages (see U 758A, 759A) through to
the definition of the plan, beginning in studies such as
U 782A. Though U 1513A seems to belong to this class
of experiments it cannot be for the Fortezza da Basso.
The cranked curtain is simply too short between the
bastions to be the Fortezza da Basso, and the use of
pertichi is not found on any other of the Florentine
sheets (the *perticho* is generally used in northern
Italy). The use of the stellar trace (assuming a bal-
anced completion of the fortress) is generally confined
to level ground. Whatever the site, work clearly had
progressed quite far. The trace and the interior have
been defined quite carefully and the notation "filo
messo" tells us that lines have been laid down follow-
ing this plan.

 The extensive use of the straightedge makes identi-
fication of the author of the sheet quite difficult. The
notations, however, are certainly in the hand of Anto-
nio the Younger. It may even be that the fortress is not
of his design. The use of orillons to one side of the lat-

eral bastions and a straight flank to the other is not
found in any of Antonio the Younger's stellar fortress
experiments. The elaborate security arrangements and
half-moon cavalier strongly recall elements in the
work of Francesco di Giorgio and Giuliano da Sangal-
lo. We propose to date the sheet around 1530, prior to
Antonio the Younger's major fortress construction
years. There seems something highly experimental in
this sheet, as if Antonio is still feeling his way into the
art and science of fortification.

BIBLIOGRAPHY: Giovannoni (1959) I: 80.

N.A./S.P.

U 1514A *recto*

ANTONIO DA SANGALLO THE YOUNGER
Rome, study for the fortifications of the Aventine and San
 Saba hills, 1537.
Dimensions: 263 x 431 mm.
Technique: Brown ink prepared with silverpoint.
Paper: Modern support, cut at edges.

INSCRIPTION: *monte; monte; monte;* (in later hand [Ferri?])
*Studio per la fortificazione dell'Aventino dall'arco di San
Lazzaro alla porta Ostiense*

The drawing is probably a development, in fair copy
without measurements, of U 1019A and shows wall
thicknesses and placement of the embrasures. The syn-
thesis of design is accompanied by an even more syn-
thesized and efficient front in that the Aventine is
defended by three rather than four bastions and San
Saba by one instead of two, as was the case in U
1019A. The reduction of the number of bastions was
made possible by their increased dimensions, in gen-
eral, and by the articulation in three rather than two
sides of the reentrant curtain between the two main
topographic elevations. The result is a more unified
and continuous construction, with embrasures that
would be extremely effective even for firing toward the
exterior. The new gate to the city is missing, but the
San Paolo gate has been preserved in the Aurelian
walls even in the two alternatives drawn on the page,
one that introduces a single, rectilinear curtain of ca.
350 meters between the Colonnella and San Saba bas-
tions, and the other with a curtain of the same length,
linked to the Colonnella bastion, but ending in a for-
ward bastion that includes the Pyramid of Caius Ces-
tius, with the Porta San Paolo gate to the side. By
conserving the latter's placement, as well as its ancient
arches and those of its forward gate, Antonio incor-
porated it in a solution much like the one he would

develop shortly therafter for the Porta Marzia in the Rocca Paolina, Perugia. The indication of the thickness of the walls in the first hypothesis makes the placement of the bastions on top of the heights understandable from the point of view of construction, once the slopes following the natural declivity were indicated as part of the brick wall. The documents speak, in fact, of considerable excavation work for the bastions on the left bank, and construction of the Belvedere bastion, on the right bank, would later prove difficult due to the thrust of its terreplein, built in a similar manner according to the natural lay of the land. As for the relationship among the faces, the flanks, and the embrasures of the bastions, notice how the faces are oriented along the possible trajectories of the embrasures on the flanks, which also are inclined, instead of opting for the easier solution of placing the embrasures at right angles to the curtain, especially in the group of three bastions on the Tiber. Even the positioning of the embrasures in the reentrant angles is an innovation, because that places defenses safely inside the fortification instead of on its salients, and the number of bastions is therefore reduced, as was already done after 1534 by Antonio the Younger in Ancona and repeated by Escriva in 1537 in the fort of Sant'Elmo in Naples, built by the Spaniards. See also U 1019A, 1015A, 1431A r. and v., 938A.

BIBLIOGRAPHY: Rocchi (1902) I: 183; II: pl. XXXI; Huelsen (1984) 329; Fiore (1986) 338.

F.P.F.

U 1515A *recto*

ANTONIO DA SANGALLO THE YOUNGER
Rome, survey drawing of the Vatican walls from the Vatican to the Pertusa gate, 1542.
Dimensions: (irregular) 217/169 x 545/544 mm.
Technique: Pen and brush with gray or diluted gray ink, prepared with stylus and dividers.
Paper: Folded in half, restored on the lower left corner and patched, with yellowed edges.
Drawing Scale: Roman *palmi* (30 Roman *palmi* = 83 mm).

INSCRIPTION: *Casa*; *Canciello*; *Mezzogiorno* / *Libecio* / *Ponente* / *Maestrale* / *Tramontana* / *Grecho* / *Levante* / *Scilocho*; *Ripa*; *Canciello*; *porta pertusa*; *porta delvarcho*

This sheet, measured and in scale, is certainly related to survey drawings done in preparation for the study of the new Vatican defenses—the land surveys in U 1012A v., in particular. It shows where Nicholas III's walls, narrower and positioned along the brow of the hill, join those of Nicholas IV, which are thicker, guarded by semicircular towers, and set back from the steep slope. This is an extremely delicate point in the line of defense, due not only to the presence of the two gates, the "porta delvercho," or Vatican, and the "porta pertusa," but also because the latter is followed by the Nicholas V circuit with the (now so-called) Radio Tower. In view of this Antonio worked out two solutions: one with a single bastion and the other with a double bastion, with differing implications, above all for the part of the walls shown in the design. To give a sense of direction and complete the precise indications of the survey, Antonio names the winds he took into account most frequently in his surveys of the Roman walls, done by compass according to the method outlined by Raphael in his Letter to Pope Leo X. See also U 1012A r. and v., 1016A r. and v., 939A, 1017A, 937A, 936A, 1876A, 1519A, 1524A, 940A r. and v., 1361A, 1018A.

BIBLIOGRAPHY: Ferri (1885) 167; Rocchi (1902) I: 198; II: pl. XLV; Giovannoni (1959) I: 365.

F.P.F.

U 1516A *recto*

ANTONIO DA SANGALLO THE YOUNGER WITH BARTOLOMEO BARONINO(?)
Ascoli Piceno, city plan, 1540.
Dimensions: 267 x 472 mm.
Technique: Pen and brown ink, stylus, pin, straightedge.
Paper: Partial new support; darkened at edges.
Drawing Scale: 100 *canne* = 83 mm (at bottom margin).

INSCRIPTION: (at right) *rivellino*; *porta maestra*; *questi scogli sono piu bassi p[almi] 40 del piano della terra*; (lower left) *porta*

There seem to be two hands present on this drawing. One belongs to the author of the tightly packed script, the notations, and (possibly) the outline of the city walls. A second hand, Antonio the Younger's, seems to have been responsible for the topographic additions (rivers and their banks). The script seems to correspond to that of Baronino, who probably prepared a roughly measured outline of the walls on which Antonio could begin to meditate on the defensive problems. Given the nature of the problems faced by Antonio on his two documented trips to Ascoli Piceno (see U 729A and 1511A) of 1532 and 1540, we would tend to associate U 1516A with the later trip.

BIBLIOGRAPHY: (not published).

N.A./S.P.

U 1517A *recto and verso*

ANTONIO DA SANGALLO THE YOUNGER
Rome, restitution of the Aurelian Walls from the planned
 Ostiense bastion to the Porta San Sebastiano, with studies
 of the Ardeatine bastion, 1537.
Dimensions: 442 x 579 mm.
Technique: Pen and brown ink, straightedge.
Paper: Center fold, edges cut except at the top, yellowed at the
 edges and along the center.
Drawing Scale: Roman *palmi*.

INSCRIPTION, Recto: (clockwise from bottom left) *Baluardo;
torre della cisterna;* (. . .*bisognia / rivedere questo / filo sesto
cosi* canceled); *scarpa nova; torremerlatainalto; tuttuno colla
p*[. . .]; *in cima alco/rdone; Li fili de pozi sono attachati /
allantenne piualti chelcordone / p*[*almi*] *5 il pozi sono largi in
cima / p*[*almi*] *4; questo resta sotto alpiano de cordone
p*[*almi*] *19*
Verso: *filo; torre ruinata; filo*

The outline drawings of the Aurelian walls on the
recto and verso of the page constitute a precious doc-
umentation of the way the walls looked in the six-
teenth century just before about 400 meters were torn
down in order to build the Ardeatine bastion. The
drawing also corresponds to the land survey in U 892A
r. and v., integrating it with the sector comprised
between the San Saba reentrant and the Ostiense *balu-
ardo* that was planned in U 1431A. In view of the large
dimensions of the Ardeatine bastion, the intermediary
bastion between the two, still visible in U 1421A, has
been eliminated. The drawing, though freehand,
shows the projections of the walls as revealed by the
survey, using an external polygon as a point of refer-
ence; it is a functional drawing for the planning of the
Ardeatine bastion, which is drawn above it in two dif-
ferent scales but in accordance with the indications in
U 892A recto. Both introduce the formula of a double
flank, detailed here perhaps for the first time, with the
distance from the walls, the differing inclination of the
flanks, the juncture with the walls, and, in the upper
design, the plan of the embrasures with the double
splay and the dogleg chamber of the scarp gallery. See
U 892A r. and v., 1289A r. and v., 1362A r. and v.,
1505A.

BIBLIOGRAPHY: Ferri (1885) 78; Huelsen (1894) 323, 326;
Rocchi (1902) I: 183–84; II: pl. XXXII; Fiore (1986) 339.

F.P.F.

U 1519A *recto*

ANTONIO DA SANGALLO THE YOUNGER
Study of the Vatican hill fortifications, 1542.
Dimensions: 608 x 897 mm.
Technique: Pen and brown ink, prepared with stylus,
 straightedge, dividers.
Paper: Heavy, cut in half and pasted vertically, partially torn
 and restored horizontally, with trimmed edges and
 restoration on the right, folds and stains.
Drawing Scale: Roman *palmi* (50 *palmi* = 114 mm).

INSCRIPTION: [*d*]*i Roma; Dalfiancho alla porta sono Canne
250; Canne 50 di palmi 10 p*[*er*] *canna; scarpa*

This geometrical, measured design shows the alterna-
tive between a single bastion and a pincer bastion on
the Sant'Antonio salient that was studied in U 1876A.
In the surveys of the Nicholas III and Nicholas IV
walls with their defensive proposals there are other
differences. The one with a single bastion on the
salient presents an interesting solution with the flanks
withdrawn on the west slope, thus sacrificing most of
the Nicholas III walls, and the curtain withdrawn in
respect to the Nicholas V walls, also to be demolished
in this sector on the east slope. By contrast, the pincer
version, though moved back with respect to the Radio
Tower, no longer to be conserved as in the first pro-
posal, would seem to extend westward toward the val-
ley. In both cases the geometrical study of the
pentagonal bastions, with their orthogonal flanks first
at the curtain to the back and then in the line of fire,
should be noted, along with the extremely careful
adaption to the precise survey of the existing walls.
This is the most accurate restitution we have of the
defenses at the uppermost levels of the Vatican hill,
derived from Antonio's survey drawing seen in
U 1021A r. and v. See also U 1012A r. and v., 1016A r.
and v., 939A, 1515A, 1017A, 937A, 936A, 1876A,
1524A, 940A r. and v., 1361A, 1018A.

BIBLIOGRAPHY: Ferri (1885) 167; Rocchi (1902) I: 198; II
pl. XLII; Giovannoni (1959) I: 82, 366; Marconi (1966) 118,
123; Fiore (1986) 340.

F.P.F.

U 1520A *recto*

ANTONIO DA SANGALLO THE YOUNGER
Stellar fortress studies, unknown location; part plan copied
 from Francesco di Giorgio, ca. 1530 (*recto*).
Dimensions: 223 x 393 mm.
Technique: Pen and brown ink on recto; red chalk text on
 verso.

Paper: Thick, reinforced at rear edges, damp stains, folded in four.

INSCRIPTION, Recto: *dua quatri in essi luna / in elaltro*; *dua triangoli / luno in esso nellaltro*
Verso: *una Rocha*; CC

The sheet is folded in four with the top section occupied by stellar fortress plans; in the bottom section, across the fold, is an outline plan section of a bastion system and portal.

Most interest has focused on the lower half of the sheet. There Antonio has copied two bastions based on a prototype by Francesco di Giorgio. Marani notes the similarity to a drawing from the Codex Magliabechiano II.1.141, fol. 74 r., which is reproduced in Martini-Maltese (1967) II: fig. 285. Marani considers the actual source for the drawing to be Magliabechiano II.1.141, fol. 233 r., which is reproduced by Fiore (1978), p. 131. Although U 1520A was not mentioned by Giovannoni (1959), in the opinion of Marani, who published it for the first time, the sheet may either have come from the Francesco di Giorgio workshop or the Francesco di Giorgio copy is a youthful drawing by Antonio the Younger on which he added the stellar plans ca. 1527 when he was interested in the fortifications of Bologna.

We would agree that the stellar plans and the notations are clearly in the hand of Antonio the Younger. But that the lower sheet necessarily belongs to a much later moment cannot be assumed. The sheet was obviously considered to be multipurpose: The fold must precede any drawing and the stellar plans are not casually placed but occupy a single quadrant. It would seem likely that the Francesco copy was laid down first and sometime later the stellar sketches were added. But there is no reason to date them to separate periods. The hard line of the Francesco plan is deceiving; it may well be by Antonio or a member of his shop. Furthermore, in our opinion, the stellar sketches are not uniquely to be associated with Bologna; they seem to fit well with work Antonio did in the 1530's at Florence and Rome as well as at Bologna. The relevance of Francesco di Giorgio to Antonio da Sangallo did not stop with the onset of the latter's mature period. Antonio the Younger also found sources for the stellar fortress among the works of Giuliano da Sangallo, see U 1665A verso.

BIBLIOGRAPHY: Ferri (1885) 78; Fiore (1978) 131; Marani (1984) 27, fig. 17.

N.A./S.P.

U 1521A *recto*

ANTONIO DA SANGALLO THE YOUNGER
Fortress with angle bastions for unidentified location, possibly northern Italy, 1520–30.
Dimensions: 301 x 226 mm.
Technique: Pen and brown ink, red chalk used for some numbers, straightedge.
Paper: Center fold.
Drawing Scale: canne and *trabucchi;* also possibly use of the *braccio.*

The drawing appears to be a demonstration sheet for the construction of an angle-bastioned fortress with bastions of different dimensions. It shows a fortress of rectangular plan with numbers along the main elements of the curtain, face, salient, and flanks. The lines of the rectangle have been extended into the face of the bastion. The length of each section of the face on either side of the extension of the curtain has been marked.

The evidence for dating this sheet is slim. On the basis of the relatively careful script and drawing we have suggested the second decade of the sixteenth century. If the abbreviation "To." is indeed the *trabucco* (roughly the length of a *canna*), then we are in all probability dealing with a site in northern Italy where the *trabucco* was commonly used. This hypothesis still does not explain the measuring system Antonio operates around the perimeter of the fortress; certain measurements are totaled, certain dimensions seem relatively precise for the length that is shown, others are not totaled, and the dimensions seem not to be related to the numbers alongside them.

BIBLIOGRAPHY: Ferri (1885) 78.

N.A./S.P.

U 1523A *recto*

ANTONIO DA SANGALLO THE YOUNGER
Fortification study, unknown location, ca. 1530.
Dimensions: (modern support) 180 x 262 mm.
Technique: Pen and brown ink.
Paper: Darkened at edges; fragmented at bottom and right side.

This sheet could be for any of the larger projects of Antonio the Younger. It shows a plan section of angle bastions with double embrasures off a single casemate at the flanks. The plan is of a relatively common triangular shape. The double embrasures at the flanks recall works undertaken by Antonio at Ancona, Pia-

cenza, Florence, and Perugia and hence the sheet can probably be dated in the 1530's. The distance along the flank is noted to be "43"; the unit of measurement is not specified although it is probably the *braccio*. Ferri gives no location for the bastion. The verso of the sheet is blank.

BIBLIOGRAPHY: Ferri (1885) 78.

N.A./S.P.

U 1524A *recto*

ANTONIO DA SANGALLO THE YOUNGER
Study for the Vatican hill fortifications, 1542.
Dimensions: 181 x 397 mm.
Technique: Pen and brown ink with a few additions in black
. chalk, use of straightedge.
Paper: Center fold, trimmed and restored on the edges,
yellowed and with a reddish stain.

The solution for the bastioned circuit with a single salient is based in this case on the most extensive geometrical rendering available done by Antonio the Younger of the existing Vatican circuit (see U 1012A r. and v.). Here it is shown from the start of the Nicholas III walls, together with those of Nicholas V, up to the "Boschetto" on the south slope. Both designs were made with a ruler and are quite accurate. The Sant'Antonio bastion salient follows the plan in U 1519A, though it is set out farther beyond the walls in order to incorporate the existing walls on the west slope in their totality, much as in U 1876A. On the south slope the new defenses have been further developed by a large bastion with faces almost on the same level and similar, therefore, to a platform. This solution was dictated by the need to remain within the narrow space between the existing walls and the valley, as well as by the large Santo Spirito bastion, corresponding to the "Boschetto" on which a cavalier has also been marked with a circle. The penciled-in variations would make the salient solution more like the one in U 1876A. The bastion-platform solution would be tried once again in U 1018A. See also U 1012A r. and v., 1016A r. and v., 939A, 1515A, 1017A, 937A, 936A, 1876A, 1519A, 940A r. and v., 1361A, 1018A.

BIBLIOGRAPHY: Ferri (1885) 168; Rocchi (1902) I: 198; II: pl. XLIV; Giovannoni (1959) I: 366.

F.P.F.

U 1525A *recto and verso*

ANTONIO DA SANGALLO THE YOUNGER
Fortification study, hornwork (*recto* and *verso*), unknown
location, ca. 1530.
Dimensions: 153 x 141 mm.
Technique: Pen and brown ink.
Paper: Darkened at edges, thin.

The sheet offers two demonstrations of the hornwork (in Italian *tenaglia*), a common way to terminate a narrow fortification along a ridgeline or valley bottom. The plan allows for flanking coverage, as is shown, between the bastions at the ends of the work, as well as for flanking fire back along the wall. The work is relatively large, 136 *piedi* or *braccia* along the short face. This kind of solution is relatively common in Antonio the Younger's later work and appears in designs for the fortress at Perugia, at Castro, and at Rome. There is no evidence to link this drawing with any site in particular. Similar experiments, for an unknown location, are found on U 1522A.

BIBLIOGRAPHY: Ferri (1885) 78.

N.A./S.P.

U 1526A *recto and verso*

ANTONIO DA SANGALLO THE YOUNGER
Ancona, plan of the city walls along north front, ca. 1534.
Dimensions: 368 x 435 mm.
Technique: Pen and brown ink, dividers, red chalk (recto); pen
and brown ink, red chalk over top (verso).
Paper: Center fold, repairs at edges.

INSCRIPTION, Verso: *meniconi*(?)

Although Ferri failed to identify the location of this drawing, it seems to be related to the sequence of Ancona drawings, as was noted by Fiore (see also U 978A, 1020A). The drawing shows proposals for the renovation of the defenses along the northern approach to the city and dates, in all probability, from the period following Clement VII's reassertion of papal control (for historical background, see U 978A). The drawing dates from a relatively early phase of this undertaking, for the form of the citadel was later changed. The four bastions proposed by Antonio the Younger between the fortress and the great bastion del Cassero to the west eventually were reduced to only one (see U 4225A).

The nature of Antonio the Younger's intervention is typical of this kind of military renovation, with a

variety of straight-flank and orillon bastions placed to provide flanking coverage. Fiore notes the great variety of plan solutions reflecting the nature of the topography. Similar solutions by Antonio can be found at other sites such as Rome (see U 1514A r.) or Genoa (U 795A).

Work was later carried out on these bastions under the direction of the Sienese architect Giovanbattista Peloro; the degree to which the design of those works can be assigned to Peloro or Antonio the Younger is not clear.

The recto is interesting for the marginal drawing of a pair of dividers as well as the nine-square grid, possibly the framework for some kind of game.

BIBLIOGRAPHY: See U 978A; Ferri (1885) 78; Giovannoni (1959) I: 82; Marconi et al. (1978) 353; Fiore (1986) 336–37, fig. 9.

N.A./S.P.

U 1528A *recto and verso*

GIOVAN FRANCESCO DA SANGALLO
Studies of scaffolding, gears, wells, buckets, before 1530.

Dimensions: 285 x 420 mm.
Technique: Pen and brown ink.
Paper: Center fold; repairs at edges.

Left half: (a) Builder's bridge (*il palcho della Madona / della Cerqua sie piedi 41 / e tre largo*). (b) Bucket-chain, detail of pump (*sechie / per chavare / laqua*). (c) Screw (*la vite palmi 1*). (d) Link-chain, detail of pump (*in questa / forme / stano e feri / delle sechie*). Right half: (e) Waterwheel for a well (*pozo daqua*) with bucket-chain (*sechie*), gear (*questa rocha a gretole*), gear (*gretole 6 qui*), water outlet (*aqua*), gear (*A cho dentti*), gear (*cho denti*), reversible screw (*vite per alzare*), handspikes (*per voltare / chavagli / uomini*). (f) Gear, detail (*A*). (g) Rectangular ring, detail (*chosi*).
Verso: (a, upper left) Buckets connected on link-chain, detail. (b) Link-chain, detail (*de Farnese*).

INSCRIPTION: (d) *Quando lavora la ruota in piano / dentata di p[almi] 8 vole un chavallo; Quanto lavora lo rochetto di p[almi] 3 / vole un uomo; La rota in choltello / p[almi] 10; La rocha dove volta le sechie / p[almi] 3 ⅟ in su le gretole dove / savolta le sechie*; (e) *Nota che tutte le misure sono in su denti o*

in su le gretole / La vite di fondo grosa un palmo La chatena dal una / al atra chiavarda p[almi] 2; Le sechi tengano 5 mezi / romaneschi e sono large 3/4 di palmo alte p[er] uno

The handwriting (recto) is that of Giovan Francesco, not that of Giovanni Battista da Sangallo to whom the sheet has been attributed. His sketch (*a*) for the church of the Madonna della Quercia in Viterbo relates to work that Antonio the Younger contracted for in 1518. He and Giovanni Battista worked there in 1524 and until 1538, and Giovan Francesco must have sketched the bridge sometime before his death in 1530. Giovan Francesco's drawing of the bucket-chain pump and details of its components is identified "Farnese" on the verso (detail *b*). That note thus locates the pump in the town of Farnese near Pitigliano in the vicinity of Lago de Bolsena, or possibly in the Farnese fort in Pitigliano, or conceivably in the Palazzo Farnese, Rome. Giovan Francesco's method of annotated illustration recalls that of his uncle, Antonio the Younger. Among other things, he notes that a horse is needed to operate the cogwheel of 8 *palmi,* and when the lantern of 3 *palmi* is running, turning can be done by a man. Bucket-chain pumps like this one were illustrated by the Anonymi with a horizontal wheel (U 4073A r.) or equipped with handspikes (U 4083A r.). Antonio the Younger illustrated them with a crank (U 4052A r.) or an overshot waterwheel (U 4052A v.). Antonio classified his examples among Waterworks ("Defitii daqua").

BIBLIOGRAPHY: Ferri (1885) 100.

G.S.

U 1552A *recto*

ANTONIO DA SANGALLO THE YOUNGER
Loreto, proposal for new fortifications for the basilica, 1517(?).
Dimensions: 274 x 203 mm.
Technique: Pen and brown ink.
Paper: Light, folded in four, cut and yellowed on the edges.

This freehand, sketchy plan of the basilica, which shows it with the facade continuous with the lateral wings of the Apostolic Palace, and including two segments along the sides of the piazza to the front, can be related to Antonio's better-known and more detailed plan of the piazza and the Apostolic Palace (U 922A). Note that this side has already been changed from Bramante's first plan (Bruschi, 1969). The design also appears to have been done hastily because it con-

tains obvious errors: The choir and transept under the dome of the basilica are missing the two eastern, semicircular forms located at the crossing of the choir and transept whereas a correction was made to add similar ones to the west, and the nave of the basilica has eight instead of twelve pilasters subdividing the aisles.

Obviously, Antonio was devoting all his attention to his proposal for fortifying the basilica, and that was the only purpose of this quick sketch. The proposal is interesting for the narrowness of the bastioned circuit, on a square base, and for the symbolic value thus given the religious citadel. The Apostolic Palace would have remained undefended, nonetheless, without additional, exterior walls. The design can be dated 1506–7 or more likely 1517, the year in which Antonio went to Loreto before work on the fortifications was begun by Cristoforo Resse (September 1518 to April 1521) following a completely different plan, which was incompatible with the present proposal. The plan is reproduced in the survey sketches attributed to Baronino (U 4109A, 1527A), and contrary to Giovannoni's opinion (1959) there is no trace of Antonio's hand even in the marginal notes. It should be pointed out, however, that just as Resse's anomalous circuit, of late-fifteenth-century inspiration, follows a plan that may be traced to the presence in Loreto of a certain "Francesco da Sena" (Dal Monte Casoni, 1919), possibly Francesco di Giorgio (Fiore, 1977), Antonio's own proposal, though more up-to-date in the use of true angle bastions, imitates Francesco di Giorgio's taste for using the fortifications to stress the preeminence of the basilica as *caput* of the ensemble. The roughness of the sketch is further confirmed by the presence of several squiggles and a profile with headgear in the lower part of the page.

BIBLIOGRAPHY: Ferri (1885) 124; Dal Monte Casoni (1919); Dal Monte Casoni (1921); Giovannoni (1959) I: 195; Duprè Theseider (1961); Bruschi (1969) 652–67, 960–79; Posner (1974); Bruschi (1974) 200–204; Fiore (1977); Marconi et al. (1978) 362–68; Grimaldi et al. (1979); Grimaldi (1981); Grimaldi (1982).

F.P.F.

U 1564A *recto*

ANTONIO DA SANGALLO THE YOUNGER
Studies of lathes, centering for a vault, and a lift.
Dimensions: (Irregular) 330 x 215 mm.
Technique: Pen and brown-black ink.
Paper: Torn from middle of left edge to top.

(a) Lathe for screws (*chomana dirittona / sta il ferro*), with detail of iron bar (*chosi stal ferro*). (b) Centering for a vault (*cientina*). (c) Lift (*da elevare pesi*) with screws (*bronzo / ferro/ ferro*) in a frame (*legniame*).

Antonio the Younger illustrated the lathe for cutting wood screws once before (U 1445A r.), and other examples of this traditional tool are by one of the Anonymi (U 4086A r.) and in the copybook of the Anonimo Ingegnere Senese (Ms Additional 34113, fol. 159 r., British Library, London). This sheet is more intelligible than the other lathe for screws (U 1441A r.). The lift (*c*) is too complex for effective use, but it was illustrated also by the Anonimo (Ms Additional 34113, fol. 159 r.). The centering (*b*) was copied from Giuliano da Sangallo's *Taccuino* (Codex S.IV.8, fol. 27 r., Biblioteca Comunale, Siena), indicating that the *Taccuino* was available to Antonio the Younger perhaps in Giuliano's lifetime. Giovanni Battista da Sangallo copied from it, too (U 1665A r.), as did Giovan Francesco (U 3950A r.).

BIBLIOGRAPHY: Ferri (1885) 88; Sangallo-Falb (1902).

G.S.

U 1564A *verso*

ANTONIO DA SANGALLO THE YOUNGER
Studies of roasting spit and gear rack.
Dimensions and Paper: See U 1564A recto.
Technique: Pen and brown-black ink.

(a) Roasting spit or smoke jack with double-cogwheel lantern. (b) Gear rack, detail (*martinetto*).

Antonio's drawing of a roasting spit (*a*) is intelligible by turning the sheet horizontal; the detail (*b*) for another mechanism takes another direction. Identical roasting spits were illustrated by Leonardo da Vinci (Codex Atlanticus, fol. 5 v., Biblioteca Ambrosiana, Milan) and by Giuliano da Sangallo (*Taccuino*, fol. 50 r., Codex S.IV.8, Biblioteca Comunale, Siena). Antonio's version, even in its loss of the upper part, adopted Leonardo's vertical post with hooks and gear, but added another gear, changed the foot to a trefoil, and shifted the mechanism to the side instead of centering it in the chimney. Antonio's other drawing of the *martinetto* appears beside a fanciful mechanism (U 1215A v.).

BIBLIOGRAPHY: Ferri (1885) 88; Sangallo-Falb (1902).

G.S.

U 1659A *recto*

G<small>IOVANNI</small> B<small>ATTISTA</small> <small>DA</small> S<small>ANGALLO</small>
Florence, Fortezza da Basso, section and partial plan of the
 barracks, late 1534.
Dimensions: 560 x 431 mm.
Technique: Pen and brown ink, compass, straightedge, pin.
Paper: Thick, completely cracked apart along center fold and
 repaired, folded in four, some burn holes.
Drawing Scale: Florentine *braccia* (25 *braccia* = 103 mm).

I<small>NSCRIPTION</small>, Recto: (section, clockwise from bottom center
 arch of keep) *piano delle cantine*; *fondamenti*; *cantina*; *piaza*;
 (with representation of guard) *porticho al piano del cortile*;
 porticho al piano delle stanze; *stanze seconde*; *stanze per li
 soldati*; *stanze per soldati*; *portiche*; (at second level) *stantie
 per soldati*; (infill of rampart) *terralglio*; (above) *la terraglio in
 questo locho e b[raccia] 38 s[oldi] 6 d[ita] 6*; (all of drawing
 marked) *Tutto questo edifitio e involta*; (plan) *A lire et soldi et
 denari[. . .]*; (infill) *Terraglio*; (in stream of lower
 countermine level) *acqua*
Verso: Figure studies in black chalk

The recto is a clean copy of the much more heavily
annotated U 931A which we have attributed to Anto-
nio the Younger. The handwriting here is that of Gio-
vanni Battista. Because of the extensive use of the
straightedge it is hard to identify the hand responsible
for the barracks. The existence of two copies of the
same subject is noteworthy but not surprising; many
other copies must have existed as part of the activity
of the Sangallo shop.

Although less heavily annotated, this drawing is
more complete than U 931A in so far as it extends all
the way through the outer scarp in both plan and sec-
tion, showing the two levels of countermine gallery.
The lower gallery is clearly shown to be full of water
and was, perhaps, intended as a drainage sump for the
underground works.

For further discussion of the barracks, see U 931A.

B<small>IBLIOGRAPHY</small>: Ferri (1885): 57.

N.A./S.P.

U 1665A *recto and verso*

A<small>NTONIO</small> <small>DA</small> S<small>ANGALLO</small> <small>THE</small> Y<small>OUNGER</small> <small>AND</small> G<small>IOVANNI</small>
B<small>ATTISTA</small> <small>DA</small> S<small>ANGALLO</small>
Studies of Brunelleschi's crane and other mechanisms used by
 Brunelleschi (*recto*). Staircase from Capua; polygonal
 fortress; entablature from Forum of Nerva, Rome,
 (*verso*). Ca. 1530(?).
Dimensions: 270 x 400 mm.
Technique: Pen and brown ink.

I<small>NSCRIPTION</small>, Recto: (left, hand of Giovanni Battista)
*Chome si muro lalanterna della cupola / di S[an]ta Maria del
Fiore*; (right, hand of Antonio the Younger) *Dal libretto / di
Giuliano*
Verso: (top) *Gradi del chuliseo di Capova*; *questo* (canceled
 words illegible); (below) *forteza*; *quarta*; (right) *Spoglia Cristi /
da libretto di / Giuliano*

This sheet brings together a number of studies typical
of the workshop and its broad interests. Though by
different hands, the studies are all taken from the
notebook of Giuliano da Sangallo (Codex S.IV.8, Bi-
blioteca Comunale, Siena). The sheet thus provides the
kind of encyclopedic reference copy drawing derived
from the sketchbook of Giuliano and testifies to the
authority of the elder family member within the circle
of Antonio the Younger. On the recto (right) appears
Antonio the Younger's drawing of load positioners
and turnbuckles. The source "in the little book of Giu-
liano" is noted (fols. 48 v., 49 r.). Giuliano did not
annotate this drawing. To the left is Brunelleschi's
lantern building crane and there the hand of Giovanni
Battista da Sangallo can be identified. It too is derived
from Giuliano's "little book" (fol. 12 r.). The annota-
tion is slightly changed. Giuliano wrote "chome si
muro la champana de la chupola di Santa Liperata,"
referring to the lantern ("champana") of the Duomo
("Liperata" or Reparata). For further borrowings
from Giuliano's "little book," see Giovan Francesco
da Sangallo's drawing of a hauler for stone blocks
(U 3950A r.), which is derived from fol. 44 r.; there the
source is unacknowledged.

The pictorial source for Giuliano's drawings was
the *Zibaldone* or sketchbook of Buonaccorso Ghiber-
ti (Codex Banco rari 228, Biblioteca Nazionale, Flo-
rence): fol. 104 r. (lantern building crane and set of
turnbuckles); fols. 116 v., 117 r. (load positioners:
"chon questo si vogieva el chastelo de la chupola").
Buonaccorso's sketchbook was also the source for
drawings by Leonardo da Vinci (Codex Atlanticus,
fols. 295 r., *b* [808 r.]; 295 v., *b* [808 v.], Biblioteca
Ambrosiana, Milan).

On the verso there is continued use of Giuliano's
sketchbook: the entablature sketch from the Colon-
nacce (then housing the church of Spoglia Cristo) at
the Forum Nervae (fol. 44 v.). These columns, so
named in the nineteenth century, refer to a pair of
marble columns with entablature, cornice, and attic
plinths on the Argiletum to the Subura near the Torre
dei Conti. They were excavated in 1930 and were
recently (1989) cleaned and restored. During the fif-
teenth and sixteenth centuries the Colonnacce was

among the most popular of Roman antiquities, sketched by dozens of artists including Il Cronaca who designed (ca. 1491) the great cornice of the Palazzo Strozzi, Florence.

Antonio the Younger's note and the sketch of the staircase derive from Giuliano's sketchbook (fol. 16 v.), as does the six-pointed fortress and round-towered fortress (fol. 27 v.). Interest in these fortress plans is found notably during the period of the construction of the Fortezza da Basso, Florence (see U 758A, 1520A). Antonio the Younger also sketched a quarter (*quarto*) of Giuliano's plan of a square building with entranceway on each side, stairways on both sides of each corner, a colonnade in the courtyard, and a peripteral colonnade. Although Antonio utilized Giuliano's sketchbook for the passageway at Capua, he was working in the area on two occasions: 1510–13 (Rocca di Capodimonte) and 1531–32 (Tomb of Piero de' Medici, Montecassino).

Dating of this sheet is problematic and can be based solely on a sense of the development of Antonio's line and handwriting. The freedom of the sketch and handwriting, as well as the association with the Fortezza da Basso, suggest a dating around 1530.

BIBLIOGRAPHY: Ferri (1885) 16; Sangallo-Falb (1902) pls. 4, 10, 12, 28, 36, 49; Scaglia (1960–61) figs. 4, 11, 12, 14; Prager, Scaglia (1970) figs. 18, 24, 25, 32; Scaglia (1991); Scaglia (1992–93).

G.S.

U 1671A *recto*

GIOVAN FRANCESCO DA SANGALLO(?)
Study for a triumphal arch.
Dimensions: 416 x 225 mm.
Technique: Pen and brown ink, stylus marks, caliper perforations in middle of arch.
Paper: Reinforced at corners, upper left, and half of right margin.

The section through a street in the center of the bottom of the drawing shows the street to be much lower than the two sidewalks at either side on which the pairs of Corinthian columns stand. Their entablature supports an arch flanked by two winged victories and two niches with figures in high relief. The attic awaits an inscription, and its triangular pediment is adorned with acroterial statues and buttressed by volutes and freestanding figures.

This elevation has traditionally been associated with some of the special effects created for Charles V's entry into Rome (1536). The absence of any reference

to pope or emperor should be noted, however: The two coats of arms suspended on the festoons belong to two cardinals (to the left are the Farnese lilies, to the right, possibly, the lion rampant). The typology of the arch should be seen in relation to the plans for the arches on Via Alessandrina (one of the few Roman streets with sidewalks). The two 90-degree *risvolti* (identifiable by the profile of the freestanding human figures in the attic) refer to various plans for the entry into the Borgo of Charles V (see U 1155A, 1672A, and even 1269A v., lower right).

BIBLIOGRAPHY: Giovannoni (1959) I: 310–11; II: fig. 328.
M.F./G.M.

U 1672A *recto*

ANTONIO DA SANGALLO THE YOUNGER
Rome, plan for an arch in the Borgo.
Dimensions: 413 x 247 mm.
Technique: Pen and brown ink, stylus, caliper holes (one each on the four columns).
Paper: Restored at the corners.

The plan is analogous to that on U 1155A recto; the two designs can be superimposed more or less exactly. The present sheet does not have the annotations and measurements of U 1155A recto; see that sheet for description.

BIBLIOGRAPHY: Giovannoni (1959) I: 310–11; Madonna (1980) fig. 83.

G.M.

U 1684A *recto*

ANTONIO DA SANGALLO THE YOUNGER AND WORKSHOP
Castro, project for a Palazzo del Comune(?), ca. 1537.
Dimensions: 410 x 521 mm.
Technique: Pen and brown ink, scored with straightedge and compass, punctures made from the rear, not related to the drawing.
Paper: Slightly yellowed and spotted; originally folded over near the top at the point where the drawing stops, and in the middle; slightly cut at the sides, tattered at the lower edge and backed, also reinforced at the creases.
Drawing Scale: palmi romani (30 *palmi* = 112 mm).

The unusual fold at the upper edge seems to have been made before the drawing, thus stopping the lines of the arches. The entablature at the upper left may be by Antonio's hand, as were undoubtedly the numbers

on the scale. Yet the (alternative) representation in perspective of the left side of the building is so awkward and dull that it is difficult to attribute it to the master. The sheet has always been described as the facade of a ducal palace (for Castro?). But in fact the windows resemble those in the sketch of the facade of the Osteria (U 750A v.), which also shows a series of arches in the upper story, albeit quite different in construction and rhythm. Giovannoni's interpretation of the ground floor as "un grande vestibulo occupante tutta la fronte e quelli rettangulari," which he connects with the Palazzo Farnese in Rome, is not very convincing. A better comparison can be made with the Palazzo Comunale in Nepi, whose construction, based on plans sent from Rome, was begun in the forties under the direction of Aristotile da Sangallo (see "Castro and Nepi"). There, a transverse hall likewise spans the entire width of the facade on the very similarly rusticated ground floor. The large central arch on the *piano nobile* of U 1684A is a motif typical of communal palaces: the "ringhiera," the large balcony window from which the decisions of the council and the judgments of the court were announced to the people. The drawing leaves no space for bells or a clock, however; apparently the design of the upper story had not yet been completely worked out. According to the scale given in the drawing, the length of the facade is ca. 135 *palmi* (30.12 m). The drawing may be connected with the foundations of a never-completed sixteenth-century building discovered in Castro by Gardner-McTaggart (see "Castro and Nepi"). I have therefore designated it here as an uncompleted, unexecuted project for a *palazzo comunale* in Castro.

BIBLIOGRAPHY: Ferri (1885) 106; Giovannoni (1959) I: 49, 167, 202, 312; Aimo, Clementi (1971) 65; Fiore (1976) 85, 86; Giess (1981) 98, 137.

H.G.

U 1787A *recto*

ANTONIO DA SANGALLO THE YOUNGER AND WORKSHOP
Nepi, studies of the fortifications, 1537–45.
Dimensions: 375/381 x 979 mm.
Technique: Pen and brown ink; on the interior of the curtain and the Nepi bastions, red tempera; the interior of the Roman bastion, yellow tempera; prepared with stylus, straightedge, and pin marks.
Paper: Two sheets of thick paper, partially yellowed, pasted together on another strip of paper.
Drawing Scale: Roman *canne* (35 *canne* = 200–199 mm; 60 *canne* = 349(?) mm; 96 *canne* = 558.5(?) mm).

INSCRIPTION: *Nepe; Abixcho; Beluardo di nepe di can[ne] 35; Cortina di nepe di can[ne] 96; Beluardo di nepe di can[ne] 35; Beluardo di Roma de can[ne] 60*

After Antonio the Younger's preliminary studies (U 954A, 955A, and 956A), this design, datable 1537–45, shows what was actually built. The dimensions of the Nepi bastion are compared with those of the larger Roman bastion. Ferri attributes the design to Baronino, and Giovannoni to Bartolomeo de' Rocchi.

BIBLIOGRAPHY: Ferri (1885) 101; Giovannoni (1959) I: 337, 448; Giess (1978) 71–72, 79; Fiore (1986) 341–42.

F.Z.B.

U 1846A *recto and verso*

GIOVANNI BATTISTA DA SANGALLO
Civita Castellana, study of the door of the fortress (*recto*). Study of a cornice (*verso*). 1538–45.
Dimensions: 276 x 205 mm.
Technique: Pen and brown ink.
Paper: Corners darkened.

INSCRIPTION, Recto: *non cie fronte spizio lo agunto io; fa fregio et uno pocho pubaso delle bugnje; porta della rocha dicivita / chastelana; ponte levatoro; pianta della porta*
Verso: *in civjta*

Noted by Giovannoni, this sketch of the portal (in elevation and in plan) shows the new form of the rusticated blocks planned and executed at the same time as that of Nepi. These new decorative additions were part of the refurbishment of older fortresses undertaken by Paul III in the Farnese territories.

BIBLIOGRAPHY: Giovannoni (1959) I: 11, 343.

E.B.

U 1847A *recto*

GIOVAN FRANCESCO DA SANGALLO AND ANTONIO DA SANGALLO THE YOUNGER
Study of obelisks.
Dimensions: 16.5 x 23 mm.
Technique: Drawings in pen, gray-black ink; pen and brown ink for note.
Paper: Darkened at edges.

(left) Three obelisks surmounted by crosses (*la palla e alta palmi 4 e la piramida e alta palmi 1003 chon lo fiancho*).
(right) Note: *Di Modena* (hand of Antonio the Younger).

In the Uffizi catalogue this sheet is attributed to Anto-

nio Labacco, but the script for the drawings of the obelisks is that of Giovan Francesco da Sangallo and the subject is clearly one for a Roman project, perhaps that at the Vatican. Antonio the Younger's note "Di Modena" is likely to be his record for classifying sets of drawings. He was in Modena in 1526.

BIBLIOGRAPHY: Ferri (1885) 94.

G.S.

U 1876A *recto*

ANTONIO DA SANGALLO THE YOUNGER
Study for the fortifications of the Vatican hill, 1542.

a

b d c

Dimensions: 291 x 427 mm.
Technique: Pen and brown ink; compass.
Paper: Lightweight, folded in four, on new support, yellowed edges cut on top and to the right.
Drawing Scale: Roman *palmi*.

INSCRIPTION: (c) S[*an*]*to anto*[*nino*]

The drawings, not completely interpreted by Rocchi (1902), represent studies of the Vatican walls from the Swiss tower, formerly the Nicholas V tower (*d*), up to the Santo Antonino (*a*), with a single bastion on the salient and the interior plan of the so-called Radio tower, and on to the Santo Spirito hill; the alternative in the form of advance pincers with respect to the same salient (*b*); a trace of a later study of the theme (*c*) marked by the caption "Santo anto[nino]," divided by the cut of the paper. Although still preliminary, the design appears to have accurate measurements and the orientation of the faces of the bastions is indicated, which makes it likely to have been the fruit of a more advanced plan. To be noted are the double-flank solutions to the bastions, which extend beyond the protuberance of Leo III's walls; the following curtain folded between the bastions, taking into consideration their relative proximity; the alternative at the top of the hill between the single bastion (*a*) and pincers, as in U 937A (*b*). In the case *a*, the main bastion of the circuit, as can be deduced by the measurements of the faces shown (600 and 605 *palmi*, equal to about 135 meters), if not by the dimensions in the design, would be the Belvedere bastion, preceded by the Swiss tower

(*d*), which emerges from the circuit. See also U 1012A r. and v., 1016A r. and v., 939A, 1515A, 1017A, 937A, 936A, 1519A, 1524A, 940A r. and v., 1361A, 1018A.

BIBLIOGRAPHY: Ferri (1885) 167; Rocchi (1902) I: 96; II: pl. XXXIX; Marconi (1966) 118, 122.

F.P.F.

U 2100A *recto*

ANTONIO DA SANGALLO THE YOUNGER
Perugia, Rocca Paolina, dedication plate lettering, 1541.
Dimensions: 244 x 442 mm.
Technique: Pen and brown ink, stylus, straightedge.
Paper: Center fold.
Drawing Scale: top line left, 12 units (in three groups of 4) = 50 mm.

INSCRIPTION, Recto: *PAVLVS . III PONTIFEX . MAX / PERVSINE . QVIETIS . FVNDATOR / AD . MALORVM . CORRECTIONE / ET . BONORVM . CONSER . ARCEM . HA[N]C / EREXIT . ANNO . DOMINI . M. D. XLI / PONTIFICAT(I* canceled, replaced with) *VS. SVI ANNO VII.* The word *titolo* is written six times within the text.
Verso: *Epitaffi di perugia per la mura / non piace al papa*

The drawing, in Antonio the Younger's hand, shows the dedicatory plaque on the Fortezza Paolina, the text of which was rejected by the pope, as is noted on the verso, in favor of a harsher message. The new plaque, probably proposed after a papal visit in the summer of 1542, stressed the role of the fortress (as opposed to the pope) in bringing peace and harmony to the troubled city.

BIBLIOGRAPHY: Ferri (1885) 110; Marconi et al. (1978) 427; Camerieri, Palombaro (1988) fig. 35.

N.A./S.P.

U 3949A *recto*

ANTONIO DA SANGALLO THE YOUNGER
Calculator of squares and square roots.
Dimensions: 254 x 397 mm.
Technique: Pen and brown ink, stylus.
Paper: On modern support, verso not visible.

INSCRIPTION: *Quadrato 100*; (at upper edge) *dentro*

The sheet seems to represent a kind of graphic table for the approximate calculation of the square of numbers between 10 and 52, and square roots between 100 and 2700. (It is also possible that the sheet might

represent a comparative table of dimensions of an expanding square.)

From an analysis of the curves traced with a dry stylus on the sheet it is possible to establish that the arc would form part of a circle with its center at the lower left hand of the sheet.

The sheet is similar to U 1466A though slightly clearer graphically and with greater detail.

Using the scale on the left-hand square one can read the number to be squared; this is done by identifying the vertical lines that define the number. Following these lines, up and then to the right, one meets the scale on the lower right margin of the sheet; thus it is possible to define the interval of the square of a given number and to determine the approximate value of the squared number.

For a square root, one reads from the lower right margin and follows the same path in the opposite direction. Thus one arrives at an approximate value of a square root for a number between 100 and 2700.

BIBLIOGRAPHY: (not published).

P.N.P./G.L.V.

U 3950A *recto*

GIOVAN FRANCESCO DA SANGALLO
Studies of hauling devices.
Dimensions: 290 x 435 mm.
Technique: Pen and brown ink.
Paper: Ink spots in three places; center fold.

Left half: (a) Stone-block transfer (*per tirare pesi*) with rope winder (*per avoltare*), gear (*rochetto*), wheels, inscribed four times (*rota*), handspikes (*arganello*), rollers (*churi*), and turning post (*lo voltano uomini o voi tirare da / chavagli*). Right half: Note: *quatro legni per lo ritto / le ruote sono in mezo.* (b) Stone-block transfer (*per tirare pesi*) with rope winder (*rota*), wheels (*rota / rota*), and handspikes. (c) Turning post, detail. (d) Rope winder, detail (*rote*).

Giovan Francesco copied *b* from Giuliano da Sangallo's *Taccuino* (Codex S.IV.8, fol. 46 r., Biblioteca Comunale, Siena), as did Antonio the Younger (U 1564A r. and v.) and Giovanni Battista (U 1665A r.). The version *a* appears to be Giovan Francesco's own variant, excepting two mechanisms like it illustrated in a Florentine copybook (Codex Magliabechiano XVIII.2.3163, fols. 24 r., 34 r., Biblioteca Nazionale, Florence) and a schematic form of one by Benvenuto Della Volpaia (Codex Ital. Cl. IV, 41, 5363, fol. 87 r., Biblioteca Marciana, Venice), which is moved by a horse.

BIBLIOGRAPHY: Ferri (1885) 89; Sangallo-Falb (1902).

G.S.

U 3950A *verso*

GIOVAN FRANCESCO DA SANGALLO
Studies of fulling mills.
Dimensions and Paper: See U 3950A recto.
Technique: Pen and brown-black ink, and ink spots at various places.

(above) Fulling mill or flax-breaker with overshot waterwheel, and tub (*gualchiera dove / sta lo panno*). (below) Fulling mill, detail of overshot waterwheel and tub (*mite*).

INSCRIPTION: (hand of Giovan Francesco) *Gualchiere lo fuso alza cholle / traverse le manganelle dove / e lo maglio che da lo panno la ruota* [. . .] *la chasetta*

Giovan Francesco explained part of the mill's operation, saying the shaft (*fuso*) raised the beaters and the transverse pieces at the point where the hammer is located. The rest of the statement after "cloth" is not intelligible due to the loss of a verb after the word "wheel."

BIBLIOGRAPHY: Ferri (1885) 89; Patterson (1956) 190–220, fig. 158.

G.S.

U 3951A *recto*

GIOVAN FRANCESCO DA SANGALLO
Studies of lifting devices.

Dimensions: 290 x 430 mm.
Technique: Pen and brown ink.
Paper: Center fold.

Left half: (a) Traveling crane (*modo da tirare pesi in alto*) with antennae (*venti*) lifting a stone block (*pietra*) on rope pulleys, and a man operating its capstan. (b) Pulley rope, detail. Right half: (c) Winch, detail (*di fero / di fero*). (d) Method to raise stone onto cart. (e) Stone-block lift mounted on a horse-drawn cart. (f) Pulley rope and stone block with ring hanger, detail.

INSCRIPTION: (d) *Modi da mettere pesi in su lle chara a uso di Roma;* (e) *A uso di Roma a chavagli; Chorde a ranpini; Modi da mettere pesi in su lle chara*

The traveling crane and its operator is a slight variant of one of the two versions that Antonio the Younger illustrated (U 1449A r.). All three are variants of Leonardo's traveling crane (Codex Atlanticus, fol. 49 v., Biblioteca Ambrosiana, Milan), differing only in the location of the winch and ropes. The word "travelling" refers more appropriately to Leonardo's drawing and to another version by Buonaccorso Ghiberti (*Zibaldone*, fol. 95 v., Ms Banco rari 228, Biblioteca Nazionale, Florence), both of which rest the mast on a flatcar. All of these cranes were surely fixed into the ground, and the antennae holding the mast erect were attached to nearby rooftops, as shown in a miniature illustrating the construction of the Tempio Malatestiano, Rimini. Two other devices by Giovan Francesco are said to be used in Rome, but one (*e*) is a slight variant of a drawing in Giuliano da Sangallo's *Taccuino* (Codex S.IV.8, fol. 46 v., Biblioteca Comunale, Siena), from which Antonio the Younger, Giovanni Battista, and Giovan Francesco copied other drawings (U 1564A r. and v., 1665A r. and v., and 3950A r.).

BIBLIOGRAPHY: Ferri (1885) 89; Sangallo-Falb (1902); Prager, Scaglia (1970) 65–109.

G.S.

U 3951A *verso*

GIOVAN FRANCESCO DA SANGALLO
Studies of a hoist and a gristmill.
Dimensions and Paper: See U 3951A recto.
Technique: Pen and brown ink.

(a) Hoist with gear, rope winder, pulley rope. (b) Gristmill in the Rocca di Selvino.

INSCRIPTION: (a) *Le traglie sono la di sopra a tre pulegie / La di sotto a due pulegie El fuso e 3/4 di pol[i]gio / La rota dentata e p[almi] 6 in su denti in / sul mezo E rochetto e p[almi] .1° lo difuora delle gretole La rota che manichi / p[almi] .3. Le manichi p[almi] 1°⁴ E serve a / chavare e mettere artiglerie / nella fosa;* (b) *Mulino nella rocha di Silvena dil Chonte Santa Fiore / che lo volta 2 uomini facilmente E de lo stile di ferro / li manichi ano di torto u[n] palmo e mezo La rota dentata / di ferro a di diamitro p[almi] .2. Lo rochetto pure di fero a diamitro / mezo palmo In sul mezo delle gretole la macina p[almi] 4*

On the verso Giovan Francesco lists components and their sizes for a hoist that he says is useful in raising and lowering artillery into the ditch. His method of annotation is the same for the hand-cranked gristmill "which two men can operate easily." He cites its loca-

tion in the Rocca di Selvino near Pitigliano, property of the Count of Santa Fiore, Guido Ascanio Sforza for whom Antonio the Younger built the Palazzo Silvestri in Rome (1534–47). An interesting aspect of this mill, as indicated in Giovan Francesco's notes, is that it is made entirely of wrought iron, which suggests he considered it unusual. For a discussion of fifteenth-century ironworkers, see Muendel (1985), who illustrates a trip-hammer and anvil near Pistoia. For mills in Pitigliano, see U 1442A r., for fortifications, U 811A r. and v., 812A r.

BIBLIOGRAPHY: Ferri (1885) 89; Muendel (1985) 29–70.

G.S.

U 3956A *recto and verso*

GIOVAN FRANCESCO DA SANGALLO
Miscellaneous mechanical studies.

```
a
b    d    e
c         f
          g
```

Dimensions: 275 x 210 mm.
Technique: Pen and brown ink.

Recto: (a) Gear with hand crank and second gear with handspikes. (b) Gear with hand crank, detail. (c) Device of six-handspikes tripping a handle to move a long wing-like arc attached to a round joint. (d) Lanterns in two details, cogwheel (center top), and a joint (lower left). (e) Study of column spacing (upper right). (f) Mausoleum of Augustus in Rome with two obelisks. (g) Plan of the Mausoleum of Augustus(?).
Verso: Wings of a bird(?) joined to a connector joint as in *c*.

The hand has been identified as that of Giovan Francesco based on the notes (incompleted words) and arabesque ornaments on the verso side similar to other sheets with Giovan Francesco's hand. (The sheet was attributed to Baldassarre Peruzzi in the Uffizi catalogue and was given by Bartoli to Antonio the Younger.) The objects sketched on the recto and verso sides of the sheet strongly resemble Leonardo da Vinci's studies of birds' wings and designs of the ornithopter (Codex Atlanticus, fols. 308 r., *a*; 309 v., *a*; 313 v., *a*, Biblioteca Ambrosiana, Milan). Giovan Francesco's examples (recto, *c*, and verso) are almost identical to Leonardo's studies on the first folio cited, which have been called studies of the wing mechanism of a flying machine, and to a sketch in Ms B, fol. 88 v. (Bibliothèque de l'Institut de France, Paris).

In addition to the machine drawings there is a sketch plan and sketch reconstruction of the Mausoleum of Augustus, showing the two obelisks flanking the entrance. On the verso appear a random selection of circles, hexagons, lozenges, triangles, some figures, a few rusticated blocks, and two perspective exercises, showing (bottom right) the diminution of figures toward a vanishing point.

BIBLIOGRAPHY: Ferri (1885) 88; Bartoli (1914–22) VI: 67–68; III: pl. 212, fig. 55; Gibbs-Smith (1978) 14, 17, 20–23; Leonardo da Vinci (1987) pl. viii, fig. 148.

G.S./I.C.

U 3970A *recto and verso*

GIOVANNI BATTISTA DA SANGALLO
Mechanical studies, including a minting press.
Dimensions: 210 x 230 mm.
Technique: Pen and brown ink.
Paper: Folded.

Recto. (a) Unidentifiable object comprising three tubes with two sack-like extremities joined together in a curve at the top. (b) Unidentifiable objects, possibly details of *a*. (c) Minting press.
Verso. (*a*) Lantern with staves for a cogwheel.

INSCRIPTION, Verso: *Scritta de danari / auti per el coraza*; *Maestro Andrea da Pilestrina*

Notes on the verso side written by Giovanni Battista da Sangallo provide the attribution for drawings on both sides. He recorded in one note that a document of payment was received for the body corselet, and in another note the name of the master Andrea da Palestrina, possibly related to Pier Luigi da Palestrina, patron of the arts and colleague of Marcello Cervini for whom Antonio the Younger made drawings for the Villa Cervini al Vivo. The minting press is identical to one by Baldassarre Peruzzi (U 504A v.).

BIBLIOGRAPHY: Ferri (1885) 89; Adams (1978b) 201–6.

G.S.

U 3975A *recto*

GIOVANNI BATTISTA DA SANGALLO
Studies of mechanics of movement.

a
 b
c d f g
 e

Dimensions: 185 x 270 mm.
Technique: Pen and brown ink.
Paper: Heavy, folded.

(a) Connecting rod of wheel-hub, detail. (b) Four-wheel wagon drawn by two oxen. (c) Connecting rod of wheel-hub, detail. (d) Whippletree for pivoting the wheels of the wagon, detail. (e) Whippletree, detail from another rear viewpoint (*diretto*). (f) Connecting rod, detail. (g) Connecting rod to another connector at front wheels, detail (*denti*).

Attribution is provided by two words in the hand of Giovanni Battista. Leonardo da Vinci studied the steering of a four-wheeled cart, the self-steering for a cart, and the transmission unit for the axle of a wagon in Codex Madrid I, fols. 58 r., 93 v., Ms 8936, Biblioteca Nacional, Madrid, and in Codex Atlanticus, fol. 4 v., Biblioteca Ambrosiana, Milan.

BIBLIOGRAPHY: Ferri (1885) 89; Jope (1956) 537–62; Leonardo da Vinci (1974).

G.S.

U 3976A *recto and verso*

ANTONIO DA SANGALLO THE YOUNGER
Studies of underwater equipment, pincers, and a rider.
Dimensions: 290 x 411 mm.
Technique: Pen and brown ink.

Recto. Left half: (a) Underwater weapon. (b) Underwater weapon with weighted hook. (c) Underwater weapon releasing arrows. (d) Pincers with four different clamps. Right half: (e) Rider on a bull wearing diving belt (*ottro*) and using a weapon attached to the bull's head.
Verso. Right half: (a) Underwater weapon with counterweight bucket. (b) Underwater weapon with counterweight box. (c) Underwater weapon. (d) Trebuchet.

These sketches after Taccola's Notebook (Ms CLM 197, part II, Bayerisches Staatsbibliothek, Munich) are stylistically identical with Antonio the Younger's drawings on other sheets from his second sketchbook where he used a free penline (U 848A r., 1451A r. and v., 1452A r. and v., among others). Several of these sheets have the same watermark. Antonio derived Taccola's engine drawings from the Anonimo Ingegnere Senese's copybook (Ms Additional 34113, British Library, London), of which a concordance is as follows: fols. 119 r., 123 v., 133 r., 135 r., 134 v., 72 v.; (verso side drawings) 118 r., 118 v., 120 r.

BIBLIOGRAPHY: Ferri (1885) 89, 92; Taccola (1984).

G.S.

U 4015A *recto*

GIOVAN FRANCESCO DA SANGALLO
Triumphal arch for Charles V's entry in Rome.
Dimensions: 560 x 422.
Technique: Pen and brown ink, red wash.
Paper: Center fold.

INSCRIPTION: *10 / l'archo*(?) */ grande / del palazo*; *Tiberio in Africha*; (on the arch in red) *Testa de larco*

The top part of the design is a schematic plan for the ground floor of the anterior side of the arch; below are the elevation and the plan of the second floor (to be compared with the anterior side of the arch on the verso).

The large rusticated arch is made up of three stories where large corner pilasters, composed of square, central nuclei, flanked by large pilaster strips on each front, frame arches formed by large hewn stones on the first two stories and an attic with an epigraph ("Testa de Larco") on the third. On top, corner statues are grouped around a high podium that bears another inscription ("Tiberio in Africha") and is surmounted by other statues holding circular shields. The entire arch is structured with rusticated ashlars that appear to replace integrally the architectural order.

As for the plan on the lower right of the page, this illustrates one of the two monumental pilasters constituting the arch with Charles V's coat of arms on the verso. On the four corners of the monumental pilaster are colossal-order semicolumns, and in the center of the three external fronts is a minor order that frames niches and aediculae in turn.

The design also shows the internal framework of the triumphal arch, composed of cylindrical supports, possibly wooden poles. The studies on the recto and verso refer without doubt to the monumental arches for Charles V's entry in Rome, as shown by the coat of arms with the two-headed Hapsburg eagle and the iconography of the African victories ("Tiberio in Africa" alludes to the storming of Tunis, and scenes of the African triumph were painted on the Piazza Venezia arch). As for the location, it is likely that the arch, with its principal front of more than 40 *braccia*, closed the entrance to Piazza Venezia at the corner of the palazzo; alternatively, it might have been meant for Campo dei Fiori, which is not documented by sources, only by the note "di Capo di Fiori" in U 1269A recto.

BIBLIOGRAPHY: Giovannoni (1959) I: 310–11; Madonna (1980) figs. 70, 71.

G.M.

U 4015A *verso*

GIOVAN FRANCESCO DA SANGALLO
Triumphal arch for Charles V's entry in Rome.
Dimensions and Paper: See U 4015A recto.
Technique: Pen and brown ink, red wash.

INSCRIPTION: (on pilaster elevation) [. . .]*iu: antiquita*(?) */ et coronatio*(?); (on arch elevation) *coronatio*

The page is divided in two equal parts. One half (at right in figure) shows an elevation of more than half of a large triumphal arch with rustication alluding to the Roman Porta Maggiore. The large pilasters that frame the vault ("di Braccia 10" in width and "20" in height) show a colossal order on pedestals above a high socle that frames a niche and an aedicula, which are also rusticated.

On the reliefs of the entablature, in the frieze, are masks and garlands in the intermediary section. The arched lintel of the arch, composed of large hewn stones, penetrates the architrave and frieze of the entablature. The attic above, where painted episodes ("coronatio") and a celebratory inscription were planned, is articulated by pilaster strips or fasces. The crown imperial eagle is buttressed on either side by large statues.

The other half of the page contains an elevation of the corner pilaster, which clarifies the rustication and the Colossal order of the niches.

BIBLIOGRAPHY: (not published).

G.M.

U 4041A *recto*

ANTONIO DA SANGALLO THE YOUNGER
Flintlock (arquebus) trigger.
Dimensions: 208 x 150 mm.
Technique: Pen and brown ink.

A simple form of trigger is illustrated on U 1441A v. and is discussed there in relation to versions by Leonardo da Vinci (Codex Madrid I, 18 v., 94 r., 98 v., 99 v., Ms 8936, Biblioteca Nacional, Madrid). In the present instance, drawn across the sheet, it is not clear why there are elaborate elements arranged across and down from each other.

BIBLIOGRAPHY: Ferri (1885) 88.

G.S.

U 4042A *recto*

<small>ANTONIO DA SANGALLO THE YOUNGER</small>
Pivoting and tilting crane.
Dimensions: 240 x 220 mm.
Technique: Pen and brown ink.

A more complete version of this crane appears on another sheet (U 1479A r. and v.), where Antonio also wrote builder's specifications, suggesting that he may have developed its form.

<small>BIBLIOGRAPHY:</small> Ferri (1885) 88.

<div align="right">G.S.</div>

U 4043A *recto*

<small>ANTONIO DA SANGALLO THE YOUNGER</small>
Studies of four compasses.
Dimensions: 235 x 157 mm.
Technique: Pen and brown ink.

Although there is probably more similarity than difference in the shapes that craftsmen gave to the compasses they made, it is remarkable that the round and curved parts of Antonio's first and third compasses are strikingly similar to examples by Benvenuto Della Volpaia (Codex Ital. Cl. IV, 41, 5363, Biblioteca Marciana, Venice). He called one of them (fol. 43 r.) "seste da carta," attributed another of the same form to "Leonardo da Vinci, sesta con 4 chiavature," and illustrated a related pair (fol. 53 v.). Other compasses are among Leonardo's drawings (Codex Atlanticus, fols. 14 r., *b*; 14 v., *b*; 259 r., *a*, Biblioteca Ambrosiana, Milan). Antonio illustrated compasses for making ellipses (U 1102A r.), as did Benvenuto (fol. 18 v.).

<small>BIBLIOGRAPHY:</small> Ferri (1885) 89; Maccagni (1967) 3–13; Maccagni (1971) 65–73.

<div align="right">G.S.</div>

U 4046A *recto and verso*

<small>GIOVANNI BATTISTA DA SANGALLO</small>
Studies of ancient heating systems.
Dimensions: 270 x 190 mm.
Technique: Pen and brown ink.

Recto, from top. (a) Rotunda water pool and hypocaust, in section. (b) Rotunda, in plan view, with water channel across and eight circular basins(?). (c) Water vessels on three steps, detail. (d) Pavement tiles(?), detail. (e) Ornament and fancy letters "A" and "L." (f) Rotunda, exterior. (g) Pavement blocks(?) with clamps over a hot-air space.

Verso: (a) Elliptical plan, opening on four sides and a corridor from one. (b) Column and entablature, detail.

This is half of a folio sheet that belonged to Giovanni Battista's sketchbook. I have used it as a criterion for the attribution to him of an annotated drawing of identical structures and others he illustrated in the margins of a Sulpizio-Vitruvius edition (Inc. F 50. 1, Biblioteca dell'Accademia dei Lincei e Corsiniana, Rome). There, as here, a rotunda of the kind preserved today in Baia, Pozzuoli, and Lago d'Averno is illustrated as a water pool with bathers in the water and on steps around the pool. Under the pavement, there are *suspensurae*, as described by Vitruvius (V.x.2.). Three water vessels on the steps are Giovanni Battista's interpretation of Vitruvius's reference to pots containing cold, warm, and hot water (V.x.1.), an interpretation that recalls that of Francesco di Giorgio and is even illustrated in the 1511 Vitruvius edition of Fra Giocondo. Wavy lines under the *suspensurae*, as Giovanni Battista shows in *c* and *g*, indicate hot air coming from the hypocaust (V.x.1–2), the furnace of which is excluded from the sketches. The rotunda in plan view has a ring of roundels, which must be another idea for the water-pool rotunda, since a channel across the form includes symbolic lines for water. In these sketches, Giovanni Battista reconstructed what Vitruvius described in the first and last chapters on baths. The last chapter dealt with the laconicum (V.x.5.). It had double walls between which hot air circulated. Water is not mentioned specifically in Vitruvius's chapters on baths, only implied in the word "balneum." Giovanni Battista combined here his understanding of Vitruvius and his study of Roman antiquities, probably ruined structures in the Kingdom of Naples, rather than in Rome.

<small>BIBLIOGRAPHY:</small> Ferri (1885) 91; Pagliara (1972) 19–25; Pagliara (1986) 5–85; Scaglia (1986) 161–84; Scaglia (1988) 85–101.

<div align="right">G.S.</div>

U 4048A *recto and verso*

<small>ANTONIO DA SANGALLO THE YOUNGER</small>
Studies of waterwheels.
Dimensions: 234 x 208 mm.
Technique: Pen and brown ink.

Recto. (a) Six-pronged waterwheel in a horizontal frame, and a case hinged to each prong. (b) Hinged case, detail. (c) Entablature profile(?).
Verso. (a) Waterwheel comprising six buckets and eight hammers.

The unannotated waterwheel relates stylistically to Antonio the Younger's annotated quinquereme ship (U 1114A r.) and marble-cutting saw (U 1496A r.). Bucket wheels like this one with hinged buckets were illustrated variously and in several examples in the Anonimo Ingegnere Senese's copybook (Ms Additional 34113, fols. 182 r., 182 v., 239 r., British Library, London), and by Leonardo (Codex Madrid II, fol. 85 v., Ms 8937, Biblioteca Nacional, Madrid), manuscripts that Antonio the Younger had studied and copied. The bucket-wheel with eight hammers on the verso was illustrated without the hammers in two Florentine copybooks dating 1548–53 (Codex Palat. 1077, fols. 135 r., 135 v., and Codex Palat. 1417, fols. 41 v., 42 r., Biblioteca Nazionale, Florence).

BIBLIOGRAPHY: Ferri (1885) 91.

G.S.

U 4052A recto and verso

ANTONIO DA SANGALLO THE YOUNGER
Studies of waterwheels.
Dimensions: 338 x 230 mm.
Technique: Pen and brown ink.
Paper: Heavy.

Recto. Bucket-chain, overshot waterwheel, crank pump.
Verso. Bucket-chain, overshot waterwheel, and gear.

INSCRIPTION, Verso: *Difitii daqua*

This sheet, half of an original folio, is among Antonio's early drafts for a series on waterworks, according to the title ("Difitii daqua") on the verso side, one of many titles he wrote on drawings (U 1438A r., 1449A r., 1496A v.). On the verso of the present sheet, there is an original foliation in the lower right corner: "A/1." On U 4057A r., by one of the Anonymi known as Copyist 8 (see Appendix to "Drawings of Machines"), there is a foliation "B/2" in the same place; the papers measure to the same size, and the watermarks are identical. Antonio the Younger was acquainted with Copyist 8 and noted on his drawing of a bucket-chain wheel, "questo dicie sadopera a serare a fossi e tira giu chopia daqua." This image had been derived from Francesco di Giorgio's *Opusculum de architectura* (Ms 197 b 21, British Museum, London). In U 4052A Antonio's drawing style has some traces of his technique of penstroke shading in his first sketchbook, which borrowed heavily on Taccola's engine drawings (U 818A r., 1432A r., 1438A r., 1450A r., 1476A r., 1481A r. and v., 4060A r. and v., 4064A r. and v., 4065A

r. and v., and others). In a second sketchbook, also derived from Taccola (U 848A r., 1451A r. and v., 1452A r. and v., 3976A r. and v., 4059A r. and v., 4060A r. and v.), his technique is a free penline. On the present folio, Antonio's style is transitional, but his subject is hardly new since bucket-chains were illustrated by Francesco di Giorgio; Antonio the Younger illustrated one (U 1494A r.), but there is no exact equivalent of these three bucket-chains in any copybook.

BIBLIOGRAPHY: Forbes (1956) 663–94.

G.S.

U 4058A recto

ANTONIO DA SANGALLO THE YOUNGER
Studies of pulleys.
Dimensions: 325 x 230 mm.
Technique: Pen and brown ink.
Paper: Heavy, gray.

(left) Pulleys, numbered 1 to 10, and rope on inclined plane (*per laiatta*). (right) Structure, detail (*per in tera; per in su*).

Antonio the Younger illustrates a few more than the ten pulleys he numbers, and his note names the mechanism's function for grain threshing (*aiata*). He illustrated a similar device (without numerals) with a treadwheel (U 1437A r.), a refined drawing in his sketchbook; by contrast, the extra large size and coarse paper of this sheet would make it an unlikely inclusion in a sketchbook.

BIBLIOGRAPHY: Ferri (1885) 89.

G.S.

U 4059A recto and verso

ANTONIO DA SANGALLO THE YOUNGER
Miscellaneous mechanical studies.
Dimensions: 295 x 230 mm.
Technique: Pen and brown ink.

Recto. (a) Climbing pole. (b) Hook with rope ladder, detail. (c) Hook with rope ladder. (d) Hook, detail. (e) Sword. (f) Hooks on a pole. (g) Hooks on pole with stirrups.
Verso. (a) Club chained to a pole. (b) Ball chained to a pole. (c) Tree branch with a sling. (d) Pole with a sling. (e) Bow and arrow. (f) Shield with arrows in loops.

This sheet was part of Antonio's second sketchbook (see U 848A). A concordance of these tools, originally in Taccola's Notebook but copied by Antonio from

Ms Additional 34113, is as follows: fols. 149 v., 149 v., 150 r., 150 r., 149 v., 190 v.; (verso side) 146 v. (all four clubs), 147 r., 147 r. Concerning the dating of this sheet, as well as U 4060A, 4064A, and 4065A, see "Drawings of Machines."

BIBLIOGRAPHY: Ferri (1885) 92.

G.S.

U 4060A *recto and verso*

ANTONIO DA SANGALLO THE YOUNGER
Studies of ship-sinking maneuvers.
Dimensions: 285 mm x 220 mm (270 mm including the once-folded margin of the sheet).
Technique: Pen and brown ink.

Recto. (top) Ship-sinking by four men operating a hooking device. (bottom) Ship-sinking by sending a pointed missile toward the enemy's ship.
Verso. (top) Ship-sinking hook launched by a lever. (bottom) Ship-sinking hook with a barrel counterweight.

It has been suggested (see U 818A r.) that the present sheet is part of Antonio's first sketchbook, where he sometimes copied and sometimes developed drawings of marine warfare from copies after Taccola that the Anonimo Ingegnere Senese copied into his copybook (Ms Additional 34113, British Library, London). The paper of this first sketchbook has an identical watermark. A concordance of Antonio's illustrations of ship-sinking devices with those in the archetype is as follows: fols. 109 r., 122 r.; (verso side) 112 r., 121 r., 123 r.

BIBLIOGRAPHY: Ferri (1885) 91.

G.S.

U 4064A *recto and verso*

ANTONIO DA SANGALLO THE YOUNGER
Mechanical studies, scaling ladders.
Dimensions: 290 x 436 mm.
Technique: Pen and brown ink.
Paper: Center fold.

Recto. Left half: (a) Scaling ladder on flatcar. (b) Scaling ladder on flatcar. Right half: (c) Ship armed with two hooks. (d) Scaling ladder on flatcar. (e) Climbing pole on flatcar. (f) Scaling ladder on flatcar.
Verso. Left half: (a) Scaling ladder on flatcar with shield. (b) Scaling ladder on flatcar with shield. Right half: (c) Scaling ladder on flatcar. (d) Scaling ladder on flatcar.

The present sheet was part of Antonio's second sketchbook (see U 848A r.). Distinction between the first and second copybook has been determined partly by the use of an identical paper, but in this case, and for U 4065A r. and v., Antonio's pen technique of shading penstrokes is that of his first sketchbook (U 818A r.), while his graphic source remained the Anonimo Ingegnere Senese's copybook. A concordance of Antonio's drawings with sources in Ms Additional 34113 is the following: fols. 138 v., 220 v., 109 r., 140 v., 207 r.; (verso side) 139 v., 137 v., 137 r., 138 v.

Bibliograpy: Ferri (1885) 91.

G.S.

U 4065A *recto and verso*

ANTONIO DA SANGALLO THE YOUNGER
Eight studies of scaling ladders on flatcars.
Dimensions: 287 x 435 mm.
Technique: Pen and brown ink.
Paper: Center fold.

This sheet was part of Antonio's second sketchbook, and probably followed U 4064A, which has drawings of the same type of scaling ladders. The sketchbook has been described previously (U 848A r.), including the source of the military devices in Taccola's Notebook (Ms CLM 197, part II, Bayerisches Staatsbibliothek, Munich). A concordance of these drawings by Antonio with others in the Anonimo Ingegnere Senese's copybook (Ms Additional 34113) that Antonio copied is as follows: fols. 138 v., 139 r., 146 r., 208 r.; (verso) 139 r., 138 v., 137 v., 138 r.

BIBLIOGRAPHY: Ferri (1885) 91; Taccola (1984).

G.S.

U 4078A *recto*

ANTONIO DA SANGALLO THE YOUNGER
Studies of hoists.
Dimensions: 290 x 422 mm.
Technique: Pen and gray-brown ink.
Paper: Center fold.

(left to right, top to bottom) (a) "1" Hoists with two-stage cogwheels and lanterns. (b) "2" Hoist with horse-trod wheel and gear. (c) "3" Hoist with gear. (d) "4" Hoist with two-stage cogwheels and lanterns. (e) "5" Hoist with cogwheel, lantern, and gear. (f) "6" Crane, variant of Brunelleschi's. (g) "7" Obelisk hauler with gear and rack.

Numerals 1 through 7 for mechanisms on this sheet are explained in entries for U 1443A r. and v., and 1471A r. and v., where the successive numerals to 28 were written; those drawings include Antonio's notes. While there is no watermark on the present sheet, other papers with numbered mechanisms executed in Antonio's free penline in his second sketchbook have an identical watermark. Antonio's source for his drawings was Francesco di Giorgio's *Trattato II* Supplement, which can be coordinated with the mechanisms numbered 1 through 7 with exact counterparts as follows: fols. 91 r., 91 v., 92 r., 92 v., 93 r. (Martini-Maltese, II: pls. 317, 318, 319, 320, 321). Antonio's other copies from *Trattato II* are on U 1482A and 1483A. Concerning the dating of these sheets, see "Drawings of Machines."

BIBLIOGRAPHY: Ferri (1885) 89; Martini-Maltese (1967) II: pls. 317–323.

G.S.

U 4120A *recto*

ANTONIO DA SANGALLO THE YOUNGER
Study of a *mazzocchio*, ca. 1526–27 or 1531.
Dimensions: 263 x 383 mm.
Technique: Pen and brown ink, stylus, compass, dividers, straightedge.
Paper: Yellowed, reinforced at corners, center fold.

This is one of four sheets showing the representation of a *mazzocchio* (see U 831A, 832A, 1464A r.). For a discussion of the *mazzocchio*, see U 831A. For a consideration of the dating of the sheets, see U 1464A where there is independent evidence for a date.

The attribution to Giovanni Battista da Sangallo is traditional, possibly based on the slightly heavier ink and a rather sharper line. Given the use of the straightedge and the absence of any contemporary inscription, I have joined this sheet to the other studies of *mazzocchi* under the name of Antonio the Younger.

The drawing shows plan and elevation of a *mazzocchio*. For bibliographic references to the *mazzocchio* as a device for the demonstration of geometric principles, see U 831A.

BIBLIOGRAPHY: (not published).

N.A.

U 4159A *recto*

ANTONIO DA SANGALLO THE YOUNGER
Triumphal arch for Piazza San Marco for Charles V's entry in Rome, 1536.
Dimensions: 273 x 414 mm.
Technique: Pen and brown ink, traces of stylus, small gaps of 0.5–2 mm diameter, caliper marks, not in scale.
Paper: Restored corners and upper right margin.

The plan shows a final variant (different from the three in U 1269A r.) of the arch between Piazza Venezia and what is now Via del Plebiscito. The front toward the piazza is composed of two symmetrical elements on the sides of the vault, each one articulated at an obtuse angle, hinged on a central semicolumn. The passageway, arranged on a circle arc, ends toward Via del Plebiscito with a small facade animated by a single semicolumn and a corner pilaster strip on each side of the vault.

The design relates to the final planning phase for the Palazzo Venezia arch. With respect to U 1269A, the width of the vault has been considerably widened. This was made possible by the demolition of the houses in front of the palazzo (which made Via del Plebiscito almost twice as wide as the Corso!). We have reconstructed the arch by comparing the design with the U 1269A studies. The usual three-part solution to the main facade, at 135-degree angles, should be compared with the pillars of Antonio's first plan for the arch (U 914A).

BIBLIOGRAPHY: Podestà (1878) 308–15, 328–29; Lanciani (1902–12) II: 58–63; Giovannoni (1959) I: 310–31; II: fig. 331; Madonna (1980) figs. 74, 79, 80.

M.F./G.M.

U 7975A *recto*

ANTONIO DA SANGALLO THE YOUNGER
Studies of crushers, paddles, and miscellaneous mechanical devices.
Dimensions: 220 x 295 mm.
Technique: Pen and brown ink.
Paper: Center fold.

Left half: (a) Pen for writing (*penna da schri/vere; rame*). (b) Plan of a building, measured. Right half: (c) Press with bag and screw for expressing liquids from olives or grapes (second stage of the process). (d) Edge runner on the mast of a paddlewheel to be turned by water (not shown) (*la rota diametrii p[almi] 16*). (e) Ring for holding handle to

turn the nut of *c*. (f) Rectangular paddle for the waterwheel of *d* (*palmi* 2).

Edge runners like this one (*d*) are components of two of Francesco di Giorgio's gristmills in *Trattato I*, fol. 34 r. (Martini-Maltese, I: pl. 63). I do not recognize on them or on the pumps any rectangular paddles or vanes as attachments to the wheel moved by water. Antonio the Younger illustrated this crusher and expressor for olives or grapes (*c*). It is similar to those built in his time, and to the expressor illustrated by the Anonimo Ingegnere Senese (fol. 74 v.). It differs from his reconstruction drawings of presses described by Cato, Palladius, and Columella (U 1469A r. and v.). This sheet bears the seal of Heinrich von Geymüller, whose collection was acquired for the Ufizzi before 1908.

BIBLIOGRAPHY: Ferri (1908); Forbes (1956) 103–46; Martini-Maltese (1967) I: pl. 63.

G.S.

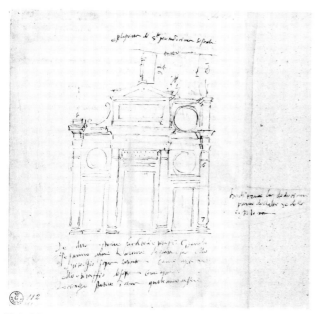

U 112A *recto*

U 112A *verso*

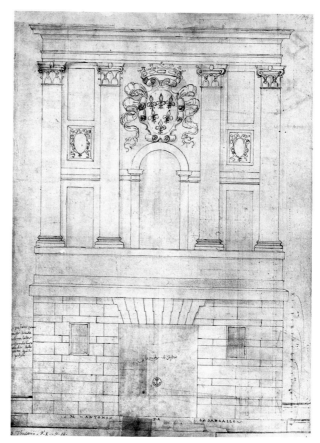

U 189A *recto*

U 271A *recto*

U 271A *recto* (detail)

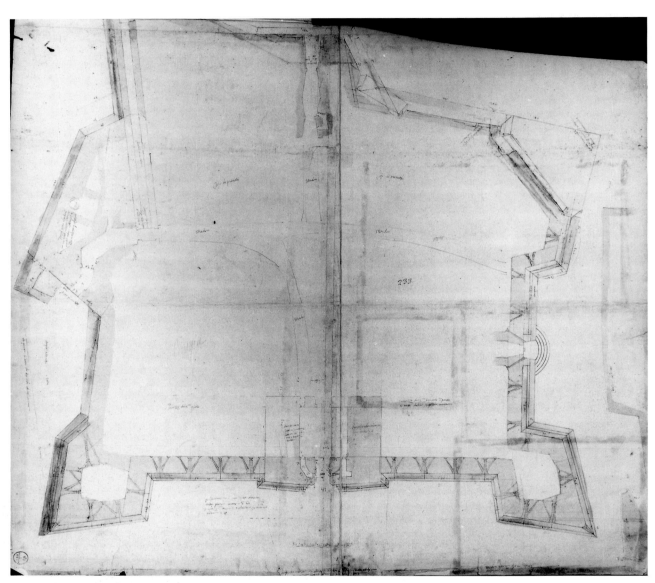

U 271A *recto* (detail)

278

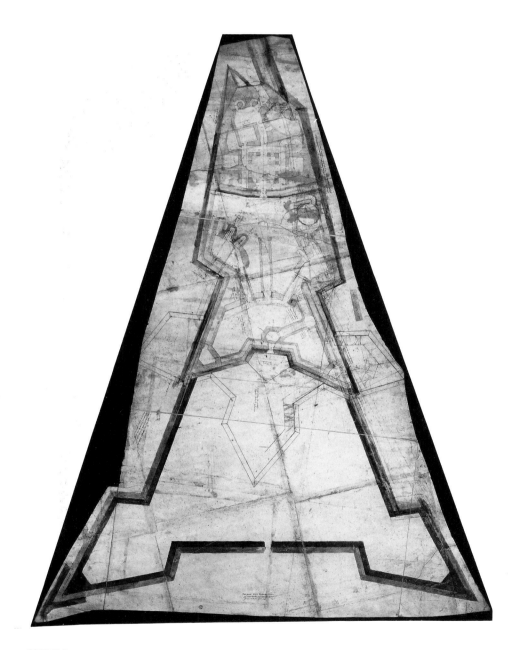

U 272A *recto*

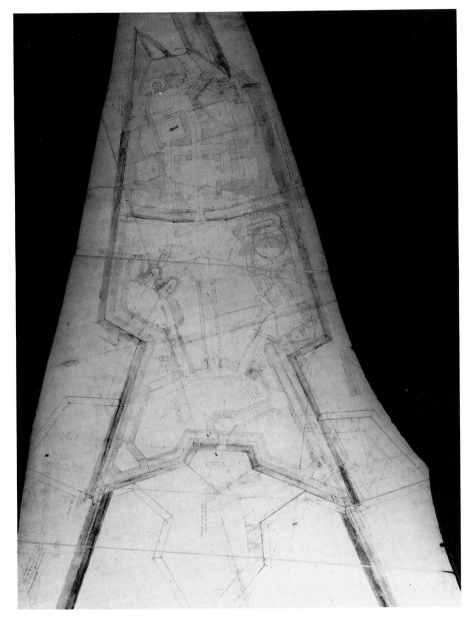

U 272A *recto* (detail)

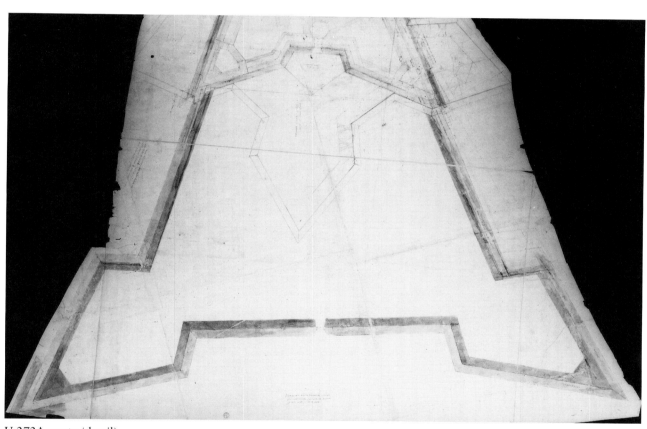

U 272A *recto* (detail)

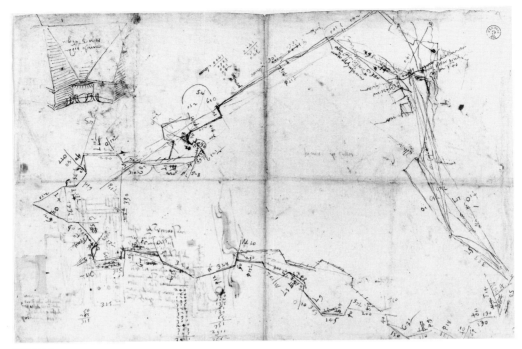

U 294A *recto*

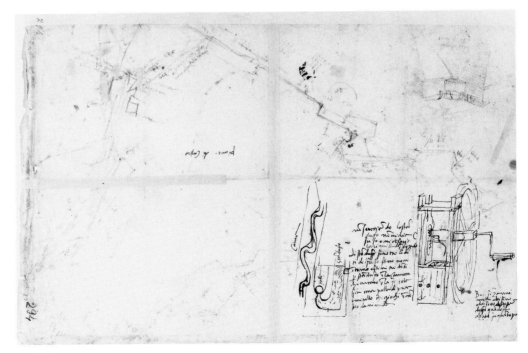

U 294A *verso*

U 295A *recto*

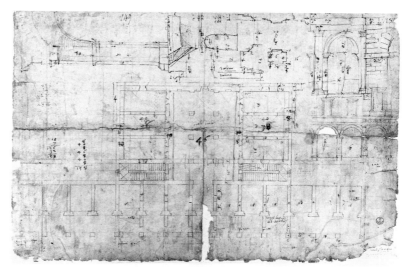

U 297A *recto*

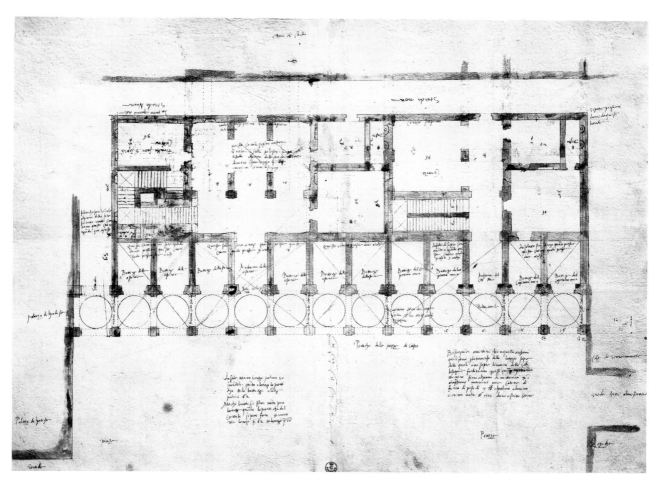

U 299A *recto*

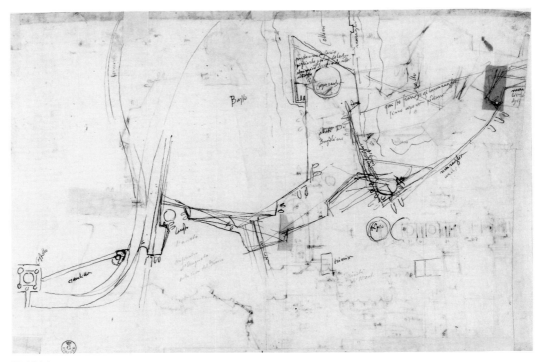

U 301A *recto*

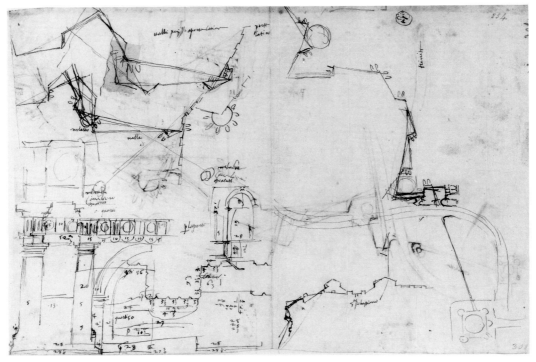

U 301A *verso*

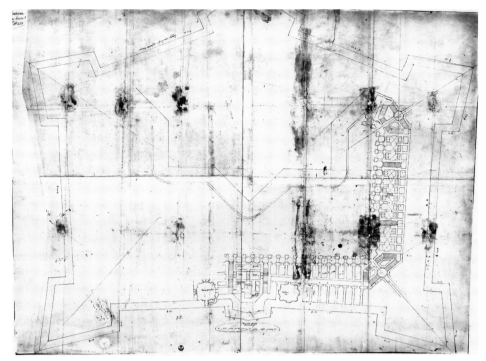

U 315A *recto*

U 316A *recto*

U 724A *recto*

U 463A *recto*

U 725A *recto*

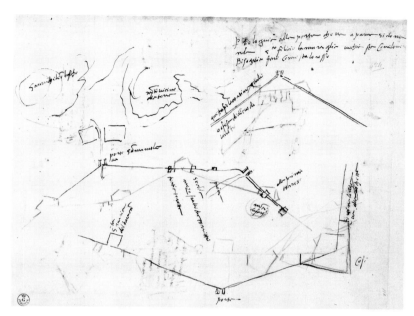

U 727A *recto*

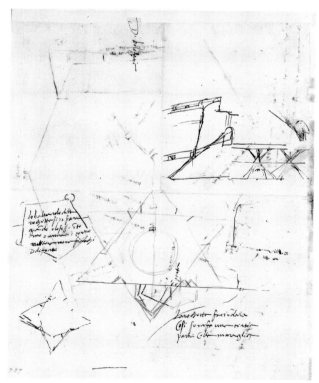

U 727A *verso*

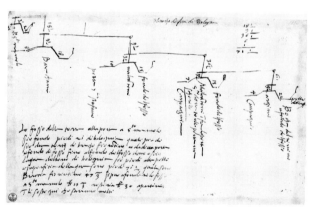

U 728A *recto*

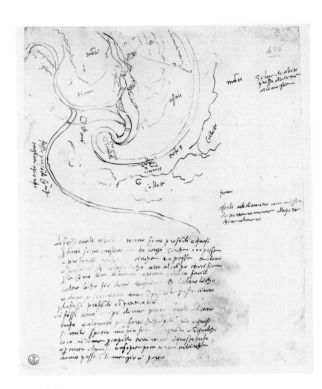

U 729A *recto*

U 729A *verso*

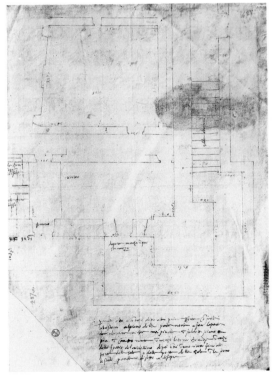

U 730A *recto*

U 730A *verso*

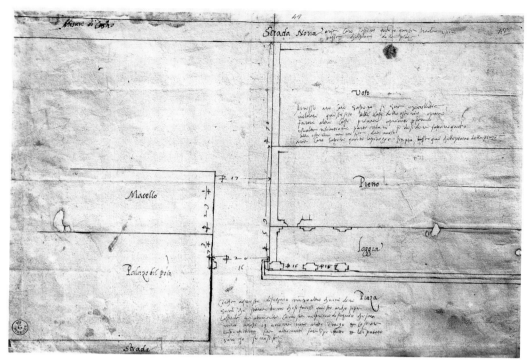

U 732A *recto*

U 732A *verso*

U 733A *recto*

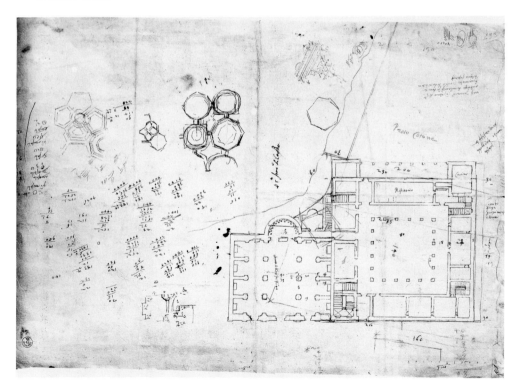

U 736A *recto*

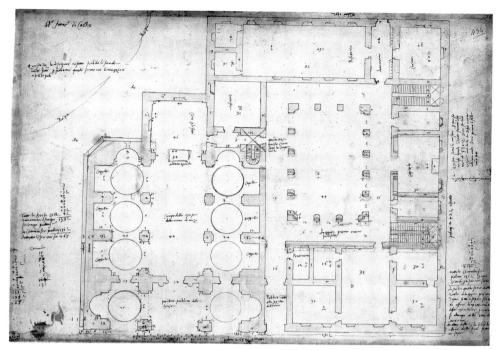

U 737A *recto*

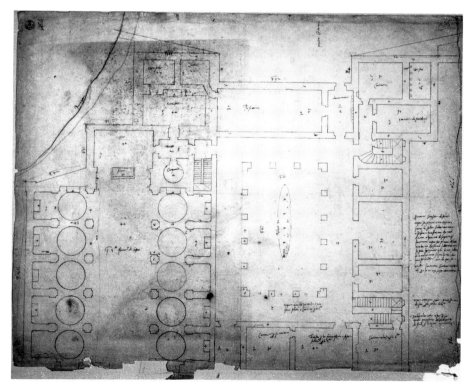

U 738A *recto*

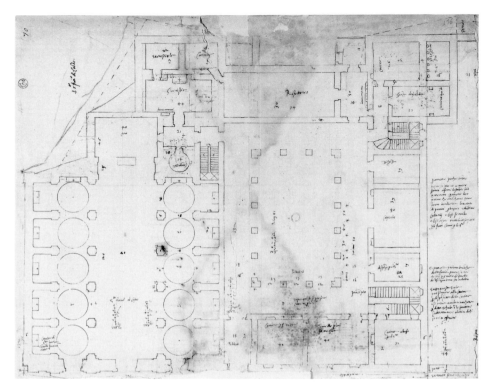

U 739A *recto*

U 739A *verso*

U 750A *verso*

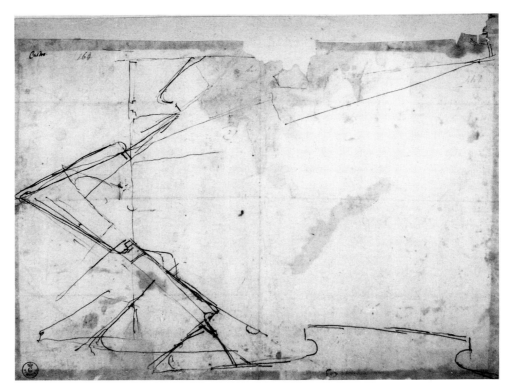

U 751A *recto*

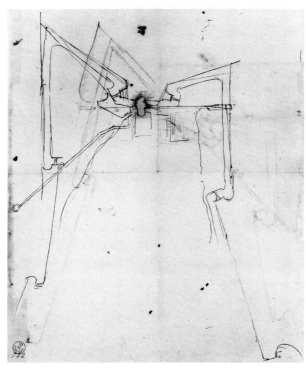

U 752A *recto*

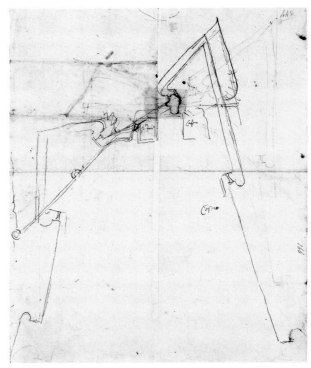

U 752A *verso*

298

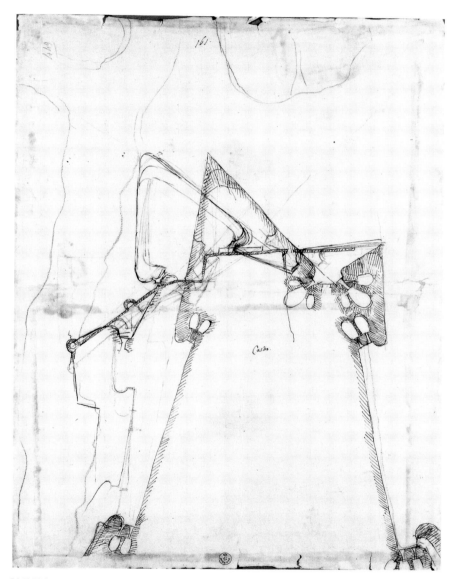

U 753A *recto*

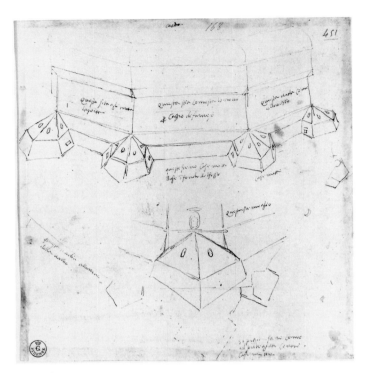

U 754A *recto*

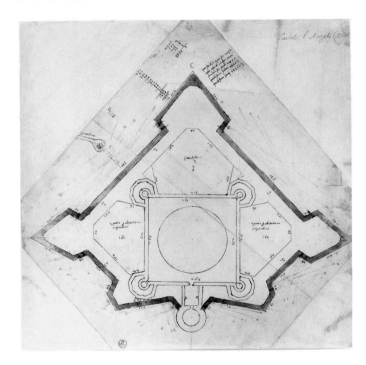

U 755A *recto*

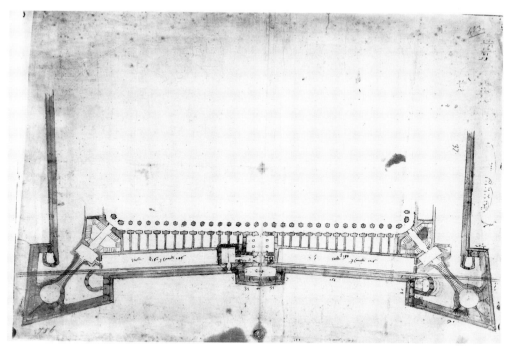

U 756A *recto*

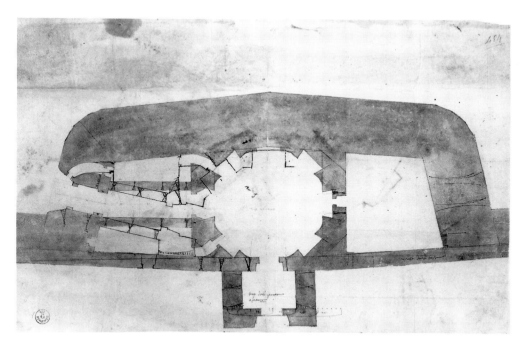

U 757A *recto*

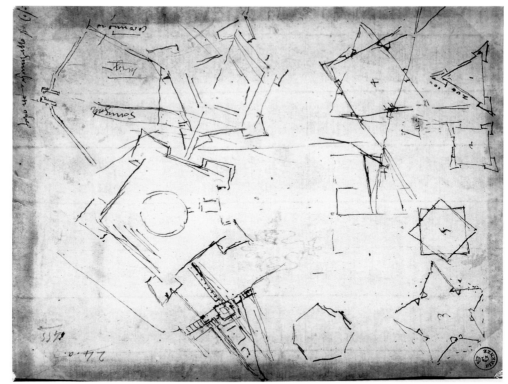
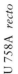

U 758A *recto*

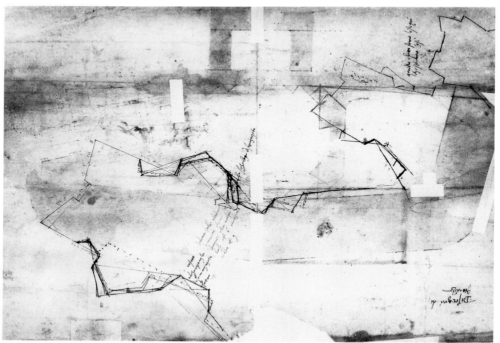

U 757A *verso*

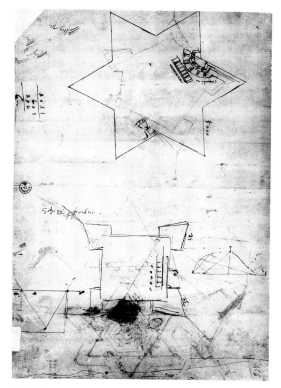

U 759A *recto*

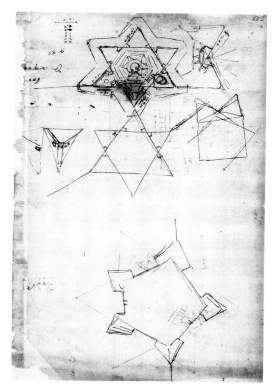

U 759A *verso*

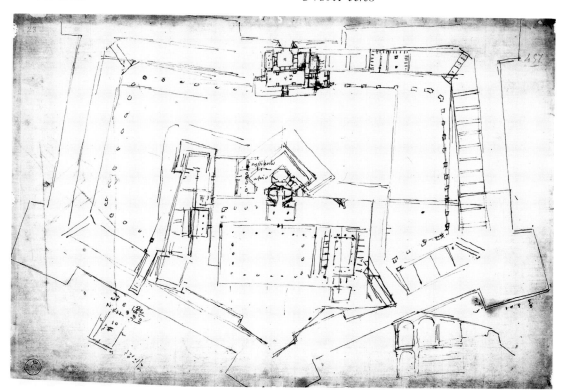

U 760A *recto*

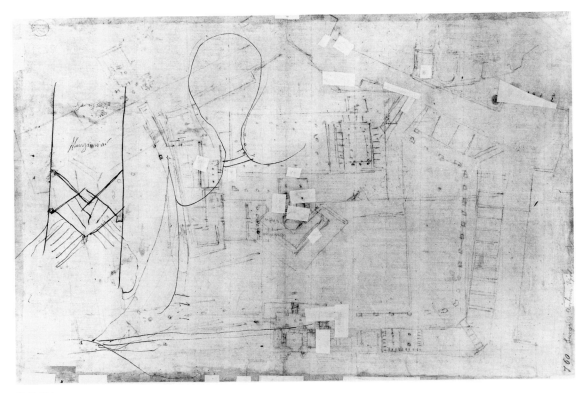

U 760A *verso*

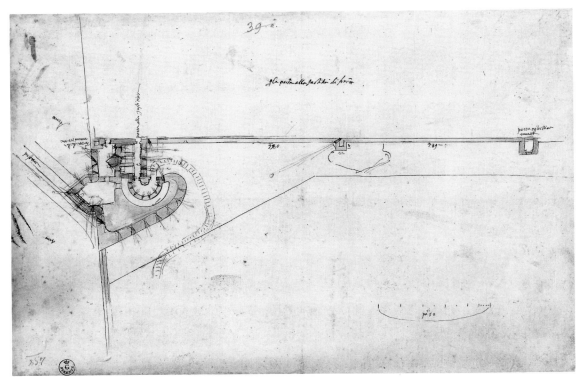

U 761A *recto*

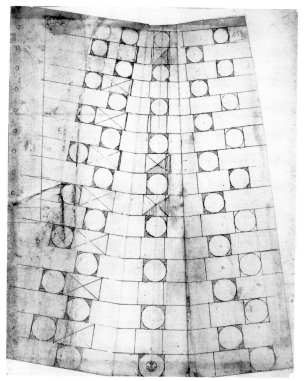

U 762A *recto*

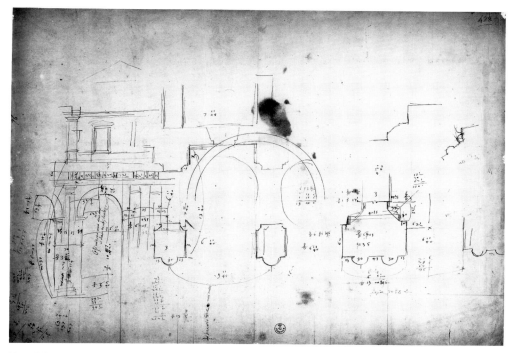

U 768A *recto*

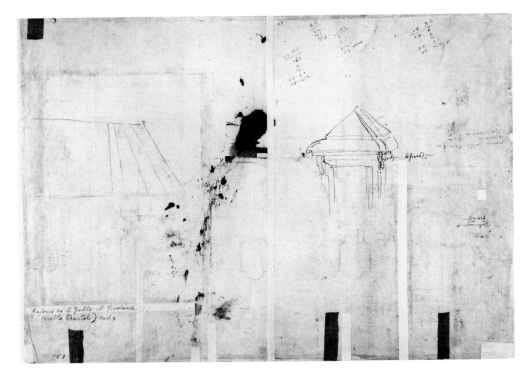

U 768A *verso*

U 769A *recto*

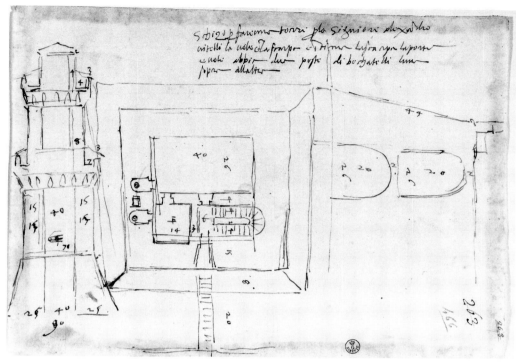

U 770A *recto*

U 771A *recto*

U 771A *verso*

U 772A *recto*

U 773A *recto*

U 774A *recto*

U 776A *recto*

U 777A *recto*

U 778A *recto*

U 779A *recto*

U 780A *recto*

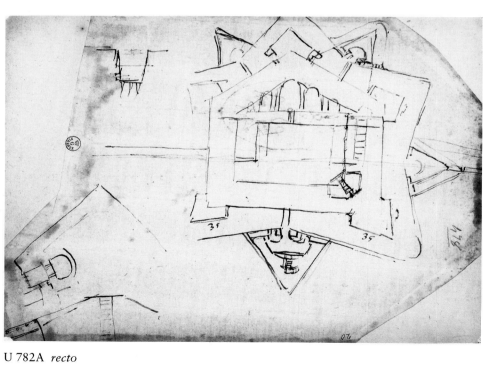

U 781A *recto*

U 782A *recto*

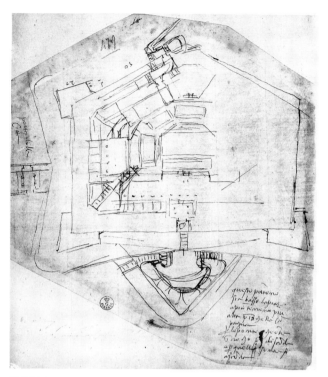

U 783A *recto*

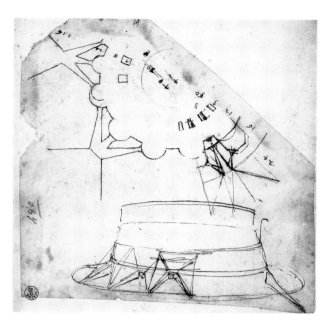

U 784A *recto*

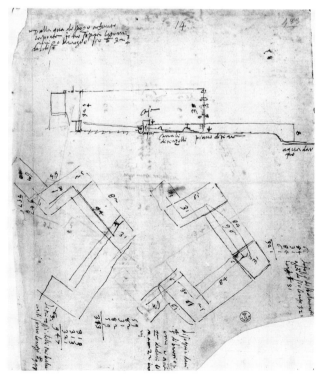

U 791A *recto*

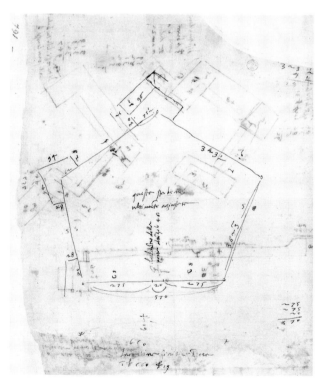

U 791A *verso*

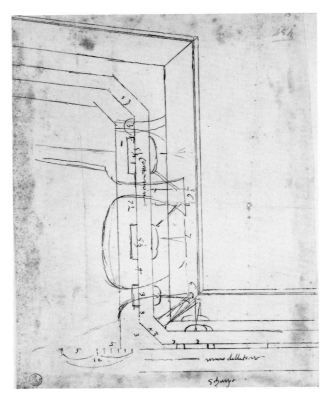

U 792A *recto*

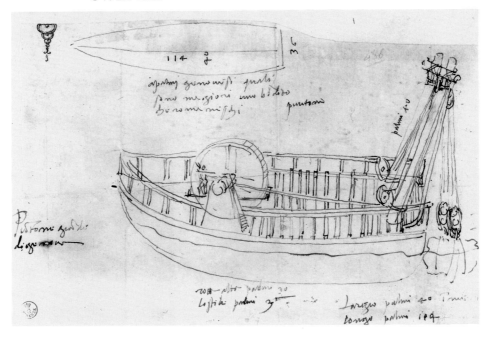

U 794A *recto*

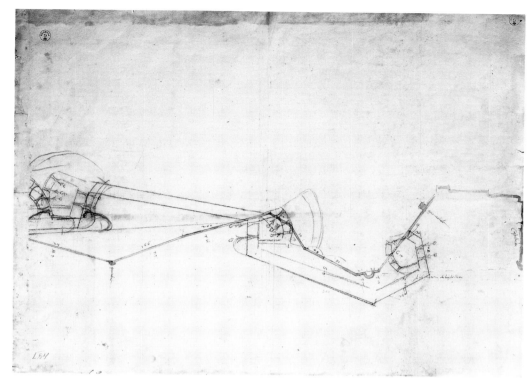

U 795A *recto*

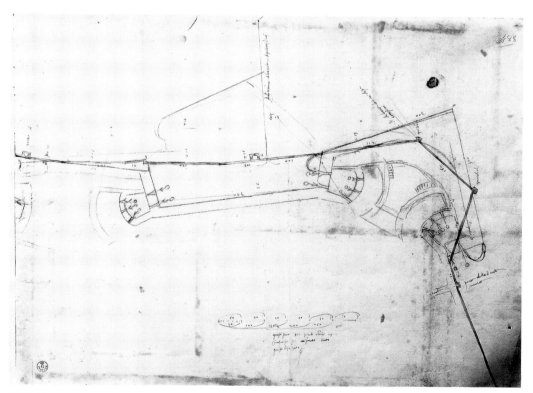

U 796A *recto*

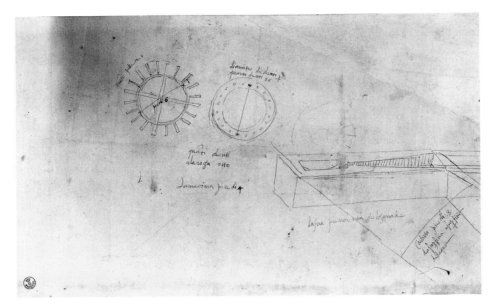

U 797A *recto*

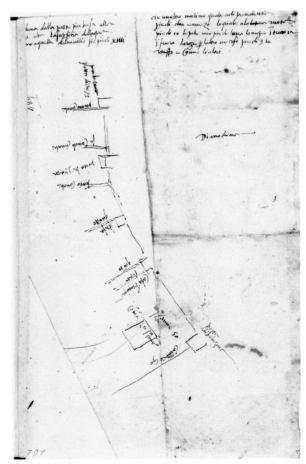

U 797A *verso*

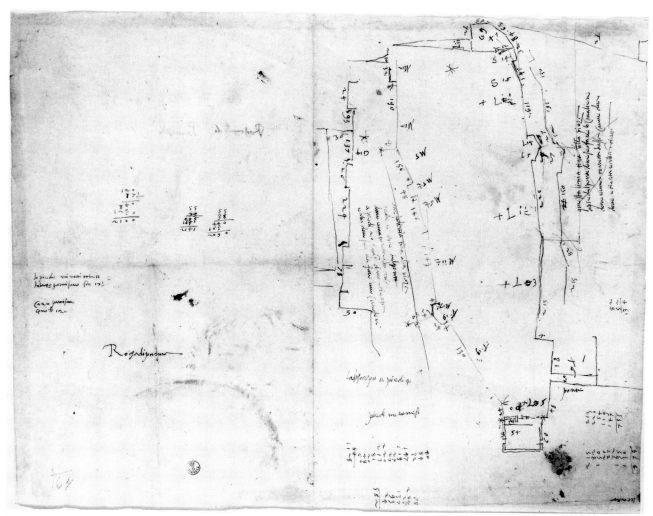

U 799A *recto*

315

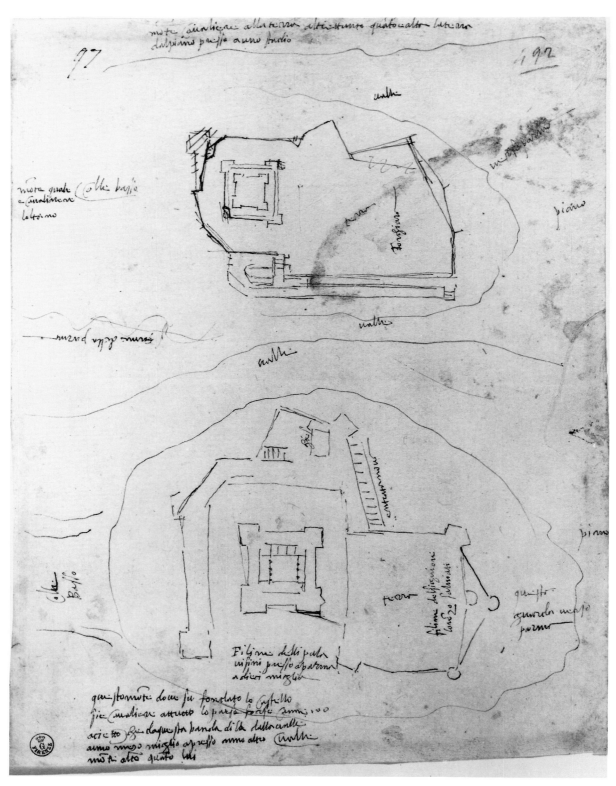

U 800A *recto*

316

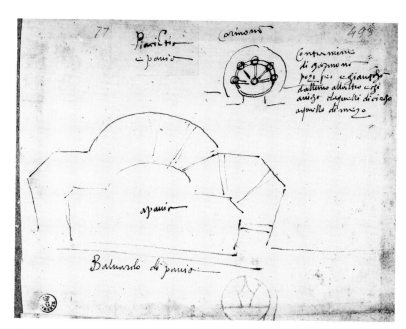

U 801A *recto*

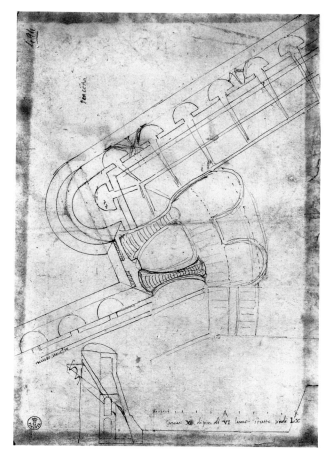

U 802A *recto*

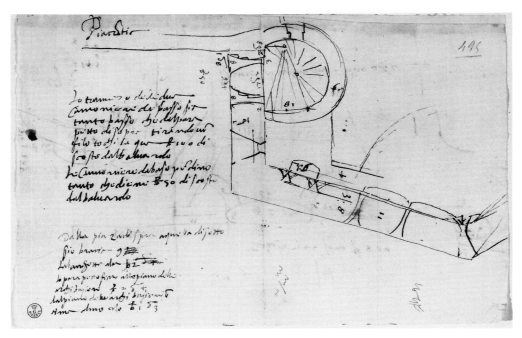

U 803A *recto*

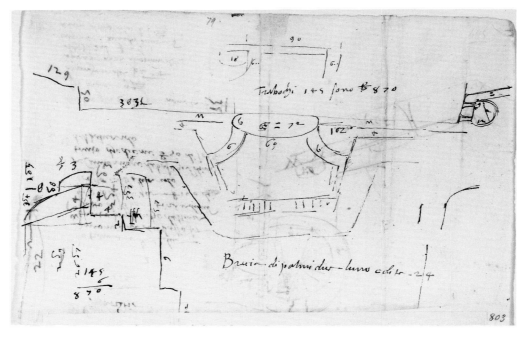

U 803A *verso*

U 804A *recto*

U 804A *verso*

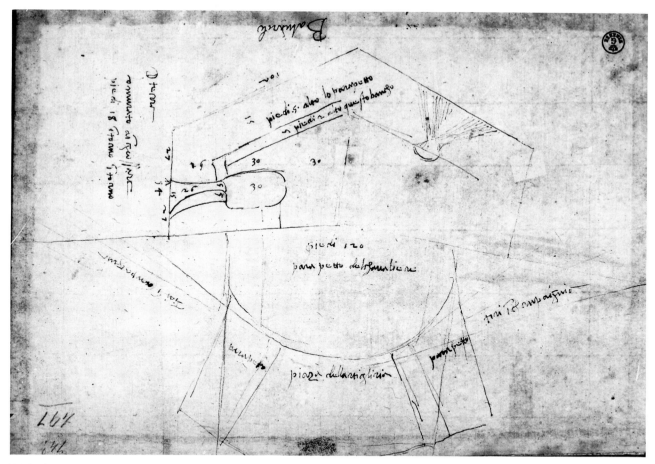

U 805A *recto*

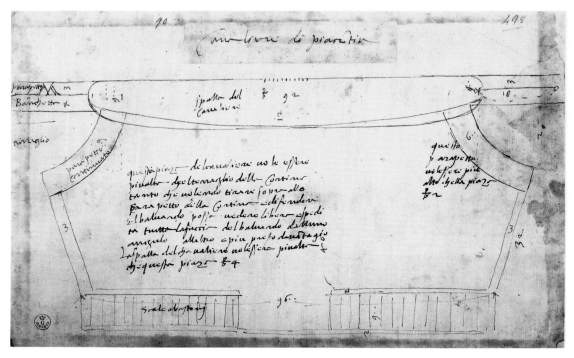

U 806A *recto*

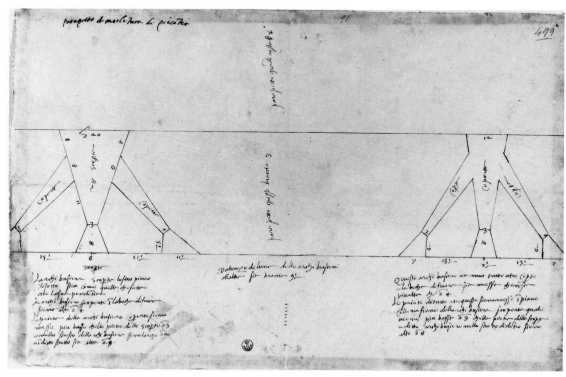

U 807A *recto*

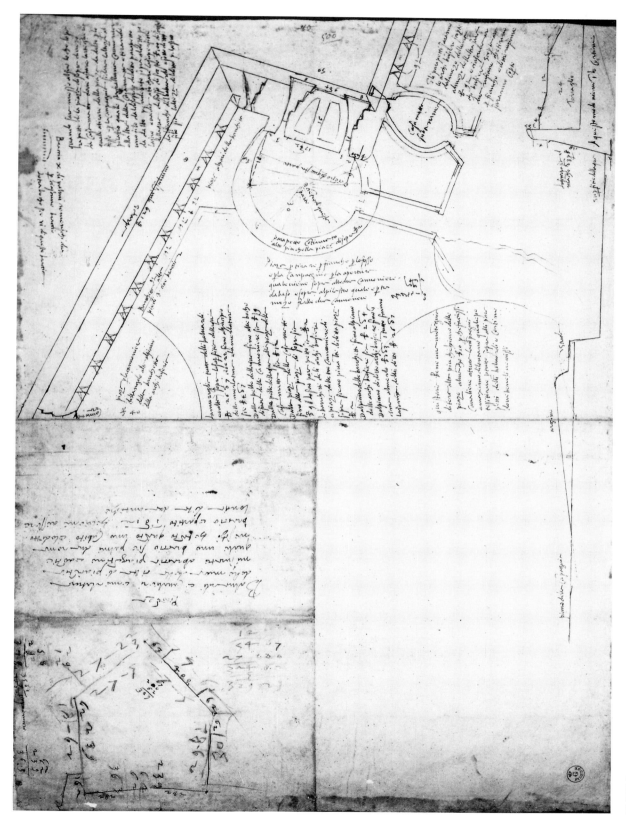

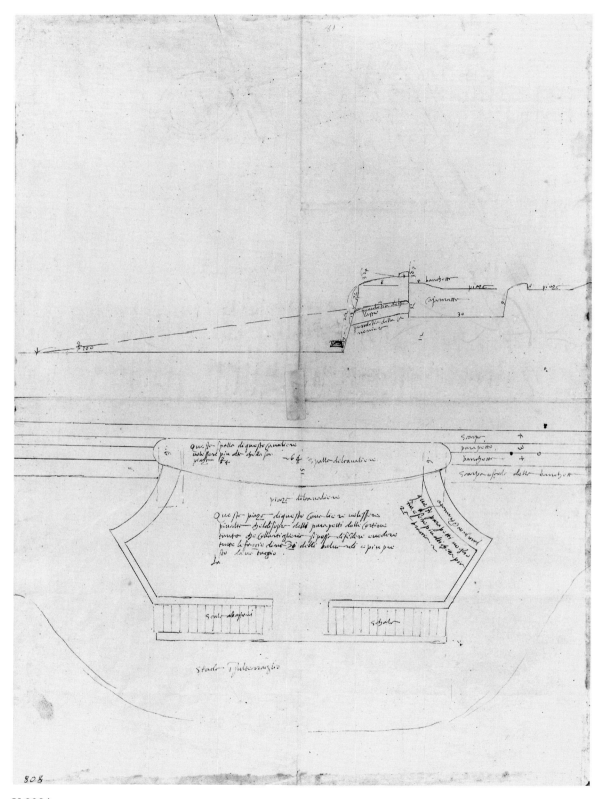

U 808A *verso*

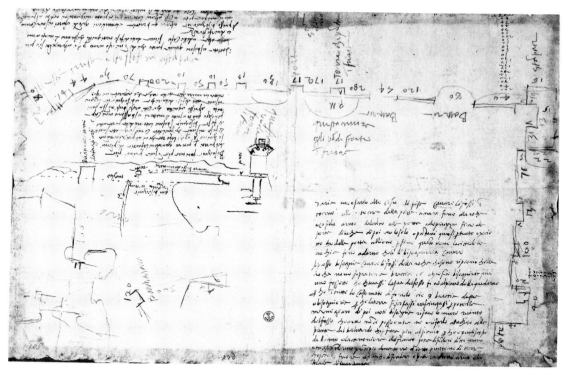

U 809A *recto*

U 809A *verso*

U 811A *recto*

U 811A *verso*

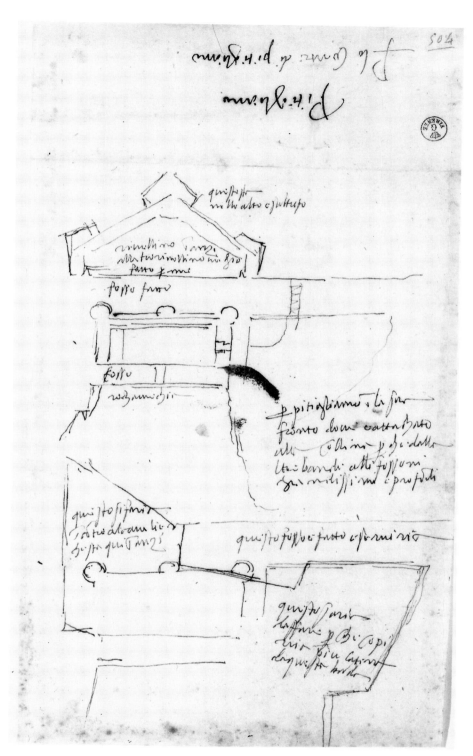

U 812A *recto*

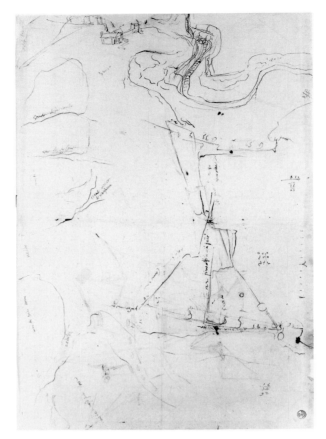

U 813A *recto*

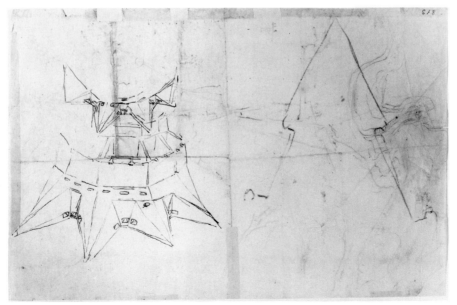

U 813A *verso*

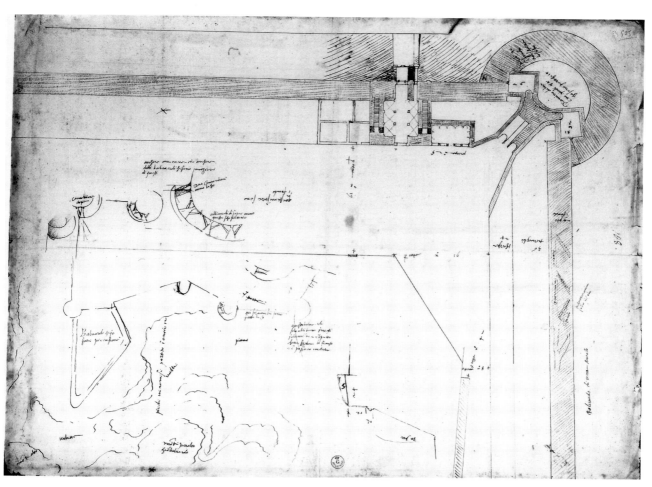

U 814A *recto*

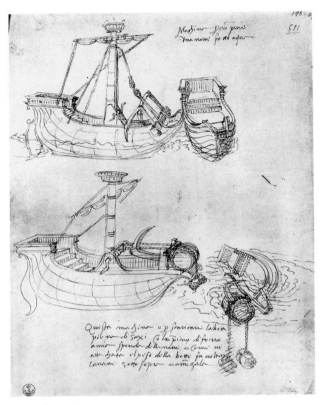

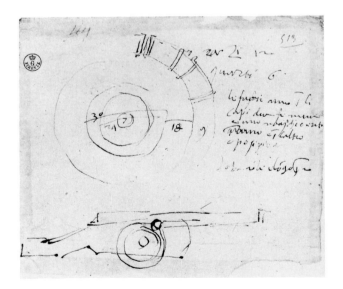

U 818A *recto*

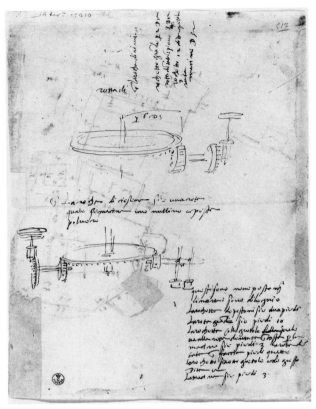

U 819A *recto*

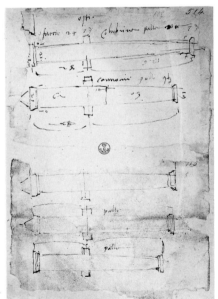

U 820A *recto*

U 821A *recto*

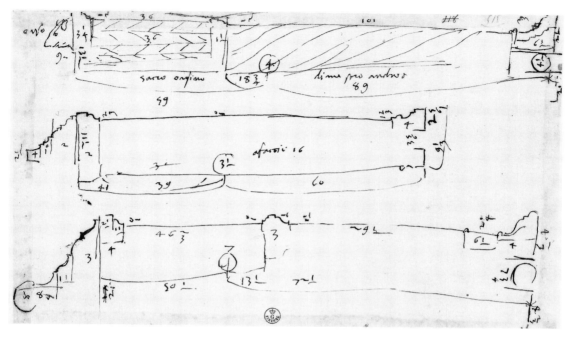

U 822A *recto*

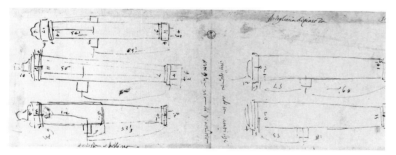

U 823A *recto*

U 824A *recto*

U 823A *verso*

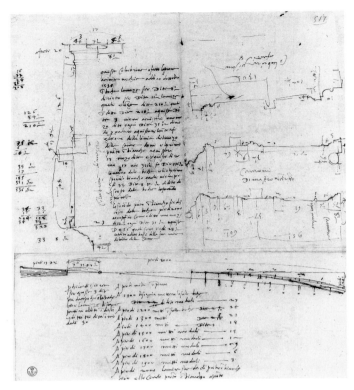

U 825A *recto*

U 825A *verso*

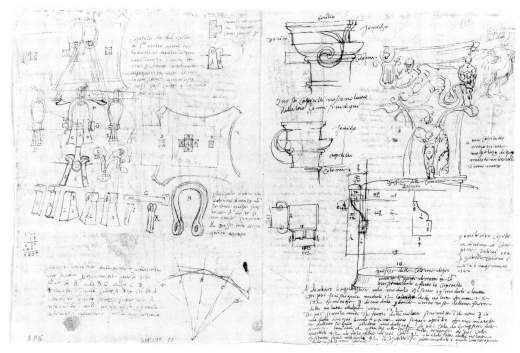

U 826A *verso*

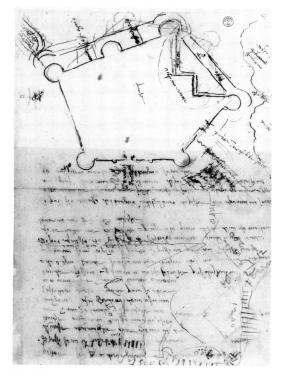

U 827A *recto*

U 827A *verso*

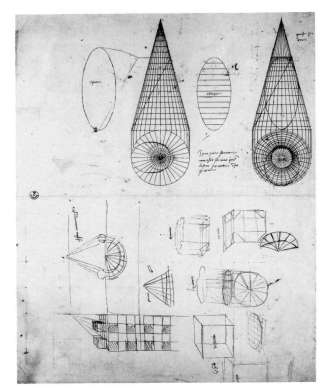

U 830A *recto*

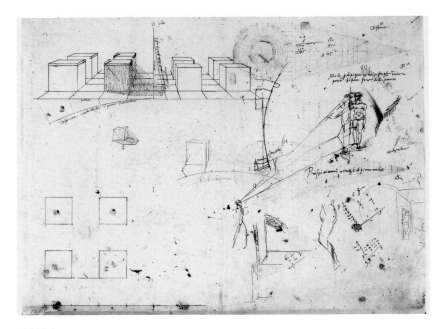

U 830A *verso*

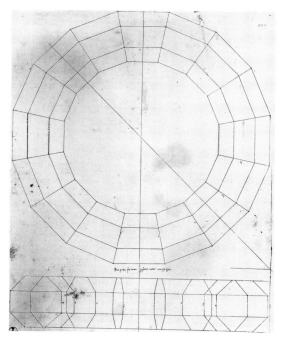

U 831A *recto*

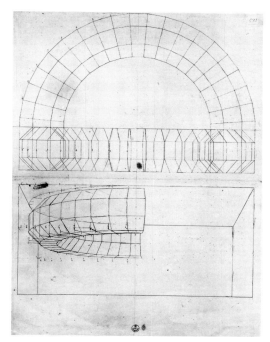

U 832A *recto*

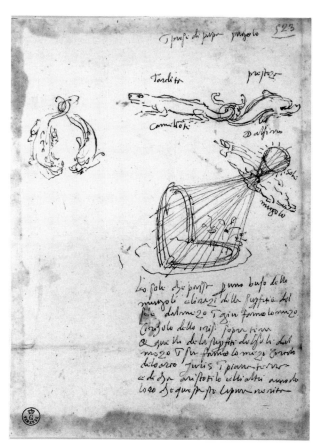

U 835A *recto*

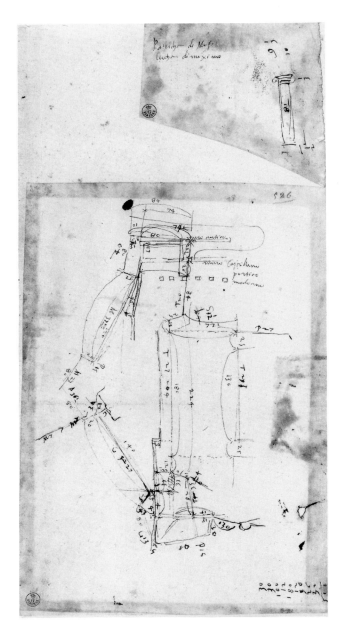

U 838A *recto*

U 839A *recto*

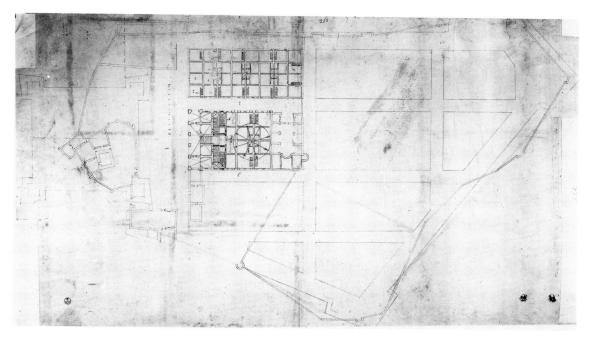

U 843A *recto*

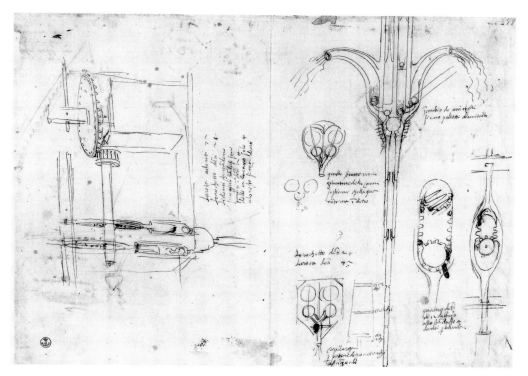

U 847A *recto*

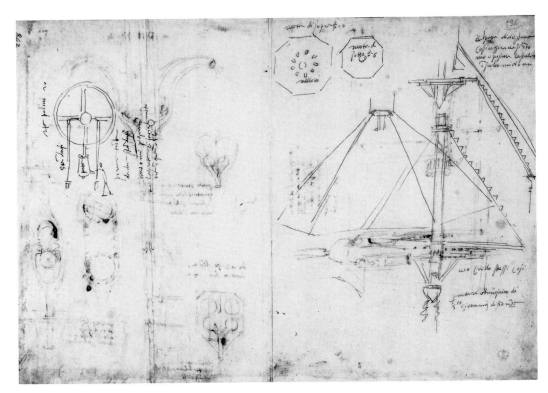

U 847A *verso*

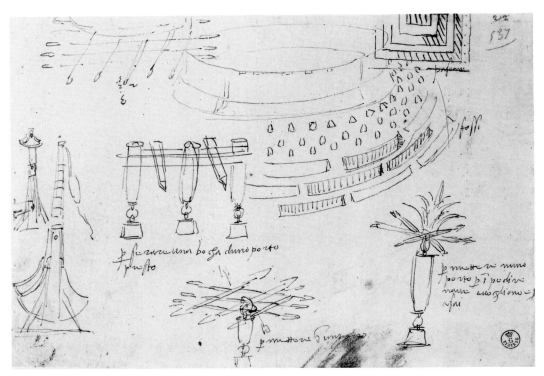

U 848A *recto*

U 849A *recto*

U 849A *verso*

U 850A *recto*

U 851A *verso*

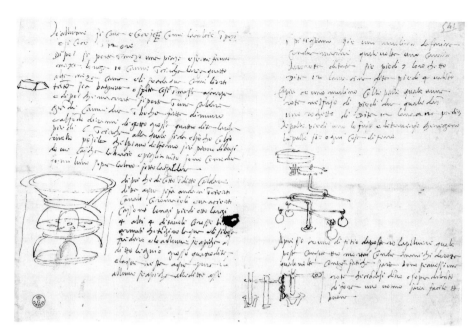

U 852A *recto*

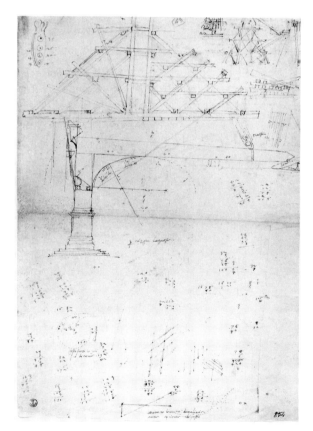

U 854A *recto*

339

U 855A *verso*

U 855A *recto*

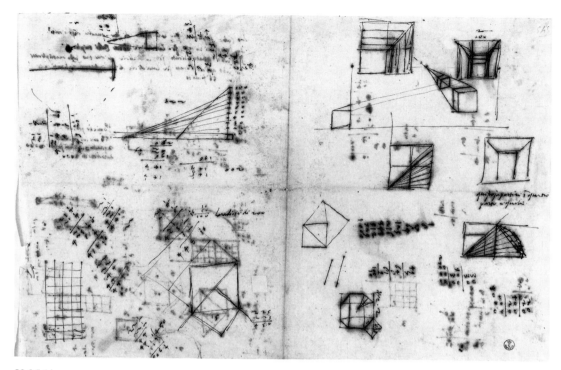

U 856A *recto*

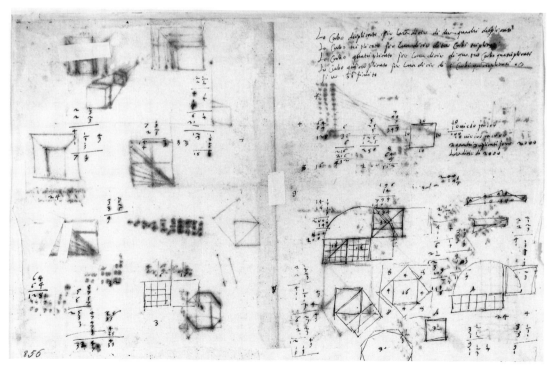

U 856A *verso*

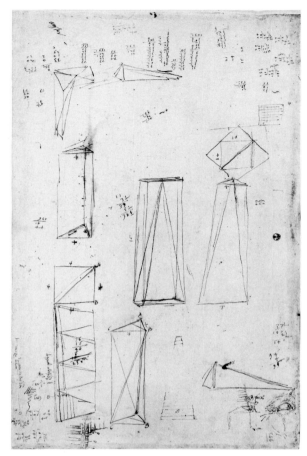

U 857A *recto*

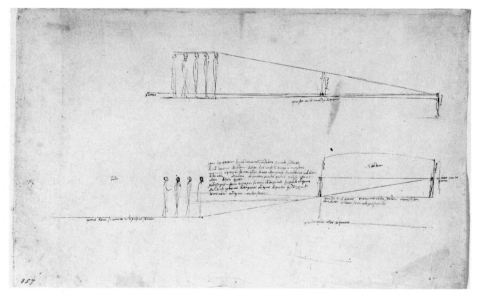

U 857A *verso*

U 858A *recto*

U 858A *verso*

U 859A *recto*

U 880A *recto*

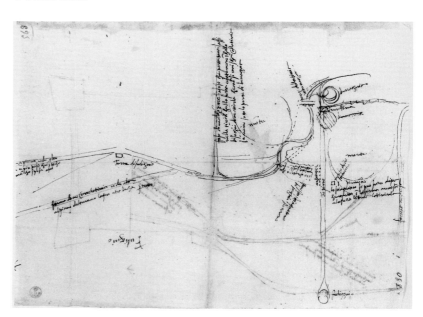

U 880A *verso*

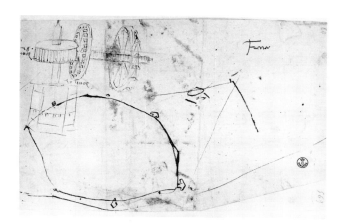

U 881A *recto*

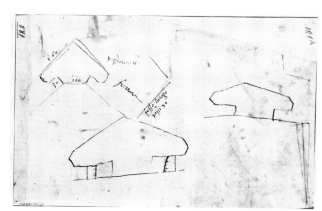

U 881A *verso*

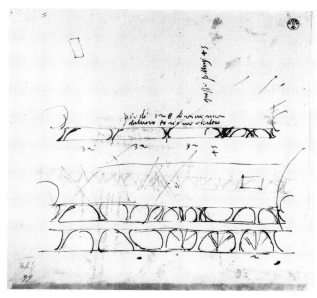

U 884A *recto*

U 884A *verso*

345

U 885A *recto*

346

U 889A *recto*

U 887A *verso*

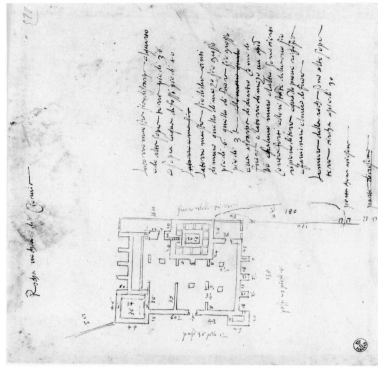

U 890A *recto*

U 889A *verso*

U 891A *recto*

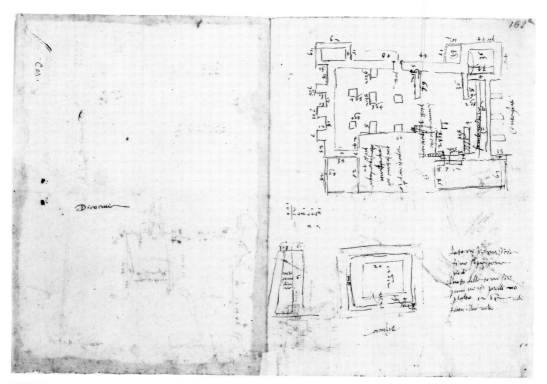

U 891A *verso*

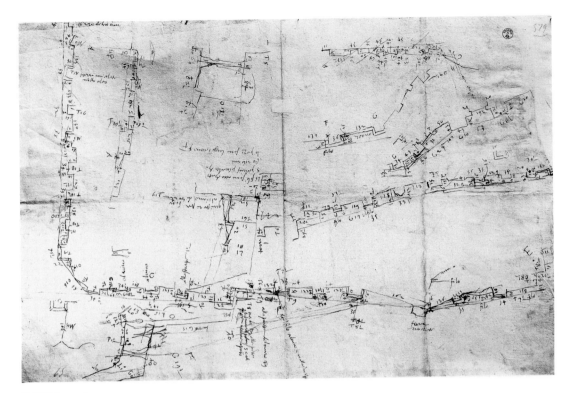

U 892A *recto*

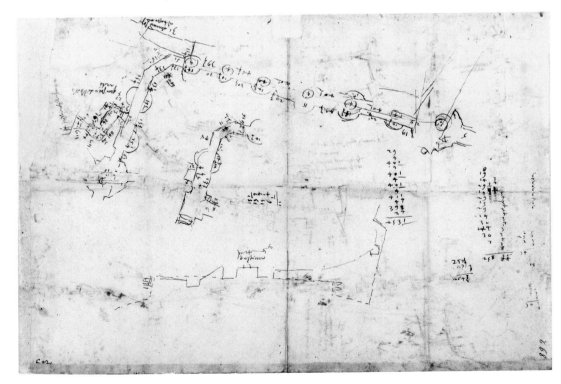

U 892A *verso*

U 893A *recto*

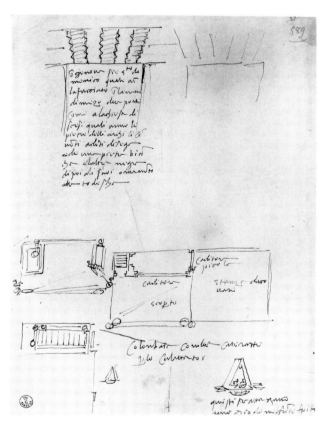

U 901A *recto*

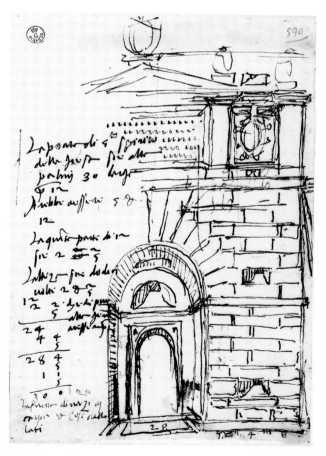

U 902A *recto*

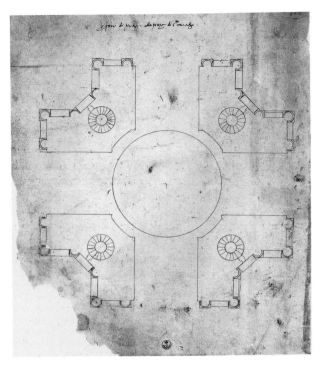

U 914A *recto*

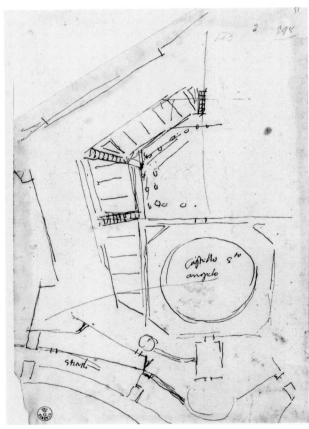

U 910A *recto*

U 929A *recto*

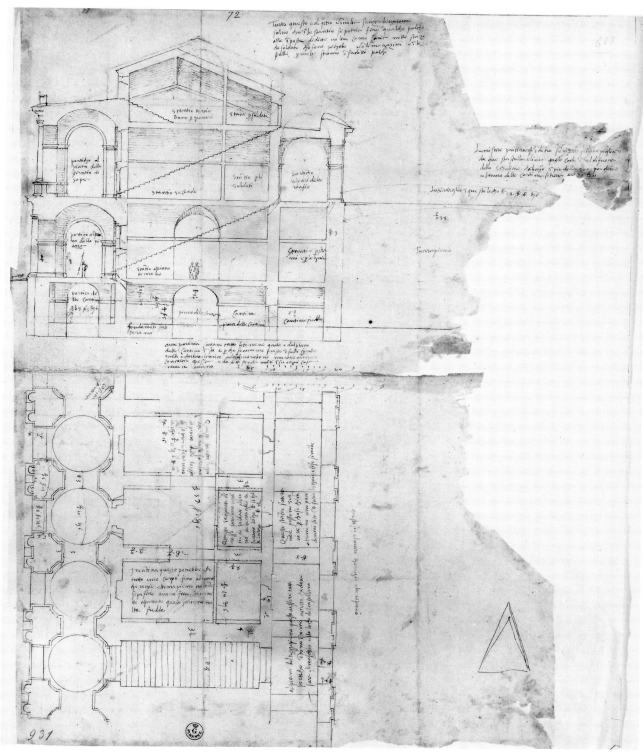

U 931A *recto*

353

U 933A *recto*

U 934A *recto*

U 934A *verso*

U 935A *recto*

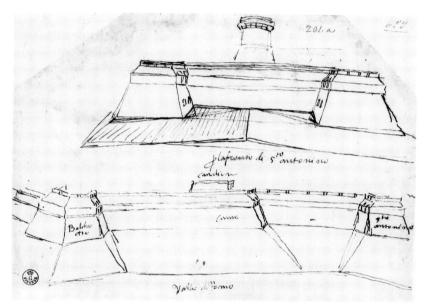

U 936A *recto*

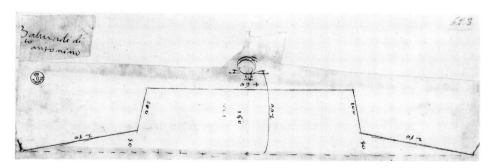

U 937A *recto*

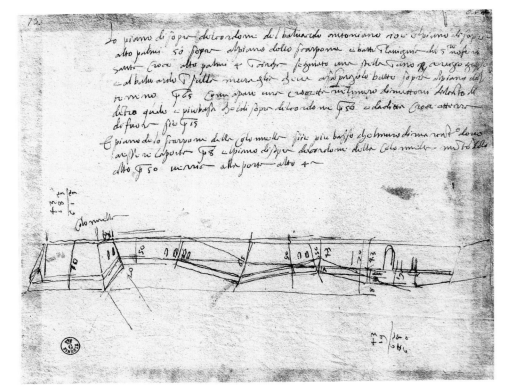

U 938A *recto*

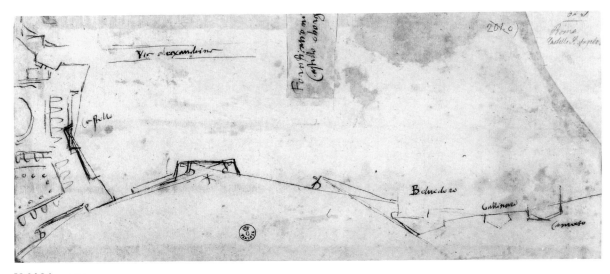

U 939A *recto*

356

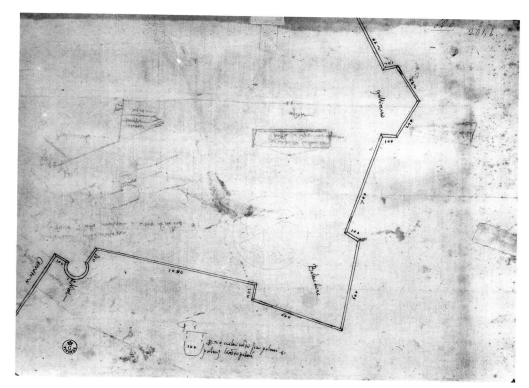

U 940A *recto*

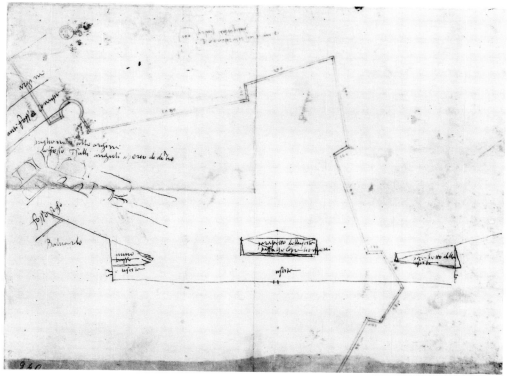

U 940A *verso*

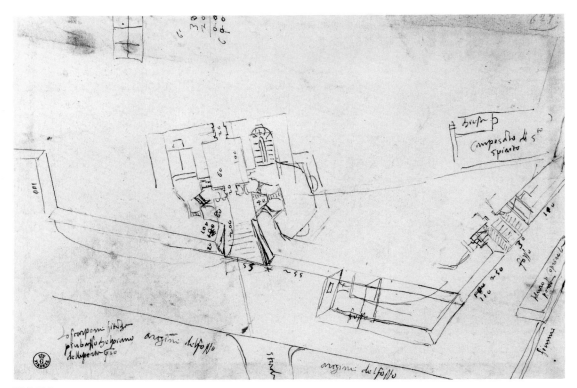

U 941A *recto*

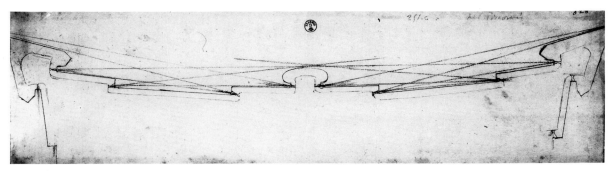

U 942A *recto*

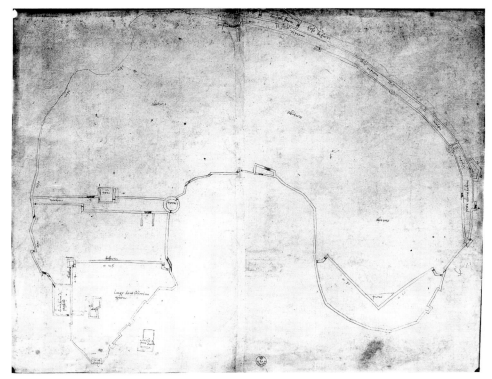

U 943A *recto*

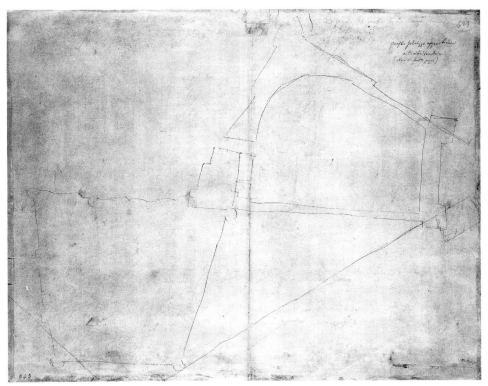

U 943A *verso*

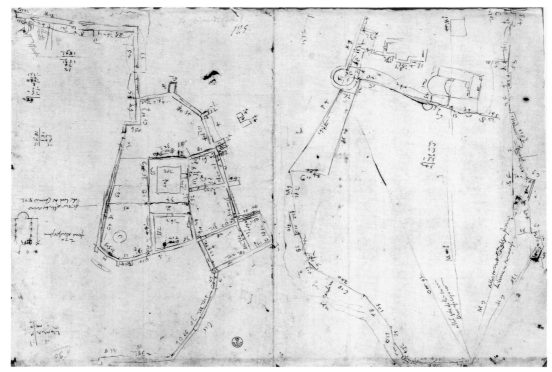

U 944A *recto*

U 945A *recto*

U 946A *recto*

U 953A *recto*

U 954A *recto*

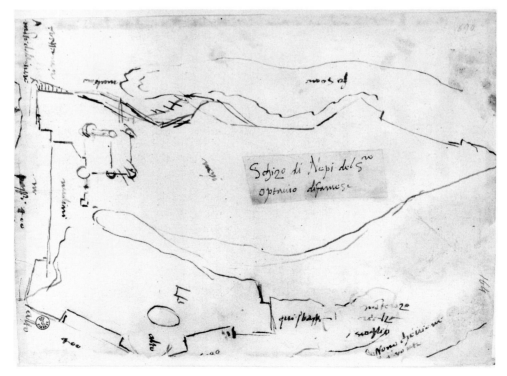

U 955A *recto*

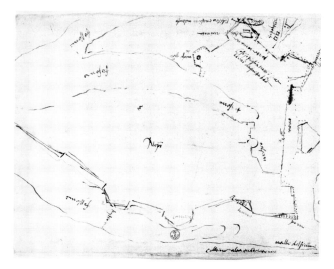

U 956A *recto*

U 958A *verso*

U 961A *recto*

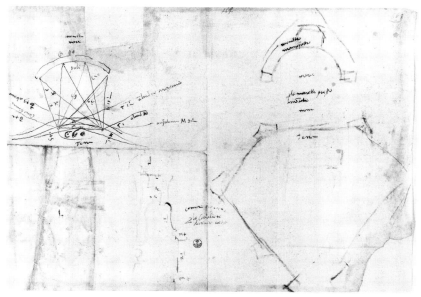

U 963A *recto*

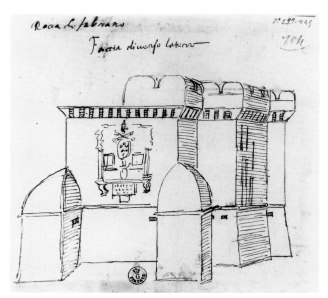

U 970A *recto*

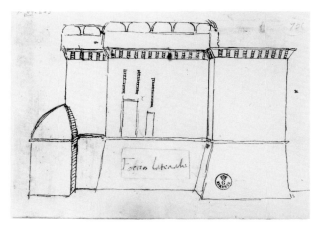

U 971A *recto*

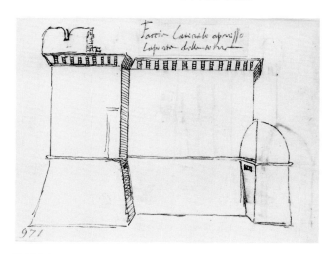

U 971A *verso*

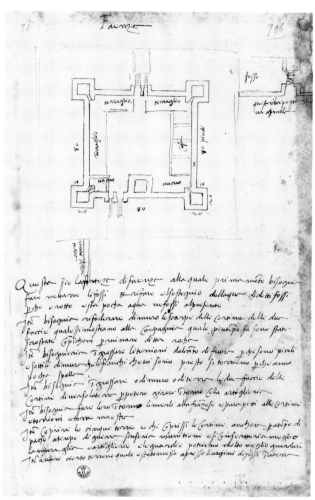

U 972A *recto*

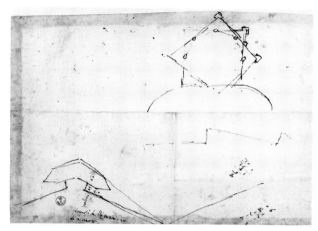

U 973A *recto*

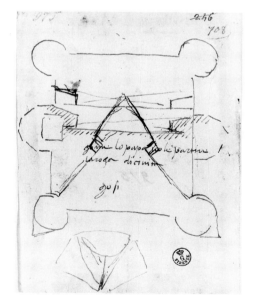

U 975A *recto*

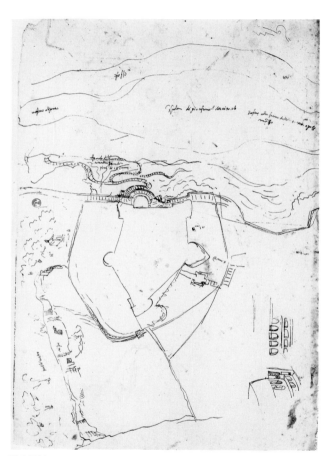

U 977A *recto*

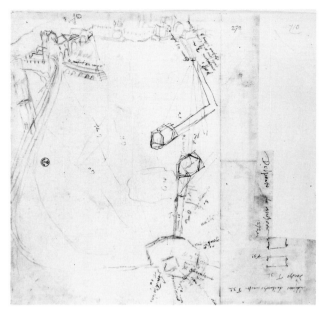

U 978A *recto*

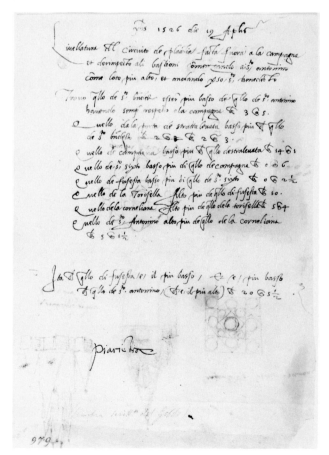

U 979A *verso*

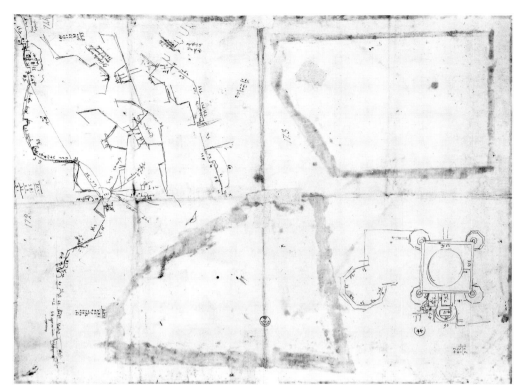

U 1012A *recto*

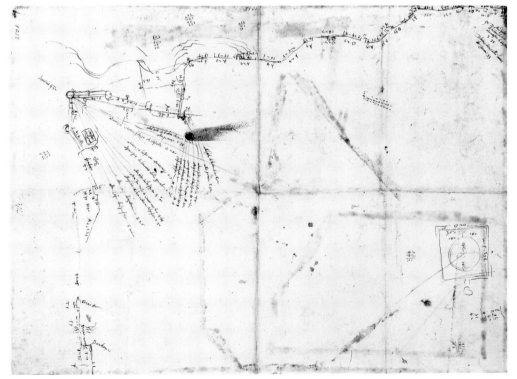

U 1012A *verso*

U 1014A *recto*

U 1015A *recto*

U 1016A *recto*

U 1016A *verso*

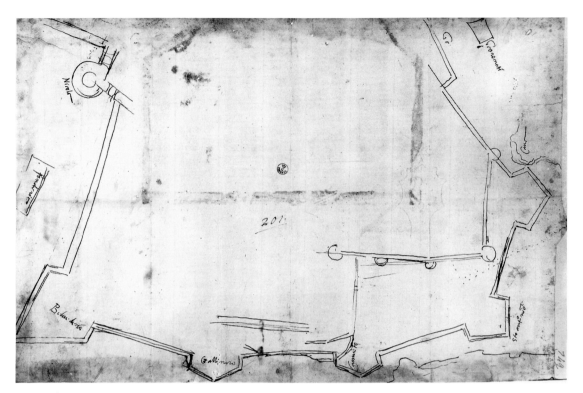

U 1017A *recto*

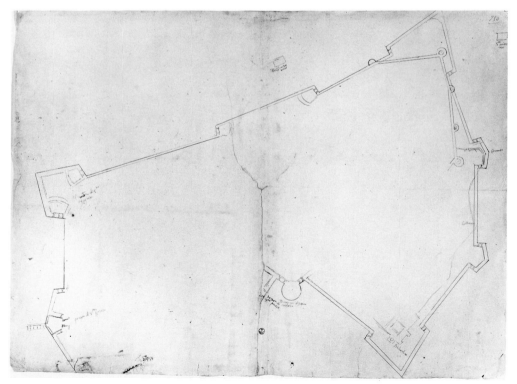

U 1018A *recto*

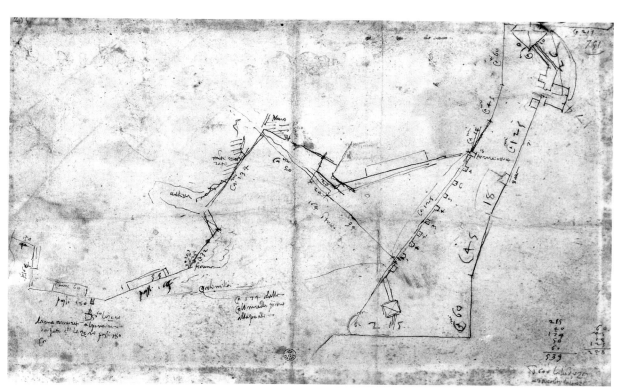

U 1019A *recto*

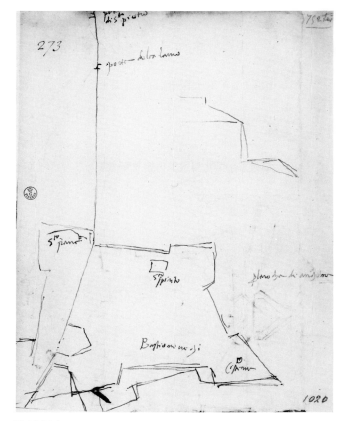

U 1020A *recto*

U 1020A *verso*

U 1021A *recto*

U 1022A *recto*

374

U 1024A *recto*

U 1025A *recto*

U 1026A *recto*

U 1026A *verso*

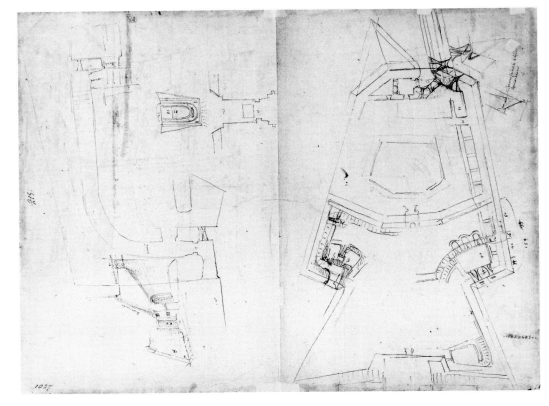

U 1027A *verso*

U 1027A *recto*

378

U 1028A *recto*

379

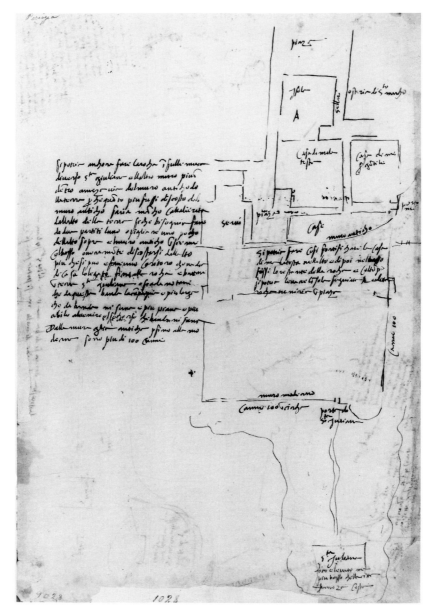

U 1028A *verso*

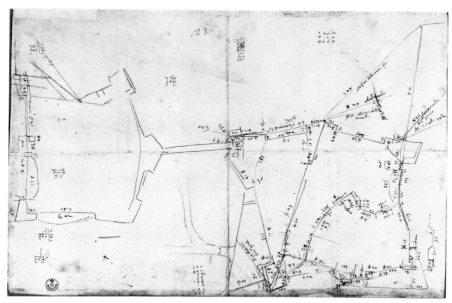

U 1029A *recto*

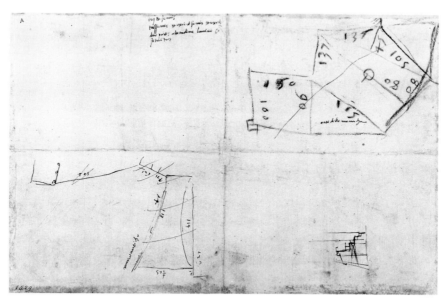

U 1029A *verso*

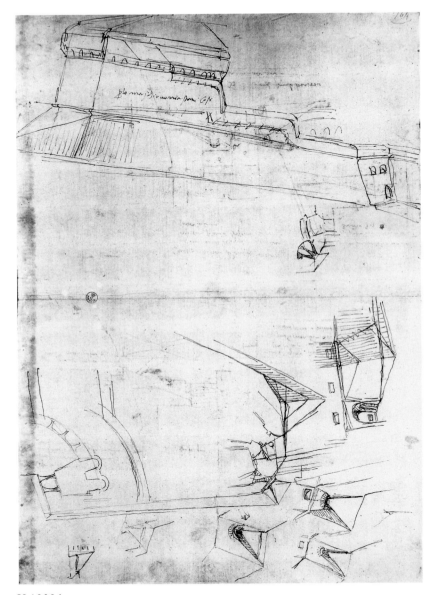

U 1030A *recto*

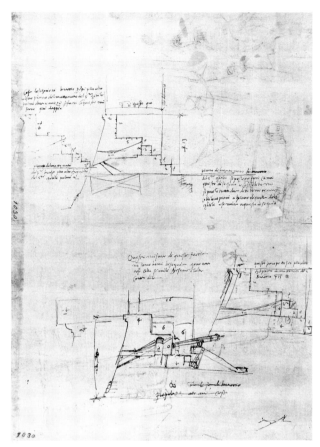

U 1030A *verso*

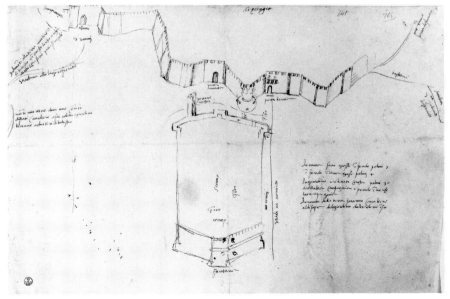

U 1031A *recto*

383

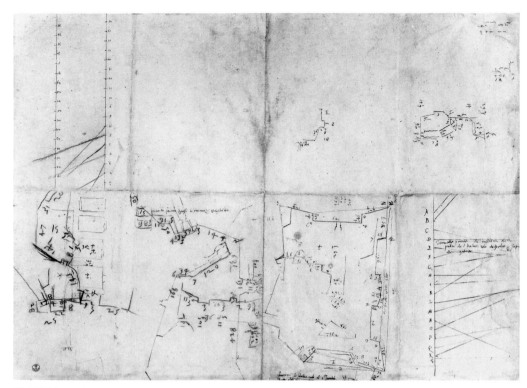

U 1032A *recto*

U 1032A *verso*

U 1041A *verso*

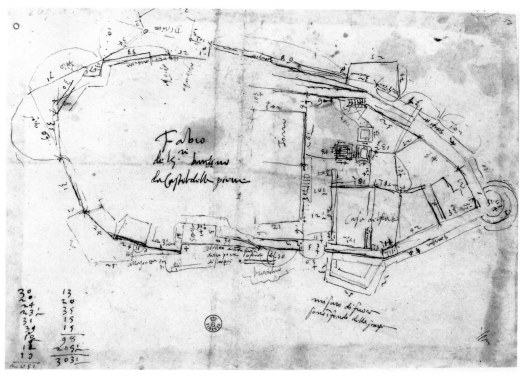

U 1049A *recto*

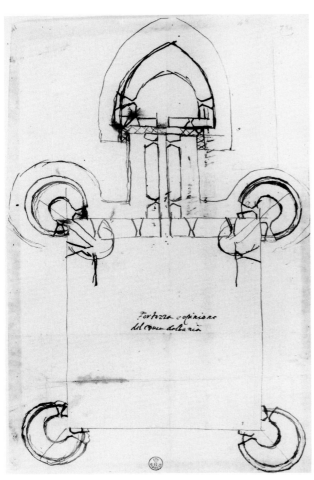

U 1051A *recto*

U 1052A *recto*

U 1053A *recto*

386

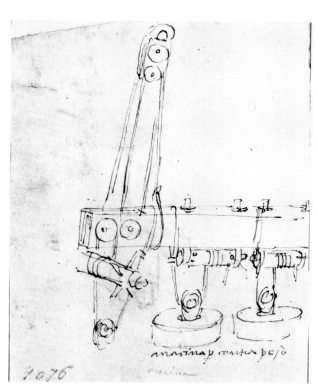

U 1076A *verso*

U 1087A *recto*

U 1092A *verso*

387

U 1096A *recto*

1096

U 1096A *verso*

U 1102A *recto*

U 1106A *recto*

U 1113A *recto*

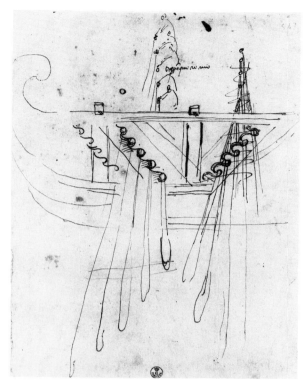

U 1114A *recto*

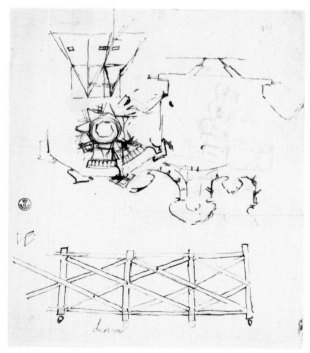

U 1118A *recto*

U 1118A *verso*

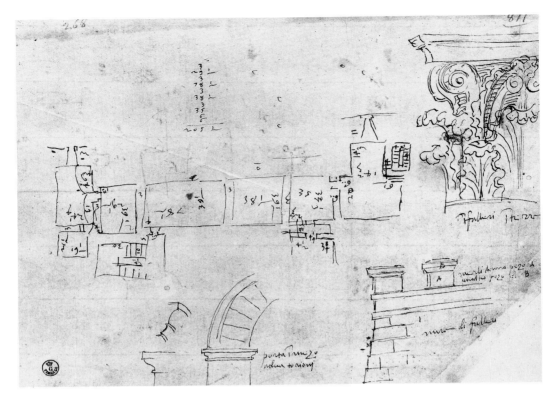

U 1145A *recto*

U 1145A *verso*

U 1155A *recto*

U 1179A *recto*

U 1185A *recto*

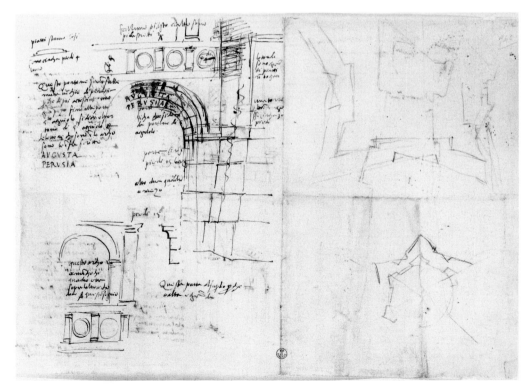

U 1207A *recto*

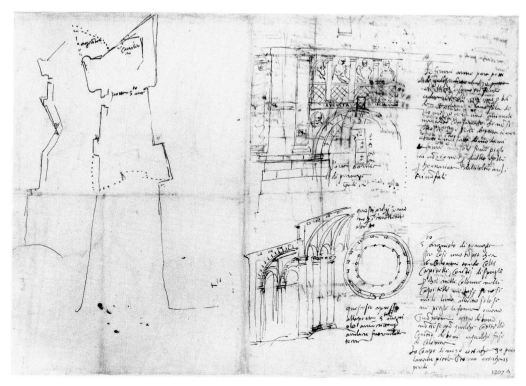

U 1207A *verso*

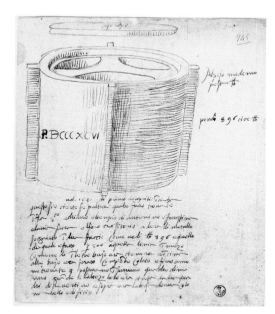

U 1212A *recto*

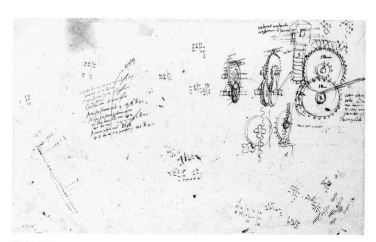

U 1215A *verso*

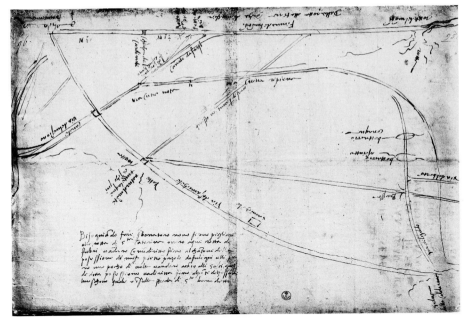

U 1217A *recto*

U 1217A *verso*

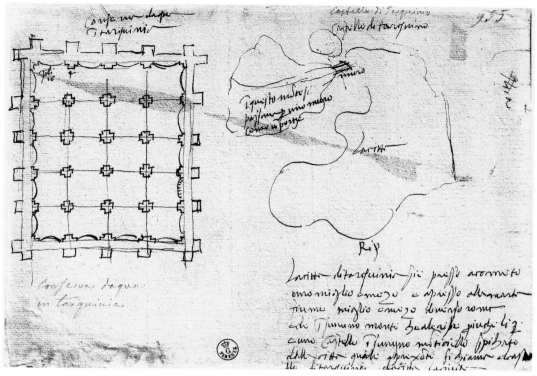

U 1222A *recto*

U 1242A *recto*

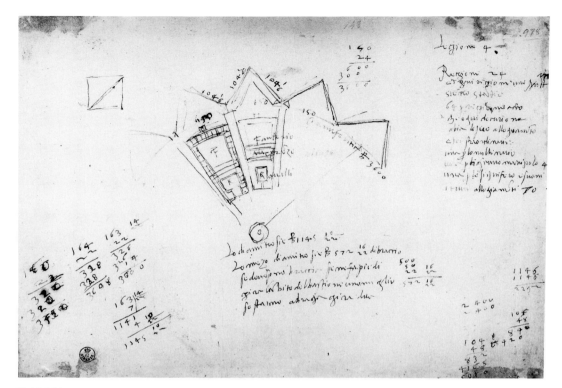

U 1245A *recto*

U 1256A *recto*

U 1268A *recto*

U 1269A *recto*

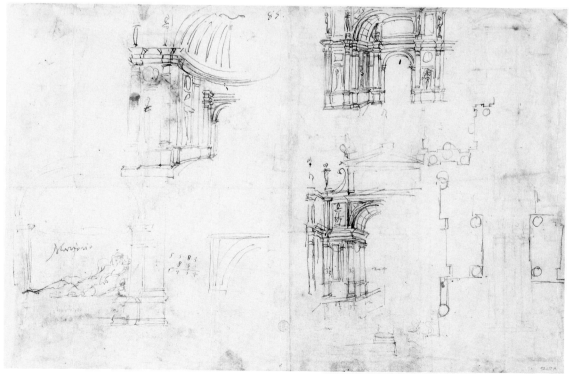

U 1269A *verso*

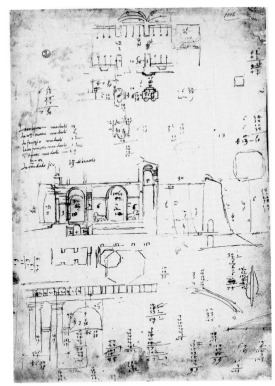

U 1282A *recto*

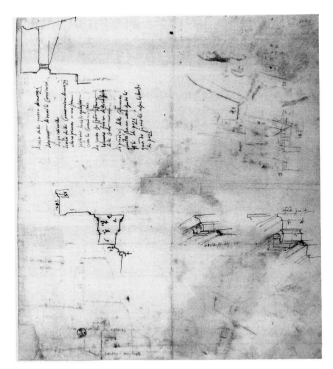

U 1289A *recto*

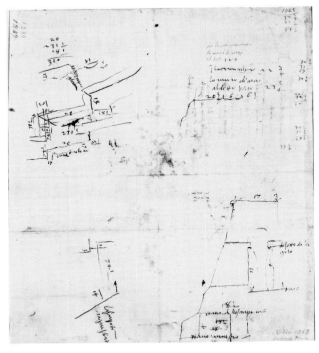

U 1289A *verso*

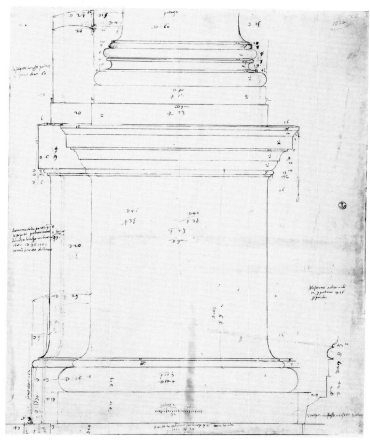

U 1290A *recto*

U 1294A *recto*

U 1302A *recto*

U 1302A *verso*

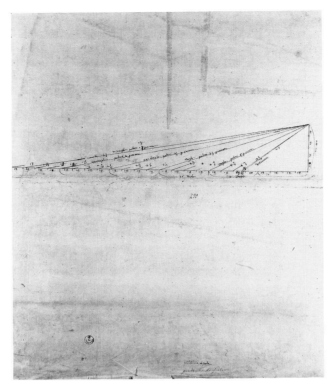

U 1317A *recto*

U 1344A *recto*

U 1344A *verso*

U 1353A *recto*

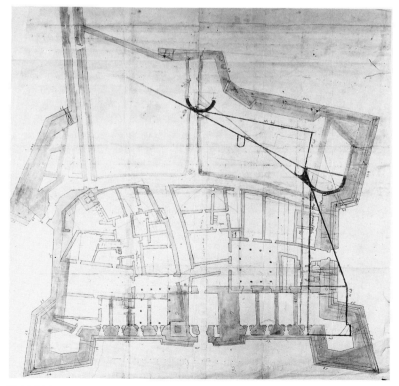

U 1354A *recto*

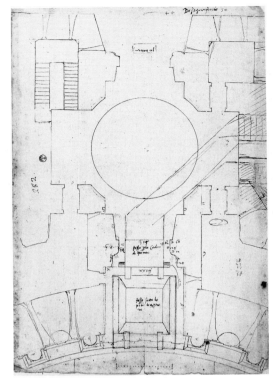

U 1359A *recto*

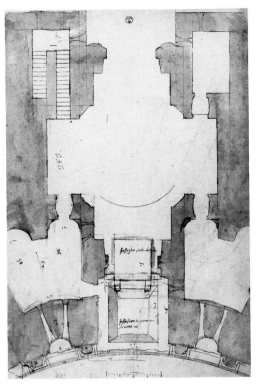

U 1360A *recto*

U 1360A *verso*

U 1361A *recto*

U 1362A *recto*

U 1389A *recto*

U 1390A *recto*

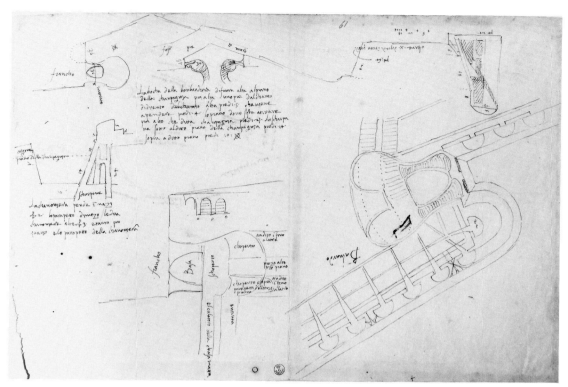

U 1392A *recto*

U 1392A *verso*

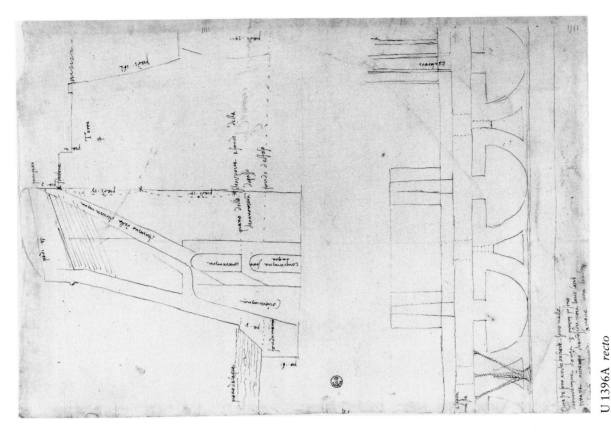

U 1396A *recto*

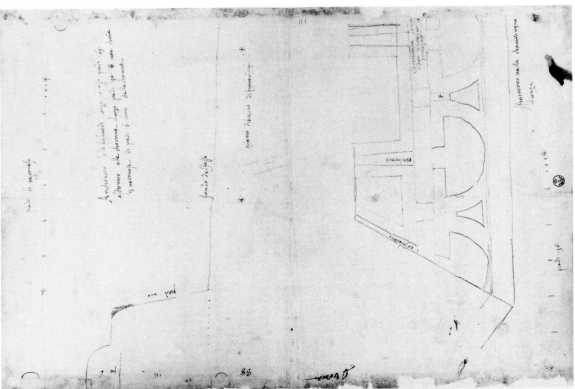

U 1395A *recto*

U 1409A *verso*

U 1419A *recto*

U 1397A *recto*

U 1424A *recto*

U 1425A *recto*

U 1431A *recto*

U 1431A *verso*

U 1432A *recto*

U 1435A *recto*

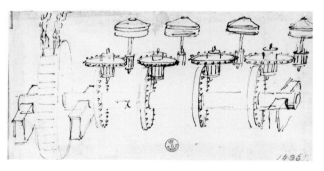

U 1436A *recto*

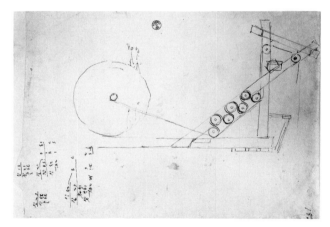

U 1437A *recto*

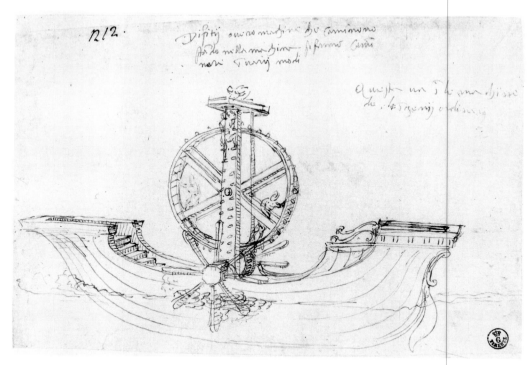

U 1438A *recto*

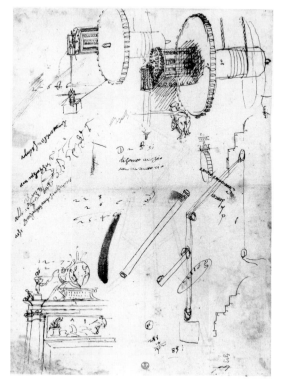

U 1439A *recto*

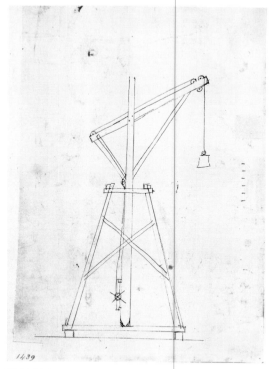

U 1439A *verso*

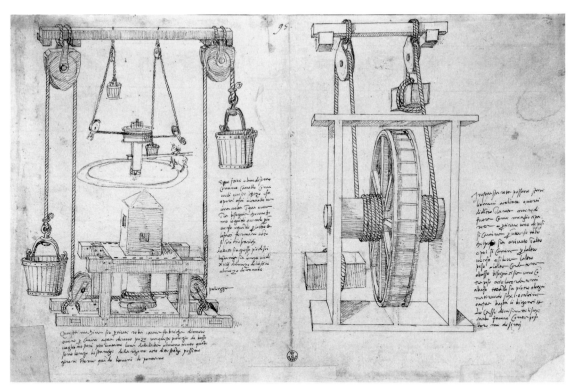

U 1440A *recto*

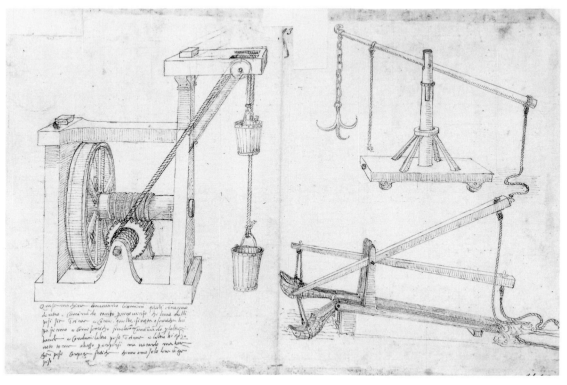

U 1440A *verso*

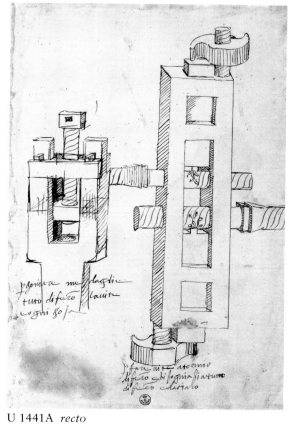

U 1441A *recto*

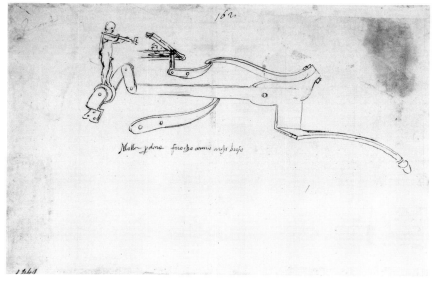

U 1441A *verso*

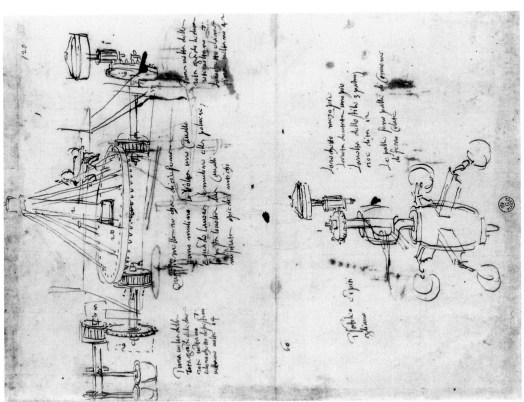

U 1442A *verso*

U 1442A *recto*

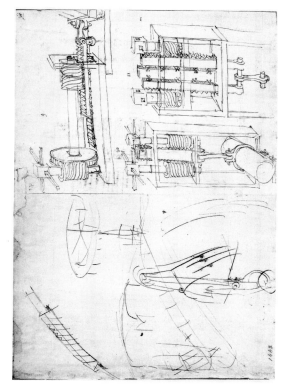

U 1443A *verso*

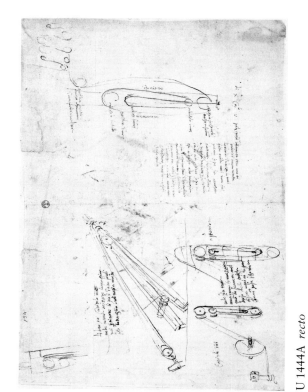

U 1444A *recto*

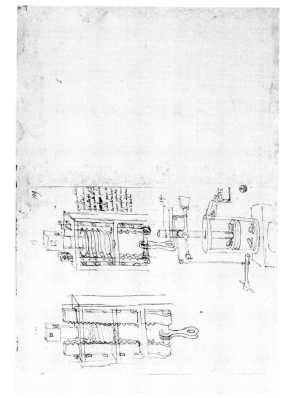

U 1443A *recto*

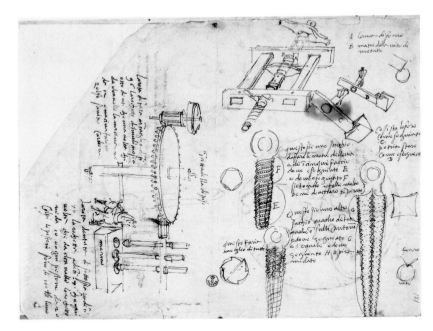

U 1445A *recto*

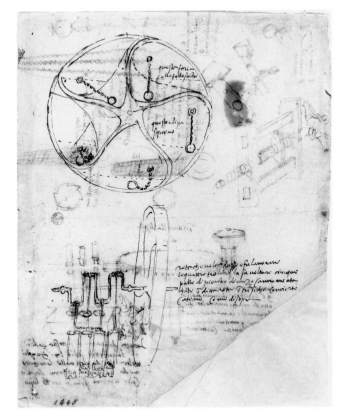

U 1445A *verso*

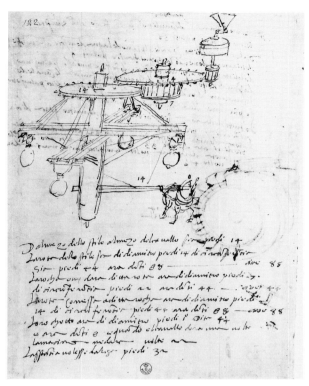

U 1446A *recto*

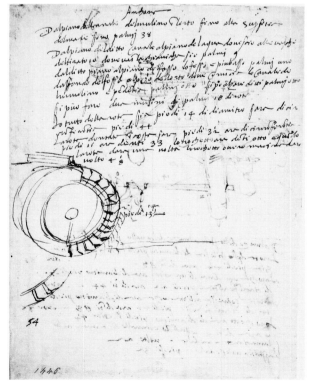

U 1446A *verso*

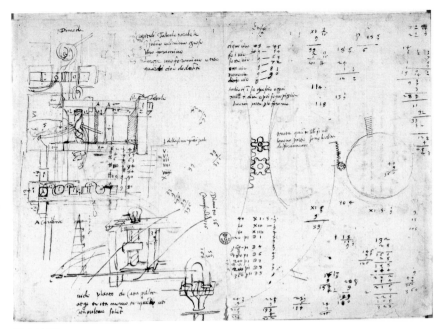

U 1447A *recto*

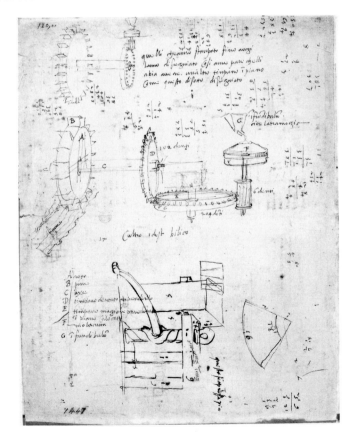

U 1447A *verso*

422

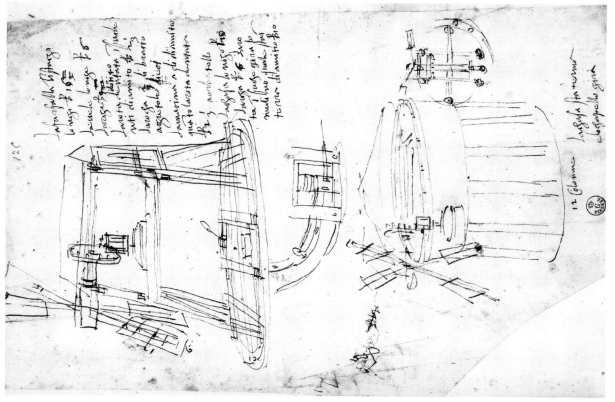

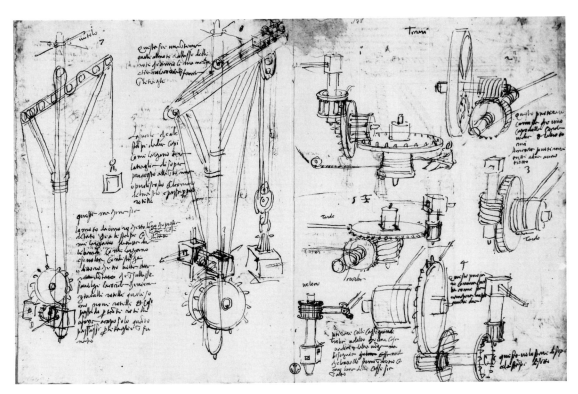

U 1449A *recto*

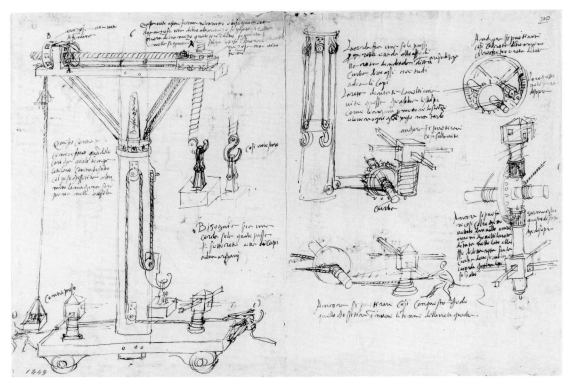

U 1449A *verso*

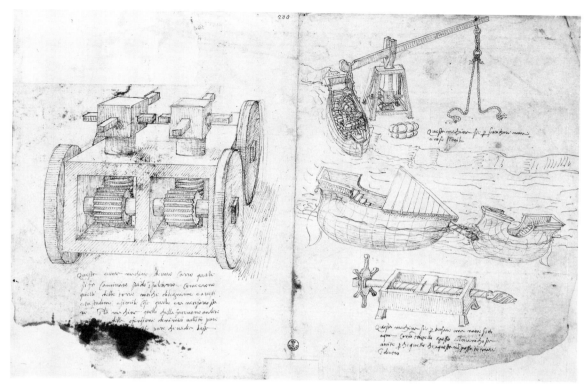

U 1450A *recto*

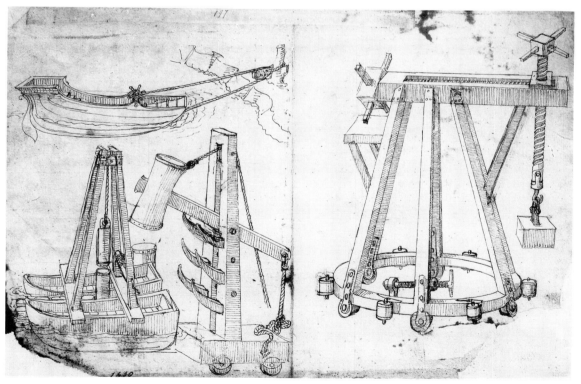

U 1450A *verso*

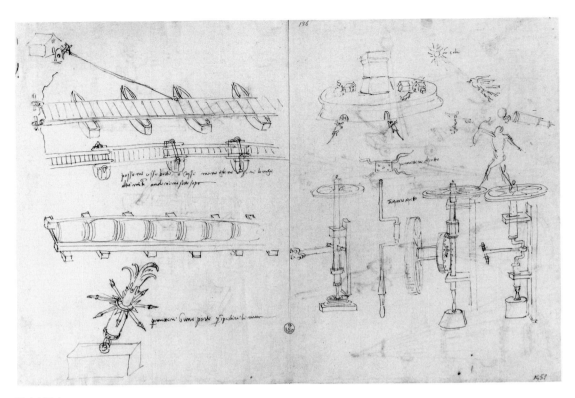

U 1451A *recto*

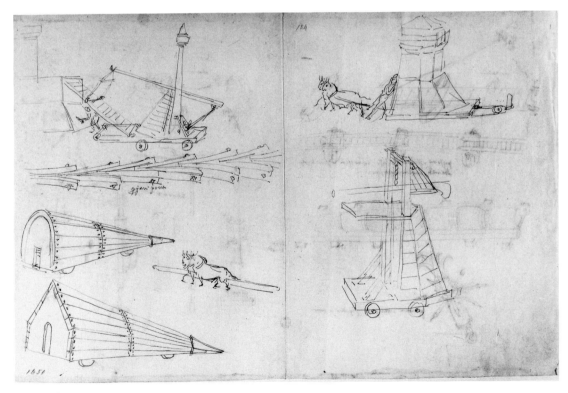

U 1451A *verso*

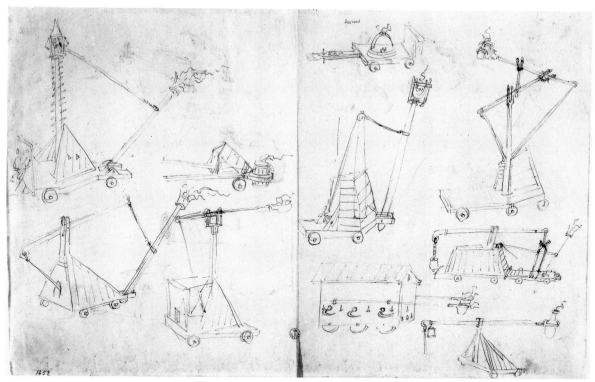

U 1452A *recto*

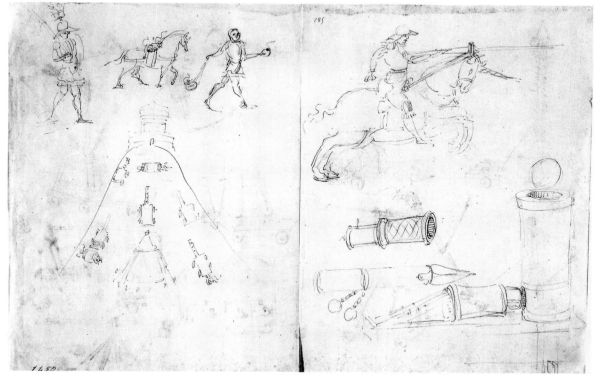

U 1452A *verso*

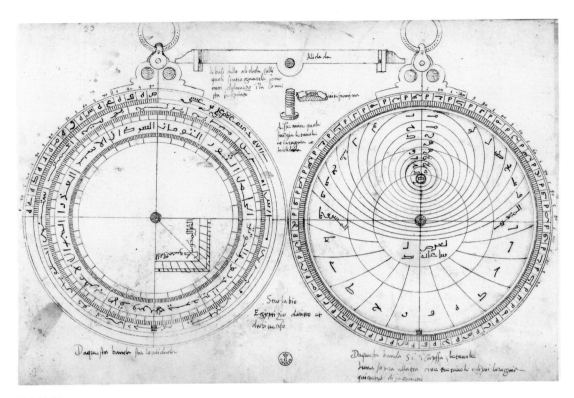

U 1454A *recto*

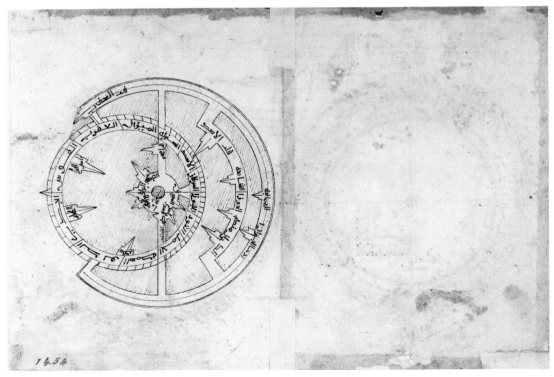

U 1454A *verso*

428

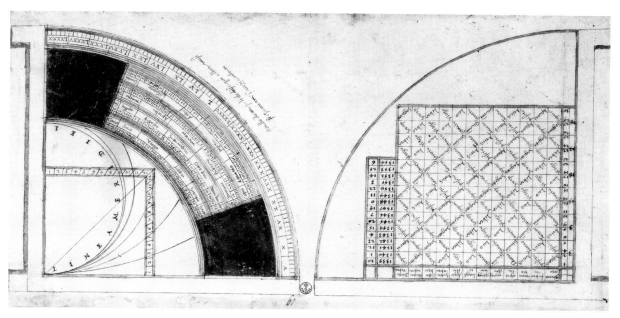

U 1455A *recto*

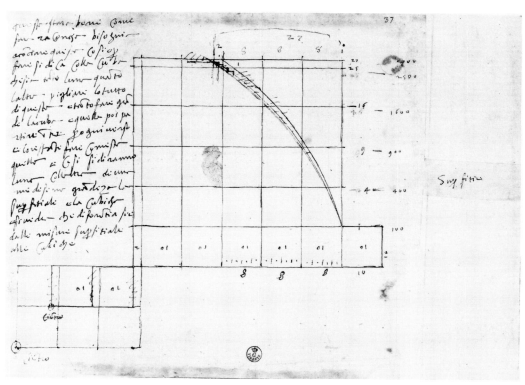

U 1456A *recto*

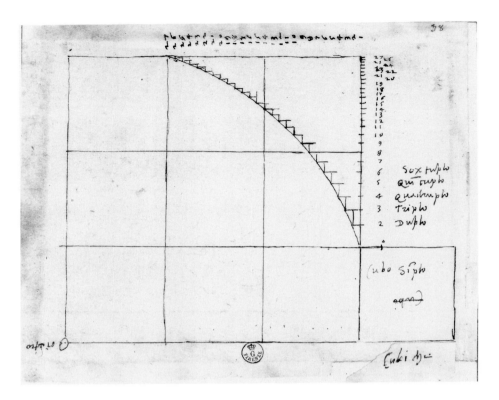

U 1457A *recto*

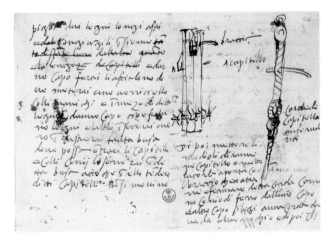

U 1458A *recto*

U 1458A *verso*

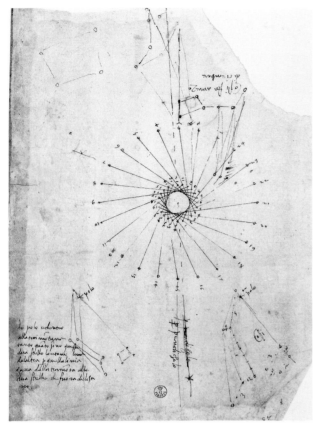

U 1459A *recto*

U 1459A *verso*

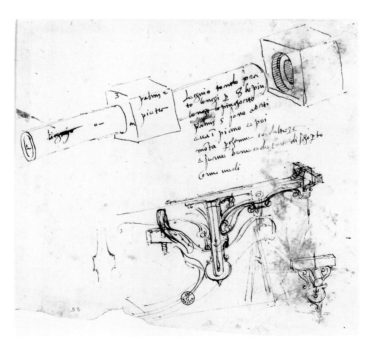

U 1460A *recto*

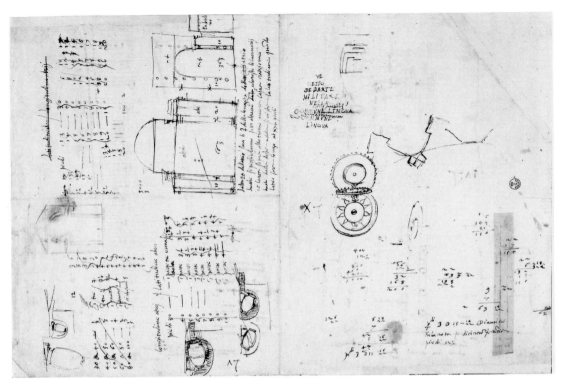

U 1461A *recto*

U 1461A *verso*

U 1463 *recto*

U 1463 *verso*

U 1464A *recto*

U 1464A *verso*

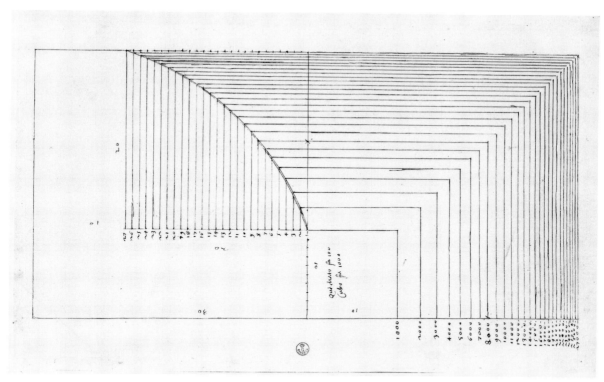

U 1466A *recto*

U 1467A *recto*

U 1468A *recto*

U 1467A *verso*

436

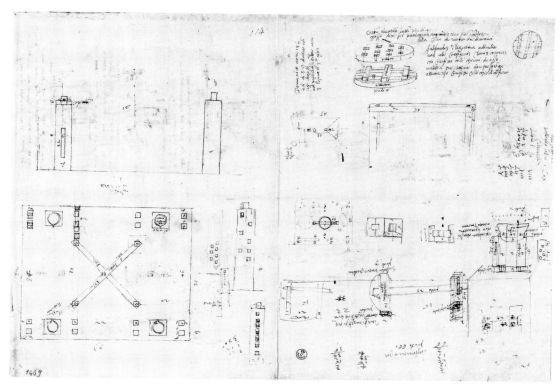

U 1469A *recto*

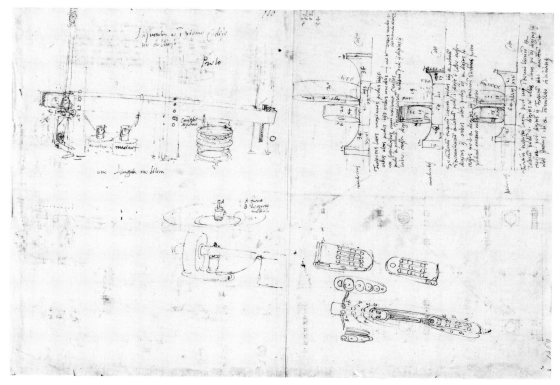

U 1469A *verso*

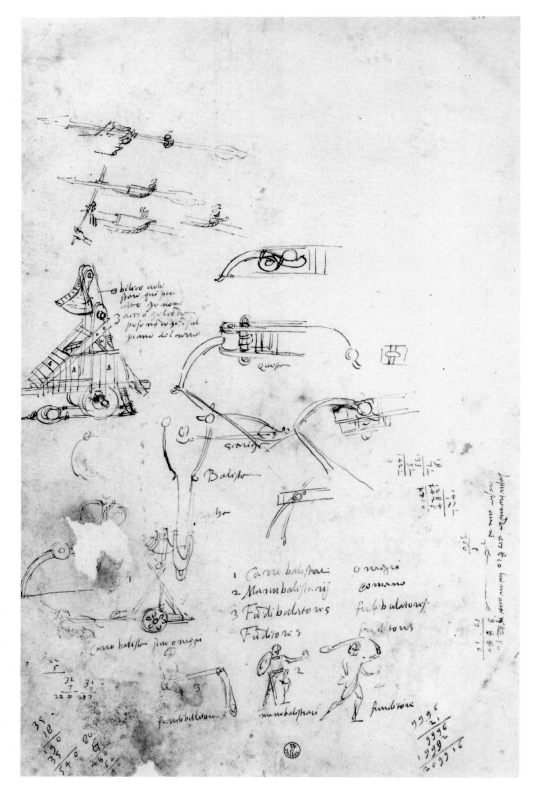

U 1470A *recto*

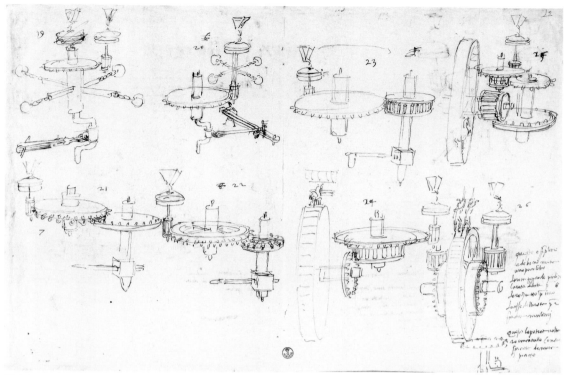

U 1471A *recto*

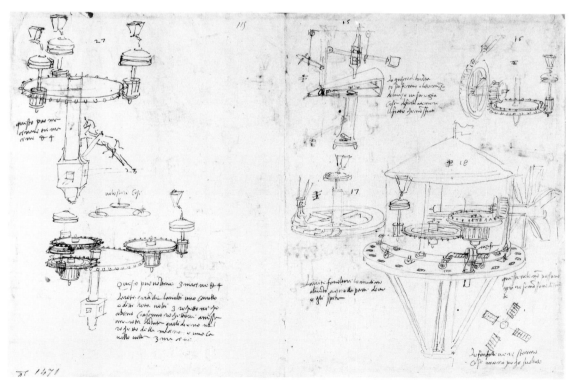

U 1471A *verso*

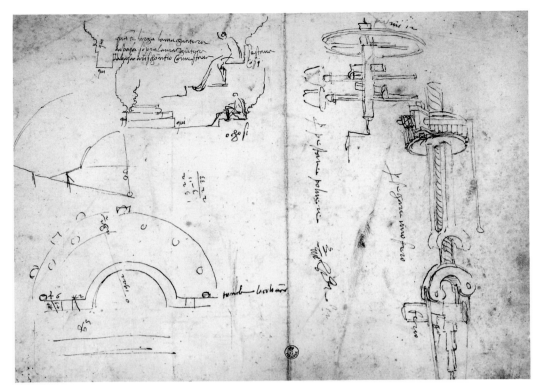

U 1472A *recto*

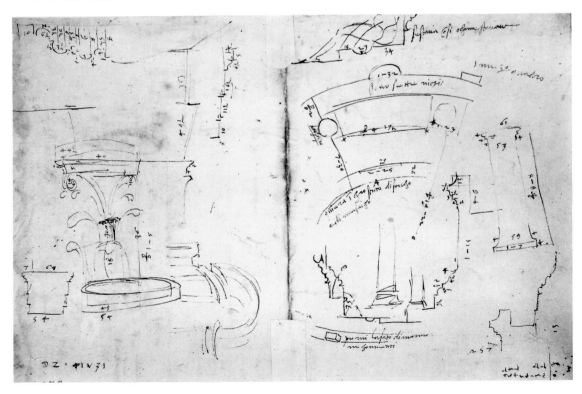

U 1472A *verso*

440

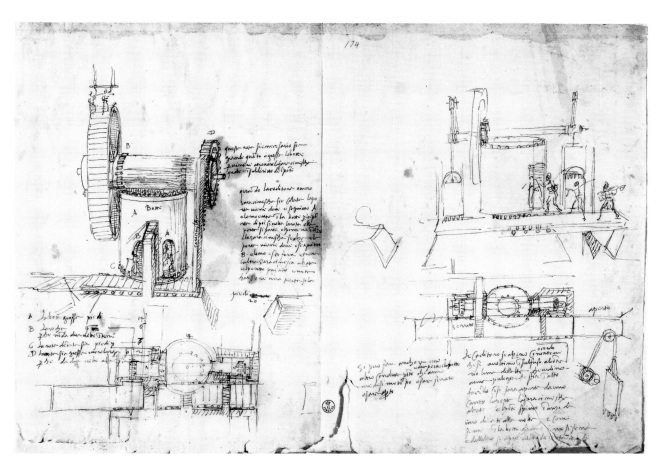

U 1473A *recto*

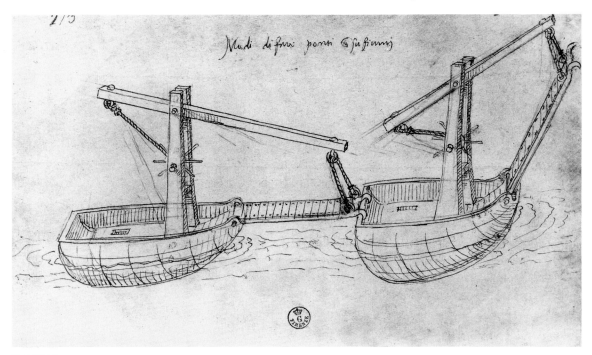

U 1476A *recto*

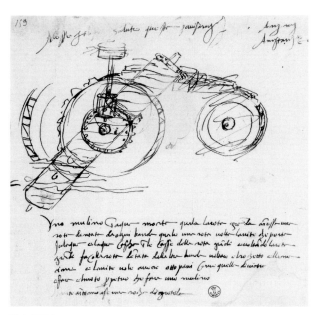

U 1477A *recto*

U 1478A *recto*

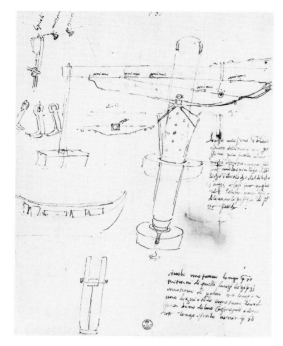

U 1479A *recto* U 1479A *verso*

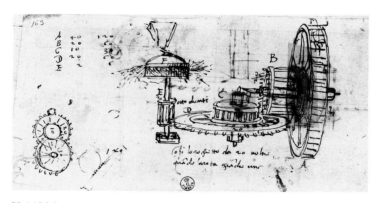

U 1480A *recto*

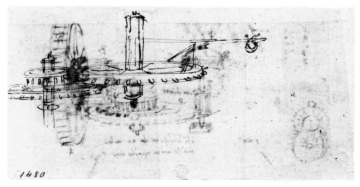

U 1480A *verso*

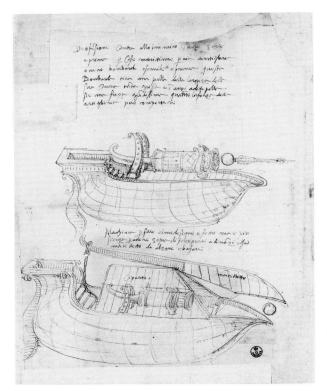

U 1481A *recto*

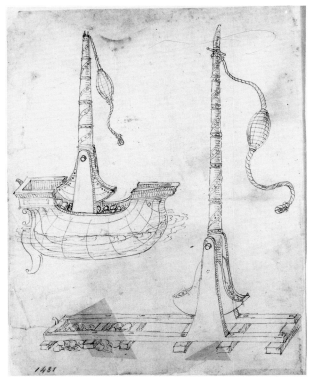

U 1481A *verso*

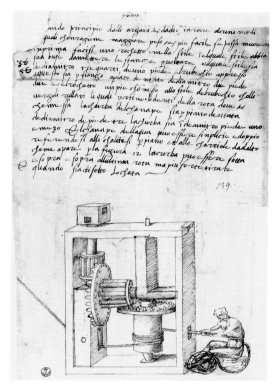

U 1482A *recto*

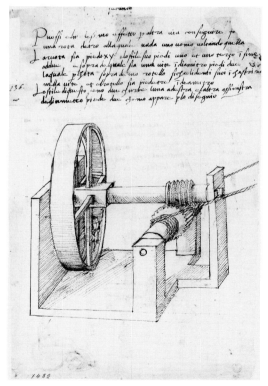

U 1482A *verso*

445

piede uno punote ego. Alsommo di questo sed uno ricepa po
rullato T di unit ro piade dua a uno quarto epquesto
psuota sotto sopra li demi della ruota di dimitro pie de
cinque la ruba desta dua a mmezo
chome appare pla fuzura

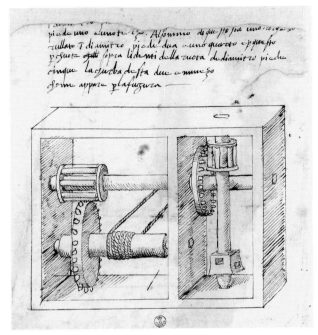

U 1483A *recto*

pla fuera sigon prende apparto no e mezo chome meglio

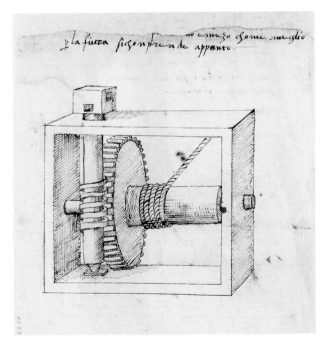

U 1483A *verso*

446

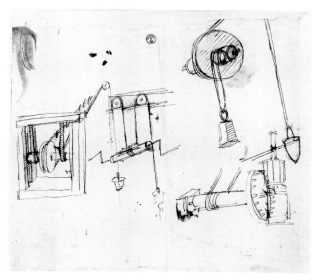

U 1484A *recto*

U 1484A *verso*

U 1485A *recto*

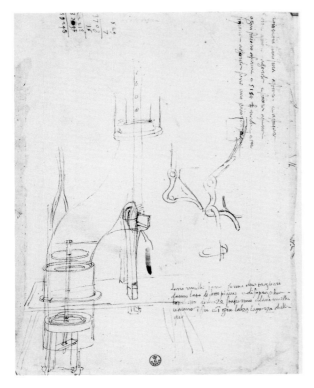

U 1486A *recto*

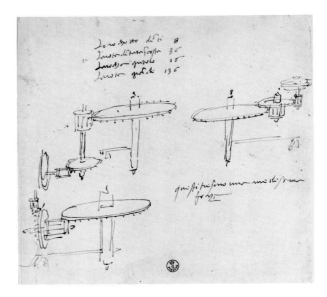

U 1487A *recto*

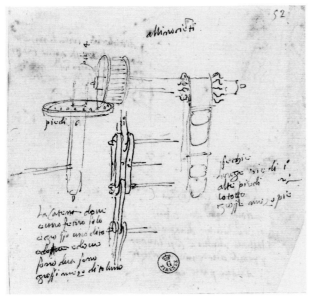

U 1488A *recto*

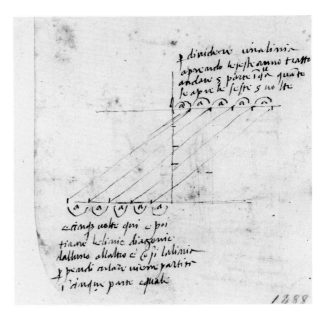

U 1488A *verso*

448

U 1490A *recto*

U 1490A *verso*

U 1491A *recto*

U 1491A *verso*

U 1492A *recto*

450

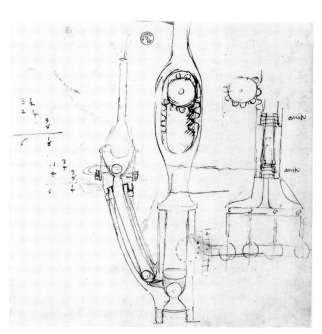

U 1493A *recto*

U 1494A *recto*

U 1494A *verso*

U 1495A *recto*

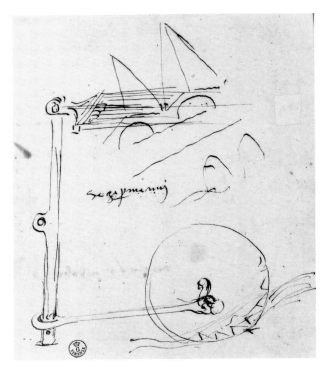

U 1496A *recto*

U 1497A *recto*

U 1498A *recto*

U 1498A *verso*

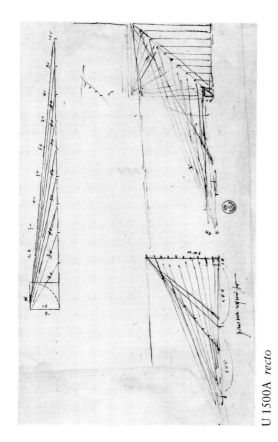

U 1500A *recto*

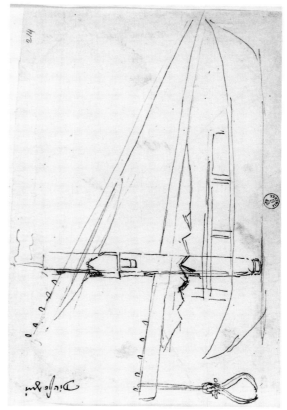

U 1501A *recto*

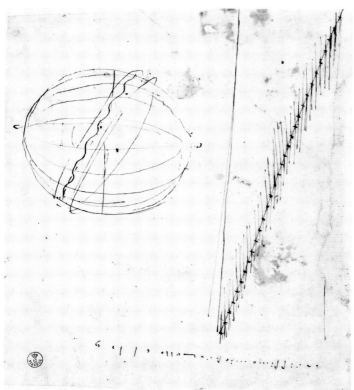

U 1499A *recto*

453

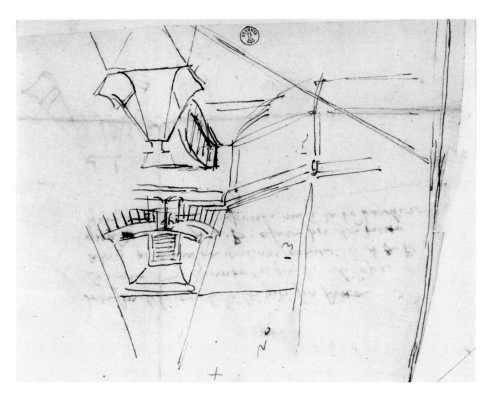

U 1502A *recto*

1502

U 1502A *verso*

454

U 1503A *recto*

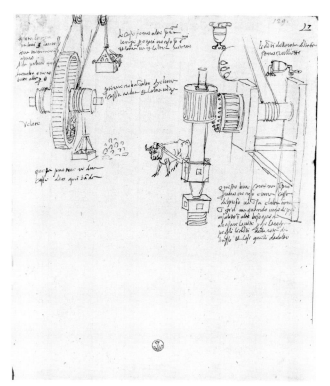

U 1504A *recto*

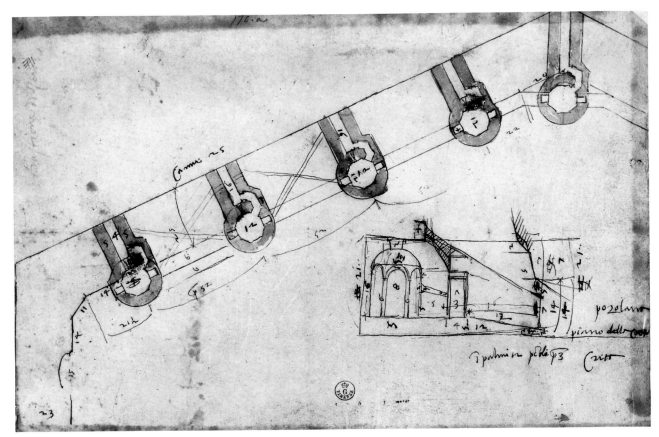

U 1505A *recto*

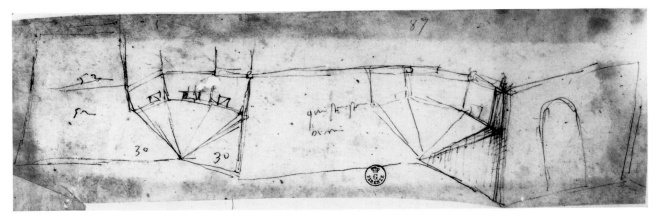

U 1506A *recto*

456

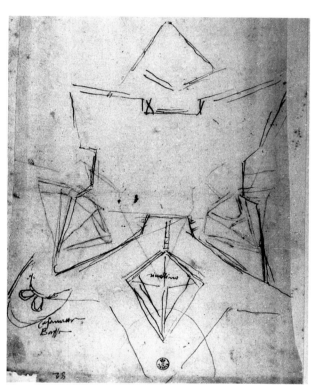

U 1507A *recto*

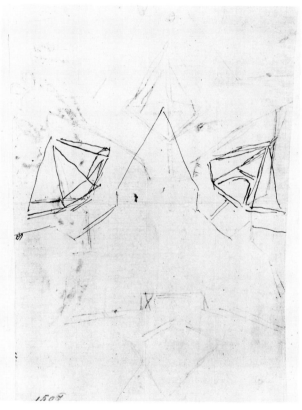

U 1507A *verso*

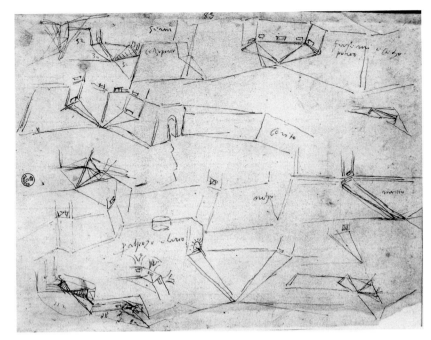

U 1508A *recto*

U 1508A *verso*

U 1509A *recto*

460

U 1510A *recto*

U 1511A *recto*

U 1511A *verso*

U 1512A *recto*

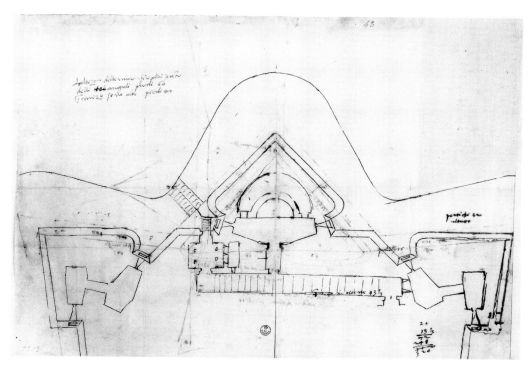

U 1513A *recto*

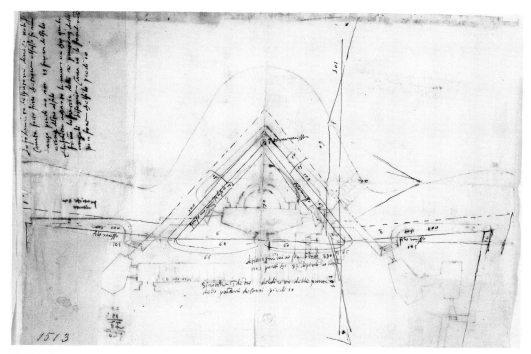

U 1513A *verso*

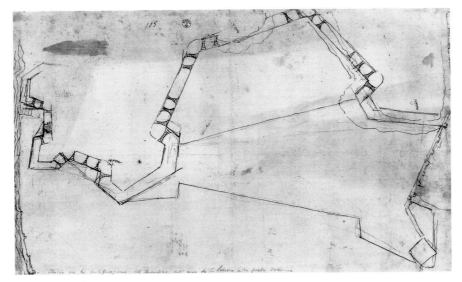

U 1514A *recto*

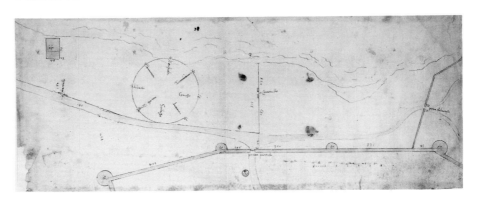

U 1515A *recto*

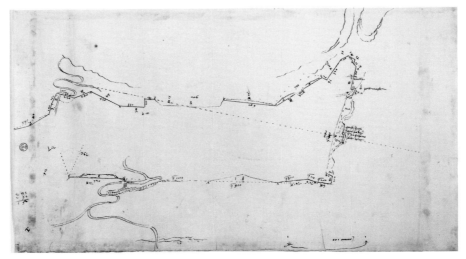

U 1516A *recto*

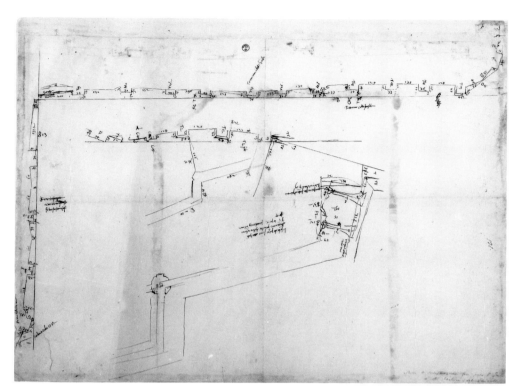

U 1517A *recto*

U 1517A *verso*

U 1519A *recto*

U 1520A *recto*

U 1521A *recto*

U 1523A *recto*

U 1524A *recto*

U 1525A *recto*

U 1525A *verso*

U 1526A *recto*

U 1526A *verso*

U 1528A *recto*

U 1528A *verso*

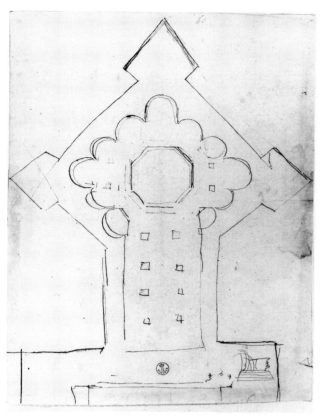

U 1552A *recto*

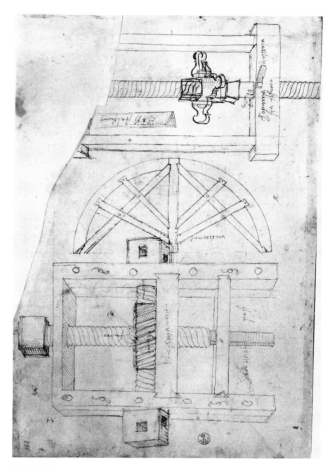

U 1564A *recto*

U 1564A *verso*

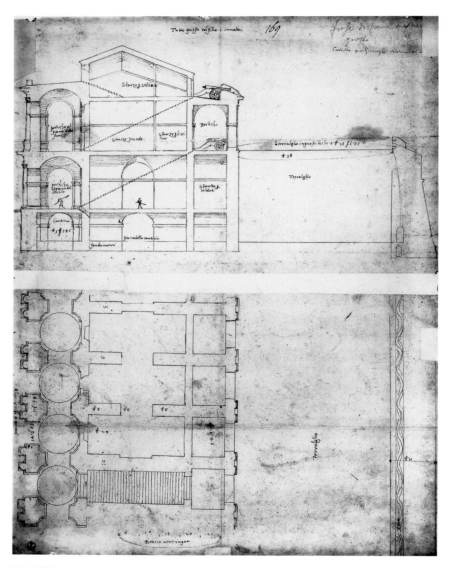

U 1659A *recto*

U 1665A *recto*

U 1665A *verso*

U 1671A *recto*

U 1672A *recto*

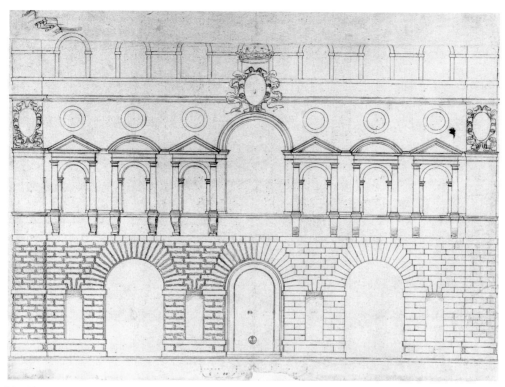

U 1684A *recto*

U 1787A *recto*

U 1846A *recto*

U 1846A *verso*

U 1847A *recto*

476

U 1876A *recto*

U 2100A *recto*

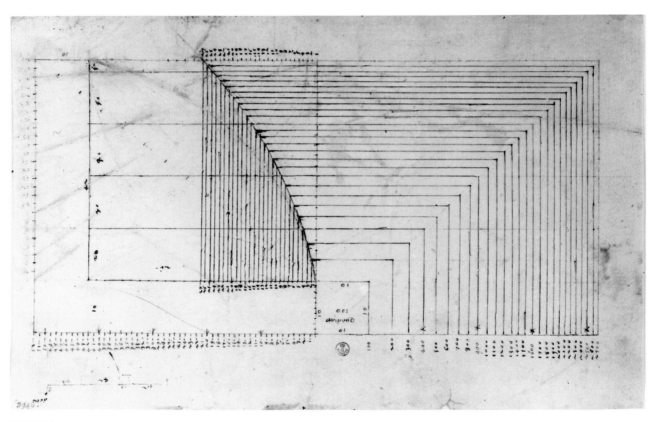

U 3949A *recto*

478

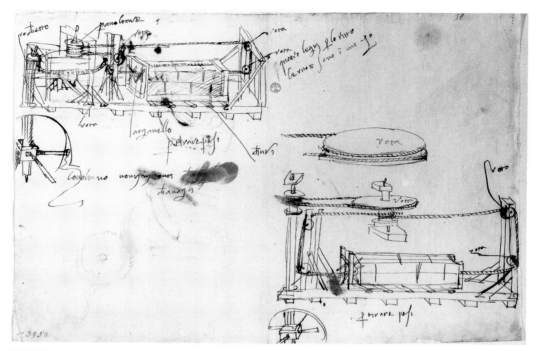

U 3950A *recto*

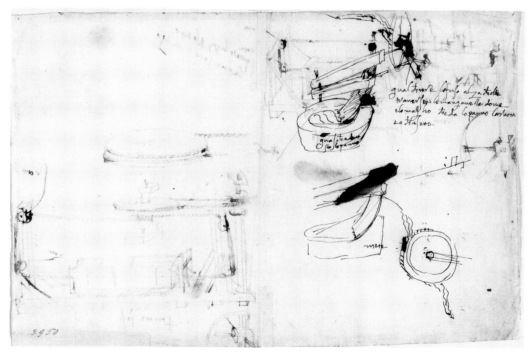

U 3950A *verso*

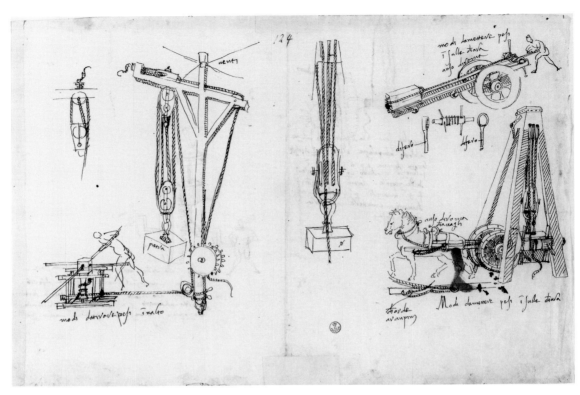

U 3951A *recto*

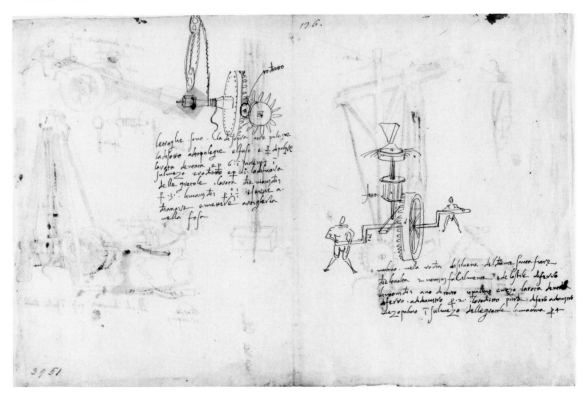

U 3951A *verso*

U 3956A *recto*

U 3956A *verso*

U 3970A *recto*

U 3970A *verso*

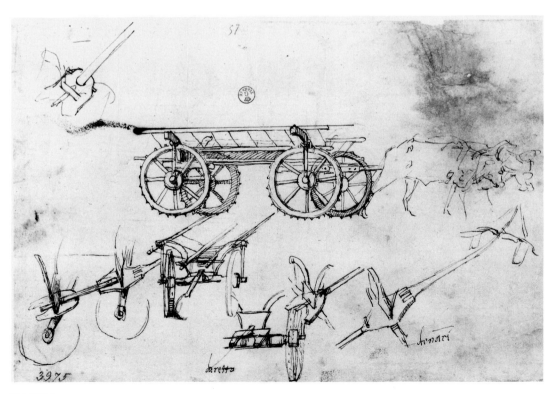

U 3975A *recto*

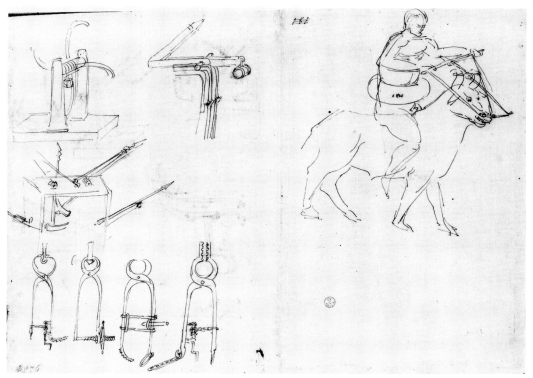

U 3976A *recto*

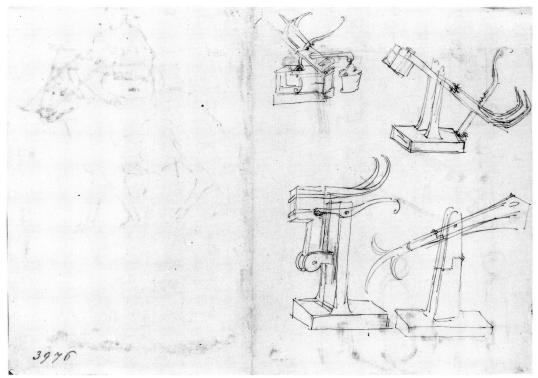

U 3976A *verso*

U 4015A *recto*

U 4015A *verso*

U 4041A *recto*

U 4042A *recto*

U 4043A *recto*

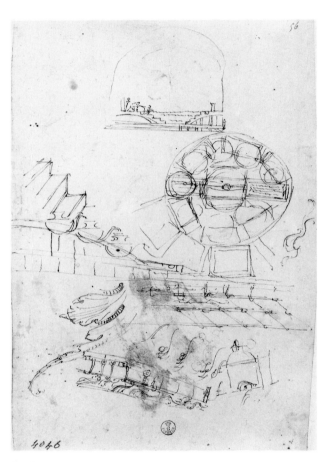

U 4046A *recto*

U 4046A *verso*

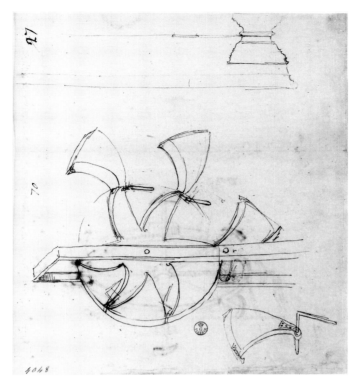

U 4048A *recto*

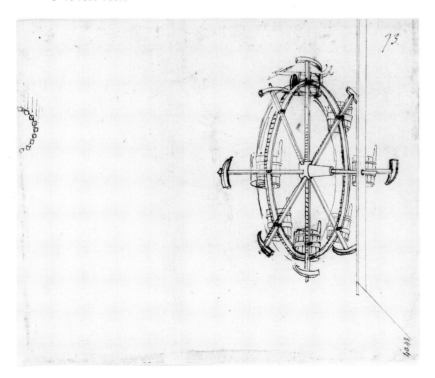

U 4048A *verso*

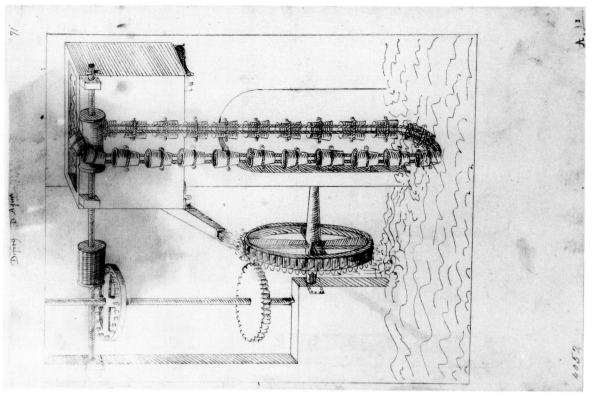

(text on drawing) Dřťy D Aṛa 71 A.13 4052

U 4052A *verso*

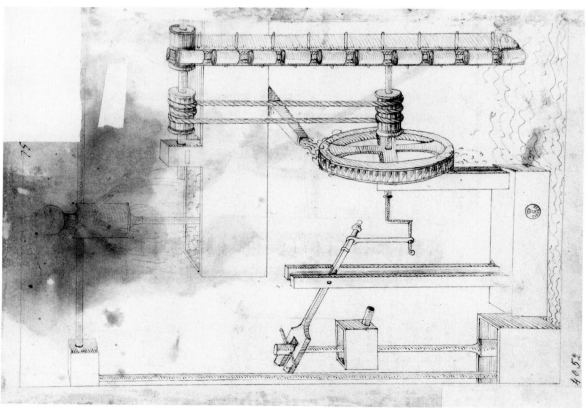

U 4052A *recto*

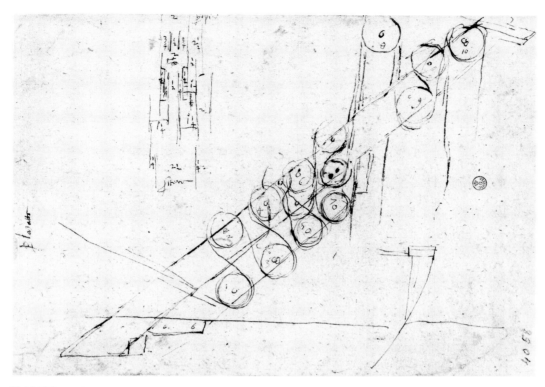

U 4058A *recto*

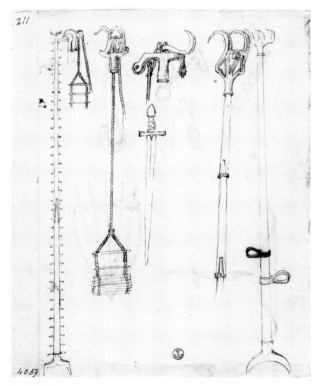

U 4059A *recto*

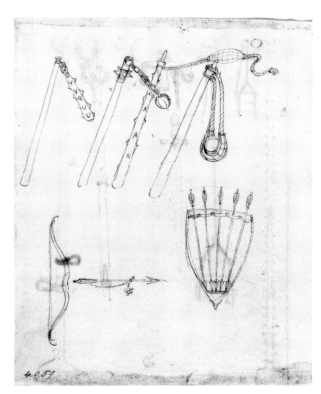

U 4059A *verso*

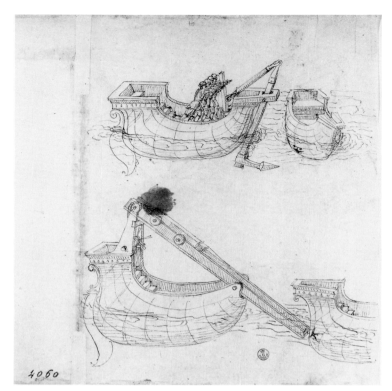

U 4060A *recto*

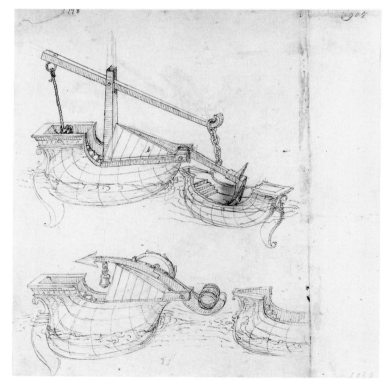

U 4060A *verso*

U 4064A *recto*

U 4064A *verso*

U 4065A *recto*

U 4065A *verso*

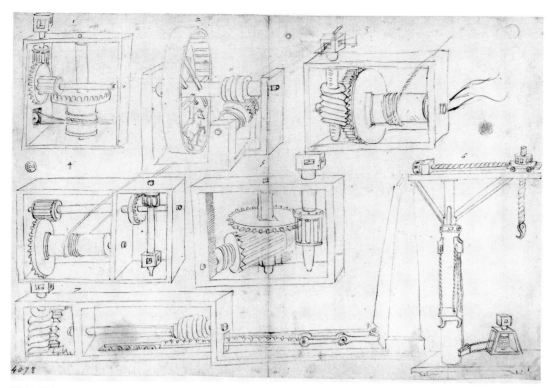

U 4078A *recto*

U 4120A *recto*

U 4159A *recto*

U 7975A *recto*

Bibliography

Conventional Abbreviations

ASP: Archivio di Stato di Parma
ASR: Archivio di Stato di Roma
Corsiniana: Roma, Biblioteca dei Lincei e Corsiniana

Ackerman (1954)
Ackerman, James S. "Architectural Practice in the Italian Renaissance," *Journal of the Society of Architectural Historians* 13: 3–11.

Ackerman (1961)
Ackerman, James S. *The Architecture of Michelangelo,* 2 vols. (London).

Adams (1978)
Adams, Nicholas. "Baldassarre Peruzzi and a Tour of Inspection in the Valdichiana, 1528–29," *Revue d'Art Canadienne/Canadian Art Review* 5: 28–36.

Adams (1978a)
Adams, Nicholas. "Baldassare Peruzzi and the Siege of Florence: Archival Notes and Undated Drawings," *Art Bulletin* 60: 475–82.

Adams (1978b)
Adams, Nicholas. "New Information about the Screw Press as a Device for Minting Coins: Bramante, Cellini and Baldassare Peruzzi," *Museum Notes of the American Numismatic Society* 23: 201–6.

Adams (1981)
Adams, Nicholas. "Baldassarre Peruzzi as Architect to the Republic of Siena, 1527–1535: Archival Notes," *Bullettino senese di storia patria* 88: 256–67.

Adams (1987)
Adams, Nicholas. "Postille ad alcuni disegni di architettura militare di Baldassarre Peruzzi," in M. Fagiolo and M.L. Madonna, eds., *Baldassarre Peruzzi: pittura, scena e architettura nel Cinquecento* (Rome): 205–24.

Adorni (1974)
Adorni, Bruno. *L'Architettura farnesiana a Parma 1545–1630* (Parma).

Adorni (1982)
Adorni, Bruno. *L'Architettura farnesiana a Piacenza 1545–1600* (Parma).

Adorni (1986)
Adorni, Bruno. "Progetti e interventi di Pier Francesco da Viterbo, Antonio da Sangallo il Giovane e Baldassarre Peruzzi per le fortificazioni di Piacenza e di Parma," in G. Spagnesi, ed., *Antonio da Sangallo il Giovane: la vita e l'opera.* Atti del 22 Congresso di Storia dell'Architettura, 1986 (Rome): 349–72.

Adorni (1989)
Adorni, Bruno. "Le fortificazioni di Parma e Piacenza nel Cinquecento. Architettura militare, espropri e disagi," in C. De Seta and J. Le Goff, eds., *La città e le mura* (Rome, Bari): 128–65.

Agrippa (1583)
Agrippa, Camillo. *Trattato di Camillo Agrippa di trasportar la guglia in su la piazza di San Pietro* (Rome).

Aimo, Clementi (1971)
Aimo, Patrizia, and Rodolfo Clementi. "La Piazza di Castro," *Bollettino della Società Storica Maremmana* 23: 51–66.

Alpheo (1870)
Alpheo, Bartolommeo. "Captura d'Ancona inovata dalla sedia apostolica de l'anno MDXXXII," in C. Ciavarini, ed., *Collezione di Documenti Storici Antichi inediti ed Editi Rari delle Città e Terre marchigiane* (Ancona): 225–36.

Amadei (1954–57)
Amadei, Federigo. *Cronaca universale della città di Mantova,* ed. G. Amadei et al., 5 vols. (Mantua).

Ancona (1982)
Paci, Renzo, Marilena Pasquale, and Ercole Sori, eds., *Ancona e le Marche nel Cinquecento: economia, società, istituzioni, cultura,* catalogue of the exhibition, Ancona, 1982.

Andrews (1978)
Andrews, David. "Masonry in Northern Lazio," *Papers in Italian Archaeology* I: 410.

Anonimo (1986)
Anonimo. *Disegni di macchine. Il Codice S. IV. 5 della Biblioteca Comunale degl'Intronati di Siena,* ed. C. A. Segnini (Siena).

Archi, Piccinini (1973)
Archi, Antonio, and Maria Teresa Piccinini. *Faenza come era* (Faenza).

Ashby (1904)
Ashby, Thomas. "Sixteenth-Century Drawings of Roman

Buildings Attributed to Andreas Coner," *Papers of the British School at Rome* 2: 1–96.

Bacile di Castiglione (1903)
Bacile di Castiglione, G. "La Rocca Paolina di Perugia," *L'Arte* 6: 347–67.

Bartoli (1914–22)
Bartoli, Alfonso. *I monumenti antichi di Roma nei disegni degli Uffizi di Firenze,* 6 vols. (Rome).

Bartolini (1986)
Bartolini Salimbeni, Lorenzo. "Due progetti irrealizzati di Antonio da Sangallo: i palazzi per Girolamo e Giovan Francesco Rosati a Fermo," in G. Spagnesi, ed., *Antonio da Sangallo il Giovane: la vita e l'opera.* Atti del 22 Congresso di Storia dell'Architettura, 1986 (Rome): 259–64.

Bazzocchi, Galbucci (1915)
Bazzocchi, Dino, and Piero Galbucci. *Cesena nella storia* (Bologna).

Bellanca (1986)
Bellanca, Calogero. "Il bastione della Colonnella, note di storia e conservazione," in G. Spagnesi, ed., *Antonio da Sangallo il Giovane: la vita e l'opera.* Atti del 22 Congresso di Storia dell'Architettura, 1986 (Rome): 383–91.

Beltrami (1902)
Beltrami, Luca. *Relazione sullo stato delle Rocche di Romagna, stesa nel 1526 per ordine di Clemente VII da Antonio da Sangallo il giovane e Michele Sanmicheli* (Milan).

Bencivenni (1982)
Bencivenni, Mario. "La rilevazione del perimetro urbano fiorentino in alcuni disegni di Antonio da Sangallo il Giovane," *Storia Architettura* 5, no. 2: 25–38.

Benigni (1924)
Benigni, Venanzio. *Compendioso ragguaglio delle cose più notabili di Fabriano* (Tolentino).

Bentivoglio (1985)
Bentivoglio, Enzo. "Documenti per il 'completamento' della porta S. Spirito di Antonio da Sangallo jr.," *Studi Romani* 33: 78–82.

Borgatti (1890)
Borgatti, Mariano. "Le mura di Roma," *Rivista d'artiglieria e genio* 2: 325–403.

Borgatti (1890a)
Borgatti, Mariano. *Castel Sant'Angelo in Roma. Storia e descrizione* (Rome).

Borgatti (1916)
Borgatti, Mariano. "Il bastione Ardeatina a Roma," *Rivista d'artiglieria e genio* 2: 207–23.

Borgatti (1926)
Borgatti, Mariano. *Borgo e San Pietro nel 1300, nel 1600 e nel 1925* (Rome).

Borgatti (1931)
Borgatti, Mariano. *Castel Sant'Angelo in Roma* (Rome).

Brenzoni (1960)
Brenzoni, Raffaello. *Fra Giovanni Giocondo Veronese* (Florence).

Brilliant (1967)
Brilliant, Richard. "The Arch of Septimius Severus in the Roman Forum," *Memoirs of the American Academy in Rome* 29: 29–271.

Bruschi (1969)
Bruschi, Arnaldo. *Bramante architetto* (Bari).

Bruschi (1974)
Bruschi, Arnaldo. "Bramante, Leonardo, e Francesco di Giorgio a Civitavecchia: La 'città con porto' nel Rinascimento," in

Studi Bramanteschi. Atti del Congresso internazionale, 1970 (Rome): 535–65.

Bruschi (1983)
Bruschi, Arnaldo. "Cordini (Cordiani? . . .), Antonio, detto Antonio da Sangallo il Giovane," in *Dizionario biografico degli italiani,* vol. 29 (Rome): 3–23.

Bruschi (1985)
Bruschi, Arnaldo. *Bramante architetto* (Rome, Bari), 2d edition.

Buddensieg (1975)
Buddensieg, Tilmann. "Bernardo della Volpaia und Giovanni Francesco da Sangallo: Der Autor des Codex Coner, und seine Stellung im Sangallo-Kreis," *Römisches Jahrbuch für Kunstgeschichte* 15: 89–108.

Bury (1979)
Bury, John B. "Francesco de Holanda: A Little-known Source of the History of Fortification in the Sixteenth Century," *Arquivos do Centro Cultural Portogues* 14: 163–202.

Busca (1601)
Busca, Gabriele. *Della architettura militare* (Venice).

Cagiano de Azevedo (1924)
Cagiano de Azevedo, Doris. "Il Vaticano nel medio evo," *Roma* 2: 165–71.

Calvi (1943)
Calvi, Ignazio. *L'architettura militare di Leonardo da Vinci* (Milan).

Camerieri, Palombaro (1988)
Camerieri, Paolo, and Fabio Palombaro. *La "Rocca Paolina" un falso d'autore* (Perugia).

Cansacchi (1938)
Cansacchi, G. "Antonio da Sangallo il Giovane in Amelia," *Bollettino dell'Istituto Storico e di Cultura dell'Arma del Genio* 8: 8–15.

Cassanelli (1974)
Cassanelli, Luciana, Gabriella Delfini, Daniela Fonti. *Le mura di Roma* (Rome).

Cato (1496)
Cato, Marcus Portius. *De re rustica,* in *Opera agricolationum: Columellae: Varronis: Catonisque: necnon Palladii, cum excriptionibus & commentariis* (Reggio nell'Emilia).

Cato (1954)
Cato, Marcus Porcius. *On Agriculture,* ed. W.D. Hooper, rev. H.B. Ash (Cambridge, Mass., London).

Cecchelli (1951)
Cecchelli, Carlo. "Documenti per la storia antica e medioevale di Castel S. Angelo," *Archivio della Società romana di Storia patria* 74: 27–67.

Celli (1895)
Celli, Luigi. *Le fortificazioni militari di Urbino, Pesaro e Sinigallia del secolo XVI costruite dai Rovereschi* (Castelpiano).

Cervia (1980)
Cervia. Storia di una civiltà salinara (Bologna).

Cesariano (1521)
Cesariano, Cesare, trans. *Di Lucio Vitruvio Pollione de Architectura Libri Dece* (Como).

Chastel (1983)
Chastel, André. *Il sacco di Roma 1527* (Turin).

Chiacchella (1987)
Chiacchella, Rita. "Per una reinterpretazione della 'guerra del sale' e della costruzione della Rocca Paolina in Perugia," *Archivio Storico Italiano* 145: 3–60.

Ciapponi (1984)
Ciapponi, Lucia A. "Disegni ed appunti di matematica in un

codice di Fra Giocondo da Verona (Laur. 29, 43)," in *Vestigia. Studi in onore di Giuseppe Billanovich* (Rome): 181–96.

Clausse (1900–1902)
Clausse, Gustave. *Les San Gallo*, 3 vols. (Paris).

Clementi (1986)
Clementi, Rodolfo. "Il progetto della porta Lamberta a Castro," in G. Spagnesi, ed., *Antonio da Sangallo il Giovane: la vita e l'opera*. Atti del 22 Congresso di Storia dell'Architettura (Rome): 373–81.

Coarelli (1974)
Coarelli, Filippo. *Guida Archeologica di Roma* (Milan).

Cobianchi, Petrucci (n.d.)
Cobianchi, Maria Teresa, and Giulia Petrucci. *Montalto di Castro. Formazione e sviluppo del territorio e del Centro Antico* (Montalto di Castro).

Columella (1496)
Columella, Lucius Junius Moderatus. *Rei rusticae*, in *Opera agricolationum: Columellae: Varronis: Catonisque: necnon Palladii, cum excriptionibus & commentariis* (Reggio nell'Emilia).

Columella (1968)
Columella, Lucius Junius Moderatus. *On Agriculture and Trees*, ed. E.S. Forster and E.H. Heffner (Cambridge, Mass., London).

Concina (1984)
Concina, Ennio. *L'Arsenale della Repubblica di Venezia* (Milan): 108–34.

Conforti (1980)
Conforti, Paolo. *Le mura di Parma*. Vol. 1: *Dalle origini alle soglie del Ducato (1545)*. Vol. 2: *Dai Farnese alla demolizione* (Parma).

Cozzi (1968)
Cozzi, Laura G. *Le porte di Roma* (Rome).

Curti (1985)
Curti, M. "La Rocca di Pitigliano. Ipotesi e considerazioni relative di disegni di Antonio da Sangallo il Giovane," *Edilizia Militare* 6, no. 15–16: 43–55.

Dal Monte Casoni (1919)
Dal Monte Casoni, Francesco. *Il Santuario di Loreto e le sue difese militari* (Recanati).

Dal Monte Casoni (1921)
Dal Monte Casoni, Francesco. *Nel IV centenario della nascita di Sisto V. Una pagina della sua vita* (Recanati).

Davari (1875)
Davari, Stefano. *Cenni storici intorno ad opera di fortificazione della città di Mantova del secolo XVI* (Mantua).

Davis (1980)
Davis, Margaret Daly. "Carpaccio and the perspective of regular bodies," in M. Dalai Emiliani, ed., *La prospettiva rinascimentale: codificazioni e trasgressioni* (Florence): 183–200.

De Angelis (1950)
De Angelis, Pietro. *L'Arciconfraternita ospitaliera di Santo Spirito in Saxia* (Rome).

De Angelis (1952)
De Angelis, Pietro. *L'Arciospedale di Santo Spirito in Saxia nel passato e nel presente* (Rome).

De Angelis D'Ossat (1943)
De Angelis D'Ossat, Guglielmo. "Gli archi trionfali ideati dal Peruzzi per la venuta a Roma di Carlo V," *Capitolium* 18: 287–94.

De Fiore (1986)
De Fiore, Gaspare. "Il 'Disegno' nei disegni di Antonio da Sangallo il Giovane," in G. Spagnesi, ed., *Antonio da Sangallo il Giovane: la vita e l'opera*. Atti del 22 Congresso di Storia

dell'Architettura, 1986 (Rome): 415–21.

Degenhart (1955)
Degenhart, Bernhard. "Dante, Leonardo und Sangallo." *Römisches Jahrbuch für Kunstgeschichte* 7: 101–292.

Degenhart, Schmitt (1968)
Degenhart, Bernhard, and Annegrit Schmitt. *Corpus der italienischen Zeichnungen 1300–1450*, vol. 1, part 2, (Berlin).

De la Croix (1960)
De la Croix, Horst. "Military Architecture and the Radial City Plan in Sixteenth-Century Italy," *Art Bulletin* 42: 263–90.

Dell'Acqua, Gentilucci (1986)
Dell'Acqua, Paola, and Marina Gentilucci. "Il progetto di Antonio da Sangallo il Giovane per il borgo di Pratica," in G. Spagnesi, ed., *Antonio da Sangallo il Giovane: la vita e l'opera*. Atti del 22 Congresso di Storia dell'Architettura, 1986 (Rome): 309–21.

Dellepiane (1984)
Dellepiane, Riccardo. *Mura e fortificazioni di Genova* (Genoa).

De Lorenzi (1966)
De Lorenzi, Paolo. *Le mura di Ravenna: le sue porte e la Rocca Brancaleone* (Ravenna).

De Marchi (1599)
De Marchi, Francesco. *Dell' architettura militare, Libri tre* (Brescia).

De Moro (1988)
De Moro, Gianni. "Giovanni Maria Olgiati (1495–1557). Contributo alla riscoperta di un 'inzegnero' lombardo al servizio di Spagna," in C. Cresti, A. Fara, D. Lamberini, eds., *Architettura militare nell'Europa del XVI secolo*. Atti del Convegno di Studi, Florence, 1986 (Siena): 149–206.

D'Onofrio (1965)
D'Onofrio, Cesare. *Gli obelischi di Roma* (Rome).

D'Onofrio (1971)
D'Onofrio, Cesare. *Castel S. Angelo* (Rome).

D'Onofrio (1976)
D'Onofrio, Cesare. *Roma val bene un'abiura* (Rome).

D'Onofrio (1978)
D'Onofrio, Cesare. *Castel S. Angelo e Borgo tra Roma e Papato* (Rome).

Duprè Theseider (1961)
Duprè Theseider, Eugenio. "Loreto e il problema della città santuario," *Studia Picena* 29: 96–105.

Egger (1902)
Egger, Hermann. "Entwürfe Baldassarre Peruzzis für den Einzug Karls V. in Rom," *Jahrbuch der Kunsthistorischen Sammlungen des Allerhöchsten Kaiserhauses* 23: 1–44.

Egger (1903)
Egger, Hermann. *Kritisches Verzeichnis der Stadtrömischen Architekturzeichnungen der Albertina* (Vienna).

Egger (1905–6)
Egger, Hermann. *Codex Escurialensis. Ein Skizzenbuch aus der Werkstatt Domenico Ghirlandaios*, 2 vols. (Vienna).

Egger (1931–32)
Egger, Hermann. *Römische Veduten*, 2 vols. (Vienna).

Fabiani (1957–59)
Fabiani, Giuseppe. *Ascoli nel Cinquecento*, 2 vols. (Ascoli Piceno).

Fabriczy (1893)
Fabriczy, Cornelius de. "Il libro di schizzi d'un pittore olandese nel Museo di Stuttgart," *Archivio Storico dell'Arte*, 6: 106–26.

Fagliari Zeni Buchicchio (1983)
Fagliari Zeni Buchicchio, Fabiano T. "Gli oratori dell'Isola Bisentina dal tempo di Ranuccio Farnese agli interventi di Anto-

nio da Sangallo il Giovane," in *Il Quattrocento a Viterbo* (Rome): 108–32.

Fagliari Zeni Buchicchio (1986)
Fagliari Zeni Buchicchio, Fabiano T. "Contributo all'attività di Antonio da Sangallo il Giovane a Civitavecchia, Gradoli e Castro," in G. Spagnesi, ed., *Antonio da Sangallo il Giovane: la vita e l'opera*. Atti del 22 Congresso di Storia dell'Architettura, 1986 (Rome): 249–57.

Fagliari Zeni Buchicchio (1988)
Fagliari Zeni Buchicchio, Fabiano T. "La rocca del Bramante a Civitavecchia: il cantiere e le maestranze da Giulio II a Paolo III," *Römisches Jahrbuch für Kunstgeschichte*, 23–24: 273–383.

Falb (1902)
Falb, Rodolfo, ed. *Il taccuino senese di Giuliano da Sangallo* (Siena).

Fancelli (1986)
Fancelli, Paolo. "Prime risultanze su porta Santo Spirito," in G. Spagnesi, ed., *Antonio da Sangallo il Giovane: la vita e l'opera*. Atti del 22 Congresso di Storia dell'Architettura, 1986 (Rome): 231–47.

Fanelli (1979)
Fanelli, Vittorio. *Ricerche su Angelo Colocci e sulla Roma cinquecentesca*, Studi e testi, 283 (Vatican City).

Fara (1988)
Fara, Amelio. *Bernardo Buontalenti: l'architettura, la guerra e l'elemento geometrico* (Genoa).

Ferri (1885)
Ferri, Pasquale Nerino. *Indice geografico-analitico dei disegni di architettura civile e militare esistenti nella R. Galleria degli Uffizi in Firenze* (Rome).

Ferri (1908)
Ferri, Pasquali Nerino. "La raccolta Geymüller-Campello recentemente acquistata dallo Stato per la R. Galleria degli Uffizi," *Bollettino d'Arte* 2: 47–65.

Fiocco (1915)
Fiocco, Giuseppe. "Giovanni Giocondo Veronese," *Atti dell'Accademia di agricoltura, scienze e lettere di Verona*, 16.

Fiore (1976)
Fiore, Francesco Paolo. "Castro capitale Farnesiana (1537–1649): un programma di 'Instauratio' urbana," *Quaderni dell'Istituto di Storia dell'Architettura* 22: 75–94.

Fiore (1977)
Fiore, Francesco Paolo. "La 'Città Felice' di Loreto," *Ricerche di storia dell'arte* 4: 37–55.

Fiore (1978)
Fiore, Francesco Paolo. *Città e macchine del '400 nei disegni di Francesco di Giorgio Martini* (Florence).

Fiore (1983–87)
Fiore, Francesco Paolo. "Francesco di Giorgio e il rivellino 'acuto' di Costacciaro," *Quaderni dell'Istituto di Storia dell'Architettura. Saggi in onore di Guglielmo de Angelis d'Ossat* n.s. 1–10 (1987): 197–208.

Fiore (1986)
Fiore, Francesco Paolo. "Episodi salienti e fasi dell'architettura militare di Antonio da Sangallo il Giovane," in G. Spagnesi, ed., *Antonio da Sangallo il Giovane: la vita e l'opera*. Atti del 22 Congresso di Storia dell'Architettura, 1986 (Rome): 331–47.

Fontana (1988)
Fontana, Vincenzo. *Fra' Giovanni Giocondo* (Vicenza).

Forbes (1956)
Forbes, R.J. "Food and Drink," "Power," "Hydraulic Engineering and Sanitation," in C. Singer, E.G. Holmyard, A.R. Hall, T.I. Williams, eds., *A History of Technology*, vol. 2 (New York, London): 103–46; 623–28; 663–94.

Foresti (1984)
Foresti, Fabio, et al. *I mulini ad acqua della Valle dell'Enza* (Casalecchio di Reno).

Forlivesi (1889)
Forlivesi, Ferdinando. *Cervia. Cenni storici* (Bologna).

Forti (1971)
Forti, Leone Carlo. *Le fortificazioni di Genova* (Genoa).

Friedman (1978)
Friedman, David. "The Porta a Faenza and the last circle of the walls of Florence," in S. Bertelli and G. Ramakus, eds., *Essays presented to Myron P. Gilmore*, vol. 2 (Florence): 179–92.

Frommel (1973)
Frommel, C.L. *Der Römische Palastbau der Hochrenaissance*, 3 vols. (Tübingen).

Frommel (1976)
Frommel, C.L. "Die Peterskirche unter Papst Julius II. im Licht neuer Dokumente," *Römisches Jahrbuch für Kunstgeschichte* 16: 57–136.

Frommel (1986)
Frommel, C.L. "Raffael und Antonio da Sangallo der Jüngere," in *Raffaello a Roma. Il convegno del 1983* (Rome): 261–304.

Fumi (1891)
Fumi, Luigi. *Il Duomo di Orvieto* (Rome).

Fuhring (1989)
Fuhring, Peter. *Design into Art: Drawings for Architecture and Ornament: The Lodewijk Houthakker Collection*, 2 vols. (London, The Hague).

Galluzzi (1980)
Galluzzi, Paolo. "Il dibattito sull'astronomia," in *Firenze e la Toscana dei Medici nell'Europa del Cinquecento. La corte il mare i mercanti. La rinascita della Scienza Editoria e Società. Astrologia, magia e alchimia*, catalogue of the exhibition, Florence, 1980: 185–94.

Gardner-McTaggart (1985)
Gardner-McTaggart, H.B. "Castro. Eine Orswünstung in Tuscanien, Archäologische Feldforschungen in einer mittalelterlichen Stadtruine in Italien," in *B.A.R. International*, ser. 262.

Gasbarri (1953)
Gasbarri, Carlo. "La Città Leonina circa il 1000," *Studi Romani* I: 625–37.

Gasbarri (1978)
Gasbarri, Carlo. "Alcune note sul Passetto di Borgo," *L'Urbe* 41, 5–6: 40–43.

Gaurico (1552)
Gaurico, Luca. *Tractatus astrologicus* (Venice).

Gazzola (1960)
Gazzola, Piero. Introduction in P. Gazzola, ed., *Michele Sanmicheli*, catalogue of the exhibition, Verona, 1960: 15–75.

Ghisetti Giavarina (1986)
Ghisetti Giavarina, Adriano. "La rocca Paolina di Perugia. Note sull'opera di Antonio da Sangallo il Giovane," in G. Spagnesi, ed., *Antonio da Sangallo il Giovane: la vita e l'opera*. Atti del 22 Congresso di Storia dell'Architettura, 1986 (Rome): 393–403.

Gianneschi, Sodini (1979)
Gianneschi, Mauro, and Carla Sodini. "Urbanistica e politica durante il principato di Alessandro de' Medici, 1532–37," *Storia della Città*, 10: 5–34.

Gibbs-Smith (1978)
Gibbs-Smith, Charles, and Gareth Rees. *The Inventions of*

Leonardo da Vinci (Oxford).

Gibbs, Saliba (1984)
Gibbs, Sharon, and George Saliba. *Planispheric Astrolabes from the National Museum of American History,* Smithsonian Studies in History and Technology, 45 (Washington, D.C.).

Giess (1978)
Giess, Hildegard. "Die Stadt Castro und die Pläne von Antonio da Sangallo dem Jüngeren (Teil I)," *Römisches Jahrbuch für Kunstgeschichte* 17: 47–88.

Giess (1981)
Giess, Hildegard. "Die Stadt Castro und die Pläne von Antonio da Sangallo dem Jüngeren (Teil II)," *Römisches Jahrbuch für Kunstgeschichte* 19: 85–140.

Gille (1956)
Gille, Bertrand. "Machines," in C. Singer, E.J. Holmyard, A.R. Hall, T.I. Williams, eds., *A History of Technology,* vol. 2 (New York, London): 629–58.

Gille (1964)
Gille, Bertrand. *Les ingénieurs de la renaissance* (Paris).

Giovannini, Ricci (1985)
Giovannini, Carla, and Giovanni Ricci. *Ravenna* (Rome, Bari).

Giovannoni (1931)
Giovannoni, Gustavo. *Saggi sull'architettura del Rinascimento* (Milan).

Giovannoni (1938)
Giovannoni, Gustavo. "Progetti sangalleschi per S. Marco di Firenze," *Atti del I Congresso Nazionale di Storia dell'Architettura,* 1936 (Florence): 231–35.

Giovannoni (1947)
Giovannoni, Gustavo. "La facciata della chiesa di S. Spirito e S. Maria in Sassia," *Bollettino del Centro di Studi di storia dell'architettura* 5: 4–5.

Giovannoni (1959)
Giovannoni, Gustavo. *Antonio da Sangallo il Giovane,* 2 vols. (Rome).

Giuliani (1970)
Giuliani, Cairoli Fulvio. "Tibur," *Forma Italiae* 1: 6 (Rome).

Golzio (1936)
Golzio, Vincenzo. *Raffaello nei documenti nelle testimonianze dei contemporanei e nella letteratura del suo secolo* (Vatican City).

Gotti (1875)
Gotti, Aurelio. *Vita di Michelangelo Buonarroti narrata con l'aiuto di nuovi documenti,* 2 vols. (Florence).

Grimaldi (1981)
Grimaldi, Floriano, ed. *Felix Civitas Lauretana* (Recanati).

Grimaldi (1982)
Grimaldi, Floriano. "Difese militari di Loreto," *Studi Maceratesi* 16: 295–304.

Grimaldi et al. (1979)
Grimaldi, Floriano, Mauro Compagnucci, and Anna Natali. *La città murata di Loreto* (Recanati).

Grohmann (1981)
Grohmann, Alberto. *Città e territorio tra medioevo ed età moderna (Perugia, secc. XIII–XVI),* 3 vols. (Perugia).

Grohmann (1981a)
Grohmann, Alberto. *Perugia* (Rome, Bari).

Grossi Gondi (1933)
Grossi Gondi, Augusto. "Dov'era Porta Angelica?" *Roma* 11: 455–56.

Guglielmotti (1860)
Guglielmotti, Alberto. *I Bastioni di Antonio da Sangallo disegnati sul terreno per fortificare e ingrandire Civitavecchia l'anno 1515* (Rome).

Guglielmotti (1880)
Guglielmotti, Alberto. *Storia delle fortificazioni nella spiaggia romana risarcite ed accresciute dal 1560 al 1570* (Rome).

Guicciardini (1927)
Guicciardini, Francesco. *Dall'Assedio di Firenze al Secondo Convegno di Clemente VII e Carlo V. Lettere inedite a Bartolommeo Lanfredini,* ed. A. Otetea (Aquila).

Günther (1985)
Günther, Hubertus. "Die Strassenplanung unter den Medici-Päpsten in Rom (1513–1534)," *Jahrbuch des Zentralinstituts für Kunstgeschichte* 1: 237–93.

Gunther (1932)
Gunther, Robert. *The Astrolabes of the World.* Vol. 1: *The Eastern Astrolabes.* Vol. 2: *The Western Astrolabes* (Oxford).

Hale (1965)
Hale, John R. "The Early Development of the Bastion: An Italian Chronology c. 1450–c. 1534," in J.R. Hale, J.R.L. Highfield, B. Smalley, eds., *Europe in the Late Middle Ages* (London): 466–94.

Hale (1968)
Hale, John R. "The End of Florentine Liberty: The Fortezza da Basso," in N. Rubenstein, ed., *Florentine Studies: Politics and Society in Renaissance Florence* (London): 501–32.

Hale (1977)
Hale, John R. *Renaissance Fortification: Art or Engineering?* (London).

Hall (1956)
Hall, A.R. "Military Technology," in C. Singer, E.J. Holmyard, A.R. Hall, T.I. Williams, eds., *A History of Technology,* vol. 2 (New York, London): 695–730.

Heydenreich (1931)
Heydenreich, Ludwig Heinrich. "Uber Oreste Vannocci Biringucci," *Mitteilungen des Kunsthistorischen Institutes in Florenz* 3: 434–40.

Heydenreich, Dibner, Reti (1981)
Heydenreich, Ludwig Heinrich, Bern Dibner, and Ladislao Reti. *Leonardo the Inventor* (London).

Heydenreich, Lotz (1974)
Heydenreich, Ludwig Heinrich, and Wolfgang Lotz. *Architecture in Italy, 1400–1600* (Harmondsworth).

Huelsen (1894)
Huelsen, Christian. "La Porta Ardeatina," *Mittheilungen des Kaiserlich Deutschen Archäologischen Instituts. Römische Abtheilung* 9: 320–33.

Huelsen (1910)
Huelsen, Christian. *Il libro di Giuliano da Sangallo. Codice Vaticano Barberiniano latino 4424,* 2 vols. (Leipzig).

Huelsen, Egger (1913–16)
Huelsen, Christian, and Hermann Egger. *Die römischen Skizzenbücher von Marten van Heemskerk im Königlichen Kupferstichkabinett* (Berlin).

Imperi (1977)
Imperi, Daniele. "Il castello di Nepi," *Quaderni dell'Istituto di Storia dell'Architettura* 24: 129–48.

Jope (1956)
Jope, E.M. "Vehicles and Harnesses," in C. Singer, E.J. Holmyard, A.R. Hall, T.I. Williams, eds., *A History of Technology,* vol. 2 (New York, London): 537–62.

Jordan (1907)
Jordan, Henrich. *Topographie der Stadt Rom im Alterthum,*

vol. I.3 (Berlin).

Kahnemann (1960)
Kahnemann, M. "Capella dei Magi nel Duomo di Orvieto," in P. Gazzola, ed., *Michele Sanmicheli architetto veronese del Cinquecento*, catalogue of the exhibition, Verona, 1960: 97–100.

Keller (1969)
Keller, Alex G. "The Oblique Treadmill of the Renaissance: Theory and Reality," in *Transactions of the 2. International Symposium on Molinology*, 1969 (Copenhagen): 225–31.

Kern (1915)
Kern, G.I. "Der Mazzocchio des Paolo Uccello," *Jahrbuch der Königlich Preuszischen Kunstsammlungen* 36: 13–38.

Labacco (1552)
Labacco, Antonio. *Libro d'Antonio Labacco appartenente a l'Architettura* (Rome).

Lamberini (1980)
Lamberini, Daniela. "Le mura e i bastioni di Pistoia: una fortificazione reale del '500," *Pistoia Programma* 7: 5–30.

Lamberini (1988)
Lamberini, Daniela. "Funzione di disegni e rilievi delle fortificazione nel Cinquecento," in *L'architettura militare veneta del Cinquecento* (Milan): 48–61.

Lanciani (1897)
Lanciani, Rodolfo. *The Ruins and Excavations of Ancient Rome* (London).

Lanciani (1902–12)
Lanciani, Rodolfo. *Storia degli scavi di Roma e notizie intorno le collezioni romane di antichità*, 4 vols. (Rome).

Langeskiöld (1938)
Langeskiöld, Eric. *Michele Sanmicheli* (Uppsala).

Langeskiöld (1962)
Langeskiöld, Eric. *La chiesa di S. Spirito in Sassia, e il mutare del gusto a Roma al tempo del Concilio di Trento* (Turin).

Leonardo da Vinci (1894–1904)
Leonardo da Vinci. *Il Codice Atlantico di Leonardo da Vinci nella Biblioteca Ambrosiana di Milano*, 3 vols. (Milan).

Leonardo da Vinci (1974)
Leonardo da Vinci. *The Madrid Codices, National Library, Madrid, Facsimile Edition of Codex Madrid I (Ms 8936), Codex Madrid II (Ms 8937)*, ed. L. Reti, 5 vols. (New York).

Leonardo da Vinci (1987)
Galluzzi, Paolo, ed. *Leonardo da Vinci. Engineer and Architect*, catalogue of the exhibition, Montreal, 1987.

Leporini (1973)
Leporini, Luigi. *Ascoli Piceno. L'Architettura dai Maestri vaganti ai Giosafatti* (Ascoli Piceno).

Lerza (1986)
Lerza, Gianluigi. "I progetti di Antonio da Sangallo il Giovane per la chiesa di S. Maria di Monserrato," in G. Spagnesi, ed., *Antonio da Sangallo il Giovane: la vita e l'opera*. Atti del 22 Congresso di Storia dell'Architettura, 1986 (Rome): 119–29.

Letarouilly (1849–66)
Letarouilly, Paul Marie. *Edifices de Rome moderne; ou, Recueil des palais, maisons, églises, couvents et autres monuments publics et particuliers les plus remarquables de la Ville de Rome*, 6 vols. (Liège, Brussels).

Letarouilly (1856–68)
Letarouilly, Paul Marie. *Edifices de Rome moderne. . .* (Paris)

Lethbridge (1956)
Lethbridge, T.C. "Shipbuilding," in C. Singer, E.J. Holmyard, A.R. Hall, T.I. Williams, eds., *A History of Technology*, vol. 2 (New York, London): 563–88.

Licht (1984)
Licht, Meg, ed. *L'edificio a pianta centrale. Lo sviluppo del disegno architettonico nel Rinascimento*, catalogue of the exhibition, Florence, 1984.

Liebenwein (1977)
Liebenwein, Wolfgang. *Studiolo. Die Entstehung eines Raumtyps und seine Entwicklung bis um 1600* (Berlin).

Lorini (1596)
Lorini, Bonaiuto. *Delle fortificationi di Buonaiuto Lorini libri cinque* (Venice).

Losito (1989)
Losito, Maria. "La gnomonica, il IX libro dei *Commentari* vitruviani di Daniele Barbaro e gli studi analemmatici di Federico Commandino," *Studi Veneziani* 18: 177–240.

Lotz (1977)
Lotz, Wolfgang. *Studies in Italian Renaissance Architecture* (Cambridge, Mass., London).

Maccagni (1967)
Maccagni, Carlo. "Notizie sugli artigiani della famiglia Della Volpaia," *Rassegna periodica di informazioni del Comune di Pisa* 3, no. 8: 3–13.

Maccagni (1971)
Maccagni, Carlo. "The Florentine Clock- and Instrument-makers of the della Volpaia Family," *XIIe Congrès international d'histoire des sciences, Paris, 1968. Actes*, Tome XA, *Histoire des instruments scientifiques* (Paris): 65–73.

Madonna (1980)
Madonna, Maria Luisa. "L'ingresso di Carlo V a Roma," in M. Fagiolo, ed., *La città effimera e l'universo artificiale del giardino* (Rome): 63–68.

Maggi (1966)
Maggi, Serafino. "L'opera di Sangallo 'il Giovane' e del Peruzzi nelle fortificazioni di Piacenza," *Castellum* 3: 60–62.

Maggi, Castriotto (1564)
Maggi, G., and J. Fusti Castriotto. *Della fortificaztione delle città* (Venice).

Magnuson (1954)
Magnuson, Torgil. "The Project of Nicholas V for Rebuilding the Borgo Leonino in Rome," *Art Bulletin* 36: 89–115.

Magnuson (1958)
Magnuson, Torgil. *Studies in Roman Quattrocento Architecture* (Stockholm).

Malagù (1960)
Malagù, Ugo. *Le mura di Ferrara* (Ferrara).

Mallett, Hale (1984)
Mallett, Michael E., and John R. Hale. *The Military Organization of a Renaissance State: Venice c. 1400 to 1617* (Cambridge).

Mancini, Vichi (1959)
Mancini, Fausto, and Walter Vichi. *Castelli rocche e torri di Romagna* (Bologna).

Manetti (1980)
Manetti, Renzo. *Michelangiolo: le fortificazioni per l'assedio di Firenze* (Florence).

Manfredi (1989)
Manfredi, Tommaso. "L'oratorio della Ss.ma Annunziata in Borgo. Problemi tecnici e formali nel processo edilizio," *Quaderni dell'Istituto di Storia dell'Architettura* n.s. 14: 55–68.

Marani (1984)
Marani, Pietro, ed. *Disegni di fortificazioni da Leonardo a Michelangelo*, catalogue of the exhibition, Florence, 1984–85.

Marani (1984a)
Marani, Pietro. *L'architettura fortificata negli studi di Leonardo da Vinci* (Florence).

Marani (1987)
Marani, Pietro. "Leonardo, Fortified Architecture and Its Structural Problems," in Paolo Galluzzi, ed., *Leonardo da Vinci, Engineer and Architect*, catalogue of the exhibition, Montreal, 1987.

Marconi (1966)
Marconi, Paolo. "Contributo alla storia delle fortificazioni di Roma nel cinquecento e nel seicento," *Quaderni dell'Istituto di Storia dell'Architettura* 13: 109–30.

Marconi (1968)
Marconi, Paolo. "Una chiave per l'interpretazione dell'urbanistica rinascimentale: La cittadella come microcosmo," *Quaderni dell'Istituto di Storia dell'Architettura* 15: 53–94.

Marconi (1975)
Marconi, Paolo. "Le architetture militari dell'Alessi e del suo tempo," in *Galeazzo Alessi e l'architettura del cinquecento*, Atti del convegno internazionale di studi, 1974 (Genoa): 311–14.

Marconi et al. (1973)
Marconi, Paolo, ed., and F.P. Fiore, G. Muratore, E. Valeriani. *La città come forma simbolica: studi sulla teoria dell'architettura nel rinascimento* (Rome).

Marconi et al (1978)
Marconi, Paolo, F.P. Fiore, G. Muratore, E. Valeriani, eds. *I Castelli: Architettura e difesa del territorio tra Medioevo e Rinascimento* (Novara).

Marinelli (1937)
Marinelli, Lodovico. *Le antiche fortezze di Romagna* (Imola).

Marini (1810)
Marini, Luigi. *Biblioteca istorico-critica di fortificazione permanente* (Rome).

Marini (1831)
Marini, Luigi. *Architettura militare di Francesco de' Marchi illustrata da Francesco Marini*, 2 vols. (Rome).

Martini (1979)
Marani, Pietro C. *Trattato di architettura di Giorgio Martini: Il Codice Asburnham 361 della Biblioteca Medicea Laurenziana di Firenze*, 2 vols. (Florence).

Martini-Maltese (1967)
Francesco di Giorgio [Martini], *Trattati di architettura ingegneria e arte militare*, ed. C. Maltese and L. Maltese Degrassi, 2 vols. (Milan).

Masetti (1964)
Masetti, Anna Rosa. *Pisa. Storia urbana* (Pisa).

Medri (1908)
Medri, Antonio. *Sulla topografia antica di Faenza* (Bologna).

Messini (1943)
Messini, Angelo. *L'architetto Antonio da Sangallo il Giovane a Foligno* (Foligno).

Mezzetti, Pugnaloni (n.d.)
Mezzetti, Carlo, and Fausto Pugnaloni. *Dell'architettura militare: l'epoca dei Sangallo e la cittadella di Ancona* (Ancona).

Miarelli-Mariani (1971)
Miarelli-Mariani, Gaetano. "Aggiunte al San Tolomeo di Nepi, il contributo di Antonio da Sangallo il giovane e di Flaminio Ponzio," *Palladio* 21: 123–50.

Miniati (1987)
Miniati, Mara, ed. *L'Età di Galileo*, catalogue of the exhibition, Florence, 1987–88.

Molajoli (1968)
Molajoli, Bruno. *Guida artistica di Fabriano* (Genoa).

Montalti (1986)
Montalti, Pino. *La cinta muraria di Cesena* (Modena).

Montanini (1922)
Montanini, Filippo. *Lettere su le origini di Fabriano* (Fabriano).

Morrison, Coates (1986)
Morrison, John S., and John F. Coates. *The Athenian Trireme: The History and Reconstruction of an Ancient Greek Warship* (New York).

Moschella (1970)
Moschella, Pietro. *Una fortezza di Antonio da Sangallo il Giovane* (Rome).

Muendel (1974)
Muendel, John. "The Horizontal Mills of Medieval Pistoia," *Technology and Culture* 15: 194–225.

Muendel (1984)
Muendel, John. "The 'French' Mill in Medieval Tuscany," *Journal of Medieval History* 10: 215–47.

Muendel (1985)
Muendel, John. "The Mountain Men of the Casentino During the Late Middle Ages," *Science and Technology in Medieval Society*, Annals of the New York Academy of Sciences: 29–70.

Muendel (1991)
Muendel, John. "The Internal Functions of a 14th-Century Florentine Flour Factory," *Technology and Culture* 32: 498–520.

Muendel (1992)
Muendel, John. "*Mansus*, Machinery, and Co-Proprietorship: The Tuscan Contribution to Medieval Associations of Industry," *Studies in Medieval and Renaissance History* 13: 69–113.

Muentz (1886)
Muentz, Eugène. "Les monuments antiques de Rome," *Revue archéologique* 8: 329.

Natalucci (1960)
Natalucci, Mario. *Ancona attraverso i secoli*, 3 vols. (Città di Castello).

Natalucci (1964)
Natalucci, Mario. "La Cittadella di Ancona," *Bollettino dell'Istituto Storico e di Cultura dell'Arma del Genio* 30: 373–91.

Oleson (1984)
Oleson, John P. "Greek and Roman Mechanical Water-lifting Devices: The History of a Technology," *Phoenix*. Supplementary vol., 16 (Toronto).

Orsini (1790)
Orsini, Baldassare. *Descrizione delle pitture sculture architetture ed altre cose rare della insigne città di Ascoli* (Perugia).

Pagliara (1972)
Pagliara, Pier Nicola. "L'attività edilizia di Antonio da Sangallo il Giovane. Il confronto tra gli studi sull'antico e la letteratura vitruviana. Influenze sangallesche sulla manualistica di Sebastiano Serlio," *Controspazio* 4, 7: 19–55.

Pagliara (1982)
Pagliara, Pier Nicola. "Alcune minute autografe di G. Battista da Sangallo," *Architettura Archivi—fonti e storia* 1: 25–50.

Pagliara (1986)
Pagliara, Pier Nicola. "Vitruvio da testo a canone," in *Memoria dell'antico nell'arte italiana*, ed. S. Settis, vol. 3 (Turin): 5–85.

Pagliara (1988)
Pagliara, Pier Nicola. "Studi e pratica vitruviana di Antonio da Sangallo il Giovane e di suo fratello Giovanni Battista," in J. Guillaume, ed., *Les Traités d'Architecture de la Renaissance*

(Paris): 179–206.

Pagliara (1990–92)
Pagliara, Pier Nicola. "Ancora su palazzo Alberini," *Quaderni dell'Istituto di Storia dell'Architettura. Saggi in onore di Renato Bonelli* n.s. 15–20 (1992), vol. I: 519–26.

Palladius (1496)
Palladius, Rutilius Marcus Terentius. *De re rustica*, in *Opera agricolationum: Columellae: Varronis: Catonisque: necnon Palladii, cum excriptionibus & commentariis* (Reggio nell'Emilia).

Pallottino (1937)
Pallottino, Massimo. "Tarquinia," in *Monumenti Antichi dell'Accademia Nazionale dei Lincei* 36.

Pastor (1923)
Pastor, Ludwig. *The History of the Popes*, vol. 4 (London).

Pastor (1959)
Pastor, Ludovico. *Storia dei Papi dalla fine del medio evo*, vol. 5 (Rome): 706–11.

Patterson (1956)
Patterson, R. "Spinning and Weaving," in C. Singer, E.J. Holmyard, A.R. Hall, T.I. Williams, eds., *A History of Technology*, vol. 2 (New York, London): 190–220.

Pedretti (1978–79)
Pedretti, Carlo. *The Codex Atlanticus of Leonardo da Vinci. A Catalogue of its Newly Restored Sheets* (London, New York).

Pensi, Comez (1912)
Pensi, Giulio, and Armando Comez. *Todi: Guida per i forestieri* (Todi).

Pepper (1976)
Pepper, Simon. "Planning versus Fortification. Sangallo's Project for the Defence of Rome," *Architectural Review* 159: 162–69.

Pepper, Adams (1986)
Pepper, Simon, and Nicholas Adams. *Firearms and Fortifications: Military Architecture and Siege Warfare in Sixteenth-Century Siena* (Chicago, London).

Perali (1919)
Perali, Pericle. *Orvieto. Note storiche di topografia; note storiche d'arte, dalle origini al 1800* (Orvieto).

Perogalli (1972)
Perogalli, Carlo. *Castelli e rocche di Emilia e Romagna* (Milan).

Philo of Byzantium (1974)
Philo of Byzantium. *Pneumatica. The First Treatise on Experimental Physics*, ed. F.D. Prager (Wiesbaden): 112–24.

Piale (1831)
Piale, S. "Delle mura e porte del Vaticano," *Atti della Pontificia Accademia Romana di Archeologia* (Rome).

Pini, Milanesi (1876)
Pini, Carlo, and Gaetano Milanesi. *La scrittura di artisti italiani*, 3 vols. (Florence).

Pinzi (1890)
Pinzi, Cesare. "Memorie e documenti inediti sulla Basilica di Santa Maria della Quercia in Viterbo," *Archivio Storico dell'Arte*: 300–332.

Platner (1911)
Platner, Samuel Ball. *The Topography and Monuments of Ancient Rome* (Boston).

Podestà (1877)
Podestà, B. "Carlo V a Roma nell'anno 1536," *Archivio della Società Romana di Storia Patria* 1: 303–44.

Polidori, Ramacci (1976)
Polidori, Ennio, and Maria Grazia Ramacci. "Fonti e docu-

menti per la storia di Castro," *Storia della Città* 1: 69–99.

Ponting (1979)
Ponting, Kenneth P., ed. and comp. *Leonardo da Vinci. Drawings of Textile Machines* (Bradford-on-Avon).

Popham, Pouncey (1950)
Popham, A.E., and Philip Pouncey. *Italian Drawings in the Department of Prints and Drawings in the British Museum. The Fourteenth and Fifteenth Centuries*, 2 vols. (London).

Portoghesi (1971)
Portoghesi, Paolo. *Roma del Rinascimento*, 2 vols. (Milan).

Posner (1974)
Posner, Kathleen Weil-Garris. "Alcune progetti per piazze e facciate di Bramante e di Antonio da Sangallo il Giovane a Loreto," in *Studi Bramanteschi*. Atti del Congresso internazionale, 1970 (Rome): 313–38.

Prager, Scaglia (1970)
Prager, Frank D., and Gustina Scaglia. *Brunelleschi: Studies of His Technology and Inventions* (Cambridge, Mass., London): 65–83.

Prager, Scaglia (1972)
Prager, Frank D., and Gustina Scaglia. *Mariano Taccola and His Book "De ingeneis"* [Codex Palat. 766] (Cambridge, Mass., London).

Prandi (1961)
Prandi, Adriano. "I restauri delle mura leoniane e del 'passetto' di Borgo," *Palatino* 5: 166–73.

Prandi (1969)
Prandi, Adriano. "Precisazioni e novità sulla Civitas leonina," *Miscellanea di studi storici per le nozze di Gianni Jacovelli e Vita-Castano* (Massafra): 107–29.

Puppi (1971)
Puppi, Lionello. *Michele Sanmicheli architetto di Verona* (Milan).

Puppi (1986)
Puppi, Lionello. "Un viaggio per il Veneto di Antonio da Sangallo e di Michele Sanmicheli nella primavera del 1526, un progetto per i Grimani; e qualche riflessione a margine," in G. Spagnesi, ed., *Antonio da Sangallo il Giovane: la vita e l'opera*. Atti del 22 Congresso di Storia dell'Architettura, 1986 (Rome): 101–7.

Quarenghi (1880)
Quarenghi, Cesare. *Le mura di Roma* (Rome).

Quarenghi (1882)
Quarenghi, Cesare. "Questioni storiche," *Il Buonarotti* ser. 3, 1 (1882): 21–38.

Quercioli (1978)
Quercioli, Mauro. *Le mura papali di Roma, Città Leonina e Gianicolo. Storia topografia-politica* (Rome).

Quercioli (1982)
Quercioli, Mauro. *Le mura e le porte di Roma* (Rome).

Ramelli-Gnudi, Ferguson (1976)
Gnudi, Martha Teach, and Eugene Ferguson. *The Various and Ingenious Machines of Agostino Ramelli (1588)* (London, Baltimore).

Ravenna (1985)
Ravenna, Paola, ed. *Le Mura di Ferrara. Immagini e storia*, catalogue of the exhibition, Rome, 1985.

Ravioli (1863)
Ravioli, Camillo. *Notizie sui lavori di architettura militare sugli scritti o disegni editi ed inediti dei nove da Sangallo* (Rome).

Ravioli (1882)
Ravioli, Camillo. "Nuove dichiarazione sopra i Sangallo e Giangiacomo Medici," *Il Buonarroti* ser. 3, 1 (1882): 146–57.

Ravioli (1887)
 Ravioli, Camillo. "Capitoli pei bastioni di Antonio da Sangallo," *Il Buonarroti* ser. 3, 3 (1887): 31–33.
Ray (1974)
 Ray, Stefano. *Raffaello architetto* (Rome, Bari).
Redig De Campos (1959)
 Redig De Campos, Deoclecio. "Les constructions d'Innocent III et de Nicolas III sur la colline Vaticane," *Mélanges d'Archéologie et d'Histoire* 71: 359–76.
Righini Bonelli (1968)
 Righini Bonelli, Maria Luisa, ed. *Il Museo di Storia della Scienza a Firenze* (Milan).
Righini Bonelli, Settle (1979)
 Righini Bonelli, Maria Luisa, and Thomas B. Settle. "Egnatio Danti's Great Astronomical Quadrant," *Annali dell'Istituto e Museo di Storia della Scienza a Firenze* 4, 2: 3–13.
Rocchi (1902)
 Rocchi, Enrico. *Le piante iconografiche e prospettiche di Roma del secolo XVI,* 2 vols. (Rome, Turin).
Rocchi (1908)
 Rocchi, Enrico. *Le fonti storiche dell'architettura militare* (Rome).
Romby, Capaccioli (1981)
 Romby, Giuseppina Carla, and Marco Capaccioli, eds. *Mulini. Edifici e strutture per l'agricoltura nel comune di Barberino di Mugello,* catalogue of the exhibition, Barberino di Mugello, 1981.
Ronchini (1864)
 Ronchini, Amadio. "Antonio da Sangallo il Giovine," *Atti e Memorie delle RR. Deputazioni di Storia Patria per le Provincie Modenesi e Parmensi* 2: 471–84.
Ronchini (1868)
 Ronchini, Amadio. "Giovambattista Pelori," *Atti e Memorie delle RR. Deputazioni di Storia Patria per le Provincie Modenesi e Parmensi* 4: 249–62.
Ronchini (1872)
 Ronchini, Amadio. "Il Montemelino da Perugia e le fortificazioni di Roma al tempo di Paolo III," *Giornale di Erudizione Artistica* I: 161–73.
Rosa (1869)
 Rosa, Gabriele. *Disegno della storia di Ascoli Piceno* (Brescia).
Rosini (1961)
 Rosini, Corrado. *Città di Castello* (Città di Castello).
Roth (1968)
 Roth, Cecil. *The Last Florentine Republic* (New York).
Rozzi, Sopri (1984)
 Rozzi, Renato, and Ercole Sopri, eds. *Ascoli e il suo territorio* (Milan).
Saliba (1991)
 Saliba, George, "A Sixteenth-Century Drawing of an Astrolabe Made by Khafif Ghulām 'Alī b. 'Īsā (c. 850 A.D.)," *Nuncius. Annali di Storia della Scienza* 6, 2: 109–19.
Salvadori, Violanti (1971)
 Salvadori, Silvano, and Francesco Violanti. "Antonio da Sangallo il Giovine: la genesi del progetto della Fortezza da Basso," *Bollettino degli Ingegneri* 19, 8–9: 26–36.
Sangallo (1910)
 Sangallo, Giuliano da. *Il Libro di Giuliano da Sangallo, Codice Vaticano Barberiniano latino 4424,* C. Huelsen, ed., 2 vols. (Leipzig).
Sangallo-Falb (1902)
 Sangallo, Giuliano da. *Il taccuino senese di Giuliano da Sangallo,* R. Falb, ed. (Siena).
Sanguinetti (1959)
 Sanguinetti, Francesco. "La fortezza di Civita Castellana e il suo restauro," *Palladio* 9: 84–92.
Scaglia (1960–61)
 Scaglia, Gustina. "Drawings of Brunelleschi's Mechanical Inventions for the Construction of the Cupola," *Marsyas* 10: 45–68.
Scaglia (1981)
 Scaglia, Gustina. *Alle origini degli studi tecnologici di Leonardo,* Lettura Vinciana XX (20 April 1980), (Vinci).
Scaglia (1986)
 Scaglia, Gustina. "'Stanze-stufe' e 'Stanze-camini' nei 'Trattati' di Francesco di Giorgio da Siena," *Bollettino d'Arte* 71, 39–40: 161–84.
Scaglia (1988)
 Scaglia, Gustina. "A Vitruvianist's 'Thermae' Plan and the Vitruvianists in Roma and Siena," *Arte Lombarda* 84–85: 85–101.
Scaglia (1988a)
 Scaglia, Gustina. "Drawings of Forts and Engines by Lorenzo Donati, Giovanbattista Alberti, Sallustio Peruzzi, The Machine Complexes Artist, and Oreste Biringuccio," *Architectura* 18: 169–97.
Scaglia (1991)
 Scaglia, Gustina. "The 'Colonnacce' of Forum Nervae as Cronaca's Inspiration for the 'Cornicione' of Palazzo Strozzi," *Mitteilungen des Kunsthistorischen Institutes in Florenz* 35: 153–70.
Scaglia (1992–93)
 Scaglia, Gustina. "Drawings of 'Roma antica' in a Vitruvius Edition in the Metropolitan Museum," *Römisches Jahrbuch für Kunstgeschichte* (in press).
Schwarz (1990)
 Schwarz, Michael V. "Ceccas Gerüst für S. Giovanni (Florenz) in einer Zeichnung Antonios da Sangallo d. J.," in *Festschrift für Hartmut Biermann,* ed. C. Andreas et al. (Weinheim): 121–28.
Semenzato (1960)
 Semenzato, Camillo. "Michele Sanmicheli architetto militare," in *Michele Sanmicheli. Studi raccolti dall'Accademia di Agricoltura scienze e lettere di Verona per la Celebrazione del IV centenario della morte* (Verona): 75–93.
Serlio (1540)
 Serlio, Sebastiano. *Il terzo libro di Sebastiano Serlio bolognese. . .,* (Venice).
Serlio (1619)
 Serlio, Sebastiano. *Tutte l'opere d'architettura e prospetiva* (Venice).
Sigismondo dei Conti (1883)
 Sigismondo dei Conti da Foligno. Le storie de' suoi tempi dal 1475 al 1510 2 vols. (Rome).
Smith (1977)
 Smith, Norman A.F. "The Origins of the Water Turbine and the Invention of Its Name," in *History of Technology: Second Annual Volume* (London): 215–59.
Somella Beda (1973)
 Sommella Beda, Giuseppina, ed. *Roma: le fortificazioni del Trastevere,* catalogue of the exhibition, Lucca, 1973.
Spagnesi (1992)
 Spagnesi, Piero. "Momenti della vicenda architettonica di Castel Sant'Angelo da Alessandro VI a Vittorio Emauele III,"

Ph.D. diss., Università "La Sapienza" di Roma, Rome.

Stevenson (1921)
Stevenson, Edward Luther. *Terrestrial and Celestial Globes: Their History and Construction* (New Haven).

Strobino (1953)
Strobino, Giovanni. *Leonardo da Vinci e la meccanica tessile* (Milan).

Taccola (1971)
Taccola, Mariano. *De machinis. The Engineering Treatise of 1449* [Ms CLM 28800], ed. G. Scaglia, 2 vols. (Wiesbaden).

Taccola (1984)
Taccola, Mariano. *De ingeneis, Books I and II and Addenda (The Notebook)* [Ms CLM 197, part II], ed. G. Scaglia, F.D. Prager, U. Montag (Wiesbaden).

Tolaini (1979)
Tolaini, Emilio. *Forma Pisarum. Storia urbanistica della città di Pisa: problemi e ricerche* (Pisa).

Tomei (1942)
Tomei, Piero. *L'architettura a Roma nel Quattrocento* (Rome): 93–101.

Turner (1986)
Turner, Anthony J., *Astrolabes, Astrolabe-related Instruments, The Time Museum, Time-measuring Instruments*, vol. 1, part 1 (Rockford, Ill.).

Tuttle (1982)
Tuttle, Richard. "Against Fortifications: The Defense of Renaissance Bologna," *Journal of the Society of Architectural Historians* 41: 189–201.

Valturius (1472)
Valturius, Robertus. *De re militari* (Verona).

Valturius (1483)
Valturius, Robertus. *De l'arte militare* (Verona).

Varchi (1838–41)
Varchi, Benedetto. *Storia Fiorentina*, ed. L. Arbib, 3 vols. (Florence).

Vasari (1846–70)
Vasari, Giorgio. *Le vite de' più eccellenti pittori, scultori ed architetti*, ed. Le Monnier, 14 vols. (Florence).

Vasari (1906)
Vasari, Giorgio. *Le Opere di Giorgio Vasari*, ed. G. Milanesi, 9 vols. (Florence).

Vasari-Milanesi (1878–85)
Vasari, Giorgio. *Le vite de' più eccellenti pittori scultori et architettori*, ed. G. Milanesi, 9 vols. (Florence).

Vasori (1980)
Vasori, Orietta. *I monumenti antichi in Italia nei disegni degli Uffizi*, ed. A. Giuliano (Rome).

Vegetius Renatus (1524)
Vegetius Renatus, Flavius. *Vegetio de larte militare ne la commune lingua novamente tradotto* (Venice).

Vegetius Renatus (1540)
Vegetius Renatus, Flavius. *Vegetio de larte militare. . .* (Venice).

Vegetius Renatus (1885)
Vegetius Renatus, Flavius. *Epitoma institutorum rei militaris*, ed. C. Lang (Stuttgart); 1st edition, *De re militari*, ed. J. Sulpitius (Rome, 1487).

Veltman (1986)
Veltman, Kim, and Kenneth Keele. *Linear Perspective and the Visual Dimensions of Science and Art* (Munich).

Venturi (1938)
Venturi, Adolfo. *Architettura del Cinquecento*, Storia dell'Arte Italiana, vol. 6, part 1 (Milan).

Vitruvius (1969)
Vitruvius. *De Architectura*, ed. J. Subiran (Paris).

Von Stromer (1977)
Von Stromer, Wolfgang. "Brunelleschis automatischer Kran und die Mechanik der Nürnberger Drahtmüle," *Architectura* 7: 163–74.

Wailes (1956)
Wailes, Rex. "A Note on Windmills," in C. Singer, E.J. Holmyard, A.R. Hall, T.I. Williams, eds., *A History of Technology*, vol. 2 (New York, London): 623–28.

Wallace (1987)
Wallace, William. "'Dal disegno allo spazio': Michelangelo's Drawings for the Fortifications of Florence," *Journal of the Society of Architectural Historians* 46: 119–34.

Wasserman (1966)
Wasserman, Jack. *Ottaviano Mascarino and His Drawings in the Accademia Nazionale di San Luca* (Rome).

Westfall (1974)
Westfall, Carroll William. *In This Most Perfect Paradise: Alberti, Nicholas V, and the Invention of Conscious Urban Planning in Rome, 1447–55* (University Park, Pa.).

Wolff Metternich (1972)
Woff Metternich, Franz Graf. *Die Erbauung der Peterskirche zu Rom im 16.Jahrhundert* (Vienna).

Zampa (1987)
Zampa, Paola. "Dall'astrazione alla regola. Considerazioni in margine ad un disegno di Antonio da Sangallo il Giovane," *Bollettino d'Arte* 72, 46: 49–62.

Indexes

bochette, 1027 r.
bombarda, 1481 r.
bombardiera, 1392 r., 1502 r.
borgo, 889 v., 939 r., 1155 r.
botta, 1440 r., 1451 r., 1473 r.
botte, 818 r., 1451 r., 1504 r.
bottega, 299 r., 1289 r.
bottuccio, 1217 r.
bracia (*handle*), 1485 r.
bracie, 852 r.
breccia, 779 r.
brecciaolo (brecioluo), 1049 r.
bronzo, 1564 r.
bugna (bugnie), 1846 r.
buoi, 1504 r.
busa, 1212 r., 1458 r., 1482 r.
busi, 294 v., 1452 r., 1454 r.
buso, 1444 r., 1469 r., 1469 v.
bussolo (busola), 934 r., 1449 v.
buttafuoco, 272 r., 814 r., 1024 r., 1027 v.
cacio, 1484 v.
caditore, 901 r., 1473 r.
calatatoi, 901 r.
calatoro, 1392 r.
calcie, 852 r., 931 r.
calcina, 1025 r., 1440 r.
caldaria, 852 r.
camera, 738 r., 740 r., 742 r., 749 r.
camera dei cuochi, 740 r.
camera per servitori, 738 r.
camerone, 299 r., 742 r.
camino, 739 r., 742 r., 945 r., 1027 v., 1396 r.
campagna, 728 r., 757 v., 783 r., 805 r., 808 r., 972 v., 979 v., 1028 v., 1031 r., 1392 r.
campanile, 737 r., 738 r., 739 r., 740 r., 771 r., 772 r., 773 r., 809 r., 1012 r., 1029 r.
campo, 729 r.
campora, 771 r., 773 r.
canale, 791 r., 797 r., 852 r., 880 r., 889 v., 891 r., 1217 r., 1242 r., 1446 v.
canape, 1482 r.
cancello, 1515 r.
canetto, 1449 v.
cani, 1495 r.
canna, 294 v.
canneto, 939 r.
cannone, 821 r., 825 r., 855 r./v., 858 r., 885 r., 1442 r.
cannoniera, 803 r., 808 r., 808 v., 809 r., 814 r., 884 v., 885 r., 1027 r., 1289 r./v., 1392 r., 1396 r.
canona, 738 r., 739 r., 740 r.
cantarile, 1029 r.
cantina, 738 r., 739 r., 743 r., 811 r., 931 r., 953 r., 1659 r.
cantonata, 730 r.
cantone, 272 r.
caocia, 1344 r.
capannati, 1389 r.
capello, 1448 r.
capi, 820 r., 1449 v.
capitello, 826 r., 1458 r.
capitolo, 737 r., 739 r.
Capituli, 1447 r., 1469 r.
cappella, 737 r., 739 r./v.

cappio, 1458 r.
cappo di corda, 1485 r.
capretta, 294 r.
cara, 3951 r.
carbone, 1445 r.
carcha, 1470 r.
cardinale, 1217 r.
cardini, 1469 r.
Carmona, 801 r.
carreto, 956 r.
carriole, 1482 r.
carro, 1450 r., 1470 r.
carro balista, 1470 r.
carta, 299 r.
casa, 271 r., 294 r., 299 r., 732 r., 736 r., 742 r., 743 r., 743 v., 748 v., 752 v., 771 r., 774 r., 791 r., 797 r., 943 r., 1012 r., 1026 r., 1028 v., 1030 v., 1049 r., 1448 r., 1504 r., 1515 r.
casa (*axle*), *see* chasa
casaccia, 746 r., 934 r./v.
casamatta, 754 r., 808 r., 808 v., 893 r., 1027 r./v., 1289 r., 1389 r., 1507 r.
casamento, 772 r., 773 r.
casarino, 294 r.
caseno, 891 v.
cassero, 1511 r.
casetta, 294 r., 891 r., 1015 r., 3950 v.
cassa, 1440 r., 1449 r., 1451 r., 1477 r., 1504 r.
cassoni, 852 r.
castagno, 1479 r.
castellano, 838 r., 931 r., 1028 r., 1511 r.
castello, 301 r., 800 r., 827 v., 910 r., 943 r., 1012 r., 1020 v., 1222 r., 1511 r.
catapulta, 1447 r.
catena (*chain*), 299 r., 742 r., 1118 r., 1445 v., 1467 r., 1469 r., 1473 r., 1488 r., 1528 r.
cateratta (*waterfall*), 1503 r.
cava, 813 r., 1017 r.
cavalatori, 748 r.
cavalierata, 1028 v.
cavaliere, 271 r., 272 r., 301 v., 724 r., 796 r., 799 r., 800 r., 805 r., 806 r., 808 r., 808 v., 809 r., 811 r., 812 r., 889 v., 936 r., 954 r., 956 r., 963 r., 1012 r., 1015 r., 1028 r., 1031 r., 1052 r., 1207 r., 1354 r., 1392 r.
cavalieretto, 1028 r.
cavalieria, 759 r.
cavallo, 272 r., 756 r., 852 r., 961 r., 1245 r., 1268 r., 1440 r., 1442 r., 1445 r., 1446 r., 1449 r., 1449 v., 1471 r., 1471 v., 1528 r., 3950 r., 3951 r.
cavedio, 745 r., 746 r., 747 r.
cavia(?), 858 r.
caviglia, 1469 v.
cavo, 963 r.
cellari, 738 r., 739 r.
centina, *see* ghientine
centro, 825 r.
centuri, 1185 r.
cerchi, 847 r., 855 r.
cerchio (delle mura), 1025 r.
chalciesi, 1482 r.

chasa (*axle*), 1448 r.
chiavarola(?), 1528 r.
chiave, 742 r., 826 r.
chiavica (chiavacha), 801 r., 1446 v.
chiesa, 737 r., 739 v., 800 r., 811 r., 811 v., 889 r., 901 r., 902 r., 941 r., 943 r., 944 r., 954 r., 956 r., 1022 r., 1026 r., 1028 r./v.
chiesetta, 954 r.
chiodo, 901 r., 1484 v.
chiostro, 739 v., 811 r.
chiusa, 1217 r.
chorobata, 1409 v.
churi (*rollers*), 3950 r.
chusarino, 294 r.
cientina, 1564 r.
ciera, 1344 r.
ciglio, 892 r.
cima, 112 r., 271 r., 272 r., 729 r., 770 r., 799 r., 808 r., 1027 v., 1031 r., 1032 r., 1212 r., 1289 v., 1440 v., 1517 r.
cinta, 729 r., 890 r., 1389 r.
circuito, 839 r., 979 r.
circulo, 316 r.
circumferentia, 755 r., 1024 r., 1242 r., 1446 r., 1446 v., 1447 r., 1461 r.
cisterna, 1020 r., 1517 r.
città, 272 r., 783 r., 809 r., 958 v., 1022 r., 1028 r., 1052 r., 1222 r., 1397 r.
cittadella, 301 r., 755 r., 809 r., 889 r., 1467 r.
cohorti, 1185 r.
colle, 773 r., 800 r., 807 r.
colletti, 729 r.
collina, 301 r., 812 r., 889 r., 956 r., 1015 r., 1028 r.
colme, 1486 r.
colomba, 945 r.
colonna, 112 r./v., 858 r., 1155 r., 1212 r., 1282 r., 1448 r., 1472 r.
colonna (*vertical edge of triangle*), 851 v.
colosseo, 956 r.
colubrina, 821 r., 825 r., 855 r., 885 r.
columbari, 901 r., 945 r.
comodità, 189 r., 729 r.
condotto, 1092 v.
coniare, 1441 r.
conio, 1458 r.
conpaso, 1491 v.
conserva, 1354 r.
conserva d'aqua, 1222 r.
conserva di legno, 1354 r.
contraforti, 833 r., 890 r., 891 v., 944 r.
contramina, 792 r., 801 r., 814 r., 1289 r., 1395 r., 1396 r.
contrapeso, 1076 v., 1440 r., 1449 v., 1470 r.
contrassegno, 934 r.
convento, 736 r., 737 r., 738 r., 739 v., 811 r., 1031 r., 1472 v.
coperchio, 1509 r.
coperto, 271 r., 272 r., 294 r.
coperto (*for artillery*), 807 r., 1481 r.
coraza, 3970 r.
corda, 1440 r., 1449 r., 1449 v., 1458 r., 1473 r., 3951 r.
corda a ranpini, 3951 r.

977 r., 978 r., 1028 r., 1217 r.
valletta, 811 r., 813 r., 814 r., 1015 r., 1019 r.
vano, 739 v., 743 r., 1290 r.
vasco, 1446 v.
veduta, 857 v., 1106 r.
vela, 1448 r., 1449 v., 1471 v.
ventelo, 1449 r.
venti (*antennae*), 3951 r.
vernici, 1469 r.
verriciello, 1458 r.
verrocchio, 1458 r.
vescovato, 299 r., 742 r., 746 r., 1217 v.
vescovo, 1217 r.
vestibolo, 745 r., 746 r., 747 r., 760 r.
vezosa, 1449 v., 1471 r.
via, 301 r., 939 r., 1179 r., 1212 r., 1217 r., 1512 r.
vicino, 727 r., 743 r., 748 r.
vignia, 938 r., 1294 r.
villani, 889 v.
vite, 1106 r., 1215 v., 1441 r., 1443 r., 1445 r., 1449 v., 1450 r., 1454 r., 1471 v., 1477 r., 1482 v., 1493 r., 1528 r.
vite a tornio, 1441 r.
volta, 297 r., 299 r., 931 r., 1014 r., 1024 r., 1354 r., 1659 r.
voltare, 299 r.
voltetta, 272 r.
volto, 754 r., 978 r., 1289 r.
zecca, 189 r., 297 r., 299 r.
zolfo, 1445 r.

Subject Index

The following index is keyed to the entries provided by the scholars and refers readers to the subjects and issues raised there. As many issues are raised under locations and the names of authors or collaborators of Antonio da Sangallo the Younger it is suggested that readers first employ the Index of Names and the Index of Places before turning to the Subject Index. The Subject Index is, in effect, a complementary index to the Index of Architectural and Mechanical Terms.

Index of Proper Names

This index provides a list of the names of
persons cited in the entries and in the
inscriptions. Names that are cited by the
Sangallo circle are highlighted in **bold**.
Names that were added on the sheets by a
later hand have been *italicized* as well.
Some regularization of spelling has taken
place so that the reader may find refer-
ences easily. Other names have been left as
found on the sheets themselves. Also
included are names of peoples (Etruscan,
Egyptian, etc.). See also the Index of Man-
uscript Sources, since many figures, such
as Francesco di Giorgio or Mariano Tac-
cola, usually are cited along with their
manuscripts.

Index of Places

Although the sheets are extensively marked with place names, it has, naturally, been possible to identify a great deal more on the drawings than what is indicated in the annotations of Antonio the Younger and his workshop. This index thus provides a summary of information provided by the drawings themselves, and we have thus adopted the identification used by the architect on the sheet. Further information has been gleaned by the scholars from the sheets and this too has been indexed. Significant discussions of the citation are marked in **bold**.

List of Sheets Included in Volume One

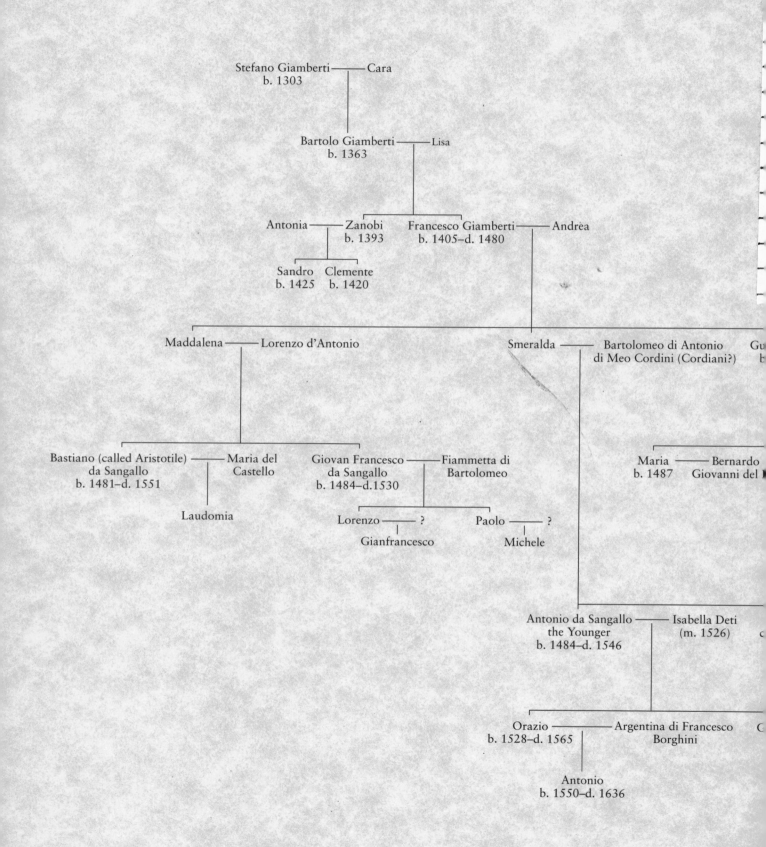

Stefano Giamberti ———— Cara
b. 1303

Bartolo Giamberti ———— Lisa
b. 1363

Antonia ———— Zanobi Francesco Giamberti ———— Andrèa
b. 1393 b. 1405–d. 1480

Sandro Clemente
b. 1425 b. 1420

Maddalena ———— Lorenzo d'Antonio Smeralda ———— Bartolomeo di Antonio Gu
di Meo Cordini (Cordiani?) b

Bastiano (called Aristotile) ———— Maria del Giovan Francesco ———— Fiammetta di Maria ———— Bernardo
da Sangallo Castello da Sangallo Bartolomeo b. 1487 Giovanni del
b. 1481–d. 1551 b. 1484–d.1530

Laudomia Lorenzo ——— ? Paolo ——— ?
 Gianfrancesco Michele

Antonio da Sangallo ———— Isabella Deti
the Younger (m. 1526)
b. 1484–d. 1546

Orazio ———— Argentina di Francesco
b. 1528–d. 1565 Borghini

Antonio
b. 1550–d. 1636